# ARTS *of* KOREA

# ARTS *of* KOREA

Contributors

Chung Yang-mo, Ahn Hwi-joon, Yi Sŏng-mi,
Kim Lena, Kim Hongnam, Pak Youngsook,
Jonathan W. Best

*Coordinating Editor*
Judith G. Smith

THE METROPOLITAN MUSEUM OF ART
YALE UNIVERSITY PRESS

This publication is issued on the occasion of the opening of the Arts of Korea Gallery at The Metropolitan Museum of Art, and the inaugural exhibition *Arts of Korea*, The Metropolitan Museum of Art, New York, June 9, 1998–January 24, 1999.

The establishment of and program for the Arts of Korea Gallery have been made possible by The Korea Foundation and The Kun-Hee Lee Fund for Korean Art.

The exhibition and this accompanying publication are made possible in part by the Samsung Foundation of Culture.

Support has also been provided by LG.

An indemnity has been granted by the Federal Council on the Arts and the Humanities.

Published by
The Metropolitan Museum of Art
1000 Fifth Avenue
New York, New York 10028

Library of Congress Cataloging-in-Publication Data

Arts of Korea / contributors, Chung Yang-mo, Ahn Hwi-joon,
    Yi Sŏng-mi, Kim Lena, Kim Hongnam, Pak Youngsook,
    Jonathan W. Best ; coordinating editor, Judith G. Smith.
        p.        cm.
    Catalog of an exhibition held at the Metropolitan
Museum of Art, June 9, 1998–Jan. 24, 1999.
    Includes bibliographical references and index.
    ISBN 0-87099-850-1 (HC)—0-300-08578-8 (Yale
University Press)
    1. Art, Korean--Exhibitions.  I. Chŏng, Yang-mo, 1934–
II. An, Hwi-jun, 1940–  III. Yi, Sŏng-mi, 1939– [et al.]
IV. Smith, Judith G., 1941–  V. Metropolitan Museum of Art
(New York, N.Y.)
N7362.A78  1998
709'.518'0747471--dc21                          98-6404
                                                  CIP

Jacket Illustration
Detail of plate 78:Unidentified artist (14th century). *Illustrated Manuscript of the Lotus Sutra.* Koryŏ dynasty (918–1392), ca. 1340. Folding book, gold and silver on indigo-dyed mulberry paper, 13 × 4 ½ in. (33 × 11.4 cm). The Metropolitan Museum of Art, Purchase, Lila Acheson Wallace Gift, 1994 (1994.207)

Book design, composition, and production by
Joseph Cho and Stefanie Lew, Binocular, New York

Printed and bound in Canada by Friesens

Four-color separations by Seh-Kwang Printing Co., Seoul

Coordinating Editor, Judith G. Smith

Editorial/Production Assistant, Hongkyung Anna Suh

Associate Editors, Elizabeth Powers and Raymond Furse

The color photographs of all the paintings and objects in Korean collections were made in Korea by Han Seok-Hong, Han's Photo Studio, Seoul.

The color and black-and-white photographs of the paintings and objects in The Metropolitan Museum of Art were made by Bruce J. Schwarz, Paul Lachenauer, and Patricia Mazza, The Photograph Studio, The Metropolitan Museum of Art.

The maps in this book were designed by Christine Hiebert, Design Department, The Metropolitan Museum of Art

# Contents

# Preface

With the opening in June 1998 of the Arts of Korea Gallery, the final step will be taken toward attaining our goal of full representation of Asian Art at the Metropolitan Museum. The establishment of the gallery and the Korean art program, a project we had long aspired to and finally embarked on in 1995, confirms the Museum's commitment to the display and study of Korean art. We are grateful to the Korea Foundation and the Samsung Foundation of Culture for their generous and unfailing support of this important undertaking. In particular, we wish to express our deep appreciation to Mme. Ra Hee Hong Lee, Director General, the Samsung Foundation, without whose wise encouragement this project would not have been realized.

In celebration of the opening of the Arts of Korea Gallery, we have organized an inaugural exhibition of one hundred masterworks of Korean art. We are most grateful to Mr. Chung Yang-mo, Director General of The National Museum of Korea, and his senior staff for their stalwart support of the exhibition and generous loan of objects, as well as to all the other lenders for their gracious participation. The exhibition was developed in consultation with an advisory committee of distinguished senior Korean art scholars: Director General Chung; and Professors Ahn Hwi-joon, Seoul National University; Yi Sŏng-mi, The Academy of Korean Studies; Kim Lena, Hongik University; Kim Hongnam, Ewha Womans University; and Pak Youngsook, School of Oriental and African Studies, University of London. Professor Kim Hongnam was appointed as Special Consultant to work with Wen C. Fong, Consultative Chairman of the Department of Asian Art, at the Metropolitan Museum, and the Asian Art department staff to help develop the project. The catalogue, reflecting the scholarly expertise of our academic and museum colleagues in Korea, presents a compelling and thorough survey of the key developments in the history of Korean art. This landmark publication will serve as an important introduction for a Western audience to the rich artistic and cultural legacy of Korea. Both these complex projects, exhibition and catalogue, were orchestrated through the efforts of Judith G. Smith, Special Assistant to the Consultative Chairman, Department of Asian Art.

The successful inauguration of the Arts of Korea Gallery owes much to the good will and determination of our Korean friends in supporting the display and study of the best of Korean art at the Metropolitan. For their help in providing the funds for the construction of the gallery, we especially wish to acknowledge the late Dr. Choi Chang-yoon, President of the Korea Foundation, and former President Dr. Kim Joungwon. Mr. Han Yong Oe, Executive Vice President of the Samsung Foundation, was instrumental in establishing the endowment fund for the Korean art program. Thanks are also owed to Mr. Kyu Sung Woo for his outstanding contribution as Design Architect of the Arts of Korea Gallery.

Philippe de Montebello, Director, The Metropolitan Museum of Art

# Preface

For over one hundred years The Metropolitan Museum of Art, a treasure house of world cultures, has exemplified the American people's appreciation of artistic excellence and their belief that international mutual understanding can arise from cultural interchange. Since my first association with the Metropolitan in 1989, I have been continually impressed with the Museum's preeminent exhibition program and its worldwide reputation for excellence in scholarship and curatorial standards.

The comprehensiveness of the Metropolitan's collections is now being further augmented by the establishment of the Arts of Korea Gallery, which has long been a fond wish of the Korean people and of many Americans as well. The inauguration of the Arts of Korea Gallery is celebrated by a special exhibition, the importance of which has few parallels outside Korea. Enriched by generous loans from individuals and institutions in Korea and abroad, it will afford an opportunity to introduce the uniqueness and beauty of Korean art, over its entire range, to countless visitors and scholars from all over the world. The Korea Foundation and the Samsung Foundation of Culture have been instrumental in supporting this great venture. Its success has been ensured by the leadership of the Metropolitan's director, Philippe de Montebello, and the efforts of Professor Wen Fong and the dedicated staff of the Department of Asian Art. On behalf of The National Museum of Korea, I congratulate the Metropolitan on the opening of the Arts of Korea Gallery and the publication of this catalogue, both of which provide a most admirable starting point for the development of the Korean art program at the Museum.

Because of special historical circumstances, the arts and culture of Korea, whose distinctive characteristics played an important role in the formation of East Asian artistic traditions, are not yet well known to the world. We art historians in Korea look forward to working with the staff of the Metropolitan Museum to bring more Korean art exhibitions and programs to the viewing public in the West.

Chung Yang-mo, Director General, The National Museum of Korea

# Acknowledgments

We wish to express our profound gratitude to Mr. Chung Yang-mo, Director General of The National Museum of Korea, for suggesting that The Metropolitan Museum of Art inaugurate its new, permanent Arts of Korea Gallery with an exhibition of major works from The National Museum of Korea and important private collections in Korea. Without the steadfast support and cooperation of Director General Chung and his able staff, this important exhibition would not have been possible. For their help in organizing the exhibition, we wish to thank the senior staffs of The National Museum, in particular, Mr. Ji Kun-Kil, Chief Curator; Messrs. Han Young-hee and Kim Seong-Goo, the curatorial heads, respectively, of the Departments of Archaeology and Fine Arts; Mr. Pak Young-bok, Chief Registrar, and Mr. Lee Kun-sang and Mss. Yu Ok-kyoung and Lee In-Yeung, Department of Registration; Mr. Ahn Byong-Chan, Conservation Laboratory; Mr. Kim Hong-sik, Director of the Cultural Exchange and Education Division, and his staff, including Mr. Jeong Yun-Kwan and Mss. Lee Hee-ran and Kim Jin-myung. We owe special thanks to Ms. Kim for her excellent services as translator and interpreter. Mr. Kang Woo-bang, Director of the Kyŏngju National Museum, and Messrs. Shin Kwangseop and An Sŏng-mo, Directors, respectively, of the Puyŏ and Taegu National Museums, graciously made available their staffs to help in photographing the objects in their collections. We also wish to extend our appreciation to each of the private institutions and collections in Korea that have participated in the exhibition, most especially the Ho-Am Art Museum, for the generous loan of important objects from its holdings.

The organization of this catalogue and exhibition has benefited from the learned expertise and guidance of our advisory committee of leading senior Korean art scholars, each of whom contributed to this book an important scholarly essay: Director General Chung and Professors Ahn Hwi-joon, Seoul National University; Yi Sŏng-mi, The Academy of Korean Studies; Kim Lena, Hongik University; Kim Hongnam, Ewha Womans University; and Pak Youngsook, School of Oriental and African Studies, University of London. Jonathan W. Best, Professor of Asian Art History at Wesleyan University, provided an essential historical overview of the political and social conditions that led to the creation of the works of art described in the catalogue. We wish to acknowledge with warm gratitude all these distinguished colleagues for sharing their lifelong research and knowledge and helping to bring to the Western audience an awareness and understanding of the very special and distinctive cultural and artistic legacy of Korea. We are also grateful to the Prospero Foundation, which provided invaluable support during the initial stages of the development of the Museum's Korean art program.

The production of this book was the cooperative effort of a dedicated team of professionals. The book's elegant design is the creation of Joseph Cho and Stefanie Lew, who

also produced the typeset pages and were involved in all phases of production. They worked under difficult circumstances, with unfailing grace and patience, to ensure the successful completion of this project. Mr. Han Seok-Hong, assisted by Mr. Kim Kwang-Seop, photographed each of the objects in Korean collections and worked tirelessly to ensure the accuracy of all color separations. Barbara Bridgers and The Photograph Studio of the Metropolitan Museum provided extensive photography services for the catalogue. We are grateful to Elizabeth Powers and Raymond Furse for their expert editorial assistance; to Angela Darling and Linda Shulsky for their help in manuscript preparation; to Mss. Soyoung Lee and Hyunsoo Woo and Mr. Yukio M. Lippit for translations; to Mr. Ken Okada for assistance in securing photographs and permissions to publish; and to Suzanne G. Valenstein, Research Curator, Department of Asian Art, The Metropolitan Museum of Art, who made available her expertise in ceramic technology. At all stages of this project, Eleanor S. Hyun, departmental intern, carried out a multitude of tasks with meticulous attention to detail and characteristic cheerfulness. Finally, we wish to acknowledge the invaluable contribution of Hongkyung Anna Suh, Curatorial Assistant in the Department of Asian Art, the Metropolitan Museum, who worked closely with us in all matters related to the establishment of the Arts of Korea Gallery, the inaugural exhibition, and this book.

Wen C. Fong
Consultative Chairman
Department of Asian Art
The Metropolitan Museum of Art

Judith G. Smith
Special Assistant to the Consultative Chairman
Department of Asian Art
The Metropolitan Museum of Art

# Lenders to the Exhibition

Buddhist Art Museum of Korea, Seoul

Mary and Jackson Burke Foundation

Chŏng Kap-bong Collection, Seoul

Dongguk University Museum, Seoul

Ewha Womans University Museum, Seoul

Ho-Am Art Museum, Yongin

Horim Art Museum, Seoul

Florence and Herbert Irving

Korea University, Seoul

Kyŏnghŭi University, Seoul

Kyŏngju National Museum, Kyŏngju

Museum of Oriental Ceramics, Osaka

The National Museum of Korea, Seoul

Puyŏ National Museum, Puyŏ

Taegu National Museum, Taegu

U Hak Collection, Seoul

Yoon Hyung-sik Collection, Haenam

# Dynastic Chronology of Korea, China, and Japan

| KOREA | | CHINA | JAPAN |
|---|---|---|---|
| | BCE | | |
| | 8000 | | Jōmon, 8000−200 BCE |
| Neolithic Period, ca. 7000−ca. 10th century BCE | | Shang Dynasty, ca. 1600−ca. 1100 BCE | |
| | 2000 | | |
| | 1000 | | |
| Bronze Age, ca. 10th−ca. 3rd century BCE | | Zhou Dynasty, ca. 1100−256 BCE | |
| | 500 | | |
| | | | Yayoi, ca. 400 BCE−ca. 300 CE |
| Iron Age, ca. 300 BCE | | | |
| | | Qin Dynasty, 221−206 BCE | |
| | | Han Dynasty, 206 BCE−220 CE | |
| Three Kingdoms Period, 57 BCE−668 CE | | | |
| Silla Kingdom, 57 BCE−668 CE | 0 | | |
| Paekche Kingdom, 18 BCE−660 CE | | | |
| Koguryŏ Kingdom, 37 BCE−668 CE | | Six Dynasties, 220−589 | |
| | | | Kofun, ca. 300−ca. 600 |
| Kaya Federation, 42−562 | | | |
| | 500 | Sui Dynasty, 581−618 | Asuka, 538−645 |
| | | Tang Dynasty, 618−907 | Early Nara, 646−710 |
| Unified Silla Dynasty, 668−935 | | | Nara, 710−784 |
| | | | Heian, 794−1185 |
| | | Five Dynasties, 907−60 | |
| Koryŏ Dynasty, 918−1392 | | Liao Dynasty, 916−1125 | |
| | 1000 | Song Dynasty, 960−1279 | |
| | | Jin Dynasty, 1115−1234 | Kamakura, 1185−1333 |
| | | Yuan Dynasty, 1272−1368 | |
| | | | Nanbokuchō, 1333−1392 |
| Chosŏn Dynasty, 1392−1910 | | Ming Dynasty, 1368−1644 | Muromachi, 1392−1573 |
| | 1500 | | |
| | | | Momoyama, 1573−1615 |
| | | Qing Dynasty, 1644−1911 | Edo, 1615−1867 |
| | | | Meiji, 1868−1911 |
| | 1900 CE | | |

*Notes to the reader*

The following standard systems have been adopted for the transliterations of East Asian names and texts: modified McCune-Reischauer for Korean (with the use of apostrophes following the conventions of *Basic Glossary of Korean Studies*, The Academy of Korean Studies, Seoul, 1993), *pinyin* for Chinese, and Hepburn for Japanese. Unless otherwise specified, foreign terms are in Korean. Exceptions in transliteration are made for some words and modern names with established spellings in other systems, such as Seoul. Sanskrit terms are transliterated without diacritical marks. Dates for the Three Kingdoms are traditional dates, and do not necessarily reflect the opinions of all scholars.

# The Three Kingdoms at the Height of Koguryŏ Expansion (late 5th Century)

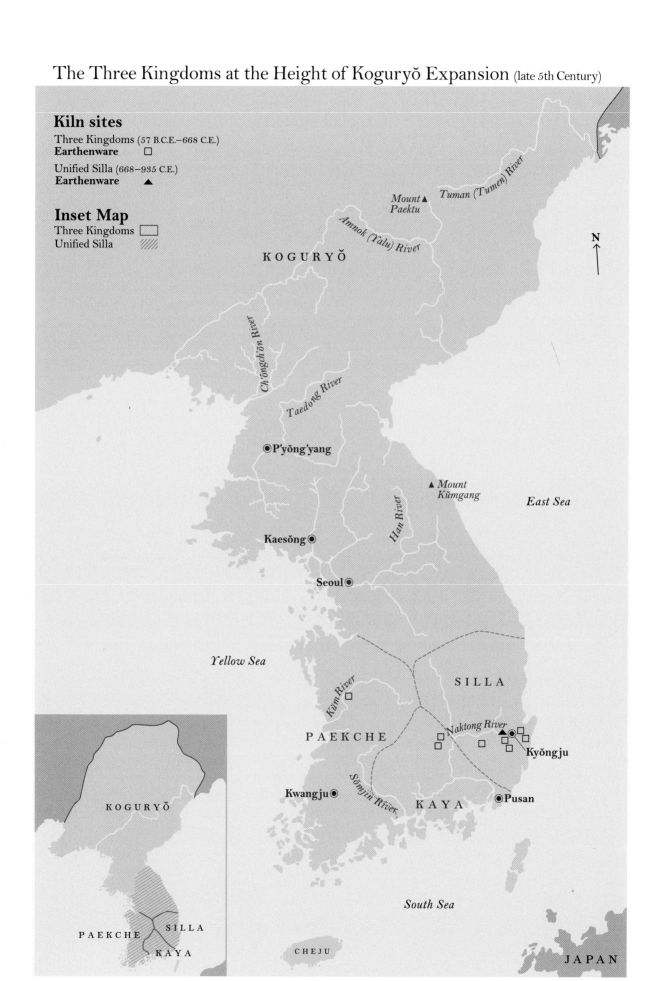

**Kiln sites**

Three Kingdoms (57 B.C.E.–668 C.E.)
**Earthenware**  ☐

Unified Silla (668–935 C.E.)
**Earthenware**  ▲

**Inset Map**

Three Kingdoms  ☐
Unified Silla  ▨

N

KOGURYŎ

*Mount* ▲
*Paektu*

*Tuman (Tumen) River*

*Amnok (Yalu) River*

*Ch'ŏngch'ŏn River*

*Taedong River*

◉P'yŏng'yang

▲ *Mount Kŭmgang*

*East Sea*

*Han River*

Kaesŏng ◉

Seoul◉

*Yellow Sea*

*Kŭm River*  ☐

SILLA

*Naktong River* ▲◉ ☐

PAEKCHE

☐ ☐
☐ ☐ ☐
☐

Kyŏngju

Kwangju◉

*Sŏmjin River*

KAYA

◉Pusan

*South Sea*

CHEJU

JAPAN

KOGURYŎ

PAEKCHE  SILLA
KAYA

# The Korean Peninsula

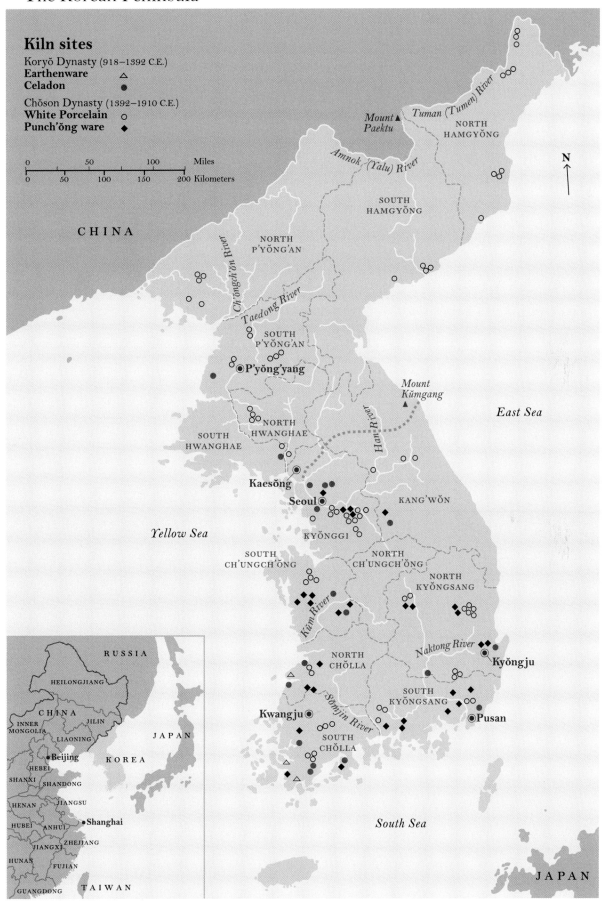

## Kiln sites

Koryŏ Dynasty (918–1392 C.E.)
**Earthenware** △
**Celadon** ●

Chŏson Dynasty (1392–1910 C.E.)
**White Porcelain** ○
**Punch'ŏng ware** ◆

| 0 | | 50 | | 100 | Miles |
|---|---|---|---|---|---|
| 0 | 50 | 100 | 150 | 200 | Kilometers |

CHINA

Mount Paektu ▲

Tuman (Tumen) River

NORTH HAMGYŎNG

Amnok (Yalu) River

SOUTH HAMGYŎNG

NORTH P'YŎNG'AN

Ch'ŏngch'ŏn River

Taedong River

N

SOUTH P'YŎNG'AN

● **P'yŏng'yang**

Mount Kŭmgang ▲

East Sea

NORTH HWANGHAE

SOUTH HWANGHAE

Han River

**Kaesŏng**

**Seoul**

KANG'WŎN

Yellow Sea

KYŎNGGI

SOUTH CH'UNGCH'ŎNG

NORTH CH'UNGCH'ŎNG

NORTH KYŎNGSANG

Kŭm River

Naktong River

NORTH CHŎLLA

● **Kyŏngju**

SOUTH KYŎNGSANG

**Kwangju**

Sŏmjin River

● **Pusan**

SOUTH CHŎLLA

South Sea

JAPAN

RUSSIA

HEILONGJIANG

CHINA    JILIN

INNER MONGOLIA    LIAONING

● **Beijing**

HEBEI

SHANXI    SHANDONG

HENAN    JIANGSU

HUBEI    ANHUI

● **Shanghai**

JIANGXI    ZHEJIANG

HUNAN    FUJIAN

GUANGDONG

TAIWAN

JAPAN

KOREA

Jonathan W. Best

Profile of the Korean Past

As recently as fifteen to eighteen thousand years ago, during the last Ice Age, the geographical disposition of northeastern Asia differed vastly from its present-day configuration. Neither the Korean peninsula nor the central islands of Japan existed as separate topographic entities. At that time the area of the present Yellow Sea formed a wide river-fed plain stretching unbroken between what are now the western shores of Korea and the eastern shores of China's Shandong peninsula. Similarly, to the south, the present Japanese islands of Honshū, Kyūshū, and Shikoku comprised a continuous landmass with the then undifferentiated Korean peninsula. But with the melting of the great glaciers, the sea level rose and the ocean's waves gradually sculpted the map of northeastern Asia as we know it. Korea emerged as a mountainous peninsula tied to Manchuria in the north, facing China to the west across the narrow Yellow Sea, and extending southward toward the Japanese archipelago. The rocky backbone of Korea is fashioned from a long chain of mountains that dominates the eastern half of the peninsula from its northern borders on the Yalu (Amnok) and Tumen (Tuman) Rivers almost to its southern extremity. Two notable lateral mountain ranges project westward from this great granite wall. One forms a protective barrier around the fertile Naktong River valley in the center of Korea's southern coast, while the other stretches most of the way across the peninsula's width to north of the Han River valley.

Geography sets history's stage. Both the peninsula's external relationship to the rest of Asia and its internal fragmentation by mountain ranges have exercised critical roles in shaping the history of the Korean people. The earliest ceramic remains from Korea most closely resemble those of Manchuria and thus provide archaeological evidence of the latter area's primal role in the formation of Korean culture. Yet archaeology also reveals that soon after the start of the first millennium b c e, if not earlier, the technologically advanced, metal culture of China began to inspire peninsular emulation in the fashioning of objects in stone and bronze for the Korean elite. Archaeology further indicates that this enrichment of Korea's material culture resulted in the steady growth of interaction with the inhabitants of the Japanese archipelago during the last centuries b c e. It is also known from early Chinese written accounts that by this date the peninsula's regional partition by the major mountain ranges had led to the development of distinctive cultures in the southeast and the southwest, along the central southern coast, and in the north. Cultural diversity among these regions not only facilitated the rise of separate royal states by the fourth century c e, but also engendered feelings of regional uniqueness, and at times even animosity, that still color intrapeninsular relations today. Yet concurrent with this divisive awareness of the regional differences has been a countervailing consciousness of peninsular solidarity. The Korean peninsula, being approximately 850 kilometers long and on average about 250 kilometers across, has long been conceptualized by both its occupants and its neighboring societies as a discrete geographical unit inhabited by a population sharing an essentially common cultural identity. Regional dissimilarities notwithstanding, Korea has made sense as a single geo-political entity. This perception, too, has exerted — and continues to exert — a fundamental influence on the course of the peninsula's history.

Traditional Korean sources present two contrasting accounts of the origins of civilization on the peninsula. One credits the achievement to an indigenous demigod, Tan'gun, whose birth more than four thousand years ago is attributed to the union of a sky deity and a bear-woman. The second account credits a Chinese noble and court minister, Jizi (Kija), who is believed to have emigrated to Korea with a large group of followers at the start of the Zhou dynasty (ca. 1100–256 b c e). The contrast between these two traditions reveals a tension that long conditioned premodern Korean perceptions of their own culture: on the one hand, there was proud awareness of cultural distinctiveness and, on the other hand, recognition of an extensive influence of Chinese civilization. An arena in which this tension is perhaps especially pronounced is the fine arts, where forms often inspired by Chinese example were produced by Korean hands to fulfill the cultural purposes and aesthetic expectations of elite Korean patrons.

## BEGINNINGS OF RECORDED HISTORY

At the end of the second century b c e the relatively passive transmission of Chinese culture to Korea by emulation and occasional immigration came to an end. The powerful

Han dynasty (206 B C E–220 C E), rulers of China, sought to prevent the formation of troublesome alliances between its nomadic neighbors beyond the Great Wall and the peoples of southern Manchuria and northern Korea by armed conquest and colonization. In the wake of the initial military onslaught of 108 B C E into Korea, Chinese authority extended down the peninsula at least as far as the Han River valley. Control of such an extensive area soon proved untenable, however, and a partial withdrawal was effected that permitted the establishment of a secure power base in northern Korea. This was a province-sized colony, the Lelang (Nangnang) Commandery in the vicinity of modern P'yŏng'yang, which was to remain a Chinese colonial bastion for over four hundred years. In addition to administering the commandery, Han officials stationed at Lelang had responsibility for overseeing most of China's diplomatic and commercial contacts with the peoples of northeastern Asia. Over time, these contacts had manifold cultural and political effects upon native populations as far north as the Sungari River in upper Manchuria and as far south as the Japanese archipelago. The Chinese colonial officials were also responsible for recording the earliest extant data about peoples of these far-flung lands.

To the northeast of Lelang, along the middle reaches of the Yalu River, lay the territory of Koguryŏ. The inhabitants of Koguryŏ were a warlike tribal people who almost from the beginning of the Chinese occupation of northern Korea were sufficiently well organized in their belligerence to pose a recurrent threat to the commandery. South of Lelang the peninsula was divided, roughly along the lines dictated by the primary mountain ranges, into three regions, each inhabited by a culturally distinct population. These populations, known collectively as the Mahan, the Pyŏnhan, and the Chinhan, formed three loose political confederations composed of multiple semi-independent communities. The Mahan, the largest of these confederations, was comprised of fifty-four communities and occupied the southwestern quarter of the peninsula. The Pyŏnhan and the Chinhan confederations were each comprised of twelve communities, the former located in the lower Naktong River valley and the latter in the southeastern littoral plain surrounding the modern city of Kyŏngju. Individual communities within the three confederations maintained — evidently at China's preference — separate diplomatic relationships with Lelang, exchanging nominal political allegiance and local products for equally nominal Chinese titles and imported luxury goods. Among the local products of special interest to Lelang was iron from the Pyŏnhan region, a commodity that according to Chinese accounts was also valued throughout the peninsula and even attracted traders from Japan. The inherently divisive Chinese policy favoring relations with individual southern Korean communities is credited with slowing the formation of cohesive political structures in the area. Yet access to Lelang's urban capital at P'yŏng'yang did provide Korean leaders with a provocative example of the power and wealth that accrued to a large, centrally organized state. It is also apparent that literate and technically skilled immigrants from Lelang significantly contributed to cultural development among the peoples of the three southern confederations. Indicative of the sophisticated lifestyle that the Confucian offi-

cials of Lelang enjoyed — and toward which the indigenous Korean elite aspired — is a small, painted lacquer bamboo basket excavated from a tomb near P'yŏng'yang and likely dating from the start of the second century (fig. 1). Imported from western China, the basket is decorated with figures representing more than ninety legendary paragons and miscreants of Confucian lore. The remarkable animated depiction of these Chinese notables constitutes one of the best of the relatively few surviving examples of Han-dynasty figure painting.

### THREE KINGDOMS PERIOD

Following the collapse of the Han dynasty in China early in the third century, the commandery of Lelang continued to function for a century or more under colonial officials who professed allegiance to a succession of the many regimes that briefly flourished in northern China. During the first half of the fourth century Koguryŏ took advantage of the instability in China, first to mount raids into southern Manchuria and then to bring Lelang under its control. The waning of Chinese authority in northeastern Asia also allowed the emergence, by the middle of fourth century, of three notable independent polities in the southern half of the peninsula. In the southeastern region of the Chinhan communities arose the indigenous, or largely indigenous, kingdom of Silla. In the south central area of the Naktong River basin, the association of Pyŏnhan communities evolved into a federation of semi-independent principalities known as the Kaya states. The territory of the Mahan in the southwest was brought under the rule of an immigrant lineage that claimed descent from the legendary founder of Koguryŏ and his even more ancient royal Manchurian ancestors. This non-native elite named their new kingdom Paekche and established its capital in the Han River valley near modern Seoul.

With the destruction of Lelang and the division of the peninsula among the three kingdoms of Koguryŏ, Silla, and Paekche plus the small princely states of Kaya, a critical new era in Korean history had dawned. Over the course of the next three hundred and fifty years the culturally and politically divided peoples of the peninsula were transformed, albeit at the cost of much bloodshed, into a single nation. Although the individual histories of the early peninsular states are too complex to detail here, they contain some elements that deserve notice because of their political or cultural relevance to the emergence of a unified Korean nation.

The unstable conditions within China that had contributed to the fall of Lelang persisted until the end of the sixth century when the Sui dynasty (581–618) finally succeeded in again unifying the Central Kingdom (the literal rendering of the traditional designation for China, Zhongguo). Just as the progressive weakening of the Chinese position at Lelang during the late third and early fourth centuries had facilitated the process of state formation on the peninsula, China's political weakness during the following two hundred and fifty years proved profoundly beneficial to the maturing of the Korean kingdoms. Throughout this lengthy period the territory of China proper was divided among the

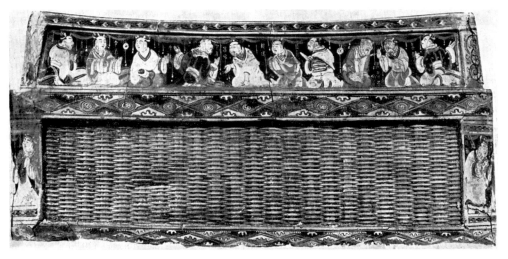

**Figure 1.** Scenes of paragons of filial piety, Three Kingdoms period, Lelang commandery (108 BCE–313 CE), early 2nd century. Basket with lacquer-painted panels, l. 15 ⅜ in. (39.1 cm). Central Historical Museum, P'yŏng'yang

domains of two or more contending dynasties whose primary ambitions were directed toward the subjugation of one another, not of Korea. During this prolonged respite from continental meddling in peninsular affairs, China's rulers especially appreciated diplomatic contact with Korean governments since the visits of foreign embassies were construed as evidence of an emperor's moral qualification to rule the Central Kingdom.

Accounts of the Korean past contained in the peninsula's earliest surviving histories, the twelfth-century *Samguk sagi* (Histories of the Three Kingdoms) and the thirteenth-century *Samguk yusa* (Memorabilia of the Three Kingdoms), become increasingly trustworthy from the fourth century onward. Consciously modeled on Chinese dynastic histories, the *Samguk sagi* is primarily concerned with the actions and personalities of the Korean royal courts. A somewhat broader view of early society can be derived from archaeological evidence, although much of what has been excavated to date also pertains to the court aristocracy. As a result, little can be reconstructed of the life of the great majority of Korea's population during the Three Kingdoms period. From textual accounts it is clear that the societies of all three states were rigidly stratified, with a fundamental distinction drawn between the freeborn and the unfree. The freeborn included both the common citizenry and the aristocracy; the unfree were slaves, a hereditary status into which prisoners of war and some types of criminals could be cast. It is further known that multiple, birth-determined gradations of rank and privilege existed within the kingdoms' aristocracies.

The histories testify that the era of the Three Kingdoms was not a time of tranquility. From the very beginning, the peninsula's royal houses faced formidable external and internal challenges to their authority. Externally, there was the constant threat of aggression from neighboring Korean states as well as the possibility of attack from Japan and, especially after the sixth century, from China. Internally, a ruler's power was dependent upon his — or in a few cases, her — ability to command the respect and support of the aristocracy. To enhance their legitimacy, monarchs sought to structure their courts on the

Chinese bureaucratic pattern. The manner, timing, and success of implementing this strategy, however, varied from kingdom to kingdom. Even though noble birth remained a prerequisite for any official position in early Korea, the bureaucratic model of government did provide the ruler with some discretion — at least theoretically — in choosing among several aristocrats qualified by birth to occupy a given post.

The rulers of the early kingdoms also controlled diplomatic intercourse with China. These contacts, cast as exchanges between legitimate sovereigns of the two nations, not only served to highlight the Korean kings' preeminent political position within their respective states, but also gave them unique access to the luxuries and honors that China's courts alone could supply. The so-called tribute system had evolved over time in a manner that benefited all parties. China's emperors could proudly assert that the moral luster of their government attracted tribute from afar, and, in return, they lavished costly gifts upon the foreign ruler perceptive enough to recognize their moral authority. In addition, a standard characteristic of the tributary relationship was the Chinese emperor's formal investiture of the foreign king in his royal title — although as often as not this investiture occurred well after the monarch had ascended the throne. Nevertheless, having one's royal authority acknowledged by an emperor of China was potentially useful to rulers of states — like those of early Korea — where the Central Kingdom was held in high esteem and rival candidates for the throne frequently abounded. Diplomatic relations with China were important in other ways as well. The kingdoms' embassies constituted a primary vehicle for trade with China; the total goods exchanged on both sides during these official visitations far exceeded the ceremonial gifts passed between king and emperor. The international connections maintained by the tribute missions also served as important conduits for the transmission of Chinese culture to Korea. An especially noteworthy example in this regard was the formal introduction of Buddhism to the kingdom of Koguryŏ as part of a late-fourth-century diplomatic initiative from a northern Chinese regime.

The sheer numbers of embassies dispatched by the three Korean kingdoms indicate the importance that peninsular rulers attached to sustaining diplomatic contacts with Chinese governments. Between the middle of the fourth and the middle of the seventh centuries, for instance, Paekche sent nearly sixty missions to China, and Koguryŏ sent more than one hundred and seventy. Silla, due to its isolated position on Korea's southeastern coast, did not enter into regular diplomatic contact with China until the latter part of the sixth century. In the course of the next one hundred years alone, however, Silla's rulers sent almost forty missions to Chinese courts.

Since China was politically divided during most of the Three Kingdoms period, geographical and political expedience determined which Chinese regime — or regimes — was chosen to receive a Korean kingdom's tribute. This choice, in turn, had implications for cultural development within the kingdom. Southern and northern Chinese courts differed significantly in their general cultural character and in the specific artistic styles that they favored. Koguryŏ, whose domains bordered on northern China and whose

Yellow Sea harbors offered access to the southern Chinese coast, regularly sent missions to the dynasties of both regions. Strategic concerns and geographic proximity, however, resulted in the dispatch of more than three times as many missions to the northern courts as were sent to the south. The extraordinary frequency of Koguryŏ's relations with northern China is reflected in the stylistic bias of its Buddhist sculptures. Paekche, due to the hostile presence of Koguryŏ across its northern border, was compelled to rely on the sea for its diplomatic communication with China. Consequently all but one of the kingdom's twenty-three tributary missions sent to China between the middle of the fourth and the middle of the sixth centuries traveled to southern courts. For a span of only twenty years beginning in 567, Paekche's rulers abandoned their policy of exclusively favoring the southern dynasties and sent regular embassies to northern courts as well. The kingdom's diplomatic partiality is also apparent in the southern Chinese stylistic influence perceptible in its early Buddhist images.

It was the prestige of Chinese culture as much as political and commercial interests that prompted the rulers of the Korean kingdoms to maintain the steady flow of tribute missions over the centuries. Stylistic shifts in Buddhist sculpture are useful indicators of the avid receptivity of the early Korean elite to selected elements of Chinese court culture. Much more significant in their long-term effects in shaping traditional Korean culture, however, were the transmissions of Confucian ideas of government and Buddhist conceptualizations of the divine. Confucianism promoted the ideal of the supreme authority of the king exercised through a bureaucratic hierarchy composed of well-educated, public-minded officials. As such, it provided Korean monarchs throughout the premodern period with a defense, never wholly successful, against aristocratic encroachment on royal prerogatives. The acceptance of Confucianism in other than its outward forms was slowed in Korea by the philosophy's substantial literacy requirements. Yet all three kingdoms adopted the bureaucratic model for their governments, and both Koguryŏ and Paekche established national academies to provide young men of aristocratic birth with a Confucian education. On several occasions Paekche reportedly requested that specialists in particular branches of Confucian learning be sent from China, and the same kingdom is also known to have provided Confucian mentors to the Japanese court. Graphic evidence of the effect that Confucian court protocol had in structuring the lives of early Korea's elites can be found in paintings adorning the walls of many Koguryŏ aristocratic tombs. One striking example comes from the tomb near P'yŏng'yang of an important governor that dates to the start of the fifth century (fig. 2). The governor is depicted seated in Chinese attire upon a raised dais while his entourage of similarly Chinese-robed functionaries, rendered in much smaller scale is shown humbly approaching on the adjacent side walls.

As with Confucian ideas, the initiation and development of Buddhism in Korea was dependent upon the early kingdoms' diplomatic relationships with China. According to the *Samguk sagi*, the religion was introduced to Koguryŏ in 372 by a monk sent from the northern Chinese state of Former Qin (352–410), and to Paekche twelve years later, in

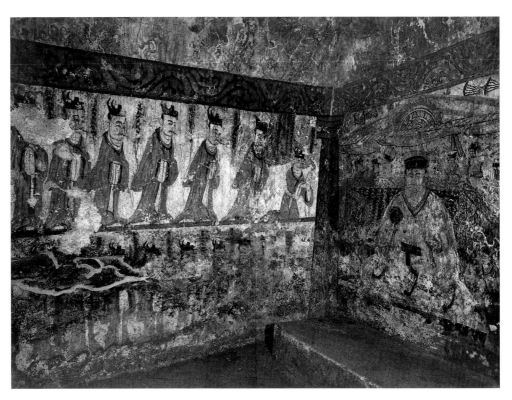

**Figure 2.** Governor and officials, Three Kingdoms period, Koguryŏ kingdom (37 B C E–668 C E), dated 408. Mural painting. North and west walls, Tŏkhŭng-ni Tomb, South P'yŏng'an Province

384, by a monk from the southern Chinese state of Eastern Jin (317–420). The Silla court, whose relative geographical isolation delayed the onset of regular tributary relations with China and thus generally slowed the penetration of sinitic culture, is reported not to have formally sanctioned the practice of Buddhism until 528. Surviving textual and material evidence indicates that while the practice of Buddhism was early granted tolerance by the rulers of Koguryŏ and Paekche, it nonetheless long remained an exotic cult largely restricted to the court. During the early sixth century, however, all of Korea's rulers appear to have become convinced — likely swayed by contemporary Chinese imperial example — of the religion's potential for strengthening and safeguarding the nation. Throughout the peninsula the increasingly close association of Buddhism and state was signaled by the erection of temples and crafting of icons at royal expense. For example, in 527 the impressive Taet'ong-sa was built at the center of the Paekche capital in part as a diplomatic gesture intended to reinforce the kingdom's ties to an especially pious Chinese sovereign. Twenty-six years later, in 553, in the Silla capital of Kyŏngju, construction was initiated on the Hwangnyong-sa, a royally endowed temple whose nine-storied pagoda and "sixteen-foot" image of the Buddha came to be revered as two of the nation's three protective talismans.

A number of Korean monks are known to have traveled to China with royal encouragement to receive religious training during the late sixth and early seventh centuries. Some remained there for the rest of their lives, but many returned home — commonly bearing sacred texts, icons, and relics — to disseminate the teachings acquired abroad.

Notable among those who returned are the Paekche monk Hyŏn'gwang (act. late 6th century) who studied under Huisi (515–577), the second patriarch of Tiantai (Ch'ŏnt'ae) Buddhism, and the Silla monk Chajang (608–686), who is credited with establishing the Vinaya sect (Kyeyul-chong) on the peninsula. Not all illustrious Korean clerics of this era felt it necessary to make the pilgrimage to China, however. Early Silla's most celebrated monk, Wŏnhyo (617–686), was as much revered for his propagation of Pure Land Buddhism among the masses as for his penetrating written explications of abstruse religious doctrine, some of which are still extant and continue to be studied in monasteries throughout East Asia.

The pious attainments of such monks as Hyŏn'gwang, Chajang, and Wŏnhyo are clearly extraordinary. The numerous tales preserved in the *Samguk yusa* of Buddhism's power to effect miracles in this world, to heal and to succor, are certainly more representative of the religious concerns of most early Korean Buddhists, clerics and laity alike. It was in no small measure the wonder-working power attributed to the religion that spurred the increasingly generous advocacy of Korea's kings in the sixth century; official patronage of Buddhism was believed to provide divine protection for the state. In addition to the construction of great temples at public expense, governments also bore the cost of magnificent rituals of national defense like the "Assembly of the One Hundred Seats of the Benevolent Kings" (*Inwang paekkojwa-hoe*) and the "Assembly of the Eight Commandments" (*P'algwan-hoe*). Well-educated clerics became advisors to the crown in Paekche and Silla, and it is known that in Paekche, at least, monks formally entered the bureaucratic ranks, military as well as civil. In Silla, during the late sixth century, the government organized a military corps of aristocratic youth, the *hwarang* (flower youth), which was dedicated to the bodhisattva Maitreya and whose members received spiritual instruction from Buddhist monks. The hwarang are credited with legendary feats of battlefield valor during the seventh-century wars of unification.

In the early Korean kingdoms Buddhism also had the political value of being a prestigious creed closely associated with the royal house, but accessible — at least in theory — to all levels of society. As such, it offered the bond of a shared belief between ruler and ruled, while simultaneously drawing attention to the king's central role in sustaining the nation through sponsorship of the imposing Buddhist rituals to protect and benefit all. Yet it was not only through the religion of the Buddha that the rulers of Silla and Paekche sought to buttress their temporal authority with supernatural luster. Archaeological evidence indicates that monarchs of both kingdoms continued to present themselves as possessing shamanic powers at least as late as the sixth century. The discovery of golden crowns of shamanistic design in the royal graves of both nations suggests that the rulers who wore them sought the sanction of ancient indigenous religious belief, as well as Buddhism, for their governance.

The warlike context of the times gave the kings of early Korea ample cause to invoke the aid of the Buddhas in the defense of their domains. During the Three Kingdoms pe-

riod, the peninsula was the site of virtually incessant armed strife. Much of the *Samguk sagi*'s narrative from the middle of the fourth to the middle of the seventh century is a record of battles, border skirmishes, piratical raids, and foreign invasions. Intrapeninsular fighting, which constituted much the greatest part of the era's warfare, initially appears to have had the limited goals of acquiring additional land and slaves to enrich a ruling house and to reward its aristocratic supporters. Military unification of the peninsula does not seem to have become a seriously contemplated objective until late in the sixth century.

The surviving historical records suggest that the first major fighting between Korean kingdoms occurred in the third quarter of the fourth century, when Paekche and Koguryŏ came into conflict over territory north of the Han River valley. Silla at this time was still largely shielded by its mountainous isolation in the southeast, although it was even then subject to the pillaging forays of Japanese marauders. By the fourth century's end, Koguryŏ had emerged victorious in the initial territorial dispute with Paekche and had followed this success by continuing to press southward — thereby menacing both southern kingdoms. Silla's rulers sought safety through compromise, essentially by placing their government under Koguryŏ's protection. Paekche's kings followed a similar course by allying themselves with Japan, essentially exchanging the products and technicians of their more sinicized elite culture for military support from the archipelago. During the late fourth and early fifth centuries, Paekche continued to resist Koguryŏ's advance, while its Japanese ally assaulted the northern kingdom's coastline and also attacked Silla, striking both from the sea and through the territory of Kaya.

The impetus behind the southward assertion of Koguryŏ's influence at this time was its celebrated martial monarch, King Kwanggaet'o (r. 391–413), under whose aggressive leadership the kingdom's northern boundaries were expanded to encompass the Liaodong peninsula and Manchuria. After his death in 413, however, the offensive threat Koguryŏ posed to its neighbors briefly subsided as the kingdom consolidated its control over recently acquired territory and, in 427, moved its capital from the banks of the Yalu River to the ancient city of P'yŏng'yang. Silla was thus enabled, first, to extricate itself from Koguryŏ's humiliating protectorate and then, in 433, to enter a mutual defense pact with Paekche. After a lull of some four decades, however, the military forces of Koguryŏ again began to probe Paekche's and Silla's border defenses. These attacks were a prelude to the northern kingdom's last massive southern thrust. In 475 the armies of Koguryŏ swept into Paekche's Han River valley heartland, captured its capital, Hansŏng (modern Seoul), and executed its reigning monarch, King Kaero (r. 455–75). Silla dispatched troops to assist its ally, but they arrived too late to prevent the absorption of the entire lower Han River valley into Koguryŏ's domain. Surviving members of the Paekche court fled south to establish a new capital at Ungjin (modern Kongju) in 475, but just sixty-three years later, in 538, the kingdom's rulers felt compelled to relocate the capital even farther south to Sabi (modern Puyŏ).

In the evolving dynamics of early Korean history, Paekche's loss of the Han River valley was to prove a key factor. To compensate for its lost territory in the north, the kingdom sought to extend its authority in the east as well as in the south. This led to encroachment upon Kaya at the same time that Silla was beginning to expand westward, also at Kaya's expense. As the resulting territorial competition between Paekche and Silla became increasingly acute, the integrity of their mutual defense pact against Koguryŏ declined. In the face of mounting suspicion and hostility, Paekche's monarchs again turned to Japan for assistance. It was in this context that Paekche's King Sŏng (r. 523–54) in 538 sent the official diplomatic mission that formally introduced Buddhism to the Japanese court. Soon thereafter all semblance of amity between Paekche and Silla was cast aside. In 553 Paekche's armies culminated a long campaign to regain the Han River valley with victories in a series of costly assaults on Koguryŏ fortifications. At this juncture, Silla troops, arriving on the pretense of offering assistance, attacked the exhausted Paekche army and took possession of the entire Han River valley. Incensed by this betrayal, King Sŏng in the following year took personal command of a retaliatory strike against Silla's western border, but the Paekche force was ambushed at night and, in the resulting melee, the king himself was captured and killed.

Silla's seizure of the Han River valley was followed eight years later, in 562, by its forceful annexation of all the remaining territory of Kaya. These acts coupled with the execution of King Sŏng caused Paekche's rulers to regard Silla as their most bitter enemy. Silla's King Chinhŭng (r. 540–76), the leader responsible for the occupation of the Han River valley and the destruction of Kaya, also launched a series of successful expeditions against Koguryŏ that brought a vast area along the peninsula's northeastern coast also under his control. Chinhŭng's conquests gave the rulers of Paekche and Koguryŏ sufficient reason to put aside their past grudges and, early in the seventh century, to begin to cooperate in military operations against Silla.

Possession of the Han River valley provided Silla with unhindered access to the Yellow Sea and thus to China for the first time in the kingdom's history. After constructing a heavily fortified port near the mouth of the Han River, Silla began to dispatch frequent embassies to the Chinese courts. Initially, while China remained politically divided between its own contending northern and southern regimes, these missions served largely cultural ends. After the Sui dynasty's successful unification of the Central Kingdom in 589, however, the significance of diplomacy for all northeastern Asian states changed abruptly, since the emperors of both the short-lived Sui regime and their immediate successors on the throne of the Tang dynasty (618–907) were quite eager to take advantage of intrapeninsular rivalries. This willingness on the part of Chinese rulers raised the possibility, unprecedented in Three Kingdoms history, that deft diplomatic maneuvering on the part of one Korean state might succeed in bringing the weight of China's armies to bear against its peninsular enemies. Korean solicitations for military assistance, however, only provided the rulers of the unified Central Kingdom with a con-

venient pretext for attacks that were, in truth, motivated by the desire for Chinese territorial expansion.

With Silla's and Paekche's encouragement, the Sui dynasty mounted four massive, but unsuccessful, assaults upon Koguryŏ's borders between 598 and 614. Between 645 and 648 the Tang emperor Taizong (r. 626–49), acting in response to Silla's pleas for aid, unleashed three more attacks that also failed to subdue the northern kingdom. Then in 660 the Tang court and its now closely bound Silla ally launched a coordinated invasion of Paekche, the Silla army advancing by land from the east and the Tang force striking by sea from the west. Caught in this pincers attack, Paekche's defenses were quickly overwhelmed and its reigning monarch captured and taken to China. The Tang-Silla allies spent the next eight years consolidating their hold over Paekche's domain and preparing for the invasion of Koguryŏ. When the campaign finally began in 668, it proved irresistible—the northern kingdom, weakened by the earlier Sui and Tang assaults and by internal political dissension, was attacked on three fronts and swiftly vanquished.

Following the allied Tang-Silla victories in Paekche and Koguryŏ, China's imperialistic intentions in Korea were laid bare. A Chinese military government was established whose jurisdiction included not only the territories of the two conquered kingdoms, but also extended—at least on paper—to Silla. In effect, this meant that the entire peninsula was to be incorporated into the Tang empire. Silla's response was prompt and vigorous. Its own troops assumed the offensive against the Tang occupation army, while the defeated forces of Paekche and Koguryŏ were enlisted to join in the common fight against foreign domination. By 676 this broad-based peninsular effort under Silla's leadership had succeeded in compelling the Chinese troops to withdraw into Manchuria and, for the first time in history, all of the peninsula—excepting a narrow band in the north—came under the sway of a single Korean government.

### UNIFIED SILLA PERIOD

The *Samguk sagi* is the primary source for written information about Silla's unified rule of the peninsula. The text's coverage of this nearly three-hundred-year span of Korean history is surprisingly sparse: only six of its twenty-eight chapters of chronicles are devoted to this period, while the remaining twenty-two treat the Three Kingdoms era. This substantial discrepancy may be partially due to the annals being limited to the affairs of a single court, yet it is still remarkable given the comparative proximity of the Unified Silla period to the date of the *Samguk sagi*'s compilation. Whatever the reason, the text's account of Unified Silla is little more detailed than that of the preceding epoch and, on the whole, is less complicated in the telling since it lacks the narrative complexity created by the interweaving histories of the three earlier states.

In the wake of the common cause made to expel the Tang occupation force, Silla's rulers moved expeditiously and with intelligent leniency to assuage past antipathies and fashion a truly unified nation. Officials of Paekche and Koguryŏ were granted ranks and

positions in the new national bureaucracy, while separate military units were created in Silla's armed forces for soldiers from the two defeated states. Adapting the model of the Tang imperial administrative structure to meet their more limited geographic needs, the early kings of Unified Silla divided the peninsula into nine provinces, each subdivided into counties and districts. As a general rule, the highest officials appointed to serve in the former domains of Paekche and Koguryŏ were Silla natives, but not infrequently the lower-echelon bureaucrats were drawn from the local aristocracy. In addition to the high-level Silla officials posted to the provinces, some members of the court nobility were urged — or even compelled — to settle in the territories of Silla's former enemies. This policy had the positive short-term effect of simultaneously reducing the increasingly keen competition for power among aristocratic families in the capital and knitting the nation more tightly together through a network of extended social and kinship ties. In the long term, however, it encouraged the creation of regionally powerful families who were to play a major role in the disintegration of the central government's authority in the ninth century.

The largely conciliatory policies of Unified Silla's first kings toward their former foes combined with the establishment of a reasonably effective structure for governing the whole country brought about a "golden age" of prosperity and peace. The concord that characterizes this age — which lasted for nearly a full century (ca. 675–765) — was due, in part, to the relative tranquility of Unified Silla's international relations. In 681, just five years after the Chinese armies had been driven from the peninsula, the Tang court sought to reestablish diplomatic ties with the government in Korea. Unified Silla's rulers, however, prudently allowed the situation on the peninsula to stabilize and waited until 699 to accept the Chinese overtures. Thereafter relations with China remained essentially amicable and close until the collapse of Tang rule in 907. The government's relations with the Japanese court were also largely amicable, although in this case the diplomatic relationship between the two nations waxed and waned in intensity, as did the depredations of Japanese freebooters along Korea's coasts. Across Unified Silla's northern frontier lay the kingdom of Parhae (Ch. Bohai; 699–926), founded late in the seventh century and thereafter ruled, it is said, by aristocratic survivors of vanquished Koguryŏ and their descendants. In any case, the domain of Parhae encompassed most of the former kingdom's extensive holdings in Manchuria. Although the relationship between the Parhae and Unified Silla courts was merely cordial at its best, armed hostilities were avoided and the peninsula was spared the serious threat of aggression from the north until after Parhae's destruction by the Khitan, a semi-nomadic people of Manchuria, in the early tenth century.

The peace that characterized Unified Silla's external relations nurtured general prosperity throughout the country and the remarkable affluence of the capital, Kyŏngju. In the *Samguk yusa*, it is reported that at the end of the ninth century Kyŏngju's population numbered nearly 180,000 households and that all of the dwellings within the city, not just

the residences of the nobility, had roofs of tile. Perhaps the most telling index of the distribution of wealth in Unified Silla society is the ownership of slaves. It is known from a few surviving eighth-century census records that even some rural villagers of modest means owned one or more slaves, and it is also reported that some of the powerful aristocratic families in the capital possessed as many as three thousand.

The peace and wealth enjoyed by Unified Silla's elite between 675 and 765 provided the context for sustained cultural growth as well. In 682 a national academy of Confucian learning was established in Kyŏngju. Like the state-funded academies that had once graced the capitals of Koguryŏ and Paekche, it was intended to provide a basic classical education for the sons of the aristocracy who aspired to public office. The curriculum was limited, with instruction being offered in a small selection of the Chinese classics, among which the especially succinct texts of the *Lunyu* (Analects) and the *Xiaojing* (Classic of Filial Piety) were emphasized. Although the government supported the academy and determined its curriculum, it was not until 788 that a civil service examination was instituted to help regulate appointment to the bureaucracy. While the examination adopted at this time was not especially demanding — the basic criterion for success was demonstration of a reading knowledge of the *Xiaojing* and one other text — this fairly humble beginning did prepare the way for the more rigorous civil service examinations of later Korean governments. The Unified Silla national academy stimulated an intellectual interest in Confucian thought that, in turn, prompted some members of the lower-ranking aristocracy in particular to travel to China for more advanced training. The Tang government offered a special civil service examination for foreign nationals, and Chinese records indicate that at least fifty-eight Koreans succeeded in this exam and accepted assignments in the Chinese bureaucracy prior to returning home.

Buddhism had deeply permeated elite Korean culture long before the political unification of the peninsula. In the former kingdom of Silla a close symbiotic relationship between church and state had existed since early in the sixth century, and this relationship was ardently continued by the rulers of Unified Silla. Enjoying the lavish patronage of the aristocracy as well as the court, Korean Buddhism entered a phase of unparalleled institutional development, societal expansion, and scholarly achievement. During the seventh and eighth centuries a number of important doctrinal traditions gained prominence in China, and these — together with the attendant iconographic and stylistic innovations in Buddhist art — were rapidly transmitted to the Korean peninsula by the numerous Unified Silla monks who went to study in Chinese monasteries. In this manner, two of the most intellectually influential sects in the history of Korean Buddhism, the Avatamsaka sect (Hwaŏm) and the meditative tradition of Sŏn (Ch. Chan; Jp. Zen), were introduced to the peninsula. Over the course of the Unified Silla period, both of these sects came to enjoy the particular favor of the aristocracy, and their temples spread throughout the land. In addition, the cult of the Healing Buddha, Bhaishajyaguru (Yaksa), attracted advocates among all levels of society, while followers of the Pure Land

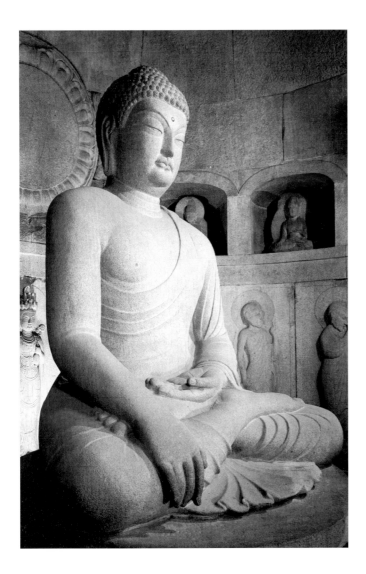

**Figure 3.** Buddha, Unified Silla period (668–935), second half of the 8th century. Granite, h. of figure 127 in. (326 cm). Sŏkkuram Cave-Temple, Kyŏngju, North Kyŏngsang Province. National Treasure no. 24

salvational sect, originally popularized by the monk Wŏnhyo in the seventh century, continued to proliferate.

Although the maturation of Korean Buddhism is reflected in the quantity of insightful religious scholarship produced during the Unified Silla period, the concern for the worldly benefits of the religion's practices and rites evidently remained paramount for the majority of adherents. Not only does the *Samguk yusa* contain many accounts of divine intervention credited to this era, but it is also known that Buddhist rituals to strengthen and protect the state continued to be regularly performed at court and at important monasteries throughout the nation. The construction of temples and the creation of major works of art were commissioned with the same purpose. Two prime examples are the late seventh-century Sach'ŏnwang-sa (Temple of the Four Heavenly Kings), built at royal order to bolster resistance against the Tang imperialist threat, and the famous eighth-century cavelike granite sanctuary of Sŏkkuram that is commonly believed to have been created, in part, to protect Korea from Japanese aggression. Sŏkkuram was built by Prime Minister Kim Tae-sŏng (d. 774) high on a mountainside facing the East Sea. The magnificent stone image of a seated Buddha within the sanctuary (fig. 3) gazes seaward in the

direction of Japan, an orientation that has given rise to the tradition concerning the image's protective function.

Well before the eighth century ended, however, it had become apparent that the most serious threat to the government of Unified Silla came from within the nation's borders. Rival factions of the ruling family increasingly resorted to intrigue, armed confrontation, and even regicide in their competition for primacy. As the situation in the capital deteriorated, powerful families in the provinces moved aggressively to extend their control over ever-broader areas. During the ninth century the authority of Unified Silla's kings diminished steadily until it hardly reached beyond the mountain-protected bastion in the southeastern corner of the peninsula that had formed the boundaries of the earlier Silla kingdom. By the start of the tenth century, the Unified Silla monarchs' claims to peninsular supremacy were already openly contested by the self-declared kings of two short-lived regional states, Later Paekche (892–936) in the southwest and Later Koguryŏ (also known as T'aebong; 901–918) in the north.

## KORYŎ DYNASTY

Histories relate that the ruler of Later Koguryŏ, having become subject to increasingly violent mental aberrations, was overthrown in 918 by a group of his own military commanders led by one of his ablest generals, Wang Kŏn (877–943). Having assumed control of his former master's northern domain, Wang (also known by the posthumous title of T'aejo or "Grand Founder"; r. 918–43) was proclaimed king of the new state of Koryŏ. Thereafter, through the adroit application of diplomacy and military force, he achieved the political reunification of the peninsula by engineering the voluntary submission of the last of the Unified Silla monarchs in 935, which was followed by the armed conquest of Later Paekche in 936. Over the course of the next century, T'aejo and his immediate royal successors sought in various ways to bolster their authority over potentially threatening aristocratic families. A new land system was instituted, for instance, whereby most of the nation's real estate was appropriated for the support of the royal government and the maintenance of its officers. This Koryŏ policy and others of similar purpose were temporarily effective in enhancing the power of the throne, but in the long term they were subverted and premodern Korean society continued to be dominated by families of high status.

It is recorded in the fifteenth-century *Koryŏ-sa*, the official history of the Koryŏ dynasty, that King T'aejo late in his life articulated Ten Injunctions to guide his descendants in governing the peninsula. His advice provides valuable insight into the beliefs and concerns of the Koryŏ court. The first injunction attributes the welfare of the nation to the beneficence of the Buddhas, yet warns against permitting the Buddhist hierarchy to meddle in politics. The importance of geomancy (Kr. *p'ungsu*; Ch. *fengshui*) in the selection of propitious sites for Buddhist temples is emphasized in the second injunction, but it is also urged that in order to preserve national vitality, the construction of temples be limited to

those sites previously identified by a certain monkly geomantic savant favored by T'aejo. The fourth injunction is especially interesting: its initial acknowledgment of Korea's institutional and cultural indebtedness to China is immediately balanced by the assertion that, in their circumstances and character, the Korean people are sufficiently different from the Chinese so that the ways of the latter should not be abjectly mimicked. This same injunction also characterizes the Khitan — the semi-nomadic tribe who had vanquished the Parhae state in 926 and were the founders of the Liao dynasty (916–1125) whose domain extended into northern China — as a nation of "beasts" not worthy of respect or emulation. While the value of Buddhism and geomancy for the preservation of the government is especially pronounced in T'aejo's Ten Injunctions, the virtue of Confucian precepts for tl.e maintenance of a well-ordered state is also recognized.

Although the distinction accorded Buddhism by the Koryŏ court contrasted markedly with the position of the contemporary Song dynasty (960–1279) in China, it was fully consistent with the policy of the rulers of the preceding Unified Silla period. The Buddhist sects that had been influential during that period continued to flourish under the munificent patronage of the Koryŏ court and aristocracy. Notwithstanding T'aejo's warnings to the contrary, temples increased in number, land holdings, and wealth — as well as in political influence — over the course of the dynasty. Koryŏ royal princes became powerful abbots, and priests became intimate royal advisors, while grandiose rituals were regularly performed at public expense for the welfare of the state and at the behest of such private devotees as could afford the cost and found gratification in the solemnities. Geomancy, closely associated with Buddhism in this period, contributed significantly to the ways in which the Koryŏ court elite ordered their lives and dealt with the world about them. Geomantic factors were always taken into consideration in the siting of palaces, temples, and graves. It was also argued in the fifth of T'aejo's injunctions that his royal descendants should reside for almost a third of every year in P'yŏng'yang, which served as one of Koryŏ's secondary capitals, because of the geomantic auspiciousness of its location. (This particular admonition was not, however, much honored by his successors.) In his eighth injunction, T'aejo even used a geomantic justification for his strong prejudice against the population of southwestern Korea.

Well before the final collapse of the Unified Silla government, the Confucian-based civil service examination had lapsed into political irrelevance. Nothing was done to revive the system until 958 when King Kwangjong (r. 949–75), the fourth of Koryŏ's monarchs, accepted a recommendation to that effect made by a Chinese official recently settled in Korea. Kwangjong evidently saw in the examination system a means of checking the political power of the most influential aristocratic families. Over time there developed several different types of examinations in the Koryŏ system, each of which dealt with a specialized aspect of Chinese learning. There was even a state-sponsored examination on Buddhist teachings through which priests could acquire official ecclesiastical rank. One indication of the value that the Korean elite came to place upon a classical education is that by

the early thirteenth century — some two centuries before Gutenberg — movable metal type had been invented to facilitate the distribution of texts. One of the earliest recorded works printed in this manner is a volume concerning Confucian ritual published in about 1234.

Toward the end of the Koryŏ dynasty, Neo-Confucianism was introduced to Korea through the efforts of peninsular scholars like An Hyang (1243–1306), who had become attracted to the philosophy while visiting Dadu (Beijing) as a member of a diplomatic mission to the Yuan dynasty (1272–1368). Neo-Confucianism, a systematic reformulation of fundamental Confucian teachings, was developed in China during the Song dynasty and given its most influential exposition by the renowned twelfth-century philosopher Zhu Xi (1130–1200). From 1313 until the rise of the Chinese republic in 1912, Zhu Xi's version of Neo-Confucianism provided the conceptual basis for China's civil service examinations and thus in effect constituted the orthodox ideology of the Chinese imperial state. Neo-Confucianism expounded a particular view of the true order of the universe, and great importance was attached to both the individual's comprehension of this view and the crucial role of the ruler within that order. It is not surprising that many of the early advocates of this philosophy in Korea came to question the domination of Koryŏ society by Buddhist clerics and a small number of aristocratic families.

King T'aejo's fourth injunction concerning Korea's relationships with China and the peoples of Manchuria reveals the difficulties of Koryŏ's international position within East Asia at the time. Koreans were fully aware of their differences from China, yet they also realized that the Central Kingdom had long been — and likely would long continue to be — a critically important source of cultural inspiration. Just beyond Korea's northern boundaries, however, ranged the nomadic and semi-nomadic inhabitants of Manchuria. Although the settled population of the peninsula might regard their northern neighbors as "beasts" and unworthy of emulation, as T'aejo had said of the Khitans, the military prowess of these peoples was repeatedly to force begrudging professions of allegiance from the Koryŏ court. At the time of the dynasty's founding during the second decade of the tenth century, China was divided into several contending states and the Khitan were already in possession of a large part of Manchuria. In 937 the Khitan ruler declared himself the emperor of the Liao dynasty, which soon expanded its domain to encompass a sliver of northern China. Shortly thereafter, in 960, the Song dynasty emerged as dominant in almost all of the remaining territory of China proper. The combination of the Korean prejudice against the Khitans and the existence of a disputed border separating the two countries quickly combined to provoke serious tensions between the Koryŏ and Liao courts. These tensions ultimately resulted in three major Liao invasions plus several smaller armed incursions into the peninsula between 993 and 1018. The Koryŏ court responded to the Khitan challenge by, on the one hand, attempting to strengthen its armies and, on the other hand, commissioning the carving of woodblocks for printing a complete edition of the Buddhist canon (Tripitaka) in order to invoke the protection of the

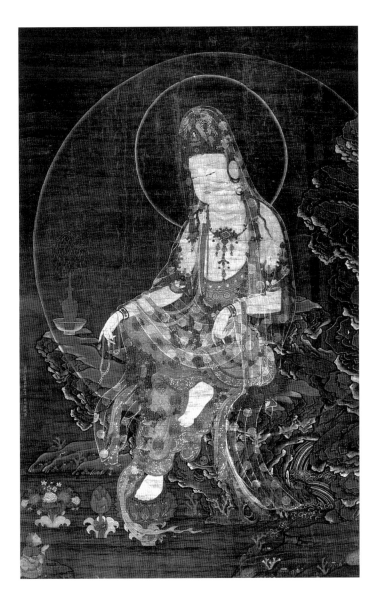

**Figure 4.** Sŏ Ku-bang (14th century), *Water-Moon Avalokiteshvara*, Koryŏ dynasty (918–1392), dated 1323. Hanging scroll, ink, mineral pigments, and gold ink on silk, 65 ⅛ × 40 in. (165.5 × 101.5 cm). Sumitomo Family Collection, Kyoto

Buddhas. The latter project, a monumental undertaking, was begun early in the eleventh century, but was not completed until 1087, long after peace had been established with the Liao emperors.

Between the late tenth and early twelfth centuries, while the Song and Liao regimes remained in opposition in China, the Koryŏ court repeatedly altered its foreign policy in response to the changing dilemmas and opportunities created by this mutual antagonism, sometimes sending embassies to both regimes and sometimes just to one. Although the might of the "barbarian" Liao court was sufficient to command Koryŏ's undivided diplomatic attentions during the middle decades of the eleventh century, throughout this period the Korean elite continued to welcome Chinese traders. Among the products of Song China that found a ready market on the peninsula were Buddhist and Confucian texts, medicines, and porcelains. Similarly, certain Korean products—including the peninsula's distinctive "kingfisher-colored" celadon wares—earned favorable notice in China. The elegant beauty of celadon seems to have struck an especially profound response among the Koryŏ nobility. They savored the display of the luxurious ceramics in their own daily

life, and the visual evidence of Buddhist paintings reveals their conviction that the mightiest beings in the Buddhist pantheon utilized Koryŏ celadon vessels as well (fig. 4).

Early in the twelfth century the Liao dynasty of the Khitans was supplanted by the Jin dynasty (1115–1234) of the Jurchens, another semi-nomadic people from Manchuria. The might of the Jurchen armies, which was sufficient to drive the Song totally out of northern China, earned the Jin regime Koryŏ's reluctant recognition. A little more than a century later, however, devastating assaults by Mongol forces overthrew first the Jin government in 1234 and then the Song in 1279. The Mongol rulers thereupon established themselves as the emperors of China and designated their new regime the Yuan dynasty. Korea, too, was ravaged by Mongol armies, suffering six invasions between 1231 and 1257. In 1231 the Koryŏ court fled from the capital of Songdo (modern Kaesŏng) and took refuge on nearby Kanghwa, a large island less than two kilometers offshore in the Yellow Sea. Members of the royal court as well as the leaders of the military government—which at that time constituted the country's real political authority—were able to live comfortably on Kanghwa, while for the next forty years the population left behind on the peninsula suffered terribly at the hands of the Mongols. It was during this period that the Koryŏ court ordered the preparation of another set of woodblocks for printing the Buddhist Tripitaka, which has been preserved intact at the Haein-sa, a temple in South Kyŏngsang Province. The carving of this second set, in all over eighty thousand woodblocks, was intended both to gain protection against the Mongol invaders and, ironically, to replace the earlier set that had been burned by the Mongols in 1232.

By 1270 a peace had been negotiated with the invaders, the political power of the military government had been broken, and the Koryŏ court entered an era lasting more than a century of very close relations—including royal intermarriage—with the Mongol emperors of the Yuan dynasty. The harmonious ties to Yuan China facilitated the importation of Cizhou wares to Korea with the result that Koryŏ celadons began to be decorated with underglaze iron-brown designs in the Cizhou style. It was probably also at this time that the decorative use of underglaze copper red, a technique believed to have originated in Korea during the twelfth century, was introduced to China.

The progressive disintegration of the Mongol regime in China during the late fourteenth century that culminated in its replacement by the indigenous Chinese dynasty known as the Ming (1368–1644) caused substantial turmoil at the Koryŏ court. Conflict arose between those who felt that Korea ought to remain loyal to the beleaguered Yuan and those who favored alignment with the emerging Ming. This tension precipitated the Koryŏ dynasty's downfall. In 1388 Yi Sŏng-gye (1335–1408), founder of the succeeding Chosŏn dynasty, was sent as commander of a contingent of Korean troops to support the Yuan cause by attacking Ming positions in Manchuria. Having reached an island midstream in the Yalu River, however, Yi turned his forces back to the capital and ousted the reigning king and the leading officials responsible for the anti-Ming policy. Although initially Yi and his coterie of Neo-Confucian reformist advisers were content to govern

indirectly through the inexperienced monarch they had placed on the Koryŏ throne, after a few years this pretense was abandoned.

Upon the deposal of the last Koryŏ monarch in 1392, Yi Sŏng-gye was proclaimed king of the new Chosŏn dynasty and the geomantically auspicious site of modern Seoul was selected for its capital. The change in dynasty brought in its wake major social and cultural changes. Yi (also known, like the first Koryŏ king, by the posthumous title of T'aejo or "Grand Founder"; r. 1392–98) and his immediate successors on the throne moved aggressively to augment the power of the royal government. Particularly noteworthy in this regard were their efforts to reduce the wealth and influence of both the Buddhist church and the noble families that had been prominent at the Koryŏ court. These ends were accomplished in large part through legislation that had the effect of making the Neo-Confucianism of Zhu Xi the official ideology of the Chosŏn state. In the brief period of his de facto rule during the final years of the Koryŏ monarchy, Yi Sŏng-gye had overseen the appropriation of privately owned lands throughout the country. Some of the lands so acquired were utilized to recompense government officials and the remainder reserved to meet the requirements of the royal state. Then, during the reigns of T'aejo and his son, T'aejong (r. 1400–1418), increasingly stringent restrictions were placed on the Buddhist church and many of its properties were confiscated as well. Together these measures effectively undercut the societal influence of both the Buddhist hierarchy and the old aristocracy, thereby clearing the way for the new hereditary elite that was to dominate Korea socially and culturally throughout the half millennium of Chosŏn rule. This new elite, known collectively as *yangban*, consisted of that small portion of the freeborn population that over time was able to monopolize civil and military posts in the national bureaucracy. Success in the civil service examinations constituted the primary gateway to the bureaucracy and, as in contemporary China, required strict adherence to a Neo-Confucian perspective on the part of the candidate. Official position within the bureaucracy, especially the civil bureaucracy, conferred prestige and financial security within Chosŏn society. Since yangban families were exempt from the corvée as well as from the payment of taxes, their male children had greater opportunity to obtain the thorough Neo-Confucian education necessary for success in the civil service examinations, which were nominally open to all freeborn males.

Neo-Confucianism having been thus embraced by the Chosŏn government, its influence came to permeate elite Korean society and culture. The hierarchical notions sanctioned by the philosophy came to undergird all social interactions from the public arena of the bureaucracy to the intimate circle of the family. Neo-Confucian values were deeply ingrained through textually prescribed ceremonies and rites for both the state and the family. The humanism of Neo-Confucianism coupled with a belief in the value of education contributed to the invention early in the fifteenth century of *han'gŭl*, a simple script

perfectly designed for the writing of spoken Korean. As such it was an ideal medium for the many who, unlike yangban males, had neither opportunity nor reason to become proficient in classical Chinese. In a similar vein, the austere aesthetic tastes and ritual requirements of the Neo-Confucian elite were responsible for the unprecedented expansion during the Chosŏn period in the production of plain white porcelain vessels (*paekcha*).

The Neo-Confucian orientation of the Chosŏn court and bureaucracy also had important repercussions for the dynasty's foreign relations. The emphasis on hierarchy basic to this philosophy prompted Korean kings to regard loyal subservience as a positive virtue in their relations with the emperors of Ming China. To Neo-Confucian values must also be attributed some responsibility for the greater prestige accorded civil over military officials, which engendered a chronic decline in the Chosŏn government's ability to protect itself against aggression from without or insurrection from within. By the end of the sixteenth century, after long years of neglect, the strength and preparedness of Korea's military forces had seriously deteriorated. It was at this juncture that in Japan the shogun Toyotomi Hideyoshi (1536–1598) brought centuries of internecine war to an end and assumed overall command of the archipelago's many battle-hardened armed forces. Faced by the potential peril posed by a vast and idle military, Hideyoshi conceived the remarkable notion of conquering Ming China and therefore requested that the Chosŏn court allow his armies free passage through the peninsula. Both common sense and Neo-Confucian loyalty to the Ming argued against Korean acquiescence, with the result that in 1592 and again in 1597 desolating Japanese assaults were loosed against the peninsula. Striking from the south, the first attack swept north as far as P'yŏng'yang, but the second was stopped before advancing half that distance.

The Chosŏn court's loyalty to the Ming was rewarded by the dispatch of Chinese armies to Korea, where they lived off the land and frequently joined in the fight against the Japanese. Between the initial onslaught of Japanese troops in 1592 and their final withdrawal in 1598, the invaders maintained themselves within massive fortifications erected along the peninsula's southern coast while they, too, lived off the backs of the Korean peasantry. During the bitter years of the Japanese occupation, large areas of southern Korea were thoroughly pillaged. Among the vast quantities of booty borne off to the archipelago were many treasures plundered from Buddhist monasteries, including paintings, sculptures, stone lanterns, and even ponderously heavy bronze temple bells. Numbers of Korean potters were also carried off to Japan, where masters of the tea ceremony had acquired a profound appreciation for the peninsula's *punch'ŏng* ceramics. The forced labor of skilled Korean potters at Japanese kilns not only benefited the production of tea ceremony wares, but also significantly hastened the development of porcelain production in the archipelago.

One result of Ming involvement in the war against Hideyoshi's troops was the further weakening of the already declining Chinese dynasty. Partially as a consequence of that involvement, the Ming court during the opening decades of the seventeenth century found

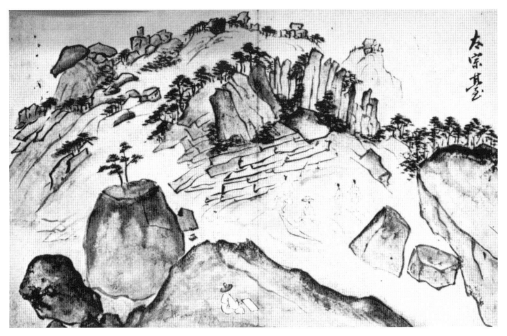

**Figure 5.** Kang Se-hwang (1713–1791), "T'aejong-dae Terrace." One double leaf from *Album of a Journey to Songdo*, ca. 1757, an album of 16 double leaves, ink and light color on paper, 13 × 21 in. (32.9 × 53.4 cm). The National Museum of Korea, Seoul

itself incapable of containing the rising military power of the semi-nomadic Manchu people — whose homeland, Manchuria, bears their name. At first, the Chosŏn government judiciously managed to avoid seriously antagonizing either the Ming or the Manchus. Then, however, a group of staunchly pro-Ming officials gained the upper hand at court, and their overt support of the ailing Chinese regime provoked major Manchu invasions of the northern portion of the peninsula in 1627 and 1636. Thus chastened, the Korean court was compelled to swear fealty to the Manchus, who soon thereafter completed their conquest of China and, in 1644, replaced the Ming with their own Qing dynasty (1644–1911).

The shock of the fall of the respected Ming, the only Chinese sovereign power with which the Chosŏn court had ever dealt, coupled with the great suffering caused by the Japanese and Manchu invasions, induced Korea's yangban elite to reassess many of the premises that had guided them in the past. One reaction to the rise of the Manchu regime in China was the development of a deeper regard for that which was Korean. Scholars and officials began to attend less to philosophical abstractions and ceremonial minutiae and took an increasing interest in Korea's history, geography, language, and agriculture. This new strain of research, now commonly termed *sirhak*, or "practical learning," began to appear early in the seventeenth century and continued in vogue until the start of the nineteenth century. Bureaucratic factionalism, which frequently had compromised the effectiveness of the Chosŏn government, was largely brought under control in the late eighteenth century. Tax regulations, too, were revised in such a way that the burden upon the peasants was somewhat lightened, the revenues of the government were enhanced, and commerce throughout the nation was stimulated. Legal changes also encouraged the private production of hand-crafted articles, including ceramics, needed by the citizenry

and the government. Accordingly the numbers of unfree artisans under state control gradually decreased until finally, in 1801, the central government formally freed all slaves remaining in its possession.

The greater attention to specifically Korean concerns manifest in sirhak scholarship began in the eighteenth century to find expression in paintings by both professional artists and gifted yangban amateurs. Increasingly, the paintings produced for Korea's elite depicted unmistakably Korean landscape and genre scenes in place of the conventional Chinese vistas that had previously pervaded the art. One especially bold example of this new direction in Korean painting is a landscape album of sixteen leaves entitled *Album of a Journey to Songdo*, a work done by Kang Se-hwang (1713–1791) as an intimate record of his responses to the natural beauty of the area around Kaesŏng (fig. 5). A comparable and somewhat earlier stylistic transformation is evident in the brushwork of the underglaze iron-brown and cobalt-blue decorations on white porcelains of the Chosŏn period. On pre-seventeenth-century vessels, the painting tends largely toward staid and fairly representational depictions of such stock Confucian motifs as pine and bamboo. After the start of the seventeenth century, however, the brushwork becomes increasingly vigorous and the repertoire of frequently encountered designs expands to include such dynamic forms as dragons and the Korean tiger. In sum, the painted decorations on the later porcelains appear much more distinctly "Korean" than those on the earlier ones.

The positive political and economic developments of the seventeenth and eighteenth centuries notwithstanding, many causes of governmental instability and social unrest remained unaddressed within Korea. The enervating effects of these problems were aggravated in the nineteenth century, first by the protracted domination of the central government by avaricious royal in-law families, and second by the disruptive pressures exerted on the government by foreign imperialist powers. Regional strategic concerns caused China, Russia, and Japan to be the most brazen in seeking concessions and influence on the peninsula. Yet the major European powers and the United States also showed little reticence in pursuing whatever concessions they believed to be in their own best national interests and, at least in some cases, presumed might benefit Korea as well. The Chosŏn government, weak and ill-prepared by tradition or experience for dealing with the challenges posed by imperialism of the late-nineteenth-century variety, strove ineffectually against the rising tide of foreign domination. By the start of the twentieth century, especially following Japan's triumph of 1905 in the Russo-Japanese War, the fate of Korea was all but sealed. With the authority of the Chosŏn government ever more compromised, the Korean people were left without any effective means to resist Japan's formal annexation of the peninsula in 1910, which initiated a period of colonial rule that lasted until 1945.

Plates

Ceramics

Long admired in China and Japan, and more recently recognized in the West for its achievements, the ceramic tradition is an enduring feature of Korea's culture. The earthenware vessels of the Neolithic period, the earliest of which date to about 7000 BCE, show already a variety of shapes and decorative techniques. By 1000 BCE, the increasingly complex social organization of the population of the Korean peninsula is suggested by the many ceramic objects produced both for everyday use and for ritual and mortuary purposes. Advances in ceramic technology in the Three Kingdoms period (57 BCE–668 CE) include the production of stoneware, requiring kiln temperatures of more than 1000° C. With the exception of Chinese stoneware, these are the earliest known high-fired wares in the world. Lead glazes, which may have been inspired by Chinese Tang dynasty (618–907) wares, first appear in Korea during Unified Silla (668–935). By the Koryŏ dynasty (918–1392) consistent advances in ceramic technology, including the use of the climbing kiln, led to the production of Korea's widely acclaimed celadon wares. Most likely derived from Chinese Yue wares, these celadons reached their high point of perfection in the mid-twelfth century. The exceptional clarity of Koryŏ celadon glazes made possible the decoration of wares with inlaid designs, a technique known as *sanggam*, which is a unique achievement of Koryŏ potters. In the twelfth century, these craftsmen were among the first to employ successfully the difficult technique of underglaze copper-red decoration on high-fired wares. Ceramic production in the succeeding Chosŏn dynasty (1392–1910) is characterized by innovative *punch'ŏng* stonewares and by white porcelain wares. The latter in particular reflect the austere tastes of the Neo-Confucian governing class. Developments in decorative techniques in porcelain wares include underglaze cobalt-blue painting, adopted from China, as well as underglaze copper-red and iron-brown decoration. There was concurrently an exploration of new ceramic forms.

## Plates 1 and 2

The earliest pottery found on the Korean peninsula dates from early in the Neolithic period, approximately 7000 B C E. Vessels were hand built from coils of clay and fired in open or semi-open kilns at low temperatures of about 700° C. These unglazed, porous wares have been found throughout Korea in large quantities and in a variety of shapes and decorative styles, reflecting the diversity of material culture of the Neolithic period and the contacts between populations living in different parts of the peninsula. Comb-pattern wares (pl. 1) are the most representative type of ceramics from Korea's prehistoric period. This exceptionally large jar, which may have been used for storage of grains, has a typically pointed base and displays striking patterns of diagonal lines that were incised into the damp clay, perhaps with a comblike implement, prior to firing. Excavated at Amsa-dong, near the Han River in modern-day Seoul, it attests to the long history of human habitation at the site. These vessels are found alongside other kinds of earthenware, such as bowls with linear relief decoration, and chipped and polished stone tools of various types.

With the introduction of bronze into Korea from the continental mainland around the tenth century B C E, the subsistence patterns of peninsular populations changed from fishing and foraging to agriculture and animal husbandry. Corresponding changes in society included an increasingly complex social hierarchy, larger village settlements, and more elaborate burial practices. The bulbous eggplant-pattern jars (pl. 2) of the late Bronze Age, found only in the southern part of the peninsula, are made of a fine-grade clay and have on their shoulders the dark gray and brown elongated patterns that give this type of ware its name. Their bold decoration represents a radical departure from the incised and applied-relief wares of the Neolithic period. Like the burnished red and black wares and footed vessels from this period, this pottery may have been for everyday use, ritual use, or both.

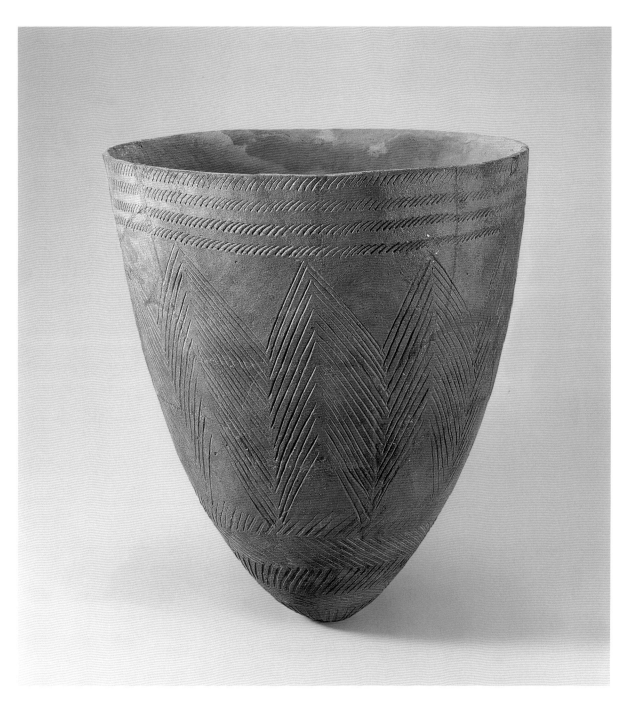

**Plate 1**
Comb-Pattern Vessel
Neolithic period, ca. 4000–
3000 B C E, from Amsa-dong,
Kangdong-gu, Seoul
Earthenware with incised
decoration, h. 15 ⅛ in. (38.4 cm)
Kyŏnghŭi University, Seoul

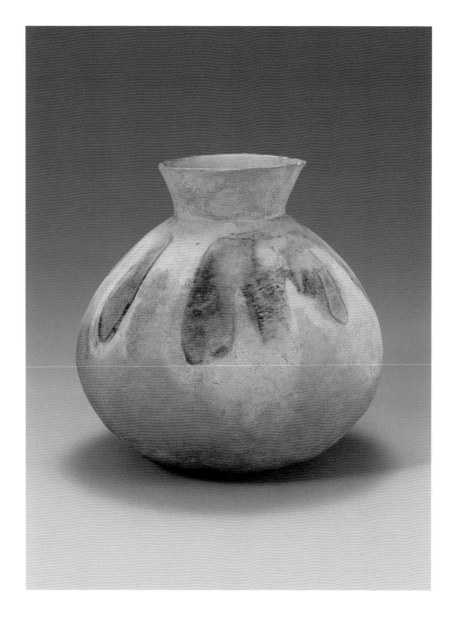

**Plate 2**
Eggplant-Pattern Jar
Bronze Age, ca. 5th century B C E,
from South Kyŏngsang Province
Earthenware with colored pigment,
h. 7 ½ in. (19 cm)
The National Museum of Korea,
Seoul

## Plate 3

From the early Iron Age, about the third century B C E, until the emergence of confederated kingdoms in the first to third centuries C E, the Korean peninsula underwent important social and cultural changes. The powerful Han dynasty (206 B C E–220 C E), the rulers of a unified China, in particular had a great impact on the Korean peninsula: the Lelang Commandery established north of the Han River in the first century B C E played a major role in the dissemination of Chinese culture in Korea. In the area south of the Han River, different tribal groups vying for power coalesced into regional federations. From these were to emerge the Kaya Federation and the powerful kingdoms of Paekche and Silla, which, along with the Koguryŏ kingdom in the north, formed Korea's first centralized aristocratic states.

The ceramics of the Iron Age take on many diverse forms. Unlike the previous period, when clay objects were hand-built, the Iron Age saw the introduction of the potter's wheel. Changes in mortuary practices were also partially responsible for new kinds of ritual vessels that may reflect the influence of Han material culture. In particular, objects raised on a foot or pedestal appear relatively suddenly in Korea, although such footed ritual vessels had already been used in Bronze Age China. The earliest extant sculptural forms also date from this period, as seen in this imposing bird-shaped vessel of the second to third century. Such objects may represent tribal totems or specific beliefs in the afterlife. Made of a soft, low-fired clay, they are clearly distinguishable from the more utilitarian pots found in great quantities at residential sites.

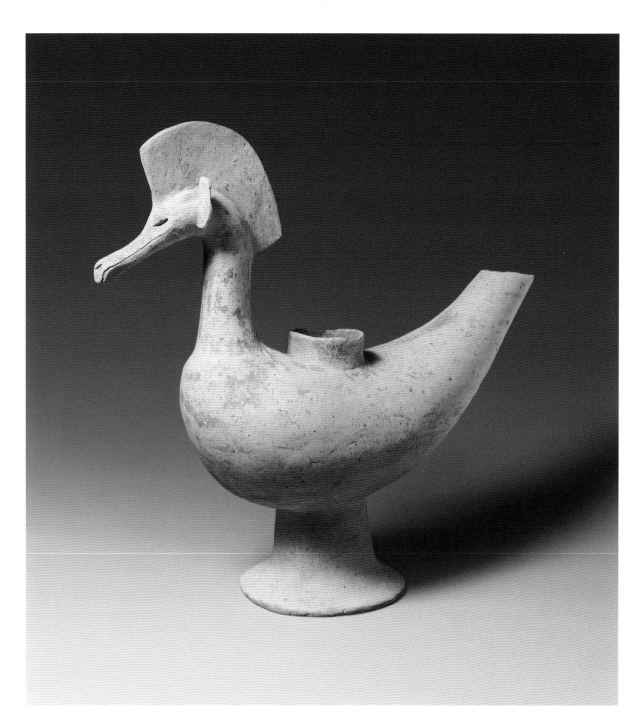

**Plate 3**
Bird-shaped Vessel
Proto–Three Kingdoms period
(1st century BCE–3rd century CE),
ca. late 2nd–3rd century CE
Earthenware, l. 14 in. (35.6 cm)
The Metropolitan Museum of Art,
Purchase, Lila Acheson Wallace
Gift, 1997 (1997.34.1)

## Plates 4 and 5

One of the political federations that emerged in the first century was known as Kaya, a small group of allied tribal states located between the kingdoms of Silla and Paekche, in the southern tip of the Korean peninsula. While they show affinities with Silla and Paekche objects, the ceramics produced in Kaya have several distinctive features and also some regional variations. Among the characteristic features of Kaya art is a pronounced interest in sculptural forms, as seen in the stoneware stand (pl. 4) dating from the fifth to the sixth century, which probably served as a support for a ritual vessel. Small sculpted animals occupy the ridges of this stand. While openwork decoration can be seen on most stands from the Three Kingdoms, this example demonstrates the Kaya preference for aligned rectangular perforations. Similar objects from the kingdom of Silla usually have staggered triangular openings.

The footed ritual wine cup in the shape of a mounted warrior (pl. 5), dated from the fifth to the sixth century, is evidence of the importance of the military in Kaya society, which depended on a strong military to fend off attacks from the neighboring states of Silla and Paekche as well as the Japanese islands to the south. The faces of the warriors in these Kaya vessels bear a remarkable similarity to those of the contemporaneous *haniwa* clay figures of humans found on the *kofun*, or tomb mounds, in Japan. Such similarities in material culture indicate the interaction, even in these early times, between the Korean peninsula and the Japanese archipelago.

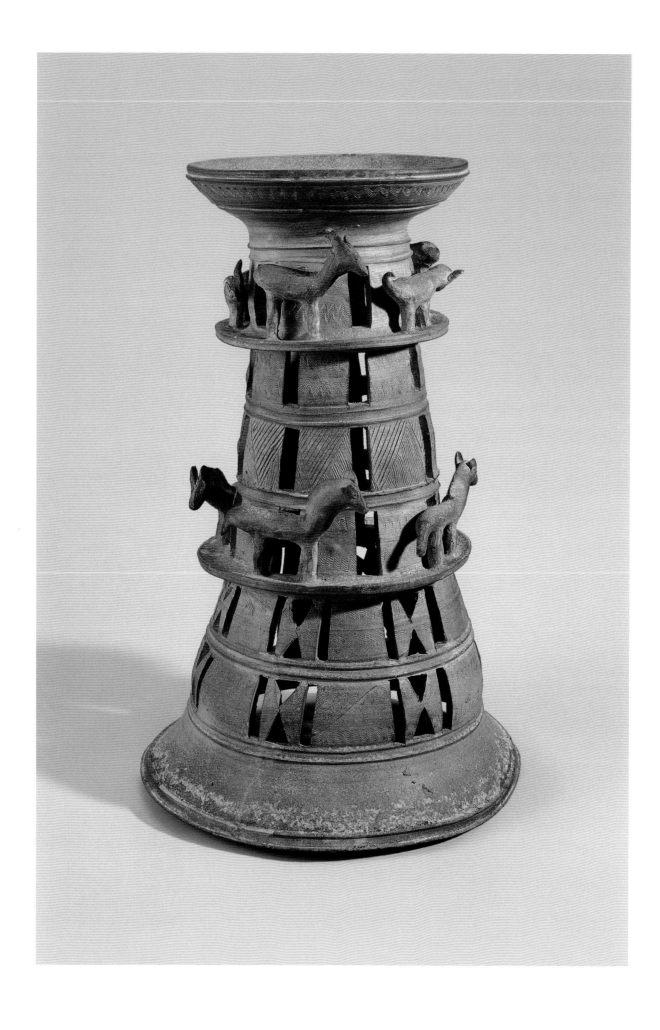

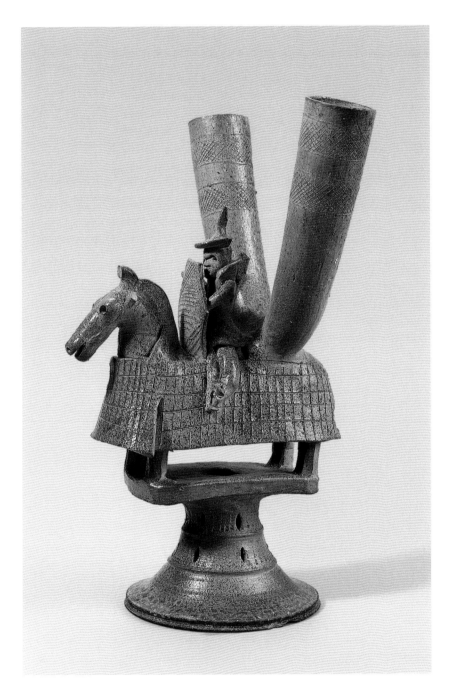

**Plate 4** (facing page)
Stand
Three Kingdoms period, Kaya Fed-
eration (42–562), 5th–6th century
Stoneware with incised decoration
and applied figures of animals,
h. 18 ¼ in. (46.3 cm)
Ho-Am Art Museum, Yongin

**Plate 5**
Double Wine Cup in the Shape of
a Mounted Warrior
Three Kingdoms period, Kaya Fed-
eration (42–562), 5th–6th century,
reportedly from Tŏksan-ni, Kim-
hae, South Kyŏngsang Province
Stoneware with ash glaze,
h. 9 ⅛ in. (23.2 cm)
Kyŏngju National Museum
National Treasure no. 275

Plate 6

With the exception of Chinese stoneware, the stoneware of the Three Kingdoms period is the earliest known high-fired ware in the world. The stonewares required temperatures of more than 1000° C to mature in the kiln. They were produced in a wood-fueled climbing kiln, a tunnel-shaped structure typically built up the side of a hill, which is ideal for producing intense and steady heat. This type of closed-kiln design allowed the restriction of the flow of oxygen into the firing chamber, resulting in the "reducing atmosphere" that is responsible for the characteristic gray color of Three Kingdoms ceramics. Other technological changes occurring at this time on the Korean peninsula include the widespread use of the potter's wheel, with which large, symmetrical pots could be produced rapidly. The potter's wheel also enabled potters to exploit the various properties of clay, such as its elasticity, more readily than with earlier methods of shaping vessels. The pottery of the Three Kingdoms period was also heavily influenced by metalware forms. The rigid profile and raised ridges of this double-handled vessel, for instance, are characteristic of contemporaneous iron vessels that potters mimicked. This vessel is rare both in its form and in its size. Such innovative forms are characteristic of objects produced in the southwestern kingdom of Paekche.

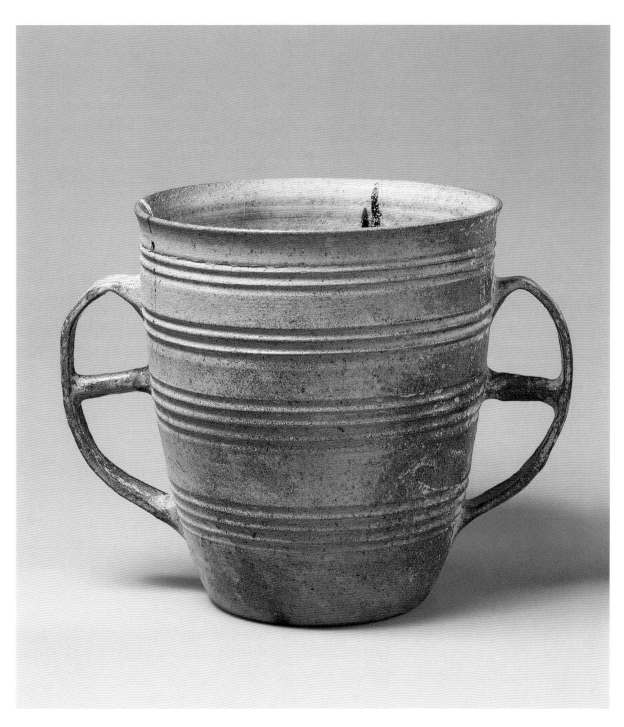

**Plate 6**
Double-Handled Vessel
Three Kingdoms period, probably
Paekche kingdom (18 BCE–660 CE),
5th–6th century
Stoneware, h. 8 in. (20.3 cm)
The Metropolitan Museum of Art,
Purchase, Lila Acheson Wallace
Gift, 1997 (1997.34.25)

## Plates 7–9

These early-seventh-century architectural tiles attest to the refined and sophisticated culture of Paekche, one of the principal powers on the Korean peninsula during the period of the Three Kingdoms. Situated in the southwestern part of the peninsula, on the Yellow Sea, Paekche maintained diplomatic relations with the various southern Chinese states during the Six Dynasties (220–589), a period of prolonged political turmoil in China following the collapse of the Han empire (206 BCE–220 CE). In addition, Paekche's embassies to Japan, which included scholars, monks, and artisans, played an important role in introducing the Chinese written language and Buddhism to the Japanese court.

The aristocracy of Paekche was more powerful than its counterparts in the kingdoms of Silla, in the southeast, and Koguryŏ, in the north. None of the resplendent palaces mentioned in historical records survives, but the lively decoration of these unglazed tiles hints at the opulence of now lost structures. These decorated tiles also provide important evidence of the early development of pictorial art in Korea. The prevalence of mountain scenes in Paekche tiles suggests a growing interest in landscape painting, which was at the time also emerging in China as a major painting genre. The layering of iconic mountains, with a central host peak and flanking guest peaks, is similar to early attempts by Chinese painters to suggest spatial recession. Isolated and rarefied mountain peaks were thought to be the ideal dwelling places of immortal beings. The landscape tiles shown here (pls. 8, 9) may represent sacred and supernatural realms, while the grimacing creature (pl. 7) seems to serve an apotropaic function, analogous to that of the guardian figures found in Asian art and architecture. Yet the specific forms of the mountains, with their highly abstracted, modular qualities, as well as the image of the creature, are distinctively Korean reinterpretations of influences from the mainland.

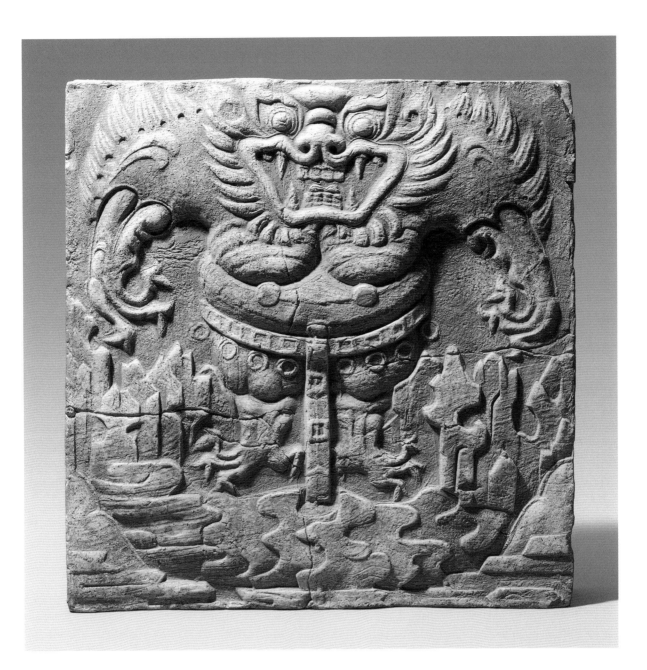

**Plate 7**
Tile
Three Kingdoms period, Paekche
kingdom (18 B C E–660 C E), early
7th century, from Kyuam-myŏn,
Puyŏ, South Ch'ungch'ŏng Province
Earthenware with relief decoration
of monster and landscape,
11 × 11 in. (28 × 28 cm)
The National Museum of Korea,
Seoul, Treasure no. 343

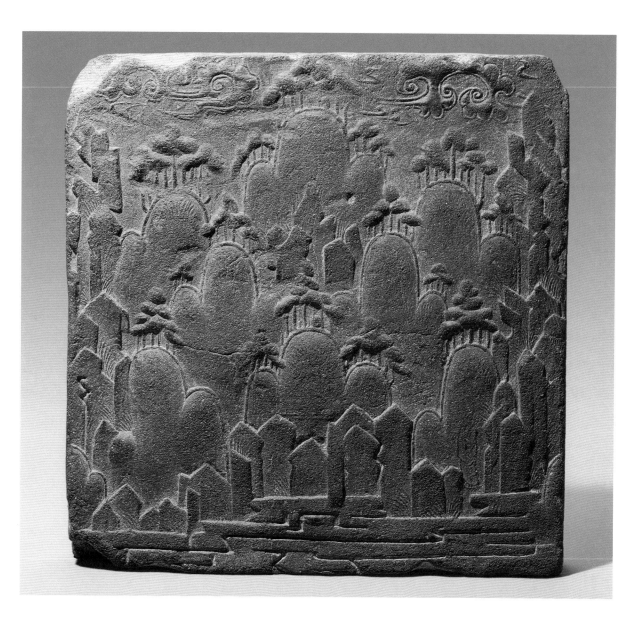

**Plate 8**
Tile
Three Kingdoms period, Paekche
kingdom (18 B C E–660 C E), early
7th century
Earthenware with relief decora-
tion of landscape, 11 ¾ × 11 ¾ in.
(29.8 × 29.8 cm)
The National Museum of Korea,
Seoul, Treasure no. 343

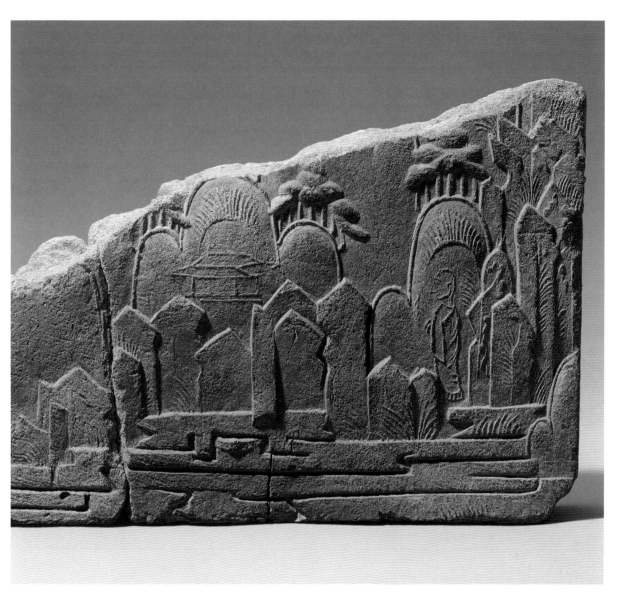

**Plate 9**
Fragment of Tile
Three Kingdoms period, Paekche
kingdom (18 B C E–660 C E), early
7th century
Earthenware with relief decoration
of landscape, l. 9 ⅞ in. (25 cm)
The National Museum of Korea,
Seoul

**Plate 10**

Bottle with Flattened Side
Unified Silla period (668–935),
8th–10th century
Stoneware, h. 9 in. (22.9 cm)
The Metropolitan Museum of Art,
Purchase, Judith G. and F. Randall
Smith Gift, 1994 (1994.226)

## Plate 10

In the late seventh century, after years of internecine warfare and constantly shifting alliances among the peninsular powers, the southeastern kingdom of Silla succeeded in uniting the Korean peninsula for the first time under a single government. The rulers of Unified Silla continued the close relationship between the state and Buddhism initiated by their predecessors, and the Buddhist establishment flourished under the patronage of the royalty and the aristocracy. The cosmopolitan Unified Silla court pursued extensive contacts with Japan as well as with the Tang dynasty (618–907) in China. Moreover, the numerous Buddhist pilgrims who traveled from Korea to China and India also brought a greater awareness of other cultures to the peninsula.

The response of Unified Silla potters to foreign influences can be seen in this flat-sided stoneware bottle of the eighth to the tenth century. The vessel's form probably derives from the leather flasks used by nomadic tribes in the northern regions of the mainland; these flasks had slightly flared lips that facilitated their suspension from saddles. The surface of this vessel is adorned only with accidental splashes of ash glaze, the result of wood ash falling on the vessel during firing. An important technological advancement in ceramic production in Korea at this time was the use of lead glazes. This technique required two firings: the first, at a high temperature, to mature the clay body, and the second at the lower temperature required for lead glazes.

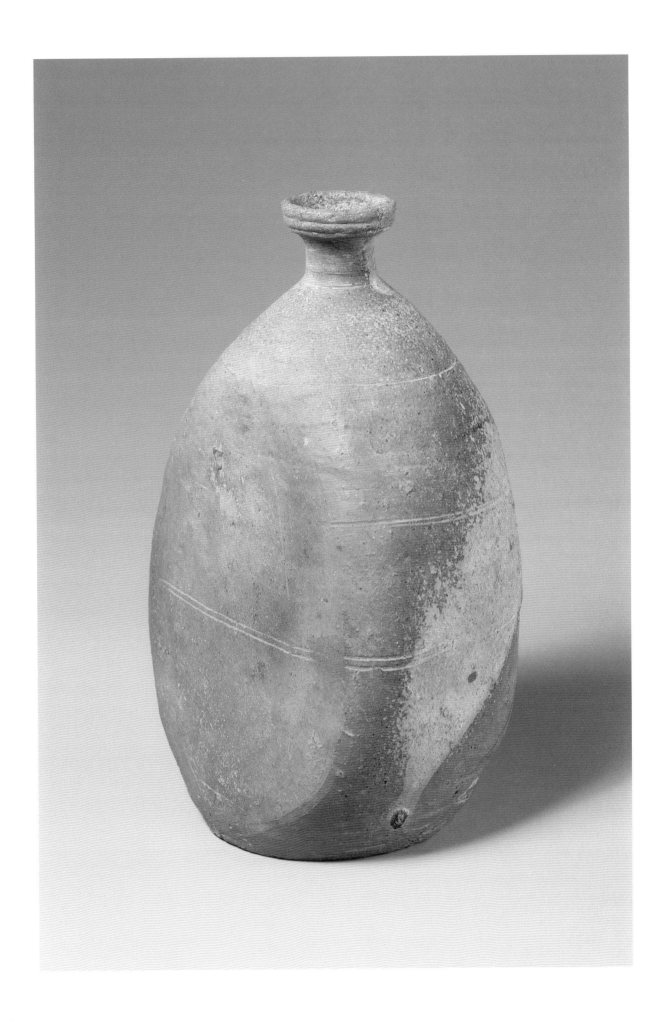

Plate 11
Wine Ewer
Koryŏ dynasty (918–1392), ca. 1100
Celadon with incised and carved
design of geese, water birds, and
reeds, h. 10 ½ in. (26.6 cm)
The Metropolitan Museum of Art,
Fletcher Fund, 1927 (27.119.2)

CERAMICS

60

## Plates 11 – 14

Celadon wares are among the most widely admired of Korean ceramics. Produced in Korea during the Koryŏ dynasty, they reached the height of their perfection in technology, form, and decoration in the twelfth and thirteenth centuries. In the color of their glazes and in shape and design, the earliest Koryŏ celadons closely resemble high-fired (above 1200° C) glazed stonewares of the eighth to the tenth century from Zhejiang Province in China. The Korean celadon industry asserted its independence, however, and by the beginning of the twelfth century had developed the celebrated glazes, refined forms, and naturalistic designs that won high praise from visiting Chinese, one of whom pronounced Korean celadons as "first under Heaven." Koryŏ glazes were prized for their remarkable translucence and characteristic color, derived from the presence of small amounts of iron in the glaze, which turns a subtle blue-green or gray-green color when fired in a reducing atmosphere.

Koryŏ potters frequently embellished their wares by incising and carving, as in these four monochrome celadons. The popular motif of water fowl among plants and trees, which decorates the gourd-shaped ewer (pl. 11), the *kundika* bottle (pl. 12), and the lobed dish (pl. 14), combines Korean aesthetic sensibilities and strong interest in naturalistic imagery. Although the kundika was originally used in Buddhist rituals, the design that adorns the bottle has no overtly religious content. This preference for decorative effect is also seen in the water dropper (pl. 13), an essential article in the scholar's study. The sculpted duck holding a vine in its mouth is evidence of the potter's superb craftsmanship. The care lavished on such small, utilitarian objects attests to the refined lifestyle of the Koryŏ aristocracy.

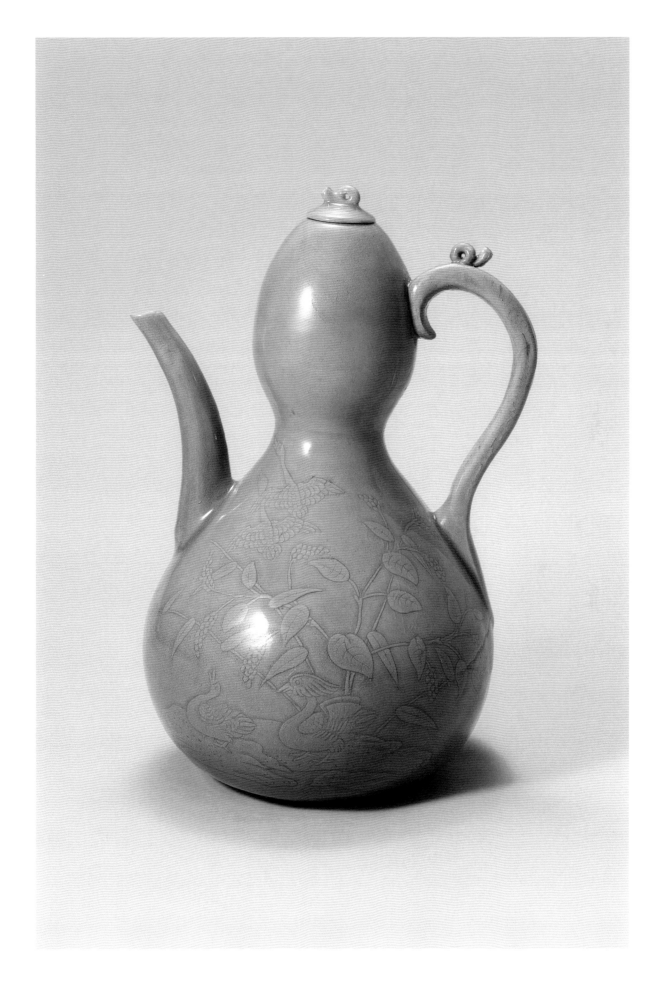

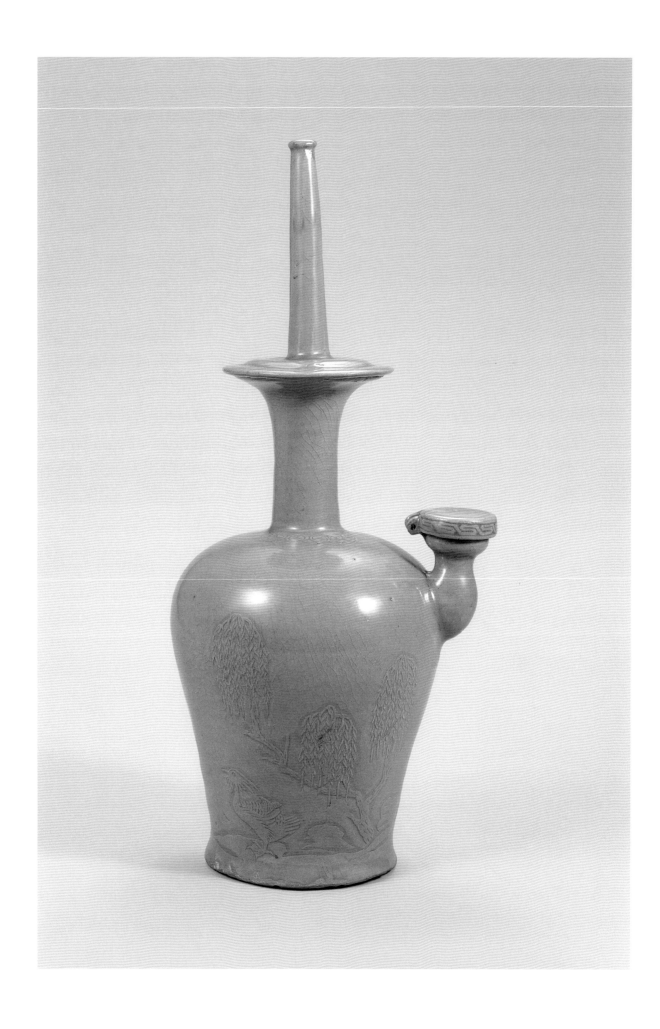

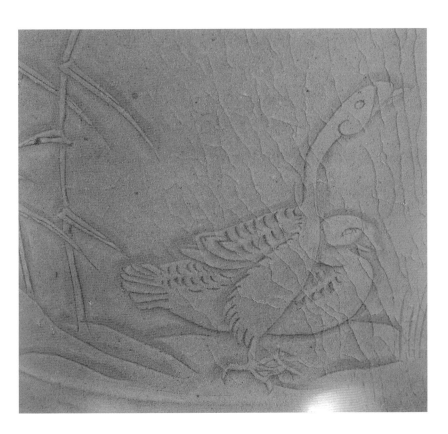

**Plate 12**
Bottle (*Kundika*), full view and
detail of other side
Koryŏ dynasty (918–1392),
mid-12th century
Celadon with incised and carved
design of water birds and willows,
h. 13 ½ in. (34.2 cm)
The National Museum of Korea,
Seoul, Treasure no. 344

CERAMICS

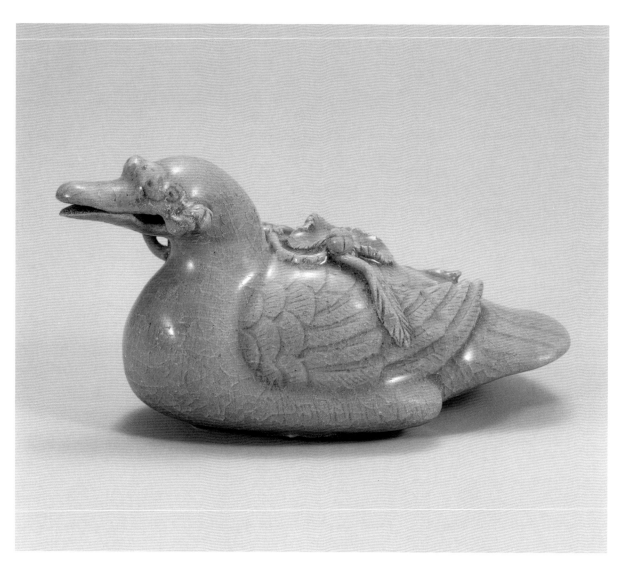

**Plate 13**
Water Dropper in the Shape
of a Duck
Koryŏ dynasty (918–1392),
12th century
Celadon, l. 5 ⅞ in. (15 cm),
h. 2 ¾ in. (7 cm)
Horim Art Museum, Seoul

**Plate 14** (facing page)
Lobed Dish
Koryŏ dynasty (918–1392),
12th century
Celadon with mold-impressed
design of fish, water birds, and
lotus, diam. 6 ⅜ in. (16.1 cm)
Ho-Am Art Museum, Yongin
Treasure no. 1031

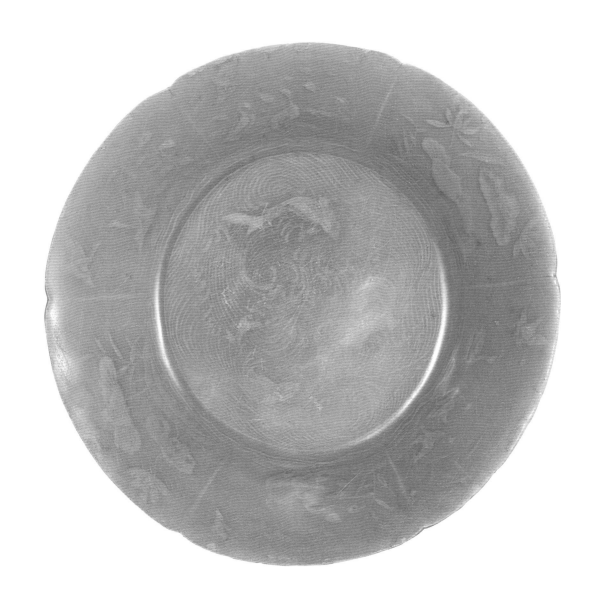

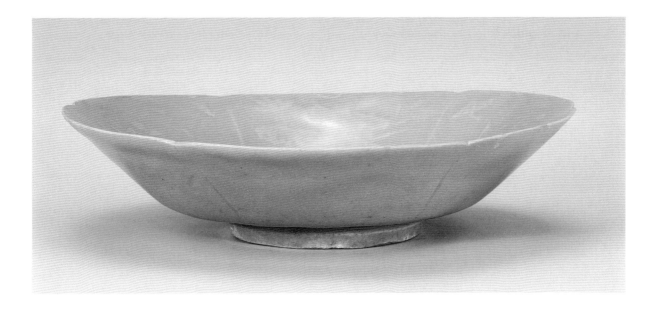

**Plate 15**
Maebyŏng (Prunus Vase)
Koryŏ dynasty (918–1392),
12th century
Celadon with inlaid design of
figures, plants, and garden rocks,
h. 15 ⅛ in. (38.5 cm)
Ewha Womans University
Museum, Seoul

## Plate 15

Inlaid celadon wares are unique to Korea. Although widely employed in Korean metalwork and lacquerware, inlays were put to use in the decoration of celadons only when glazes of sufficient clarity were developed in the first half of the twelfth century. In this technique, known as *sanggam*, the design is carved into the moist clay body, then filled in with a white or black substance before glazing and firing. The design is clearly visible through the glaze; this would not have been possible with the earlier, more opaque glazes introduced from China. What began as a minor decorative technique used in combination with incised and carved designs became the most frequently used type of decoration at the height of the celadon tradition. The sharp, well-controlled lines as well as the colors of inlays offered greater pictorial possibilities than earlier decorative methods.

This *maebyŏng*, or prunus vase, inlaid with four scenes depicting two people in a garden setting was clearly meant to be appreciated for the pictorial quality of its decoration. The pair may be husband and wife, in which case the scenes perhaps portray idealized tableaux of marital bliss. The figures are shown playing musical instruments, viewing a painting, and writing calligraphy. In the fourth scene, one figure holds up a mirror in front of the other. All of these activities take place in an elegant garden setting, with ornamental rocks and plants, including chrysanthemums, peonies, and bamboo. The large scale of these landscape elements in relation to the figures distinguishes them as separate decorative motifs.

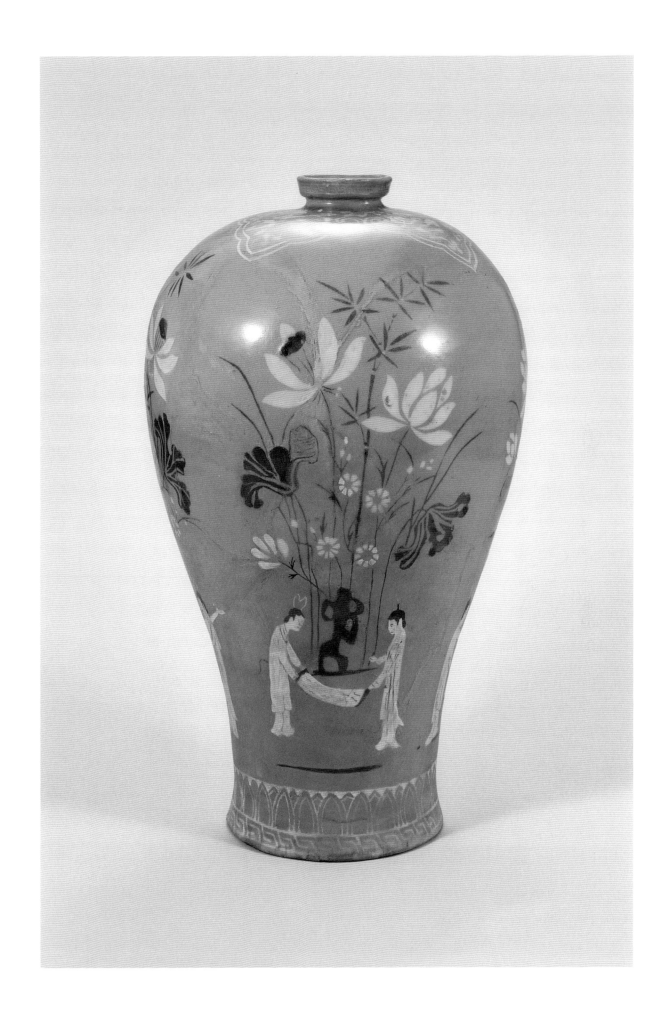

**Plate 15**
Maebyŏng (Prunus Vase), details

## Plates 16–19

Koryŏ potters employed the technique of *sanggam* inlay in a variety of ways. One of the best known examples of this type of decoration is this twelfth-century rectangular plaque (pl. 16), which seems to have been produced for purely ornamental purposes. The flat object presents an ideal pictorial surface for a delicately rendered scene of waterfowl among reeds and bamboo enclosed within a simple geometric border. This decoration is remarkable for its idyllic naturalism.

Relations with China had an ongoing impact on the Korean ceramic industry. For example, the regular tribute sent by the Koryŏ court to the Chinese Yuan dynasty (1272–1368) included ceramics that reflected Chinese tastes, as evidenced by the border decorations and ogival panels on a vase inlaid with a design of a figure in a pavilion (pl. 17), dated to the thirteenth century. Yet, another vase with a large and freely rendered cranes-and-clouds design (pl. 18), whose shape differs noticeably from its Chinese prototype, clearly demonstrates the independence of the Korean ceramic tradition by this time. Another important example of distinctly Korean wares is a long-necked bottle with a design of flowers and dragons (pl. 19). The technique of producing the underglaze copper-red color on this piece was probably an invention of Koryŏ potters, who had succeeded in producing the copper-red color early in the twelfth century.

**Plate 16**
Plaque
Koryŏ dynasty (918–1392),
12th century
Celadon with inlaid design of
water birds, reeds, and bamboo,
5 ⅞ × 8 in. (14.9 × 20.4 cm)
Museum of Oriental Ceramics,
Osaka

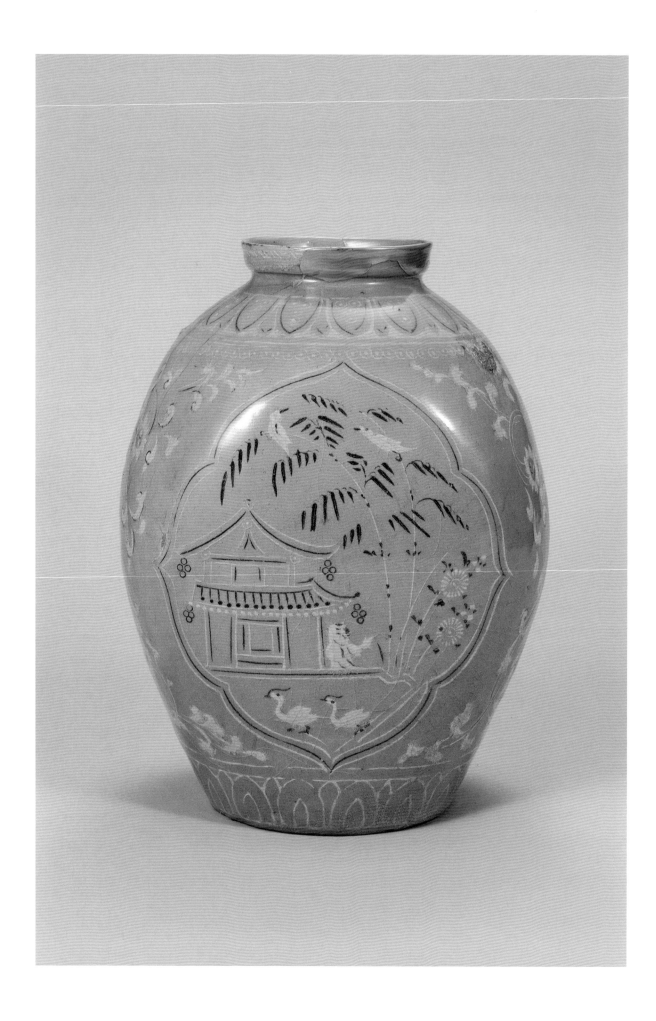

**Plate 17**
Vase, full view and detail
of other side
Koryŏ dynasty (918–1392),
13th century
Celadon with inlaid design of figure
in a pavilion, h. 9 ⅞ in. (25.2 cm)
The National Museum of Korea,
Seoul

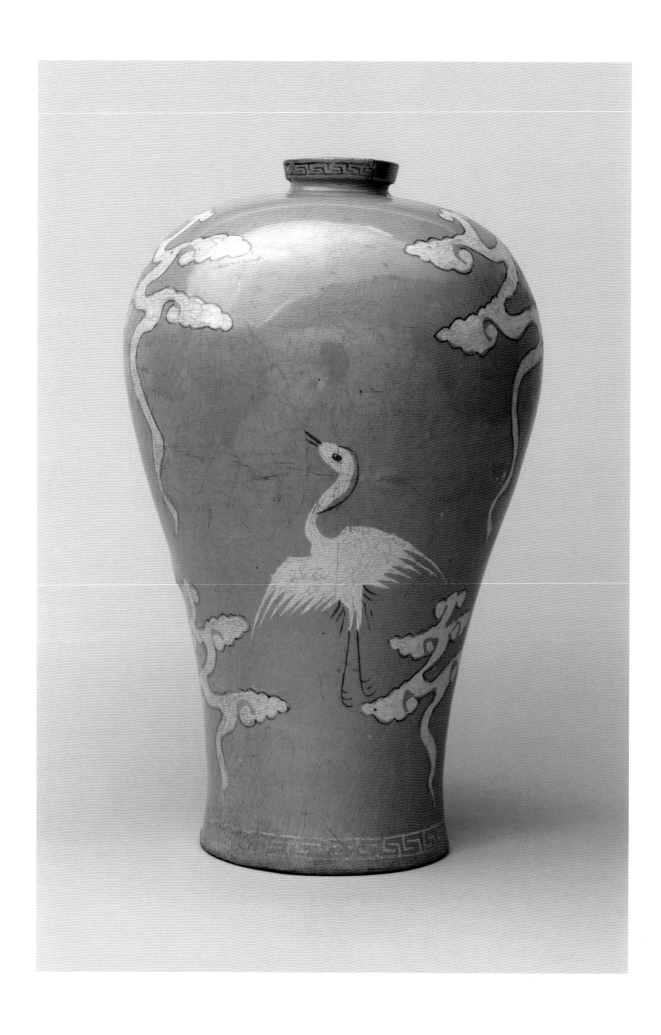

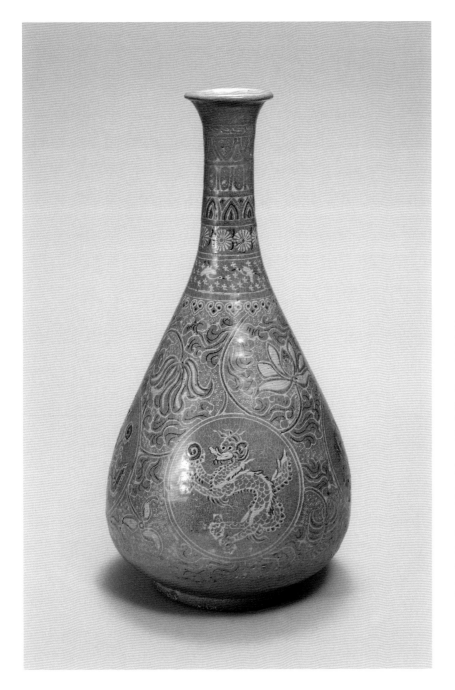

**Plate 18** (facing page)
Maebyŏng (Prunus Vase)
Koryŏ dynasty (918–1392), late
13th–early 14th century
Celadon with inlaid design of cranes
and clouds, h. 11 ½ in. (29.2 cm)
The Metropolitan Museum of Art,
Fletcher Fund, 1927 (27.119.11)

**Plate 19**
Bottle
Koryŏ dynasty (918–1392),
13th century
Celadon with underglaze copper-
red and inlaid design of flowers and
dragons, h. 15 in. (38.3 cm)
Horim Art Museum, Seoul
Treasure no. 1022

**Plate 20**
Maebyŏng (Prunus Vase)
Koryŏ dynasty (918–1392),
12th century
Celadon with underglaze iron-brown
decoration of bird, butterflies, and
vines, h. 11 ½ in. (29.1 cm)
Ho-Am Art Museum, Yongin

## Plates 20–22

In addition to the well-known monochrome and inlaid celadons, the technique of painting in iron oxide under a celadon glaze was fully exploited during the Koryŏ period to produce bold decorations on robustly shaped vessels. Celadons painted in underglaze iron are fired in oxidation, resulting in a yellowish or brownish glaze color as opposed to the green tones of celadons fired in a reducing atmosphere. The designs are painted directly onto the ceramic body and consequently tend to be more bold and spontaneous in execution than the more laboriously applied inlays.

The twelfth-century *maebyŏng* (pl. 20), with its lively decoration of a bird and two butterflies above scrolling vines, displays the exuberant brushwork characteristic of these wares. The expressive possibilities of this decorative technique are seen in the cylindrical-shaped vase (pl. 21) adorned with the single motif of a willow tree. This minimal drawing has the graphic, emblematic quality of a Chinese character, with only the most essential elements of representation. The quiet yet spontaneous quality of the drawing complements the casual and rough-hewn appearance of the vase.

In some cases, the entire vessel has been covered with iron slip before being glazed and fired. The design of ginseng leaves on another twelfth-century maebyŏng (pl. 22) was created by scraping away the iron slip and applying white slip. The uneven application of the slip enhances the dramatic contrast of the white decoration against the dark brown ground and also imparts a sense of texture and volume to the leaves. The improvisatory sensibilities underlying these wares come to the forefront in the next major period of Korean ceramics with the development of *punch'ŏng* wares in the Chosŏn dynasty.

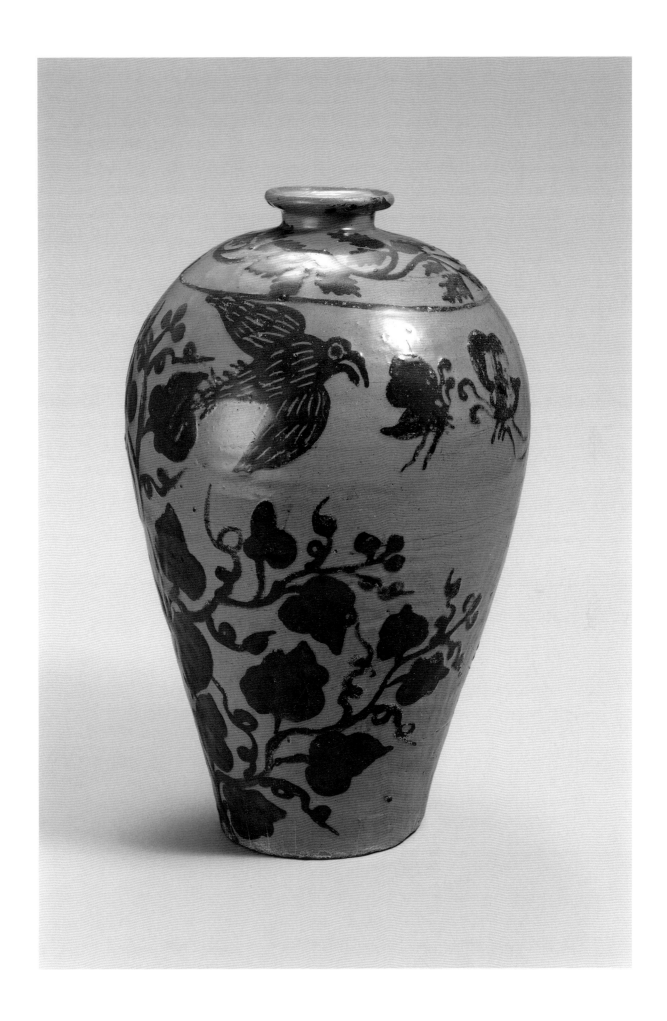

CERAMICS

77

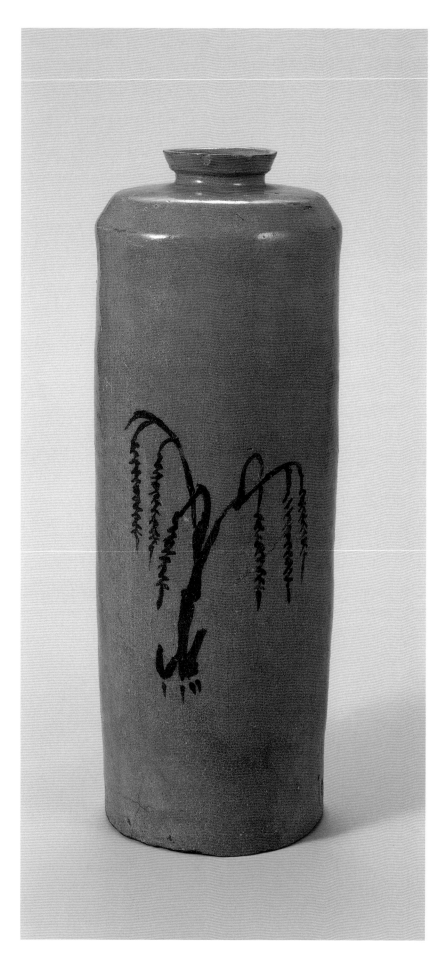

**Plate 21**
Vase
Koryŏ dynasty (918–1392),
12th century
Celadon with underglaze iron-
brown decoration of willow,
h. 12 ⅜ in. (31.6 cm)
The National Museum of Korea,
Seoul, National Treasure no. 113

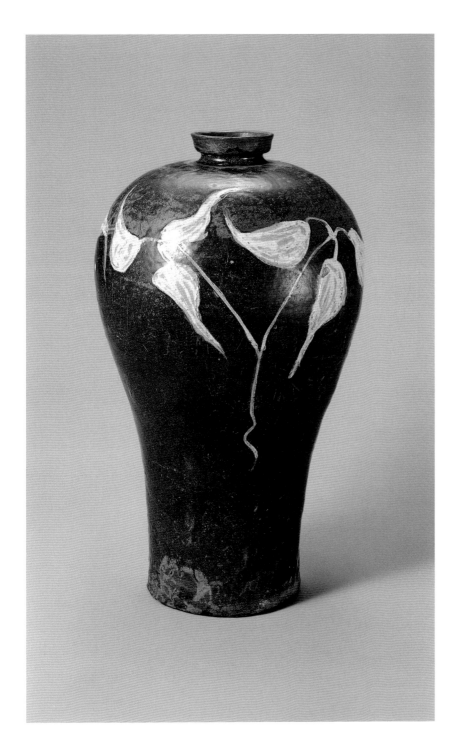

**Plate 22**
Maebyŏng (Prunus Vase)
Koryŏ dynasty (918–1392),
12th century
Celadon with underglaze iron-
brown and inlaid design of gin-
seng leaves, h. 10 ⅞ in. (27.5 cm)
The National Museum of Korea,
Seoul, Treasure no. 340

**Plate 23**
Bottle
Chosŏn dynasty (1392–1910),
15th century
Punch'ŏng ware, h. 12 ⅞ in. (32.6 cm)
Ho-Am Art Museum, Yongin

## Plates 23 – 25

*Punch'ŏng* ("powder-green") wares, so-called because of their bluish-green clear glaze, flourished in the fifteenth and sixteenth centuries. With the establishment of the Chosŏn dynasty in 1392, the Korean ceramics industry, which had begun to deteriorate in the final years of the Koryŏ period, was revived and began to produce porcelains as well as punch'ŏng. Technical similarities and improvised decorations point to the late Koryŏ celadon tradition as the source of early punch'ŏng. The forms of early punch'ŏng wares are also indebted to the high centers of balance and more sturdy profiles of late Koryŏ celadons. For example, hand-carved inlay had by the late Koryŏ been simplified to stamped designs, a technique that is taken to an extreme in a fifteenth-century punch'ŏng bottle (pl. 23), its entire surface stamped with circles derived from celadon chrysanthemum patterns. Instead of local areas of inlay, in this example the whole piece was dipped into white slip and the excess wiped off to reveal the filled-in stamped areas.

This simplified inlay technique soon gave way to decorative strategies that allowed a spontaneous, freehand style comparable to that seen on Koryŏ celadons painted in underglaze iron (see pls. 20–22). By the sixteenth century, objects were simply dipped into slip, to make them look like porcelain ware. The most innovative development in punch'ŏng ware, however, involved other decorative techniques. In some cases, the slip was cut away to create sgraffito designs of striking playfulness and vibrancy (pl. 24), while in other cases, the objects were simply brushed with slip, resulting in startlingly abstract and dynamic designs (pl. 25). The punch'ŏng tradition ended in Korea with the devastating invasions of the peninsula led by the Japanese warlord Toyotomi Hideyoshi (1536–1598), whose campaigns included the forced relocation of entire pottery-making villages to Japan, where these wares were popular with practitioners of the tea ceremony.

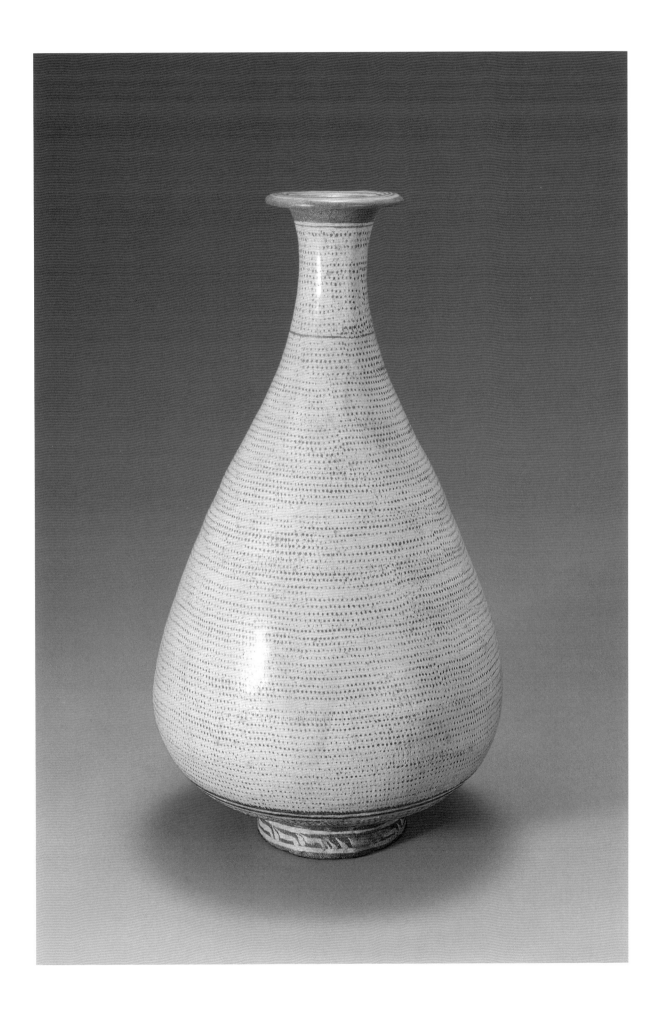

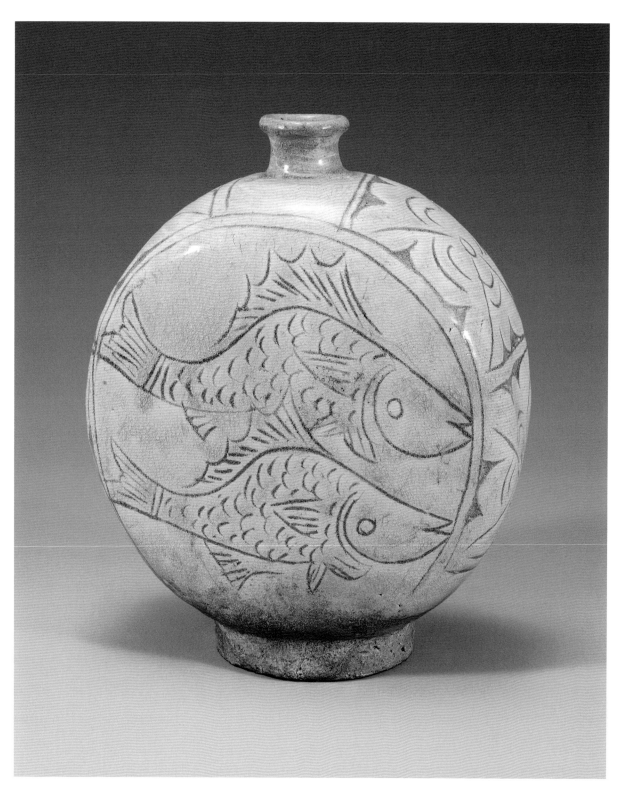

**Plate 24**
Flask-shaped Bottle
Chosŏn dynasty (1392–1910),
15th century
Punch'ŏng ware with incised
design of fish, h. 10 ⅛ in. (25.6 cm)
Ho-Am Art Museum, Yongin

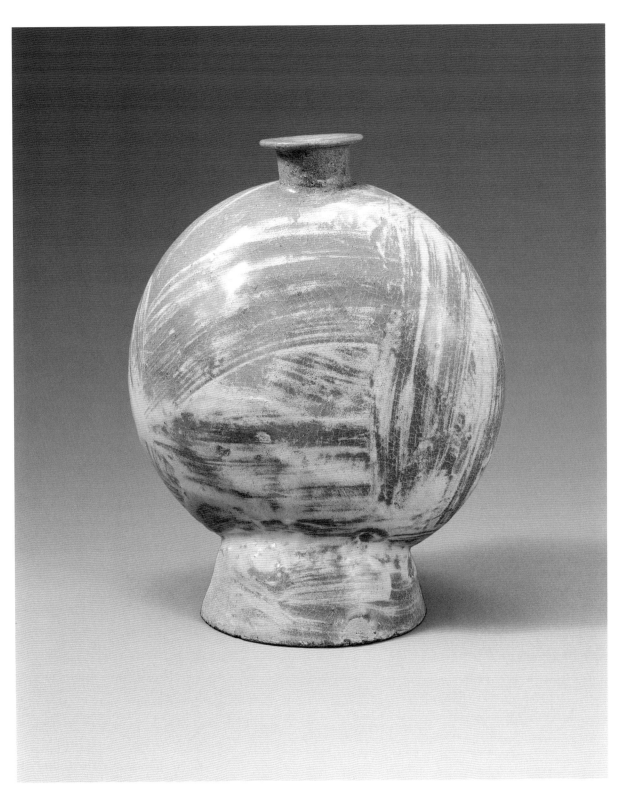

**Plate 25**
Flask-shaped Bottle
Chosŏn dynasty (1392–1910),
16th century
Punch'ŏng ware, h. 8 ⅝ in. (22 cm)
Ho-Am Art Museum, Yongin

**Plate 26**
Bottle
Chosŏn dynasty (1392–1910),
15th century
White porcelain, h. 14 ¼ in. (36.2 cm)
The National Museum of Korea,
Seoul, Treasure no. 1054

## Plates 26 – 29

Porcelain manufacture, which requires a special clay and extremely high firing temperatures (1300°–1350° C), was first developed in China. In their shapes, the earliest Korean porcelains reveal the influence of similar wares from the latter part of the Yuan (1272–1368) and early Ming (1368–1644) dynasties. They are quite distinct from contemporaneous *punch'ŏng* ceramics, having instead lower, wider centers of gravity and more stately profiles (pl. 26).

White-bodied porcelain wares became popular with the advent of the Chosŏn dynasty, and continued to be produced throughout the period. The early phase of porcelain production, from the founding of the dynasty at the end of the fourteenth century to the mid-seventeenth century, is characterized by undecorated white wares (pl. 28), although blue-and-white decorated wares began to be produced in the fifteenth century. These white wares reflect the austere tastes associated with Neo-Confucianism, which was embraced by the Chosŏn rulers as the official ideology of the new state.

The lessening of the influence of Confucian teaching on the arts and the increasing impact of foreign influences, including those from the West, led in the mid-eighteenth century to a variety of shapes, designs, and decorative techniques in Korean porcelains. Porcelain was even used for large, utilitarian objects. Among the most striking of these are the large jars produced by joining two bowl-shaped forms at their rims. The example shown here (pl. 29) would have been especially admired for its irregular shape, a result of slight sagging during the firing of the vessel.

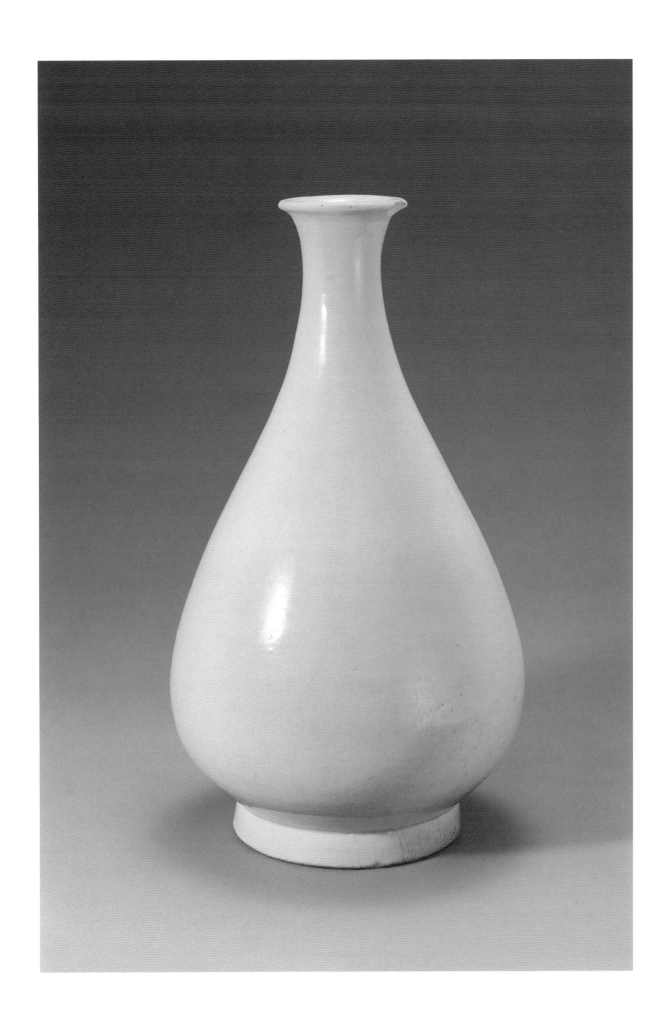

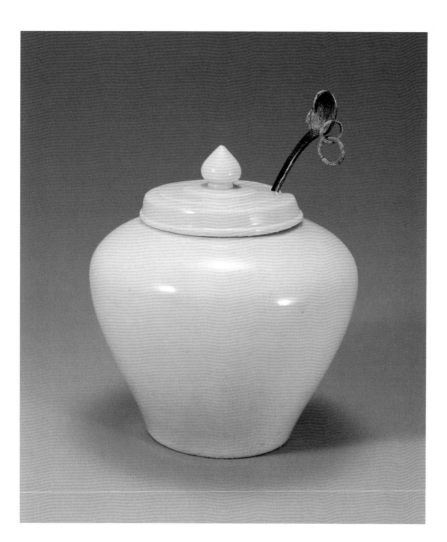

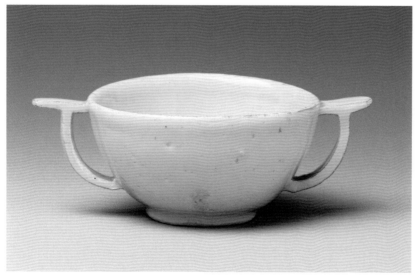

**Plate 27**
Covered Jar with Spoon
Chŏson dynasty (1392–1910),
16th century
White porcelain jar,
h. 5 ⅝ in. (14.3 cm); bronze spoon,
l. 6 ¾ in. (17.1 cm)
Chŏng Kap-bong Collection, Seoul

**Plate 28**
Wine Cup
Chosŏn dynasty (1392–1910),
15th century
White porcelain, h. 1 ⅝ in. (4.1 cm)
The Metropolitan Museum of Art,
Rogers Fund, 1917 (17.175.1)

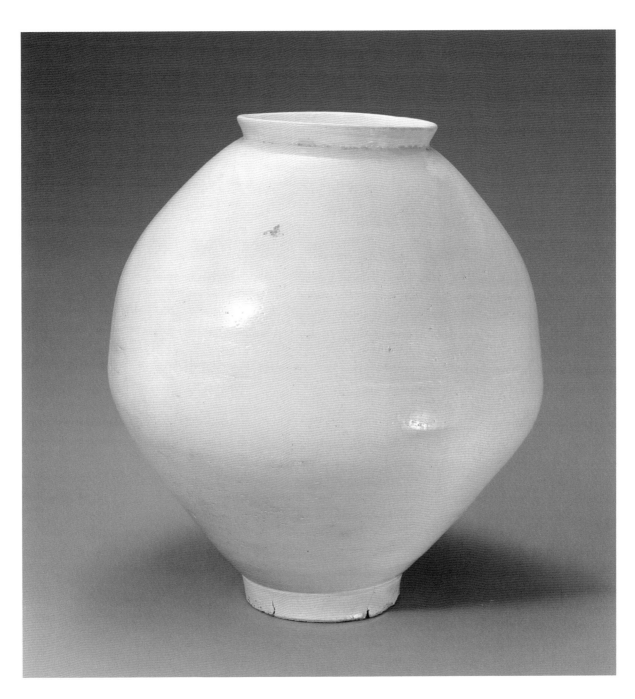

**Plate 29**
Large Jar
Chosŏn dynasty (1392–1910),
18th century
White porcelain, h. 19 in. (48.2 cm)
U Hak Collection, Seoul
National Treasure no. 262

## Plates 30 – 34

Although plain white-bodied porcelains were favored throughout the Chosŏn period, decorated versions of the same wares were also produced in large quantities. The Chinese blue-and-white wares of the Ming dynasty (1368–1644) served as one model for Korean potters, who adopted the technique of underglaze cobalt-blue decoration in the fifteenth century. Since the only source of the mineral at the time was Persia, cobalt was at first used sparingly, as in the vase with a decorative motif of birds among plum branches (pl. 32). Examples of more generous use of the precious material include a wine cup (pl. 30) and a large vase decorated with plum and bamboo (pl. 31). To the Chinese poet-scholar, plum blossoms and bamboo symbolized steadfastness in the face of adversity. Such Confucian ideals were espoused as well by the Chosŏn scholar-official class. The importance of Confucian doctrine in Chosŏn society is also evident in the eighteenth-century dish (pl. 34) whose cobalt-blue inscription identifies it as a stand for ritual offerings to ancestors.

While the style of painting, the shape, and the prominent border panels of the large blue-and-white vase are indebted to Chinese models, Korean potters developed innovative alternatives to such highly schematic decoration. For instance, decorative painting was often applied with little reference to the shape of the object, as exemplified by the randomness of a line drawing of chrysanthemums fanning out over three bevels of an octagonal bottle (pl. 33), produced in the seventeenth century.

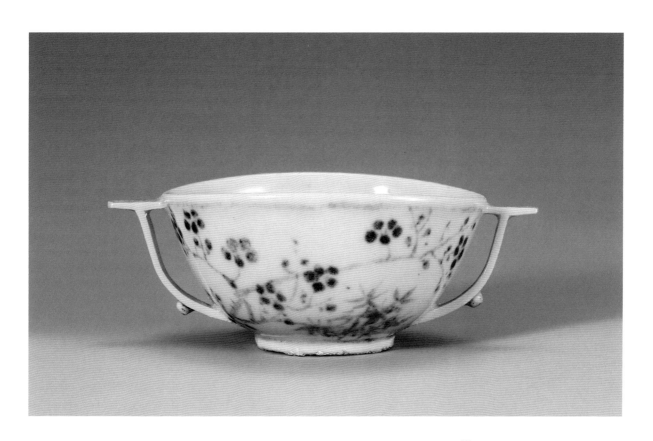

**Plate 30**
Wine Cup
Chosŏn dynasty (1392–1910),
15th century
Porcelain with underglaze cobalt-
blue decoration of plum and bam-
boo, h. 1 ½ in. (3.7 cm)
Ho-Am Art Museum, Yongin

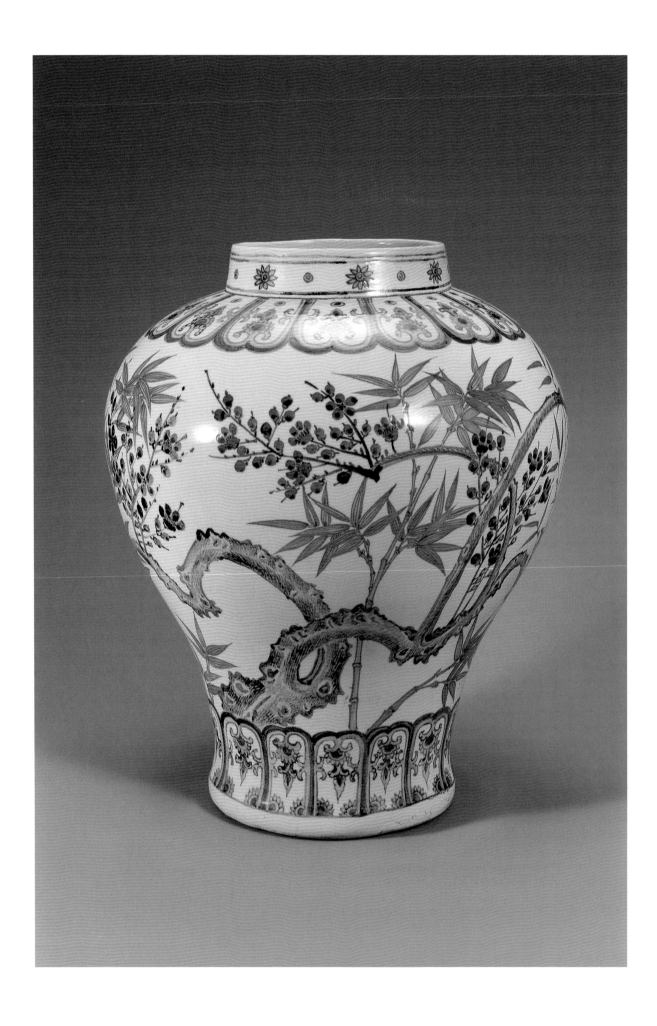

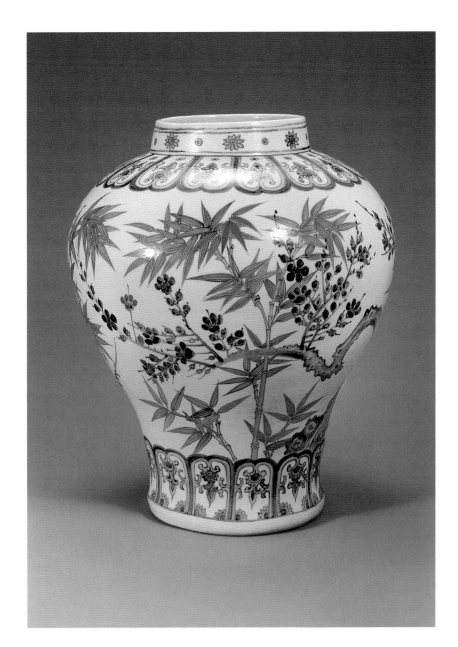

**Plate 31**

Jar, two views
Chosŏn dynasty (1392–1910),
mid-15th century
Porcelain with underglaze cobalt-
blue decoration of plum and
bamboo, h. 16 ⅛ in. (41 cm)
Ho-Am Art Museum, Yongin
National Treasure no. 219

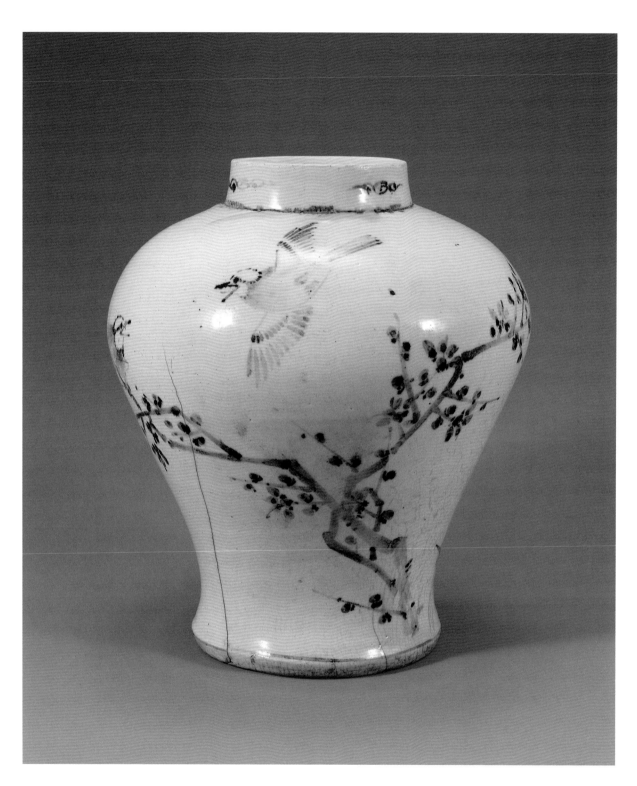

**Plate 32**
Jar
Chosŏn dynasty (1392–1910),
15th century
Porcelain with underglaze cobalt-
blue decoration of birds and plum,
h. 9 ⅝ in. (24.5 cm)
The National Museum of Korea,
Seoul

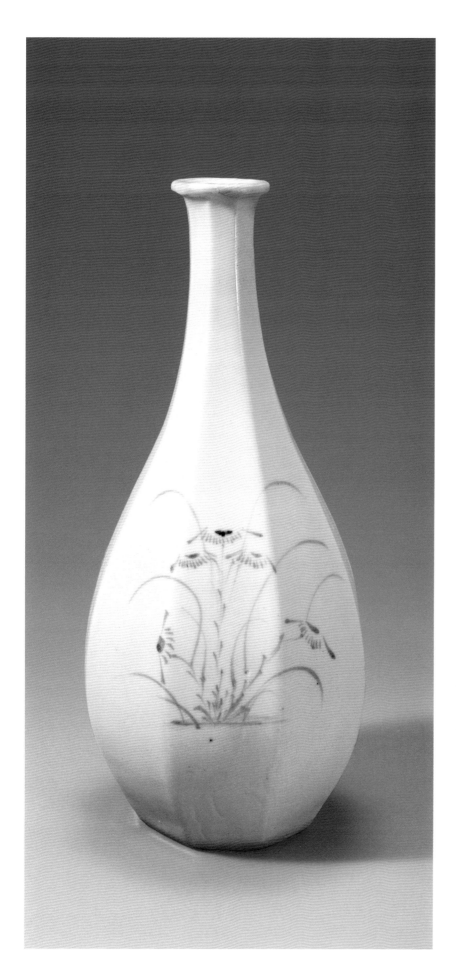

**Plate 33**
Beveled Bottle
Chosŏn dynasty (1392–1910), late
17th century
Porcelain with underglaze
cobalt-blue decoration of chrysan-
themums, h. 10 ⅞ in. (27.5 cm)
Gift of Pak Pyŏng-nae, The
National Museum of Korea, Seoul

**Plate 34**
Ritual Dish
Chosŏn dynasty (1392–1910),
18th century
Porcelain with underglaze
cobalt-blue inscription, h. 3 ⅛ in.
(7.9 cm), w. 8 ¾ in. (22.2 cm)
Chŏng Kap-bong Collection, Seoul

## Plates 35–37

The excellence achieved by Korean potters painting in underglaze iron is evident in a highly formal vase (pl. 35) from the seventeenth century. Similar in shape to contemporaneous wares of the Ming dynasty (1368–1644), it is ornamented with a depiction of the popular motif of plum and bamboo, framed by Chinese-style borders at the shoulder and foot. The fluency and practiced ease of the painting suggest that it was executed by a specialist, probably from the royal academy. Indeed, ink-bamboo painting was one of the subjects included in the examination administered to candidates for the painting academy. The wide, thick portions of the bamboo leaves on this vase have been achieved with a thick layer of underglaze iron, which has burned through the clear glaze to form rust-colored areas that lend texture and volume to the painting.

A less academic style of painting is represented by a large sixteenth-century jar (pl. 36) with a decoration of a dragon amid clouds in underglaze iron. Unlike the fierce and forbidding dragons found in the arts of China and of earlier periods in Korea, Chosŏn dragons are characterized by their humor, exuberance, and warmth. The loose and improvisatory painting style complements the formal dynamism of the supernatural creature.

Underglaze copper-red decoration, an extremely difficult technique most likely invented by Koryŏ potters, was revived in the eighteenth century with the flourishing of the decorative arts. The large porcelain jar with a design of grapevines (pl. 37) represents a group of ceramics from an unidentified kiln, possibly a private provincial kiln in northern Kyŏnggi Province, that is remarkable for its exclusive and liberal use of copper-red. All jars of this shape produced at the kiln have the distinctively exaggerated everted lip and the band of double raised lines at the shoulder.

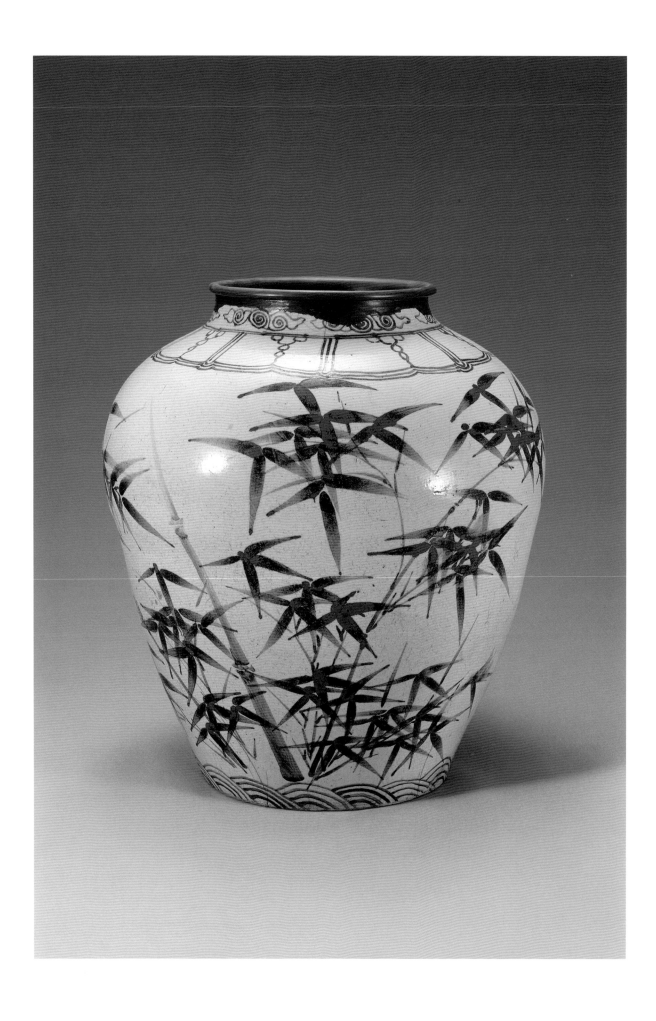

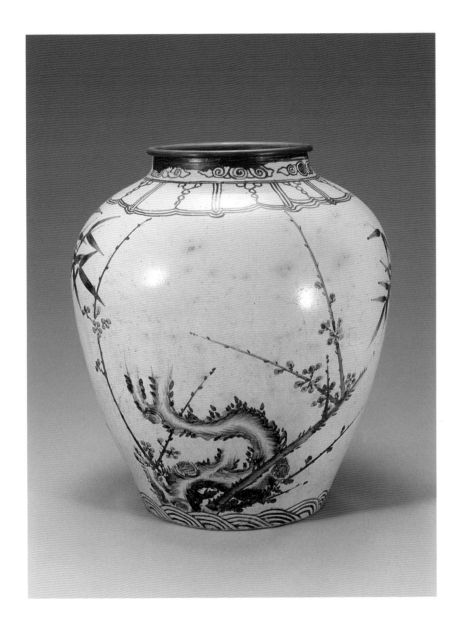

**Plate 35**
Jar, two views
Chosŏn dynasty (1392–1910),
17th century
Porcelain with underglaze iron-
brown decoration of bamboo and
plum, h. 15 ¾ in. (40 cm)
The National Museum of Korea,
Seoul, National Treasure no. 166

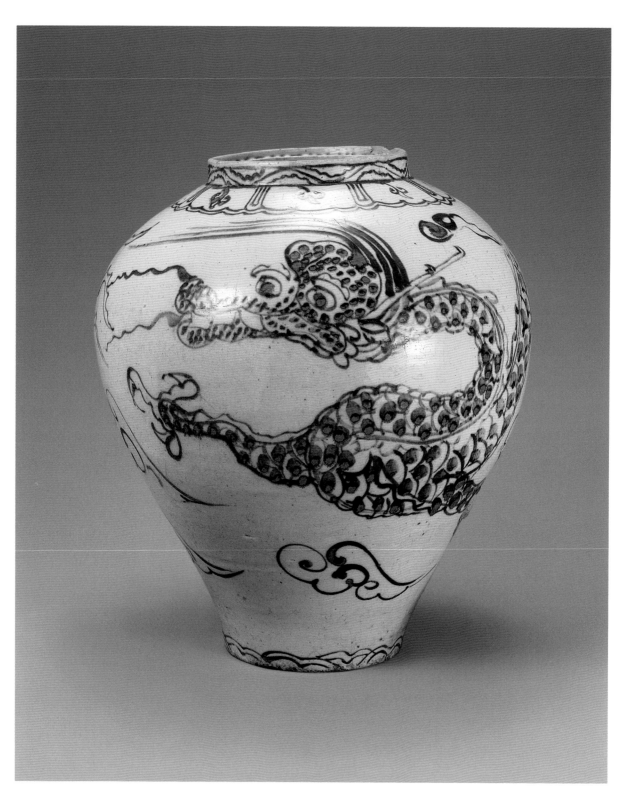

**Plate 36**
Jar
Chosŏn dynasty (1392–1910),
16th century
Porcelain with underglaze iron-
brown decoration of dragon,
h. 14 in. (35.7 cm)
The National Museum of Korea,
Seoul

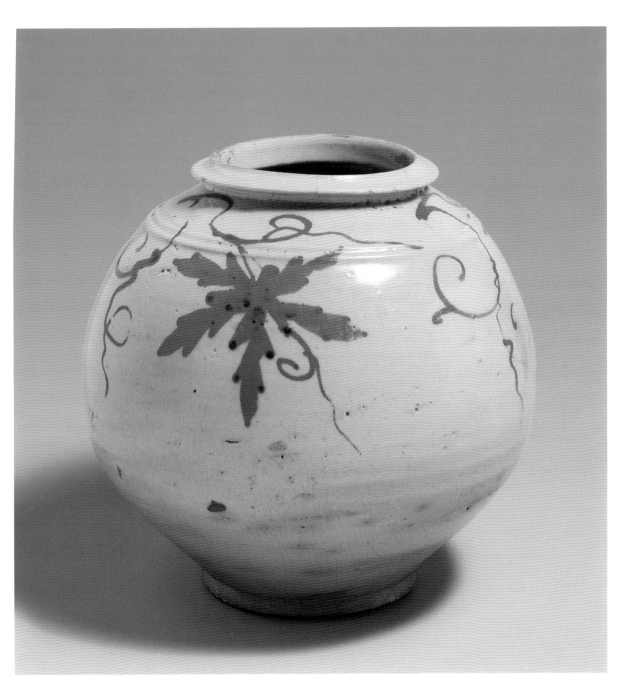

**Plate 37**
Jar
Chosŏn dynasty (1392–1910), 18th
century
Porcelain with underglaze copper-
red decoration of grapevine,
h. 10 in. (25.5 cm)
The Metropolitan Museum of Art,
The Harry G.C. Packard Collection
of Asian Art, Gift of Harry G.C.
Packard, and Purchase, Fletcher,
Rogers, Harris Brisbane Dick, and
Louis V. Bell Funds, Joseph Pulitzer
Bequest, and The Annenberg Fund
Inc. Gift, 1979 (1979.413.2)

**Plate 38**
Water Dropper in the Shape of a
Peach
Chosŏn dynasty (1392–1910),
19th century
White porcelain with under-
glaze cobalt-blue and copper-red
decoration of peach blossoms in
relief, h. 4 in. (10 cm)
Ewha Womans University
Museum, Seoul

## Plates 38 – 40

The fall of the Chinese Ming dynasty (1368–1644) to the Manchus and the establishment of the Qing dynasty (1644–1911) in the mid-seventeenth century compelled Chosŏn intellectuals to question the pervasive influence of Chinese thought and culture in Korean society. This lead in turn to an increasing interest in Korea's history, geography, and language. Ceramics were not excluded from this reassessment, and there was a vigorous exploration of new shapes, techniques, and decorations well into the nineteenth century.

The gentle profile and tall, straight lip of a vase with underglaze cobalt-blue decoration (pl. 40) are common features of Korean porcelains from the latter part of eighteenth and early nineteenth centuries. Its use of a narrative tableau is rare in Korean ceramics: on one side of the vase, screeching magpies in a pine tree draw the attention of an irascible yet comical tiger, and on the opposite side, a *haet'ae*, or mythical lion-dog, cavorts under a tree. The skillful painting as well as the style of border decoration suggest the vase was produced at the royal kilns.

A variety of high-quality objects, such as the peach-shaped water dropper (pl. 38) and wine cup (pl. 39), were made for use by the scholar-official class. These small objects combine sculpture, relief decoration, and painting in underglaze cobalt-blue and copper-red. Such elaborate and luxurious items were prized as much for their aesthetic qualities as for their utilitarian function.

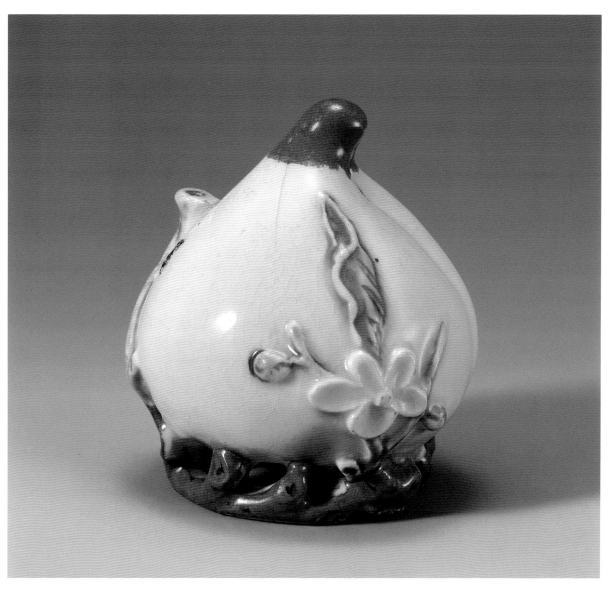

**Plate 39**
Wine Cup in the Shape of a Peach
Chosŏn dynasty (1392–1910),
19th century
White porcelain with underglaze
cobalt-blue and copper-red
decoration, h. 1 ⅛ in. (3 cm)
Ewha Womans University
Museum, Seoul

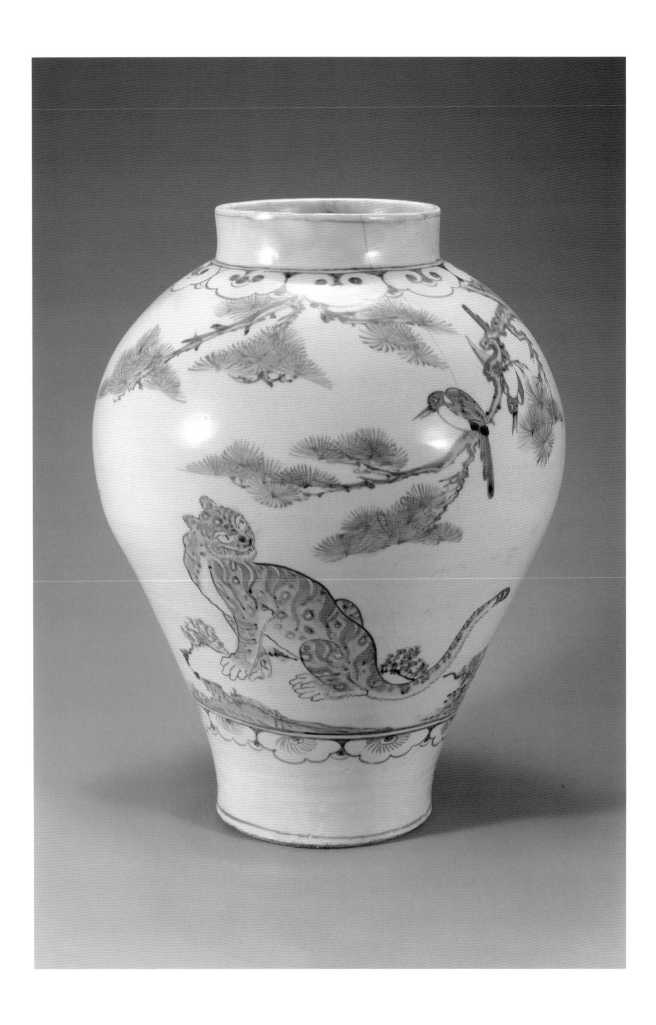

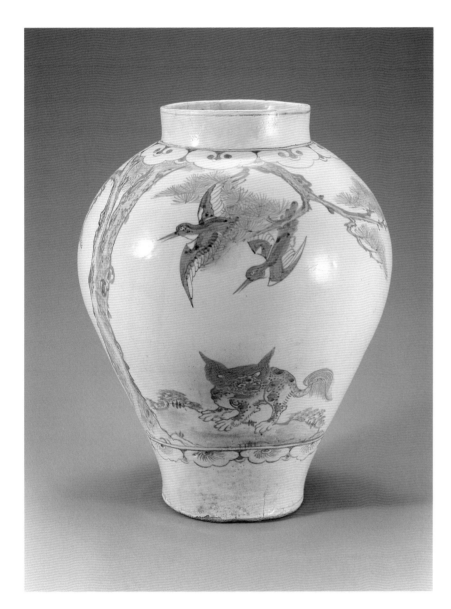

**Plate 40**
Jar, two views
Chosŏn dynasty (1392–1910),
second half of the 18th century
Porcelain with underglaze cobalt-
blue design of tiger, magpies, and
*haet'ae*, h. 16 ½ in. (42 cm)
The National Museum of Korea,
Seoul

Metalwork and Decorative Arts

Bronze technology, imported into Korea from the northern part of the continental mainland around the tenth century BCE, was used by the inhabitants of the peninsula to create a variety of ritual and utilitarian objects. In addition to such weapons as daggers and spearheads, among the objects most often recovered from Bronze Age tombs are cast-bronze mirrors ornamented with linear, geometric designs. The tombs of the royalty and aristocracy of the Three Kingdoms period (57 BCE–668 CE) have yielded large quantities of jewelry and other personal and ceremonial ornaments that reflect the refined tastes and the authority of the elite in the early peninsular states. Silla in particular was known to medieval Islamic merchants as the "kingdom of gold," a description verified by the spectacular gold ornaments, including elaborate crowns and intricately crafted earrings, found in tombs from the late fourth to the early sixth centuries. Buddhism, the dominant system of thought throughout Korea from the late Three Kingdoms period to the end of the Koryŏ dynasty (918–1392), had a pervasive influence on the arts. This influence is apparent in exquisite devotional objects, including reliquaries and portable shrines, as well as silver-inlaid bronze incense burners and bronze bells and gongs used in Buddhist ceremonies. Though the tradition of lacquer manufacture in Korea can be traced back to the Bronze Age, it was during the Koryŏ dynasty that lacquerware reached a high point of technical and aesthetic achievement, as evidenced by mother-of-pearl inlaid boxes used for storing incense or sutras. The rise of the *yangban*, or military and scholar-official class, in the early years of the Chosŏn dynasty (1392–1910) also stimulated the production of fine lacquerware and wood furniture as well as other objects for everyday use.

**Plate 41**
Mirror
Late Bronze Age, 3rd century B C E
Bronze, diam. 4 ¼ in. (10.7 cm)
Puyŏ National Museum

## Plates 41 and 42

Metallurgy and bronze technology were introduced into the Korean peninsula around the tenth century B C E, most likely from the northern regions of the continental mainland. By the seventh century B C E, a Bronze Age material culture of remarkable sophistication, with influences from northeastern China as well as Siberian and Scythian bronze styles, was flourishing on the peninsula. The bronzes found in the numerous dolmen tombs (burial sites formed of upright stones supporting a horizontal slab) contain a higher percentage of zinc than those of the neighboring bronze cultures. The earliest bronze objects produced in Korea consist largely of swords and spears, though excavations have also yielded objects that perhaps served ritual functions. A long rectangular bronze object (pl. 42) is fitted with two semicircular eyelets and has sharp projecting points at the four corners. It is decorated with bands of incised hatching and the image of a human hand at one end. Although its function is not clear, the object may represent a tribal or clan totem, or may relate to rituals associated with hunting.

Among the most frequently found bronze artifacts excavated from Bronze Age sites are mirrors, the oldest of which date from the sixth to the fourth century B C E. A somewhat later example (pl. 41) has the fine incised geometric designs and the pair of off-center eyelets that are typical of Bronze Age Korean mirrors. The other side of this mirror, polished to a high sheen, served as the reflective surface. As bronze technology became more advanced, Korean bronze casters overcame the problems involved in lowering the surface tension of molten bronze and thereby achieved very thin, raised decorations. Although these designs are unique to Korea, the existence of decorated mirrors in China with cosmological associations suggests that the zigzags, circles, and spirals of the Korean examples had a symbolic value as well.

**Plate 42**

Bronze Object
Late Bronze Age, 4th century B C E,
from Yesan, Dongsŏ-ri, South
Ch'ungch'ŏng Province
Bronze, l. 9 ⅝ in. (24.5 cm)
Puyŏ National Museum

## Plates 43 – 45

By the fourth century, the Korean peninsula was divided among three centralized states, the kingdoms of Koguryŏ in the north, Paekche in the southwest, and Silla in the southeast. A fourth political entity made up of a group of city-states, known as the Kaya Federation, was situated between Silla and Paekche. In each of the three kingdoms, the royalty and aristocracy created a demand for luxury goods, symbols of power and political authority. Burial sites in the ancient territory of Silla have yielded the largest quantities of such objects, including jewelry and weapons made of precious materials. The contents of Silla tombs have remained intact due to the relatively impenetrable tomb structure, which was constructed of wood, sealed with clay, and covered with mounds of stones and earth. Koguryŏ and Paekche, in contrast, adopted the Chinese style of tomb design with more accessible entrances.

The motif of intertwined dragons on the gold hilt with pommel (pl. 43), dating from the fifth to the sixth century, reflects Central Asian and Siberian influences. Silla, which due to its relatively isolated location on the southeastern coast did not have diplomatic contacts with China until the latter part of the sixth century, preserved these influences in its art, whereas Koguryŏ and Paekche readily embraced new trends from the mainland. The most exquisite of the objects found in Silla tombs are personal ornaments. Pure gold earrings (pl. 44) display a variety of designs, from simple cut gold sheet to filigree and granulation. The ultimate source of such elaborate techniques as granulation is probably the Greek and Etruscan goldsmiths of Western Asia and Europe, whose skills were transmitted to northern China and later to Korea. A gilt-bronze Silla crown (pl. 45) with three branching projections in a stylized tree shape and delicate gold foil-and-wire spangles shows affinities with Central Asian examples.

**Plate 43**
Gold Hilt with Oval Pommel
Three Kingdoms period, Silla
kingdom (57 B C E–668 C E),
5th–6th century
Gold, l. 5 ⅜ in. (13.8 cm);
pommel, diam. 2 ¼ in. (5.8 cm)
Ho-Am Art Museum, Yongin
Treasure no. 776

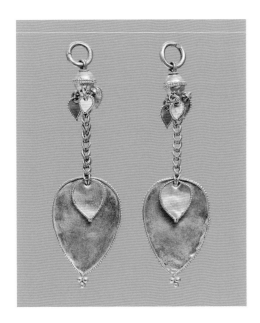

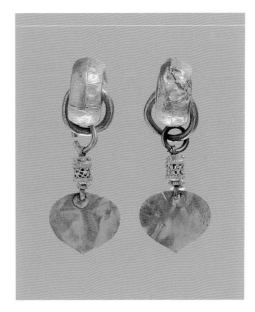

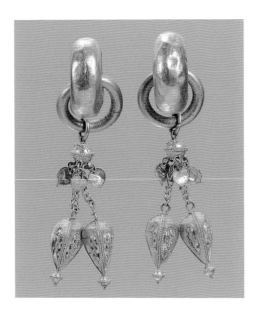

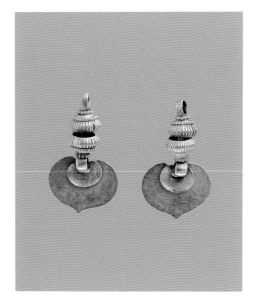

**Plate 44**
Four Pairs of Earrings
Three Kingdoms period,
Silla Kingdom (57 B C E–668 C E) and
Kaya Federation (42 C E–562 C E)
Gold
The Metropolitan Museum of Art,
Harris Brisbane Dick Fund, 1943

**44A.** (top left)
Kaya, late 4th–early 5th century,
l. 3 ¾ in. (9.5 cm) 43.49.1,2

**44B.** (top right)
Silla, late 4th–early 5th century,
l. 2 ½ in. (6.4 cm) 43.49.13,14

**44C.** (bottom left)
Silla or Kaya, 6th century,
l. 4 ⅛ in. (10.5 cm) 43.49.5,6

**44D.** (bottom right)
Silla, late 4th–early 5th century,
l. 1 ⅛ in. (2.9 cm) 43.49.15,16

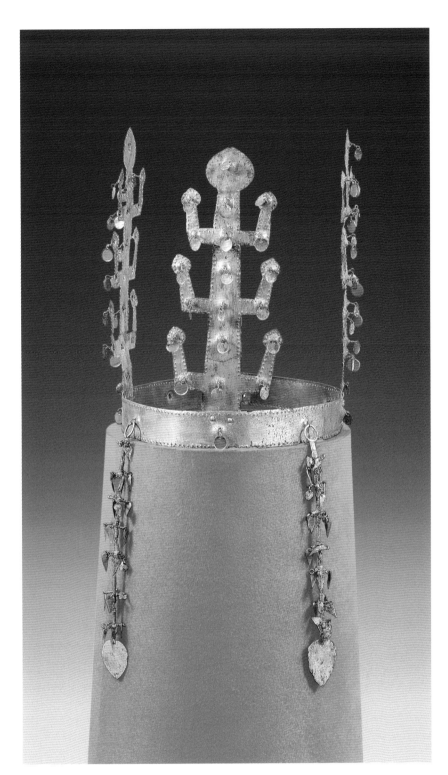

**Plate 45**
Crown
Three Kingdoms period,
Silla kingdom (57 B C E–668 C E),
5th–6th century
Gilt bronze, h. 8 ⅛ in. (20.6 cm)
Ho-Am Art Museum, Yongin

111

**Plate 46**
Reliquary
Unified Silla dynasty (668–935),
8th–9th century, from a pagoda
at Songnim-sa Temple, Ch'ilgok,
North Kyŏngsang Province
Gilt bronze and glass,
h. 6 ¼ in. (15.9 cm)
Taegu National Museum
Treasure no. 325

## Plates 46 and 47

Buddhism was introduced to Korea from China in the Three Kingdoms period, first to Koguryŏ and Paekche in the fourth century and then to the more conservative kingdom of Silla in the sixth century. During the following Unified Silla period, Buddhism flourished throughout the peninsula due to the active support of both the royal court and the aristocracy. The country engaged in large-scale building of monasteries and the creation of numerous Buddhist images. Among the most impressive of the state-sponsored building projects during this period is Sŏkkuram, an eighth-century grotto-temple of remarkable beauty and tranquility located on Mount T'oham, east of modern Kyŏngju.

Reliquaries, which contained relics of the historical Buddha Shakyamuni, were central objects of Buddhist worship and were placed inside pagodas, the focal point of the temple plan. An exquisitely crafted example was excavated from the base of a pagoda in Songnim-sa Temple (pl. 46). Placed in the center of the reliquary is a green glass cup decorated with twelve rings of coiled glass applied to the surface. The cup is similar to the one preserved in the Treasury of the Shōsō-in, Nara, which predates the mid-eighth century, and derives from Persian or Syrian prototypes. The glass rings were originally inset with roundels of glass and pearls. Inside the cup is a small green glass bottle, which held the relics of the body of the Buddha (*sarira*), usually represented by tiny crystal-like particles.

Reliquaries were usually enclosed in one or more outer containers, which sometimes were inscribed. A soapstone container (pl. 47), recovered from Tonghwa-sa Temple, in North Kyŏngsang Province, is inscribed with a date of 863. Four gilt-bronze panels that formed the box in which the soapstone container was placed are decorated with triads of the four major Buddhas. They may be identified as Shakyamuni, Vairochana, Bhaishajyaguru, and Amitabha.

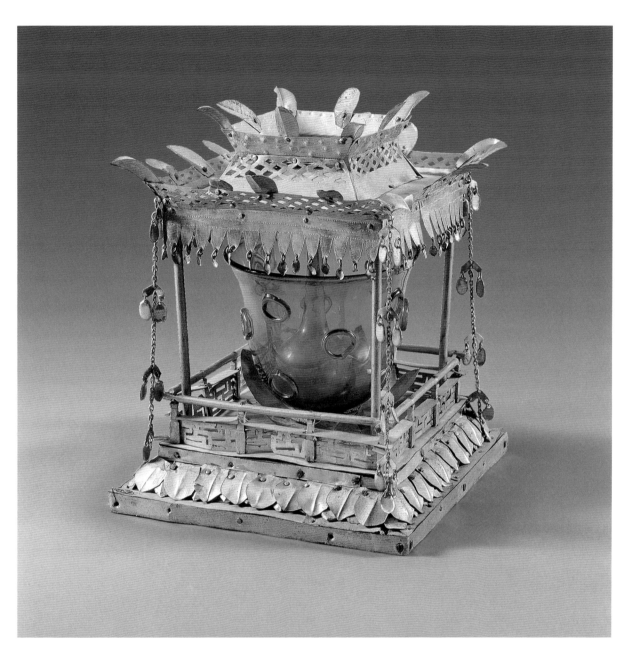

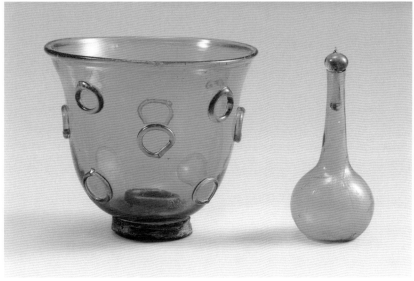

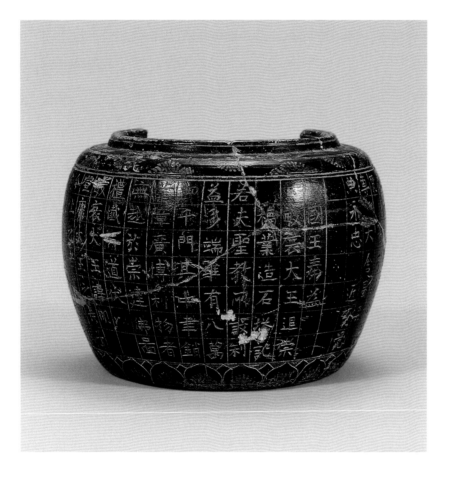

**Plate 47**
Container and Four Panels
from a Sarira Reliquary
Unified Silla dynasty (668–935),
dated 863, from a pagoda at
Tonghwa-sa Temple, Taegu,
North Kyŏngsang Province

Container:
Soapstone, h. 3 ⅜ in. (8.5 cm)
Dongguk University Museum,
Seoul, Treasure no. 741

Panels:
Gilt bronze, 6 × 5 ⅝ in.
(15.3 × 14.2 cm)
Taegu National Museum

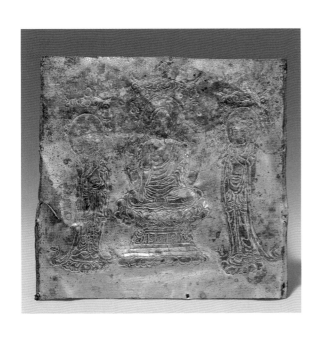

## Plates 48 and 49

This thirteenth-century bronze temple gong (pl. 48), the largest ever excavated on the peninsula, is a remarkably well-preserved example of a Korean Buddhist musical instrument. The innermost area of the gong's surface, which is the striking platform, has a relief design of a lotus pod with seeds surrounded by a band of striations that resemble chrysanthemum petals. Two concentric bands of composite floral designs with lotus leaves flank a single band of stylized cloud patterns.

The small cast-bronze bell (pl. 49), which also dates from the thirteenth century, during the Koryŏ period, is of a type that originated in Unified Silla. It is surmounted by a dragon, which clasps a precious jewel in its left paw instead of holding it in its mouth. Three similar jewels adorn the sound pipe located behind the dragon. The top of the bell proper is encircled by a raised flange of pointed winglike designs, with a band of scrolling floral patterns below. Four large panels, each with nine floral bosses, and four kneeling *apsaras* (heavenly beings) descending from heaven, their hands held in gestures of adoration, decorate the body of the bell. The two striking platforms are in the shape of multi-petaled floral medallions. Despite its modest scale, the bell preserves a feature of its larger counterparts that is unique to Korean bells: the dragon-shaped handle and the sound pipe, which extends the duration of the bell's sound. Gongs and bells, used to call monks and worshipers to meditation and to mark the hours of the day, are important accessories for the daily rituals of Buddhism.

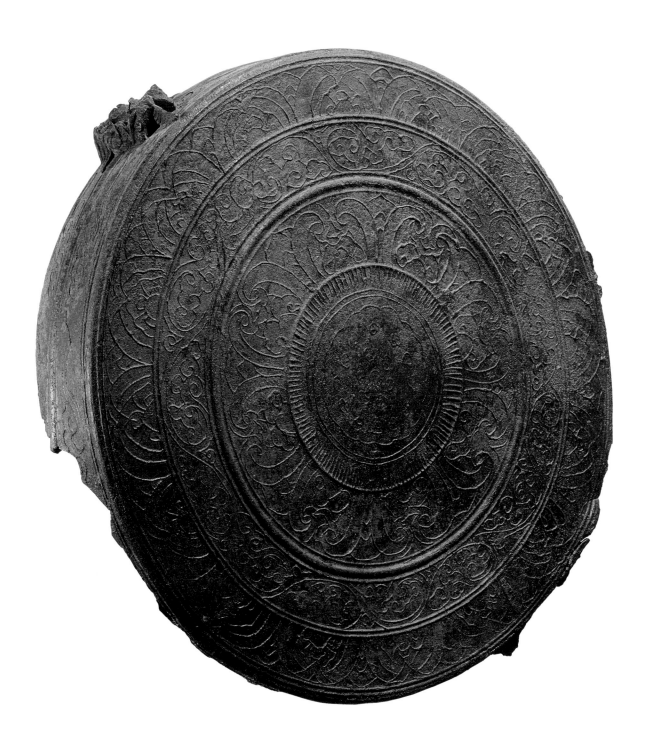

**Plate 48**
Buddhist Temple Gong
Koryŏ dynasty (918–1392),
13th century, from the temple
site of Kaet'ae-sa, Nonsan,
South Ch'ungch'ŏng Province
Bronze with relief decoration,
diam. 41 ⅜ in. (105 cm)
Puyŏ National Museum

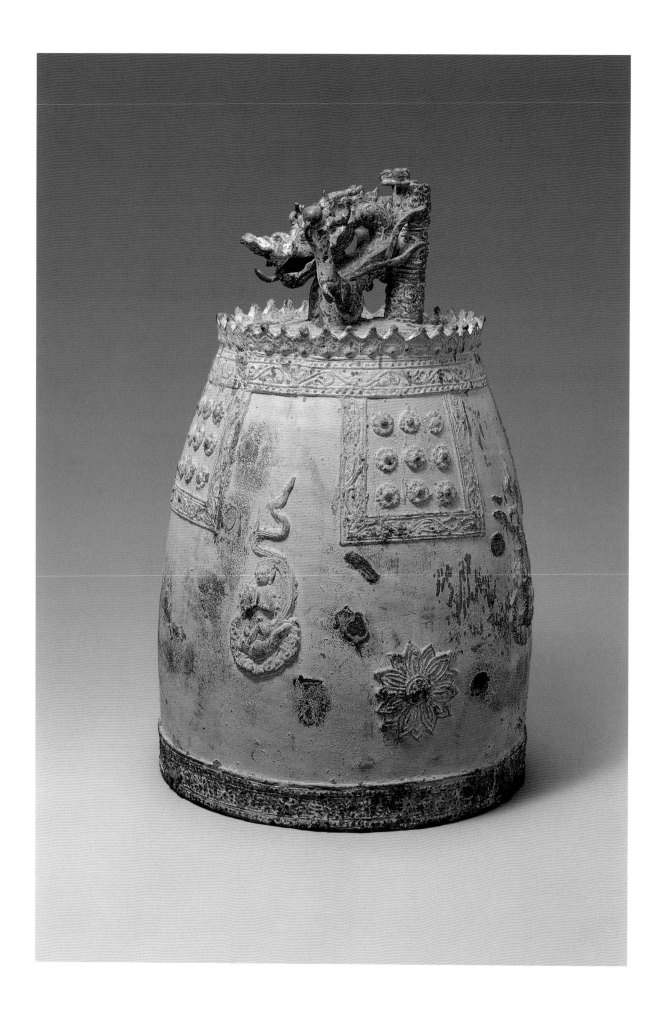

**Plate 49**
Buddhist Temple Bell
Koryŏ dynasty (918–1392),
13th century, reportedly from a
temple site in the Kaesŏng area,
Kyŏnggi Province
Bronze, h. 15 ¾ in. (40 cm)
The National Museum of
Korea, Seoul

**Plate 50**
Incense Burner
Koryŏ dynasty (918–1392), 11th–
12th century, from the temple site
of Pong'ŏp-sa, Kyŏnggi Province
Bronze, h. 34 ¼ in. (87 cm)
Ho-Am Art Museum, Yongin

## Plates 50 – 53

The variety of shapes and decorative styles of small Buddhist ritual objects attests to the diversity of material culture in the Koryŏ period, as well as the wealth of the state-sponsored Buddhist establishment. The refined lines and balance of this large bronze incense burner (pl. 50) also epitomize the exquisite sense of proportion that characterizes the arts of the Koryŏ period. This impressive example of the bronze caster's art was excavated from the temple site of Pong'ŏp-sa, in Kyŏnggi Province. According to its inscriptions, a monk called Wŏn'gu donated 26 *kŭn* (approximately 15.6 kilograms) of bronze for its production. The removable lid and base were secured to the body of the vessel with nails. A more sculptural form is the small incense burner in the shape of a lotus flower with a base in the shape of a lotus leaf (pl. 51). From paintings of the period, it is known that censers of this type had a lid and handle, which are missing from this piece.

An example of Koryŏ inlaid metalwork is a *kundika* (or, holy water bottle), from the thirteenth century (pl. 52). Slimmer than its celadon counterparts, it has a unique octagonal top portion. The silver-wire inlaid decoration of trees and riverbanks lined with reeds is seen in other inlaid metalware as well as in Koryŏ celadons (see pls. 11, 12, and 16). This religious object also provides evidence of secular landscape painting produced during the Koryŏ dynasty, very few examples of which survive. A similarly resplendent depiction of this river theme is seen in an incense burner dated 1289 (pl. 53), whose chalice shape with a wide, flat rim was popular into the Chosŏn dynasty. Enclosed within the four foliate panels are dragons and phoenixes, which, though not particular to Buddhism, are auspicious symbols appropriate for such a ritual object.

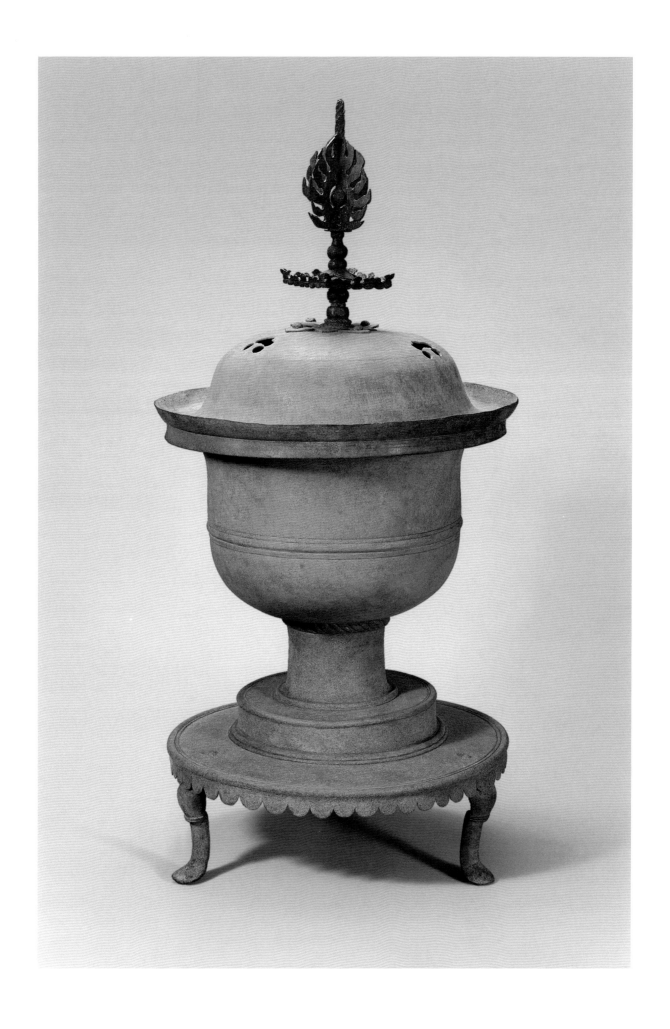

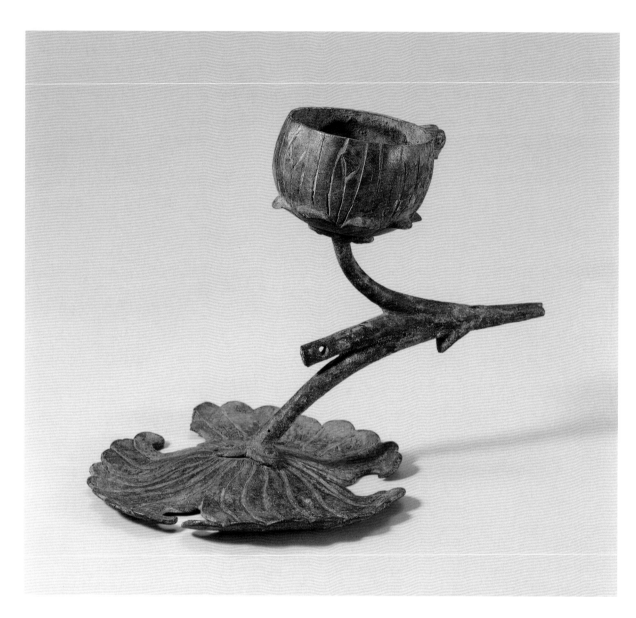

**Plate 51**
Incense Burner in the Shape of a Lotus
Koryŏ dynasty (918–1392), dated 1077
Bronze, h. 5 ¾ in. (14.7 cm); base, diam.
7 ⅜ in. (18.8 cm)
The National Museum of Korea, Seoul

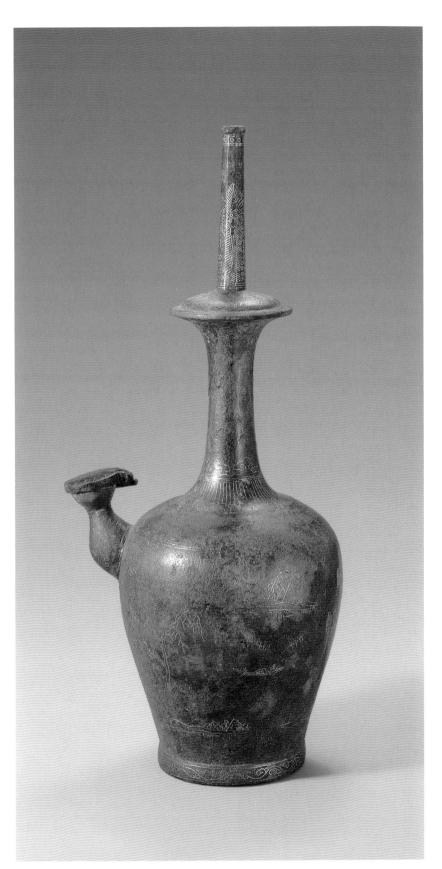

**Plate 52**
Bottle (*Kundika*)
Koryŏ dynasty
(918–1392), 13th century
Bronze with silver-wire inlay design
of landscape, h. 14 ⅞ in. (37.8 cm)
The National Museum of Korea,
Seoul

METALWORK & DECORATIVE ARTS

123

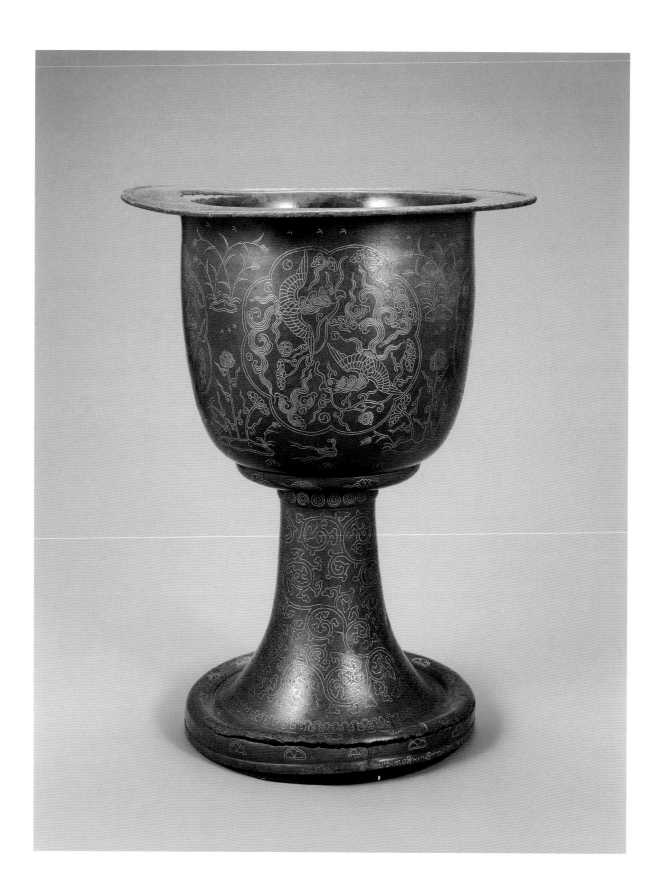

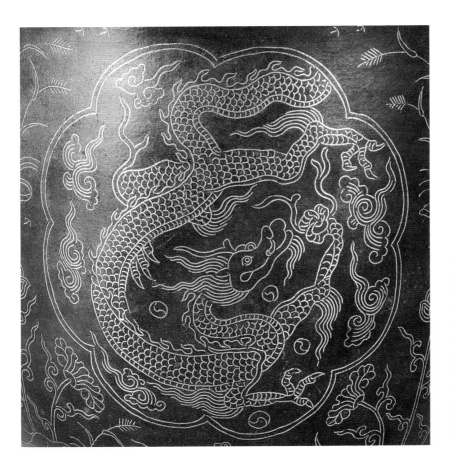

**Plate 53**
Incense Burner, full view and
detail of other side
Koryŏ dynasty (918–1392),
dated 1289, from the temple site
of Hŭng'wang-sa, Kaesŏng,
Kyŏnggi Province
Bronze with silver-wire inlay
design of dragon, phoenixes, water
birds, and plants, h. 15 in. (38.1 cm)
Ho-Am Art Museum, Yongin
National Treasure no. 214

**Plate 54**
Portable Shrine
Koryŏ dynasty (918–1392),
14th century
Gilt bronze, silver, and
wood, h. 11 in. (28 cm)
The National Museum of
Korea, Seoul

## Plate 54

This portable shrine in the shape of a palatial hall is decorated with images from the Buddhist pantheon on all of its surfaces. The construction and materials are lavish: a wooden base provides support for the gilt-bronze interior and front panels, the inscribed silver side and rear exterior panels, and a brilliantly patinated bronze roof, whose blue-green color is perhaps meant to suggest celadon tiles. The central images that would have been placed in the shrine are now lost. On the rear interior panel Shakyamuni Buddha and two attendant bodhisattvas are seated on lotus thrones, surrounded by ten disciples, including Kashyapa and Ananda, who stand on either side of the Buddha. The bodhisattvas Samantabhadra (on an elephant) and Manjushri (on a lion), who would normally be in attendance at the Buddha's side, appear instead on the interior side panels. The interior of the doors depict the fierce and grotesquely muscular images of two guardian figures known as the Benevolent Kings. On the exterior side panels are incised depictions of the Four Heavenly Kings, and on the rear panels are shown eight lesser deities above a broad band decorated with lotus flowers, a symbol of the Buddha's perfect purity in an impure world. Even the interior ceiling and floor are decorated, with a dragon in an ogival panel above and lotus flowers below. In its shape and in its overall decoration of symbolic images, this small shrine serves not only as a focus for worship but also as an architectural space representing the Buddhist cosmos. Although of miniature size, the shrine nevertheless suggests the possibility of enclosing worshipers within its sacred space.

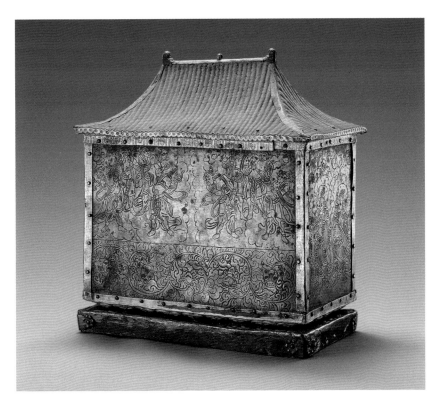

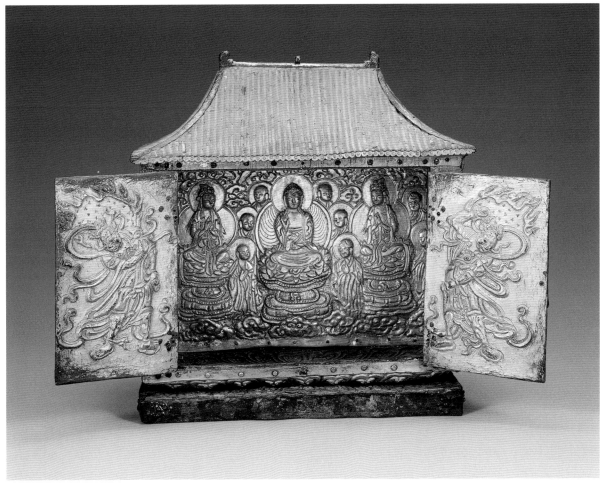

**Plate 55**
Incense Container
Koryŏ dynasty (918–1392),
10th–12th century
Lacquer with mother-of-pearl
and tortoiseshell inlay (over
pigment) and brass wires,
h. 1 ⅝ in. (4.1 cm), l. 4 in. (10.2 cm)
The Metropolitan Museum of Art,
Fletcher Fund, 1925 (25.215.41a,b)

## Plates 55 and 56

Inlaid lacquers of the Koryŏ dynasty are of unprecedented delicacy and intricacy. They combine texture, color, and shape to produce a dazzling effect in both large objects (as in several sutra containers preserved in Korea and Japan) and in smaller objects of a more delicate scale, as seen in this trefoil container (pl. 55), one of the finest examples of the inlay technique. It is inlaid with mother-of-pearl and colored tortoiseshell on a black lacquer ground to produce a dense pattern of chrysanthemum flowers and foliate scrolls. The edges of the box are reinforced with twisted brass wire. In the technique of inlaying tortoiseshell employed here, thin pieces of tortoiseshell were painted on the reverse with red and yellow colors and the pieces were then applied to the object with the painted side face down. The object's shape suggests that it may have been part of a set containing incense, an essential accompaniment of Buddhist ritual. Since inlaid lacquerware peels and cracks when exposed to moisture, it is difficult to preserve; as a result, objects of this age, quality, and pristine state are extremely rare.

The production of inlaid lacquer continued in the Chosŏn period, during which time the fine detail and mosaic-like patterns of Koryŏ inlaid lacquers were replaced by larger and more prominent designs. The scrolling floral vine on a fifteenth-century box (pl. 56) is formed with thin strips of mother-of-pearl, with larger, crackled pieces depicting acanthus-like leaves and peony flowers. The small circles that fill the interstices reveal a greater interest in emphasizing the overall texture of the inlaid design than in drawing attention to its pictorial effect. This change parallels differences that can be seen on Koryŏ inlaid celadons (see pls. 15–19) and on Chosŏn punch'ŏng ware (see pls. 23–25).

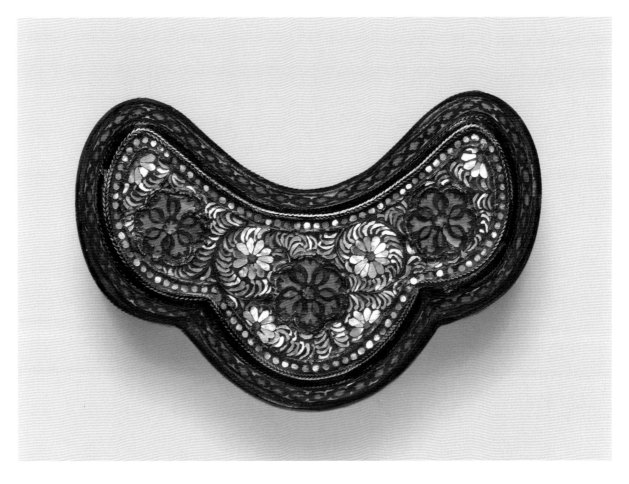

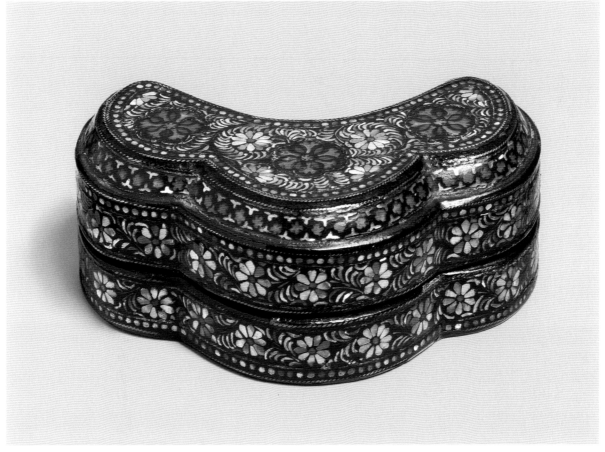

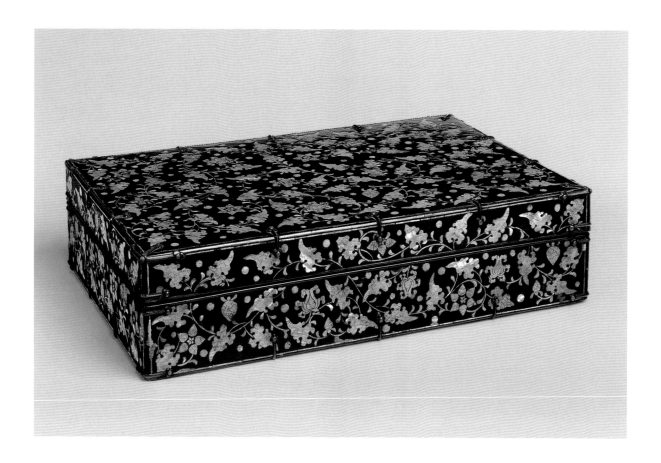

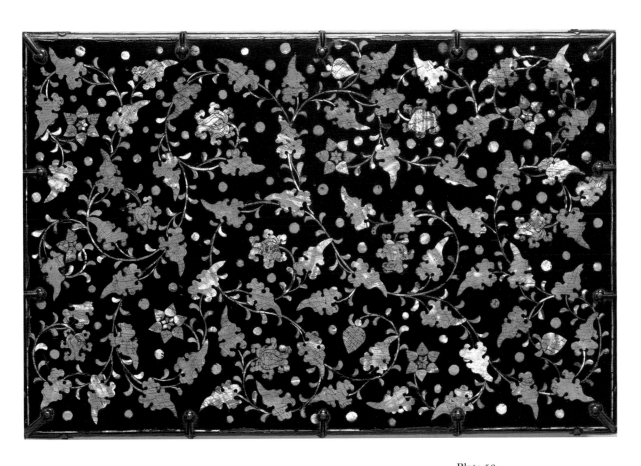

**Plate 56**
Stationery Box
Chosŏn dynasty (1392–1910),
15th century
Black lacquer with mother-of-
pearl inlay, l. 14 ⅜ in. (36.5 cm),
h. 3 ½ in. (9 cm)
Promised Gift of Florence and
Herbert Irving

## Plate 57

One decorative technique employed during the Chosŏn period, which allowed colorful and rich representative possibilities, took advantage of the translucent qualities of ox-horn. The origin of the ox-horn painting (*hwagak*) technique can be traced back to the Three Kingdoms period, in the fifth century. In this nineteenth-century example, the ox-horn was cut, soaked in water, and boiled, and then pressed into thin flat sheets. The sheets were painted with auspicious symbols — cranes, tigers, phoenixes, and deer — in bright colors before being attached to the wooden box with the painted surfaces down. The horn sheets were given a coat of varnish for protection, which, over a period of time, has produced a somewhat cloudy effect and imparted a mellow tone to the bright pigments. The tortoiseshell border of the lid lends additional variety in the decorative pattern and the texture. This labor-intensive technique was normally reserved for small objects such as containers for personal belongings, including jewelry, sewing materials, or toiletries. Occasionally, larger items such as two- or three-tiered chests were also decorated in this manner for use in royal palaces.

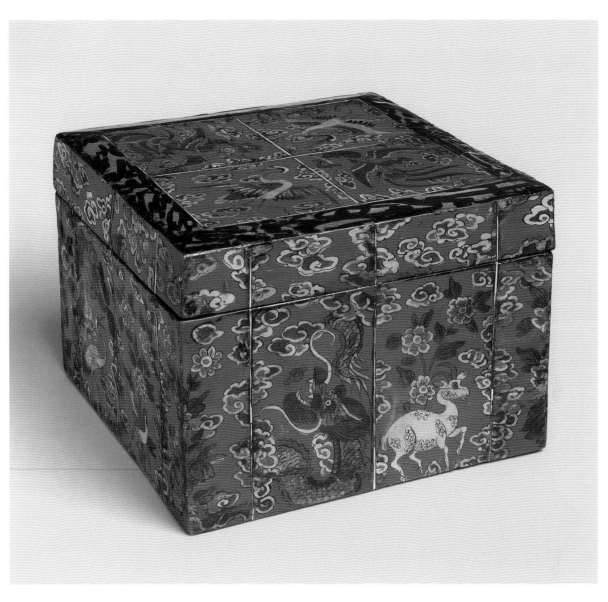

**Plate 57**
Box
Chosŏn dynasty (1392–1910),
19th century
Painted wood with flattened ox-horn
inlay, h. 6 in. (15.2 cm), l. 8 ⅝ in.
(21.9 cm), w. 8 ⅝ in. (21.9 cm)
Lent by Florence and Herbert Irving

**Plate 58**
Inkstone
Chosŏn dynasty (1392–1910),
18th–19th century
Stone with carved design of frog
and lotus leaf, h. 1 × l. 8 × w. 4 ½ in.
(2.6 × 20.3 × 11.4 cm)
The National Museum of Korea,
Seoul

## Plates 58 and 59

With the promotion of Neo-Confucianism as the governing philosophy in the Chosŏn dynasty, a new elite class came to dominate political, economic, and cultural life in Korea. Known collectively as the *yangban*, this hereditary class monopolized the civil and military positions in the government. They cultivated such Confucian virtues as simplicity and frugality in daily life and extended this restraint to all aspects of life, including the furnishings and implements of the *sarangbang*, or study, the domain of the male head of a yangban household. There, an official received and entertained guests and attended to worldly affairs. The objects in a scholar's sarangbang exemplified his social and political status as well his moral standards and aesthetic sensibilities.

An essential item in the sarangbang was a table for the storage and use of inkstones. This example (pl. 59), with a pine stand and persimmon panels, recalls the "Guidelines for Crafts" contained in the *Kyŏngguk taejŏn* (National Code) of 1471, the first comprehensive legal code of the Chosŏn dynasty: "Wood grains are beautiful in themselves… One should not add carved decorations and bright varnishes; this [austerity] is known as upright elegance." Persimmon wood, with its striking grain, adds bold color, texture, and line to this otherwise simple stand, which is free of carvings and varnish. The drawer is designed to lie flush with the side panel, so that the smooth face of the stand and the line of the grain are uninterrupted. An inkstone adorned with a lotus leaf in relief (pl. 58) provides a well for water and a surface on which the ink is ground. The tiny frog at rest in the corner of the large lotus leaf is a clever reference to the function of the object.

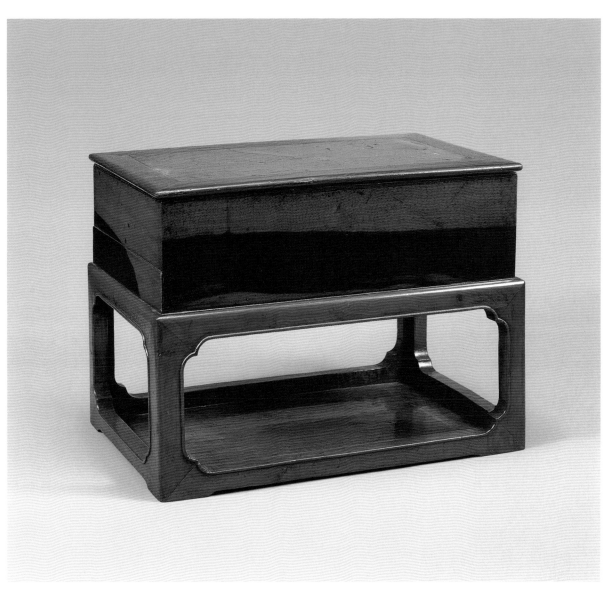

**Plate 59**
Inkstone Table
Chosŏn dynasty (1392–1910),
19th century
Persimmon wood, h. 8 ¾ × l. 11 ⅞ ×
w. 7 ½ in. (22.1 × 30.3 × 19 cm)
The National Museum of Korea,
Seoul

Buddhist Sculpture

Some of the finest and most technically accomplished Buddhist sculpture in East Asia was produced in Korea. Buddhism, first introduced into the peninsula from China late in the fourth century, during the Three Kingdoms period (57 BCE–668 CE), flourished in Korea through the Unified Silla (668–935) and Koryŏ (918–1392) periods. Practiced and supported at first by the royal courts and the aristocracy as part of a larger program to consolidate the power of the state, the foreign religion gradually gained adherents among all levels of society. A number of Korean monks are known to have traveled to China and even to India, where Buddhism originated, to receive religious training as early as the late sixth and early seventh centuries. Many of them returned to Korea, often bearing sacred texts and images, to disseminate the teachings acquired abroad. It was through Korea that Buddhism was formally introduced to Japan, in 538, where it likewise played a decisive role in the formation of early Japanese art and culture. Although the number of large-scale Buddhist works declined during the Chosŏn dynasty (1392–1910) when Neo-Confucianism became the state ideology, private devotional images continued to be made. The predominance of Buddhism as a spiritual force in Korean society is attested by the broad range and high quality of sculpture, paintings, and other Buddhist works of art produced for personal worship and for use in monasteries and state temples. An understanding of Korean Buddhist sculpture involves comparisons with Chinese prototypes, and in some cases with models that can be traced back to Central Asia and to India. While Korean Buddhist sculpture is stylistically indebted to these foreign traditions, Korean artists were often selective, adopting certain models that they in turn developed into images with a distinctive Korean appearance, particularly in facial expression, or varied through different carving or casting techniques.

**Plate 60**
Seated Maitreya
Three Kingdoms period,
late 6th century
Gilt bronze, h. 32 ¾ in. (83.2 cm)
The National Museum of Korea,
Seoul, National Treasure no. 78

138

## Plate 60

This seated bodhisattva Maitreya in contemplation is one of the most famous Korean Buddhist statues. Maitreya was thought to hold the promise of enlightenment for all sentient beings. His dwelling place is the Tushita heaven, from which he will descend as the Buddha of the Future. The depiction of this deity in contemplation derives from an iconographic convention originally applied to images of the historical Buddha Shakyamuni, who before attaining enlightenment was known as the prince Siddhartha Gautama and whose contemplation of the suffering of sentient beings was a pivotal cause of his search for enlightenment, which led to his final rest in nirvana. Maitreya was a popular deity in the Three Kingdoms period. He also became especially important in the ethos of the *hwarang* (flower youth), an elite organization of young men of the aristocracy established by the Silla government whose mission was to defend the country against foreign invaders and whose leader was believed to be an incarnation of the bodhisattva Maitreya.

This late-sixth-century Maitreya is notable for the serenity of his expression and the refined beauty of proportion and line that characterizes the best Korean Buddhist sculpture. The facial expression and delicately posed hand raised to the right cheek create a sense of introspection and profound concentration that is reinforced by the slight bend of the shoulders and the forward-leaning posture of the torso. The quiet yet intense presence of the deity is also enhanced by the smooth lines describing the draped cloth of the garment. The extraordinary thinness of the bronze of this statue (less than one centimeter thick), as well as the seemingly effortless depiction of the right arm and hand in the round, testify to the accomplished casting skills of artisans of the Three Kingdoms period.

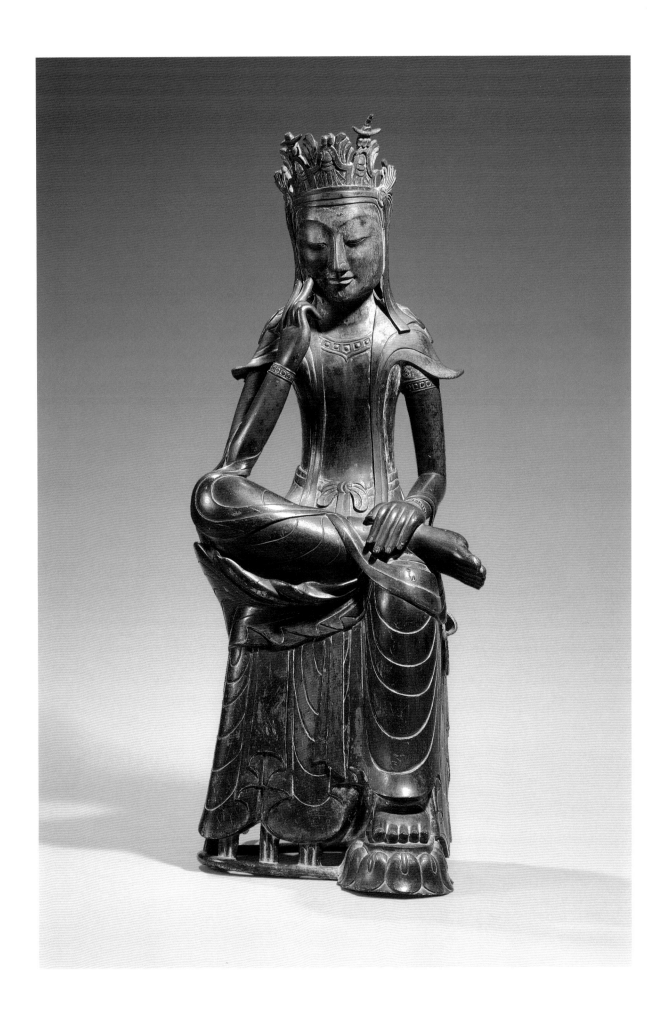

**Plate 60**
Seated Maitreya, back

## Plates 61 and 62

By the sixth century, Buddhism had become the official religion throughout the Korean peninsula. Buddhist sculpture created during that time begins to show distinctive indigenous characteristics and reflects as well Korea's diverse contacts with other artistic traditions. The gilt-bronze standing Buddha with his right hand in the *abhaya*, or fear-not, gesture and his left in the *varada*, or wish-granting, gesture (pl. 61) was a popular type in the sixth century. The three distinct hemlines of the garment — usually only two are shown — reflect the influence of Chinese stylistic conventions, particularly those of the Northern Wei (386–534) and Eastern Wei (534–550) dynasties.

A slightly later statue, probably from the kingdom of Silla (pl. 62), portrays a Buddha holding a round jewel-like object, which is believed to be a symbol of healing, leading to the tentative identification of this image as Bhaishajya-guru, the Buddha of Medicine. His left hand raised in the fear-not gesture, the figure stands in the *tribhanga*, or "thrice-bent" posture, a style prevalent in India during the Gupta period (4th–6th century). The influence of the Gupta stylistic tradition is also visible in the clinging drapery. The baring of one shoulder, characteristic of images of this type of Buddha in seventh-century Silla, is not often found in Chinese sculpture and may reflect as well the influence of Indian Buddhist art, possibly transmitted through Southeast Asia and southern China. Other features of this image that help to place it in the tradition of Three Kingdoms Buddhist art of the seventh century are its large head and its fully sculpted back. In the back of the head is a small opening intended possibly to receive a halo. The childlike face adds to the charming innocence of this image.

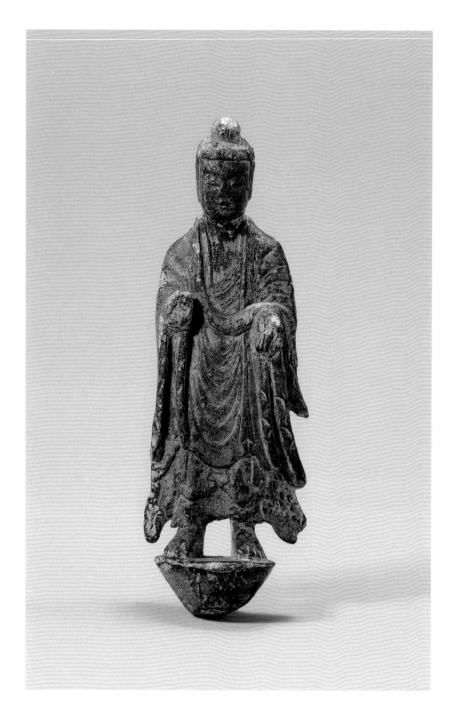

**Plate 61**
Standing Buddha
Three Kingdoms period, 6th century
Gilt bronze, h. 5 in. (12.5 cm)
Horim Art Museum, Seoul

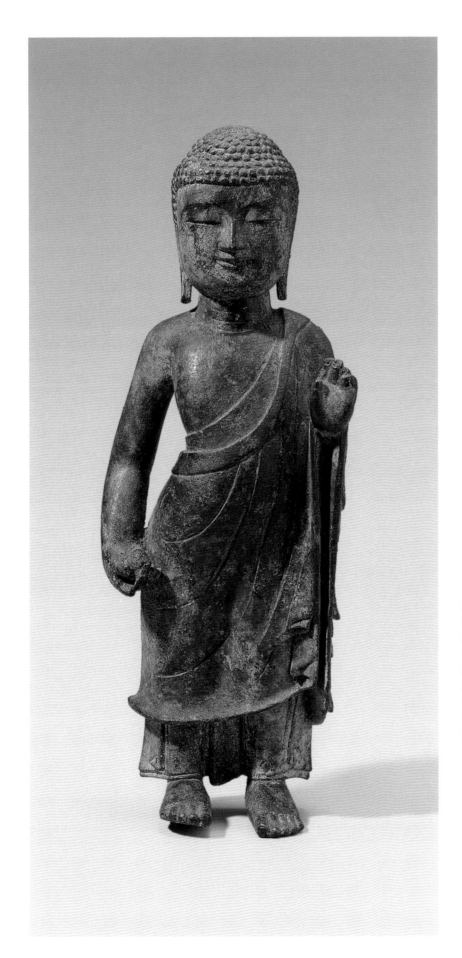

**Plate 62**
Standing Buddha of Medicine
(Bhaishajyaguru)
Three Kingdoms period, probably
Silla kingdom (57 BCE–668 CE),
first half of the 7th century
Gilt bronze, h. 12 ¼ in. (31 cm)
The National Museum of
Korea, Seoul

## Plates 63 and 64

The slim body and highly stylized drapery lines of this statue from the late sixth to the early seventh century of the bodhisattva Maitreya (pl. 63), who came to be regarded as the Buddha of the Future, are stylistically similar to sculpture produced in the Paekche kingdom. Although the image of the contemplative bodhisattva was popular at the time, this statue's elongated body, with no differentiation of chest and waist, and its small moustache are unique among early Korean Buddhist statues. Also worth noting is the sun-and-crescent-moon motif on the crown as well as the flared profile of the pedestal, over which the deity's robe falls in distinctively rhythmic lines.

Found in Puyŏ, the last capital of the Paekche kingdom, a standing figure of the bodhisattva Avalokiteshvara (pl. 64) dating from the first half of the seventh century displays the classic characteristics of Paekche sculpture: a slightly bent right knee that results in the subtle *tribhanga* posture, a full face with an inviting smile, and graceful, flowing drapery. In Mahayana Buddhism, the Buddhas are assisted by bodhisattvas, compassionate beings who have delayed their entrance into Buddhahood in order to direct believers to enlightenment. This bodhisattva, identifiable by the small image of Amitabha Buddha in his crown, holds in his right hand a wish-granting jewel. Avalokiteshvara was one of the most popular deities in East Asian Buddhism, especially because of his association with Amitabha, who offers rebirth in his Western Paradise to those who worship him by chanting his name. The willowy, feminine aspect of Avalokiteshvara is derived from Chinese statues produced during the Sui (581–618) and early Tang (618–907) dynasties. The Buddhist art of Paekche was highly refined, and its influence on Buddhist art in Japan in the Asuka period (538–645) reflects the important role that Paekche played in the introduction of the new religion to that country.

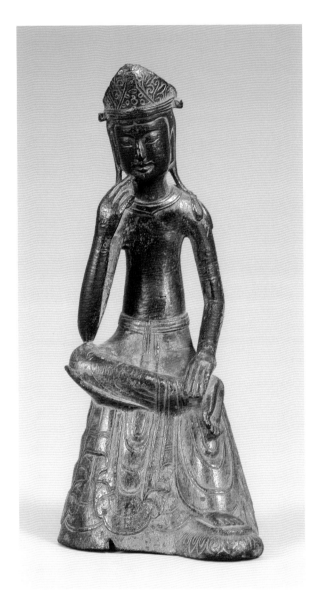

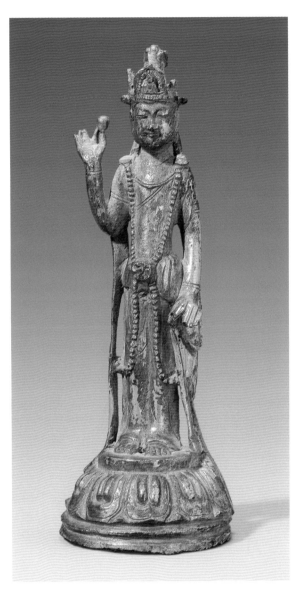

**Plate 63**
Seated Maitreya
Three Kingdoms period, probably
Paekche kingdom (18 B C E–660 C E),
late 6th–early 7th century
Gilt bronze, h. 8 ⅛ in. (20.6 cm)
The National Museum of Korea,
Seoul

**Plate 64**
Standing Avalokiteshvara
Three Kingdoms period, Paekche
kingdom (18 B C E–660 C E), first half
of the 7th century, from Kyuam-ni,
Puyŏ, South Ch'ungch'ŏng Province
Gilt bronze, h. 8 ¼ in. (20.9 cm)
Puyŏ National Museum
National Treasure no. 293

**Plate 65**
Seated Buddha
Three Kingdoms period, Silla king-
dom (57 BCE–668 CE), first half of
the 7th century, from Inwang-dong,
Kyŏngju, North Kyŏngsang Province
Granite, h. 44 ⅛ in. (112 cm)
Kyŏngju National Museum

## Plate 65

This granite statue of a seated Buddha was found at the temple site of Inwang-dong, located in the city of Kyŏngju, in the southeastern part of the Korean peninsula, the capital of both the Silla kingdom and Unified Silla. The Buddha has a childlike face with a peaceful and benevolent expression. His right hand probably originally formed the *abhaya* (fear-not) mudra, and his left hand the *varada* (wish-granting) mudra, a combination of hand gestures commonly found in seated Buddha figures of the seventh century. Remarkably, the figure, halo, and pedestal were all carved from a single piece of stone, which has eroded over time, lending further softness to the already gentle contours of this statue. Unlike the somewhat mannered lines of slightly later rock-cut sculptures and monumental bas-relief Bud-dhist art, the contours of this image, although highly abbreviated, flow naturally and spontaneously, overlapping as they outline the two crossed legs. The outer garment worn by the Buddha covers both shoulders, and the folds of the long skirt cascade over the base.

Silla, the most conservative of the peninsular states, was the last of the three kingdoms to accept Buddhism as the official religion. This took place in 528, more than a century and a half after the religion was recognized by the king-doms of Koguryŏ and Paekche. Although the stately rhythms of the Buddha's robes and the slight smile that lends serenity to the face are part of the legacy of late-sixth-century Buddhist sculpture of the Chinese Northern Qi (550–577) and Sui (581–618) dynasties, the full, round form of the face and the rather stocky proportions of the body are typical stylistic characteristics of Silla stone sculpture.

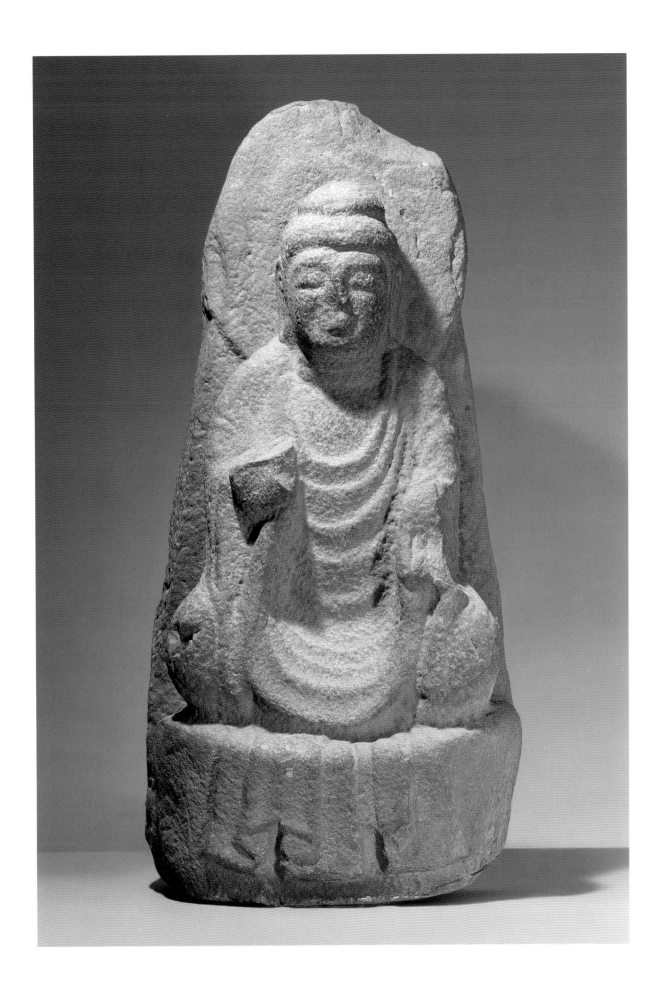

**Plate 66**
Buddha Triad
Unified Silla dynasty (668–935), ca.
680, from Anap-chi Pond, Kyŏngju,
North Kyŏngsang Province
Gilt bronze, h. 10 ⅝ in. (27 cm)
Kyŏngju National Museum

## Plate 66

The twelfth-century *Samguk sagi* (Histories of the Three Kingdoms) tells us that the Silla king Munmu (r. 661–81), who united Korea and established Unified Silla in 668, constructed the *Wŏl-chi* (Moon Pond) in 674 as the center-piece of the royal palace garden in Kyŏngju. After the fall of Unified Silla in the early tenth century, the site was abandoned and the pond came to be called *Anap-chi* (Pond of Wild Geese and Ducks). When the pond was drained in 1977, it yielded large numbers of Unified Silla objects, both secular and Buddhist. Among the earliest group of Buddhist images was this gilt-bronze Buddha triad, found along with another, similar triad and eight bodhisattvas, all seated on lotus thrones and surrounded by large, exquisitely modeled openwork aureoles. The objects probably formed a set, perhaps part of a portable wooden shrine, that was used for private worship within the palace compound.

The plaque testifies to the enormous favor enjoyed by Buddhism during the Unified Silla period, when the religion was lavishly patronized by the court and the aristocracy. The Buddha holds his hands in the *dharmachakra* (teaching) mudra, which symbolizes the turning of the wheel of the Buddhist law. This hand gesture was popular in Indian Buddhist sculpture of the Gupta period (4th–6th century) and appears in China early in the Tang dynasty (618–907). Seated on a lotus throne, the central deity is flanked by two graceful bodhisattvas, who bend their waists toward him. The drapery of the Buddha's robes reveals the fullness of the body underneath. The solid and weighty presence of the Buddha, the realistic modeling of all three figures, and the elaborately decorated double-lotus pedestal and openwork aureoles contribute to the three-dimensional sculptural effect, the result of a highly accomplished casting technique.

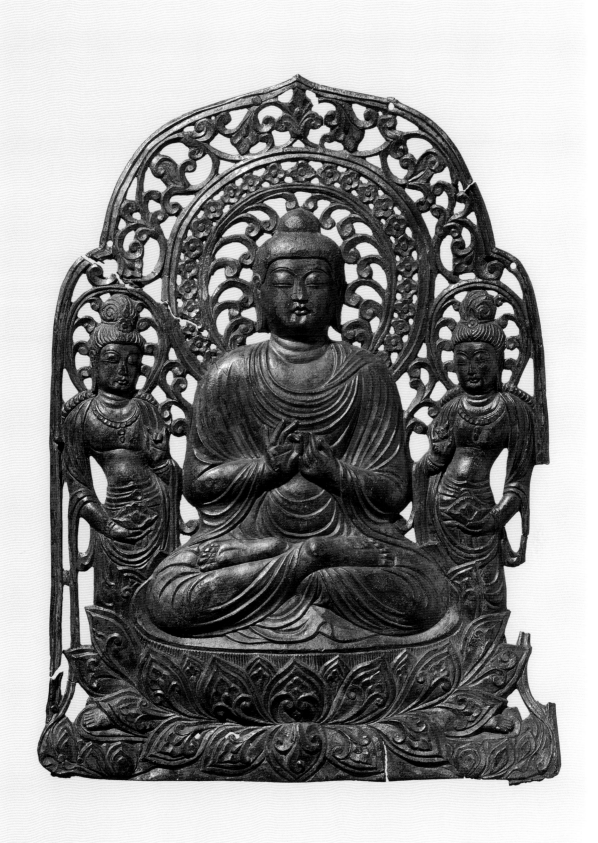

Plates 67 – 69

Unified Silla Buddhist statues reflect the strong iconographic and stylistic influence of Buddhist art of the Tang dynasty (618–907), a result of the close contact between the Buddhist establishments of Korea and China. Moreover, the cosmopolitan style of Unified Silla sculpture offers evidence of influences from Indian Buddhist art, transmitted indirectly through the Tang as well as directly through the many Koreans who undertook the pilgrimage to the homeland of the historical Buddha.

One widely accepted categorization of standing Buddha images from the Unified Silla period defines two basic types based on the appearance of the garments. The first type (pl. 67) is characterized by U-shaped garment folds that fall from the chest to below the knees. This style first gained popularity in Korea in the late seventh century, after the unification of the peninsula. The regular, naturalistic appearance of the drapery folds on this statue indicate a slightly later date, sometime in the first half of the eighth century. The round, idealized face and arched eyebrows reflect Korean transformations of the high Tang style.

The second type (pls. 68 and 69) features U-shaped drapery folds from chest to waist, with two symmetric double U-shaped folds delineating the form of the legs. There is often a modification of the garment on the upper part of the body, with the outer robe either draped over the right arm, as in the Metropolitan Museum statue, or gathered slightly and tucked in at the waist, as shown in the Buddha of Medicine (Bhaishajyaguru) from The National Museum of Korea. The large image of the Buddha of Medicine (pl. 69) is identifiable by the medicine bowl he holds in his left hand. The right arm, with the hand held in the teaching gesture, was cast separately from the rest of the body.

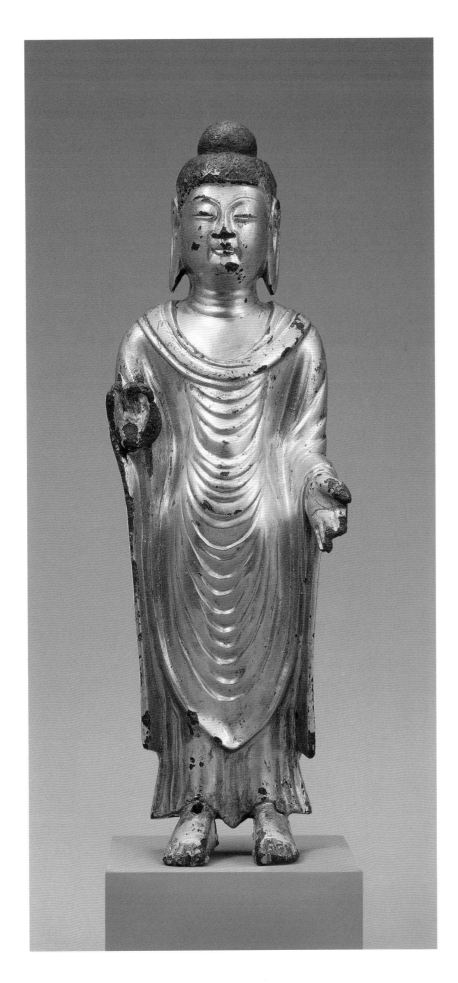

**Plate 67**
Standing Buddha
Unified Silla dynasty (668–935),
first half of the 8th century
Gilt bronze, h. 8 ⅛ in. (20.6 cm)
Dongwŏn Collection, The National
Museum of Korea, Seoul

151

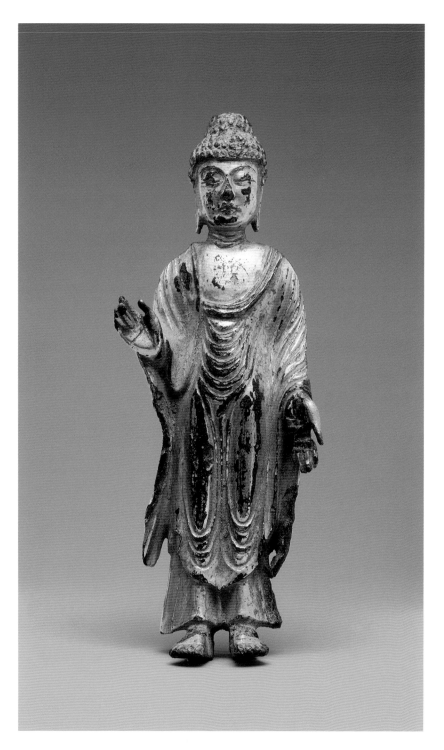

**Plate 68**
Standing Buddha
Unified Silla dynasty (668–935),
8th century
Gilt bronze, h. 5 ½ in. (14 cm)
The Metropolitan Museum of Art,
Rogers Fund, 1912 (12.37.136)

**Plate 69** (facing page)
Standing Buddha of Medicine
(Bhaishajyaguru)
Unified Silla dynasty (668–935),
8th century
Gilt bronze, h. 16 ¼ in. (41.4 cm)
The National Museum of Korea,
Seoul

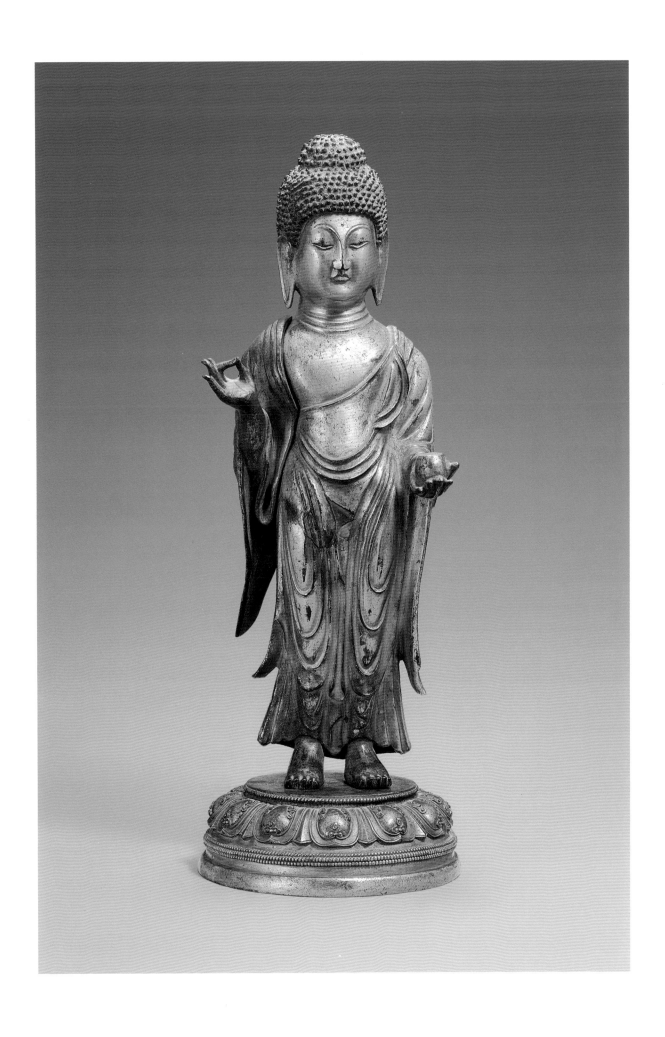

## Plate 70

The royalty and aristocracy of the Koryŏ dynasty were generous benefactors of the Buddhist establishment, and some of the most exquisite and sumptuous art in Korean history was created under their patronage. The Buddhist clergy enjoyed special privileges at the court, often serving as trusted royal advisors, an association that proved disastrous for Buddhism when the Koryŏ fell to the Chosŏn dynasty at the end of the fourteenth century.

This head of what must have been an imposing statue represents one of the best surviving examples of Buddha images produced in iron in the late Unified Silla and early Koryŏ periods. The *ushnisha*, the bump on the crown of the head attesting to transcendent wisdom and one of the distinguishing marks of the Buddha, is large in comparison to known Unified Silla examples, as is the area of the head covered by the snail-shell curls of hair. The small, slightly smiling mouth, the high cheekbones, and the narrow, long eyes and high arched eyebrows are other characteristic features of Buddha images of the early Koryŏ period, in the tenth and eleventh centuries. Between the eyebrows is a large cavity in which was mounted a precious stone to depict the *urna*, or "third eye," another iconographic feature of the Buddha, which symbolizes his divine ability to see other worlds, as well as the past and the future. The manufacture of iron Buddha images began at the end of Unified Silla and continued through the early Koryŏ period. Several examples of seated iron Buddhas with heads much like this one were found in the region of Wŏnju, in Kang'wŏn Province, where apparently there was a workshop that specialized in casting iron images.

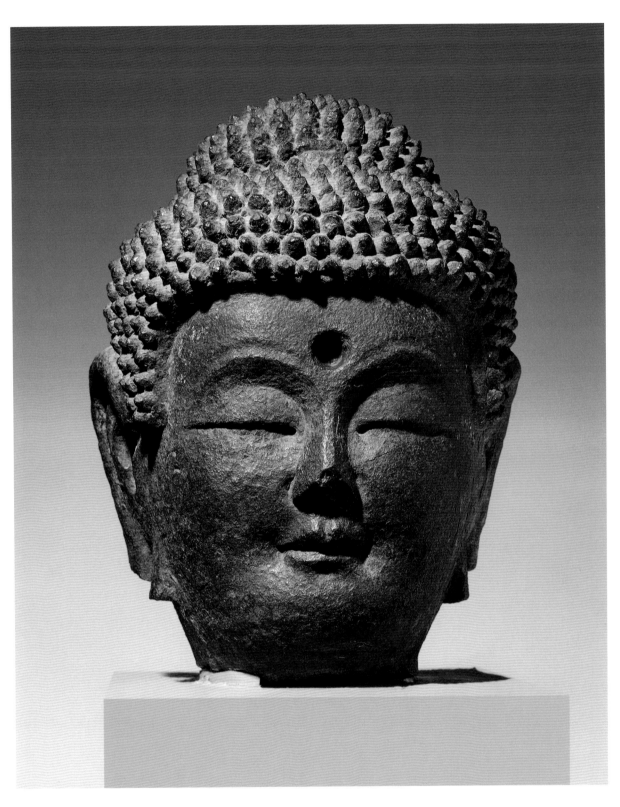

**Plate 70**
Head of Buddha
Koryŏ dynasty (918–1392),
10th–11th century
Iron, h. 14 ¾ in. (37.4 cm)
The National Museum of Korea,
Seoul

## Plates 71 and 72

The Chosŏn dynasty's embrace of Neo-Confucianism in the late fourteenth century was part of a deliberate program to augment the power of the country's new rulers. The court suppressed the Buddhist establishment, which was associated with the corrupt government of the late Koryŏ. The more modest scale of Chosŏn Buddhist art during this time reflects the diminished wealth and influence of Buddhism and the lack of state-sponsored projects. During this period Buddhism was espoused largely by the common people, along with some wealthy adherents, principally women from the royalty or aristocracy, and most religious objects produced were intended for private worship.

A gilt-bronze seated figure of the bodhisattva Avalokiteshvara (pl. 71) preserves the elegance and traditional elements of the Koryŏ style, particularly in its posture of royal ease, with the right leg bent and the left leg pendant. The jewelry and the ornate double-lotus thrones hint at the influence of Tibetan Lamaism, a form of Buddhism that was introduced to Korea from China during the Mongol Yuan dynasty (1272–1368). The statue is reportedly from Mount Kŭmgang, in Kang'wŏn Province, which according to historical records was a major center of Buddhist activities in the late Koryŏ period. The three small seated images (pl. 72) are from a set of twenty-three figures recovered from a pagoda at Sujong-sa Temple, in Kyŏnggi Province. The largest figure, representing the Vairochana Buddha, has his hands in the *bodhyagri* mudra, with the five fingers of the right hand clasping the index finger of the left hand. According to an inscription on the base, the image was commissioned in 1628 by the Queen Mother Inmok, wife of King Sŏnjo (r. 1567–1608). The bodhisattva wearing a crown and with both hands raised to the shoulder displays the iconographical features associated with the Lochana Buddha, who represents the concept of the Absolute Buddha in its numerous manifestations.

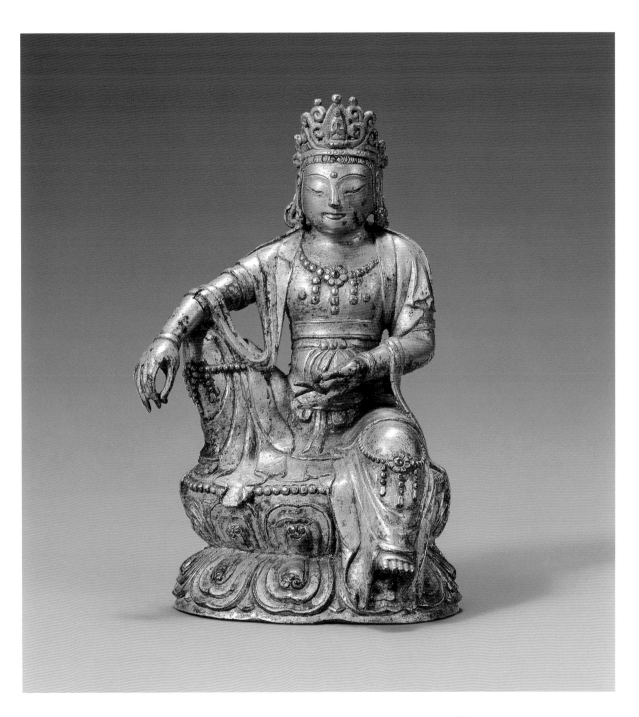

**Plate 71**
Seated Avalokiteshvara
Late Koryŏ (918–1392)–early
Chosŏn (1392–1910) dynasty,
late 14th–early 15th century,
reportedly from Kŭmgang'wŏn-ni,
Haeyang-gun, Kang'wŏn Province
Gilt bronze, h. 7 ⅛ in. (18.1 cm)
The National Museum of Korea,
Seoul

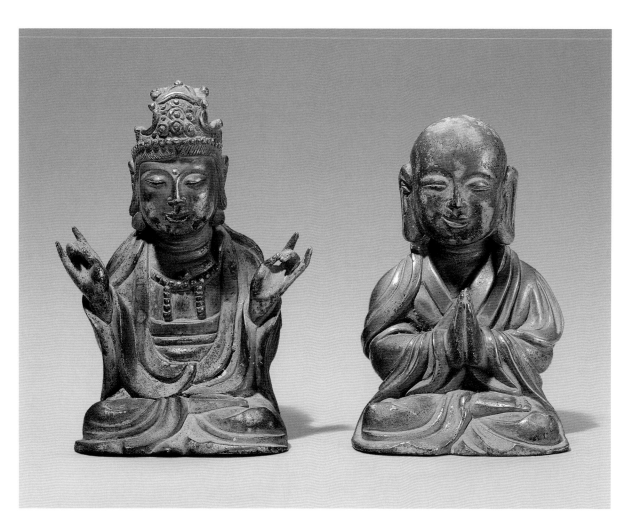

**Plate 72**
Vairochana (facing page)
Lochana and Monk (this page)
Chosŏn dynasty (1392–1910),
dated 1628
Three figures from a set of 23, from
a pagoda at Sujong-sa Temple,
Namyangju-gun, Kyŏnggi Province
Gilt bronze, h. 5 in. (12.6 cm);
4 ⅛ in. (10.6 cm); 3 ⅞ in. (9.7 cm)
The National Museum of Korea,
Seoul

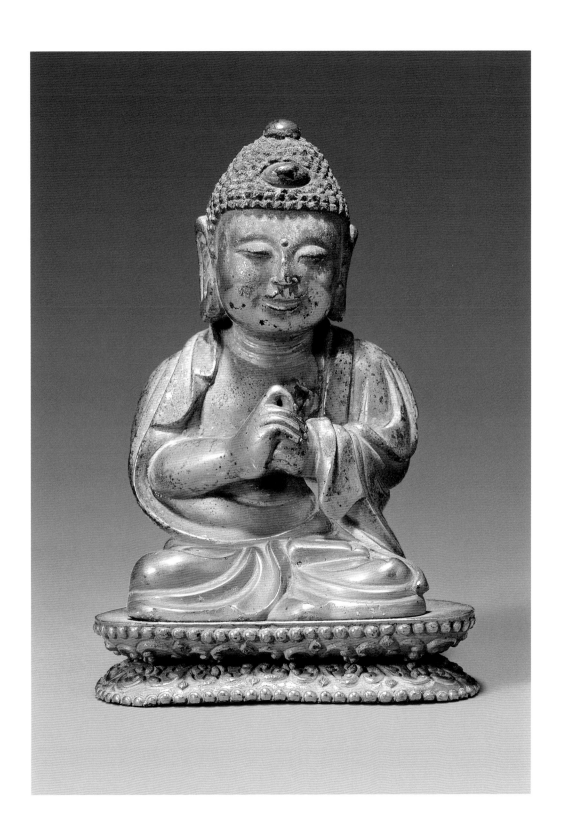

Painting

Bronze Age depictions of humans and animals, in the form of petroglyphs, offer the earliest extant evidence of painting in the Korean peninsula. But it is in the wall paintings of tombs of the kingdom of Koguryŏ (37 BCE–668 CE) that are found the true beginnings of painting. Although few paintings survive from the Three Kingdoms period or the subsequent Unified Silla (668–935), Buddhist devotional works produced during the Koryŏ dynasty (918–1392), a number of which are preserved in collections in Japan, include lavishly detailed paintings of Buddhist deities and illuminated transcriptions of canonical texts. Evidence of painting in Korea is more complete for the Chosŏn dynasty (1392–1910). Early Chosŏn painting is represented by the landscapes of the preeminent painter An Kyŏn (act. ca. 1440–70), who drew upon Chinese themes, techniques, and critical traditions. From his innovative interpretations of these sources, An Kyŏn developed a distinctively Korean landscape idiom that was continued by his many followers. Works that can be confidently assigned to individual artists become more numerous in the mid- and late-Chosŏn period. Among the most important of these painters is Chŏng Sŏn (1676–1759), traditionally acknowledged as the leading exponent of true-view landscapes, a new trend in painting in Korea in the eighteenth century that advocated the depiction of actual Korean scenery as an alternative to the classical themes of Chinese painting. Other subjects favored by Chosŏn painters include scholarly themes, such as plum and bamboo, and portraits. Genre painting, whose acknowledged master practitioners were Kim Hong-do (1745–1806) and Sin Yun-bok (ca. 1758–after 1813), portrayed the daily life of the Korean people in all its variety and liveliness.

**Plate 73**
Unidentified artist
*Amitabha Triad*
Late Koryŏ dynasty (918–1392)
Hanging scroll, ink and color on silk,
47 ⅞ × 32 ¼ in. (121.6 × 81.9 cm)
The Metropolitan Museum of Art,
Rogers Fund, 1930 (30.76.298)

## Plates 73 and 74

The Amitabha Buddha was the focal image of worship in Pure Land Buddhism, which enjoyed great popularity during the Koryŏ dynasty. Devotees were promised entrance to Amitabha's Western Paradise upon the recitation of his name. The hieratic arrangement of this painting of Amitabha (pl. 73) was one of the most popular compositions during the Koryŏ dynasty. Seated on an elaborate lotus throne, and flanked by the bodhisattvas Avalokiteshvara and Mahasthamaprapta, the impassive deity displays the *dharmachakra* hand gesture, which symbolizes the preaching of the Buddhist law. Following iconographic convention, the Buddha is dressed in simple robes in contrast to the bodhisattvas, who are adorned with lavish jewels and gauzy sashes. However, even Amitabha's relatively austere garments have been embellished with the elaborate gold detailing that was a specialty of the Koryŏ painting workshops. Gold details also adorn the throne and lotus flower supports for the bodhisattvas' feet as well as the edge of each nimbus. The intense color of Koryŏ Buddhist paintings results from the two layers of mineral pigments that were applied on the back and front of the silk after it was dyed a light brown color and sized with alum and glue.

The imagery of Kshitigharbha (Chijang), savior of beings in hell, and the Ten Kings of Hell (pl. 74) was another popular theme in Koryŏ Buddhist painting. Portrayed as government officials, the Ten Kings were conceived of as judges who examined the karmic record of the souls of the deceased before determining their fate in the next lifetime. Such paintings were often the focus of worship during the mourning period for the dead, in which ritual offerings and good deeds were performed on behalf of the deceased with the hope of assisting the soul's journey to a favorable rebirth.

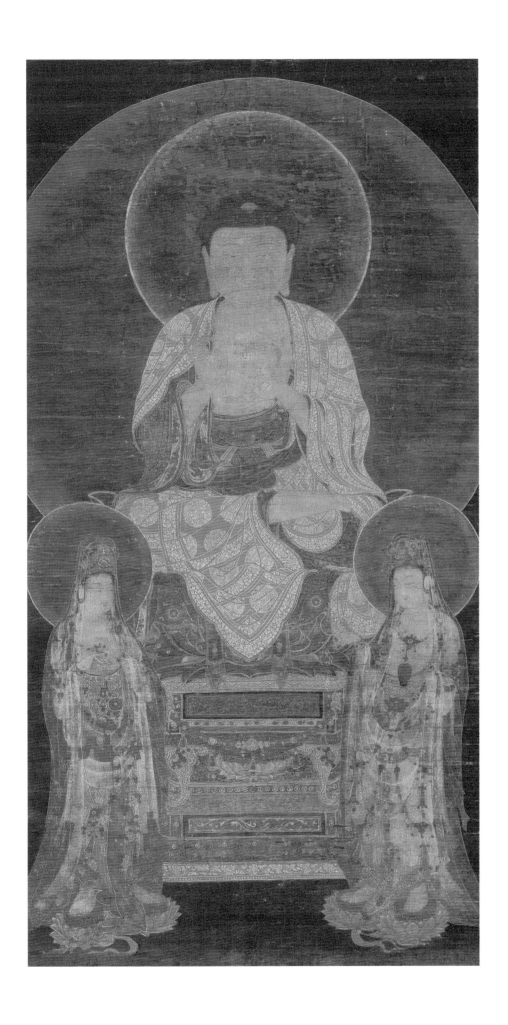

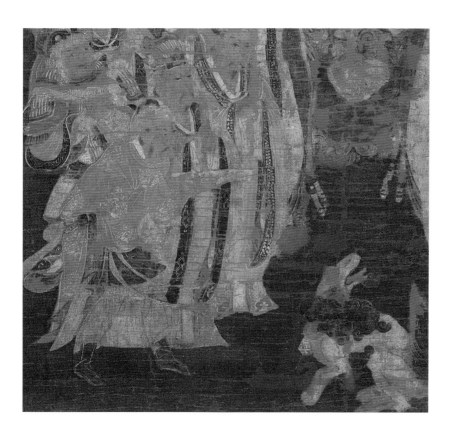

**Plate 74**
Unidentified artist (13th century)
*Kshitigarbha (Chijang) and the Ten
Kings of Hell*, full view and detail
Koryŏ dynasty (918–1392)
Hanging scroll, ink and color on
silk, 43 ⅞ × 23 ¾ in. (111.4 × 60.3 cm)
Horim Art Museum, Seoul
Treasure no. 1048

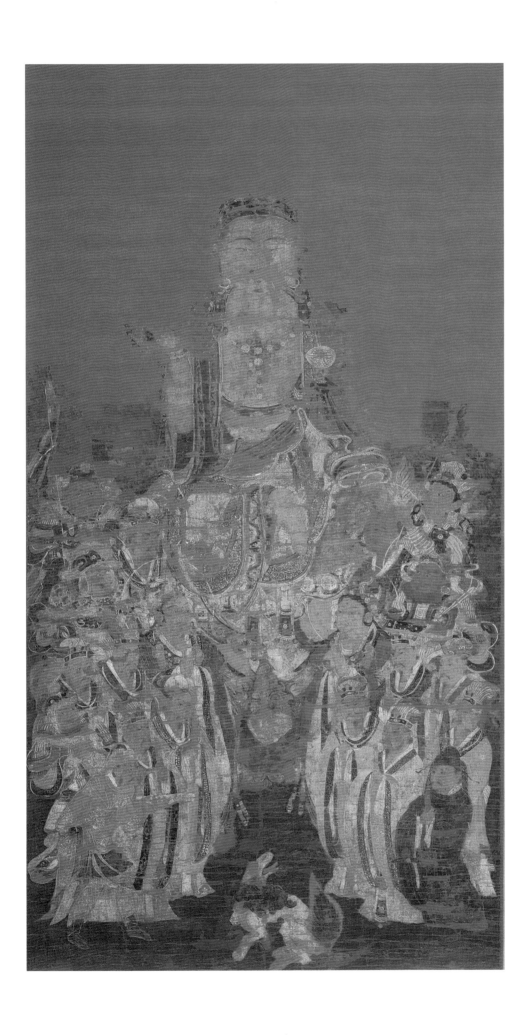

Plate 75

This superb painting depicts one of the most popular Buddhist deities during the Koryŏ period. The bodhisattva Avalokiteshvara appears in other paintings as an attendant to Amitabha (see pl. 73). Here he is seen alone, as the Water-Moon Avalokiteshvara, an iconographic type that seems to have originated in China during the Tang dynasty (618–907).

The usual attributes of this deity are present in this portrayal: the image of Amitabha in his crown and the willow branch that symbolizes healing, displayed in a *kundika* bottle placed in a clear glass or crystal bowl. Avalokiteshvara is attired in beautiful robes and sashes, with intricate gold details on his jewelry and clothing. Holding a crystal rosary in his right hand, he is seated on a rocky outcrop with his right leg crossed and his left foot placed on a lotus-flower support. In the water surrounding him are small rocks from which protrude pieces of precious coral. Barely discernible in the background to his left are several large bamboo stalks. At the top of the painting, above the nimbus and aureole, is a depiction of a moon, where a hare pounds the elixir of immortality under a cassia tree, a theme based on a well-known Chinese legend. Shown in worship of the deity are the boy Sudhana, who appears in the sutra on which the water-moon iconography is partially based, and a retinue of officials and supernatural beings offering precious gifts. The iconographic sources for this composition, of which there are other well-known examples (most notably in the Daitoku-ji Temple and the Sumitomo Family Collection, both in Kyoto), include Buddhist and Daoist texts and various textual and pictorial references from China and Central Asia as well as native Korean legends.

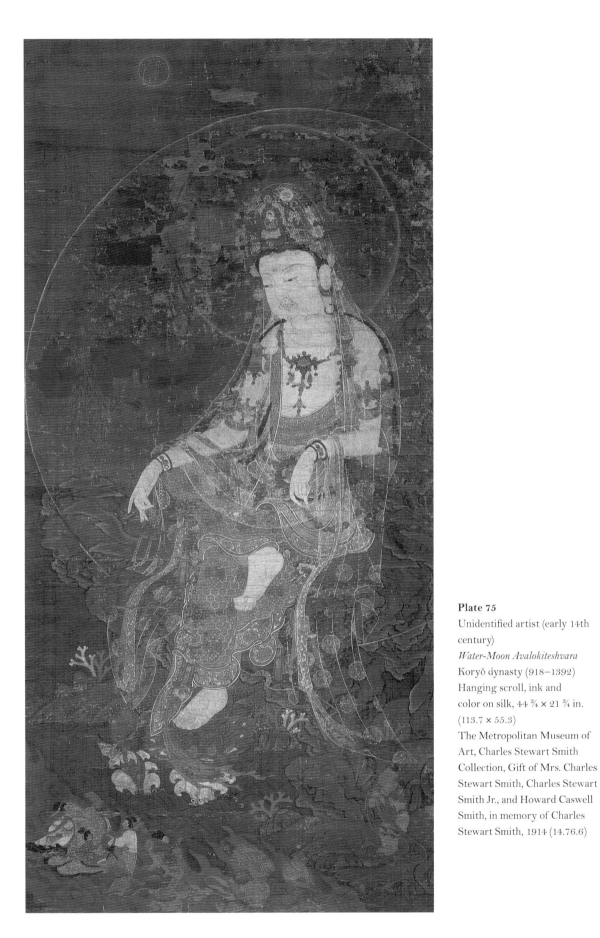

**Plate 75**
Unidentified artist (early 14th
century)
*Water-Moon Avalokiteshvara*
Koryŏ dynasty (918–1392)
Hanging scroll, ink and
color on silk, 44 ¾ × 21 ¾ in.
(113.7 × 55.3)
The Metropolitan Museum of
Art, Charles Stewart Smith
Collection, Gift of Mrs. Charles
Stewart Smith, Charles Stewart
Smith Jr., and Howard Caswell
Smith, in memory of Charles
Stewart Smith, 1914 (14.76.6)

**Plate 76**
Unidentified artist
(first half of the 14th century)
*Amitabha and Kshitigarbha* (*Chijang*)
Koryŏ dynasty (918–1392)
Hanging scroll, ink and color on
silk, 37 ¼ × 21 ⅞ in. (94.6 × 55.6 cm)
The Metropolitan Museum of Art,
Rogers Fund, 1913 (13.5)

## Plates 76 and 77

The popularity of the bodhisattva Kshitigarbha, or Chijang, in Koryŏ Pure Land Buddhism is demonstrated by the frequent depiction of the deity in devotional painting. Not only is he shown presiding over the Ten Kings of Hell (see pl. 74), but he is also portrayed alone (pl. 77), as a monk holding his attributes: a mendicant's staff and a wish-fulfilling *cintamani*. The iconography of the bodhisattva in this painting matches that of tenth-century depictions of Kshitigarbha from the Chinese cave-temple of Dunhuang, but the highly stylized drapery and flat, abstracted quality of the painting suggest a late-fourteenth-century date.

In contrast to this popular portrayal of Kshitigarbha, the combination of the Buddha Amitabha and the bodhisattva Kshitigarbha in one composition (pl. 76) represents the only known example of this iconography in Koryŏ Buddhist painting. Both deities are depicted frontally; slight movement, indicated by the flow of the robes and Kshitigarbha's swaying jewelry, increases the visual interest. A possible iconographic source for this composition is a tenth-century wall painting, also from Dunhuang, that underlines the association of the two deities with the afterlife. In the Dunhuang painting, Amitabha and Kshitigarbha appear in the context of their respective domains, the Western Paradise and the realm of Hell, with full retinues. The abbreviation of the present composition from a detailed depiction befitting an architectural context, such as a grotto-temple, to the essential iconological statement of the two deities shown alone is appropriate for the smaller format of a hanging scroll.

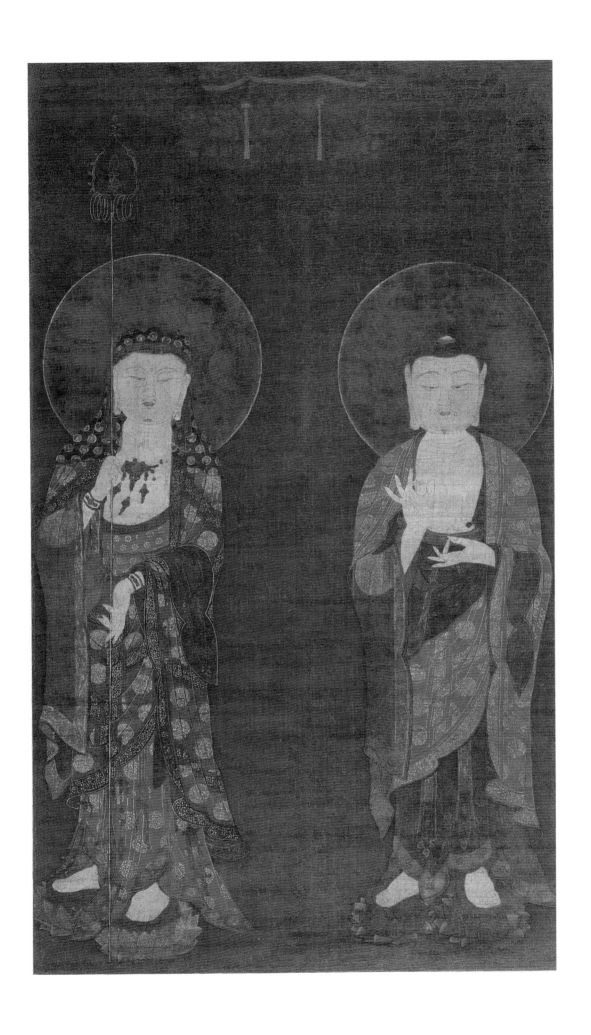

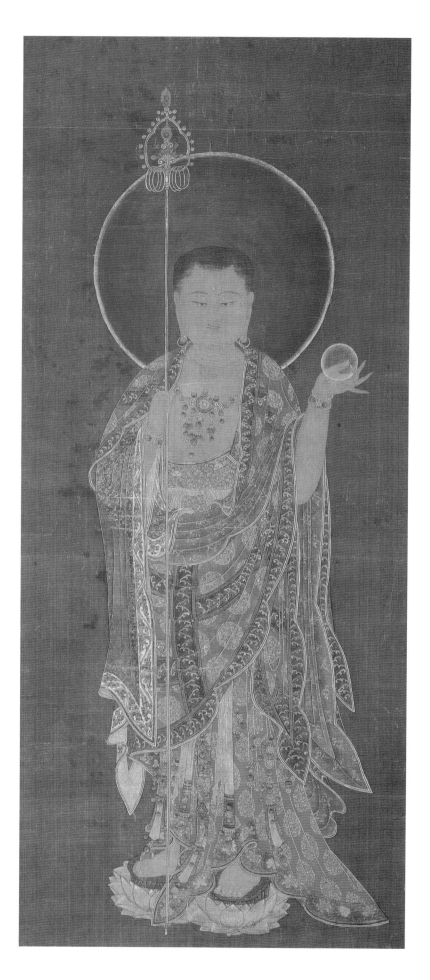

**Plate 77**
Unidentified artist (late 14th century)
*Kshitigarbha* (*Chijang*)
Koryŏ dynasty (918–1392)
Hanging scroll, ink, color, and gold
paint on silk, 33 ¼ × 14 ½ in.
(84.5 × 36.8 cm)
The Metropolitan Museum of Art,
H.O. Havemeyer Collection, Gift of
Horace Havemeyer, 1929 (29.160.32)

## Plates 78 and 79

Illustrated Buddhist scriptures, or sutras, produced at the Royal Scriptorium during the Koryŏ period were highly valued by monasteries and temples throughout northeast Asia. Produced on indigo-blue dyed paper, usually in rectangular accordion format, these volumes are characterized by exquisite calligraphy written in gold or silver pigment, often preceded by elaborate frontispiece illustrations that describe episodes from the sutra text. These fourteenth-century examples demonstrate the standards of excellence for which Koryŏ sutras are renowned.

The first, the *Lotus Sutra*, is a seminal text in Mahayana Buddhism and one of the two most frequently copied sutras. The lavish illustration of the Metropolitan volume (pl. 78), executed with dazzling technical virtuosity, portrays popular tales from the sutra, which addresses the question of universal salvation and the means by which sentient beings can be led to enlightenment and the attainment of Buddhahood.

The other frequently copied text in the Koryŏ period was the *Avatamsaka Sutra*, which is the basis for the Pure Land belief in the Western Paradise of the Amitabha Buddha. The frontispiece illustration to this volume (pl. 79) shows the boy pilgrim Sudhana, on a journey in search of the ultimate truth, receiving instruction from three teachers. One of the fifty-three teachers he visits in his search for enlightenment, not shown here, is the bodhisattva Avalokiteshvara; thus there are frequent depictions of Sudhana worshipping this deity (see pl. 75). A dedicatory inscription at the end of the transcribed text informs us that this copy of the sutra was commissioned by a Koryŏ official in honor of his deceased parents and to gain merit for himself and his family. Copying or commissioning a copy of a Buddhist scripture was considered one of the meritorious acts by which devotees could increase their chances of rebirth in paradise.

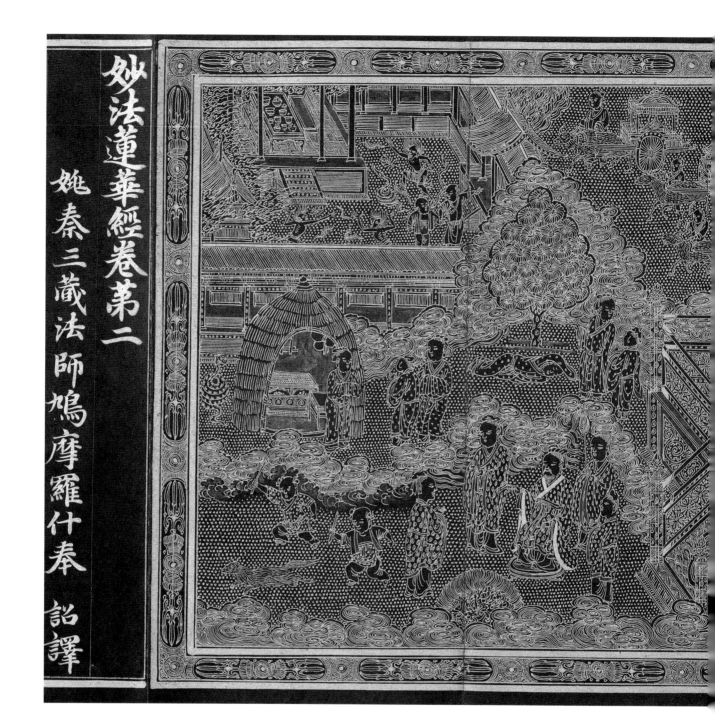

妙法蓮華經卷第二

姚秦三藏法師鳩摩羅什奉　詔譯

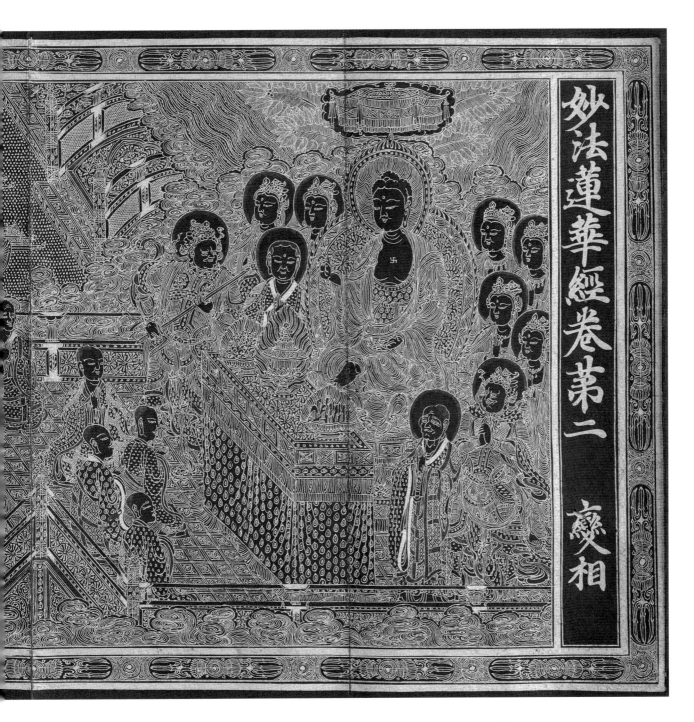

妙法蓮華經卷第二

變相

**Plate 78**
Unidentified artist (14th century)
*Illuminated Manuscript of the Lotus Sutra*
Koryŏ dynasty (918–1392), ca. 1340
Folding book, gold and silver
on indigo-dyed mulberry paper,
13 × 4 ½ in. (33 × 11.4 cm)
The Metropolitan Museum of Art,
Purchase, Lila Acheson Wallace Gift,
1994 (1994.207)

大方廣佛華嚴經卷第三十一

罽賓國三藏般若奉

詔譯

善知衆藝童子

徧友童子

大方廣佛華嚴經卷第三十一變相

天主光天女

**Plate 79**
Unidentified artist (14th century)
*Illuminated Manuscript of the*
*Avatamsaka Sutra, Volume 31*
Koryŏ dynasty (918–1392), dated 1337
Handscroll, gold and silver on
indigo-dyed mulberry paper,
12 ¼ × 347 in. (31 × 881.7 cm)
Ho-Am Art Museum, Yongin
National Treasure no. 215

## Plate 80

This Chosŏn painting depicts Shakyamuni, the historical Buddha, attended by two bodhisattvas, probably Manjushri and Samantabhadra, who are shown here, as they often are in Korean Buddhist art, without their traditional attributes of a lion and a six-tusked elephant. This triad recalls the exquisite Buddhist paintings of the Koryŏ dynasty, but with significant stylistic departures. The Buddha has the smaller facial features and the pointed *ushnisha* (the cranial protuberance that is one of his attributes) characteristic of Chosŏn Buddhist images. Moreover, the details rendered in gold pigment, while continuing the Koryŏ practice of embellishing paintings with the precious substance, are more dynamic and expressive, especially in the description of the textile patterns. Gold pigment was also used for the inscription, which states that the scroll was part of a set of four hundred triads commissioned by the Queen Dowager Munjong (d. 1565) to ensure blessings for her son, King Myŏngjong (r. 1545–67), and to commemorate the restoration of Hoeam-sa Temple, a major Sŏn (Ch. Chan; Jp. Zen) monastery in Kyŏnggi Province. The set originally consisted of fifty images in color and fifty images in gold pigment featuring each of four major Buddhas: Shakyamuni, Maitreya, Bhaishajyaguru, and Amitabha. The present work is one of four known paintings from the set.

Queen Dowager Munjong was a crucial figure in Chosŏn dynasty Buddhism. Because of the early deaths of her husband and his successor (her stepson, who ruled for one year), she became her young son's regent in 1546 and ruled the country until her death in 1565, just days after the ceremonies marking the completion of renovations to the Hoeam-sa Temple. Under her rule, the anti-Buddhist policies of the Chosŏn royal court were rescinded, leading to a brief flourishing of Buddhism.

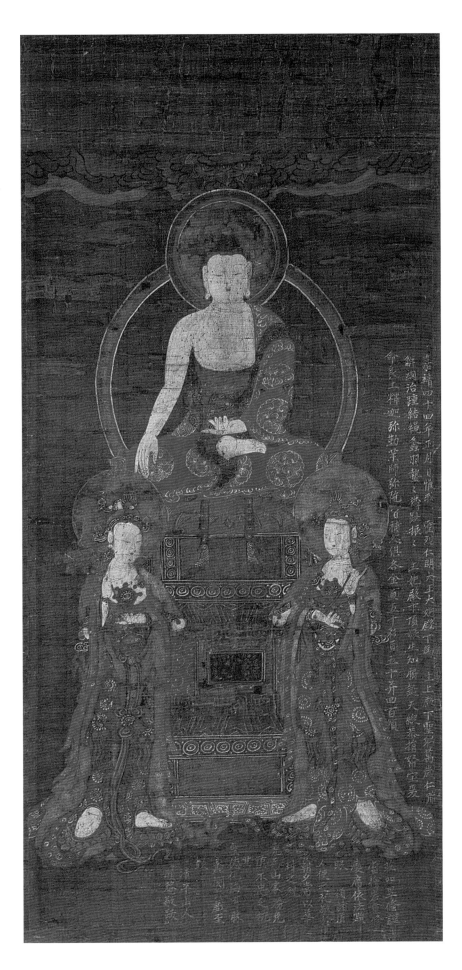



嘉靖四十四年四月日惟恭□
餘綱治鍊結縄鑫羽軰々髻開振ㄑ
命良工糟迦 弥勒芉間弥陀□積人俱各金
距列仁朙六王大処威下座 上下祗十重石葛萬威仁願
玉炉殿下頂晶出知 脇談天曁泰拍節宣慶
王炬殿女々既百五十弃四百间

**Plate 80**
Unidentified artist (16th century)
*Shakyamuni Buddha Triad*
Chosŏn dynasty (1392–1910),
dated 1565
Hanging scroll, ink, color,
and gold paint on silk,
27 ⅜ × 13 in. (69.5 × 33 cm)
Mary and Jackson Burke
Foundation

## Plate 81

This large painting on hemp, from the late sixteenth century, depicts the Indian deity Brahma, with a retinue of attendants and musicians. Although Brahma was a major Hindu deity, he was incorporated into the Buddhist pantheon as a guardian of Buddhist teachings. His abode, the Brahma heaven, was construed as a place of pleasure, populated with heroes, entertainers, and musicians, like those who form such an important part of this composition. The leftward orientation of the figures suggests that the painting was meant to be displayed with a similar representation of Indra, another Hindu deity who was absorbed into the Buddhist pantheon and who is often paired with Brahma.

The towering figure of Brahma dominates the composition, which is filled with three rows of attendants. In the back row are attendants bearing such ceremonial objects as fans, a lantern, and a spear, as well as two officials who represent the sun and moon. In the middle row, Brahma is flanked by two bodhisattvas with their hands joined in worship and four musicians. In the front row, two attendants, on whose shoulders rest the hands of the gigantic Brahma, are flanked by six musicians. The entire group is surmounted by elaborate jeweled canopies. The elongated proportions of the figures and the schematic facial features, hair, and robes are all executed with a heightened sensitivity to color, texture, and detail. The highly mannered style of the figural representation parallels several other Chosŏn Buddhist paintings of the late sixteenth century, as do the abstract quality of the lines and the large composition, which fills the entire painting surface. Such paintings, known as *sinjung t'aenghwa*, or "hanging paintings of devas [guardians of Buddhist teachings]," would have been an integral part of Buddhist rituals, especially those performed to ensure protection for the country during the many periods in which it suffered frequent foreign invasions.

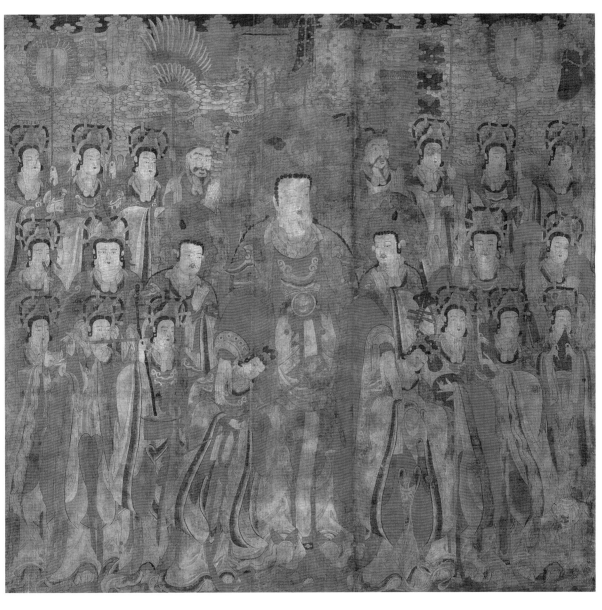

**Plate 81**
Unidentified artist (late 16th century)
*Brahma* (*Pŏmch'ŏn*)
Chosŏn dynasty (1392–1910)
Hanging scroll, ink and color on hemp,
84 ½ × 88 ½ in. (214.6 × 224.8 cm)
The Metropolitan Museum of Art,
Gift of Mrs. Edward S. Harkness,
1921 (21.57)

**Plate 82**
Ŭi Gyŏm (18th century) and others
*Water-Moon Avalokiteshvara*
Chosŏn dynasty (1392–1910),
dated 1730
Hanging scroll, ink and color on silk
57 × 41 ½ in. (143.7 × 105.5 cm)
Buddhist Art Museum of Korea,
Seoul, Treasure no. 1204

## Plate 82

The popularity of the Water-Moon Avalokiteshvara continued into the Chosŏn dynasty, as attested by this painting, which preserves the essential details of this deity's iconography: his rocky throne, the *kundika* with a willow branch, and the presence of the boy pilgrim Sudhana (see pl. 75). The bamboo stalks visible on the left of the deity are another Koryŏ convention. Significant departures from the Koryŏ style are the frontal pose, the elongated figure, and the small facial features, as well as the stylized, abstract lines used to depict the deity's robes and the waves that surge beneath his feet. Sudhana is also in a more prominent position, directly to the right of the bodhisattva.

The inscription in the rectangular cartouche at the bottom of the painting provides information concerning the production of the painting. The work was commissioned in the year 1730, by, among others, five married couples who donated the materials, such as the silk and different pigments. This year is recorded using a Chinese Qing dynasty (1644–1911) reign date (8th year of Yongzheng), a customary practice in Korea until the mid-nineteenth century. The inscription includes a felicitation for the reigning monarch, King Yŏngjo (r. 1724–76), and also records the names of the *kŭmŏ*, or monk-painters, and the monks who supervised them and ensured the iconographic accuracy of the painting as well as ritual propriety during its production. The last of these rituals, as with all Buddhist paintings, would have been the *chŏmansik*, or "eye-dotting ceremony," during which the eyes of the deity were painted, thus completing the composition as well as the process of consecrating the image as a devotional object.

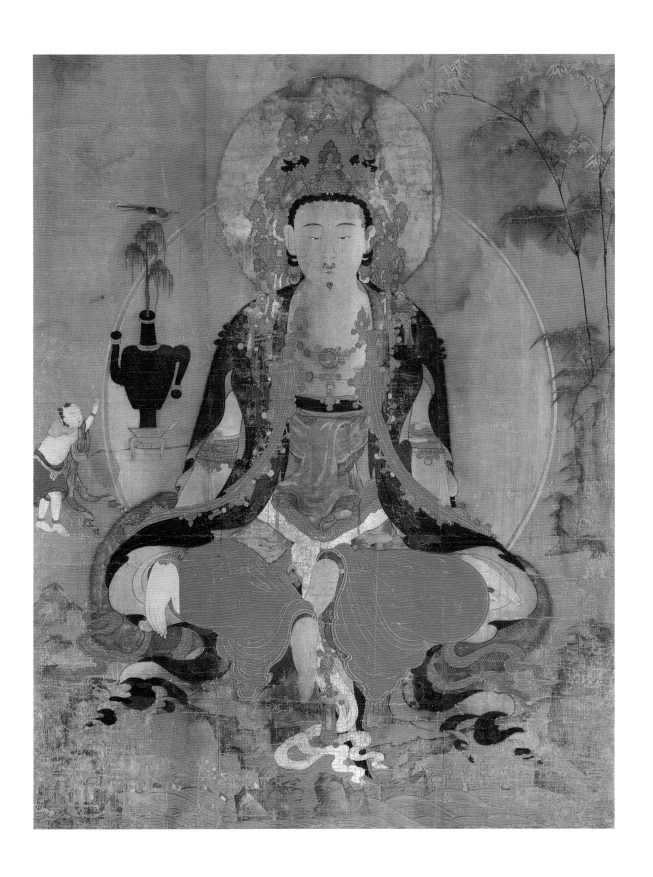

## Plates 83 – 85

The early years of the Chosŏn dynasty were a time of great ambition and energy, as the rulers of the new dynasty carried out social and political reforms that distinguished them from the preceding Koryŏ kings. Artistic activity also benefited from the vitality of this time, but because of repeated foreign invasions throughout the course of the dynasty, very little remains of early Chosŏn painting. Thus the few surviving examples are crucial to our understanding of the artistic achievements of this period. The most influential artist of the time was An Kyŏn (act. ca. 1440–70), a court painter who was favored by the eminent collector and art patron Prince Anp'yŏng (1418–1453). The lively brushwork and dramatic contrasts of dark and light in these early Chosŏn paintings reflect the dominant influence of An Kyŏn, whose painting style was inspired by Chinese monumental landscapes, particularly those of the Northern Song master Guo Xi (ca. 1000–ca. 1090) and his followers.

These stylistic characteristics of the An Kyŏn school of painting were particularly well-suited to the depiction of the celebrated theme Eight Views of the Xiao and Xiang Rivers, which was first formalized in China during the eleventh century and became popular in Korea in the fifteenth century. Eight Views compositions were based on a set of poems extolling the beauty and melancholy of the entire landscape of mountains, rivers, and marshes in the Lake Dongting region, in the modern Chinese province of Hunan. A complete set of Eight Views paintings is preserved in the album illustrated here (pl. 83), while individual scenes are depicted in a pair of hanging scrolls (pl. 84) and in a single hanging scroll (pl. 85). In contrast to the horizontal handscroll format favored by Chinese artists, Korean depictions of this theme are commonly presented in hanging scroll format, and often mounted as a screen.

**Plate 83**
Attributed to An Kyŏn (act. ca. 1440–70)
*Eight Views of the Xiao and Xiang Rivers*
Chosŏn dynasty (1392–1910)
Album of eight leaves, ink and light color
on silk, 14 × 12 ¼ in. (35.4 × 31.1 cm)
The National Museum of Korea, Seoul

leaf 4

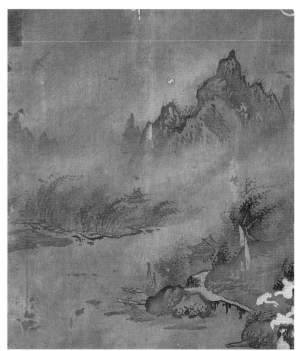

leaf 3

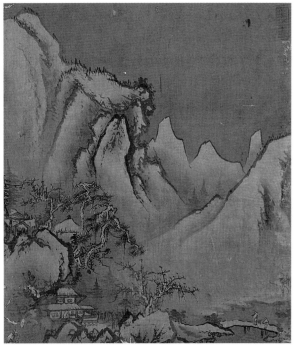

leaf 8

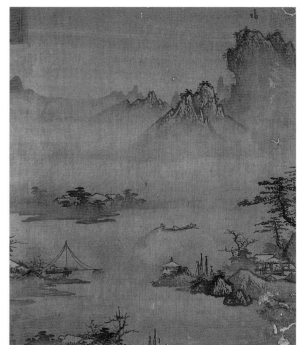

leaf 7

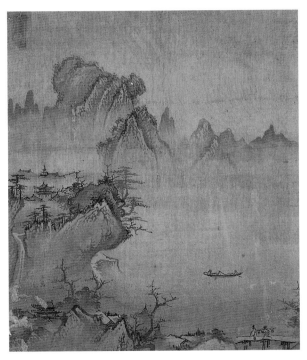

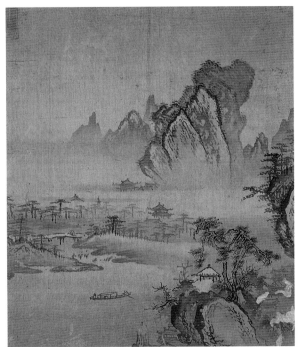

leaf 2

leaf 1

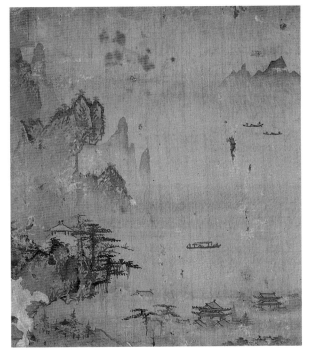

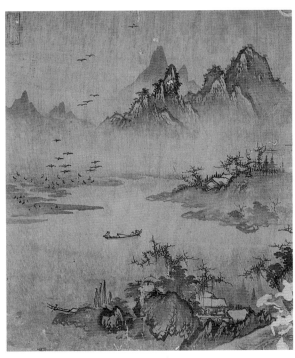

leaf 6

leaf 5

**Plate 83**

Attributed to An Kyŏn (act. ca. 1440–70)

*Eight Views of the Xiao and Xiang Rivers*

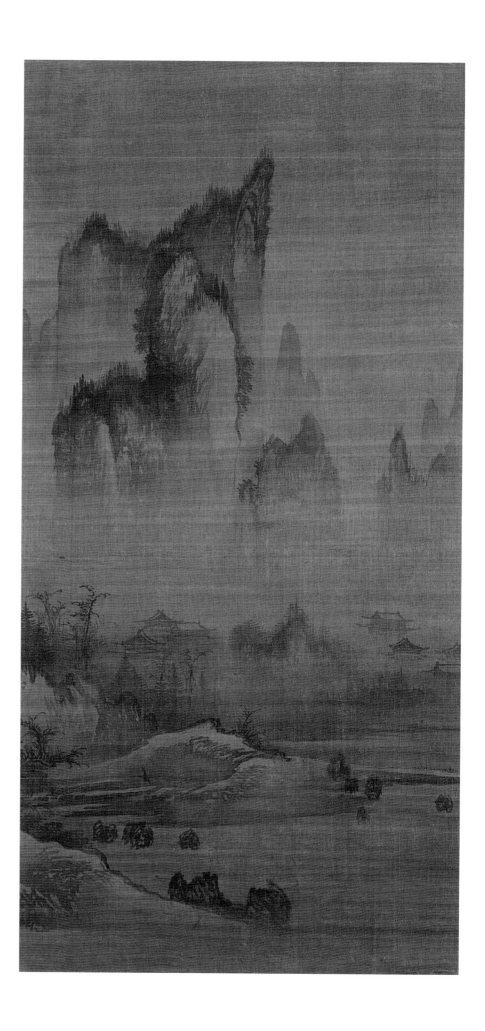

*Evening Bell from
Mist-shrouded Temple*

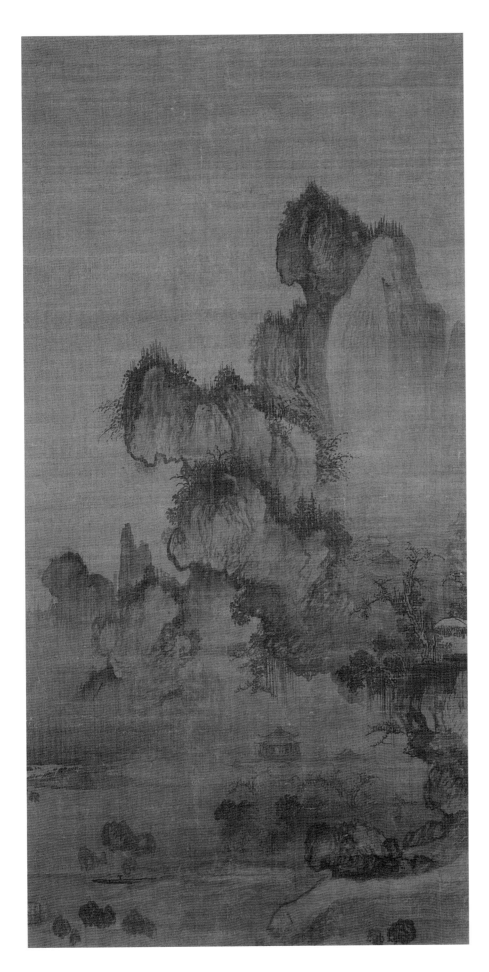

**Plate 84**
Unidentified artist
(15th century)
*Landscapes in the Style
of An Kyŏn*
Chosŏn dynasty (1392–1910)
Pair of hanging scrolls, ink
on silk, 34 ¾ × 17 ¾ in.
(88.3 × 45.1 cm)
The Metropolitan Museum
of Art, Purchase, Joseph
Pulitzer Bequest, and Mr.
and Mrs. Frederick P. Rose
and John B. Elliott Gifts,
1987 (1987.278a,b)

*Autumn Moon over Lake
Dongting*

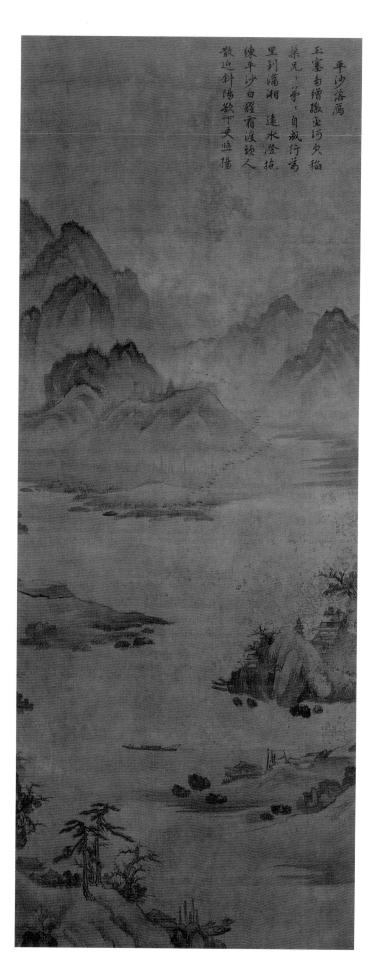

平沙落鴈
玉塞旬縐緻盡巧欠稻
柴兄、爭、自成行萬
里列瀟湘　遠水澄拖
練平沙白耀霜渡頸人
散迎斜陽歡下火隄楊

**Plate 85**
Unidentified artist
(late 15th–16th century)
*Wild Geese Descending to Sandbar*
Chosŏn dynasty (1392–1910)
Hanging scroll, ink on silk,
49 ¾ × 29 ⅛ in. (126.4 × 48.5 cm)
The Metropolitan Museum of Art,
Purchase, Harris Brisbane Dick
Fund, John M. Crawford Jr.
Bequest, and The Vincent Astor
Foundation Gift, 1992 (1992.337)

## Plates 86 and 87

Yi Am was the great-grandson of King Sejong's (r. 1418–50) fourth son, Prince Imyŏng (1418–1469), and enjoyed great success as a court painter, even winning a royal prize for painting in 1545. Only about ten of his paintings survive, most of which are in collections in Japan, where Yi Am's works were appreciated and studied by such artists as Kanō Eino (1631–1697) and Tawaraya Sōtatsu (act. late 16th–early 17th century), one of the founders of the Rinpa school. This charming composition by Yi Am (pl. 86), the best known of his extant paintings, depicts three puppies beneath a flowering tree. One puppy sleeps, another is seated quietly, and the third, in the foreground, plays with a grasshopper he has just caught. A large butterfly and a bee have attracted the attention of a pair of birds perched overhead in the tree. The same three puppies appear in other paintings by the artist, suggesting that he drew these compositions from life, and over a relatively short period of time.

Kim Sik served as a government official but also enjoyed success as a painter. He painted in the style of the versatile artist Kim Che (1524–1593), who was Kim Sik's grandfather, but was actually his great-uncle. (Because he had no son, Kim Che adopted his nephew, Kim Sik's father.) Although he painted birds and flowers, the artist is best remembered for his faithful continuation of his grandfather's powerful paintings of oxen. Salient features of the family style include the depiction of the powerful beasts using ink washes rather than linear brushstrokes, and twisting postures, such as that of this mother cow who tenderly licks her suckling calf (pl. 87). The relatively flat, abstract style of this painting contrasts with his grandfather's more naturalistic paintings.

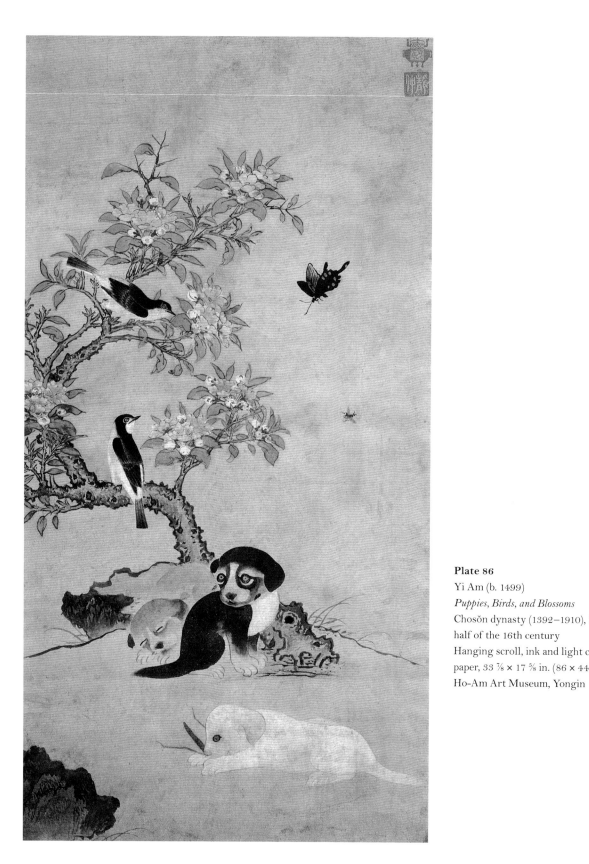

**Plate 86**
Yi Am (b. 1499)
*Puppies, Birds, and Blossoms*
Chosŏn dynasty (1392–1910), first
half of the 16th century
Hanging scroll, ink and light color on
paper, 33 ⅞ × 17 ⅝ in. (86 × 44.9 cm)
Ho-Am Art Museum, Yongin

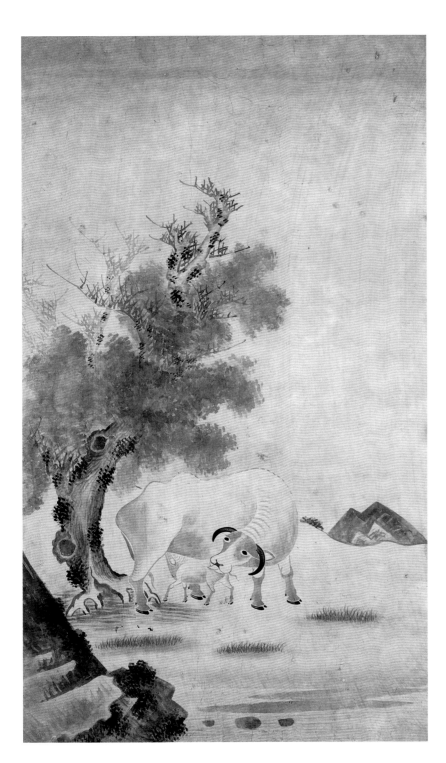

**Plate 87**
Kim Sik (1579–1665)
*Two Oxen*
Chosŏn dynasty (1392–1910),
late 16th century
Hanging scroll, ink and light color on
paper, 38 × 22 ¾ in. (96.5 × 57.6 cm)
The National Museum of Korea,
Seoul

## Plates 88 and 89

Yi Chŏng was a great-great-grandson of King Sejong (r. 1418–50), and was a poet and calligrapher as well as a renowned bamboo painter. Bamboo was a metaphor for the upright yet flexible scholar because it grows straight, but yields to the wind. Bamboo's formal possibilities were also an ideal vehicle for the display of brushwork, as in this depiction of a misty grove in a strong wind (pl. 88). Yi Chŏng uses bold, powerful strokes for the windswept leaves, and provides depth and atmosphere by using contrasting ink tones, varying from the most diluted for the background leaves to the deep rich tones of the foremost stalks. His confident, robust style was said to have become even more vital after he was wounded in the arm during the Japanese invasion of 1592.

Ŏ Mong-nyong, a celebrated painter of plum, came from a prominent family; his grandfather and father both served as important officials. However, he himself never advanced in government service beyond the level of county magistrate, choosing instead to make his name as a painter, for which he was considered, along with Yi Chŏng, one of the best artists in the country. Plum blossoms appear in the early spring, when there is often still snow on the ground, and were thus likened to the virtuous man who thrives even in adverse conditions, and were thus a favorite subject for scholarly painting and poetry. In this depiction of an old weathered plum tree in the moonlight (pl. 89), Ŏ Mong-nyong establishes a contrast between the slender stalks and fragile blossoms and the broken and rough main branches of the trees from which they grow. The barest suggestion of a nearly full moon complements the powerfully angular, vertical lines of the plum branches.

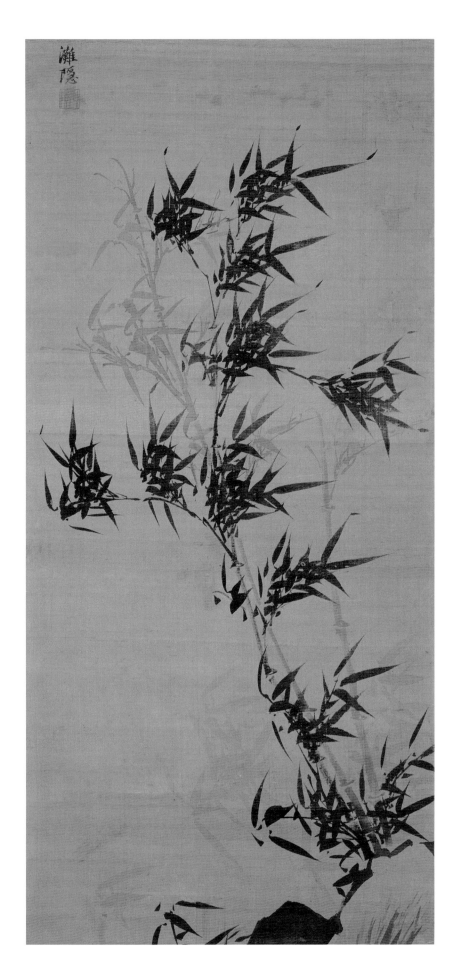

**Plate 88**
Yi Chŏng (1541–1622)
*Ink Bamboo*
Chosŏn dynasty (1392–1910)
Hanging scroll, ink on silk,
45 ½ × 21 in. (115.6 × 53.3 cm)
Mary and Jackson Burke
Foundation

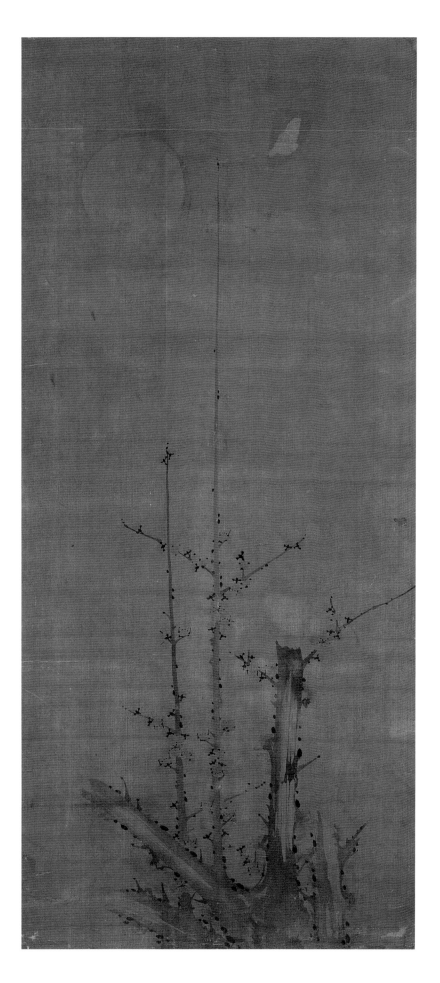

**Plate 89**
Ŏ Mong-nyong (b. 1566)
*Plum*
Chosŏn dynasty (1392–1910),
17th century
Hanging scroll, ink on silk,
47 × 21 in. (119.2 × 53 cm)
The National Museum of
Korea, Seoul

## Plates 90 and 91

In Korea portraits were painted to commemorate important occasions and for ritual use. If portraits painted from life were lost, worn, or damaged, it was common practice to repair originals through extensive retouching, or even create entirely new portraits. This practice demonstrates that portraits functioned not merely to record the outward appearance of the sitter, but, more importantly, to serve as a focus for mortuary and ancestral rites. An example of a posthumous portrait is this image of an official (pl. 90), traditionally identified as Cho Mal-saeng. Seated in a chair with cabriole-style arms, the subject is shown in three-quarter view, wearing an official's cap and a dark robe with a prominent *hyungbae*, or rank badge. This embroidered silk panel, which indicated the standing of government officials, was not in use during the sitter's lifetime; the form of the cap is also a later design. Moreover, the painting style compares very closely with that of portraits reliably dated to the seventeenth century.

Few works exemplify the excellence of eighteenth-century portraiture as well as this image of Yi Chae (pl. 91). A high-ranking vice minister and academician, Yi Chae is also known for his studies in physiology. This portrait shows him seated in three-quarter view, wearing a simple cap and a white robe with a sash. The meticulously naturalistic rendering of his wrinkled face, including long eyebrows and thoughtful, intelligent eyes above a wispy graying beard, conveys the vital sense of personality and individualism that is possible only in a drawing from life. The detailed description of the subject's face is complemented by his robe, whose folds and seams are drawn with fluid, rhythmic lines and which is enhanced with the slightest hint of shading. His black cap, lapels, sash edges, and cuffs add bold, dramatic touches to the composition.

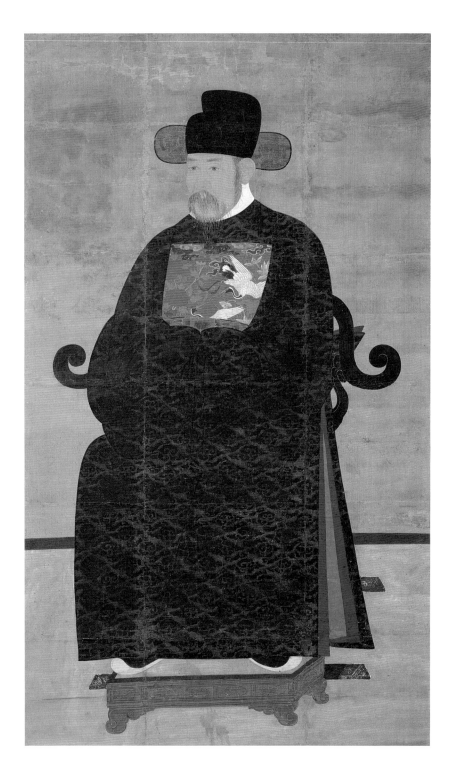

**Plate 90**
Unidentified artist (17th century)
*Portrait of an Official*
(traditionally identified as Cho
Mal-saeng, 1370–1447)
Chosŏn dynasty (1392–1910)
Hanging scroll, ink and color on silk,
70 ¼ × 41 in. (178.3 × 104.4 cm)
The National Museum of Korea,
Seoul

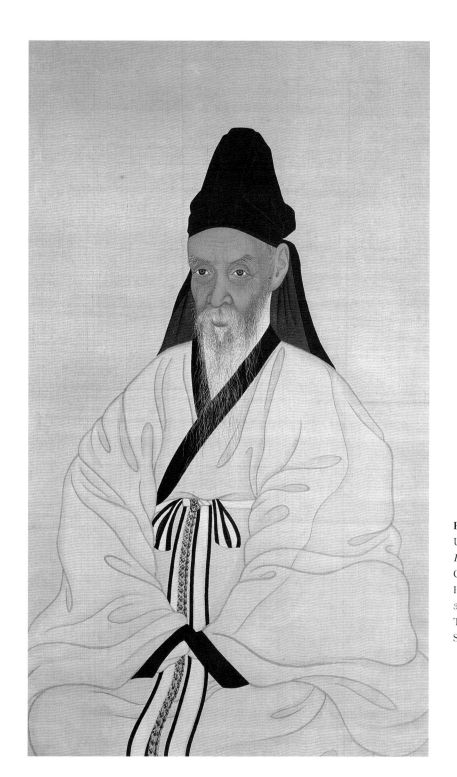

**Plate 91**
Unidentified artist (18th century)
*Portrait of Yi Chae* (1680–1746)
Chosŏn dynasty (1392–1910)
Hanging scroll, ink and color on silk,
38 ¼ × 22 ⅛ in. (97.2 × 56.3 cm)
The National Museum of Korea,
Seoul

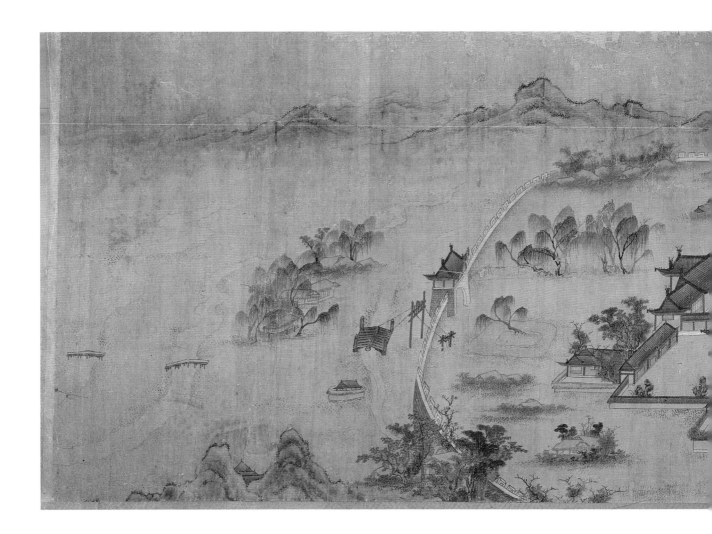

## Plate 92

Artists in the Chosŏn royal painting academy were required to be versatile: they painted portraits of the royal family and court figures, produced paintings for presentation to foreign envoys or to the courts of neighboring countries, and commemorated in painting such events as coronations, military processions, and ceremonies. The latter in particular provide colorful evidence of court life and governmental structure as well as of stylistic developments in the painting academy.

These professional painters were also often included in official missions to Japan and China. Han Si-gak, for instance, a painter and instructor in the academy, accompanied a Chosŏn diplomatic mission to Japan in 1655. Known as a figure painter, he also proved himself to be an able landscape painter. This painting demonstrates both his ease in combining these different genres and his skill in the highly demanding and technical style of architectural drawing known as *kyehwa* (Ch. *jiehua*), or "ruled-line" drawing. The subject of the painting is a special examination for the two branches of government, held in Hamgyŏng Province (in present-day North Korea). In the second section of the scroll (pp.200–201), civil service candidates, who were tested on their knowledge of Confucian rituals and texts, have gathered in a courtyard to attend a memorial ritual that includes standard-bearers and musicians. A sharp compositional contrast to the decorum of this scene is the vigor and movement of the mounted archery exam for military candidates, shown in the first section (above). A raised red flag indicates a candidate has succeeding in hitting the first of his targets; judges, attendants, and other competitors await his next shot.

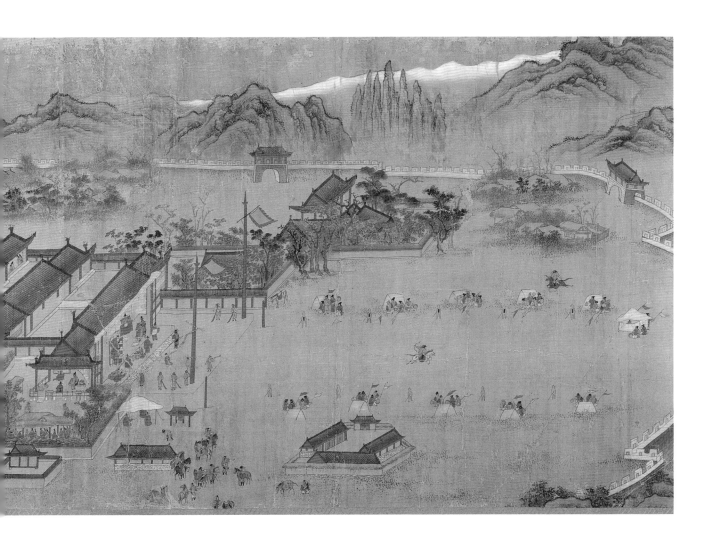

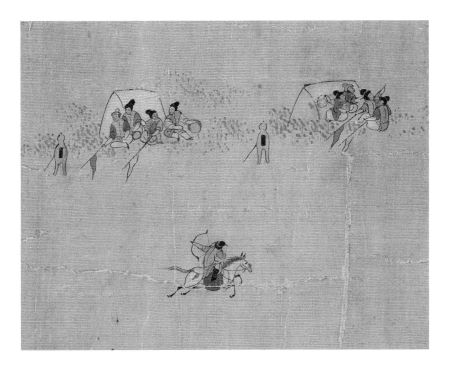

**Plate 92**
Han Si-gak (b. 1621)
*Special National Examination for Applicants from the Northeastern Provinces*
Chosŏn dynasty (1392–1910), second half of the 17th century
Handscroll, ink and color on silk, 22 ¾ × 265 ½ in. (57.9 × 674.1 cm)
The National Museum of Korea, Seoul

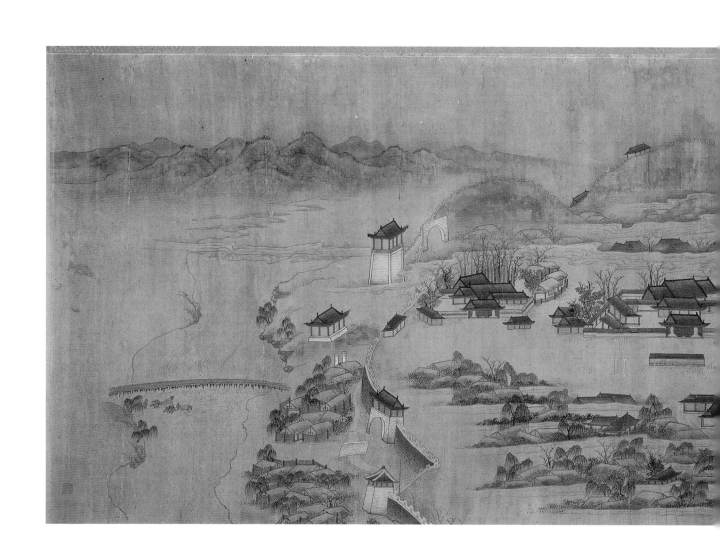

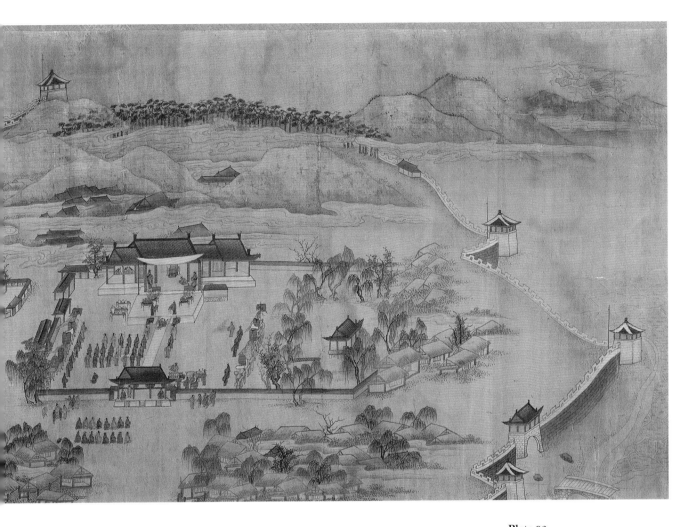

**Plate 92**
Han Si-gak (b. 1621)
*Special National Examination for*
*Applicants from the Northeastern*
*Provinces*

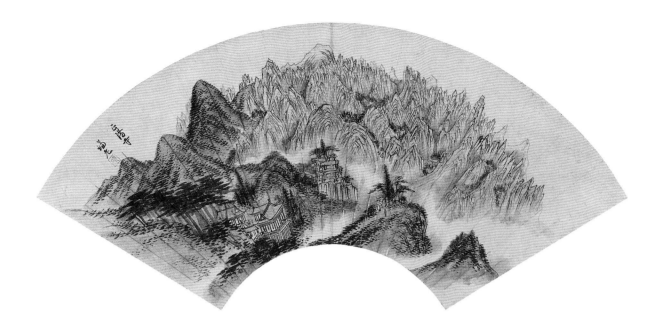

## Plates 93 – 96

Chŏng Sŏn, one of the most important painters of the eighteenth century, synthesized in his long career diverse art-
istic sources into a style of great originality and individuality. His innovations and range are evident in his numerous
depictions of Mount Kŭmgang, a celebrated mountain range in Kang'wŏn Province. In addition to many overall
views of the region, he produced a number of small scenes depicting famous sites at this popular destination, includ-
ing Chŏng'yang-sa Temple (pl. 93). A Chinese subject, Mount Lu, in Jiangxi Province (pl. 94), was thought to be a
dwelling place for immortals and was a classical literary and artistic subject in Korea as well as China. Following this
tradition, Chŏng included two lines of poetry in his inscription to his painting: "The great pines in dense groves like
soldiers in ranks / The furious waterfall plunges with the sound of ten thousand horses." The brushwork delineating
the sheer cliffs conveys the sense of speed and urgency remarked on in his inscription, and its mature confidence sug-
gests that this undated painting is a later work.

As a major exponent of true-view landscape painting (*chin'gyŏng sansuhwa*), which advocated using native Korean
scenery as the subject of landscape painting, Chŏng Sŏn most often portrayed sites in Korea famous for their natural
beauty. *Pure Breeze Valley* (pl. 95), which records one of his favorite sites in the capital city (modern Seoul), is remark-
able for the dark, saturated ink that describes the whitish rock face of the mountain. This dramatic style is also used
in his *Three-Dragon Waterfall at Mount Naeyŏn* (pl. 96), a site in North Kyŏngsang Province, where Chŏng served as a
magistrate from 1732 to 1738. In his inscription to the painting, Cho Yŏng-sŏk (1686–1761), a well-known scholar-
painter and Chŏng Sŏn's close friend and neighbor, declares that he was only able to appreciate the mountain after he
saw Chŏng's painting.

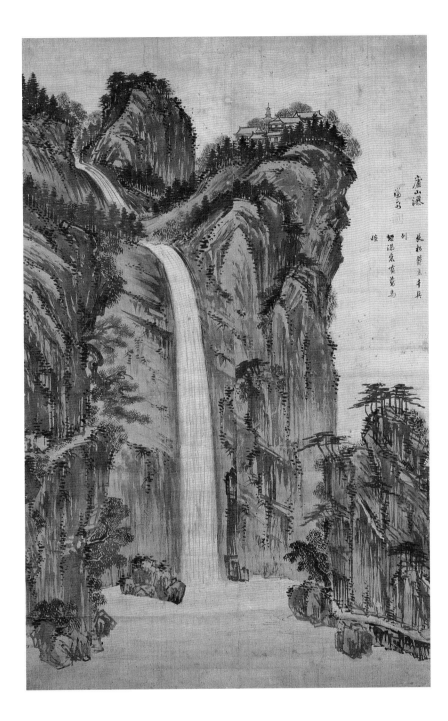

長板飛玄千兵

烈

廬山瀑

飛瀑窚寬萬馬

喧

Plate 93 (facing page)

Chŏng Sŏn (1676–1759)

*Chŏng'yang-sa Temple*

Chosŏn dynasty (1392–1910)

Fan mounted as a hanging scroll,

ink and light color on paper,

9 × 24 ¼ in. (22.7 × 61.5 cm)

The National Museum of

Korea, Seoul

Plate 94

Chŏng Sŏn (1676–1759)

*Waterfall at Mount Lu (Yŏsan)*

Chosŏn dynasty (1392–1910)

Hanging scroll, ink and light

color on silk, 47 ½ × 25 ¼ in.

(120.7 × 64.2 cm)

The National Museum of

Korea, Seoul

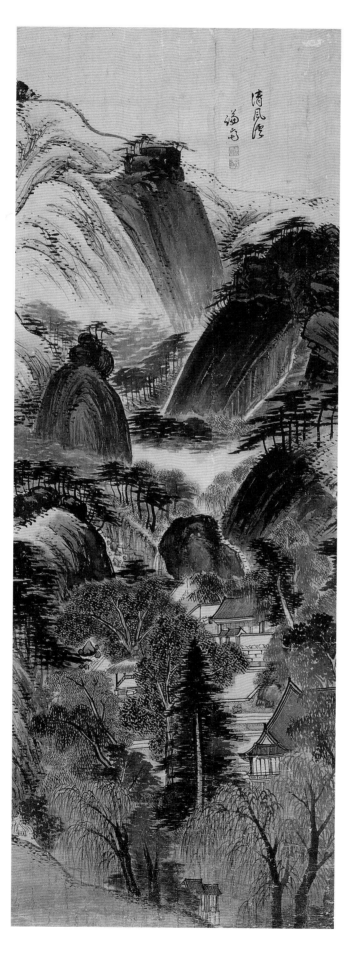

清風溪
謙齋

**Plate 95**
Chŏng Sŏn (1676–1759)
*Pure Breeze Valley*
Chosŏn dynasty (1392–1910)
Hanging scroll, ink and light color
on paper, 38 × 14 ¼ in. (96.1 × 36 cm)
Korea University, Seoul

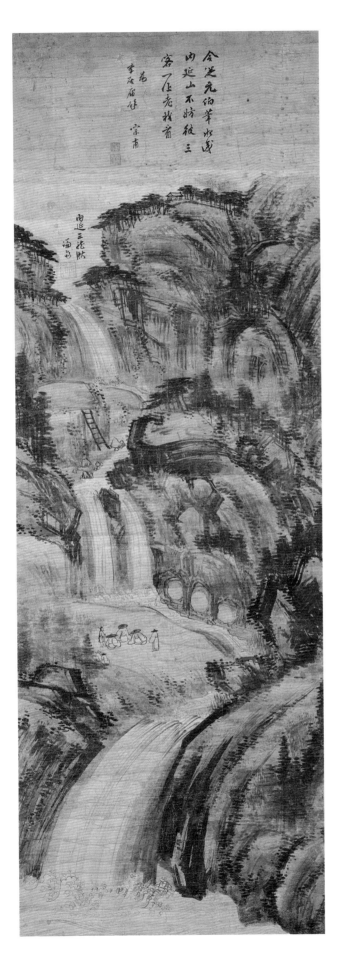

今送元伯掌水漁
内延山不防彼三
客庄老我有
右
李在府任　宗甫

內延三花畎
滿旬

**Plate 96**
Chŏng Sŏn (1676–1759)
*Three-Dragon Waterfall at
Mount Naeyŏn*
Chosŏn dynasty (1392–1910),
first half of the 18th century
Hanging scroll, ink on paper,
53 × 22 ⅛ in. (134.7 × 56.2 cm)
Ho-Am Art Museum, Yongin

## Plate 97

Chŏng Su-yŏng painted these leaves during a six-month period in 1799, from sketches he had made during a trip to Mount Kŭmgang two years earlier. Part of an album illustrating major sites in the area of Mount Kŭmgang, they continue the tradition of true-view landscape painting established in the eighteenth-century. The two single-leaf illustrations show the Nine-Dragon Waterfall and the Snowy Spray [Cataract] Pond. The larger double-leaf compositions depict Manp'ok-tong (Ten-Thousand Waterfall Valley) and include an inscription on a large boulder at Manp'ok-tong by Yang Sa-ŏn (1517–1584, an itinerant explorer of the mountain range), which was one of the most popular sites at Mount Kŭmgang. This inscription, which reads "Pongnae P'ung'ak wŏnhwa dongch'ŏn," translates to "The summer and autumn transformations [of these mountains are like] the realm of the immortals." Pongnae (Ch. Penglai), the fabled island of the immortals, is an alternate name for Mount Kŭmgang in the summer, and P'ung'ak, or Autumn Foliage [Mountain], is another alternate name.

Chŏng drew on many sources for his artistic and intellectual interests. He was influenced by Korean models such as Chŏng Sŏn (see pls. 93–96), as well as important artists of the Chinese landscape painting tradition. These influences, however, are not prominent in his mature style, which emphasizes realistic description over stylistic references. Chŏng's great-grandfather, the *sirhak* scholar Chŏng Sang-gi (1678–1752), produced the first map of Korea with an accurate scale, and this family tradition of cartography and geography seems to have predisposed Chŏng Su-yŏng to an interest in the accurate depiction of landscape. This is evident not only in his painting style, but also in his inscriptions throughout the album, which, rather than the customary artist's poetic reaction to the scenery, describe, in a highly precise manner, the topography of the site shown, and its location with regard to other famous attractions.

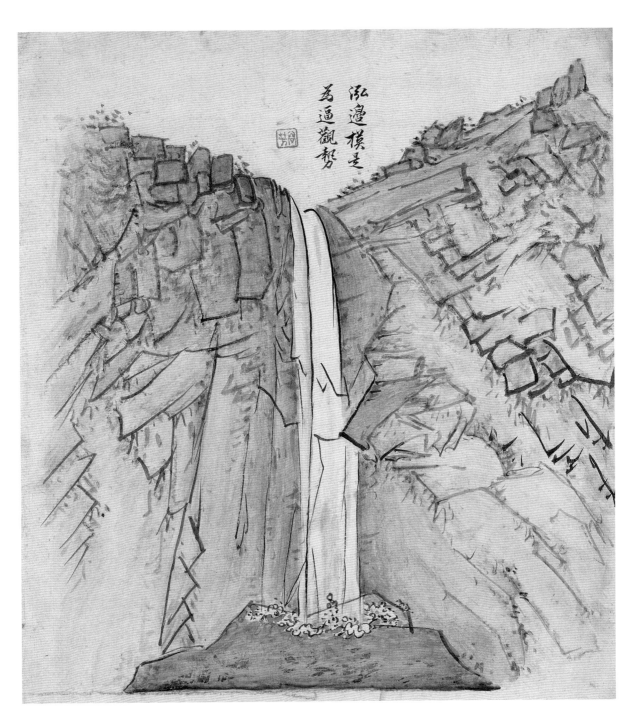

泓<br>邊<br>模<br>是<br>爲<br>逼<br>觀<br>勢

**Plate 97**
Chŏng Su-yŏng (1743–1831)
*Album of Sea and Mountains*
Chosŏn dynasty (1392–1910),
dated 1799
Six leaves from an album of 46
leaves depicting 26 scenes of
Mount Kŭmgang, ink and color on
paper, 12 × 13 ¼ in. (30.8 × 33.8 cm)
The National Museum of Korea,
Seoul

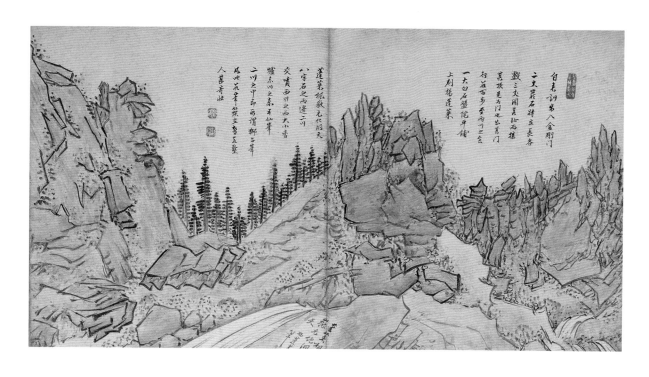

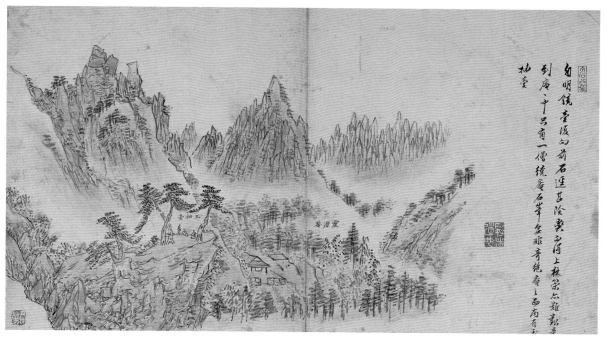

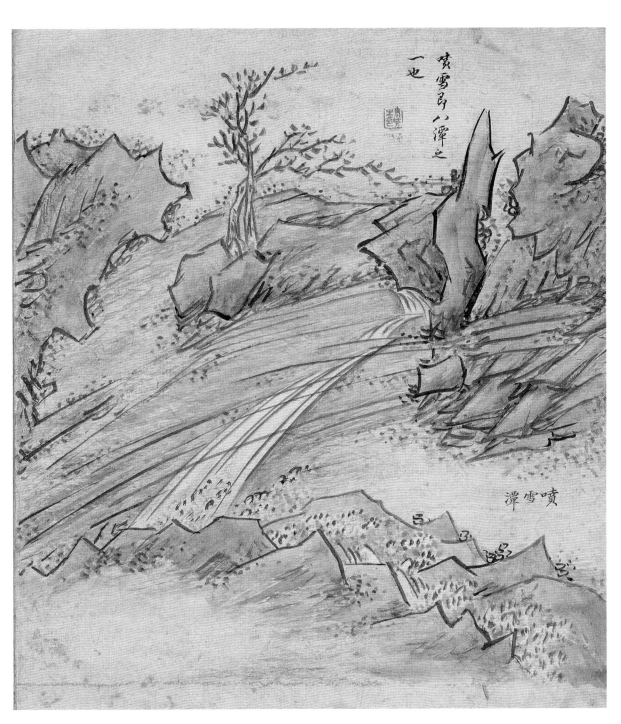

噴雪昻八潭之
一也

潭雪噴

**Plate 97**
Chŏng Su-yŏng (1743–1831)
*Album of Sea and Mountains*

## Plate 98

As part of the great intellectual activity and innovation in Korea during the eighteenth century, there was a renewed emphasis on the continuation and establishment of native traditions of philosophy, history, and, of course, art. One of the most important results of this emphasis was the flourishing of a unique tradition of genre painting, which is exemplified by a leading painter of the time, Kim Hong-do. Renowned for his versatility as well as his prodigious talent — among the subjects in which he excelled were landscapes, portraits, Buddhist and Daoist art, and paintings of plants and animals — Kim's genre paintings are humorous and lively.

Kim created numerous depictions of the daily life of all classes of Chosŏn society, leaving us an artistic legacy matched by few other artists, as well as an abundance of pictorial evidence for this period of Korean history. In this album, the most famous of his genre painting albums, Kim portrays various facets of village life with an unerring candor and sense of humor. Moments of work and leisure receive equal attention to detail: an industrious team of builders can be seen planing wood and tiling a roof; a dancer performs exuberantly to the accompaniment of a small troupe of musicians; and a group of woodcutters enjoys a break before taking up their heavily laden *chige*, or backpacks. Two wrestlers are avidly cheered on by all except the refreshments vendor, who has more important matters on his mind. Such lively, animated compositions demonstrate Kim's unique talent for sensitive observations of individual personalities and narrative detail.

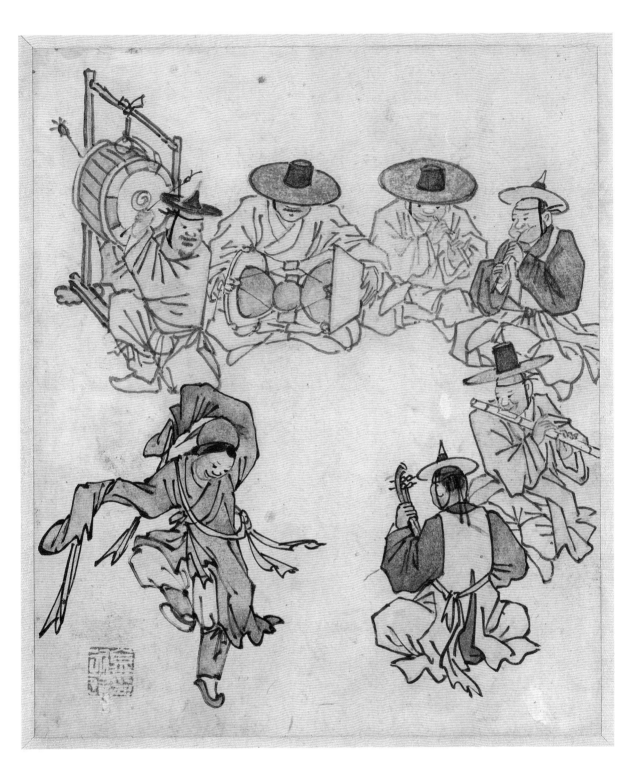

"Dancer and Musicians"

**Plate 98**
Kim Hong-do (1745–1806)
*Genre Paintings*
Chosŏn dynasty (1392–1910),
second half of the 18th century
Six leaves from an album of 25
leaves, ink and light color on
paper, 11 × 9 ½ in. (28 × 24 cm)
The National Museum of Korea,
Seoul, Treasure no. 527

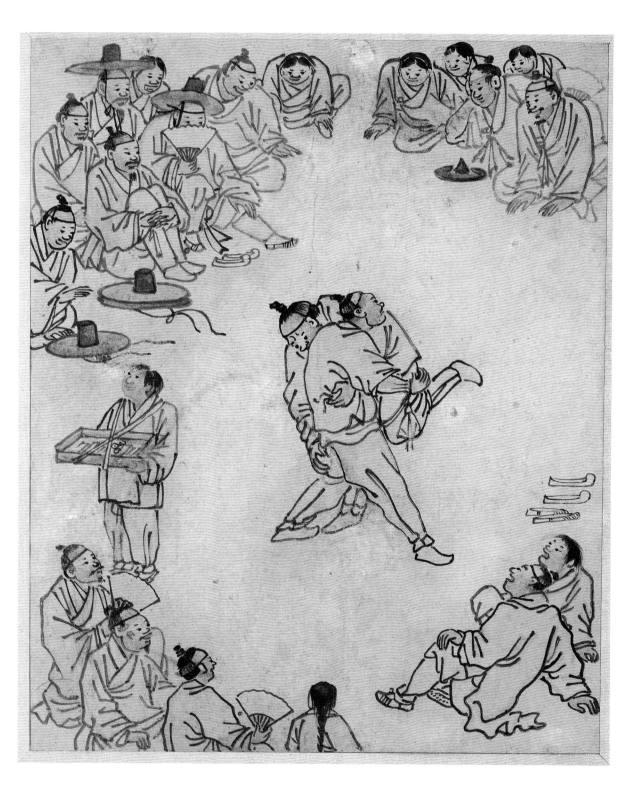

"Wrestlers"

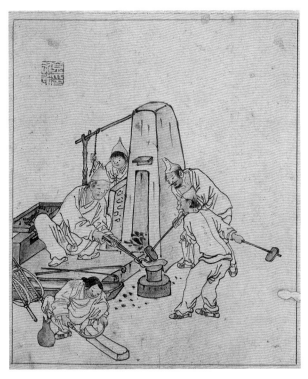

PAINTING

213

*Clockwise from top left:*
"Blacksmiths"
"Carpenters"
"Women Washing Clothes"
"A Game of Konu"

**Plate 98**
Kim Hong-do (1745–1806)
*Genre Paintings*

## Plates 99 and 100

Sin Yun-bok's genre paintings emphasize the overall atmosphere of a scene, an approach that suits the sensual air and luminous colors of his limpid, exquisitely detailed painting style. Solitude contrasts with sociability in two leaves showing scenes from everyday life. A woman walks on a street, her head and face modestly concealed behind a *ch'ŏne* cloak, her solitude emphasized by the stone wall beside which she strolls. In contrast, the two women on the road to market are engaged in lively conversation. Sin Yun-bok has chosen to emphasize their interaction by presenting them against an empty background, whereas the solitary nature of the woman walking is enhanced by the imposing stone wall that stands between her and the house beyond. These leaves, vastly different from the depictions of genteel and timid upper-class ladies or beautiful *kisaeng* courtesans for which he is best known, demonstrate Sin Yun-bok's distinctive compositional style and his ability to create vivid atmosphere.

More typical of his genre paintings is a depiction of a kisaeng enjoying a quiet moment with a reed instrument (Kr. *saenghwang*; Ch. *sheng*) and a long tobacco pipe. Her sprawled knees and careless hairdo create an effect of voyeurism, which enhances the eroticism of the lush garden filled with lotus flowers. Another painting in this vein is a portrait of a woman (pl. 100), probably a kisaeng, attired in the voluminous skirt and upper garment that make up the traditional Korean costume, between which a glimpse of skin is visible as she lifts her hands to adjust her elaborate hairdo. This provocative image is traditionally attributed to the figure painter Yun Tu-sŏ (1668–1715), but is probably the work of a slightly later artist.

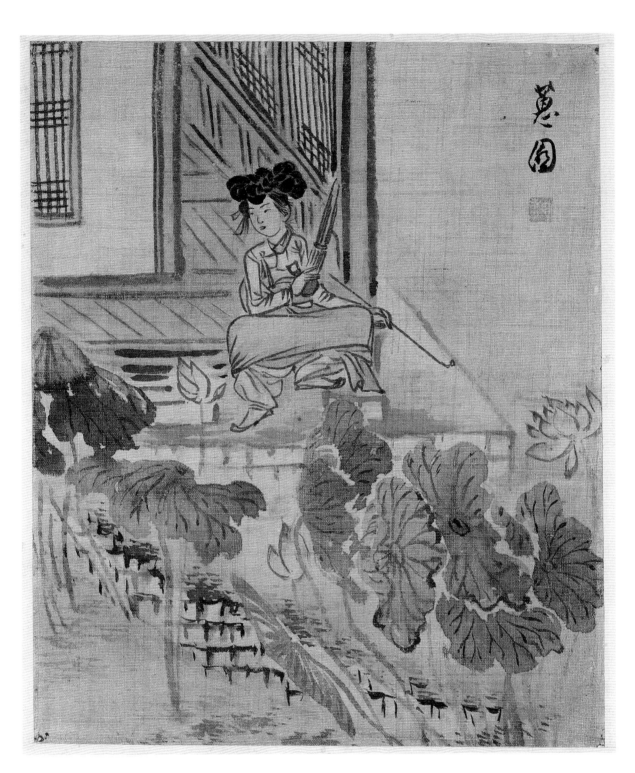

"Woman by a Lotus Pond"
Ink and light color on silk,
11 ¾ × 9 ¾ in (29.6 × 24.8 cm)

**Plate 99**
Sin Yun-bok (ca. 1758–after 1813)
*Genre Paintings of Women*
Chosŏn dynasty (1392–1910)
Three leaves from an album of 7 leaves
The National Museum of Korea,
Seoul

**Plate 99**
Sin Yun-bok (ca. 1758–after 1813)
*Genre Paintings of Women*

"Woman Wearing a Ch'ŏne Cloak" (left)
Ink and light color on silk,
10 ⅞ × 9 in. (27.7 × 23 cm)

"Market Road" (right)
Ink and light color on silk,
11 ¼ × 7 ½ in. (28.5 × 19 cm)

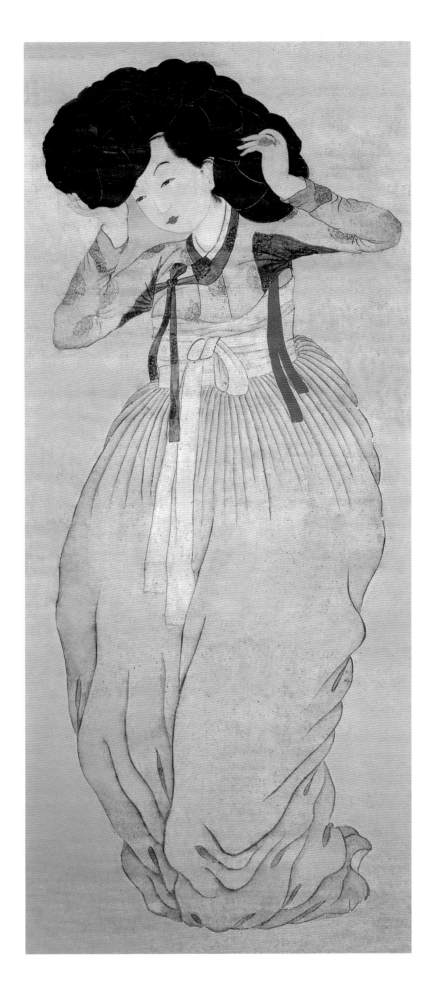

**Plate 100**
Unidentified artist (19th century),
traditionally attributed to Yun
Tu-sŏ (1668–1715)
*Standing Beauty*
Chosŏn dynasty (1392–1910)
Hanging scroll, ink and color on
paper, 46 × 19 ¼ in. (117 × 49 cm)
Yoon Hyung-sik Collection,
Haenam

Essays

Chung Yang-mo

The Art of the Korean Potter:
From the Neolithic Period to the Chosŏn Dynasty

Of all the arts of Korea, ceramics have received the most attention outside the peninsula. Long admired in China and Japan, and more recently recognized in the West for its achievements, the ceramic tradition is an enduring feature of Korean culture. Yet the study of Korean ceramics has tended to focus on specific types of wares, such as celadons of the Koryŏ dynasty (918–1392) or porcelains of the Chosŏn dynasty (1392–1910), at the expense of broader treatments of Korea's long tradition of ceramic production and the historical and cultural context in which the objects were produced. In Korea, as in many other cultures, ceramics, crafted from the clays of the earth, provide important insights into the artistic tastes of the people that made and used them and also reveal much about the influence of historical circumstances on the forms and designs of the objects themselves. Only when viewed in this historical and cultural context can the glorious achievements of Korean ceramics be understood and appreciated.

### NEOLITHIC PERIOD AND BRONZE AND EARLY IRON AGES

Modern archaeology has shed much light on the origins and civilization of the Korean people. Humans have inhabited the Korean peninsula from as early as the Pleistocene epoch, about 500,000 B C E.[1] By the Neolithic period, the inhabitants of the peninsula were primarily hunters, fishers, and foragers, living in small settlements of semi-subterranean, circular dwellings near rivers or coastal areas.

Pottery is one of the defining features of all Neolithic cultures. The earliest known Neolithic pottery in Korea has been dated to about 7000 B C E. The variety of shapes and decorative techniques of excavated wares reflects the diversity of material cultures of the Neolithic period and points to contacts between populations living in different areas of the peninsula as well as with those on the continental mainland and the islands that constitute modern Japan.

The earliest pots were hand-crafted of sandy clay and fired in open or semi-open kilns at relatively low temperatures of about 700° C. These porous, unglazed wares vary in shape according to the region from which they come. Vessels excavated from dwelling sites north of the Taedong River, in what is now North Korea, typically have a flat bottom and minimal or no decoration, while those unearthed south of the river, commonly known as comb-pattern earthenwares (*chŭlmun t'ogi*), have a coniform or round base and are decorated with incised linear patterns (pl. 1).[2] This difference is difficult to explain solely on the basis of archaeological findings, but it is possible that the material culture of the area in which early flat-bottomed wares were produced was influenced by people who inhabited Manchuria (the present provinces of Liaoning, Jilin, and Heilongjiang, in northeast China).[3]

The earliest decorated vessels, dating from 7000 B C E, were excavated at Yang'yang-gun, Osan-ni, in the central eastern province of Kang'wŏn (fig. 1). This type of vessel is decorated with designs in applied relief similar to those of vessels excavated on the coast of South Kyŏngsang Province and on Hŭksan Island, South Chŏlla Province, revealing that such vessels were common throughout areas along the southeast and southwest coast. Likewise, the upper levels of the site at Kang'wŏn also contained comb-pattern vessels of the southern type, further evidence of contact among settlements in different areas of the peninsula.

While wares with relief or applied-relief decoration are not uncommon, the so-called comb-pattern vessels occur throughout the peninsula during the Neolithic period,[4] although they are especially concentrated in the western and southern coastal regions. These vessels are decorated with patterns of diagonal lines that were incised into the damp clay, perhaps with a comb-like implement, before firing. They are found alongside other kinds of earthenware, such as bowls with linear relief decoration (fig. 2), and chipped and polished stone tools of various types.

Comb-pattern wares are considered the most representative type of ceramics from Korea's prehistoric period, as much for their arresting visual presence as for their widespread production. The example illustrated in plate 1 was excavated from Amsa-dong, a site along the sandy banks of the Han River in modern-day Seoul that dates from as early as 5000 B C E. Its main decorative motif is a herringbone pattern, frequently found on comb-pattern wares. The bands of short diagonal lines encircling the rim are also typical of this type of pottery. The many archaeological layers at Amsa-dong attest to a long and continuous history of human habitation at this site. Domesticated crops, such as various

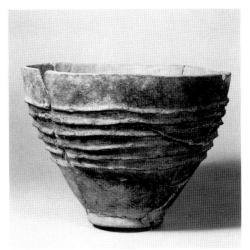

**Figure 1.** Bowl, early Neolithic period, ca. 7000–5000 B C E, from Yang'yang-gun, Osan-ni, Kang'wŏn Province. Earthenware with applied-relief design, h. 4 ⅞ in. (12.4 cm). Dong'a University Museum, Pusan

**Figure 2.** Bowl, Neolithic period, ca. 7000–5000 B C E, from Yang'yang-gun, Osan-ni, Kang'wŏn Province. Earthenware with linear relief decoration, h. 6 ⅝ in. (16.7 cm). Seoul National University Museum

kinds of millet-like grains, seem to have supplemented the marine diet of riverine and coastal Neolithic settlements, and large jars, like the one shown here, may have been used for storage of grains.[5] In the central and western areas of Korea, the early comb-pattern vessels are decorated from the base to the rim with bands of different incised designs, including the herringbone pattern. Use of decoration, however, diminishes over the centuries, so that by the Bronze Age, the vessels are entirely without decoration. In the southern area of the peninsula, the decorations initially are limited to the rim, then expand to cover the entire exterior of the vessel, and finally, in a reversal of the trend, disappear.

Migration into the Korean peninsula from neighboring regions in Manchuria and Siberia intensified in the Bronze Age. Bronze technology and rice cultivation were both introduced to Korea around the tenth century B C E, most likely by agrarian peoples moving onto the peninsula from China during the late Shang (ca. 1600–ca. 1100 B C E) and Zhou (ca. 1100–256 B C E) periods. Bones of domesticated pigs found at sites dated to the Bronze Age are evidence of a growing reliance on animal husbandry as well. Beginning in about 1000 B C E a more complex social organization is indicated by increasingly elaborate burial practices. Dolmen tombs, formed of upright stones supporting a horizontal slab, are more numerous in Korea than in any other country in East Asia, and coincide with the introduction of bronze technology, as do other new forms of burial, such as cists (burial chambers lined with stone) and earthenware jar coffins.

The influx of different populations into the Korean peninsula during the Bronze Age also led to wide regional variations in the material, shape, and function of ceramic wares.[6] Among the diverse forms of vessels from this period, red wares, black wares, and painted wares are thought to have been used for ceremonial or ritual purposes. Footed vessels, almost all of which come from tombs (fig. 3), were first produced during the later part of this period and the beginning of the Iron Age, in the third to second century B C E. It has

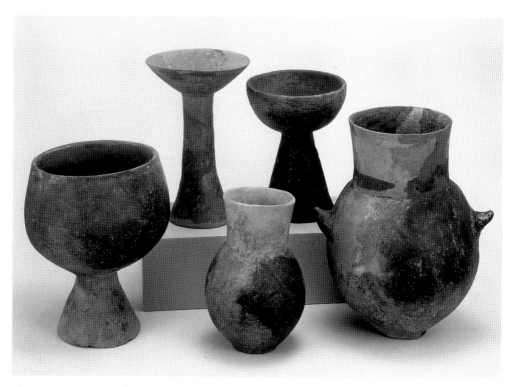

**Figure 3.** Footed vessels and flat-bottomed jars, early Iron Age, ca. 3rd–2nd century B C E, from a tomb at P'aldal-dong, Taegu, North Kyŏngsang Province. Earthenware, h. of jar on right, 11 ⅛ in. (28.3 cm). The National Museum of Korea, Seoul

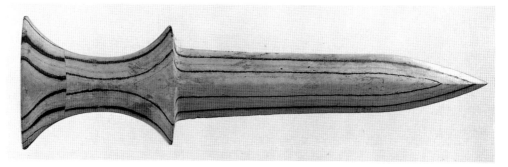

**Figure 4.** Stone dagger, late Bronze Age, 5th–4th century B C E, from Chindong-ni, Wich'ang-gun, South Kyŏngsang Province. Stone, l. 10 ⅞ in. (27.5 cm). Kyŏngju National Museum

been suggested that they may be native ceramic interpretations of the Chinese bronze *dou*, a covered ritual vessel with a shallow bowl and a high foot that was first produced in the late Western Zhou period (ca. 1100–771 B C E). Utilitarian versions of this form occur in earthenware, lacquer, and wood, but everyday objects and ritual objects are for the most part quite different in shape and quality of material, a reflection of an increasingly complex belief system that included elaborate burial rites and specialized funerary objects. The more complex social hierarchy that developed from the earlier Neolithic culture is also discernible in the styles of tombs and types of tomb furnishings. It seems that the most powerful class in this society was represented by shamans and priests. Shamans' tombs contain numerous bronze objects, including rattles and mirrors (see pl. 41), that may have been used as ritual implements, as well as such bronze weapons as swords and spears. The numerous stone scythes, adzes, and other farming implements found at resi-

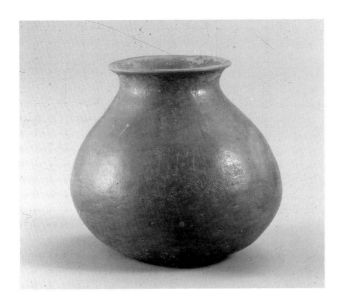

**Figure 5.** Jar, late Bronze Age, ca. 6th century B C E, from Sanch'ŏng-gun, South Kyŏngsang Province. Earthenware, burnished red, h. 5 in. (12.8 cm). The National Museum of Korea, Seoul

dential sites indicate that by the late Bronze Age agriculture was sufficiently well developed on the Korean peninsula to support a privileged ruling class. Stone tool technology is much more refined by this time, and tombs have yielded polished stone swords and daggers of striking beauty that are thought to have been used for ritual purposes (fig. 4). These delicate and brittle weapons show no signs of having been used in combat.

The base clay of Bronze Age pottery varies considerably in composition: coarse clays are often mixed with large quantities of sand or steatite to make strong utilitarian vessels, whereas very fine clays are used for ritual objects or luxury goods. The round-bottomed or conical-shaped vessels of the Neolithic period for the most part disappear and are replaced by yellowish- or reddish-brown flat-bottomed vessels bearing little or no decoration.[7] From about the sixth century B C E we find burnished red wares that appear to have been produced primarily for ceremonial purposes (fig. 5). This kind of ware, made of an iron-rich clay, typically has a bulbous shape and flared rim, and is characterized by a smooth, lustrous surface and rich red color. The red color and sheen are produced by applying an iron-rich pigment, such as ochre, to the vessel and then burnishing the object before firing. Until recently, burnished red wares had been excavated only from stone cist or dolmen tombs. However, the latest excavations of residential sites in Hŭnam-ni and Yŏju, in Kyŏnggi Province, and Songgung-ni, in the city of Puyŏ, have uncovered burnished red wares in such utilitarian forms as rice bowls, cups, and footed cups. Like the small jars found in tombs, these are made of finer clay and have thinner walls than flat-bottomed undecorated wares, and were probably intended for ritual use. Burnished black wares in various shapes have also been found in tombs dating from the fourth to third century B C E, but in fewer numbers than the red wares. These vessels were formed of refined clay, painted with a pigment containing powdered black lead, and then fired.[8]

The eggplant-pattern jars of the Bronze Age, similar in shape to many burnished red wares, have rounded bodies and short, flaring rims (pl. 2). These jars have on their shoulders the dark gray and brown elongated patterns that give this type of ware its name. The

clay used for these vessels is grayish white in color and of very fine texture. Their bold decoration, achieved by applying colored pigment directly on the clay body, evidences a radically different decorative approach from the incised and applied-relief wares of the Neolithic period. Found only in Kyŏngsang and Chŏlla provinces in the southern part of the peninsula, these striking wares appear to be confined to dolmen or stone cist tombs, with the exception of a few examples excavated from the residential site of Taep'yŏng-ni, in Chinyŏng County, South Kyŏngsang Province.

From the early Iron Age, in about the third century B C E, until the emergence of confederated kingdoms in the first to third centuries C E, the Korean peninsula underwent further important social and cultural changes, in part provoked by the unification of the various Chinese states beginning in the Warring States period (481–221 B C E) and culminating with the unification of China under the Qin (221–206 B C E). The subsequent Han dynasty (206 B C E–220 C E) in particular had a great impact on the Korean peninsula: the four commanderies established north of the Han River in the first century B C E played a major role in the dissemination of Chinese culture in Korea. The largest and longest-lasting of these was the Lelang commandery, centered at the present-day capital of North Korea, P'yŏng'yang. It was established in 108 B C E and incorporated by the kingdom of Koguryŏ in the year 313, long after the disintegration of the Han dynasty in China. These commanderies brought Korea into the Chinese cultural sphere, and it is in this period that references to the eastern "barbarians" appear in Chinese historical sources.[9] In the area south of the Han River, three new tribal federations, known as Pyŏnhan, Mahan, and Chinhan, were established as a result of the restructuring of the state of Chin. From these were to emerge the Kaya Federation and the powerful kingdoms of Paekche and Silla, which, along with the Koguryŏ kingdom in the north, formed Korea's first centralized aristocratic states.

It is not yet clear when iron technology first appeared in Korea, but it seems to have been widespread by 300 B C E. It was most likely brought from China, where iron had been cast from probably at least the sixth century B C E. The widespread use of locally mined and smelted iron in Korea extended to utilitarian tools for farming and carpentry. Mortuary and domestic architecture becomes more elaborate during this period, with the introduction of multichambered tombs and above-ground dwellings.

The ceramics of the Iron Age take on many diverse forms (fig. 3). Unlike the previous period, when clay objects were hand-built, the Iron Age saw the introduction of the potter's wheel. The earliest extant sculptural forms also date from this period, as seen, for example, in an imposing bird-shaped vessel of the late second to the third century (pl. 3).

### THREE KINGDOMS PERIOD

In the first century B C E powerful tribal clans on the Korean peninsula began to coalesce into what would eventually become three centralized aristocratic states. By the third century C E, royal houses and aristocratic families of the kingdoms of Koguryŏ (37 B C E–

668 CE), in the north, Silla (57 BCE−668 CE), in the southeast, and Paekche (18 BCE−660 CE), in the southwest, had begun to consolidate their dominance over their respective societies.[10] A small group of city-states known as the Kaya Federation (42−562 CE) occupied land between Silla and Paekche, but never became a centralized state. The Kaya were eventually conquered by Silla in 562 as part of its campaign to unify the peninsula, which was accomplished in 668. During much of the Three Kingdoms period, China was undergoing a period of political upheaval, following the fall of the Han dynasty in the early third century. Each of the three kingdoms vying for power on the peninsula sought to strengthen its position through alliances with the contending states on the Chinese mainland.

Koguryŏ, the largest of the three kingdoms, expanded its territory northeast into Manchuria, and at the height of its power in the fifth century controlled over two-thirds of the Korean peninsula. Encounters with the Chinese were inevitable, and frequent border clashes took place between Koguryŏ and the northern kingdoms of the Six Dynasties (220−589) as well as the subsequent Sui (581−618) and Tang (618−907) dynasties. Indeed, only Koguryŏ's tenacious resistance against Sui and Tang expansionism prevented Chinese conquest of the Korean peninsula. Despite these military engagements, Silla and Paekche also interacted with China, and, like Koguryŏ, willingly adopted elements of Chinese statecraft and Confucianism. Chinese writing, which had been introduced to Korea at about the same time as iron technology, was adapted to the Korean language using a system known as *idu*.

Buddhism also came to Korea from China, transmitted first to Koguryŏ, in 372, and then to Paekche, in 384. Silla was less receptive to the foreign religion, officially recognizing it only in 528. Both Buddhism and Confucianism were used by the royal houses as a means of consolidating their power and unifying their subjects. With its emphasis on loyalty to the sovereign and deference to elders and superiors, Confucianism proved particularly useful in these efforts. Buddhist deities were construed as protectors of the state, and the Buddhist clergy closely allied itself with state institutions, sometimes serving as political advisors. The influence of Buddhism on the artistic developments of this time is evident in the architecture and sculpture that survive (pls. 60−65).

Because of its technological and stylistic achievements, the stoneware of the Three Kingdoms period is crucial to an understanding of the Korean ceramic tradition. With the exception of Chinese stoneware, these are the earliest known high-fired wares in the world, requiring kiln temperatures of more than 1000° C. They were produced in a wood-fueled climbing kiln, a tunnel-shaped structure typically built up the side of a hill, which is ideal for producing intense and steady heat. Another advantage of this closed-kiln design, as opposed to the earlier open or semi-open kiln, is that the flow of oxygen entering the firing chambers can be restricted. The resulting "reducing atmosphere" is responsible for the characteristic gray color of Three Kingdoms ceramics, some of which, like the contemporaneous low-fired green-glazed wares, have accidental ash glazes. High-fired wares,

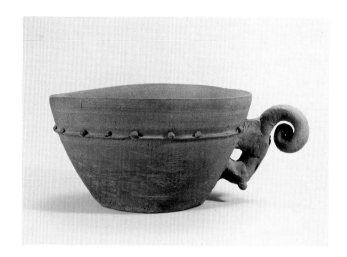

**Figure 6.** Cup with handle in the shape of an elephant, Three Kingdoms period, Paekche kingdom (18 B C E–660 C E), 6th century, from Sŏch'ŏn, South Ch'ungch'ŏng Province. Stoneware, h. 5 ⅛ in. (13 cm). Puyŏ National Museum

which are non-porous and suitable for storing liquids, were apparently in widespread use in Korea at this time, as tombs typically yield prodigious amounts of such wares. That this kind of ware was used in everyday life as well as in tomb burials is confirmed by their presence at such early Three Kingdoms residential sites as Siji-dong, in Taegu, North Kyŏngsang Province.

High-fired glazes mark another important development in ceramic technology in this period. At first accidentally produced by wood ash circulating in the kiln during firing, these earliest glazes were subsequently achieved by coating the clay bodies with ashes before firing or by fanning the ashes during firing.

A strong preference for sculptural forms is a characteristic feature of wares produced in the Kaya Federation, as seen in the bird-shaped vessel dating from the late second to the third century (pl. 3), which was probably a ritual wine cup. Animal-shaped vessels are more often found in Kaya tombs than in those of Silla or Paekche. The Kaya interest in sculptural forms is also evidenced by the double wine cup in the form of a mounted warrior (pl. 5), reportedly from the area of modern Kimhae, in South Kyŏngsang Province, and dating from the fifth to the sixth century. Both rider and horse are fully armored and prepared for battle. That a ritual vessel should take this form demonstrates the importance of the military in Kaya society. As a small association of city-states, Kaya depended upon a strong military to fend off attacks from the surrounding states of Silla and Paekche, as well as from the Japanese islands to the south and southeast. The faces of the mounted warriors in these Kaya vessels are reminiscent of the *haniwa* sculptures of the Japanese Kofun period (4th–6th century). Usually found on the *kofun*, or burial mounds, that give the period its name, haniwa sculptures take numerous forms, including figures of humans and animals and of objects such as boats. An even stronger link to the haniwa-producing Japanese states is a site in the area of the city of Kwangju, South Chŏlla Province, where a keyhole-shaped burial mound with similar, although smaller, haniwa-type figures has been excavated. Since the burial site dates to about the same time as the Japanese Kofun period, some scholars have suggested that it may be the progenitor of a tradition that was later greatly elaborated on in Japan; alternatively, the proliferation of

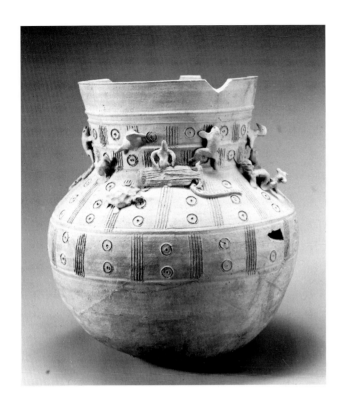

**Figure 7.** Jar, Three Kingdoms period, Silla kingdom (57 BCE–668 CE), 5th–6th century. Stoneware with incised design and applied figures of humans and animals, h. 13 ⅜ in. (34 cm). Kyŏngju National Museum

such sites in Japan may argue for a Japanese origin of a tradition whose influence is reflected in the Korean site.[11]

Of the three kingdoms, Paekche was the most receptive to influences from outside the peninsula, and its rulers were keenly interested in all things foreign and exotic. These influences can be discerned in some of the Paekche ceramics, such as a stoneware cup with an elephant-shaped handle (fig. 6), dating from the sixth century. Although less is known about this kingdom than its neighboring state of Silla, Paekche enjoys the reputation of having been the most sophisticated and refined of the three kingdoms. Situated in the southwest of the peninsula, with much of its territory extending along the coastline, Paekche maintained close ties to China across the Yellow Sea to the west and to the Japanese islands to the southeast. It played a pivotal role in the establishment of Buddhist art and culture in Japan during the Asuka period (538–645).[12] The loss of artistic treasures resulting from the almost total destruction of Paekche during Silla's wars of conquest in the seventh century is somewhat mitigated by the preservation in Japan of Buddhist art made by Paekche artisans.[13] Also, because of the way they were constructed, Paekche tombs were easily plundered, in contrast to the virtually impenetrable Silla tombs, many of which have survived intact. What remains of Paekche art offers tantalizing glimpses into this cosmopolitan society. Architectural tiles, one decorated with the image of a grimacing monster (pl. 7) and two with landscape designs (pls. 8, 9), hint at the opulence of the now lost palaces of Paekche. These designs are some of the earliest known evidence of the development of pictorial art, particularly that of landscape painting, in Korea.

In contrast to Paekche, Silla was the most resistant to outside influences, as demonstrated by its late acceptance of Buddhism. It was the most culturally conservative of the

three kingdoms, and its art and architecture retained archaic elements well into the Three Kingdoms period, thereby providing secondary evidence of earlier traditions on the Korean peninsula. A large stoneware jar demonstrates the Silla approach to sculptural figures (fig. 7), which utilizes separately sculpted and applied figures of humans and animals. This decorative technique is also seen on Silla objects similar to the tall Kaya stand with sculpted animals (pl. 4), though Silla figures are rarely as prominent.

Given the geographical proximity and close contact between the two areas, the decorative techniques of Silla and Kaya are often difficult to distinguish, especially in the case of such frequently found objects as the large stoneware stands for round-bottomed jars that are thought to have been used for ceremonial purposes. The perforations on Kaya stands are usually rectangular in shape and aligned in vertical columns, as in plate 4, while those on Silla stands are typically triangular in shape and have a staggered configuration. There are also many examples of stands that fall between these two types (Pak, fig. 1). The stands, often adorned with geometric incised and stamped patterns, were probably used during rituals to commemorate the dead. The widespread use of such imposing objects reflects the increasingly lavish public displays of wealth and authority that were part of the aristocratic culture of the Three Kingdoms period.

### UNIFIED SILLA

Through a series of military and political moves, Silla achieved dominance over the Korean peninsula by the end of the seventh century. Its campaign of unification began with the defeat of the Kaya Federation in 562, after which an alliance with the Chinese Tang empire helped Silla to defeat the kingdoms of Paekche in 660 and Koguryŏ in 668. This termination of the internecine warfare among the three kingdoms meant that when the Tang moved to bring the entire Korean peninsula under its control, it was thwarted by Silla, now reinforced by the armies of the kingdoms it had conquered. Silla succeeded in securing control of the territory of Paekche and the southern part of Koguryŏ, and in 676 expelled the Tang forces from the peninsula. The northern part of Koguryŏ was split between a Tang protectorate and the new kingdom of Parhae (Ch. Bohai), founded by a former Koguryŏ general; Parhae's aristocracy was from Koguryŏ, but its subjects were indigenous Manchurians. It was in the territory controlled by Unified Silla (668–935), however, that Korean culture was to flourish, and it was Unified Silla's political and cultural legacy that was handed down to subsequent rulers of Korea.[14]

Consolidation of the three kingdoms under a single ruling house led to an increase in the wealth of the aristocracy. Kyŏngju, the capital of the former kingdom of Silla and the capital of Unified Silla, was a prosperous and wealthy metropolis. The new government supported Buddhism as the state religion and maintained close relations with Tang China and Japan through trade as well as diplomatic and scholarly exchanges. Buddhism's influence on the arts intensified during this period as the number of Buddhist adherents increased and the religion began to permeate all aspects of life. In fact, some of the most

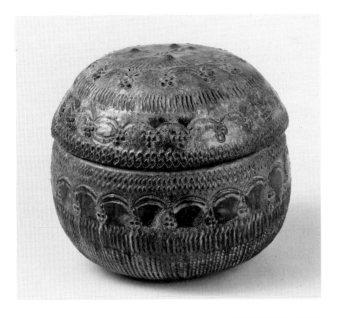

Figure 8. Funerary urn. Unified Silla
(668–935), ca. 8th century, from
Kyŏngju, South Kyŏngsang Province.
Stoneware with stamped decoration
and greenish glaze, h. 6 ½ in. (16.5 cm).
The National Museum of Korea,
Seoul. National Treasure no. 125

Figure 9. Funerary urn with granite
container.

refined and sophisticated Buddhist art and architecture in East Asia was produced in Korea during this period. The constant flow of Korean travelers to China, and the occasional intrepid pilgrim to India, contributed to a growing receptivity to foreign ideas, including Confucian philosophy and education, which continued to flourish under the rulers of Unified Silla.

The impact of these intellectual and political influences is evident in the art and architecture of the Unified Silla period, which show unprecedented beauty in their harmonious balance and their refinement in proportion and line; ceramics are no exception to this aesthetic and technical excellence. Whereas the earlier hand-crafted ceramic vessels of the Bronze and Iron Ages were indebted to the hard profiles of the costly metalwares that they were probably meant to imitate, Unified Silla pottery displays greater exploration of the malleable qualities of clay when thrown on a wheel. A funerary urn (fig. 8) protected by an outer granite container (fig. 9) demonstrates in its decoration a strong tendency to associate religion with nature. Funerary urns were used to hold cremated remains, following Buddhist custom, but their stamped and incised designs rarely contain explicit Buddhist references. They are instead decorated with secular designs such as clouds, birds, and flowers, as seen on this example.

This urn is also a representative example of Unified Silla developments in ceramic technology. Such a greenish lead-glazed urn would have been fired twice. The first firing, a biscuit firing, was at a high enough temperature to mature the body. The object was then covered with a lead glaze, which requires firing at a lower temperature. Double-fired wares are found as early as the seventh to the ninth century in Korea, although they are relatively rare, and represent a different technology from wares that are given a single, high-temperature firing. Chinese wares of the Tang dynasty with monochrome or polychrome lead glazes first appear in Korea during the early Unified Silla period and might have inspired the Korean lead glazes. Moreover, Chinese celadons have been found in Korea from the fourth to the fifth century. Although celadon wares were not made in Korea at this time, during the late Unified Silla period, in the first half of the ninth century, the peninsula established closer contacts with the Chinese coastal province of Zhejiang, where Yue celadons were manufactured; by the second half of the ninth century, celadons were produced in Korea all along the southwest coast.

Other evidence of the response of Unified Silla potters to foreign influences can be observed in the stoneware bottle with a flattened side (pl. 10), which seems to be a reference to the flasks used by nomadic horsemen in the northern regions of the continental mainland. Central Asian and Near Eastern influences are also evident in the floriate decorative motifs of such architectural elements as roof, roof-end, and floor tiles (fig. 10).

## KORYŎ DYNASTY

Beset by power struggles between the court and the aristocracy, Unified Silla went into decline in the late eighth century. The rise of local military garrisons and landed gentry families in the countryside, along with increasing unrest among the peasants, led to a steady deterioration of the social fabric. Rebel movements gradually encroached upon government authority, and in 901 a Silla prince who had been ousted during the political struggles proclaimed the establishment of a new state, the Later Koguryŏ. He was succeeded in 918 by Wang Kŏn (r. 918–43), who assumed control over Silla and Later Paekche (founded in 892) and united the peninsula under a new dynasty, which he named Koryŏ. In 926 the northern kingdom of Parhae fell to Khitan invaders, founders of the Liao dynasty (916–1125), in northeast China. The Parhae aristocracy, descendants of the old Koguryŏ ruling house, took refuge with the Koryŏ court.

The spread of Confucianism during the Unified Silla period continued unabated under the new Koryŏ dynasty. However, despite the state's commitment to the principle of rule by civil officials in accordance with Confucian doctrine, the hereditary privileges of the aristocracy were preserved to a great degree. Buddhism, especially the meditative Sŏn (Ch. Chan; Jp. Zen) school that had been introduced to Korea during the latter part of the Unified Silla period, grew in popularity and was a major creative force in the arts. Since regular contacts with Japan and China included the exchange of religious as well as secular art, many Koryŏ Buddhist paintings are preserved today in Japan. The vogue for

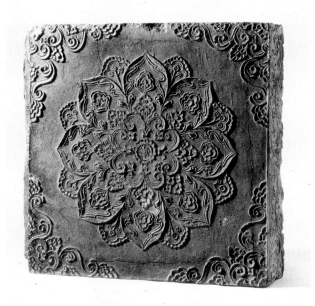

**Figure 10.** Architectural tile with floral medallion, Unified Silla (668–935), dated 680. Stoneware, 12 ⅜ × 12 ½ in. (31.5 × 31.7 cm). Kyŏngju National Museum

Chinese culture permeated every aspect of Koryŏ court life, even though relations with the mainland were not always friendly. In the northern part of the peninsula, Koryŏ engaged in border struggles with the Khitan Liao, as well as the Jurchen, the former subjects of Parhae. The Jurchen founded the Jin dynasty in 1115, conquered the Khitan Liao in 1125, and two years later took the Northern Song capital of Kaifeng, forcing the Chinese court to relocate in the south. Koryŏ avoided invasion by the Jin only by becoming a vassal of the powerful state. Thereafter it maintained a delicate balance in its relations with the Jin (1115–1234) and the Chinese Southern Song court (1127–1279). Yet, Koryŏ clearly favored the Chinese over the Jin, who were considered barbarians by Chinese and Koreans alike.

The elegant, refined lifestyle of the Koryŏ court and aristocracy is clearly reflected in the arts of the period, which inherited and maintained the aesthetic sophistication of Unified Silla. Finely detailed bronzes (pls. 51–54), lacquerware (pl. 55), and ceramics intended as devotional objects reflect the increasingly personal nature of Buddhist religious expression. The technique of inlaying, first developed during this period, was fully exploited in various media. Examples are silver-wire inlay in bronzes (pls. 52, 53), mother-of-pearl and tortoiseshell inlay in lacquerware (pl. 55), and the black and white inlays in celadons (pls. 15–18). Koryŏ potters also embellished their celadon wares with incised, carved, and relief decoration (pls. 11–13), and developed and perfected the difficult technique of underglaze copper-red decoration (pl. 19).

The prototypes for Korean celadons are most likely Chinese Yue wares, first imported in the ninth century from Zhejiang Province in southeastern China, a region with which the peninsula had long conducted maritime trade. The characteristic color of this type of stoneware is the result of small amounts of iron present in the glaze, which turns jade green when fired in a closed kiln with a reduced flow of oxygen. The first celadon-produc-

ing kilns, built in the second half of the ninth century, are found only in the southwestern provinces (about ten kilns have been discovered so far). The wares produced by these kilns are very close to their Chinese prototypes, and it may be that Chinese potters came to Korea to assist the local potters in establishing their kilns.

In the tenth century, the Korean celadon industry began to assert its independence and establish its own special characteristics. Not only did the forms become more distinctive, but the glaze of the wares was also moving toward its special color and clarity. By the end of the eleventh century and the first half of the twelfth century, the celadon industry was flourishing, combining celebrated jade-green glazes, refined forms of great subtlety and grace, unique decorative techniques, and naturalistic designs. It reached its pinnacle in the mid-twelfth century. The main centers for production of high-quality celadon wares at the height of the Koryŏ celadon tradition were the official kilns in Kangjin County, South Chŏlla Province, and Puan County, North Chŏlla Province. The achievements of the Korean celadon industry made a singular impression on the scholar-official Xu Jing (1091–1153), a member of the entourage accompanying a Chinese envoy from the Northern Song emperor Huizong's court to Korea in 1123. In his account of the journey, *Xuanhe fengshi Gaoli tujing* (Illustrated Record of the Chinese Embassy to the Koryŏ Court During the Xuanhe Era), he remarked: "As for celadons, the Koreans call them 'kingfisher' colored [wares].... In recent years, their manufacture has been skilled [*qiao*] and, moreover, their color is beautiful [*jia*]."[15] Another Chinese author known only by his sobriquet, Taiping Laoren, compiled a list of objects that are "first under Heaven," probably about the same time as Xu Jing's account. Under the category of celadons he noted: "As for the 'secret color' of celadons, the 'secret color' of Koryŏ is first under Heaven. Although [potters of] other areas imitate them, none of them can achieve [the same qualities]."[16]

The decoration of celadon wares first occurs in the tenth century, beginning with incised designs. These incised designs — including floral scrolls, generally referred to in Korea as *tangch'omun*, or the "Tang grass pattern," and chrysanthemums — resemble the minimal decoration found on Chinese Five Dynasties (907–60) ceramics. This decorative style is seen on a bowl of the early tenth century with a design of floral sprays (fig. 11). The undecorated band at the rim of the bowl is characteristic of these early pieces, as is the use of the bowl's interior as a picture plane for an asymmetrical design. Early decorative motifs, as seen here, are very naturalistic and spontaneous, two qualities that remain characteristic of the designs on later incised and carved Korean celadon wares.

Beginning in the late eleventh century, new designs and compositions appear. On bowls, instead of the plain band around the rim, two decorated areas, along the rim and on the floor, frame the central decorative motif. The same development occurs in the ornamentation of bottles, where the subsidiary designs are applied to the shoulder and lower part of the bottle, and the main design to the body. This decorative scheme of central and framing designs became popular after the beginning of the twelfth century.

**Figure 11.** Bowl, Koryŏ dynasty (918–1392), early 10th century. Celadon with incised design of floral sprays, h. 1 ⅞ in. (4.8 cm). The Metropolitan Museum of Art, Gift of R.H. Macy and Co., 1919. 19.39.4

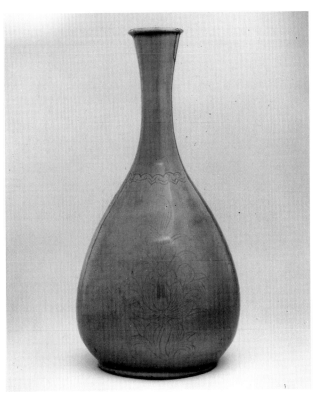

**Figure 12.** Bottle, Koryŏ dynasty (918–1392), early 12th century. Celadon with incised design of lotus flowers and floral scrolls, h. 12 ½ in. (31.8 cm). The Metropolitan Museum of Art, Gift of R.H. Macy and Co., 1919. 19.39.1

A celadon bottle with a long neck and gently rounded body (fig. 12) is an example of one of two typical bottle shapes of the twelfth century. Its decoration consists of incised lotus flowers and Tang-pattern floral scrolls, above which is a more deeply incised band consisting of shapes similar to the head of a *yŏŭi* (Ch. *ruyi*) sceptor. The other bottle shape is characterized by an everted rim, a somewhat longer neck, and a slightly fuller body. The example illustrated in figure 13 has an overall decoration of carved and incised bamboo stalks, which taper and merge subtly to accommodate the slim neck.

A combination of incising and relief carving was used to create the design on the gourd-shaped wine ewer (pl. 11) of water fowl among reeds, a motif that appears often on

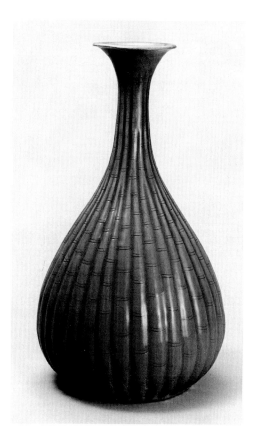

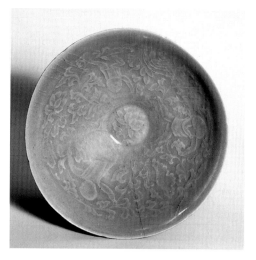

**Figure 13.** (left) Bottle, Koryŏ dynasty (918–1392), late 12th century. Celadon with carved and incised decoration of bamboo, h. 13 ¼ in. (33.6 cm). Ho-Am Art Museum, Yongin. National Treasure no. 169

**Figure 14.** (right) Bowl, Koryŏ dynasty (918–1392), early 12th century. Celadon with mold-impressed decoration of boys playing among lotus flowers and floral scrolls, diam. 7 ⅝ in. (19.4 cm). The Metropolitan Museum of Art, Gift of Sadajiro Yamanaka, 1911. 11.8.6

Koryŏ celadons of the twelfth and thirteenth centuries. The use of this and closely related ornamental themes on a variety of shapes and media reveals the Korean fascination with highly representational, intimate tableaux of the natural world that portray a sense of order in nature (see, for example, pls. 12, 14, 16, 52, 53). Similar developments in the contemporaneous Southern Song painting academy are a reminder that, despite political allegiance to the northern Jin dynasty, Korea had strong artistic and cultural affinities with Southern Song China.[17]

Although less frequently employed than other decorative techniques, mold-impressed decoration can be found on some celadons of the eleventh and twelfth centuries. Examples are a bowl with a design of three boys playing among lotus flowers and Tang-pattern floral scrolls (fig. 14) and a lobed dish decorated with fish, water birds, and lotus (pl. 14). In this method of shaping and decorating ceramics, the damp clay was thrown directly onto a convex clay mold affixed to the potter's wheel. The deeply carved design on the mold left a positive imprint on the interior of the bowl. Alternatively, low-relief and high-relief designs could be applied to the surface of an object (fig. 15; pl. 13).

Another kind of celadon ware has an inlaid decoration under the glaze. This technique, called *sanggam*, is unique to Korea and derives from metal inlay (pls. 52, 53) and inlaid lacquerware (pl. 55) as well as from the techniques of incised and carved decoration. Designs are carved into the clay body, and the resulting grooves filled with a white or black clay solution. The entire object is biscuit fired and then glazed and fired again, after which the inlaid design shows clearly through the typically crackled celadon glaze. The

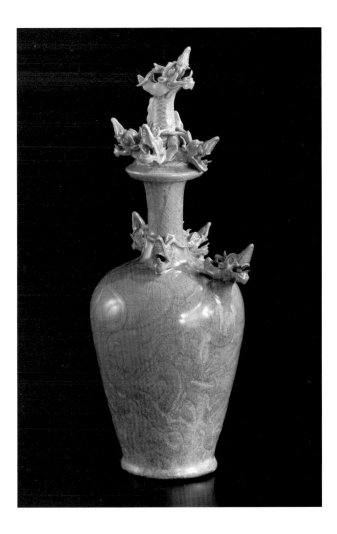

**Figure 15.** Bottle (*kundika*), Koryŏ dynasty (918–1392), first half of the 12th century. Celadon with carved, incised, and applied-relief decoration of dragons, h. 13 ¾ in. (33.5 cm). The Museum Yamato Bunkakan, Nara

successful adaptation of this inlay technique to celadons by Korean potters was made possible by the distinctive celadon glazes developed during the Koryŏ dynasty. Renowned for their color and luminous clarity, the glazes allow the decoration underneath to show through with exceptional sharpness. Koryŏ celadon glazes reached their culmination in the early twelfth century, attaining a subtle jade-green color without the impurities that hinder clarity and luminescence.

After a period of experimentation at the end of the tenth century, sanggam was fully developed by the early twelfth century, at the height of the Korean celadon tradition, when inlay became the most widely used method of decoration. By the mid-twelfth century, the Koryŏ glazes had already reached a point where their clarity and brilliance made celadons a natural vehicle for inlaid designs. In its initial phase, sanggam is usually used in combination with incised or deeply carved designs. Sanggam designs are found either on the interior or the exterior of objects, but never on both surfaces.

Early sanggam patterns are naturalistic, imitating the designs employed in early incised, carved, or applied-relief decoration of celadon wares. Widely spaced motifs of naturalistically depicted cranes, clouds, and flowers give way by the mid-twelfth century to more stylized decorative techniques, as seen in a melon-shaped ewer (fig. 16). Here, the "cut-flower" decoration is as interesting for the flow and rhythm of lines as for the realistic

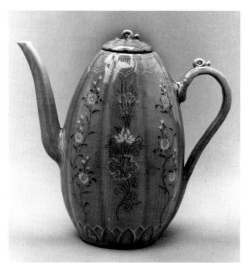

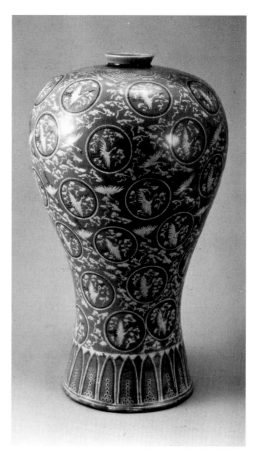

**Figure 16.** (above) Wine ewer, Koryŏ dynasty (918–1392), mid-12th century. Celadon with inlaid design of chrysanthemums and lotus flowers, h. 10 in. (25.4 cm). The Metropolitan Museum of Art, Rogers Fund, 1913. 13.195.1a,b

**Figure 17.** (right) Maebyŏng (prunus vase), Koryŏ dynasty (918–1392), mid-12th century. Celadon with inlaid design of cranes and clouds, h. 16 ⅝ in. (42 cm). Kansong Art Museum, Seoul. National Treasure no. 68

description of the flowers. It is a short step from this to the well-known inlaid celadon *maebyŏng* or prunus vase (fig. 17), with its entire surface covered with a design of cranes and clouds, parts of which are enclosed in uniformly spaced circles that form a textile like pattern. A later version of this motif, more loosely rendered, is found on a maebyŏng of the late thirteenth to the early fourteenth century (pl. 18). A fine example of the sanggam inlay technique is seen on a small dish dated to the second half of the twelfth century, probably from the Puan kiln, in North Chŏlla Province (fig. 18). The bees encircling the central medallion are inlaid in white, and their interior details and outlines enhanced with black inlay. In the so-called reverse inlay technique, developed during the twelfth century, the areas around the design are carved away and then inlaid in white to create the background, as seen in a small bottle embellished with a design of leaves (fig. 19).

Underglaze copper-red decoration on high-fired wares is also most likely an invention of Koryŏ potters, who had succeeded in producing this color early in the twelfth century. Copper oxide is the most difficult of the metallic oxides to control. If improperly fired, it can turn to a green or greenish-brown shade, or even dissipate. In order to achieve a good red color, the copper oxide must be fired in a reduced-oxygen environment. The color of copper-red decoration in Korean ceramics is exceptionally rich and strong. When it was first employed in Korea for the decoration of celadon wares, in the first half of the twelfth century, copper oxide was used as an underglaze pigment. This differs from the slightly later copper-red splashes found in the blue-glazed Jun wares of China, in which

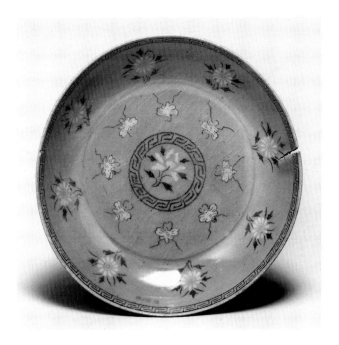

**Figure 18.** Dish, Koryŏ dynasty (918–1392), second half of the 12th century, probably from Puan, North Chŏlla Province. Celadon with inlaid design of bees and chrysanthemums, diam. 6 in. (15.2 cm). The Metropolitan Museum of Art, Rogers Fund, 1917. 17.175.16

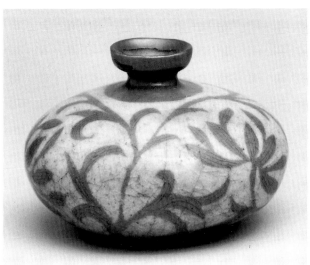

**Figure 19.** Bottle, Koryŏ dynasty (918–1392), late 12th century. Celadon with reverse inlaid design of leaves, h. 2 ¼ in. (5.7 cm), d. 3 ¼ in. (8.3 cm). The Metropolitan Museum of Art, Rogers Fund, 1917. 17.175.9

the copper pigment is in the glaze itself. In the twelfth to the fourteenth century copper red was used under the glaze in wares decorated in the sanggam technique to highlight and accentuate the design (pl. 19).

Another kind of Koryŏ ware classified as celadon has iron-oxide painting under the glaze. As opposed to the green tone of reduction-fired celadons, these underglaze iron-painted wares have a yellowish or brownish hue, the result of their having been fired in oxidation. The improvisatory decorations on these wares (pl. 20) recall the robust designs of contemporaneous Chinese Cizhou wares (fig. 20). Their decorative motifs, executed in bold and lively brushwork, seem infused with spontaneity (pl. 21). However rough they may appear at first glance, these wares are not the product of a tradition in decline, for they were produced at the same time as some of the finest green-toned celadons of the Koryŏ period. It is better to view them as illustrating one of several varieties of celadon wares produced at the Koryŏ kilns, most likely for a different category of consumers.

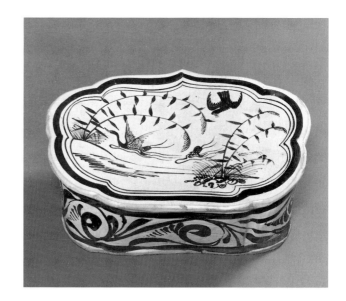

**Figure 20.** Pillow, late Northern Song-Jin dynasty, 12th–13th century. Cizhou ware, stoneware painted in brownish black on white ground, l. 16 ⅛ in. (41 cm). The Metropolitan Museum of Art, Gift of Ernest Erickson Foundation, 1985. 1985.214.132

An alternate use of iron oxide is seen in the so-called black wares of the Koryŏ celadon tradition (pl. 22). The entire unfired vessel is first coated with an iron slip, after which the decorative motifs are produced by carving the patterns of the design into the slip. The carved areas are painted with white slip, using a brush, before the celadon glaze is applied. The unevenly applied brushstrokes impart an impression of texture and volume.

The quality of celadons declined sharply around the second half of the thirteenth century, a result of the aggressive Mongol expansion that eventually led, in 1232, to the relocation of the Koryŏ court to the island of Kanghwa, off the western coast of the peninsula. For the next thirty years, Mongol forces ravaged the peninsula, in the process destroying many monuments and cultural treasures. In 1270, torn by internal power struggles and no longer able to depend on the devastated and demoralized peasant population for support, the Koryŏ government abandoned its resistance to the Mongols, commencing a long period of subservience as a vassal state of the Mongol Yuan dynasty (1272–1368) on the mainland. Koryŏ crown princes resided in the Yuan capital at Dadu (modern Beijing) until they ascended the throne, taking Mongol princesses for their queens; in some instances they retired to Dadu after ceding the throne to successors. This close contact with the Mongols is reflected in such objects as a thirteenth-century inlaid celadon vase with a design of a figure in a pavilion (pl. 17). The flattened sides of this vase are reminiscent of the shapes of nomadic vessels designed for easy transport on horseback. In addition, the ogival panels and simplified decorative bands of lotus petals at the top and bottom of the vase contain stylistic influences from earlier decorative traditions of Korean celadons as well as innovative elements that indicate a strong Yuan influence. Gilded and inlaid wares contemporaneous with this type of vase, such as a small covered jar (fig. 21), show a return to earlier Korean decorative patterns. Although they were produced in small numbers in Korea from at least the first half of the twelfth century, there are few extant examples of gilded celadons in Korea dating from before the time of Mongol domination. Since such objects were part of the regular tribute to the Yuan court, their

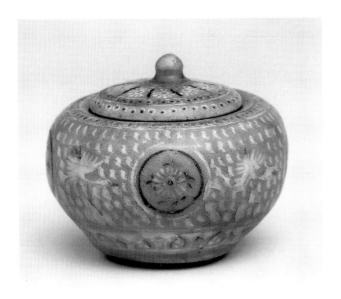

**Figure 21.** Jar, Koryŏ dynasty (918–1392), second half of the 13th century. Celadon with inlaid design of cranes and clouds and traces of gilding, h. 2 ½ in. (6.4 cm). The Metropolitan Museum of Art, Gift of Sadajiro Yamanaka, 1911. 11.8.4

production increased in the late thirteenth and fourteenth centuries, but declined sharply thereafter.

The rougher shapes, coarse clays, and impure glazes that characterize the last phase of celadon production in Korea reflect the economic and social decline in the final years of the Koryŏ dynasty, whose ravaged infrastructure in the wake of widespread Mongol looting could not sustain the luxury industry of fine celadons. The styles and decorative techniques of sanggam inlay designs become simplified, with hand-carved designs almost completely replaced by stamped designs or highly abbreviated forms of earlier motifs. For example, the intricately carved cloud pattern of the mid-twelfth century is reduced to a short dash (fig. 21). By the fourteenth century, many celadons are almost unrecognizable as having evolved from the delicate and elegant wares of the earlier tradition. These later wares are the starting point for the unique *punch'ŏng* wares of the Chosŏn dynasty.

## CHOSŎN DYNASTY

By the mid-fourteenth century, the Yuan dynasty had begun to deteriorate, gradually losing control in China as well as in its vassal state of Korea. In 1368 the Chinese rebel leader Zhu Yuanzhang (Hongwu emperor, r. 1368–98) successfully ousted the Yuan and established the Ming dynasty (1368–1644). In Korea, King Kongmin (r. 1351–74), the last authoritative ruler of the Koryŏ dynasty, adopted a pro-Ming policy and took action to suppress the powerful families who had benefited from cooperation with the Mongols. Although the reforms he instituted were popular among the population at large, including the newly influential *yangban*, or literati class, who dominated both the civil and the military branches of government, they were not completely effective; King Kongmin was ultimately assassinated and succeeded by a series of puppet kings.

In 1388 a weakened and divided Koryŏ court sent a military expedition to invade Manchuria, in response to a declaration by the Ming dynasty of its intention to claim the northeastern territory of Koryŏ. One of the expedition's commanders, Yi Sŏng-gye

(1335–1408), who had achieved renown for his expulsion of Japanese pirates terrorizing Korea's coastline, favored a pro-Ming policy and opposed the idea of the expedition. Leading his troops back to the capital at Kaesŏng, he seized control of the government. Yi Sŏng-gye then instituted sweeping land reforms that in effect destroyed the power of the elite families who had been the target of the earlier unsuccessful reforms of King Kongmin. With the support of the yangban, he also set out to undermine the authority and privileges of the Buddhist clergy, who were seen as inextricably bound to the corrupt and decadent Koryŏ court. In 1392, having consolidated his power and eliminated his rivals, Yi founded a new dynasty, which he named Chosŏn, after an ancient Korean kingdom that flourished in the fourth century B C E, and became its first ruler (King T'aejo; r. 1392–98).

The royal house of Yi was to rule Korea until the end of dynastic control in the early twentieth century. This new dynasty, with its capital at Hanyang (modern Seoul), strove to distance itself from the former Koryŏ court. The practice of Buddhism was discouraged, and official patronage of the religion severely curtailed in favor of increasing support for Neo-Confucian educational and governmental policies, based on the dominant school of Confucian philosophy and statecraft in China established by the Southern Song philosopher Zhu Xi (1130–1200). This systematic repression of Buddhist institutions, which were associated with the abuses of the late Koryŏ court, led to a sharp decline in the number of Buddhist adherents.

The commitment to Neo-Confucian thought was particularly widespread among the literati, whose fortunes at first improved considerably under the Chosŏn dynasty. The literati assumed the duties formerly fulfilled by the aristocracy and land-owning families of the Koryŏ. Though Korea's civil service examinations were ostensibly open to all educated males, in fact the vast majority of candidates were from the yangban, which had almost exclusive access to education. In 1446 the yangban monopoly on education was challenged with the introduction of an indigenous writing system, *Hunmin chŏng'ŭm* (Correct Sounds to Instruct the People), known today as *han'gŭl*. The only purely alphabetic system of writing in East Asia, it was devised by King Sejong (r. 1418–50) for the benefit of women and non-yangban men, who had no opportunity to learn classical Chinese, a language that took years to master but that was inadequate as a written system for the Korean language. The reign of Sejong, marked by important achievements in technology and the arts, was a high point of the early Chosŏn dynasty.

For much of the mid-Chosŏn period, in the late sixteenth and early seventeenth centuries, Korea was in political and intellectual turmoil. The country was the target of two major military campaigns, in 1592 and 1597, waged by the Japanese warlord Toyotomi Hideyoshi (1536–1598), which ravaged the peninsula. In 1636 Manchu armies, taking advantage of the weakened and disorganized Ming court in China, also launched an invasion of Korea, but with less damaging results than the war with Japan. The indecision and ineffectiveness of Ming troops during the Japanese invasions and the rise of the Manchus as

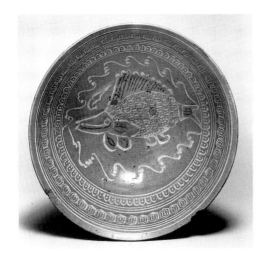

**Figure 22.** Bowl, Chosŏn dynasty (1392–1910), early 15th century, probably from Kyeryong-san kiln, South Ch'ungch'ŏng Province. Punch'ŏng ware with inlaid design of fish, diam. 7 ½ in. (19.1 cm). The Metropolitan Museum of Art, Anonymous Loan. L.1973.96.3

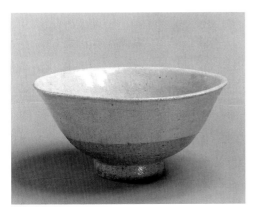

**Figure 23.** Bowl. Chosŏn dynasty (1392–1910), 16th century. Stoneware with white slip and clear glaze, d. 6 ¾ in. (17.2 cm). The Metropolitan Museum of Art, Gift of Mr. and Mrs. Michael Oliver, 1983 (1983.557.2)

a new regional power intensified the growing debate at the Chosŏn court about the role of Chinese culture in Korea. Some officials supported continued political and cultural loyalty to the Ming, whereas others advocated that the country abandon what was perceived as a slavish imitation of Chinese culture and concentrate instead on the development of indigenous institutions and traditions. Following the defeat in 1644 of the Ming dynasty and the establishment of the Qing dynasty (1644–1911) by the Manchus, the debate grew even more heated, with pro-Chinese factions arguing for the support of Ming loyalist movements and anti-Chinese factions pointing to the fall of the Ming as a vindication of their opposition to Chinese cultural dominance in Korea. By the beginning of the eighteenth century, those in favor of promoting an independent Korean culture prevailed at court, and as a result of their political, economic, and social policies, emphasis was placed on the encouragement of distinctive native traditions in the fine arts, literature, and the decorative arts.[18] The eighteenth century saw the rise of *chin'gyŏng sansuhwa*, or "true-view" landscape painting, whose subject matter was the scenery of Korea rather than classical themes of Chinese landscape painting that had previously dominated Korean painting.[19] The newly found confidence in Korean cultural and artistic traditions was also expressed in the Chosŏn potters' explorations of new, distinctive shapes and decorative motifs in ceramics.

Chosŏn ceramics consist mainly of two categories: white porcelain (*paekcha*) and a stone-ware known as punch'ŏng. In the early years of the Chosŏn dynasty, Korean potters, working with new energy and confidence, attempted to revitalize what remained of the Koryŏ celadon tradition. The result of these efforts were punch'ŏng wares. The term is a contraction of *punjang hoech'ŏng sagi*, literally "ceramic ware of a grayish-green clay body covered with white slip and a clear greenish glaze." Punch'ŏng was produced only in the fifteenth and sixteenth centuries, yet during this short time the industry flourished, and a variety of wares was made at kilns throughout the peninsula. Thought of as utilitarian objects in Korea, punch'ŏng wares were widely appreciated for their aesthetic appeal in Muromachi Japan, where the great tea master Sen no Rikyū (1522–1591) helped to create a taste for their bold, rustic forms and vigorous designs.

Punch'ŏng represents an important development of the Korean ceramic tradition. Its indebtedness to the native Koryŏ celadon tradition is seen in the grayish-green glaze, though, containing less iron oxide, punch'ŏng glazes are not as green in tone. Also, the use of white slip in punch'ŏng was initially derived directly from the decorative techniques favored in celadons of the second half of the thirteenth to the fourteenth century: carved sanggam inlay, as well as sanggam inlay combined with the limited use of stamped designs. Punch'ŏng wares from the early fifteenth century often have both inlaid and stamped designs, such as the bowl with a fish design (fig. 22). This bowl also preserves the Koryŏ use of black inlay, which disappears soon after this time. By the latter part of the fifteenth century, the labor-intensive and time-consuming process of exquisite inlay was abandoned, and Korean potters' explorations of the possibilities of slip in the ornamentation of punch'ŏng took them in radically different directions. In one new technique, the design is stamped into the moist, grayish stoneware clay, a white slip is applied to the stamped object, and the excess is wiped away to create a smooth surface. The object is then covered with a high-fired glaze.

The transition sketched here can be illustrated by the design on a punch'ŏng bottle (pl. 23), a stamped pattern of tiny circles that originated in the popular chrysanthemum motif of Koryŏ celadons (fig. 16). This motif was first abbreviated to circles with radial spokes for the chrysanthemum petals, and then reduced to densely packed circles. Typical of early punch'ŏng is the use of stamped decoration over the entire surface of the object. By the middle of the sixteenth century, stamped wares were no longer produced, and vessels entirely covered with white slip became the most popular type of punch'ŏng (fig 23). Potters sometimes employed the sgraffito technique, incising or carving the design into the still-wet slip to reveal the clay body beneath. A flask-shaped bottle (pl. 24) displays two types of sgraffito decoration: *chohwa*, or "carved flowers," in which the design (in this case, the two fish) is incised in rapidly drawn lines, and *pakchi*, or "stripped background," in which the background of the design is scraped away, as is shown in the floral design on the sides of the bottle. Sgraffito decoration was produced primarily in North and South

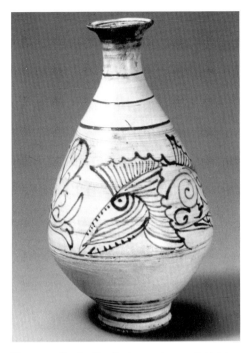 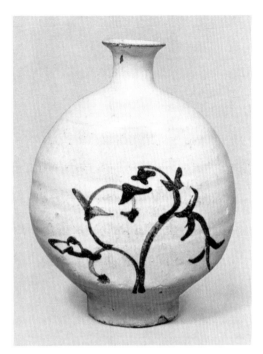

**Figure 24.** Bottle, Chosŏn dynasty (1392–1910), late 15th century. Punch'ŏng ware, style of Kyeryong-san kiln, South Ch'unch'ŏng Province, with white slip and underglaze iron-brown decoration of lotus and fish, h. 12 ¼ in. (31.1 cm). Ho-Am Art Museum, Yongin

**Figure 25.** Bottle, Chosŏn dynasty (1392–1910), 16th–17th century. Punch'ŏng ware, style of Kohŭng-gun kiln, South Chŏlla Province, with white slip and underglaze iron-brown decoration of plant, h. 8 ⅜ in. (21.2 cm). Museum of Oriental Ceramics, Osaka

Chŏlla provinces, whereas stamped wares are characteristic of punch'ŏng from Kyŏng-sang Province. The use of sgraffito decoration in punch'ŏng in turn declined as consumers increasingly favored the snowy whiteness of porcelain. Punch'ŏng wares created in response to this interest were indeed close to porcelains in color, but with the striking surface effects obtained by applying the white slip with a brush (pl. 25) or by dipping.

Underglaze iron painting over white slip was produced exclusively by two kilns in the southwestern part of the peninsula from the late fifteenth to the mid-sixteenth century, the majority coming from the Kyeryong-san kiln, in South Ch'ungch'ŏng Province, where the white slip was applied all over the surface of the vessel with a brush (fig. 24). The dynamic qualities of these wares are enhanced by bold, splashy underglaze designs. From a smaller kiln at Kohŭng-gun, Undae-ri, in South Chŏlla Province, came wares that were painted with quieter, more subdued brushwork (fig. 25). These types of objects were produced in small numbers in the mid-sixteenth century, when the earlier stamped and sgraffito decorative techniques in punch'ŏng were declining in popularity.

The punch'ŏng tradition ended in Korea with the devastating invasions of the peninsula led by the Japanese warlord and unifier of the Japanese archipelago, Toyotomi Hideyoshi. Hideyoshi's campaigns in Korea included the kidnapping of potters and the forced relocation of entire pottery-making villages to Japan to satisfy the growing local demand for Korean ceramics, in particular the punch'ŏng wares favored by the practitioners of the tea ceremony. The importation of these skilled artisans also marked the beginning of porcelain production in Japan. Although the Korean porcelain industry was

revived under Chosŏn court patronage in the seventeenth and eighteenth centuries, the punch'ŏng tradition did not survive.

Punch'ŏng wares and the white-bodied porcelains of the Chosŏn dynasty had their inspiration in different historical circumstances, both originating in China. The shapes and decorative techniques of Koryŏ celadons, derived from Chinese Yue wares of the Tang and Five Dynasties periods, evolved into a distinctly Korean tradition before being transformed in the Chosŏn dynasty in the production of punch'ŏng. The porcelains were influenced largely by similar wares from the later Yuan and Ming periods in China. For example, the fifteenth-century punch'ŏng bottle in plate 23 harks back to the late Koryŏ inlaid celadon bottle in plate 19, but has a more dynamic shape with a shorter neck, plump body, and narrow foot, while a porcelain bottle of the same date (pl. 26) shows the influence of late-fourteenth- and early-fifteenth-century Chinese porcelains. (However, in comparison to the Chinese porcelains, this bottle has a more restrained and stable form.)

The porcelain kilns of the Chosŏn period produced objects of varying levels of quality. The best grade of porcelain was made for the court at the royal kilns in Kwangju, in Kyŏnggi Province, as well as the provincial kilns under the auspices of the Saongwŏn, the royal bureau of ceramic production. The royal kilns were relocated every ten years or so, in order to ensure a constant supply of firewood, immense amounts of which are consumed to produce the temperatures of 1300°–1350° C needed for firing porcelain. Other provincial kilns produced both punch'ŏng and porcelain for local use, and occasionally as tribute to the court. The finer-grade ceramics were fired in protective individual saggers, which helped both to prevent the accumulation of ash on the vessels and to preserve the shapes of the thinner, more delicate wares. In contrast, ceramics for everyday use were fired in stacks for production efficiency, so that a kiln could turn out in one firing about ten times as many wares of ordinary quality as those of superior quality.

The early phase of Chosŏn porcelains, dating from the inception of the dynasty in 1392 up to the mid-seventeenth century, consists mostly of undecorated white wares (pl. 26) and reflects the dynasty's austere Confucian ideals. Historical or classical narrative themes, used in the decoration of Chinese ceramics of the Yuan and Ming dynasties, rarely appear in Korea. The glazes tend to be applied somewhat thickly and have a bluish tone that enhances the impression of whiteness and freshness. A small number of porcelains are painted in underglaze cobalt-blue or underglaze iron-brown. The two nearly identical wine cups (pls. 28, 30), probably intended for use in Confucian rituals to commemorate the dead, exemplify the austerity for which the Chosŏn ruling class strived. A ceremonial dish for the offering of food to ancestral spirits also attests to the prominence of Confucian rituals in daily life during the Chosŏn period (pl. 34).[20] A large number of mortuary objects in various shapes, often bearing the Chinese character che ("sacrifice" or "offering"), as seen on this dish, survive from the eighteenth century and later.[21]

CHUNG YANG-MO

246

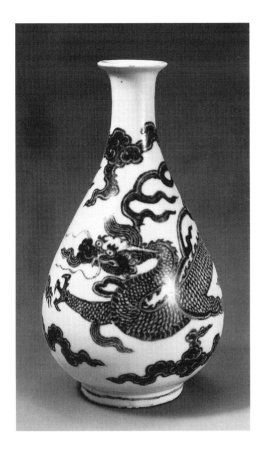

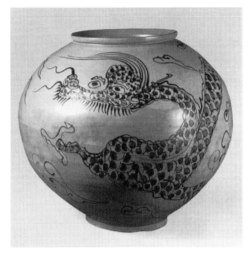

**Figure 26.** (left) Bottle, Chosŏn dynasty (1392–1910), 15th–16th century. Porcelain with underglaze cobalt-blue decoration of dragon among clouds, h. 9 ⅞ in. (25.0 cm), Ho-Am Art Museum, Yongin. Treasure no. 786

**Figure 27.** (right) Vase, Chosŏn dynasty (1392–1910), second half of the 17th century. Porcelain with underglaze iron-brown decoration of dragon, h. 13 ⅜ in. (33.9 cm). The National Museum of Korea, Seoul

The plum-and-bamboo motif painted in underglaze blue on the ceremonial wine cup of plate 30 alludes to the traditional associations of these perennial plants with the Confucian ideals of the literati: the gentlemanly virtues of uprightness and moral rectitude in the face of hardship. The expressively rendered design also reflects the influence of the style of painting espoused by Chinese literati artists. In another example of the plum-and-bamboo motif (pl. 31), however, the design is painted in a highly descriptive and realistic style, with unmodulated lines that are filled in with a slightly lighter color to render volume.[22] According to Chinese art-historical theory of the time, this type of painting was reserved for professional painters and artisans. That such a decorative and representational technique was used in Korean art to convey a scholarly theme suggests that literati painting was understood by Chosŏn court painters mainly as a set of formal and thematic options, independent of the symbolism with which they were traditionally imbued. High-quality porcelains such as this blue-and-white jar were produced at the royal kilns, where court painters were often called upon to decorate the objects, especially those intended for presentation to the Chinese court. A court painter was also responsible for the painting of the large eighteenth-century jar (pl. 40) decorated with an underglaze cobalt-blue design of a tiger, a *haet'ae* (an auspicious mythical animal), and magpies.

Dragons were another favored decorative motif on Korean ceramics. Seventeenth-century dragons (fig. 27) differ stylistically from their earlier counterparts (fig. 26), which are more carefully depicted with very fine details and tend to be less humorous and

benign in appearance. The heads of the later dragons are typically larger, with longer horns, whimsical whiskers, and fur that flips up over the head.

The large seventeenth-century jar pictured in plate 35 shows the popular motif of plum and bamboo painted in underglaze iron oxide. Displaying the confidence of a master painter, the design gives the subtle effect of three-dimensional modeling in the areas in which the iron has been applied more thickly and therefore burned through the clear glaze. Although the wide lotus-petal band on the shoulder of the vase is very similar to those found on Ming blue-and-white porcelains during and after the Jiajing era (1522–66), it is closer to the lotus-petal borders seen on sixteenth-century punch'ŏng ware. Though underglaze iron painting began in Korea in the Koryŏ dynasty and can be seen in fifteenth- and sixteenth-century punch'ŏng wares associated with the Kyeryong-san and Kohŭng-gun kilns (figs. 24, 25), it is rarely found in early Chosŏn porcelains. In the seventeenth century, it was often used as a decorative medium for porcelains, but thereafter declined in popularity. Nevertheless, some of the most beautiful decorated ceramics of the Korean tradition were produced using this technique, as evidenced by the plum-and-bamboo vase as well as the large vase with an exquisite grapevine design (fig. 28).

The porcelain jar painted in underglaze copper red (pl. 37), as well as several similar examples in the National Museum of Korea, represents a group of ceramics made at the same kiln in the eighteenth century, when a new era in the decorative arts began. This group is remarkable for the liberal and exclusive use of copper red, which was usually employed only sparingly for decorative accents in official blue-and-white wares. Although the actual site has not yet been discovered, the kiln that produced these ceramics was probably a private provincial kiln in northern Kyŏnggi Province, possibly in the old Koryŏ capital of Kaesŏng or on the nearby island of Kanghwa. The decorative motifs of wares from this kiln are very diverse, and include tigers, cranes, lotus flowers, and, as seen in the underglaze copper-red jar, grape leaves. All of these engaging and sometimes playful designs were painted by talented local artisans and produced at one kiln. The glaze on these wares is bluer than other Chosŏn porcelain glazes, and, when combined with the unique grayish color of the clay body, gives these objects their distinctive color, which complements the bright, bold copper red. Besides the extraordinarily fine underglaze red color, the shape of the jar also appears to be unique to wares assigned to this as yet unidentified kiln site. All jars of this shape produced at the kiln have the distinctively exaggerated everted lip, and they are further characterized by the band of double raised lines on the shoulder of the vessel, which provides a visual anchor for the decorative motif.

Although the technique of painting in underglaze copper red was refined during the Koryŏ, no early Chosŏn examples survive, despite records of the use of copper red. This was partly because of the technical difficulties of firing the copper-red pigment, but also because the flamboyance of the red decoration was contrary to the Confucian ideal of austerity. In the early Chosŏn period, when the rulers of the new dynasty were intent upon distancing themselves from the preceding Koryŏ dynasty, such reminders of a former era

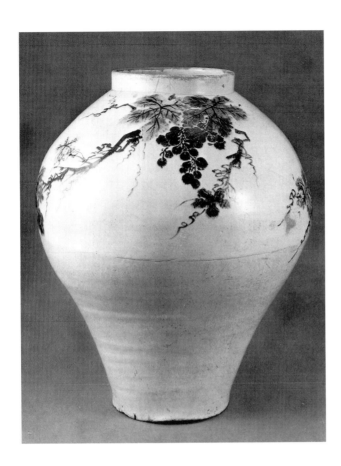

**Figure 28.** Vase, Chosŏn dynasty (1392–1910), second half of the 17th century. Porcelain with underglaze iron-brown decoration of grapevines, h. 21 in. (53.3 cm). Ewha Womans University Museum, Seoul. National Treasure no. 107

of luxury and lavishness were especially frowned upon. Some copper-red decorated wares survive from the mid-Chosŏn period, but it is with the flourishing of the decorative arts in the eighteenth century that this ornamental technique becomes widespread.

The sudden increase in the variety of shapes, glazes, and designs in eighteenth-century Korean porcelains reflects the lessening of the influence of Confucian teaching on the arts. Growing foreign influences, including those from the West, received through China and Japan, were partly responsible for this displacement and for the expansion of the Korean potters' repertoire in the mid-eighteenth century. After the second half of the eighteenth century, innovative forms and the use of decorative motifs even on wares produced for yangban scholars gradually became more acceptable, and potters were free to express their creativity (pls. 38, 39). Potters also freely exploited the tradition of painting in underglaze cobalt (pl. 40) as well as iron oxide to create an increasingly rich vocabulary of designs.

Throughout the history of Korean ceramics we see the attempt to combine functionality of objects with forms and designs that possess a natural, spontaneous quality totally lacking in pretension or self-consciousness. The Korean potter did not resort to exaggerated forms or unnecessary decoration to achieve a sense of perfection or artificial beauty. Instead, the true beauty of Korean ceramics lies in their pure and modest forms, which are determined by technique and function, and in their minimal decoration. Subtle rhythms, oftentimes whimsical designs, and an emphasis on overall balance and harmony have yielded objects that always seem familiar and intimate. ❧

Kim Lena

Tradition and Transformation in Korean Buddhist Sculpture

The introduction of Buddhism to Korea in the late fourth century during the Three Kingdoms period (57 BCE–668 CE) had a decisive effect on the formation of early Korean art and culture. Besides the importation of Buddhist texts from China and the arrival of monks to propagate the difficult doctrines, temples and pagodas were constructed in which devotional images were enshrined. Eventually, this foreign religion, which had originated in India, gained widespread acceptance among Koreans, in the process transforming not only indigenous religious life and thought but the cultural patterns of Korean society.

Of the three kingdoms, Koguryŏ (37 BCE–668 CE), situated in the northern part of the peninsula, was the first to accept the new religion. This took place in 372, when King Sosurim (r. 371–84) was presented a Buddhist text and image by a monk named Shundao, an official envoy from the king of the Former Qin (352–410), one of a series of non-Chinese states that controlled northern China during what is commonly known as the Six Dynasties (220–589), a period of prolonged political turmoil in China following the collapse of the Han empire (206 BCE–220 CE). For much of this period China was divided, with the north eventually ruled by the Toba Tartars, founders of the Northern Wei dynasty (386–534), and the south by Chinese. The Northern Wei rulers became ardent supporters of Buddhism, and the sculpture produced under their patronage represented the first major impact of the religion upon China.

Buddhism was introduced into Paekche (18 B C E–660 C E), the kingdom situated in the southwestern part of the Korean peninsula, in 384 through a monk, Marananta, from the Eastern Jin (317–420), the first of a succession of Chinese dynasties that ruled southern China from 317 to 589. Paekche, whose access to China was largely confined to the sea, regularly sent trade and diplomatic missions to the southern dynasties, while Koguryŏ in the north maintained relations with dynasties in both the northern and southern part of the mainland. Thus the artistic productions of Koguryŏ and Paekche reflect their differing contacts with these two centers of Buddhist influence in China.

Only much later, in 528, did the kingdom of Silla (57 B C E–668 C E), in the far southeastern corner of the peninsula, officially recognize Buddhism, though the religion was known to the local society by the early fifth century through the activities of monks from Koguryŏ.

In each of the three kingdoms, the patronage of the royal court and ruling aristocracy assisted the propagation of the Buddhist faith as well as the production of Buddhist art. Within a few years after the introduction of Buddhism, several temples are known to have been built in the Koguryŏ capital of P'yŏng'yang and in Hansŏng (modern Seoul), the first capital of Paekche. It can be assumed that Buddhist images were enshrined in the major halls of the temples and worshiped. Ceremonies were held there to guarantee the well-being of individuals and the state, and increasingly to ensure protection from foreign invasions. As objects of worship, Buddhist deities were represented in idealized forms conforming to established iconographic patterns seeking to portray the Buddha as divine. As the Enlightened One, the Buddha embodies the teachings of Buddhism and possesses superhuman physical characteristics that distinguish him from ordinary human beings. On his head are locks of curly hair in the shape of snail shells. A protrusion on the top of his head, the *ushnisha*, indicates that he possesses supreme wisdom. A "third eye," the *urna*, on his forehead represents his supernatural vision, one that sees the world of the past as well as the future. Various hand gestures, or *mudras*, symbolize the Buddha in the states of meditation or enlightenment, or represent incidents in his life or of his teaching. He always wears a simple garment without any ornamentation, symbolizing that he has freed himself from earthly cares and the cycle of rebirth. His various postures — whether standing or seated on a throne — are also part of Buddhist iconography.

Such basic iconographic features originated in India, passed through Buddhist centers in Central Asia and China, and reached the Korean peninsula and then Japan. In the process of this successive transmission, the general iconographic patterns themselves underwent few changes, but aesthetic preferences and technical proficiency in the respective countries and at different periods naturally produced stylistic variations. Thus, later local variations in ornamentation or in the mode of draping garments, for example, can be distinguished from earlier prototypes. An understanding of Korean Buddhist sculpture involves comparisons with immediate Chinese prototypes, from both northern and southern China, and in some cases with models that can be traced back to Central Asia and to

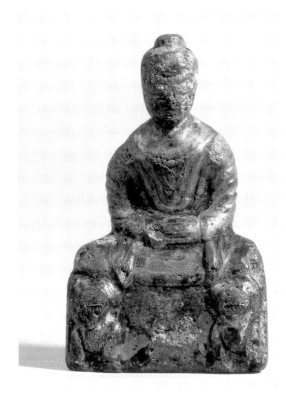

**Figure 1.** Seated Buddha,
Three Kingdoms period, Koguryŏ
(37 B C E–668 C E) or Paekche kingdom
(18 B C E–660 C E), 5th century, from
Ttuksŏm, Seoul. Gilt bronze, h. 1 ⅛ in.
(4.9 cm). The National Museum of
Korea, Seoul

India. While Korean Buddhist sculpture is stylistically indebted to these foreign tradi-
tions, Korean artists were often selective, adopting only certain models that they in turn
developed into images with a distinctive Korean appearance, particularly in facial expres-
sion, or varied through different carving or casting techniques. The interpretation of
these models also differs within Korea according to region and period. An overview of
Korean Buddhist sculpture during succeeding periods will enlarge our understanding of
the development of East Asian Buddhist sculpture in general, for it was through Korea
that Buddhism was formally introduced to Japan, in 538, where it likewise played an im-
portant role in the formation of early Japanese art and culture.

## THREE KINGDOMS PERIOD

The earliest known extant Buddhist sculpture found in Korea is a small gilt-bronze statue
of a seated Buddha (fig. 1) dated to the fifth century, which was discovered at Ttuksŏm,
near the Han River in the eastern section of Seoul, part of the ancient territory of Paekche.
The Buddha clasps his two hands before him in a variation of the *dhyana* (meditation)
mudra.[1] He is seated on a rectangular pedestal, on either side of which are two lion statues
cast in relief. The lions, which signify his royal birth and power, are often seen in early
representations of the Buddha from Gandhara, located within what is now Pakistan, as
well as in early Chinese images. The Ttuksŏm statue might be a copy of a Chinese figure
from the late fourth or early fifth century. A comparable image from north China is a
seated gilt-bronze Buddha datable to the Northern Wei dynasty, in the museum of the
Tokyo National University of Fine Arts and Music.[2] If the Ttuksŏm figure is indeed an

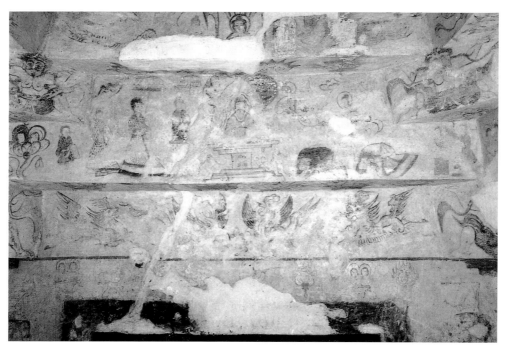

**Figure 2.** Buddha, Three Kingdoms period, Koguryŏ kingdom (37 BCE–668 CE), late 5th century. Mural painting. Ceiling, main burial chamber, Changch'on Tomb no. 1, Ji'an, Jilin Province, China

early Korean statue, it could be a Paekche piece, based on its provenance, or a Koguryŏ piece, based on stylistic affinities with northern Chinese models resulting from Koguryŏ's frequent contacts with the northern nomadic states.

A painted rendition of this type of seated Buddha (fig. 2) is preserved in Changchuan (Changch'ŏn) Tomb no. 1, a late-fifth-century Koguryŏ tomb located in Ji'an (Chiban), the site of the first capital of Koguryŏ, just north of the Yalu River in the modern Chinese province of Jilin.[3] A scene on one side of the lantern ceiling in the main burial chamber depicts the Buddha seated on a high rectangular pedestal, his hands held in front in the meditation pose. Two lions appear at the lower part of the pedestal. To either side of the Buddha are figures shown standing or kneeling in adoration, while two reborn souls emerge from a lotus flower at the lower right of the scene.

The Ttuksŏm type of seated Buddha continued to be made in Koguryŏ and Paekche, but in the later examples the two lions disappear and the rectangular base is either covered with folds of the Buddha's garment or supplanted by a base of lotus-petal design. Fragments of seated Buddha figures made of clay, found at the Koguryŏ temple site of Wŏno-ri, near P'yŏng'yang, are of the latter style.[4] An example of a statue with the garment draped over the base is a soapstone Buddha image of the second half of the sixth century from the temple site of Kunsu-ri, in Puyŏ, the last Paekche capital (fig 3). The arrangement of the Buddha's outer robe in overlapping folds over the base reveals the artist's conscious attempt to render realistic draping. The warm smiling expression on the face of the Kunsu-ri Buddha and the suggestion of human intimacy are characteristic Korean features that distinguish Paekche sculptures from the more austere Northern Wei images and the rather stiff and solemn faces of early Japanese images. Such characteristics

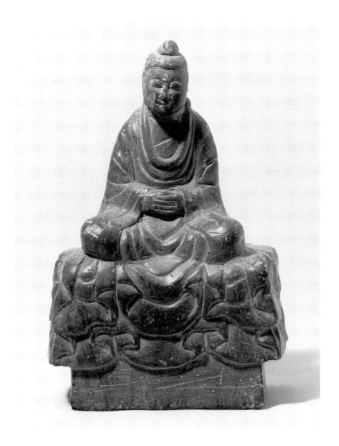

**Figure 3.** Seated Buddha, Three Kingdoms period, Paekche kingdom (18 B C E–660 C E), second half of the 6th century, from temple site of Kunsu-ri, Puyŏ, South Ch'ungch'ŏng Province. Soapstone, h. 5 ¼ in. (13.5 cm). The National Museum of Korea, Seoul. National Treasure no. 329

**Figure 4.** Pedestal of a seated Buddha, Three Kingdoms period, Paekche kingdom (18 B C E–660 C E), 7th century, from kiln site at Ponŭi-ri, Ch'ŏng'yang, South Ch'ungch'ŏng Province. Pottery, h. 39 ⅜ in. (100 cm), w. 110 ¼ in. (280 cm). Puyŏ National Museum

are often attributed both to Paekche's close ties with the southern Chinese dynasties and to the artistic perceptions of Paekche Buddhist artists. A similar treatment of the base of a statue can also be seen in a pottery pedestal discovered near a kiln site in Ch'ŏng'yang, South Ch'ungch'ŏng Province, in the ancient territory of Paekche (fig. 4). The size of the pedestal — measuring 100 centimeters in height and 280 centimeters in width — suggests that the image of the Buddha it once supported was very large. Judging from the rounded hem flowing down in the center, it is likely that the Buddha's hands were held in the meditation gesture. The relatively simplified rendition of the drapery folds suggests a slightly later date than the Kunsu-ri soapstone Buddha.

Covering the base of a statue in garment folds is a stylistic feature that is found in Buddhist images produced in southern China in the late fifth century, for instance in the large seated stone Buddha in a cave at the Xixiasi Temple, in Nanjing,[5] or in the seated image of Amitayus, the Buddha of Infinite Life, of the Southern Qi dynasty (479–502),

which is dated 483 and was unearthed in Mouxian County, Sichuan Province.[6] Although this style was probably initiated in the south, it was transmitted soon thereafter to northern China as evidenced by sculptures at Yungang and Longmen that date, respectively, from the late fifth and early sixth centuries.[7]

Despite the influence in China of Indian and Central Asian monks at the Northern Wei court, where they were essential for the propagation of Buddhist doctrines, learned Chinese monks in the south played an important role in translating Buddhist texts and interpreting the doctrines of the foreign religion, an influence that spread northward and is reflected in Northern Wei Buddhist art beginning in the late fifth century. In addition, Northern Wei rulers gradually became sinicized, even adopting, for example, traditional Chinese dress and customs. By the early sixth century, the Northern Wei Buddhist sculptural style was fully sinicized. Thus, to establish a single stylistic lineage from Chinese prototypes in Korean Buddhist sculpture of the Three Kingdoms period is difficult, because by the first half of the sixth century, both northern and southern China had already begun to share a common sculptural style.

Comparisons are often made between the Paekche seated Buddhas and the famous Shakyamuni Triad at Hōryū-ji Temple, in Nara, dated by inscription to 623,[8] making it the earliest known dated Japanese Buddhist statue. Though the arrangement of garment folds cascading over the dais of the Buddha figure is similar, the pattern of the folds has become flat and schematized. A more basic difference is in the hand gestures. By the time the Hōryū-ji triad was made, the meditation gesture for the seated Buddha was no longer popular in China or Korea. In the Hōryū-ji sculpture, instead of the meditation gesture, one hand displays the *abhaya*, or fear-not mudra, and the other hand the *varada*, or wish-granting gesture. Thus, the triad displays a combination of old and new stylistic features.

Making such comparisons and, indeed, providing an overview of artistic developments are complicated by the lack of firm dating and provenance. Among the extant Buddhist sculptures from the Three Kingdoms period there is only one that bears an inscription identifying both when and where the work was produced. It is a gilt-bronze standing Buddha discovered at Ŭiryŏng, South Kyŏngsang Province (fig. 5). The forty-nine-character inscription written in Chinese on the back of the flame-shaped nimbus states that the statue was made in Ko[gu]ryŏ at Tong-sa (Eastern Temple) in Lelang, a reference to the Koguryŏ capital of P'yŏng'yang, and was commissioned by an abbot, his disciples, and lay Buddhists. It is dated the seventh year of the reign of Yŏn'ga, in the cyclical year *kimi*. No reference to this reign period appears in the historical record. Moreover, the village of Ŭiryŏng, where the statue was found, was once part of the ancient kingdom of Silla, which might lead one mistakenly to ascribe the piece to Silla were Koguryŏ not mentioned in the inscription. Again, we must turn to a stylistic comparison with Chinese examples to discover a clue to dating.

The Yŏn'ga Buddha wears a simple garment, with drapery folds that flare out into zigzag endings. His right hand is in the fear-not gesture and his left in the wish-granting

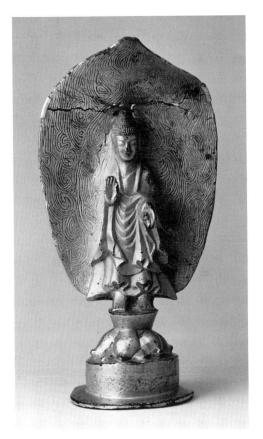

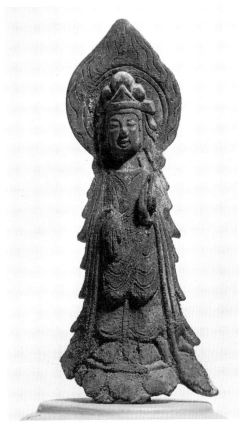

**Figure 5.** Standing Buddha, Three Kingdoms period, Koguryŏ kingdom (37 B C E–668 C E), dated *kimi* year (539), from Ŭiryŏng, South Kyŏngsang Province. Gilt bronze, h. 6 ⅜ in. (16.3 cm). The National Museum of Korea, Seoul. National Treasure no. 119

**Figure 6.** Standing Bodhisattva, Three Kingdoms period, Paekche kingdom (18 B C E–660 C E), second half of the 6th century, from temple site of Sin-ni, Puyŏ, South Ch'ung-ch'ŏng Province. Gilt bronze, h. 4 ½ in. (11.5 cm). The National Museum of Korea, Seoul. Treasure no. 330

gesture, a combination that became common for Buddha figures, both standing and seated. The large mandorla is incised with a loosely organized design of flame patterns, which symbolize the radiant wisdom of a divine being. The arrangement of the garment, with one end crossed at the waist and then draped over the left arm, appears in Northern Wei sculpture near the end of the fifth century and becomes a popular style in both stone and gilt-bronze images in the early sixth century. Other sinicized features are the slightly elongated shape of the face, the undergarment, a portion of which is shown beneath the lowered neckline of the outer garment, and the fishtail endings of the garment hem. Close examples are the central Buddha images in the famous Northern Wei gilt-bronze altarpieces in the Metropolitan Museum, one of which is dated 524. Based on these comparative works, we can ascribe the Yŏn'ga Buddha to the sixth century, with the earliest possible date corresponding to the *kimi* year being 539.

Though the style of the Yŏn'ga Buddha offers clear evidence of Northern Wei influence on Koguryŏ, a similar statue has also been found in the Paekche region, a gilt-bronze standing Buddha from the sixth-century temple site of Powŏn-sa, in Sŏsan, South Ch'ungch'ŏng Province.[9] Paekche, whose relations with China were largely confined to the southern courts, received Northern Wei stylistic elements mostly through Koguryŏ,

which exerted a strong influence on Paekche culture. Further evidence of the common stylistic elements that co-existed among Koguryŏ and Paekche Buddhist images is a small gilt-bronze standing Buddha of the sixth century, exhibited here for the first time (pl. 61). The treatment of the outer garment, with one end draped over the left arm, is similar to that of both the Yŏn'ga and Powŏn-sa statues. Indeed, the statue reveals a precise representation of three garments: at the neckline an undergarment is visible, over which appears a diagonal portion of another garment across yet another undergarment. The three successive hemlines of the garments are delineated as well. There is a softness in the modeling of the face, and the drapery folds convey a sense of volume. The increase in the number of folds and the slightly more relaxed draping of the garments suggest a somewhat later date for this piece than the Yŏn'ga and Powŏn-sa examples.[10]

The form of Buddhism practiced in both China and Korea was Mahayana (the Greater Way), which had wide appeal since it was believed to provide salvation for all sentient beings. The Mahayana pantheon includes a number of bodhisattvas, the compassionate helpers of the Buddha who have earned enough merit to become Buddhas themselves but delayed entering Buddhahood in order to save mankind from the cycle of rebirth and direct it to enlightenment. With the increasing popularity of Mahayana doctrines, the Buddhist triad, consisting of a central Buddha figure flanked by two attendant bodhisattva figures, became a popular sculptural subject. From clay molds found at the Koguryŏ temple site of Wŏno-ri, mentioned above, we know that statues of Buddhas and bodhisattvas were mass produced. The many fragments of mold-pressed clay figurines found there give us some idea of early Korean sculptural representations of bodhisattvas.[11] The Wŏno-ri bodhisattvas wear a flat necklace with a point at the center and a scarf that falls down in front where it crosses at the knees and is pulled up again over both arms. The zigzag edges of the scarf and the skirt pleats form a symmetrical pattern over the legs. The round pedestal of inverted lotus petals on which the bodhisattva figures stand is similar to that of the seated Buddhas discovered together at the same site. The rounded modeling of the faces and bodies of these figures as well as the voluminous pleats of the garments follow a style seen in Northern Wei and Eastern Wei (534–550) sculpture of the first half of the sixth century.

Several bodhisattva images from Paekche—including two gilt-bronze standing figures, both datable to the second half of the sixth century, from the temple sites of Kunsuri[12] and Sin-ni (fig. 6) in Puyŏ—are similar to the Wŏno-ri bodhisattvas. One common feature is a scarf, fastened by small ornamental discs at the shoulders, that crosses the chest and falls down the sides, terminating in several flaring finlike edges. In these Paekche bodhisattvas the round face is softly modeled, while the drapery folds are arranged in an orderly, symmetrical fashion.

A comparison of the central figure of two late-sixth-century gilt-bronze Buddhist triads—one in the Kansong Art Museum, bearing the date of the *kyemi* year, or 563,[13] and the other discovered in Koksan, in the northern province of Hwanghae, dated the

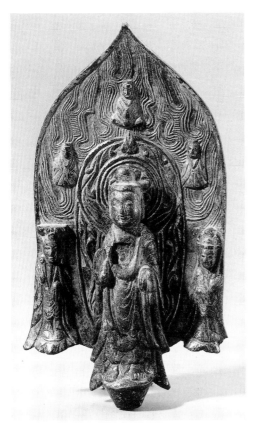

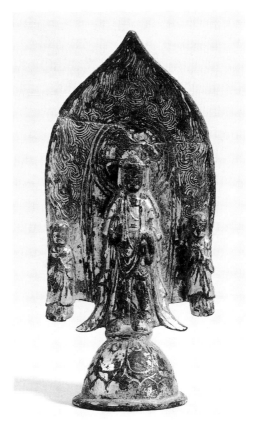

**Figure 7.** Buddha triad, Three Kingdoms period, Koguryŏ kingdom (37 B C E–668 C E), dated *sinmyo* year (571), from Koksan, Hwanghae Province. Gilt bronze, h. 7 ⅛ in. (18 cm). Ho-Am Art Museum, Yongin. National Treasure no. 85

**Figure 8.** Bodhisattva triad, Three Kingdoms period, late 6th century, excavated north of Ch'unch'ŏn, Kang'wŏn Province. Gilt bronze, h. 3 ½ in. (8.9 cm). Ho-Am Art Museum, Yongin. National Treasure no. 134

*sinmyo* year, or 571 (fig. 7)—with the earlier Yŏn'ga statue of 539 reveals a greater interest in a rounder modeling of the image and a more natural flow of the garment folds. In both of these later examples, the flame pattern on the mandorla is more organized, while the addition of vine scrolls around the head of the Buddha enriches the decorative appearance of the triad. These developments reflect a style that can be seen in slightly earlier images produced during the short-lived Eastern Wei dynasty, which further developed the Northern Wei tradition of more naturalistic and voluminous rendering of the body and garments.

According to the inscription on the Koksan triad, the donors requested an image of Amitayus (Muryangsu-bul), or the Buddha of Infinite Life—another name for Amitabha, the Lord of the Western Paradise, where sentient beings find respite from the endless cycle of rebirth. In the upper part of the mandorla are three Buddhas. In this case, they may represent the three Buddhas of the past or perhaps the Buddhas of the three worlds, past, present, and future. In another late-sixth-century triad (fig. 8), the central image is a bodhisattva, flanked by tonsured priests, their hands held in the *anjali* (prayer) mudra. The style of the bodhisattva recalls the type already seen in the images from Kunsu-ri and Sin-ni (fig. 6), while the flame pattern is more curved than in the Koksan triad (fig. 7).

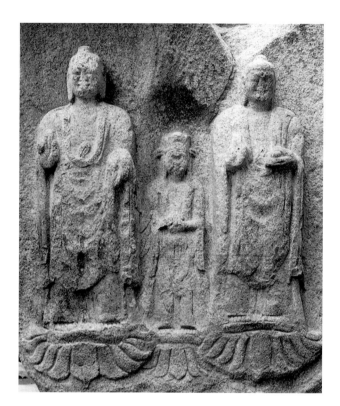

**Figure 9.** Buddha triad, Three Kingdoms period, Paekche kingdom (18 B C E–660 C E), late 6th century. Rock carving, h. of bodhisattva (center), 51 ⅛ in. (130 cm). T'aean, Sŏsan-gun, South Ch'ungch'ŏng Province

While these Korean Buddhist triads resemble Eastern Wei examples, they also show a close affinity with some newly discovered Buddhist statues from Jisong, in China's eastern coastal province of Shandong, that can be assigned to the second half of the sixth century.[14] From ancient times the Shandong region had been the focal point for cultural contacts between China and the Korean kingdoms, and it offered the closest sea route to Paekche.[15] Shandong was also the melting pot, in the Eastern Wei and Northern Qi (550–577) periods, for the cultures of northern and southern China. Further research on the Shandong images may shed light on cultural intercourse between Chinese and Korean Buddhist communities, especially those of Paekche, during the Three Kingdoms period.

Located near the western coast of ancient Paekche, the Sŏsan region of South Ch'ungch'ŏng Province preserves several important Buddhist images carved in relief in the living rock. One early example is a Buddha triad located on the side of a cliff at T'aean, overlooking the Yellow Sea (fig. 9). In the center of the triad is a small standing bodhisattva holding a round jewel-like object in both hands. Flanking this image are two Buddhas, the one on the left holding a covered medicine jar, identifying the figure as Bhaishajyaguru, the Buddha of Medicine, and the one on the right showing both the fear-not and wish-granting hand gestures. During the summer of 1995, the earth mound that covered the lower part of this triad was removed, revealing the beautifully executed lotus-petal pedestals on which the three statues stand as well as the well-proportioned character of the triad as a whole.

The central bodhisattva and two attending Buddhas of the T'aean triad represent a rare combination. A bodhisattva holding a jewel is also a new iconographic element, particularly popular in Paekche, which found its way to Japan where it became part of the

repertoire of bodhisattva images during the Asuka period (538–645). An early Asuka gilt-bronze bodhisattva at Hōryū-ji, also holding a jewel, allows us to reconstruct the shape of the T'aean bodhisattva's three-pointed crown, now damaged.[16] South China seems to have been the source of inspiration for this iconography, since a similar type appears among Buddhist sculptures of the Liang dynasty (502–557) discovered at the temple site of Wan-fosi, in Chengdu, Sichuan Province.[17]

This type of bodhisattva holding a jewel with both hands was apparently worshiped as Avalokiteshvara, Lord of Infinite Compassion, the most popular of the bodhisattvas. The identification of the figure is based on a comparison with a Japanese bodhisattva figure of the same type in gilt bronze, which is inscribed with the cyclical year *sinhae*, corresponding to 651.[18] The figure wears a crown with an image of the seated Buddha Amitabha incised in the center, a traditional attribute that identifies the bodhisattva as Avalokiteshvara. The Buddha holding a medicine jar is another new element of iconography and indicates that the worship of the Medicine Buddha, whose function is to heal illness, played an important role in the practice of Buddhism in Paekche.

Also to be noted in the T'aean triad are the continuous U-folds falling from the lowered neckline of the outer garments of the two Buddhas. Such garment folds have already been seen in the Buddha of the Koksan triad from 571, and reflect Indianizing trends that came into vogue in the latter half of the sixth century in China, during the Northern Qi and Sui (581–618) dynasties. Other Korean images showing such treatment are two Buddha images carved in high relief on two faces of a four-sided block of granite in Hwajŏn-ni, Yesan, South Ch'ungch'ŏng Province (fig. 10). Part of a monument that was discovered about fifteen years ago, it has added greatly to our understanding of early stone sculptures in the western coastal region of Paekche. The seated Buddha, the main image of worship in the group, displays a deeply carved flame pattern around the lotus halo behind the now missing head of the Buddha. The treatment of the garments is quite different from that found in Indian images and rarely seen in China or Japan: the right shoulder is covered by an undergarment, which falls straight to the waist in vertical pleats, while the outer garment is draped along the top of the shoulder and down the arm.[19]

Another well-known and fine example of an image carved in relief on a rock cliff, also from former Paekche territory in Sŏsan Prefecture, is the Sŏsan Buddha triad (fig. 11).[20] The standing, central Buddha is flanked on the right by a bodhisattva holding a jewel with both hands and on the left by a seated pensive bodhisattva, who is believed to represent the future Buddha Maitreya. The presence of two different types of bodhisattvas — one standing and the other seated in a pensive posture — flanking the central figure of the Buddha is unusual. Probably the central Buddha was meant to represent Shakyamuni, the historical Buddha, attended by Avalokiteshvara and Maitreya, who were the most popularly worshiped deities in the early stage of Buddhism in Korea.

The inclusion in the Sŏsan group of the standing bodhisattva holding a jewel, recalling the central deity of the T'aean triad, is further evidence of the popularity of this icono-

 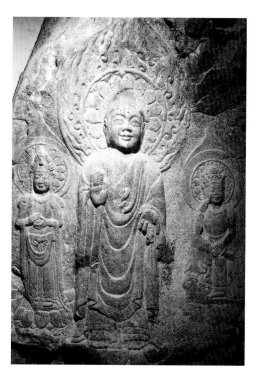

**Figure 10.** Two Buddhas, Three Kingdoms period, Paekche kingdom (18 B C E–660 C E), late 6th century. Carving on four-sided boulder, h. 39 ⅜ in. (100 cm). Hwajŏn-ni, Pongsan-myŏn, Yesan-gun, South Ch'ungch'ŏng Province. Treasure no. 794

**Figure 11.** Buddha triad, Three Kingdoms period, Paekche kingdom (18 B C E–660 C E), early 7th century. Rock carving, h. of Buddha, 110 ¼ in. (280 cm). Unsan-myŏn, Sŏsan-gun, South Ch'ungch'ŏng Province. National Treasure no. 84

graphic element in Paekche Buddhist art. The design of the bodhisattva's crown, which features decorative floral patterns on both sides, found its way to Japan, appearing in, for example, the aforementioned gilt-bronze statue dated 651. At the center of the top of both crowns are also displayed a disc and a crescent-shaped moon, identified as the sun and the moon.[21] This type of crown originated in Persia and is found in bodhisattva images in the Yungang caves in northern China. Thought to symbolize the divinely bestowed power of kings, they became part of Buddhist art motifs that traveled along the Silk Road and were incorporated into the earliest bodhisattva iconography in China.

Compared with the earlier T'aean Buddhist triad, the Sŏsan triad reflects an improvement in the modeling of the round body and in the carving of the smaller number of naturally flowing garment folds. These Sŏsan images are also famous for their warm, smiling countenances: this human intimacy promotes a calm, relaxed mental state in which the worshiper might ascend to a transcendental state of religious awareness. The friendly smile—often referred to as the "Paekche smile"—the relaxed posture, and the natural treatment of the garment folds are all characteristic features of Paekche Buddhist sculptures. They mark a new phase of sculptural style in the early seventh century, resulting from greater familiarity with Chinese Buddhist images from the late Northern Qi and early Sui dynasties.

Silla, situated in the southeastern part of the Korean peninsula and thus more isolated geographically from the mainland, was slower to adopt Buddhism and was likewise one

step behind Koguryŏ and Paekche in the production of Buddhist images. Indeed, some of the earlier types of Koguryŏ and Paekche images are not found among Silla sculptures, extant examples of which mostly date from the seventh century. We know from the documentary record, however, that the first temple built in the capital city of Kyŏngju, Hŭngnyun-sa Temple, was completed in 544, shortly after Silla's official recognition of Buddhism. Some roof and floor tiles have been identified from the site. A more important temple in terms of royal patronage was Hwangnyong-sa, also in Kyŏngju, completed in 569. None of the wooden structures of this temple complex remains, though the foundation stones for the pillars of the lecture hall, the Golden Hall (main worship hall), and the nine-storied pagoda testify to the great size and scale of the temple compound. An auspicious Buddha triad, the central figure of which was said to stand "sixteen feet" tall (a symbolic measurement), was successfully cast in bronze for the site in 576. In the *Samguk yusa* (Memorabilia of the Three Kingdoms), it is recorded that the Buddha statue was modeled after an Indian image supposedly sent by King Ashoka, the great patron of Buddhism during the third century B C E.[22] It is impossible of course to reconstruct the Buddha triad, though there remain three large stone foundations from the actual triad that was worshiped until it was destroyed during the Mongol invasions of Korea during the thirteenth century. A gilt-bronze fragment of a head found at the same temple site has large snail-shaped hair locks and is thus considered to be a remnant of a huge Buddha image. Since the Hwangnyong-sa statue may have served as the model for many later Silla images, extant examples from the early seventh century onward provide some indication of what it might have looked like.

The best-known stone example of early Silla sculpture is the Buddha triad at Pae-dong, Kyŏngju, at the western foot of Namsan (South Mountain), the most famous Buddhist mountain sanctuary in Korea (fig. 12). The central standing Buddha of the Pae-dong triad wears a simple garment with a rounded neckline. The folds of the garment fall naturally in several consecutive U-shapes conforming to the modeling and the simple silhouette of the body. The Pae-dong Buddha serves as a good counterpart to the Paekche Sŏsan triad in the common treatment of the garment with a reduced number of folds, demonstrating the penetration into Silla of the sculptural style, derived from Northern Qi and Sui models, that began to appear in the seventh century, namely, a rounder form of modeling and a more natural and simplified treatment of the garment conforming to the shape of the body. This change in sculptural style can also be seen in the round form and elegant silhouette of the body of a gilt-bronze standing Buddha from Yangp'yŏng, Kyŏnggi Province (fig. 13). The tightly fitting garment, with a few reduced and gentle U-shaped folds, seems to cling to the body. While the Buddha's posture is dignified, his benevolent smile entices the viewer to approach. The style of this piece recalls such Northern Qi and Sui statues as the marble Amitabha in the Royal Ontario Museum, Toronto, which is inscribed with a date of 587.[23] The subtle warmth of the countenance and the undisguised casualness in the treatment of the garment folds differentiate the Korean statue from the

more precisely modeled Chinese counterparts with their uniform drapery folds. The self-possessed ease of the Yangp'yŏng statue is also at variance with the austere posture of Chinese images.[24]

Another type of standing Buddha that came to be represented by the early seventh century shows the garment covering only one shoulder, usually the left (pl. 62). Often this type of Buddha figure holds in one hand a round jewel-like object that can serve as a symbol of healing medicine, thus the identification of the figure as the Medicine Buddha. It is characterized by an exaggerated stance called *tribhanga*, or "thrice-bent" posture, in which one hip is raised and the opposite leg thus relaxed, and by a garment tightly clinging to the body, recalling an Indian sculptural idiom of the Gupta period of north India from the fourth to sixth century.[25] The Buddha's square-shaped face and the faint smile resemble the expression of the Pae-dong Buddha. The smile is not as inviting as that of the Buddha of the Sŏsan triad, conveying instead a sense of a benevolent presence. Among the nearly twenty extant examples of this type is one from the temple site of Hwang-nyong-sa, and two from among images from the temple site of Suksu-sa, near Yŏngju, in North Kyŏngsang Province.[26] As no comparable example is readily found among Chinese works, it is likely that the style was introduced into Silla directly from India. In this connection, historical records document a monk named Anham who returned to Korea in the early seventh century accompanied by three Indian monks. It is recorded that the monks stayed at Hwangnyong-sa, where they translated Buddhist texts.[27]

The seated Buddha image with hands held in the meditation gesture was superseded in the seventh century by another seated image, one displaying the combined gestures of the fear-not and wish-granting mudras. A granite statue from Inwang-dong, Kyŏngju (pl. 65), is the only figure carved in the round among several such seated Buddha images. The Buddha's nose and hands have been damaged, but the fairly good condition of the rest of the image allows one to recognize some distinguishing features of seventh-century Silla images. The outer garment worn by the Buddha covers both shoulders, and its folds fall naturally in multiple U-shapes over the crossed legs. The Buddha is seated on a flat semicircular base, which is carved from the same block of stone as the figure and the round halo. The folds of the long skirt, which are arranged naturally with overlapping zigzag edges, cascade over the base. There are other examples of this type,[28] including those from North Ch'ungch'ŏng Province, an important strategic region that first belonged to Paekche, then to Koguryŏ, and was finally taken over by Silla. Thus, by the seventh century, it is difficult to establish clear distinctions in stylistic descent among the Three Kingdoms images beyond noting that the works generally follow a sixth-century Chinese style that also went on to become popular in Japan during the Asuka period. The same combination of hand gestures appears in the image of the Great Buddha at Asuka-dera,[29] a small temple that now stands on the site of Hōkō-ji, the monastery built in 588 by the influential patrons of early Japanese Buddhism, the Soga clan. The sculptors who made the statues for the temple were mostly immigrant Korean artisans from

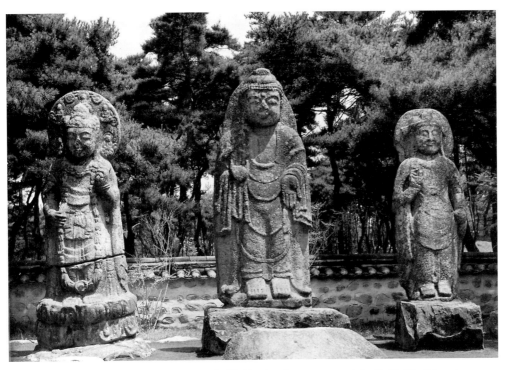

**Figure 12.** Buddha triad, Three Kingdoms period, Silla kingdom (57 B C E–668 C E), first half of the 7th century. Granite, h. of Buddha 108 ¼ in. (275 cm). Pae-dong, Kyŏngju, North Kyŏngsang Province. Treasure no. 63

Paekche or their descendants. According to the records, the large bronze Buddha, which has been extensively restored, was made in 606 by the sculptor Tori, a highly esteemed third-generation Paekche craftsman who also made the well-known Shakyamuni Triad of 623 for Hōryū-ji.

It is difficult to generalize whether Koguryŏ or Paekche played a stronger role in influencing the development of Japanese Buddhist art. Though Paekche was closer historically and culturally to the Asuka court, Koguryŏ also played a significant role in the early phases of Buddhist art in Japan. Silla, on the other hand, entered late into the arena but quickly embraced the Buddhist religion and began to exert a strong influence in Japan in the seventh century.

Another element of Buddhist worship in China — the cult of the Amitabha Buddha — was also transmitted to Korea during the Three Kingdoms period, as can be seen in early-seventh-century images of the bodhisattva Avalokiteshvara. Avalokiteshvara, as mentioned earlier, can be identified iconographically by the crown he wears in which appears the figure of Amitabha, his spiritual father (see figs. 14, 15). Bodhisattva images of this time favor a double crossing of the scarf across the body, once at the waist and then at the knees, as in the gilt-bronze example from Samyang-dong, in Seoul (fig. 14). This style, along with the use of jewelry, reflects Sui-dynasty trends. In most cases the deity stands in a relaxed posture with the weight of the body on one leg. Beaded jewel ornamentation may be added over the body in an X-shape, as in the Kyuam-ni gilt-bronze bodhisattva from Paekche (pl. 64). Here, the elongated body of the figure is bent slightly at the narrow waist. Interest in voluminous modeling is apparent in the round face and in the way the

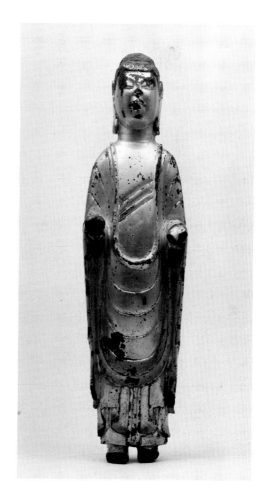

**Figure 13.** Standing Buddha, Three Kingdoms period, early 7th century, from Kangsang-myŏn, Yangp'yŏng-gun, Kyŏnggi Province. Gilt bronze, h. 11 ¾ in. (30 cm). The National Museum of Korea, Seoul. National Treasure no. 186

**Figure 14.** (facing page, left) Standing Avalokiteshvara, first half of the 7th century, from Samyang-dong, Seoul. Gilt bronze, h. 8 in. (20.3 cm). The National Museum of Korea, Seoul. National Treasure no. 127

**Figure 15.** (facing page, right) Standing Avalokiteshvara, Three Kingdoms period, Silla kingdom (57 B C E–668 C E), 7th century, from Sŏnsan, North Kyŏngsang Province. Gilt bronze, h. 8 ¼ in. (21 cm). The National Museum of Korea, Seoul. National Treasure no. 184

scarf, which seems to fall naturally, is caught at one end by the fingers of the left hand. An additional emphasis on three-dimensionality is apparent in the separation of the arms from the body and the continuation of the jewel ornamentation to the back of the figure. Although the casting technique and the details of the modeling are not meticulous, the generally harmonious proportions of the body, the inviting warmth of the facial expression, and the animated hand gestures all convey a lively and somewhat casual demeanor, a feature often encountered in Korean Buddhist images.[30]

Another gilt-bronze Avalokiteshvara, this one from Silla, discovered at Sŏnsan, in North Kyŏngsang Province, is at the same time more decorative in its body ornamentation and rigid in its posture (fig. 15). This lavishly decorated statue, which features a necklace with pendant ornaments, recalls the large stone image of the bodhisattva Avalokiteshvara in the Boston Museum of Fine Arts,[31] datable to the late Northern Zhou (557–581) or early Sui dynasty and a type that has been related to sculptures from Chang'an (modern Xi'an), which served as the capital in the Northern Zhou and in the Tang (618–907) period. These models must have been known to Korean sculptors, an indication of the active contacts between Korea and the mainland during the Sui and early Tang periods.

Among the most popular bodhisattva figures from the Three Kingdoms period is the so-called pensive bodhisattva, who sits with one leg pendant while the right hand touches the cheek. The model for this bodhisattva type, the young prince Siddhartha contem-

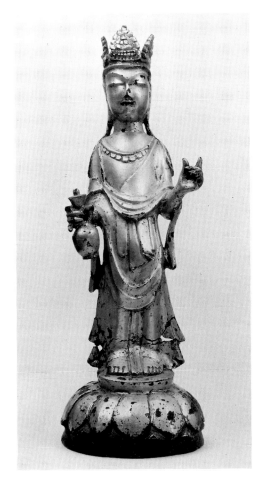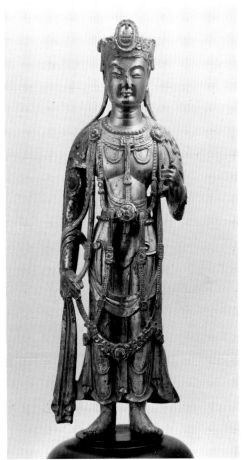

plating his role in the salvation of sentient beings, appeared first in India before being transmitted to China. This pensive figure, radiating an air of expectancy and promise, came to be regarded as the Buddha of the Future, or Maitreya, residing at present as a bodhisattva in the Tushita heaven. This type first appears in Koguryŏ in the sixth century, as seen in a gilt-bronze statue from P'yŏngch'ŏn-ni, P'yŏng'yang.[32] It is also found in Paekche in the sixth century, as represented by the statue from Mount Pusŏ mentioned below, and in the early seventh century, as represented, for example, in the Sŏsan Buddha triad (fig. 11) discussed above.

A small but fine gilt-bronze statue of a pensive bodhisattva of the late sixth to early seventh century (pl. 63) has traces of gold on its surface. Its crown, of a triangular shape with incised floral patterns, is topped with a sun disc above a crescent-shaped moon, which recalls the crown of the standing bodhisattva in the Sŏsan Buddha triad. A necklace and incised armlets decorate the simple form of the upper body, which is unusually elongated and without differentiation in the modeling of the chest and waist. The overlapping folds of the skirt, which appear very natural, drape the seat in an orderly fashion. The spiral design on the cushion on the back of the figure breaks the falling pattern of the skirt folds. Although the provenance of this piece is not known, it is usually ascribed to Paekche as its drapery pattern is similar to that of a fragment of a pensive bodhisattva statue in soapstone unearthed at Mount Pusŏ, in Puyŏ, and datable to the sixth century.[33]

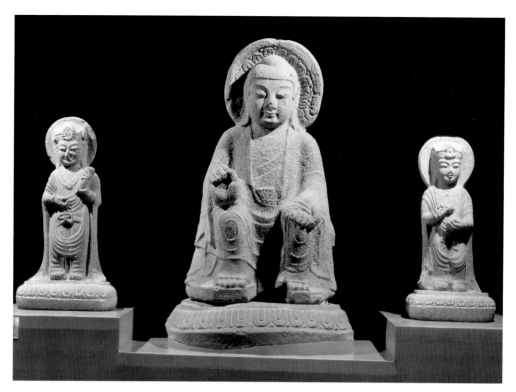

**Figure 16.** Buddha triad, Three Kingdoms period, Silla kingdom (57 B C E–668 C E), ca. 644, from Samhwa-ryŏng, Mount Namsan, Kyŏngju, North Kyŏngsang Province. Granite, h. of Buddha, 63 in. (160 cm); h. of bodhisattvas, 39 ⅜ in. (100 cm) and 38 ⅝ in. (98 cm). Kyŏngju National Museum

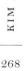
The best known of the more than twenty bodhisattva statues in pensive posture from the Three Kingdoms period are two large gilt-bronze statues in The National Museum of Korea, Seoul. Referred to as National Treasures no. 78 (pl. 60) and no. 83, they lack any inscription or specific reference in the historical record concerning their provenance.[34] Measuring 83.2 and 93.5 centimeters in height, respectively, these two statues exemplify, in their refined casting technique and skillful modeling, the highest levels of craftsmanship of the Three Kingdoms. The transitions between the parts of the body and between the overlapping garment folds and the detailed attention to ornamentation are subtle and meticulous. Each statue follows a different iconographic model. The dress, the scarves, the modeling of the body, and the "archaic smile" of the former suggests an Eastern Wei prototype, while the latter is an example of the Northern Qi tradition.

National Treasure no. 78 (pl. 60) is described as a "pensive bodhisattva wearing a crown topped with sun and moon design" since the broken part at the center of the crown is presumed to have originally held a sun disc atop a crescent-shaped moon. A similar motif has already been pointed out in connection with the crown of the standing bodhisattva in the Sŏsan triad and the small gilt-bronze pensive bodhisattva (pl. 63). The pointed necklace and the scarf that covers both shoulders and drapes down in front in an X-pattern can also be found in earlier bodhisattva images of the Three Kingdoms. The manner in which the scarf is draped at the back into a single U-shape finds an affinity in several Paekche bodhisattva statues of gilt bronze, particularly among those holding a jewel in both hands. The carving is shallow and the modeling is somewhat schematized, but the

precision and elegance in the lines convey a gentle movement that gives a lively feeling to the image. A subtle smile on the face invites the worshiper to share the deity's peace of mind and to experience his generosity and benevolence. An investigation of the statue's casting has revealed that the bronze is less than one centimeter thick, indicating a very sophisticated level of bronze-casting skill.

The larger of the two statues, National Treasure no. 83, is much simpler yet fuller in the modeling of the body, while the deeply cut folds of the skirt that cascade over the round base on which the bodhisattva is seated are more natural and realistic. A feeling of liveliness is created by the formal interplay between the austere simplicity with which the upper body is rendered and the more complex treatment of the lower half with a tightly clinging skirt over rounded knees. This statue, along with National Treasure no. 78 exhibited here, stands as an impressive piece not only technically for the superb casting of gilt bronze in a large format, but also for its transformation of a devotional image into a work of art.[35]

A statue of a pensive bodhisattva, carved of wood, in Kōryū-ji, Kyoto, compares very closely with National Treasure no. 83. The overall appearance of the figure, the shape of the crown, the simple modeling of the body, and the overlapping drapery folds suggest a Korean origin. In addition, the red pine wood used for this sculture was not a common material for Japanese wooden statues of the Asuka period. This bodhisattva statue can be linked to Silla on stylistic grounds and on the basis of historical references that document connections between the founder of the Kōryū-ji temple and the Silla Buddhist community.[36]

Representative of the last phase of Silla Buddhist sculpture, from around the mid-seventh century, is a stone Buddha triad that was discovered near the mountain peak of Samhwa-ryŏng at Mount Namsan, Kyŏngju (fig. 16).[37] The central Buddha is seated with both legs pendant, a new iconographic element. The position of the hands is also uncommon: the right hand is raised with all five fingers bent, while the left hand holds the end of the garment on the lap. The belt fastened around the waist with a ribbon knot is also an interesting new addition. An effort to suggest a realistic rendering of garment folds is indicated by the raised spiral pattern on the portion of the garment covering the legs. Otherwise the image, carved in the round, displays no clear articulation of the chest, hips, or legs. The head is large in proportion to the body so that the whole image looks stocky. All of this represents a conservative carving technique compared to the more realistic modeling of the body seen in smaller gilt-bronze images during the same period.

The two bodhisattvas flanking the central Buddha have facial expressions of childlike innocence. No specific attribute or hand gestures identify them. The crossing of the scarf twice across the body accords with a seventh-century style that is particularly reminiscent of the bodhisattva Avalokiteshvara from Samyang-dong (fig. 14). The posture of the bodhisattvas appears erect, but a side view reveals a slight bend of one leg, an indication of the thrice-bent posture and another characteristic feature of seventh-century-style bodhisattva statues reflecting Sui influence.

It is recorded in the *Samguk yusa* that a temple, Saeng'ŭi-sa, was built at Samhwa-ryŏng in the year 644 to enshrine an image of the Maitreya Buddha after the monk Saeng'ŭi encountered the Buddha disguised as a monk on his way up the mountain.[38] Another reference in the same source mentions that the monk Ch'ungdam regularly offered a tea ceremony before the image of Maitreya at Saeng'ŭi-sa on the third day of March and the ninth day of September.[39] The date mentioned in this record accords with the style and iconography of the Samhwa-ryŏng stone triad, which follows a fashion prevalent in Chinese sculptures from the late Sui and early Tang.

Comparisons of Korean Buddhist images of the Three Kingdoms with Japanese images of the early Nara period, in the second half of the seventh century, indicate a common style and iconography. However, since very few records or images remain, such comparisons can only offer suggestions. One case is the beautiful wooden statue of Avalokiteshvara at Hōryū-ji, known as the Kudara Kannon.[40] Kudara is the Japanese name for Paekche, though, in this instance, there is no temple record concerning the history of the statue, either its date of carving or whether it was made in Paekche or by Paekche immigrants in Japan. It is said that the name was ascribed to the statue at the beginning of the twelfth century because its unusual foreign elements recalled Paekche sculptures. Scholars seem to agree that it was made in Japan since it was carved from Japanese camphor, a material often used in such seventh-century wooden sculptures as the famous Yumedono Kannon at the same temple. The Yumedono Kannon, however, follows the conservative Japanese Tori style (a reference to the sculptural style established by Tori, the descendant of Paekche immigrants who created the Hōryū-ji Buddha) prevalent already in the early seventh century, while the Kudara Kannon represents an advanced seventh-century style reflecting Sui and early Tang influence. The softly modeled face with its warm, inviting smile reminds one of the facial expressions seen in such Paekche statues as the Sŏsan triad. Likewise, the delicate carving of the body and the garments, the elegant posture of the elongated body, and the openwork crown stand somewhat apart as foreign elements among more typical Japanese sculptures of the time. One is therefore inclined to suggest for the Kudara Kannon a possible Paekche connection. Of the very few Paekche Buddhist sculptures that survive, none are in wood. The existing examples of Buddhist images in Japan that show Korean influence, like the Kudara Kannon, are helpful in reconstructing how Korean statues, especially those of Paekche, might have looked.

## UNIFIED SILLA

Buddhism continued to prosper and play an influential role in religious and artistic life after the Silla kingdom unified the Korean peninsula by overthrowing Paekche in 660 and Koguryŏ in 668. In the subsequent Unified Silla period, which lasted nearly three hundred years, from 668 to 935, the royal court and aristocracy were ardent patrons of the construction of temples and pagodas and the production of Buddhist images. Visiting monks from China brought newly translated Buddhist texts, which led to the establishment of

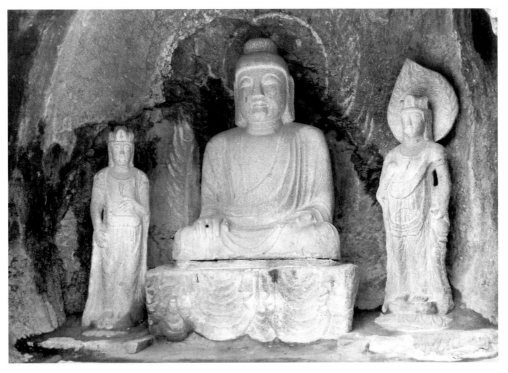

Figure 17. Amitabha Buddha triad, Unified Silla (668–935), second half of the 7th century. Granite, h. of Buddha, 113 ⅜ in. (288 cm). Kunwi-gun, North Kyŏngsang Province. Treasure no. 109

several sects. There were also frequent exchanges of envoys with the Chinese Tang court, and Silla society became more cosmopolitan through its acceptance of Tang Buddhist culture and art. Eminent Korean monks traveled to China as well,[41] and also had direct contacts with the Indian Buddhist community.

While newly introduced types and styles of Buddhist images from China and India enriched the iconographical repertoire and contributed to the common international style that characterized Buddhist sculptures of the period, artistic traditions inherited from the fallen Koguryŏ and Paekche kingdoms played a role in the formation of Unified Silla art.[42] The indigenous traditions of the Silla kingdom likewise contributed to the development of Unified Silla sculpture. Evidence of this can be seen in the Amitabha Buddha triad at Kunwi, North Kyŏngsang Province (fig. 17), dating from the second half of the seventh century, probably not long after unification.[43] The stocky body and large, solemn face of the Buddha and the shape of the crowns of the bodhisattvas resemble the sculptural idiom of the earlier Samhwa-ryŏng Buddha triad at Mount Namsan, in Kyŏngju (fig. 16), but the elongated bodies of the bodhisattvas and the scarfs they wear draped across the body display a naturalistic rendering that comes from a more advanced workmanship in carving stone. The relaxed and natural tribhanga stance of the two figures was in vogue in China from the Sui dynasty onward.

Many extant Buddhist works from the early Unified Silla period testify to the belief that personal well-being as well as protection of the nation from external threats could be secured by devotion to Buddhism. The concept of *hoguk pulgyo*, literally "protect-the-nation Buddhism," was the driving force behind the production of large-scale images and

the construction of temples with the support of the royal family or the government. For example, the Sach'ŏnwang-sa (Temple of the Four Guardian Kings) was established in Kyŏngju, the capital of Unified Silla, in response to the threat of invasion by the Tang army, which sought to extend Chinese settlement in Silla territory after having assisted Silla to unify the peninsula. The consecration ceremony for the temple was held in 671. It is recorded that soon thereafter a storm arose, causing the Tang ships and armies to sink in the Yellow Sea. Based on the foundation stones of the wooden structures, Sach'ŏn-wang-sa, which was completed in 679, is considered the earliest known Buddhist temple in Korea laid out on an architectural plan with two pagodas.

Fragments of molded earthenware guardian kings have been unearthed from the Sach'ŏnwang-sa site (fig. 18). The images, thought to have been placed on the walls of the pagodas, are individually molded in high relief on panels measuring almost 80 centimeters square. They are covered with a green lead glaze. From remaining fragments two images have been reconstructed to give us the general figuration of armored guardians seated on the backs of crouching demons whose faces appear contorted with pain.[44] Both guardians hold weapons, one an arrow and a bow, and the other a sword. The modeling of the faces of the demons and the legs of the guardian figures is realistic, and the ornamentation of armor worn by the guardians is detailed.

Besides serving as clear examples of the realistic rendering of Unified Silla sculpture in the late seventh century, these guardian figures also reveal a close relationship between Unified Silla and contemporaneous Tang sculptural trends in Buddhist iconography and style. Similar guardian images in sculptural form appear in China in the cave temples of Dunhuang and Longmen from the mid-seventh century. A good comparative example can be seen in the Fengxiansi cave-temple at Longmen, constructed between 672 and 675 during the reign of Emperor Gaozong (r. 649–83).[45] At the sides of the high lotus pedestal of the main Vairochana Buddha are guardians in half-seated posture.

Another example of the belief in the protecting power of the Buddhist faith can be found about thirty kilometers east of Kyŏngju, near the eastern sea coast, at the temple site of Kamŭn-sa, which was completed in 682. In the sea not far from the temple site is a group of rocks called Taewang-am (Rock of the Great King), a reference to King Munmu (r. 661–81), who successfully carried out Silla's unification of the peninsula, laid the foundation for political stability, and initiated the prosperous era of Buddhist culture and internationalism in Unified Silla art. Before he died, the king expressed a wish to be cremated, according to Buddhist custom, and have his ashes spread over the Eastern Sea so that he might be reborn as a sea dragon and thereby protect the nation from neighboring Japan. It has been suggested that the rock is his underwater burial site. Whether the ashes were spread over the site or whether a reliquary was buried there is not known.

Buddhist gilt-bronze reliquary boxes were discovered at the Kamŭn-sa site, one from the West Pagoda in 1960 and another from the East Pagoda in the spring of 1996. These four-sided reliquary boxes (*sariham*) of finely crafted metalwork contain elaborately

**Figure 18.** Directional Guardian, Unified Silla (668–935), ca. 679, from temple site of Sach'ŏnwang-sa, Kyŏngju, North Kyŏngsang Province. Earthenware with green lead glaze, 20 ⅞ × 23 ⅝ in. (53 × 60 cm). Kyŏngju National Museum

shaped miniature shrines in which are placed glass bottles to hold the relics (Kr. *sari*; Sk. *sarira*) of the Buddha. To each outer side of the reliquary box a directional guardian image in bronze repoussé was attached, including an image of the guardian of the East (Dhritarashtra) who grasps in his left hand a mace and stands on a crouching demon (fig. 19).[46] Though some of the images are partly broken, these two sets of four guardians are among the earliest examples in Korea of standing armored guardians. The details of the armor, the curly hair, round faces, and standing postures resemble very closely those of the guardians at the Fengxiansi cave-temple at Longmen. Thus, the iconography of armored guardians seems to have been well established in China by the second half of the seventh century. Since we know that the Kamŭn-sa guardian images were made at the time of the temple's construction in 682, they are a good example of the international style of Unified Silla Buddhist art prevailing during that period.

Another important example demonstrating common iconography and the international style are the gilt-bronze plaques found in Anap-chi (Pond of Wild Geese and Ducks), Kyŏngju, part of the royal palace garden that was begun in 674.[47] While most of the artifacts discovered in the pond during the excavation in the 1970s served a purely secular function in court life, a number were Buddhist images. These include two Buddha triads and two sets of four seated bodhisattvas, which are thought to be among the earliest group of Buddhist objects found at Anap-chi probably used for private worship within the palace compound. In the triad exhibited here (pl. 66) the central Buddha is seated on a decorative lotus pedestal, his hands in the form of the *dharmachakra*, or gesture of preaching. The garment he wears covers both shoulders and flows naturally over the body in raised folds with double ripples, suggesting volume and realistic texture. The outer rim of the openwork aureole has several small holes for nails, which suggests that these plaques were probably fixed to the wooden surface of a small portable shrine. The triad can be dated to about 680 based on inscriptions on square floor tiles decorated with relief floral patterns found at one of the buildings at the Anap-chi site.

**Figure 19.** Dhritarashtra, Unified Silla (668–935), 682, from sarira reliquary, East Pagoda of Kamŭn-sa Temple, Yangbuk-myŏn, Wŏlsŏng-gun, North Kyŏngsang Province. Gilt bronze, h. 10 ⅝ × 7 ½ in. (27 × 19 cm). The National Research Institute of Cultural Properties

**Figure 20.** Mold for a seated Buddha, Unified Silla (668–935), late 7th century, from West Pagoda of Hwaŏm-sa Temple, Masan-myŏn, Kurye-gun, South Chŏlla Province. Bronze, 2 ¾ × 3 ⅛ in. (7.1 × 8.1 cm). The National Research Institute of Cultural Properties

The triad's two attending bodhisattvas hold lotus flowers in full bloom and stand in the tribhanga pose, with their waists bent toward the Buddha. One foot of each bodhisattva is partially visible behind the lower part of the lotus pedestal, another indication of the attention to detail by the sculptor of this triad. Their wavy hair arranged in high chignons, round faces, broad chests, and narrow waists all add to the full and sensuous modeling of their bodies and indicate the arrival of the new bodhisattva style then prevalent in Tang China. There also exists a formal tension between the fullness of the bodies and the tightly worn garments, which contributes to the dignity the images convey. This characteristic as well as the advanced casting technique became the basis of the international style shared by both Korean and Japanese sculptures.

Comparable Chinese and Japanese examples suggest that the type of Buddha image discovered at Anap-chi represents the Buddha Amitabha.[48] The depictions of Amitabha and his attendants in the Western Paradise that can be seen in the wall paintings in the Golden Hall at the Japanese temple Hōryū-ji closely resemble in iconography the Anap-chi Buddha triad. Another very similar Japanese image in bronze is found among the gilt-bronze repoussé images of Amitabha and his attendants, including the ones in Hōryū-ji and the Tokyo National Museum,[49] which date from the early eighth century. A bronze mold for mass production of clay images of a preaching Buddha, recently discovered in Korea at the West Pagoda at the temple site of Hwaŏm-sa, in Kurye, South Chŏlla Province (fig. 20),[50] shows a Buddha comparable to the Anap-chi figure not only in hand gesture but also in the treatment of the garment in front. The mold indicates as well the popularity of this image type in Unified Silla during the late seventh century.

**Figure 21.** Standing Buddha, Unified Silla (668–935), ca. 692, from temple site of Kuhwang-dong, Kyŏngju, North Kyŏngsang Province. Gold, h. 5 ½ in. (14 cm). The National Museum of Korea, Seoul

**Figure 22.** Standing Maitreya, Unified Silla (668–935), 719, from temple site of Kamsan-sa, Naedong-myŏn, Wŏlsŏng-gun, North Kyŏngsang Province. Granite, h. 72 ¼ in. (183 cm). The National Museum of Korea, Seoul. National Treasure no. 81

All of these examples offer clear evidence of shared stylistic features, not only in the iconography but also in the treatment of garment folds, the fullness of the faces and bodies of the figures, and the sensuous appearance of the bodhisattvas. The discovery of the Anap-chi Buddhist triad thus offers an important link in the development of the international style, in which Indian prototypes flourished in China during the Tang period, were adapted in Korea in the Unified Silla, and underwent a further transformation in Japan in the Tenpyō period (729–48).

From the late seventh to the early eighth century, Unified Silla Buddhist images attained full volume and realism in the modeling of the body and of the garment folds, a result of the great refinement achieved in the techniques of stone-carving and bronze-casting. Representative pieces from around the year 700, commissioned by the royal family, are the Buddha statues discovered in a reliquary box recovered from the pagoda at the Kuhwang-dong temple site, in Kyŏngju.[51] Two pure gold Buddha statues, one standing (fig. 21) and one seated,[52] reflect the high level of workmanship and the style prevalent at that time in the capital. On the basis of the style, which is characterized by the realistic treatment of the naturally flowing garment folds and by the modeling of the full face and body, the seated Buddha is thought to represent the Amitabha Buddha, whose name is mentioned in the inscription, dated 706, on the inside of the cover of the reliquary box

in which the figures were found. The masterly technique of the openwork mandorla also points to a later date for this figure than that of the standing Buddha. This standing Buddha follows a more conservative treatment in the continuous U-shaped folds of the garment and in the somewhat hesitant facial expression. It is generally thought that the standing image was installed in the pagoda at the time of its erection in 692 while the seated Buddha was installed at a later date.

The treatment of the garment folds in the Kuhwang-dong standing Buddha is further developed in a gilt-bronze standing Buddha image (pl. 67), formerly in the Tong'wŏn Collection and now in The National Museum of Korea. This figure is characterized by the idealized facial countenance, the naturally flowing garment folds falling in concentric U-shapes, and the dignified posture, all of which reflect an early-eighth-century sculptural style.

Most Unified Silla standing Buddha figures, whether in stone or in gilt bronze, belong to one of two types in the treatment of the garment folds over the legs. The first type, seen in the two previously discussed standing figures (fig. 21, pl. 67), shows a drapery pattern of multiple U-folds over the entire body, including the legs. The second type is well represented by the Metropolitan piece exhibited here (pl. 68). It is characterized by garment folds that separate at the waist and fall over the legs in symmetric double U-folds. The classic example of this type of garment treatment in the Unified Silla is found in a life-size granite statue of a Buddha from Kamsan-sa, a temple site in Kyŏngju.[53] The inscription, dated 719, on the back of the mandorla of this impressive figure informs us that it is the Buddha Amitabha, which was carved along with a statue of the bodhisattva Maitreya for the temple at the request of a retired official, Kim Chi-sŏng. This type of standing Buddha image goes back to Central Asian models and can be found in caves at Yungang and Longmen dated to the late fifth and mid-seventh centuries, respectively. In Korea the type appears early in the Unified Silla period and was widely copied.[54] In the second type, there is often a modification of the garment on the upper part of the body, with the garment either draped over the right arm as in the Metropolitan piece, or gathered slightly and tucked in at the waist as in a gilt-bronze standing Buddha of Medicine in The National Museum of Korea (pl. 69).

The bodhisattva statue from Kamsan-sa offers another outstanding example of shared Tang sculptural features, namely, the sensuous modeling of the full body, the relaxed posture, and rich ornamentation (fig. 22). Other elements derived from Tang models that contribute to the international style include the shape of the headdress, the necklaces, and the mode of wearing the scarf diagonally across the chest. Good comparative Chinese examples from the early eighth century are the bodhisattva relief figures from Baojingsi, Xi'an.[55] In its overall style, the bodhisattva can also be profitably compared with figures in the wall paintings of Hōryū-ji or with the reconstructed bodhisattva drawings on the wooden door panels of the Tachibana Shrine, also at Hōryū-ji, datable to the first half of the eighth century.[56]

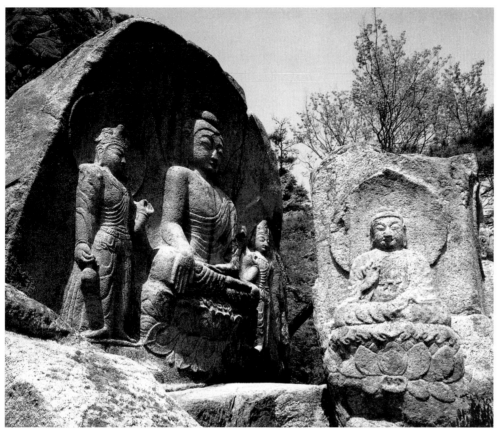

**Figure 23.** Seated Buddhas and Buddha triad, Unified Silla (668–935), early 8th century. Rock carving, h. of Buddhas, 104 ¾ in. (266 cm). Ch'ilburam, Mount Namsan, Kyŏngju, North Kyŏngsang Province. Treasure no. 200

Scattered in and around the ancient Silla capital of Kyŏngju are many Buddhist sites. Mount Namsan, south of the city, still preserves temple sites and Buddhist images from both the Silla kingdom and Unified Silla. Most of these images are carved in relief on the rock cliffs, but some are incised or sculpted in the round. Among the best preserved and most important examples of Unified Silla Buddhist sculpture at Mount Namsan is a group of seven images at Ch'ilburam — four seated Buddhas carved in relief on a four-sided stone pillar and a triad consisting of a Buddha and two bodhisattvas carved out of the rock surface facing the pillar — datable to the early eighth century (fig. 23). The Buddha images on the pillar represent the Buddhist paradises of the four cardinal directions based on established Buddhist cosmology.

The *bhumisparsha*, or earth-touching, gesture of the central Buddha in the Ch'ilburam triad is a new addition to Buddhist iconography in Korea during the eighth century. The earth-touching gesture signifies the moment of enlightenment of the historical Buddha Shakyamuni, when he called on the earth god with his right hand to witness his victory over the temptations of the demon Mara. In his *Da Tang xiyouji* (Travel Record of the Western Regions), the Chinese monk Xuanzang (602–664) records that an auspicious image of the seated Buddha with the same hand gesture was enshrined at the Mahabodhi Temple in Bodhgaya, in the modern state of Bihar, in northeastern India.[57] This is the site of the bodhi tree, under which the prince Siddhartha Gautama meditated and attained

enlightenment. The image was worshiped by Buddhist pilgrims, and the statue was copied and served as the model for many later Chinese images.[58] This earth-touching mudra appears in Tang sculptures in the late seventh century. It can be seen in the Long-men caves, especially among the main Buddha images at the Leikudai cave dating from the period of Empress Wu (r. 690–705). Several stone panels with relief images of Buddha triads from Baojingsi Temple in Xi'an, bearing inscriptions dated 703, 704, and 724, also portray the central Buddha with hands formed in the earth-touching gesture.[59] These panels, which are representative of Tang sculpture in the early eighth century, generally serve as good stylistic comparisons with the Ch'ilburam group, for example, in the way the scarves are worn diagonally across the chests of the attendant bodhisattvas.

Another important stone Buddhist monument from the second quarter of the eighth century is the Samyŏnsŏkpul, or "four-sided boulder with Budda images," a group of carved images located at the foot of Mount Sogŭmgang, in the northern part of Kyŏngju.[60] It shows a variety of Buddhist iconography as well as the refined carving skill achieved by Unified Silla sculptors by the early eighth century. The most important figure in the group, in terms of the iconography, is an incised image of an eleven-headed, six-armed Avalokiteshvara on the north side of the pillar.[61] It is the only known remaining multi-faced and multi-armed Avalokiteshvara from Unified Silla. The worship of this divinity played a prominent role in esoteric Buddhism, in which the supernatural aspects and magical power of the deity are emphasized. Various esoteric forms of the Avalokiteshvara can be seen in China in wall paintings at Dunhuang and in Japan in sculpture from the Tenpyō period, such as the Fukūkenjaku Kannon at Tōdai-ji Temple, Nara. In Korea, an eleven-headed, two-armed Avalokiteshvara image exists among the carved reliefs in the Sŏkkur-am cave, in Kyŏngju, and another example carved in the round is in the Kyŏngju National Museum.

It is in the cave-temple of Sŏkkuram that one finds the finest group of stone sculptures from eighth-century Unified Silla. Located on top of Mount T'oham in the eastern outskirts of Kyŏngju, this man-made cave was carefully assembled with cut stone panels according to a precisely calculated architectural scheme. The *Samguk yusa* records that the high official Kim Tae-sŏng (d. 774), as an expression of his reverence for the parents of his former and present lives, ordered the building of the Sŏkkuram grotto and the main temple, Pulguk-sa, at the foot of Mount T'oham.[62] Construction, begun in 751, was not finished at the time of his death in 774, at which time the government took over the project.

The cave consists of a rectangular anteroom and a round main hall with a domed ceiling, connected by a narrow corridor. At the center of the round chamber sits the main Buddha image, high on a lotus throne with his right hand in the earth-touching gesture (fig. 24; Best, fig. 3). His posture is majestic, and his idealized facial features display a warm, benevolent smile. The simple modeling of the broad chest, the round and voluminous crossed legs, and the discreet suggestion of movement in the fingers imbue the image with life, spirituality, and dignity.

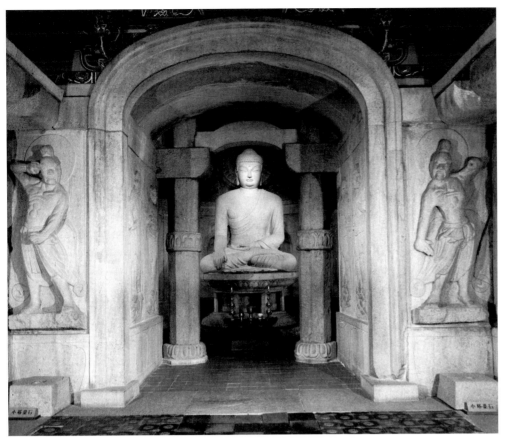

**Figure 24.** Seated Buddha, Unified Silla (668–935), second half of the 8th century. Granite, h. 127 in. (326 cm). Sŏkkuram Cave-Temple, Kyŏngju, North Kyŏngsang Province. National Treasure no. 24

Research has shown that the size of the Buddha is almost identical to that of the seated Buddha at the Mahabodhi Temple in Bodhgaya, as described in Xuanzang's travel record. Many seated Buddha images extant from the late Gupta (4th–6th century) to the Pala (8th–13th century) period displaying the earth-touching gesture certainly reflect the popularity of the type in India. They compare well with the Sŏkkuram Buddha not only in the hand gesture but also in the mode of wearing the garment with the right shoulder bare and in the fan-shaped garment folds between the crossed legs.

The Buddha is surrounded by two devas, Brahma and Indra, by two bodhisattvas, and by ten disciples, all arranged symmetrically on either side of the entrance, along the interior wall. The famous eleven-headed bodhisattva Avalokiteshvara is at the back center, behind the Buddha. Four directional guardians are carved on either side of the walls of the corridor, and in the anteroom each wall is carved with the Eight Parivaras, or demonic guardians, representing various classes of lesser gods who protect the Buddhist realm and teachings. The images and the cave embody the Buddhist paradise: the various levels of the Buddhist hierarchy—the Buddha, bodhisattvas, devas, and arhats (*nahan*)—are arranged according to the order of their ranks and roles in the Buddhist pantheon.

Except for the Buddha, all the images are carved in relief on rectangular panels, which themselves form the interior walls of the artificially structured domed cave. All have been carved with refined skill in the modeling of the bodies, showing subtle move-

**Figure 25.** Seated Vairochana Buddha, Unified Silla (668–935), datable to 766. Granite, h. of Buddha, 42 ½ in. (108 cm). Temple site of Sŏngnam-sa, Mount Chiri, Naewŏn-sa, Sanch'ong, North Kyŏngsang Province

ments in their elegant postures. The idealized facial features and expressions invite the worshipers to enter a deep devotional state. The garments, which overlap on multiple levels, and the exquisite ornamentation of the jewelry are described with such clarity and detail that they almost seem to have been drawn rather than sculpted. There is a balance in the proportion of the figures, even when one takes into account the size and the distance between the deity and the viewer. This artistic interpretation of spirituality and benign dignity, enhanced by carving of the highest technical achievement, culminates in the representation of the eleven-headed Avalokiteshvara. There are subtle differentiations in the several layers of the planes of body, the drapery folds, and the jeweled ornamentation. The Sŏkkuram images mark the height of the stylistic development of Unified Silla Buddhist sculpture, while the architectural structure of the domed cave temple is unique.[63]

The Sŏkkuram Buddha started a vogue in the representation of seated Buddha images in the late Unified Silla period. Many extant seated figures from the late eighth to the ninth century, most of which are in stone or iron, follow the type, which continued to be made until the early Koryŏ dynasty (918–1392). During this time local characteristics became pronounced — the countenance was shown with high cheekbones or raised slit eyes, while bodies became slimmer. In the process the type lost its earlier dignity, but attained more naturalness and humanistic expression.

With the decline of Buddhism in Tang China from the late eighth century and certainly after the Buddhist persecutions of the mid-ninth century, many Unified Silla monks returned to Korea from their studies in China and became active as Sŏn (Ch. Chan; Jp.

**Figure 26.** Seated Vairochana Buddha, Unified Silla (668–935), dated 865. Top'ian-sa Temple, Tongsŏng-myŏn, Ch'ŏrwŏn-gun, Kang'wŏn Province. Iron, h. 35 ⅞ in. (91 cm). National Treasure no. 63

Zen) priests, establishing Sŏn Buddhist temples at nine regional centers on the peninsula. In Korea, Sŏn Buddhism emphasized textual studies as an important part of religious practice, and it is known to have been influenced by the *Avatamsaka Sutra* (Kr. *Hwaŏm-gyŏng*; Ch. *Huayan jing*), a text that was highly regarded because of its revelations about the evolution of Buddhist thought, from its early beginnings to the complex doctrines of Mahayana Buddhism. The sutra, first introduced in Korea in the late seventh century by the eminent Silla monk Ŭisang (625–701), was incorporated in Sŏn Buddhism.

Vairochana, the most important of the five transcendant Buddhas and the supreme deity of the *Avatamsaka Sutra*, was evidently popular in the late Unified Silla. The images of the Buddha were enshrined in many temples associated with Sŏn Buddhism, which became the dominant sect in Korea from the ninth century onward. Vairochana is identified by his characteristic mudra, *bodhyagri*, in which the five fingers of the right hand clasp the index finger of the left hand, symbolizing, among other things, the unity and harmony of wisdom and knowledge, of sentient beings and the Buddha, of innocence and enlightenment.

In Korea, the earliest known datable image of Vairochana that displays this hand gesture is the seated stone Buddha at the temple site of Sŏngnam-sa at Mount Chiri, North Kyŏngsang Province (fig. 25).[64] A sarira jar inscribed with a date of 766 was found inside the hollow lotus pedestal on which the Buddha is seated. The inscription mentions the making of the Vairochana Buddha, evidence of the early appearance of the iconography in Unified Silla. Most other Unified Silla images of this Buddha date from the ninth century,[65] including an iron statue from Top'ian-sa Temple, in Ch'ŏrwŏn district,

Kang'wŏn Province, an area that was on the northern border of Unified Silla territory (fig. 26). An inscription cast on the back of the figure states that it was made in the year 865 by a group of local Buddhists for the temple, which still exists today. (The statue and the high lotus pedestal, also cast in iron, survived intact through the Korean War of 1950–53, when the area was at the center of intense military activity.) The Top'ian-sa Vairochana displays local stylistic features characteristic of late Unified Silla, such as the schematized layers of the garment folds, the narrow span of the shoulders, and the contrasting width of the crossed legs. This figure is one of many Buddha images cast in iron, a material that came into wide use for large-scale statues between the ninth and eleventh centuries in Korea.[66]

Four gilt-bronze panels from a pagoda at Tonghwa-sa Temple, in Taegu, North Kyŏngsang Province, each incised with a Buddha triad, offer evidence of esoteric Buddhist imagery in Unified Silla in the second half of the ninth century (pl. 47). The panels originally formed a reliquary box, in which an inscribed stone sarira jar was placed. The inscription states that the reliquary was placed in the pagoda in 863 in honor of the spirit of King Minae (r. 838–39), who died at a young age, a victim of political conflict at the court.[67]

One of the Buddha triads includes a seated Vairochana, his hands held in the characteristic bodhyagri gesture. In this instance, the Buddha wears the crown of a bodhisattva, an iconographic element clearly derived from his status as Mahavairochana (the Great Illuminator), the source of the entire universe in esoteric Buddhism. This form of Buddhism, which developed in China from the middle of the eighth century, was not as influential in Unified Silla as it was in Japan where it was practiced by the prominent Shingon sect. Although its doctrines, and especially its complex rituals, must have been well known to the Unified Silla Buddhist community, esoteric Buddhism was apparently overshadowed in Korea by the popularity of the Avatamsaka teachings propagated by Sŏn Buddhists. The other three triads on this reliquary box include a Buddha displaying the earth-touching gesture, a Buddha with his hands in the teaching (*vitarka*) gesture, and a Buddha holding a medicine jar. This iconography does not accord exactly with the orthodox esoteric mandala, in which the crowned Mahavairochana Buddha of the Diamond World appears in the center of the four directional Buddhas. The incised lines of the triads are somewhat loose and casual, but the posture of the bodhisattva figures, the shape of the lotus pedestals, and the designs above the figures are fluently drawn and offer a good example of ninth-century pictorial versions of Buddhist images.

Facing the Tonghwa-sa pagoda from which this reliquary comes is a small chapel that houses a stone seated Vairochana Buddha, an image thought to date from the time of the reliquary.[68] The sculptural style manifests several characteristics that became common in Korean Buddhist sculpture by the ninth century, such as a compact body and uniform, regular garment folds. The U-folds of the garment covering the crossed legs of the Buddha are another characteristic of seated Buddha figures of the late Unified Silla. As is the

case with the iron Vairochana from Top'ian-sa, there also occurs around this time a decline in the austerity of expression in comparison with eighth-century images. The facial features, formerly idealized, become more human and are gradually replaced with a more Korean-looking countenance, one with high cheekbones, narrow eye slits, and an unpretentious, warm smile.

In the final years of the Unified Silla period, Buddhist activities shifted from the capital to local regions due to constant power struggles and political instability at the court. Some members of the ruling family fled to the countryside, where they built up competing power bases and became great patrons of Buddhism and its monasteries. Thus we find many important Buddha images from this period outside the capital. From the ninth century onward, seated Buddha images generally follow two types. The first is the sculptural idiom of the Sŏkkuram Buddha image with the earth-touching mudra. There are slight variations in the treatment of the garment folds, but the fan-shaped folds between the crossed legs are usually preserved.[69] The second type of seated Buddha image follows the iconography of the Vairochana Buddha, with the bodhyagri mudra, and is itself a late development.

The diminishing influence of Tang Chinese Buddhist art, from the late eighth century onward, and the rise of Buddhist centers away from the capital city led to freer interpretation of earlier established styles of Buddha images. The late sculptural style of the Unified Silla period is characterized by the appearance of such native elements as less austere facial features, unpretentious expressions, freer deployment of garment folds and ornamentation, and more compact bodies. The move away from earlier international stylistic elements in favor of the development of a native artistic tradition eventually gives rise to a distinctly Korean type of Buddhist sculpture.

## KORYŎ DYNASTY

Buddhism enjoyed widespread favor during the Koryŏ period and flourished under the patronage of the royal court as the state religion. The center of political power shifted from the southeast region, the location of the former Unified Silla capital Kyŏngju, to the central region of the peninsula and the new capital Kaegyŏng (modern Kaesŏng, in North Korea). This change affected the building of temples and pagodas and the production of Buddhist sculptures. Wang Kŏn (T'aejo; r. 918–43), the founder of the Koryŏ dynasty, constructed ten temples in Kaegyŏng one year after the establishment of the dynasty in 918. In an attempt to consolidate royal power and to gain support of the powerful Buddhist hierarchy, Wang Kŏn also had temples built in local areas where the struggle for political unification had been waged. Buddhism was privately supported by many members of the royal family as well as newly installed Koryŏ officials and even the local strongmen of the former Unified Silla. At the time the Koryŏ dynasty was established, China was divided into several contending states, both Chinese and non-Chinese. Throughout the Koryŏ period, the court maintained relations with the different succeeding dynasties on the

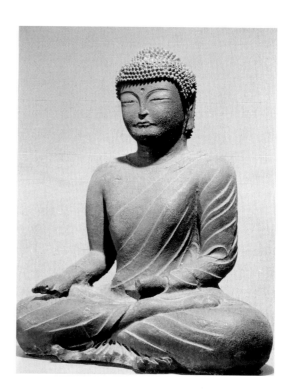

**Figure 27.** Seated Buddha, Koryŏ dynasty (918–1392), 10th–11th century, from near Wŏnju, Soch'o-myŏn, Wŏnsŏng-gun, Kang'wŏn Province. Iron, h. 37 in. (94 cm). The National Museum of Korea, Seoul

mainland — Liao (916–1125), Song (960–1279), Jin (1115–1234), and Yuan (1272–1368) — and the influence of these various dynasties is reflected in Koryŏ Buddhist sculpture.

Though there is documentary evidence concerning the production of many Buddhist images in the new capital of Kaegyŏng, few examples have survived. The once flourishing Buddhist culture and art of the Koryŏ period can best be observed among the remains of temples, pagodas, and *pudo*, memorial stupas of eminent monks, and the accompanying inscribed stelae that are scattered throughout the countryside. Pudo, which contain the relics of Sŏn monks, began to appear in the early ninth century during the Unified Silla period. Few of the extant Buddhist sculptures from Koryŏ are dated, nor is there any record of their production in most cases.

At the beginning of the Koryŏ period, most images still follow the general types and styles of late Unified Silla sculpture. An iron seated Buddha from Ch'un'gung-ni, Kwangju, Kyŏnggi Province, for instance, is almost a replica of the Sŏkkuram Buddha: it displays the earth-touching hand gesture, and one shoulder is covered by the garment that then falls in continuous fan-shaped folds between the crossed legs.[70] The change in style in early Koryŏ sculpture, in part due to the iron medium, can be seen in a certain stiffness in the modeling of the body and the mannered carving of the facial features. Images of the Buddha Vairochana were also produced in the Koryŏ period in both iron and stone, as seen, for example, in an iron seated Vairochana dating from the tenth to the eleventh century. The rough finish of the curled hairs and the visible joint marks from the casting process contribute to the less refined appearance of the figure as viewed today, but it would originally have been gilded.[71]

A more specifically Koryŏ interpretation of Unified Silla prototypes can be seen in several extant iron images from the area of Wŏnju, Kang'wŏn Province, which have dis-

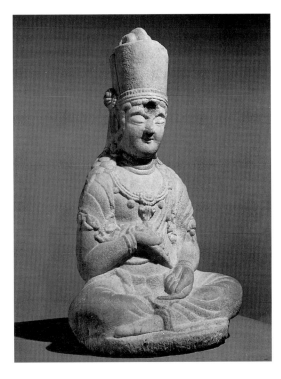

**Figure 28.** Seated Bodhisattva, Koryŏ dynasty (918–1392), 10th century, from temple site of Hansong-sa, Kangnŭng, Kang'wŏn Province. Marble, h. 36 ⅜ in. (92.4 cm). The National Museum of Korea, Seoul. National Treasure no. 124

carded the earlier gentle, curved lines in their modeling in favor of slender bodies with less subtle articulation of the structure of the body (fig. 27). The garment folds in turn cling closely to the elongated bodies, and the once idealized facial features have been transformed into more uniquely Korean countenances with prominent eyebrows and cheekbones, long horizontal slits for eyes, and small mouths. The iron Buddha head illustrated in plate 70 shares these characteristics with the Wŏnju images. The face appears smaller, with less volume to the cheeks, and the heavy snail-curls of the hair are prominent. The Buddha's mystical smile and serene expression are characteristically Korean and convey a feeling of spirituality combined with benevolence. It seems that there was an active iron-casting workshop in the Wŏnju area in the early years of the Koryŏ period. Although records have not yet revealed any local patrons or a Buddhist community in the area, the images certainly form a distinct local group.

Bodhisattva figures of the early Koryŏ period also differ from Silla models, as demonstrated by a group of stone seated bodhisattvas from the Kangnŭng area, in Kang'wŏn Province. Three examples—a seated marble bodhisattva from the Hansong-sa temple site (fig. 28) and two kneeling images, one from the front of the pagoda at the Sinbok-sa temple site[72] and another from the front of the nine-story octagonal pagoda at Wŏl-chong-sa, Mount Odae[73]—all wear high cylindrical crowns and display similar facial features in their full, round cheeks and chins and long curved eyes. They also resemble one another in the plump modeling of their bodies and the thick carving of necklaces and armlets. In their ornamentation and in the shape of the headdresses, these statues reveal stylistic affinities with Chinese images produced during the Five Dynasties (907–60) and the Liao dynasty.[74] Similar Liao bodhisattva figures are found at the Lower Huayansi Temple, in Datong, the earliest group of which dates from 1038.

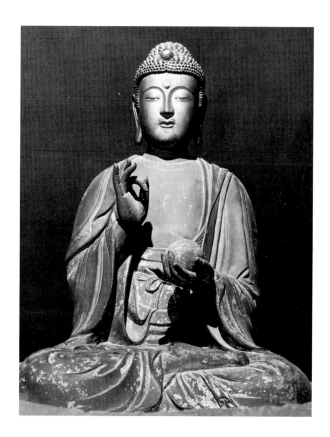

**Figure 29.** Seated Buddha of Medicine (Bhaishajyaguru), Koryŏ dynasty (918–1392), dated 1346. Bronze, h. 34 ⅝ in. (88 cm). Changgok-sa Temple, Ch'ŏng'yang, South Ch'ungch'ŏng Province. Treasure no. 337

Overpoweringly large images in stone were produced in the tenth century in the southwestern part of the peninsula. A bodhisattva statue measuring about eighteen meters high at the temple of Kwanch'ok-sa, Nonsan, North Chŏlla Province, is a representative example.[75] According to a temple record, this image, better known as the Ŭnjin Mirŭk, or Maitreya of Ŭnjin, was finished in 968. It took about thirty years to complete under the supervision of the eminent monk Hyemyŏng, who was active during the time of King Kwangjong (r. 949–75). During this period the political system of the new centralized government was consolidated. These unusually large Buddhist images reflect not only the awesome nature of the divinity but also the political power of the sovereignty that produced the works. Such figures clearly indicate the Koryŏ sculptor's effort to create types that fit the spirit of the time, showing little regard for realistic modeling or for following the standard iconography of bodhisattvsa images.[76]

The dominant sect of Buddhism in Korea was based on the doctrines of the *Avatamsaka Sutra*, but gradually a more accessible teaching, Pure Land Buddhism, which centered on the worship of the Amitabha Buddha, gained popularity among the masses. One of the military clans, the Ch'oe family, which rose to power in 1170 and whose dominance lasted about one hundred years, was associated with Sŏn Buddhism and a belief in the powers of Amitabha. Unfortunately, it is difficult to assess the production of sculpture related to Sŏn Buddhism from the mid-Koryŏ period, in the twelfth to the thirteenth century, as there are few surviving images that can be reliably dated to this time.

The most important dated Koryŏ Buddhist sculptures are from the fourteenth century. These images show that two stylistic types were in vogue at the time, one influenced

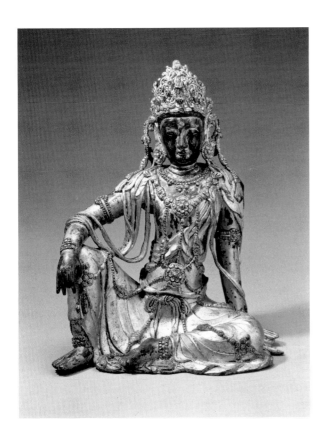

**Figure 30.** Seated Avalokiteshvara, Koryŏ dynasty (918–1392), 14th century. Gilt bronze, h. 15 ⅛ in. (38.5 cm). The National Museum of Korea, Seoul.

mainly by Liao and Jin sculpture and the other by Lamaist Buddhism supported by the Mongol Yuan court. A gilt-bronze seated Buddha of Medicine from Changgok-sa Temple, Ch'ŏng'yang (fig. 29), and a very similar statue once worshiped at Munsu-sa Temple, Sŏsan,[77] both in South Ch'ungch'ŏng Province, date from the year 1346. As was often the case, the date was included in votive inscriptions written during temple rituals, which were then placed inside the images at the time of consecration. Both statues are skillfully cast in bronze, and both have noble facial features and balanced body proportions, contributing to the overall dignified appearance of the figures. The smooth modeling of the bodies, with gentle curves and natural folds of the thick garments, lends the appearance of volume. The manner in which the garment is worn, covering both shoulders yet revealing a metal ornament on the left side that secures the inner dress, and the ribboned band across the chest are prominent elements in Koryŏ Buddhist art.[78] Stylistic prototypes are found in China among sculptures of the Liao and Jin dynasties. For instance, the Buddha statues of 1038 in Lower Huayansi Temple, Datong, offer similar examples. Besides official contacts between the Koryŏ court and the Liao and Jin courts, both of which were active patrons of Buddhism,[79] frequent exchanges occurred among the respective Buddhist communities.

From about 1270, with the advent of the Mongols and the founding of the Yuan dynasty in China, Korea also became subject to the influence of Lamaist Buddhism. Introduced to the Koryŏ Buddhist community, it found favor especially among members of the court and aristocracy.[80] The second type of late Koryŏ Buddhist sculpture thus shows the influence of Lamaist Buddhism, particularly of Tibetan Lamaist Buddhism, a form of

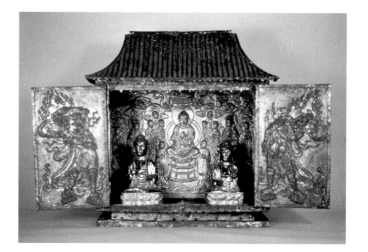

**Figure 31.** Portable Shrine, Koryŏ dynasty (918–1392), 14th century. Gilt bronze, 17 ⅛ × 15 in. (43.4 × 38 cm). Ch'ŏnŭn-sa Temple, Kwang'ŭi-myŏn, Kurye-gun, South Chŏlla Province

esoteric Buddhism of which the Yuan Mongols became avid followers. The best-known Korean image of this type is the gilt-bronze seated bodhisattva Avalokiteshvara in The National Museum of Korea, said to be from Hoeyang, Mount Kŭmgang, in Kang'wŏn Province.[81] The elaborately decorated triple-pointed crown, the large round earrings in the shape of open flowers, and the richly jeweled ornamentation on the body are certainly not from the Korean tradition of Buddhist images, but show the influence of early Tibetan bodhisattva images that ultimately goes back to Nepalese prototypes. Still, even with these distant sources, one can discern in this image some of the gentle, soft qualities characteristic of Koryŏ taste. Another gilt-bronze figure of Avalokiteshvara reflects similar Lamaist elements (fig. 30). He is shown seated in the position called "royal ease," with the right leg raised, as in the pose of the Water-Moon Avalokiteshvara, a popular image in China during the Song dynasty and frequently depicted in Koryŏ Buddhist paintings.

Elements of these late Koryŏ images, such as the elaborately decorated crown, lavish ornamentation on the body, and double tiers of the lotus pedestal, are distinctive characteristics of Lamaist Buddhist sculpture that were continued in the early Chosŏn dynasty (1392–1910), though with a tendency toward simplification in order to conform to more traditional types of Koryŏ images. The transitional stage from late Koryŏ to early Chosŏn images of Avalokiteshvara is exemplified by a gilt-bronze statue thought to be from Mount Kŭmgang (pl. 71). Lamaist elements also affected the style and iconography of Buddhist paintings in the late Koryŏ and early Chosŏn periods, with some of the features of the painted deities reflecting their counterparts in sculpture.

The variety of styles of Buddhist art is also on view in the portable shrines designed to look like temple buildings. Inside these miniature shrines small Buddhist images would be placed, and the interior walls and sometimes the exterior walls would be decorated with Buddhist images executed in repoussé. The gilt-bronze portable shrine exhibited here (pl. 54) has a blue-green roof as if to depict a building whose roof is covered with celadon tiles.[82] Although the central images have been lost, when the shrine is opened, two door guardians wearing fluttering scarfs and flame-shaped halos are revealed. Represented in repoussé relief on the back wall of the interior is a seated Buddha triad sur-

rounded by ten standing lohans, all shown against stylized floating clouds, suggesting a scene from one of the Buddha's paradises. On the side walls are the bodhisattva Samantabhadra, seated on an elephant, and his companion bodhisattva, Manjushri, seated on a lion. The two bodhisattvas serve as attendants to either the Buddha Shakyamuni or the Vairochana Buddha, giving us valuable information as to the identity of the now lost Buddha image originally placed inside the shrine. The exterior of the shrine depicts, in incised lines, four directional guardians and eight lesser gods, thus completing the Buddhist pantheon. A very similar portable shrine which still preserves two small enshrined seated Buddha images is in the collection of Ch'ŏnŭn-sa Temple, in Kurye, South Chŏlla Province (fig. 31).[83] The iconography of the door guardians, the style of the Buddha images, the shape of the lotus pedestals, and other ornamental details indicate that these portable shrines date from the fourteenth century.

An understanding of the last phase of Koryŏ sculpture is also provided by the relief images carved on pagodas. A ten-story marble pagoda, originally from the temple site of Kyŏngch'ŏn-sa near the capital Kaegyŏng, is an important monument for the study of a newly introduced form of pagoda as well as late Koryŏ sculptures.[84] The three-tiered base and the first three stories of the pagoda are built on a plan that resembles a Tantric Buddhist mandala, and the remaining seven, smaller stories on a square plan. Each story has a projecting roof which is carved in the shape of a tile-covered roof. Various assemblies of Buddhist images, some of which are identified by inscription, are carved in relief on each of the four sides of the first three stories, providing valuable clues for iconographic study of Buddhist deities. On the first story is a votive inscription, dated 1348 and written in both Chinese and Mongolian, stating that Yuan artisans worked on the pagoda. However, the carved figures reveal few Lamaist elements, but instead follow the early Koryŏ sculptural tradition.[85]

The architectural plan of the Kyŏngch'ŏn-sa pagoda and the iconography of the Buddhist images were closely copied about a hundred years later, in 1467, during the reign of the Chosŏn ruler King Sejo (r. 1455–68), for the pagoda at Wŏn'gak-sa.[86] This structure still stands on the old temple site in a public park, T'apkol Kong'wŏn (Pagoda Park), in Seoul.

<div align="center">CHOSŎN DYNASTY</div>

During the Chosŏn period, Buddhism was suppressed in favor of Neo-Confucianism and the political system based on this philosophy. Aside from a temporary flourishing during the reigns of kings Sejo and Myŏngjong (r. 1545–67), few Buddhist activities were carried out on an official level. King Sejong (r. 1418–50), the inventor of the Korean alphabet, han'gŭl, made an important contribution in promoting the religion by compiling Korean translations of such important Buddhist texts as Wŏrin ch'ŏn'gang-ji-gok (Songs of the Moon's Reflections on a Thousand Rivers), which relates the story of the life of the historical Buddha Shakyamuni and emphasizes the concept of filial peity, and making them available in printed editions for ordinary readers. Although Buddhism was officially out of

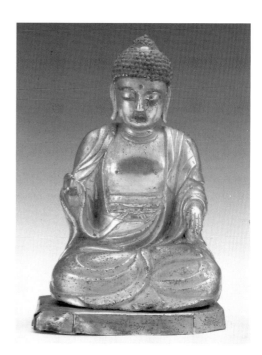

**Figure 32.** Seated Buddha, Chosŏn dynasty (1392–1910), dated 1493, from pagoda at Sujong-sa Temple, Wabu-myŏn, Namyangju-gun, Kyŏnggi Province. Gilt bronze, h. 3 ⅞ in. (10 cm). The National Museum of Korea, Seoul

favor, it remained a popular religion among the court and upperclass ladies and the ordinary populace in the countryside. While Neo-Confucianism occupied the intellect, Buddhism continued to provide spiritual solace.

An early representative example of Chosŏn Buddhist sculpture is a group of gilt-bronze images and a miniature gilt-bronze portable shrine that were found in the first story of the octagonal, five-storied pagoda at Sujong-sa Temple, in Namyangju district, Kyŏnggi Province. The temple was founded in 1459, during the reign of King Sejo. The portable shrine contains a seated Buddha (fig. 32) and two attending bodhisattvas. A votive inscription placed inside the Buddha informs us that the figure was made in the year 1493 at the request of several court ladies. Inscribed on the underside of the Buddha is the donor's name, Lady Kim, one of King Sejo's consorts.

This late-fifteenth-century Buddha statue follows the type and style of late Koryŏ images, for instance, the Changgok-sa Buddha of Medicine (fig. 29) of 1346. Some simplification is apparent in the treatment of the drapery folds, partly due to the smaller size of the image and the more compact body. The miniature shrine gives important evidence for the study of early Chosŏn Buddhist painting since on the outside back wall is depicted a painting of a Buddha and ten attendant bodhisattvas and lohans.[87]

From different parts of the same pagoda at Sujong-sa, more than twenty images of Buddhas and bodhisattvas were discovered (pl. 72). All are seated in a slightly bent posture and have oversized heads with innocently smiling faces, but it is difficult to establish any systematic arrangement of the images or their meaning as a group. Some can be identified by their iconography. The figure that displays the hand gesture in which the five fingers of the right hand clasp the index finger of the left hand, for instance, represents the Vairochana Buddha. Another figure, that of a monk, shows the hands formed in the anjali, or prayer, mudra. An inscription on the bottom of the pedestal of the Vairochana

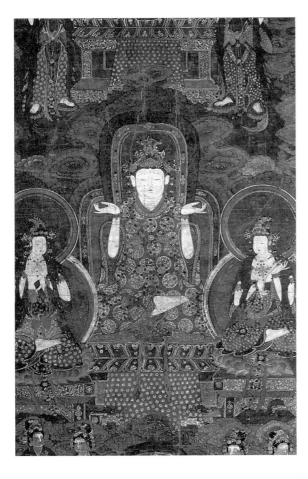

**Figure 33.** Lochana Buddha, Chosŏn dynasty (1392–1910), 16th century. Detail of hanging scroll, ink and color on silk, 62 ⅝ × 42 ⅝ in. (159 × 108.2 cm). Jūrin-ji, Hyōgo Prefecture, Japan

states that the image was cast in 1628 at the wish of Queen Inmok, wife of King Sŏnjo (r. 1567–1608). Thus, this second group of Sujong-sa images displays an early-seventeenth-century style and was probably made at a workshop related to the royal inner court.

Also included in this group is a bodhisattva figure depicted with both hands raised to shoulder height with palms facing upward. The bodhisattva is adorned with a tall but simply decorated headdress and a single beaded necklace with two pendants. This iconography was widely used for the Lochana Buddha during the late Chosŏn dynasty. An early appearance of this type in China is found on a rock-cut relief at the entrance of the Qinglindong cave at Feilaifeng, Hangzhou.[88] Images of this crowned bodhisattva representing the Lochana Buddha can be seen in the illustrated frontispieces—either produced as woodblock prints or drawn by hand with gold pigment on indigo blue or white paper—in many Koryŏ texts of the *Brahma-jala* or *Avatamsaka* sutras. The frontispiece of the *Wŏn'gak-kyŏng Sutra*, written in gold on white paper and dated 1357, now in the collection of the Horim Museum, is an important early Koryŏ example showing this iconography.[89] A sixteenth-century painting, in the Jūrin-ji Temple, in Hyōgo Prefecture (fig. 33), shows the Lochana Buddha with both hands raised.[90]

Many temples in the Korean countryside enshrined the Lochana Buddha within a group of three Buddhas that symbolized the three bodies of the supreme Buddha: the Vairochana Buddha, the embodiment of the Absolute Buddha with his particular hand gesture, the bodhyagri mudra; the historical Buddha Shakyamuni, with the bhumisparsha,

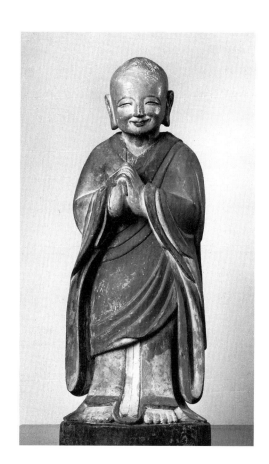

**Figure 34.** Kashyapa, Chosŏn dynasty (1392–1910), dated 1700. Wood with polychrome, h. 22 in. (55.9 cm). The Metropolitan Museum of Art, Gift of Abby Aldrich Rockefeller, 1942. 42.25.8

or earth-touching, mudra; and the Lochana Buddha in the form of a bodhisattva, with both hands raised to the shoulders. This concept of the three bodies of the Buddha is derived from the text of the *Brahma-jala* and the *Avatamsaka* sutras, in which it is explained that Lochana is the enlightened Buddha in the form of a bodhisattva who represents the concept of the Absolute Buddha in its numerous manifestations.

Most surviving Chosŏn Buddhist images found in temples date from after the Japanese invasion of Korea in 1592. The ensuing war lasted seven years, during which most Buddhist sanctuaries and their artifacts were devastated. From the seventeenth century onward, active reconstruction was carried out, and many Buddhist images were produced. Some were cast in bronze, but many were carved in wood and then gilded or sometimes lacquered.

A fine polychrome wooden sculpture from the Metropolitan Museum (fig. 34) can be identified as Kashyapa, the eldest of the two principle disciples of the historical Buddha Shakyamuni.[91] According to the inscription placed with the votive offerings inside the image, the sculpture was made on March 29, 1700, together with a Buddha and other lohan figures, at a temple retreat on Mount Turyun in Yŏng'am district, now part of Taehŭng-sa Temple in the Haenam region of South Chŏlla Province.

The standing figure, his two raised hands clasped in front, wears a blue robe edged in red and a red outer robe with a green border. The fine carving technique testifies to the skill of the sculptor. The figure's relaxed stance and well-articulated facial features convey an expression of benevolence and wisdom. Of the many wooden statues found in Korean temples today, few are as expertly crafted or as engaging as the Metropolitan piece.

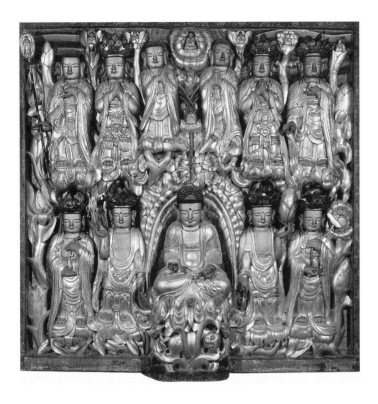

**Figure 35.** Amitabha Buddha and Attendants, Chosŏn dynasty (1392–1910), 1782. Wood panel with gilding and polychrome, 71 ¼ × 72 in. (181 × 183 cm). Yaksu-am Hermitage, Silsang-sa Temple, Namwŏn, North Chŏlla Province. Treasure no. 421

In general, Buddhist images were placed on an altar. On the wall behind the image paintings would often hang, offering graphic presentations of the teachings of the Buddha or depictions of paradise scenes. In certain temples, however, *mokkak pult'aeng*, wooden panels carved with Buddhist images in relief, were hung behind the altar. The composition of the panels varies, and the number of figures is different in each case. Among approximately six examples of such wooden panels known today is one in Silsang-sa Temple, Namwŏn, North Chŏlla Province, made in 1782 (fig. 35).[92] It shows the Amitabha Buddha attended by eight bodhisattvas and two lohans arranged in two tiers, a simplified version of the assemblage of the Buddha. One of the lohans in the top row is more mannered in its carving and lacks the spiritual quality in facial expression of the Kashyapa statue in the Metropolitan collection.

The images on the wooden panels represent the last phase of the Buddhist sculptural style of the Chosŏn dynasty. The figures are stiff, almost frozen, lacking any lifelike expression. Very little attempt is made to differentiate or even suggest their individuality. In general, the works are highly mannered, displaying a strong tendency to imitation of earlier styles and models. Nonetheless, these images are a reflection of the sculptural art of the late Chosŏn period when the gap between religious sculpture and folk art began to close. Affinities between the two suggest the extent to which Buddhism had permeated the life of the people as well as a common taste that was shared among ordinary Koreans. Since Buddhism is still an active religion, its sculptural tradition continues today, though in the images created there is little effort to reflect the spiritual aspects of the religion. Instead old masterpieces, among them the highly revered Sŏkkuram sculptures, continue to offer the most popular models. ๑

Ahn Hwi-joon

# The Origin and Development of Landscape Painting in Korea

Korea, like China, possesses a long tradition of landscape painting, a vehicle used to portray both nature itself and the human conception of nature. Landscape elements were depicted at first as patternized and iconic forms, and used as settings for the illustration of narrative themes and poetry. Over time, however, landscape painting developed into a distinct and independent genre, and eventually gained esteem as the highest form of painting.

In East Asia, nature was traditionally perceived as a living entity: mountains were considered its body, rocks its bones, water its blood, trees and grass its hair, and fog its breath.[1] The challenge presented to the artist in conveying the vast expanse of nature on a two-dimensional picture surface accorded landscape painting an even more exalted position than figure painting. For this reason, an insight into the development of landscape painting is essential to the understanding of the Korean painting tradition.

### THREE KINGDOMS PERIOD
### Koguryŏ

The beginning of landscape painting in Korea can be traced back to the kingdom of Koguryŏ (37 BCE–668 CE), the northernmost of the three states that dominated the Korean peninsula from the first century

BCE to the seventh century.[2] Based on extant examples, painting first developed in Koguryŏ about the fourth century. However, given the frequent contacts between Koguryŏ and China, where examples of landscape painting can be found as early as the Han dynasty (206 BCE–220 CE), it is probable that paintings were produced in Koguryŏ before this time.[3]

The earliest extant Korean painting incorporating landscape elements is a mural depicting a hunting scene (fig. 1) from a Koguryŏ tomb in Tŏkhŭng-ni, in T'aean, South P'yŏng'an Province, dated by inscription to the year 408.[4] The painting, on the eastern section of the vaulted ceiling of the tomb's front chamber,[5] portrays a party of hunters on horseback — arrows drawn and ready — in pursuit of their prey. The landscape setting of the chase consists of a few simply rendered images of mountains outlined in dark ink and filled in with light color, resembling a two-dimensional stage set. From the mountain peaks grow oddly shaped trees of such exaggerated scale that they might be taken as iconic references to mountain forests. That these landscape elements serve as background for the narrative of the hunt rather than the main subject of the mural is further emphasized by their small size in relation to that of the hunters and their quarry. Here, nature is not presented as a larger-than-life force, but rather as an integral part of human activity. The landscape elements, with their simplified, patternized forms, serve both a functional and an aesthetic purpose: they provide the setting for the main story as well as amplify the lively and rhythmic lines with which the human figures and animals are rendered.

The dramatic urgency of the hunt, the tension between hunter and hunted, is expressed with even greater force and realism in a mural painting from the fifth-century Muyong-ch'ong (Tomb of the Dancers), located in the modern Chinese province of Jilin (fig. 2) in an area that was part of the ancient territory of Koguryŏ. In this painting, which appears on the west wall of the main burial chamber opposite the painting of dancers from which the tomb derives its name, the spatial relationship of the mounted hunters and the animals they pursue is articulated more clearly and realistically, thus conveying a stronger sense of narrative than the more loosely arranged figures in the Tŏkhŭng-ni hunt scene. The painting also demonstrates important developments in the rendering of landscape elements during this period. Although they function mainly as symbolic representations, the flat, schematic mountains and archaic trees more closely approximate the scale of the natural world. There appears to be a greater interest in internal description through the use of modulated lines, which serve to impart visual energy to the composition, reinforcing in turn the sense of rapid movement and lively drama. Both the staggered arrangement of the mountains and the use of different colors to portray them — white for the nearer mountains, red for those in the middle distance, and yellow for those far away — evidence rudimentary attempts at depicting spatial recession.

The achievement in the portrayal of the mountains in the Muyong-ch'ong mural can be more readily appreciated by comparing the painting with another hunting scene from an early-fifth-century Koguryŏ tomb in Yaksu-ri, located in Kangsŏ-gun, South P'yŏng'an

**Figure 1.** *Hunting scene*, Three Kingdoms period, Koguryŏ kingdom (37 BCE–668 CE), dated 408. Detail of wall painting, Tŏkhŭng-ni tomb, front chamber, east ceiling. Kangsŏ-gun, South P'yŏng'an Province

**Figure 2.** *Hunting scene*, Three Kingdoms period, Koguryŏ kingdom (37 BCE–668 CE), second half of the 5th century. Detail of wall painting, Muyong-ch'ong (Tomb of the Dancers), main chamber, west wall. Jilin Province, China

**Figure 3.** *Hunting scene*, Three Kingdoms period, Koguryŏ kingdom, (37 BCE–668 CE), early 5th century. Detail of wall painting, Yaksu-ri tomb, front chamber, west and south walls. Kangsŏ-gun, South P'yŏng'an Province

Province (fig. 3). Although the configuration of the mountain groups in the two tomb paintings is similar, the Yaksu-ri mountains are more rudimentary in form, and, unlike Muyong-ch'ong, the color has not been used to suggest spatial relationships.

Another significant stylistic trend during this period is seen in the depiction of trees. Unlike the small, static trees in the Tŏkhŭng-ni tomb mural, the trees in the Muyong-ch'ong hunt scene are painted with bold, energetic lines similar to those that define the contours of the mountains and the figures. The swaying motion of the trees and the

**Figure 4.** *Landscape*, Three Kingdoms period, Koguryŏ kingdom (37 BCE–668 CE), late 6th century. Detail of wall painting, Kangsŏ taemyo tomb, main chamber, east ceiling support. Kangsŏ-gun, South P'yŏng'an Province

**Figure 5.** *Landscape*, Three Kingdoms period, Koguryŏ kingdom (37 BCE–668 CE), late 6th century. Detail of wall painting, Kangsŏ taemyo tomb, main chamber, west ceiling support. Kangsŏ-gun, South P'yŏng'an Province

schematic depiction of foliage as an oval mass set atop fingerlike branches are also found in a mural painting from an adjacent tomb, known as the Kakchŏ-ch'ong (Tomb of the Wrestlers), dated to the same period.[6] The rendering of the trees and overall designlike quality of the landscape in these Koguryŏ hunting scenes reflect the stylistic influence of Han China.[7] In light of the active cultural exchange that occurred between Koguryŏ and China during this time, it is not surprising to find similarities in the decoration of tombs of the ruling elite and the aristocracy. What distinguishes the style of painting in the Koguryŏ tombs from the Han prototype is its more pronounced rhythmic quality.

The next stage in the development of early Korean landscape painting is represented by mural paintings from the Kangsŏ taemyo (Great Tomb of Kangsŏ), in Sammyo-ri, Kangsŏ-gun, South P'yŏng'an Province, which is thought to have been constructed in the late sixth century.[8] On the southern wall of the burial chamber and on the western and eastern supports of the chamber ceiling, mountains are painted. The painting on the eastern ceiling support (fig. 4) illustrates in particular the stylistic transition in the depiction of landscape elements from the earlier fifth-century tomb murals. In sharp contrast to the symbolic, graphic representations of mountains in earlier murals, these mountains are

**Figure 6.** *Landscape*, Three Kingdoms period, Koguryŏ kingdom (37 BCE–668 CE), 7th century. Detail of wall painting, Nae-ri Tomb no. 1, northwest ceiling support. Taedong-gun, South P'yŏng'an Province

**Figure 7.** *Landscape with Flowers and Clouds and the Dark Warrior of the North*, Three Kingdoms period, Koguryŏ kingdom (37 BCE–668 CE), first half of the 7th century. Detail of wall painting, Chinp'a-ri Tomb no. 1, north wall. Chunghwa-gun, South P'yŏng'an Province

more realistic, presenting clearly defined spatial relationships between near and far peaks. In the center stands the host mountain, on either side of which are smaller guest mountains. Between these are scattered rocky cliffs, the jagged edges of which provide an interesting visual contrast with the sloping contours of the earthen host and guest mountains. The tripartite composition, the suggestion of volume conveyed by the shaded contours of the mountains, and the differentiation between the types of mountains (rocky and earthen) indicate an increased interest in landscape painting to portray real, tangible phenomena rather than to serve as a symbolic setting for narrative elements.

Another landscape scene from the same tomb, on the western ceiling support (fig. 5), further demonstrates this development. It includes a well-balanced triad of mountains (toward which a red-robed Daoist immortal flies on the back of a phoenix) and realistically painted trees. The small mountains receding into the far distance appear to be floating in the sea. It is clear that the landscape elements in the Kangsŏ paintings have a very different function in the overall composition than those in the earlier Koguryŏ tomb murals. Whereas before it served simply as background for the principal narrative, in Kangsŏ the landscape is intended actually to portray nature, a development that may be considered an advancement in the concept of landscape painting.

In the first half of the seventh century, landscape painting style in Koguryŏ underwent yet another change, as exemplified by mural paintings in two tombs in South P'yŏng'an Province: Nae-ri Tomb no. 1, in Shijŏk-myŏn, Taedong-gun (fig. 6), and Chinp'a-ri Tomb no. 1, in Chunghwa-gun (fig. 7).[9] Like those in the Kangsŏ tomb mural, the

**Figure 8.** *Landscape*, Three Kingdoms period, Silla kingdom (57 BCE–668 CE), dated 479 or 539. Detail of wall painting, Sunhŭng-ni tomb, north wall, east corner. Yŏngju-gun, North Kyŏngsang Province

mountains in the Nae-ri tomb display a tripartite composition of host and guest peaks. Here, however, the profile of the central mountain is steeper, conveying a greater sense of height. In addition, the trees along the mountain ridges are less static, recalling those on a lacquer-painted panel at Tamamushi Zushi, the famous early-seventh-century shrine at Hōryū-ji Temple, Nara, which reveals a strong influence of Koguryŏ art.[10] In both paintings the trees share the stylistic characteristics of clustered leaves and curvilinear trunks rendered in the "boneless technique" (Kr. *mugol*; Ch. *mogu*).

An even greater sense of movement and dynamism is expressed in the mural painting at the Chinp'a-ri tomb. On each side of the northern wall of the burial chamber are paintings that depict in the foreground tall trees atop low hills, which flank a central image of an intertwined black tortoise and snake, the Dark Warrior of the North (Kr. *hyŏnmu*; Ch. *xuanwu*), one of the four creatures associated in East Asia with the cardinal directions. The trees are less anthropomorphic, with the trunks, limbs, and leaves clearly differentiated and described in detail. The wind-blown trees and swirling clouds show the influence of Chinese painting style of the Six Dynasties period (220–589), as can be seen, for example, in the scenes engraved on the sides of an early-sixth-century stone sarcophagus in the Nelson-Atkins Museum of Art, Kansas City.[11] As in the Chinp'a-ri mural, the trees in the foreground serve to frame the main subjects of the scene. While executed in a different medium, the Chinese engraving nonetheless offers a valid stylistic comparison with the Koguryŏ painting. Indeed, it is obvious that the Koguryŏ artists adopted the landscape style of the Six Dynasties period, from which they in turn developed their own more rhythmic, forceful style. What began in Koguryŏ as a largely symbolic representation of landscape gradually moved, at least by the early seventh century, toward a view of landscape as a subject worthy of realistic portrayal in its own right.

## Paekche

Unlike Koguryŏ in the north, there are no known surviving paintings with landscape elements from the kingdom of Paekche (18 BCE–660 CE), which occupied the southwestern part of the Korean peninsula. The only extant material providing evidence of Paekche landscape painting style are two earthenware tiles (pls. 8, 9), which are among a group of

eight tiles with relief designs of animals and fantastic creatures, flowers, or landscape excavated from the site of a Buddhist temple in Puyŏ, South Ch'ungch'ŏng Province, the last capital of Paekche. Considered a product of the first half of the seventh century, the tiles display in their decoration a technical and stylistic sophistication that bespeaks a long process of development of landscape illustration prior to this time. Many of the same landscape elements found in Koguryŏ tomb murals are also seen in the Paekche tiles: clusters of host and guest peaks, jagged rock formations, trees that emphasize the outlines of the mountains, and arabesque cloud formations. The composition is balanced, and the mountains are stacked vertically, conveying the impression of spatial recession, depth, and volume. This technique of indicating the position of objects farther back on the ground plane by placing them higher on the pictorial surface is also seen in Koguryŏ murals, but the Paekche tile goes a step further in emphasizing spatial recession in its use of overlapping forms to reinforce the relationship between near and far mountains.

## Silla

The only known example of landscape painting from the kingdom of Silla (57 BCE–668 CE), in the southeastern part of the peninsula, is a mural from the Sunhŭng-ni tomb in North Kyŏngsang Province, discovered in 1985 (fig. 8).[12] On the south wall is an inscription with a cyclical year that allows the tomb to be dated to either 479 or 539. On the northern and eastern walls are scenes showing mountains of varying sizes aligned along the horizon. The effect is that of a stage set, with the treatment of landscape elements similar to that in the Koguryŏ Tŏkhŭng-ni tomb of 408 (fig. 1). The Sunhŭng-ni tomb is located in an area of ancient Silla territory that bordered on Koguryŏ, and the similarity in landscape treatment points to artistic exchange between the two neighboring kingdoms during the fifth century.

### UNIFIED SILLA

During the Unified Silla period (668–935), with the rich tradition of the Three Kingdoms period to draw upon and an active and ongoing cultural exchange with China's Tang dynasty (618–907), the production of landscape painting in Korea must have increased. Though we have no extant examples of such painting, it is possible to surmise its characteristics from written documents. For example, the *Samguk sagi* (History of the Three Kingdoms), compiled in the twelfth century, provides an account of the Unified Silla artist Solgŏ, who is described as having been born into a poor family but as being artistically gifted from birth.[13] According to this account, his painting of an aged pine tree on the wall of the famous Hwangnyong-sa Temple, in Kyŏngju, the capital of Unified Silla, was so realistic that birds would fly toward the tree, hit the wall, and fall to the ground.

When we consider that in China the blue-and-green landscape style was in vogue and in Japan the Yamato-e style of landscape (based on the Chinese style) flourished, it seems reasonable that landscape painting in Unified Silla also displayed a tendency toward the

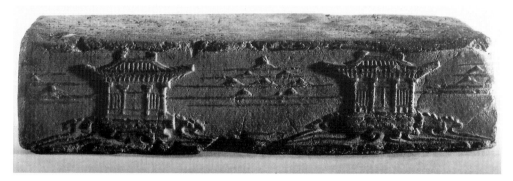

**Figure 9.** *Brick*, Unified Silla period (668–935), 8th century, from Sach'ŏnwang-sa, Kyŏng-ju, North Kyŏngsang Province. Stoneware with decoration of pavilions in a landscape, 2 ⅝ × 11 in. (6.7 × 28 cm). Kyŏngju National Museum

blue-and-green idiom. A brick excavated from the temple site of Sach'ŏnwang-sa, Kyŏng-ju, attests to the possibility that landscape was frequently used in architectural decoration (fig. 9). The small mountains behind a pair of pavilions recede toward the distance in a manner similar to that seen in the Kangsŏ taemyo tomb (fig. 5).

### KORYŎ DYNASTY

Following the establishment of the Koryŏ dynasty (918–1392) in the early tenth century, painting became an activity undertaken not only by professional painters for practical purposes, but also by members of the royal court and the aristocracy for pleasure. The Koryŏ period as well marks a transition in the Korean tradition of landscape painting. The natural landscape is no longer a subject cast in a secondary, functional role but one pursued for its own sake. As with previous periods, however, too few works survive to construct a detailed and accurate history of the development of landscape painting during this period. It is believed, though, that it developed in a fertile area of cultural interface with China, which continued from the Song dynasty (960–1279) through the Yuan (1272–1368) and the early years of the Ming (1368–1644) dynasties.[14]

There is a particular dearth of extant material from the first half of the Koryŏ period. In relation to the early stage of Koryŏ landscape painting, it is worthwhile to take note of mural paintings produced for the tomb of the founder of the dynasty, Wang Kŏn (King T'aejo, r. 918-43). These paintings—depicting the "three friends of winter," pine, plum, and bamboo—are executed in ink and light color on a stone surface that was first coated with a thin layer of lime (figs. 10, 11). The three plants frame images of a blue dragon and a white tiger, representing the cardinal directions east and west, respectively, on the eastern and western walls. Although in themselves they do not constitute a landscape, the three friends of winter—symbols of moral rectitude and steadfastness in the face of adversity—may certainly be considered a part of it. In view of its traditional symbolic meaning, it is possible that the motif was used in this context to signify the loyalty and allegiance of the king's subjects. The pine, plum, and bamboo are all rendered in an abbreviated form. For instance, the pair of pine trees have small twigs with symmetrically aligned needles while the plum blossoms and the bamboo stalks are painted in the outline

Figure 10. *Three Friends of Winter*, Koryŏ dynasty (918–1392), mid-10th century. Wall painting, tomb of King T'aejo (r. 918–43). Kaep'ung-gun, Kyŏnggi Province

Figure 11. *Three Friends of Winter*, Koryŏ dynasty (918–1392), mid-10th century. Wall painting, tomb of King T'aejo (r. 918–43). Kaep'ung-gun, Kyŏnggi Province

technique. Despite the rudimentary style, the bamboo stalks and leaves are depicted with minute, sharp lines that convey a remarkable sense of liveliness.

Another work relating to early Koryŏ landscape painting is the *Ŏje pijangjŏn*, a multi-volume woodblock-printed book illustrating Buddhist teachings, now divided between the Sŏng-am Archive of Classical Literature in Seoul and the Nanzen-ji Temple in Kyoto.[15] The second illustration in volume six of the book (fig. 12) demonstrates a relatively high level of sophistication in the portrayal of landscape on a two-dimensional surface during the first half of the Koryŏ dynasty, as well as the strong influence of Chinese landscape painting of the Northern Song (960–1127) period.

In this narrative illustration, a monk is shown sitting in a modest hut at the far right, preaching to his student. To their left, across a narrow bridge, a layman holding a staff in his right hand arrives to receive the monk's instruction. Another monk walks away toward the mountains, at the far left of the scene, on his way to preach to the unconverted. Though they clearly play a central role in the narrative, these figures represent only a small part of the total image, most of which is devoted to a description of the surrounding landscape. The relative scale of near mountains to far mountains, as well as of mountains

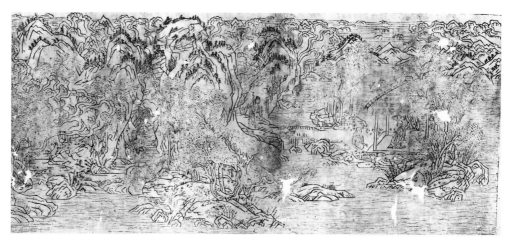

**Figure 12.** *Landscape,* Koryŏ dynasty (918–1392), 11th century. Woodblock print, from *Ŏje pijangjŏn,* 9 × 20 ¾ in. (22.7 × 52.6 cm). Sŏng-am Archive of Classical Literature, Seoul

to trees, shows an interest in depicting realistically the proportions of the various landscape elements in order to portray a sense of inhabitable space. Another device to create the illusion of three-dimensional spatial continuity is the use of winding streams to guide the viewer's eye to the far distance. Such objects as this woodblock print suggest that Koryŏ artists were aware of contemporaneous developments in China during the late Five Dynasties (907–60) and early Northern Song dynasty. Based on written sources, we know that between the latter half of the eleventh century and the early part of the twelfth century, numerous Northern Song landscape paintings made their way to Korea, and Koryŏ landscapes likewise were taken to China.[16]

At least by the first half of the twelfth century, a different kind of landscape painting — one that featured actual places on the Korean peninsula — had begun to appear. A good example of this development are the recorded works by the artist Yi Nyŏng (act. ca. 1122–46), who created such paintings as *Yesŏng River* and *Southern Gate of Ch'ŏnsu-sa Temple.*[17] In addition, paintings by unidentified artists with such titles as *Mount Kŭmgang, Chinyang Landscape,* and *Eight Scenes of Songdo,* which are recorded in written documents, testify to what appears to be an active production of works based on real landscape scenes.[18] However, these Koryŏ paintings probably have no direct relationship to the development in the Chosŏn dynasty (1392–1910) of true-view landscape painting, which is stylistically based on the so-called Southern School of Chinese painting.[19]

It is difficult to determine from the small body of surviving works which specific landscape painting styles were popular during the Koryŏ period. However, based on written documents and the history of Korea's active relations with China at the time we can surmise that the three styles then dominant in China — those of Li Cheng (919–967) and Guo Xi (ca. 1000–ca. 1090), known as the Li-Guo style, that of Mi Fu (1052–1107), and the court painting style of the Yuan dynasty — also constituted the main stylistic trends in Korea. Among these, the Li-Guo idiom seems to have reached the peninsula sometime between the late eleventh and early fourteenth century. Developed by the Northern Song

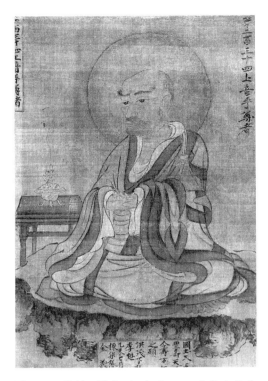

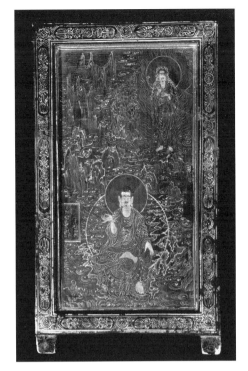

**Figure 13.** Unidentified artist (13th century), *Portrait of a Lohan*, ca. 1235, no. 254 of *Five Hundred Lohans*. Hanging scroll, ink and light color on silk, 21 ¾ × 15 in. (55.1 × 38.1 cm). Private collection, Japan

**Figure 14.** Noyŏng (14th century), *Kshitigarbha (Chijang) and Attendants*, dated 1307. Lacquer screen with gold paint, 8 ⅞ × 5 ⅛ in. (22.4 × 13 cm). The National Museum of Korea, Seoul

landscape masters Li Cheng and Guo Xi, the Li-Guo style was ultimately consolidated by Guo Xi and is based largely on his stylistic innovations. During the 1070s, when Guo's renown was at its peak, the Koryŏ court enjoyed especially friendly relations with China. In 1074 King Munjong (r. 1046–83) sent his envoy Kim Yang-gam (11th century) on a diplomatic mission to the Northern Song court and instructed him to purchase Chinese paintings. Two years later, Munjong sent several artists along with an official delegation headed by Ch'oe Sa-hun (11th century) to the Chinese court to copy the wall murals of the Xiangguosi Temple in Bianjing (modern Kaifeng), the capital of the Northern Song.[20] In the course of diplomatic exchanges between the two countries, the Northern Song emperor Huizong (r. 1100–1125) sent numerous books, examples of calligraphy, paintings, and art objects to King Yejong (r. 1105–22), which were kept in the various Koryŏ palaces, such as Ch'onjang-gak, Ch'ŏngyŏn-gak, and Pomun-gak. Paintings by the emperor himself were, of course, included in these royal collections.

It is likely that a fair number of Northern Song landscapes brought to Korea were passed down to the Chosŏn rulers, as evidenced by the extensive collection of Chinese paintings assembled by Prince Anp'yŏng (1418–1453), the foremost collector of the time. For instance, according to the *Hwagi* (Commentaries on Painting) section of the *Pohanjaejip* (Anthology of Writings by Pohanjae) by Sin Suk-chu (1417–1475), a catalogue of the prince's collection compiled in 1445, he owned two landscapes by the tenth-century artist Guo Zhongshu and seventeen works (mostly landscapes) by Guo Xi, in addition to paint-

**Figures 15A** (right), **15B** (left). Attributed to Ko Yŏn-hŭi (Gao Ranhui, 14th century), *Summer Landscape* (right) and *Winter Landscape* (left). Pair of hanging scrolls, ink on silk, 48 ⅞ × 22 ¾ in. (124 × 57.9 cm). Konchi-in Temple, Kyoto

ings by Li Gonglin (ca. 1041–1106), Su Shi (1037–1101), Wen Tong (1018–1079), and Cui Que, brother of Cui Bo (act. ca. 1060–85), a contemporary of Guo Xi.[21]

Given the keen interest in Chinese art and culture among the Koryŏ ruling class and aristocracy and the court's regular contacts with China, Koryŏ painters would certainly have been familiar with Guo Xi's landscape style. In fact, we know that two of Guo's works entitled *Clearing Mist in Autumn Scenery* were presented to the Koryŏ court by the Northern Song emperor Shenzong (r. 1068–85) shortly after his accession to the throne.[22]

The Guo Xi style was probably transmitted anew to Korea in the late Koryŏ period through the paintings of Yuan artists. In the early years of the Yuan dynasty, the Koryŏ king Ch'ungsŏn (r. 1308–13) lived in the Yuan capital, Dadu (modern Beijing), where he established a library called Man'gwŏn-dang (Hall of Ten Thousand Volumes). Ch'ungsŏn encouraged artistic and cultural activities within his inner circle of scholars and advisors, and his library seems to have functioned as a kind of cultural center and meeting place for Korean scholar-painters, such as Yi Che-hyŏn (1287–1367), and Chinese artists, including

**Figure 16.** Yi Che-hyŏn (1287–1367), "Crossing the River on Horseback." Album leaf, ink and color on silk, 5 ½ × 11 ⅜ in. (13.9 × 28.8 cm). The National Museum of Korea, Seoul

Zhao Mengfu (1254–1322) and Zhu Derun (1294–1365). Zhao, an eminent calligrapher and painter who had a profound effect on the course of Chinese art and art history, established what would later be called the Southern School of painting, based on the revival and reinterpretation of the landscape styles of the tenth-century artists Dong Yuan (d. 962) and Juran (act. ca. 960–95). He also painted in the Li-Guo style. A protégé of Zhao Mengfu and a leading Yuan painter in the Li-Guo style, Zhu Derun was a close acquaintance of King Ch'ungsŏn and Yi Che-hyŏn, and, along with Yi, an avid promoter of Chinese painting.[23]

Among several late Koryŏ works that attest to the continuing appeal of the Guo Xi style in Korea are the *Portrait of a Lohan* (fig. 13), by an unidentified artist, and Noyŏng's *Kshitigarbha and Attendants* (fig. 14). The first painting, which according to the inscription was executed in about 1235, depicts a lohan seated on a rock that is rendered in highly dynamic and descriptive lines.[24] Characteristic of the Li-Guo style are the dramatic contrasts of light and dark used to model the surface texture and volume of the rock.

The second work, a depiction of the bodhisattva Kshitigarbha (Chijang), is signed by Noyŏng, an otherwise unknown artist who created this image in gold paint on a single-panel lacquered wood screen in the year 1307.[25] The jagged quality of the mountains invites comparisons with Mount Kŭmgang in the northern part of the Korean peninsula, whose distinctive karst peaks were a popular subject in later landscape painting. The texturing of the mountains is reminiscent of the Li-Guo style. A possible stylistic precedent for the depiction of such mountains may be the paintings of the Northern Song artist Xu Daoning (ca. 970–ca. 1051), a key figure in the continuation and stylistic development of the Li-Guo tradition.[26] The Li-Guo style in Korea demonstrates the continuing engagement of Koryŏ artists with artistic trends in China, and their success in developing new directions within stylistic traditions.

Besides the Li-Guo idiom, the famous "ink dot" style of the Northern Song calligrapher and painter Mi Fu, a painting technique that is well represented by the works of his son Mi Youren (1074–1151), appears to have had a significant effect on Koryŏ landscape painting and was also favored by some Chosŏn-period artists. Again, the lack of surviving

**Figure 17.** Unidentified artist,
*Banana Tree in the Night Rain*, probably
Korean, Chosŏn dynasty (1392–1910),
dated 1410. Hanging scroll, ink on pa-
per, 37 ¾ × 12 ⅛ in. (95.9 × 30.9 cm).
Tokyo National Museum

works from the Koryŏ dynasty makes it difficult to prove this assumption. The only exist-
ing evidence of such influence on Koryŏ artists is a pair of hanging scrolls in the
Konchi-in Temple, Kyoto, entitled *Summer Landscape* and *Winter Landscape* (figs. 15A, B),
traditionally attributed to the obscure fourteenth-century Chinese artist Gao Ranhui.[27]
Painted in the Mi style, especially as it was interpreted by the Yuan painter Gao Kegong
(1248–1310), these landscapes are more characteristic of Koryŏ paintings than those of
either China or Japan.[28]

In *Summer Landscape* (fig. 15A) the foreground trees stand in full foliage along the
riverbank. On the other side of the river is a hut, dimly visible through a thick mist that
hovers between the foreground and the mountains in the distance. The rather undistin-
guished mountains are covered with evenly formed ink dots, the hallmark of the
Mi-school style. A waterfall flows down the nearest mountain. All of these pictorial and
stylistic features make it highly likely that this is a work of a Koryŏ artist. Similar charac-
teristic details are found in the other painting in the pair, *Winter Landscape* (fig. 15B),
though the contours of the mountains are rendered more roughly and unevenly. The
right side of the central mountain is delineated with brush strokes that are thick and

Figure 18. Attributed to King Kongmin (r. 1351–74), "Hunting." Album leaf, ink and color on silk, 9 ⅝ × 8 ⅝ in. (24.5 × 21.8 cm). The National Museum of Korea, Seoul

unusually shaped, almost identical to those in the summer scene. The snow-laden branches of the foreground trees are very similar to those in Yi Che-hyŏn's "Crossing the River on Horseback" (fig. 16). While somewhat awkward in style, the summer and winter landscapes are important evidence of the influence of the Mi school in late Koryŏ painting.

The predominant Chinese landscape style in the Southern Song dynasty (1127–1279), the Ma-Xia style, seems to have had less of an impact on Koryŏ painting. The Ma-Xia style is named for the Ma family of painters, whose two most illustrious members were Ma Yuan (act. ca. 1190–1225) and his son Ma Lin (ca. 1180–after 1256), and for another Southern Song court painter, Xia Gui (act. ca. 1195–1230), all of whom created paintings of great technical prowess and unsurpassed lyricism. Works by Ma Yuan were known in Korea during the Chosŏn period, possibly handed down from the preceding Koryŏ dynasty.[29] Yet in Sin Suk-chu's *Hwagi*, which records the art collection of Prince An-p'yŏng, Ma Yuan is mistakenly listed as a Yuan painter, possibly an indication that Southern Song painting was not well known at the time. In fact, during the formative period of the Ma-Xia school in China, from the end of the twelfth to the early thirteenth century, the relationship between Korea and the Southern Song court was erratic due to the ever-present threat represented by the northern Jin (1115–1234) court, which at times prevented Korean rulers from maintaining official relations with the southern Chinese court. An anonymous painting, *Banana Tree in the Night Rain* (fig. 17), executed in 1410, in the early years of the Chosŏn dynasty, is considered by many scholars to be a Korean work reflecting the Southern Song painting style.[30] From this work we may surmise that the Ma-Xia style was adopted in Korean landscape painting no earlier than the end of the Koryŏ period.

Likewise, the painting style of artists who were active in the Yuan court does not appear to have exerted any impact on Korean painting until the final years of the Koryŏ. Two examples that demonstrate this influence are Yi Che-hyŏn's "Crossing the River on Horseback" (fig. 16) and a painting of a hunt scene (fig. 18), possibly a fragment of a larger painting, attributed to one of the later rulers of the Koryŏ, King Kongmin (r. 1351–74). In its description of the figures and their clothing, as well as the landscape, Yi Che-hyŏn's

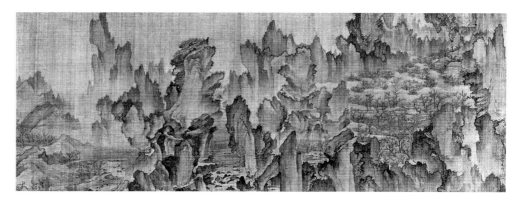

**Figure 19.** An Kyŏn (act. ca. 1440–70), *Dream Journey to the Peach Blossom Land*, dated 1447. Handscroll, ink and light color on silk, 15 ¼ × 41 ¾ in. (38.6 × 106.2 cm). Tenri Central Library, Tenri University, Nara. Important Cultural Property of Japan

painting evinces clear stylistic ties with Chinese court painting of the Yuan period. Yi, as mentioned earlier, spent time in the Yuan capital where he undoubtedly became familiar with the court painting tradition.

### EARLY CHOSŎN DYNASTY

In the early Chosŏn period, from the founding of the dynasty in 1392 to about 1550, landscape painting flourished and developed in a new direction. Drawing on the native Koryŏ painting tradition and adapting recently introduced styles from China's Ming dynasty, Chosŏn artists began to produce landscape paintings with more distinctly Korean characteristics.

The single most important landscapist during this time was the court artist An Kyŏn (act. ca. 1440–70).[31] Taking inspiration from the Northern Song Guo Xi idiom — the major factor in the formation of his style — An Kyŏn created a style of landscape that reflected the traditions he inherited yet at the same time was unmistakably his own. His style had a tremendous effect on Korean landscape painting both during his lifetime and in later generations. Two works demonstrate the particular compositional structure, spatial arrangement, and brushwork so closely identified with An Kyŏn and his followers. The first of these is his famous handscroll, *Dream Journey to the Peach Blossom Land* (fig. 19), the only extant work bearing the artist's signature and a date. The other is the album *Eight Views of the Four Seasons*, which has been attributed to him.

Painted in 1447 at the behest of his patron, Prince Anp'yŏng, *Dream Journey* is a remarkable painting. It depicts a dream, which is described by the prince in his colophon to the painting, wherein he was transported to the Peach Blossom Land, a utopian world described in a fable by the Chinese recluse poet Tao Qian (Tao Yuanming; 365–427). A magnificent landscape encloses the secluded Peach Blossom Land, portrayed in the right half of the painting. As if to emphasize the magical quality of this place that was thought to be immune to the effects of historical change and turmoil, the ground plane of the right portion of the scroll is sharply tilted and twisted. The energetic brushstrokes and dynamic forms create a compositional rhythm of vertical and diagonal lines that animates

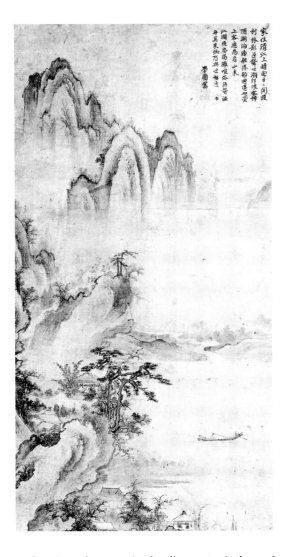

**Figure 20.** Yang P'aeng-son (1488–1545), *Landscape*. Hanging scroll, ink on paper, 34 ¾ × 8 ¼ in. (88.2 × 46.5 cm). The National Museum of Korea, Seoul

and unites the seemingly disparate, independent clusters of landscape elements. Also characteristic of early Chosŏn landscape painting in the Guo Xi idiom are the dramatic contrasts of light and dark that contribute to the overall integration of the landscape elements, as well as the skillful depiction of wide vistas and deep spatial recession.

Although *Dream Journey to the Peach Blossom Land* is the only existing authenticated work of An Kyŏn, an album of landscape paintings in The National Museum of Korea may be reliably attributed to the artist. *Eight Views of the Four Seasons* represents the An Kyŏn style so closely that we may surmise that it was painted by the master himself or an immediate follower. All eight leaves display the characteristically unilateral and yet harmonious compositions of the An Kyŏn style;[32] one leaf in particular, "Late Spring" (Kim Hongnam, fig. 18A), exemplifies the overall style of the album. The visual emphasis on the lower left corner derives from the "one-corner" composition made popular by Southern Song court artists, yet the painting is more complex than it might appear to be upon first glance. The horizontal arrangement of the foreground elements echoes the band of mountains in the far distance, while the large boulder formation and pine tree extend diagonally toward the far shore of the river. Even the thatched houses and pavilion on the foreground island find a counterpart in the tiled-roof complex on the far shore of the river. The carefully

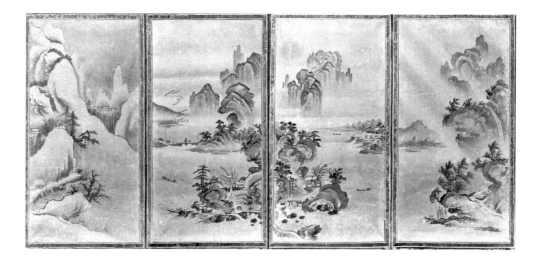

described fore- and background elements, with a relatively unarticulated middle area, create the effect of an open, uncluttered vista, whose isolated and disparate landscape elements are held together through skillful use of unified brushwork and compositional rhythms.

The continuation of the An Kyŏn style is evident in such paintings from the first half of the sixteenth century as *Eight Views of the Xiao and Xiang Rivers* (pl. 83), which also demonstrates the stylistic changes in the Li-Guo tradition wrought by its main interpreter in Korea.[33] These include larger landscape elements that take up a greater proportion of the picture surface, resulting in a closer, more intimate atmosphere, so that the viewer feels drawn into the scene. The brushwork is also more jagged, with a short, almost staccato feeling that departs from the more fluid, yet dynamic brushstrokes of the earlier phase of the tradition.[34]

Other early-sixteenth-century paintings such as the *Landscape* (fig. 20) by Yang P'aeng-son (1488–1545) and the *Eight Views of the Xiao and Xiang Rivers* (fig. 21), by an unidentified artist, feature the more complex spatial relationships and articulation of distinct foreground, middle distance, and background that are other hallmarks of Korean landscape painting in this period.[35] Persistent elements of the fifteenth-century-period style include the stark contrasts in light and dark and the integration of isolated landscape elements through compositional relationships.

It is also important to note that the An Kyŏn style was adopted by the fifteenth-century Japanese master Shūbun and his followers in the Muromachi period (1392–1573). The striking similarities in composition and treatment of space in the work of the two artists is evidenced in a comparison of the album leaf "Late Spring" from the *Eight Views of the Four Seasons*, attributed to An Kyŏn, with the famous painting *Reading in the Bamboo Studio*, in the Tokyo National Museum, attributed to Shūbun.[36]

Although the An Kyŏn school of painting flourished in Korea well into the mid-Chosŏn period, an alternate tradition began with the art of Kang Hŭi-an (1419–1464), whose paintings drew upon the so-called Zhe school of professional painters of the early Ming dynasty, who in turn continued a tradition based on the Southern Song court style.[37]

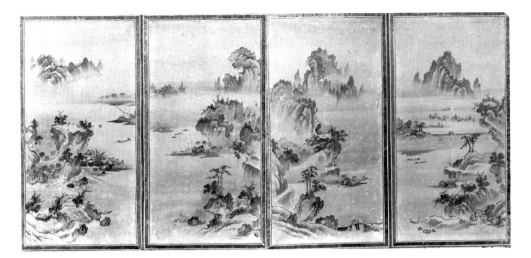

**Figure 21.** Unidentified artist (early 16th century), *Eight Views of the Xiao and Xiang Rivers,* before 1539. Eight-panel screen, ink on paper, each panel 38 ¾ × 19 ⅝ in. (98.3 × 49.9 cm). Daigan-ji Temple, Hiroshima. Important Cultural Property of Japan

The most reliable example of Kang's style is "Lofty Scholar Contemplating Water" (fig. 22), an album leaf that portrays a gentleman leaning casually on a boulder by a stream or river, gazing thoughtfully at the flowing water.[38] The only human figure in the tightly composed painting, he is framed by a canopy of branches and foliage that trail from a sheer cliff, with rocks and water reeds at the bottom edge of the painting completing the effect of a completely enclosed, intimate tableau. The tranquil air of the scene is further enhanced by the simplicity and boldness of the brushstrokes used to render the forms. The figure of the scholar is particularly well executed, with a few sparse yet highly effective lines used to describe the folds of his ample robe and his thoughtful expression. The main characteristics of this painting—simplicity, bold brushwork, and the very theme of a lone scholar finding spiritual retreat in nature—show the strong influence of Southern Song styles as exemplified by such masters as Ma Yuan, as well as the main interpreters of their style in the Zhe school, most notably Wu Wei (1459–1508).[39]

Compelling as Kang's style is, the An Kyŏn school of painting enjoyed greater popularity during the early Chosŏn period. It was not until the mid-Chosŏn that the Zhe school style as interpreted and transformed by Kang gained a greater following, among such sixteenth-century artists as Yi Pur-hae (b. 1529), Ham Yun-dŏk, Yun In-gŏl, and Yi Kyŏng-yun (1545–1611).[40]

Another important painter of the late fifteenth to mid-sixteenth century, Yi Sang-jwa, drew more directly on the so-called Ma-Xia tradition of Southern Song painting. *Walking Under the Pine and Moon,* attributed to Yi, is indebted to the Ma-Xia style in its one-corner composition and, in particular, the angular quality of the pine trees (fig. 23). The importance of the foreground figures is enhanced by the barely discernible distant mountains.

The distinctive style of the Chinese artists Mi Fu and his son Mi Youren—which, as was mentioned earlier, seems to have been known during the Koryŏ dynasty—also had followers in the early Chosŏn. The Mi-family style is characterized by large dotted

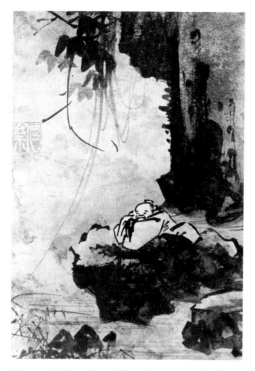

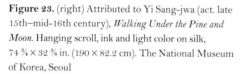

Figure 22. (above) Kang Hŭi-an (1419–1464), "Lofty Scholar Contemplating Water." Album leaf, ink on paper, 9 ¼ × 6 ⅛ in. (23.5 × 15.7 cm). The National Museum of Korea, Seoul

Figure 23. (right) Attributed to Yi Sang-jwa (act. late 15th–mid-16th century), *Walking Under the Pine and Moon.* Hanging scroll, ink and light color on silk, 74 ¾ × 32 ⅜ in. (190 × 82.2 cm). The National Museum of Korea, Seoul

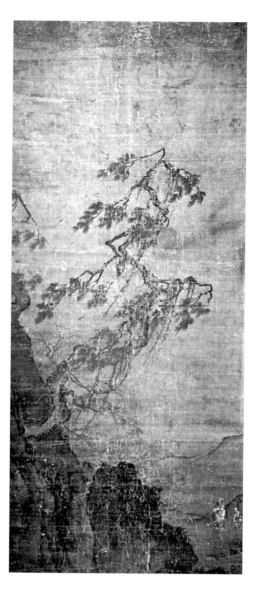

textures created with a fully saturated brush that, in combination with dense clouds, result in rich atmospheric effects. In the late fifteenth century, Sŏ Mun-bo, Yi Chang-son, and Ch'oe Suk-ch'ang were the main Korean followers of the Mi style.[41] A landscape attributed to Sŏ Mun-bo, *Cloudy Mountains* (fig. 24), is particularly successful in transforming Mi's style into a distinctive personal vision. It also draws elements from the early Yuan-dynasty scholar-painter Gao Kegong,[42] though Sŏ's painting is sharper in execution and does not draw greatly upon Gao's signature treatment of mountaintops. This densely packed painting shows an empty thatched pavilion on a rocky outcropping overlooking a river. In the background, partially obscured by a grove of pine trees, a main architectural complex is visible, with several multi-storied buildings with tile roofs. The backdrop for these human traces is a magnificent mountain range beyond the river, made all the more remarkable by the heavy clouds that obscure its base. Thick, tangible, nearly solid clouds are a main feature of the Mi style, and Sŏ puts them to effective use here, as clear markers of the distinction between the elusive, rarefied realm of the mountains and the rather less exalted human sphere.

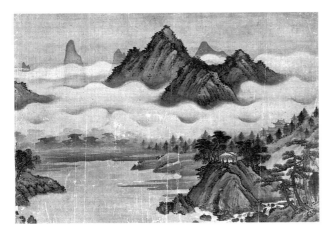

**Figure 24.** Attributed to Sŏ Mun-bo (late 15th century), "Landscape." Album leaf, ink and light color on silk, 15 ⅝ × 23 ⅝ in. (39.7 × 60.1 cm). The Museum Yamato Bunkakan, Nara

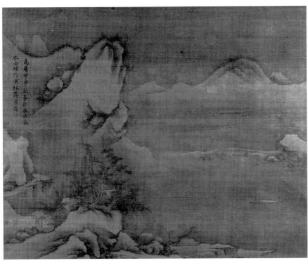

**Figure 25.** Kim Che (1524–1593), *Cold Forest on a Clear Winter Day*, dated 1548. Hanging scroll, ink and light color on silk, 20 ⅝ × 26 ½ in. (52.3 × 67.2 cm). The Cleveland Museum of Art

All of these early Chosŏn painters of landscapes show divergent interests and point to the availability of a wide number of stylistic sources, both Chinese and Korean, during the fifteenth and early sixteenth centuries. Chosŏn painters also had a profound impact on Japanese paintings of the Muromachi period, notably those by such artists as Yi Su-mun and Munch'ŏng, whose presence in Japan is confirmed by the survival of major attributed works in Japanese collections, as well as by Japanese paintings that were influenced by their styles.[43]

### MID-CHOSŎN DYNASTY

The major schools of painting of the early Chosŏn period were elaborated and developed into distinctly Korean styles during the subsequent phase of artistic development, from about 1550 to 1700, which was characterized above all by a synthesis of stylistic precedents. Ever mindful of their predecessors, Chosŏn artists found their personal voices by combining divergent historical sources, both foreign and native. These sources included the An Kyŏn style, the Southern Song court painting style, the Ming Zhe school style, as well as the Mi family style as interpreted by Ming-dynasty painters.

The major followers of the An Kyŏn style in the mid-Chosŏn period are Kim Che (1524–1593), Yi Chŏng-gŭn (b. 1531), Yi Hŭng-hyo (1537–1593), and Yi Ching (1581–

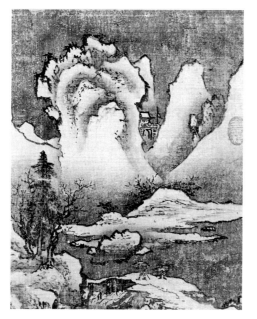

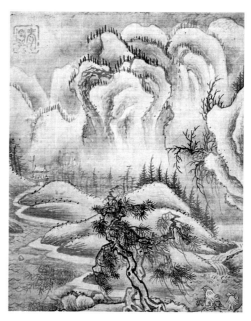

**Figure 26.** Yi Chŏng-gŭn (b. 1531), "Snow Landscape." Album leaf, ink and light color on silk, 7 ¾ × 6 ¼ in. (19.6 × 15.8 cm). The National Museum of Korea, Seoul

**Figure 27.** Yi Hŭng-hyo (1537–1593), "Snow Landscape." Album leaf, ink on silk, 11 ½ × 9 ¾ in. (29.3 × 24.9 cm). The National Museum of Korea, Seoul

after 1645). Kim was a particularly versatile artist, painting in both the An Kyŏn idiom as well as the Zhe school style. *Cold Forest on a Clear Winter Day* (fig. 25), dated 1548, demonstrates An Kyŏn's influence. Compositionally indebted to the *Eight Views of the Four Seasons* album attributed to An Kyŏn, *Cold Forest* also contains distinct elements that are Kim's own additions to the established vocabulary of the An Kyŏn tradition.[44] Most notable of these is the powerful presence at the left of the painting of a mountain cliff, whose monolithic grandeur commands immediate attention as it directs the viewer's gaze to the distant mountains. This directional impetus is reinforced by the small pine-covered bluff directly beneath the massive peak. The right side of the painting shows a different sort of space altogether: rather than a purely foreground focus — as on the left, where the large mountain blocks visual access to all but the very tops of the distant peaks — the right side of the composition recedes gradually into the distance along a series of horizontal elements: skiffs, a snow-covered bridge, and spits of land. These unusual compositional features, as well as the Zhe school style boldness and simplicity of the large mountain on the right, distinguish Kim's art from earlier landscapes in the style of An Kyŏn.

A continuation of the An Kyŏn style is seen in Yi Chŏng-gŭn's "Snow Landscape" (fig. 26), which has the typical clusters of isolated landscape elements. Yet this particular painting focuses our attention on a large central peak, around which are arranged other, smaller peaks and land masses. The emphasis on the central peak is enhanced by the greater detail with which it is depicted, with careful descriptions of its inner contours, whereas the surrounding mountains are left flat and starkly white. An additional element of compositional complexity is introduced by the spatial recession along the valleys framed by the mountainsides, as opposed to recession along a straight line, as in early

**Figure 28.** Yi Ching (1581–after 1645), *Gold-Painted Landscape.* Hanging scroll, gold ink on silk, 34 ⅝ × 24 ⅛ in. (87.8 × 61.2 cm). The National Museum of Korea, Seoul

Chosŏn paintings. The resulting sense of intricate depth and space are distinctive characteristics of mid-Chosŏn landscapes in the style of An Kyŏn.

Yi Hŭng-hyo's "Snow Landscape" (fig. 27) displays somewhat similar features, with a well-described central peak surrounded by relatively simplified flanking mountains. The emphasis on centrality is further heightened, however, by the small foothills in the middle distance and a pair of twin pines in the foreground, which combine with the large mountain to form an axis around which the other elements of the painting are arranged. The severity of this main element in the composition is mitigated by the meandering road that guides the eye of the viewer to a walled compound in the distance and by the energetic forms of the mountains, which, like Yi Chŏng-gŭn's mountains, seem to be in constant motion and upheaval.

The influence of the An Kyŏn tradition was strong in the seventeenth century, as demonstrated by Yi Ching's *Gold-Painted Landscape* (fig. 28). The focus of this stunning painting in gold ink on black silk is a massive pine tree on a rocky promontory, which shades what appears to be a luxurious residential compound consisting of a main building and a two-tiered pavilion overlooking the water. The emphasis on the middle distance, as well as the addition of mountain groups that look like clouds, distinguish this painting from those of the preceding period. Yet the energetic brushwork as well as the specific forms of the mountains — which are depicted with rhythmic lines, while spiky trees outline the distant peaks — place it firmly within the tradition of the An Kyŏn school.

The mid-Chosŏn dynasty emerges as an important period in the development of landscape painting in Korea. Whereas previously, distinct schools of painting were blended in the search for a personal vision of art and history, distinctive artistic person-

**Figure 29.** Kim Che (1524–1593), *Boy Leading a Donkey*. Hanging scroll, ink and light color on silk, 43 ¼ × 18 ⅛ in. (111 × 46 cm). Ho-Am Art Museum, Yongin. Treasure no. 783

alities now become more assertive. Their approach to stylistic precedents becomes more flexible than that of their predecessors, who adhered to a smaller range of artistic sources. This period is marked also by the rise in popularity of the Zhe school style, which became the dominant painting idiom in the mid-Chosŏn period. The most important exponents of this style were the artists Kim Che, Yi Kyŏng-yun, and Kim Myŏng-guk (1600–after 1662).

Kim Che has already been discussed in relation to the An Kyŏn style; his prominence as a painter of the Zhe school tradition epitomizes the great ease with which mid-Chosŏn painters moved between different artistic modes. Kim's *Boy Leading a Donkey* (fig. 29) shows a charming rustic scene of a boy tugging at the reins of a recalcitrant donkey, in a pristine natural setting with a large, weathered pine tree looming in the foreground and an imposing cliff in the middle ground. The pine tree plays a particularly vital role in the

**Figure 30.** Atributed to Yi Kyŏng-yun (1545–1611), *Landscape with Figures.* Hanging scroll, ink and light color on silk, 35 ⅞ × 23 ⅜ in. (91.1 × 59.5 cm). The National Museum of Korea, Seoul

scene, uniting the distant mountains and the rock-strewn boulder. The rugged mountain face is described with bold brushstrokes and sharply contrasting areas of plain silk, resulting in a dramatically rendered rock face that echoes the tactile quality of the massive foreground boulder. The narrative elements, as well as the bold, simplified brushwork of this painting and its large format, secure its place within the Zhe school tradition.

Another work in this tradition, *Landscape with Figures* (fig. 30), attributed to Yi Kyŏng-yun, portrays two robed scholars conversing in a vast landscape. One of the men is attended by a small boy; the other is accompanied by a boy, who is boiling tea, and a crane, a Daoist symbol of longevity. Once again, the sharp contrasts of light and dark and the enlarged scale of the figures are hallmarks of the Zhe school style, but the artist's distinctive touches make this painting different from Kim Che's work. These include a more expansive sense of space, a more fully articulated middle ground, and a clearer sense of deep spatial recession. Moreover, the brushwork shows a remarkable textural consistency, and is more uniform than in Kim's painting, which displays great variations in brush movement and ink tone. In contrast, Yi's brushwork is fine and highly descriptive, deliberately and carefully building up forms and modeling surfaces.

The maturation of the Zhe school style in the mid-Chosŏn can be seen in the work of Kim Myŏng-guk, particularly *Travel Through Deep Mountains* (fig. 31). Deeply indebted to the work of the Chinese Zhe school painter Wu Wei and his followers, this painting shows

**Figure 31.** Kim Myŏng-guk (1600–after 1662), *Travel Through Deep Mountains.* Hanging scroll, ink on hemp, 40 × 21 ⅝ in. (101.5 × 54.9 cm). The National Museum of Korea, Seoul

**Figure 32.** (facing page) Yi Chŏng-gŭn (b. 1531), *Landscape in the Style of Mi Fu.* Handscroll, ink on paper, 9 ¼ × 47 in. (23.4 × 119.4 cm). The National Museum of Korea, Seoul

a scholar setting off on an excursion, mounted on a donkey and accompanied by a small boy laden with supplies. We see the scholar just at the moment when he turns to take final leave of a servant standing at the gate of his humble thatched cottage. This touching scene is set in a stark landscape of snow-covered mountains. The influence of painters such as Kim Che is evident in the treatment of the mountain face, with wet ink strokes that compare very closely to the main mountain of *Boy Leading a Donkey.* The crisp air of a cold winter day is evoked by the jagged, improvisatory brushwork, whose force and strength lend an unprecedented energy and agitation to Kim's rough, forceful style.

The third important painting tradition of the mid-Chosŏn period was the so-called Southern School style. The paintings and writings of one of the leading figures in this school, Wen Zhengming (1470–1559), were known in Korea in the early seventeenth century, as recorded in the *Annals of King Sŏnjo* and in the writings of the scholars Hŏ Mok (1595–1682) and Kim Sang-hŏn (1570–1652).[45] Based upon the ideal of the scholar who paints for the purpose of personal cultivation and self-expression rather than for commercial gain, the term "Southern School" was coined by the late Ming scholar-official, artist, and calligrapher Dong Qichang (1555–1636), whose division of Chinese art history into Southern School (amateur) painters and Northern School (professional) painters was influenced by the two different schools of Chan Buddhism (Kr. Sŏn; Jp. Zen). Due to its amateur status and self-expressive aims, the Southern School was accorded higher status than the Northern School, whose professional painters worked only to

please patrons, and were therefore regarded by Dong as belonging to the category of craftsmen rather than artists. Dong also posited certain stylistic differences, which were adopted by later painters and became firmly associated with either the amateur or the professional artist.

Although Dong himself does not seem to have been as dogmatic about distinctions between the Northern and Southern schools as his followers were to become, his theories were nevertheless highly influential in China, and exerted power in Korea as well, where Southern School painting as propounded by its main Chinese adherents began to gain in popularity in the mid-Chosŏn period. Its artistic influence can be seen in the works of such painters as Yi Chŏng-gŭn, Yi Yŏng-yun, and Yi Chŏng.[46] The inscription on Yi Chŏng-gŭn's handscroll *Landscape in the Style of Mi Fu* (fig. 32), dedicating the painting to one Kim Hyŏn-sŏng (1542–1621), states that it is a free interpretation of Mi's *Appreciating the Rain in a Thatched Hut.* The scroll opens with a house nestled in a grove behind small round hills. Seated in the house is a solitary figure, who watches another figure approach, protected from the rain with an umbrella. The scroll then reveals a riverbank that recedes into a mist-enshrouded complex of buildings in the far distance. The rich, wet ink and broad, gentle brushwork are particularly well suited for the depiction of misty, rainy weather, and are the characteristic features of the Mi family style, with its use of heavy dots to create forms and convey texture. Mi Fu was a prominent member of the Southern School, whose great renown as a calligrapher assured his status and whose serene

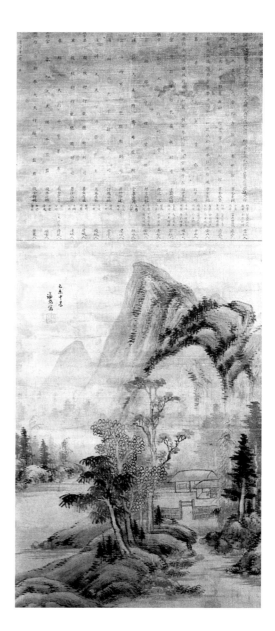

**Figure 33.** Chŏng Sŏn (1676–1759), *Yuksangmyo*, dated 1739. Hanging scroll, ink and light color on silk, 57 ½ × 24 ⅜ in. (146 × 62 cm). Private collection, Seoul

landscapes were widely imitated by practitioners of the Southern School style in both China and Korea. However, despite its inscription, with its reference to Mi's landscape, this painting is influenced more by the understanding of the Mi style during the late Ming period — especially in the appearance of the foreground hut and the overall mood of the work — than by any direct knowledge of Mi Fu's paintings.

## LATE CHOSŎN DYNASTY

The late Chosŏn period, from about 1700 to 1850, saw the decline in popularity of other stylistic trends in favor of a landscape style solidly based on Chinese Southern School painting, an idiom that by this time encompassed not only interpretations of Yuan and Ming painters but those of artists of the Qing dynasty (1644–1911) as well. The stylistic models for Southern School painting in Korea were the major artists in this lineage as canonized by Dong Qichang — among them Mi Fu, Huang Gongwang (1269–1354), and Ni Zan (1301–1374) — and their emulators in later times. Thus Korean Southern School

**Figure 34.** Kang Se-hwang (1713–1791), "Paeksŏk-tam Pond." One double leaf from *Album of a Journey to Songdo*, ca. 1757, an album of 16 double leaves, ink and light color on paper, 13 × 21 in. (32.9 × 53.4 cm). The National Museum of Korea, Seoul

painting was rich in stylistic models. Late Chosŏn painters could, to describe just one possibility, take as their starting point Qing-dynasty interpretations of Ming-dynasty followers of a Yuan-dynasty artist.

The major Korean application of Southern School painting was known as "true-view landscape painting" (*chin'gyŏng sansuhwa*), and its most important practitioner was Chŏng Sŏn (1676–1759). Credited with the "Koreanization" of Chosŏn painting, Chŏng's earlier works display deep affinities with the style of the Wu school of painting of the Ming dynasty, whose principal proponents were Wen Zhengming and Shen Zhou (1427–1509).[47] Although his paintings also show traces of the Southern School style, Chŏng's true-view style seems to have emerged from his incorporation of these various sources into his own unique and powerful artistic vision. The most representative extant dated painting by Chŏng Sŏn, from 1734, is a depiction of Mount Kŭmgang, the spectacular mountain range on the northeastern coast of the Korean peninsula that was a favorite subject of painters in the Koryŏ and Chosŏn periods, and especially from the eighteenth century onward.[48]

Chŏng Sŏn's followers included such important artists as Kang Hŭi-ŏn (1710–1764), Kim Yun-gyŏm (1711–1775), Kim Ŭng-hwan (1742–1789), Yi In-mun (1745–1821), and Kim Sŏk-sin (b. 1758).[49] Chŏng's crystallization of Chinese-style landscape into a distinctly Korean art form cannot be understood, however, without a consideration of the Southern School tradition of the Ming and Qing dynasties.[50] A landscape entitled *Yuksangmyo* (fig. 33) can shed light on the crucial role of the development of this Chinese artistic tradition, while also demonstrating Chŏng's transformation of these influences. Painted in 1739 as an official commemorative landscape, the subject of this scroll is a memorial hall built in 1725 for royal concubines. Its nearly archival status is confirmed by the official inscriptions above the painting, which record the names of the officials who presided over the design and construction of the hall. A foreground cluster of low earthen mounds leads back to the memorial hall. On the mounds grow several trees drawn in a classical post-Yuan Southern School idiom, as are the simple buildings that make up the memorial complex. Yet the far background hills and mountains are rendered in Chŏng's signature style, with his distinctive formal rhythms and brushwork. Painted when Chŏng was sixty-two, this work is an outstanding example of the continuing influence of Southern School painting on the art of Chŏng Sŏn, even after his full maturation as an artist.

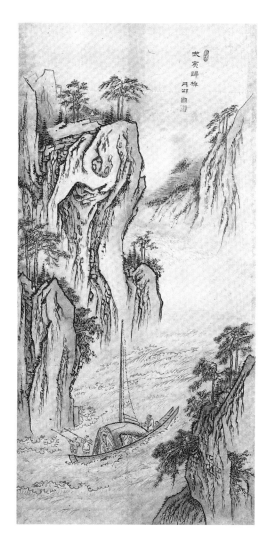

**Figure 35.** Kim Hong-do (1745–1806), *Sailing Home from Wuyi Valley.* One hanging scroll from *Eight Scenes from Famous Tales,* a set of 8 hanging scrolls, ink and light color on paper, 44 × 20 ¾ in. (111.9 × 52.6 cm). Kansong Art Museum, Seoul

Among the other important literati and professional painters of the late Chosŏn period to adopt the Southern School style were Kang Se-hwang (1713–1791), Yi In-sang (1710–1760), and Sin Wi (1769–1847). Kang Se-hwang incorporated in his painting style a wide range of historical and contemporary influences, including the work of such Chinese painters as Mi Fu, Zhao Mengfu, Huang Gongwang, Wen Zhengming, Shen Zhou, and Dong Qichang, as well as Western painting techniques available to Korean artists through China.[51] The album leaf, "Paeksŏk-tam Pond" (fig. 34), from a larger album that Kang painted to commemorate his travels to Songdo, demonstrates his use of divergent stylistic references and techniques. The large boulders are subtly rendered, their volumes and surfaces described with modulated watercolors that clearly draw from the Western technique of chiaroscuro. Yet the modeling of the rocks, not with highly descriptive color and shading, but with highly animated, calligraphic brushwork, shows Kang's intimate knowledge of Southern School painting techniques, which valued calligraphic brushwork more highly than realistic representation. Despite their reference to a variety of stylistic sources, however, Kang's paintings are not simply eclectic, but are imbued with the artist's distinctive techniques, which include strong compositional structures, animated brushwork, and the establishment of a powerful mood.

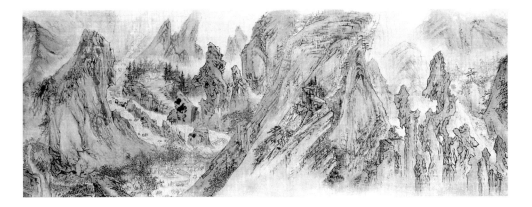

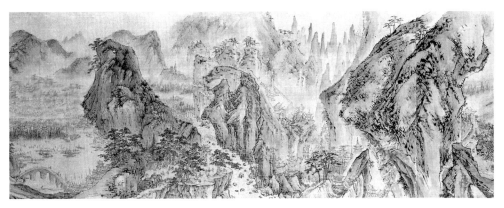

**Figure 36.** Yi In-mun (1745–1821), *Streams and Mountains Without End.* Details of handscroll, ink and light color on silk, 17 ¼ × 337 in. (43.8 × 856 cm). The National Museum of Korea, Seoul

Versatility and the synthesis of divergent influences were characteristics of artists during the late Chosŏn period. Perhaps the foremost example of this ideal is Kim Hong-do (1745–1806), who, as well as being an accomplished landscape painter, was also renowned as a master of figure, genre, bird-and-flower, animal, and religious painting. A highly prolific court artist who left an enormous body of work, Kim Hong-do was truly one of the most powerful artistic personalities of his time.[52] *Sailing Home from Wuyi Valley* (fig. 35), one of a series of eight hanging scrolls that illustrate scenes from famous Chinese stories, is a stunning example of his influential landscape style. Although the subject is ostensibly the small boat in the near distance, the most visually arresting elements of this painting are the towering cliff formations that loom over the river rapids. The twisting, craggy surfaces of the cliffs and the lively pine trees are described with Kim's sharp, versatile, and powerful brushwork, which provides spontaneity and variety to the tightly knit composition. Kim Hong-do's unmistakable mastery and talent had a profound impact on the artistic community of his time.[53]

This community included another court painter, Yi In-mun (1745–1821), whose masterpiece *Streams and Mountains Without End* (fig. 36) demonstrates the refinement and sophistication of late Chosŏn landscape painting. A grand vision of the ever-changing aspects of nature, this scroll features a panoramic scale that makes it one of the most celebrated landscape paintings in Korea. Yi's handscroll follows an unusual rhythm. There are no obvious compositional divisions, but rather a continuous progression through a widely

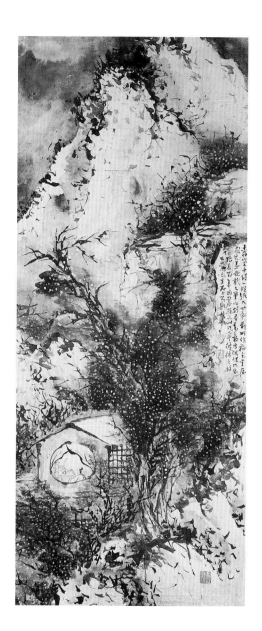

**Figure 37.** Cho Hŭi-ryong (1797–1859), *Plum Blossom Study.* Hanging scroll, ink and light color on paper, 41 ¾ × 17 ¾ in. (106.1 × 45.1 cm). Kansong Art Museum, Seoul

varying range of landscape formations and styles. The spectrum of stylistic references, compositional strategies, and dazzling virtuoso brushwork in a single painting is unparalleled, and establishes Yi as a key figure in the history of later Korean painting.

### END OF THE CHOSŎN DYNASTY

In the final years of the Chosŏn dynasy, the true-view landscape style espoused by the leading artists of the previous period was adopted by some professional artists and anonymous folk painters. The Southern School replaced Chŏng Sŏn's true-view landscape style as the dominant style among such significant painters as Kim Chŏng-hŭi (1786–1856) and his followers, including Cho Hŭi-ryong (1797–1859), Hŏ Ryŏn (1809–1892), Chŏn Ki (1825–1854), Kim Su-ch'ŏl (19th century), and Chang Sŭng-ŏp (1843–1897).[54]

Cho Hŭi-ryong's *Plum Blossom Study* (fig. 37) demonstrates the artist's innovations within the Southern School tradition. A modest hut is partially obscured by plum blossoms as white and thick as the snow that still blankets the mountains in this early spring

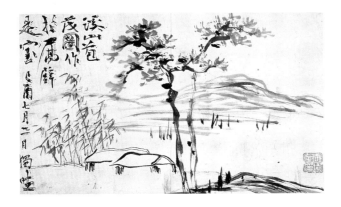

**Figure 38.** Chŏn Ki (1825–1854), "Mountain Canyon and Trees," dated 1849. Double album leaf, ink on paper, 9 ⅝ × 16 ⅜ in. (24.5 × 41.5 cm). The National Museum of Korea, Seoul

scene. Barely visible through the round window of the hut is a lone scholar sitting in contemplation in his study, surrounded by books, studio implements, and a branch of blossoming plum. Cho sets up a poignant contrast between the tranquility and introspection of the man and the lushness of his surroundings, which seem to brim with life and energy. Although nearly the entire surface of the painting is covered with paint, the scene remains uncluttered, perhaps because of the vibrant yet well-controlled brushwork, whose roughness and spontaneity impart an expansive air to the composition. At the same time, the profusion of plum blossoms helps to unify the composition through the use of a consistent textural motif. The overall effect is of a fantastic retreat, a spiritual haven from the conditions of ordinary existence.

This fascination with escape and transcendence of the everyday world is also seen in the work of Cho's friend and contemporary Chŏn Ki. Although Chŏn painted in a similarly lush and highly embellished style, he is more famous for his sparse, astringent style, as exemplified by "Mountain Canyon and Trees" (fig. 38). This is painting stripped of all but the most essential elements. Chŏn's dry brush describes the barest forms of two empty huts with a bamboo grove and twin trees. Some swiftly sketched mountains, a simple bridge, and a short inscription fill out the composition. The inspiration for this painting idiom is the oeuvre of the eccentric, nearly obsessive Chinese artist Ni Zan, who spent much of his long life re-creating a basic composition consisting of the same elements: empty pavilions, sparse trees, and distant mountains. Yet while Ni Zan had a distinctive brushwork style that was both highly descriptive and elegantly calligraphic and self-expressive, Chŏn's approach to this stylistic idiom, which possessed, by the nineteenth century, the most unimpeachable pedigree, bespeaks an intensive and highly personal artistic quest. Painted in 1849, when Chŏn was twenty-four, this painting shows the great energy of a young and ambitious painter, whose untimely death five years later abruptly ended the maturation of a remarkable talent.

Cho and Chŏn were both well known during their lifetimes, but had no significant successors in the twentieth century. Perhaps the only artists whose legacies thrive today are Hŏ Ryŏn and Chang Sŭng-ŏp. Hŏ painted in the Southern School manner, as seen in a landscape painted on a fan (fig. 39) that features a large central mountain in front of which is a small fenced compound and trees. A man carrying a staff crosses a footbridge over a

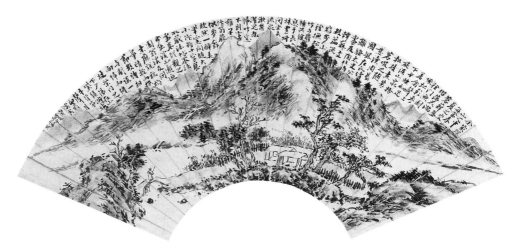

**Figure 39.** Hŏ Ryŏn (1809–1892), *Landscape*, dated 1866. Fan mounted as album leaf, ink and light color on paper, 7 ⅞ × 24 in. (20 × 61 cm). Seoul National University Museum, Seoul

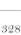

stream, walking toward the seemingly empty buildings in the clearing ahead. Filling the space at the top of the painting above the mountains is a lengthy inscription extolling the pleasures of this simple mountain retreat, whose literary and artistic references reinforce the stylistic aspects of the painting that are associated with the canon of Southern School compositional schemes. Hŏ's personal innovations within this spectrum include the vivid contrasts in the main mountains, as well as the rough, improvisatory brushwork. These distinctive stylistic signatures are still influential in contemporary Korean art.

More than any other painter at the end of the Chosŏn period, Chang Sŭng-ŏp represents the transition to modernity. Chang's depictions of such time-honored Chinese narrative themes as "The Homecoming of Tao Yuanming" as well as his paintings in the manner of historically significant Chinese artists, such as Huang Gongwang, attest to his stylistic roots in Southern School landscape painting. This indebtedness is visible in a painting entitled simply *Landscape* (fig. 40). One of eight hanging scrolls in a set, this eccentric composition features rocky mountains that billow out dramatically. Barely visible in the foreground at the lower right are two figures crossing a footbridge on their way from a thatched pavilion that overlooks the mountain stream. Their destination is the residence nestled among the cliffs and trees in the middle distance, accessible by a small path that winds along the bank of the stream, with rough, craggy cliffs looming above. In the upper part of the painting a waterfall cascades down the steep face of the far peak. An extraordinary feature of this painting are the twisting, repeating forms of the three main segments of the landscape, which establish a strong rhythm of compositional elements in a manner rarely seen in Korean paintings. This interest in surface interaction and the graphic potential of representational landscape — which came at a time when Korea was on the brink of modernity and engaging in cautious interaction with Meiji Japan and the West — establishes Chang's position as one of the foremost artists of this important transitional period. ❧

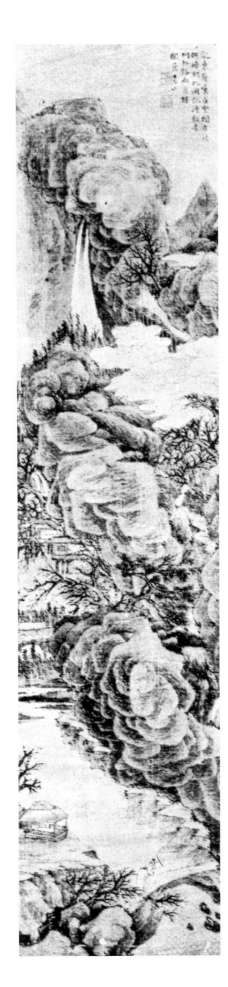

**Figure 40.** Chang Sŭng-ŏp (1843–1897), *Landscape.*
One hanging scroll from *Landscapes*, a set of 8 hang-
ing scrolls, ink and light color on silk, 53 ¾ × 12 ¾ in.
(136.5 × 32.5 cm). Kansong Art Museum, Seoul

Yi Sŏng-mi

# Artistic Tradition and the Depiction of Reality:
# True-View Landscape Painting of the Chosŏn Dynasty

In the long span of the Chosŏn dynasty (1392–1910), a general cultural efflorescence occurred during the reigns of two enlightened monarchs, Kings Yŏngjo (r. 1724–76) and his grandson Chŏngjo (r. 1776–1800). Two areas of painting in particular, true-view landscape painting and genre painting, flowered in the eighteenth century, and, indeed, are among the most esteemed achievements of the late Chosŏn period. The former, because of its association with the increasing emphasis on the development of Korean cultural and historical identity, is usually singled out as the expression of the "ethos of Korea." This essay will examine the development and flowering of true-view landscape painting in the late Chosŏn within this larger context.

It is assumed that in the early stages of the development of East Asian painting, most paintings categorized as "landscapes" were not symbolic but representational depictions of the real world. Yet, however much landscape painting might seek to depict actual topography, the artistic representation of the natural world became subject to certain conventions. In China, themes from well-known literary works, such as "Peach Blossom Spring" (*Taohua yuan*), by the early-fifth-century poet Tao Qian (365–427), and "Ode to the Red Cliff" (*Chibi fu*), by the great Northern Song poet and calligrapher Su Shi (1037–1101), were particularly popular painting subjects. In addition, places of exceptional beauty and historical importance in China were reproduced in sets of four, eight, and even nine scenes, the Eight Views of the Xiao and Xiang Rivers being one

**Figure 1.** Chŏng Sŏn (1676–1759), *Clearing after Rain on Mount Inwang*, dated 1751. Hanging scroll, ink on paper, 31 ⅛ × 54 ⅜ in. (79.2 × 138.2 cm). Ho-Am Art Museum, Yongin. National Treasure no. 216

of the most famous themes. Landscape painting of the early Chosŏn period developed under the influence of such Chinese landscape painting conventions and brush techniques. However, this gradually gave way to a new development in the mid-Chosŏn period, and finally, in the eighteenth century, Korean painters established the more indigenous tradition of true-view landscape painting, which depicts Korean scenery.

*Chin'gyŏng* (Ch. *zhenjing*; Jp. *shinkei*), meaning "real scenery," is the Korean term for what has come to be known as "true-view" landscape. In Korea today, the term designates not simply realistic landscape depictions but paintings of Korean sites executed in techniques and in a manner first developed during the eighteenth century to portray specifically Korean scenery.[1] Probably the best example of an eighteenth-century true-view landscape is *Clearing after Rain on Mount Inwang* (fig. 1), dated 1751, by Chŏng Sŏn (1676–1759). In this work the artist used bold, sweeping brushstrokes in dark ink to portray the massive rocky faces of Mount Inwang emerging from the mist just after the rain. It was undoubtedly in response to such an image that the noted critic and painter Kang Sehwang (1713–1791), in a recorded colophon to an album of paintings by the artist, wrote: "Chŏng Kyŏmjae [Sŏn] excelled in true-view landscape painting of the Eastern Nation [*tongguk chin'gyŏng*]."[2] The Eastern Nation of which he speaks is, of course, Korea.

The Chinese term for "real scenery" (*zhenjing*) appears as early as the tenth century, in a treatise by Jing Hao (act. ca. 870–ca. 930) entitled *A Note on the Art of the Brush* (*Bifa ji*). In his classification of paintings into four grades (divine, marvelous, strange, and skillful), Jing Hao explains that in paintings belonging to the "strange" class, the traces of the brush and ink are "unfathomable," causing the disparity with real scenery.[3] About a century later, during the Northern Song dynasty (960–1127), we find the term "real landscape" (*zhen shanshui*) in a celebrated treatise on landscape painting by Guo Xi (ca.

**Figure 2.** Kang Hŭi-ŏn (1710–1764), "Mount Inwang Seen from Tohwa-dong." Album leaf, ink and light color on paper, 9 ⅝ × 16 ¾ in. (24.6 × 42.6 cm). Private collection

1000–ca. 1090), *The Lofty Message of Forest and Streams (Linchuan gao zhi)*.[4] In the Chinese texts, the terms *zhenjing* and *zhen shanshui* seem to point to exactly what the words mean, a representational depiction of topography. In modern Korean scholarship, however, *chin'gyŏng sansu* refers not to "real-scenery landscape painting" but instead has the meaning "true-view landscape painting."

To understand what is meant by "true view," it is helpful to review how the expression has evolved over time. Recent studies reveal that during the late Chosŏn period, the word *chin'gyŏng* was usually written with the character *kyŏng*, meaning "boundary" or "realm," rather than with the character *kyŏng*, meaning "scenery."[5] This character, however, referred not to locations in the real world but to the realm of the immortals (*sŏn'-gyŏng*), indeed one quite apart from the mundane world. Though by the early eighteenth century, the character *kyŏng* (boundary) was replaced with *kyŏng* (scenery), when speaking of true-view landscapes, other connotations adhered to the term.

*Chin'gyŏng* is often used interchangeably with *silgyŏng*, meaning "real scenery." The character *sil* (Ch. *shi*) means "real" but does not commonly imply "truth," in the philosophical sense of the term, as does the character *chin*. In a recent study reviewing a group of words sharing the syllable *chin*—*chinmun* (true writing), *chinsi* (true poetry), *chinhwa* (true painting)—it was found that in the eighteenth-century context these words all imply an ideal artistic state close to that encompassed in the term "workings of heaven" (Kr. *ch'ŏn'gi*; Ch. *tianji*), which has been defined as the "instinctive, natural operation of the artist's mind in a state of inspiration."[6] Therefore, when Korean scholars of the eighteenth century used the term *chin'gyŏng*, they seem to have had in mind more than "real" scenery; the term encompasses scenery that, while true to actual Korean landscapes, is also the most exemplary and the most ideal in the country, such as that of Mount

Kŭmgang (Diamond Mountain). Located along the east coast in northern Kang'wŏn Province, in present-day North Korea, Mount Kŭmgang is indeed well represented in true-view landscape paintings of the eighteenth and nineteenth centuries.

Other words sharing the character *chin* that are not conceptual but more concrete in meaning also shed light on the semantic range of the term *chin'gyŏng*. The Chosŏn dynasty's palace records of special events (*Togam ŭigwe*) occurring during the eighteenth and nineteenth centuries provide descriptions of royal weddings as well as the painting and copying of royal portraits, and for each of these events there are detailed lists of the materials used. Among the lists of pigments and inks used in painting screens or portraits, the palace records include sets of contrasting terms employing the initial syllable *tang* or *chin*, for instance, *tangbun* and *chinbun*, or *tangmuk* and *chinmuk*.[7] In Korea and Japan, beginning in the Tang period (618–907), articles of Chinese origin were referred to with the prefix *tang*. Thus, in the above records, *tangbun* refers to Chinese white pigment, as opposed to Korean white pigment; and *tangmuk* to inksticks made in China, in contrast to *chinmuk*, domestically produced inksticks.

The *Dictionary of Korean Terms Written in Chinese Characters* (*Han'guk hanjaŏ sajŏn*) defines the term *chinmuk* as "ink of the best quality."[8] Thus, in all the words listed above the prefix *chin* would seem not only to refer to things Korean, but also to include a value judgment: things of the best quality. In the historical and cultural context of the late Chosŏn period, the term *chin'gyŏng sansu*, then, probably refers to painting depicting specifically Korean scenery that is, at the same time, regarded as ideally the most beautiful and the best in the country.

Extending these multiple layers of meaning that distinguish and elucidate what is specifically Korean about true-view painting is an inscription by the above-mentioned Kang Se-hwang on another true-view landscape, this one by Kang Hŭi-ŏn (1710–1764), titled "Mount Inwang Seen from Tohwa-dong" (fig. 2). One of the most prominent mountains in the western section of Seoul, Mount Inwang is still a favored theme of contemporary painters. In his inscription, Kang draws attention not to an idealized treatment of a Korean scene but rather to the mimetic aspects of the representation:

> Painters of true-view landscapes [*chin'gyŏng*] are always worried that their paintings
> might look like maps. However, this painting successfully captures the resemblance
> [to real scenery] while not sacrificing the [old] masters' methods.[9]

The mountain, as is illustrated by the two eighteenth-century paintings in figures 1 and 2, naturally appears different because of the vantage point from which the artist chose to depict it. (Figure 3, a photograph of Mount Inwang taken from the 37th floor of the Lotte Hotel in the center of modern Seoul, approximates the view depicted by Chŏng Sŏn.) But Kang Se-hwang's inscription on the Kang Hŭi-ŏn painting elucidates two seemingly opposed qualities of true-view painting as the genre was developing in the eighteenth century. The first is what might be seen as the traditional aspect of *chin'gyŏng*, its

**Figure 3.** Mount Inwang, Seoul. Photograph by Yi Sŏng-mi, 1997

concern with following the "old masters' methods." By this Kang means traditional Chinese painting methods, which Kang Hŭi-ŏn clearly has had recourse to in depicting a Korean scene. The second aspect is the innovative and novel treatment of landscape, employing new brush methods and compositions of the painter's own devising to suit the particular scenery being depicted, which Chŏng Sŏn has just as evidently accomplished.

In the eighteenth century, the painting of Korean scenery took on new importance. Though there was a tradition of landscape painting prior to the late Chosŏn period, certain social, cultural, and intellectual forces caused Koreans to consider the distinctiveness of Korea itself, which in turn led to attention being paid to the painting of the country's topography. It was due to this attention that true-view landscape painting began to develop and to follow a diverse two-and-a-half century course, from the second half of the seventeenth century to the late nineteenth century. In the process, it interacted with other painting traditions and styles and produced prominent artists whose works exemplify the stages of its development.

### PRELUDE TO TRUE-VIEW LANDSCAPE PAINTING IN THE LATE CHOSŎN PERIOD: THE DEPICTION OF ACTUAL KOREAN SITES

No Korean maps prior to the early Chosŏn period survive, though such maps, with accurately rendered topography, were made for practical purposes, primarily military.[10] Kang Se-hwang's inscription on Kang Hŭi-ŏn's painting of Mount Inwang refers to the rendering of actual Korean sites in maps, which in fact were produced by court painters. Indeed, some late Chosŏn maps display an artistic quality nearly equal to that of landscape paintings.

Since there are so few surviving landscape paintings from the Koryŏ dynasty (918–1392) and earlier, we must turn to literary evidence for information concerning early paintings of Korean sites. One artist whose works have been documented is the famous Koryŏ painter Yi Nyŏng (act. ca. 1122–46). Among his paintings commemorating Korean sites are *Scenery Along the River Yesŏng*, *South Gate of Ch'ŏnsu-sa Temple*, *Landscape of Chinyang*, and *Eight Scenes of Songdo*, Songdo referring to the capital of Koryŏ (present-day

Kaesŏng).[11] The only surviving example of an early depiction of Korean scenery is a small lacquer screen by Noyŏng, dated 1307 (Ahn, fig. 14), on which is painted what is believed to be the earliest representation of Mount Kŭmgang.[12] Noyŏng's depiction of the jagged granite peaks so typical of this mountain was to be followed by many painters of the late Chosŏn.

In the early years of the Chosŏn period, with the establishment of the new capital at Hanyang (present-day Seoul), painting was drafted into service to extol the natural beauty of the capital as well as the majestic appearance of its palace buildings and fortress; a screen painting entitled *Eight Scenes of the New Capital*, recorded in the *Veritable Records of King T'aejo* (r. 1392–98), is one example.[13] Although painting sets of eight scenes was traditional practice by the fourteenth century, the titles of the scenes depicted in this series indicate that it departs somewhat from tradition by representing not only natural scenery but also scenes of human activity in and around the new capital: the Kijŏn (the area surrounding the capital);[14] the Walled City and Its Palaces and Gardens; Official Buildings; Residential Buildings; East Gate Military Training Grounds; Boat Traffic on the Sŏ River; Passersby along the Southern Ford; and Horses in the Northern Suburbs.

Although no paintings of these titles survive, their mention in the *Veritable Records* indicates that works depicting the actual scenery in and around the capital city were produced at the beginning of the Chosŏn dynasty. The *Veritable Records* also reveal that paintings of scenic spots in Korea were much in demand by emissaries from the Chinese Ming court, the most frequently requested being those of Mount Kŭmgang.[15] The Yanghwa-do Ford, a scenic spot along the Han River in Seoul, and Mount Samgak, also in Seoul, seem also to have been favorite subjects. For instance, Yun Feng, a Ming envoy to the court of King Munjong (r. 1450–52), asked for a set of paintings of the four seasons at the Yanghwa-do Ford on his departure for China.[16] In 1560 Korean officials traveling to P'yŏng'yang to pay respects to the portrait of King T'aejo kept in the Yŏngsung-jŏn Hall were ordered by King Myŏngjong (r. 1545–67) to take along a court painter in order to have the scenery in P'yŏng'yang painted and mounted as a screen.[17] The oldest extant screen painting depicting P'yŏng'yang dates from the seventeenth century.[18] Documents show that this city, which served as the western capital of the dynasty, was a subject of painting throughout the Chosŏn period.

One genre of painting from the early Chosŏn to include actual Korean sites was documentary painting. Among such works are those produced by the court painting bureau, the Tohwa-sŏ, to record state examinations, which took place on a specific date and at a specific site.[19] The continuation of this tradition can be seen in a seventeenth-century handscroll, *Special National Examination for Applicants from the Northeastern Provinces* (pl. 92), by Han Si-gak (b. 1621).[20] Among privately commissioned documentary paintings showing actual localities, the best surviving ones record gatherings of scholars. Known as *kyehoe-do*, multiple copies of these paintings were typically produced so that each participant could own a copy.[21] A well-preserved early example is *Gathering of*

Figure 4. Unidentified artist (16th century), *Gathering of Scholars at Tŏksŏ-dang Hall*, ca. 1570. Hanging scroll, ink on silk, 39 ¾ × 22 ¾ in. (101 × 57.7 cm). Seoul National University Museum. Treasure no. 867

*Scholars at Tŏksŏ-dang Hall* (fig. 4). The format of a kyehoe-do painting usually shows a tripartite division: the top part is occupied by the title of the painting, written in seal script; the middle part portrays the gathering, including the landscape and figures; in the lower part is a list of names of the participants with their official titles and other important biographical data.

In the case of *Gathering of Scholars at Tŏksŏ-dang Hall*, the place depicted was originally located at the Tumo-p'o Ford, on the Han River.[22] The date of the painting, about 1570, has been deduced from the year in which the scholars named on the work were granted an official leave for study.[23] Although the scenery is much changed since the sixteenth century, one can still identify the shapes of the Maebong mountains in the distance; in this sense, the painting can be considered representative of sixteenth-century real-scenery painting.[24] That scenic spots along the Han River were frequently recorded in painting is documented in the *Veritable Records of King Chungjong* (r. 1506–44). In 1537 a scene of boating on the river was painted and presented to two Chinese emissaries to the

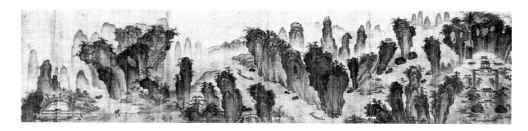

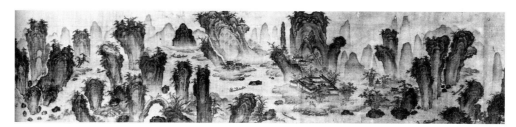

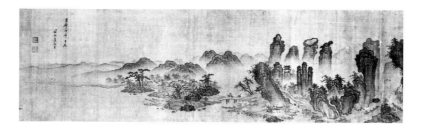

**Figure 5.** Yi Sŏng-gil (b. 1562), *Nine-Bend Stream of Mount Wuyi*, dated 1592. Handscroll, ink and light color on silk, 13 ¼ × 157 ½ in. (33.6 × 400 cm). The National Museum of Korea, Seoul

court of King Chungjong. They are recorded to have been overwhelmed by the beauty of the painting, exclaiming: "This is indeed a priceless treasure!"[25]

The development of true-view landscape painting can also be gleaned from examining how Korean painters explored and then transformed a specifically Chinese theme, namely, the mountain retreat of Zhu Xi (1130–1200), the great Southern Song Neo-Confucian scholar.[26] Mount Wuyi (Mui-san), in western Fujian Province, was the site chosen by Zhu for his retirement. There he had a complex of buildings and pavilions built along the Nine-Bend Stream (Kr. Kugok-kye; Ch. Jiuqu xi) to be used by himself and his disciples for teaching, study, and contemplation. It is unclear whether Zhu Xi's hermitage was painted as a series of scenes forming a long handscroll during his lifetime or shortly thereafter. The first recorded accounts of paintings called *The Nine-Bend Stream at Mount Wuyi* or with similar titles[27] appear during the Yuan dynasty (1272–1368). The basis for the pictorial representation is Zhu Xi's poem "Boating Song [along the streams] at Mount Wuyi," which describes the natural beauty of his mountain abode.

The Nine-Bend Stream tradition and its pictorial representation made their way to Korea in the early years of the Chosŏn dynasty, when Neo-Confucianism was adopted by the court as the official ideology of the state. Korean Neo-Confucian scholars wrote poetry to match the rhyme of Zhu Xi's poem and styled their works after the landscape paintings of Mount Wuyi and the Nine-Bend Stream, including Zhu Xi's hermitage. One group of scholars, headed by the philosopher-teacher Yi I (1536–1584), became adherents

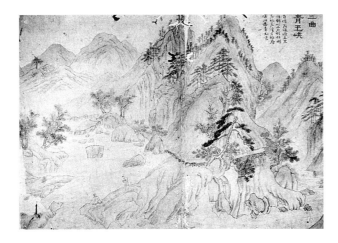

**Figure 6.** Cho Se-gŏl (1636–1705), "Blue Jade Valley." Two leaves from *Nine-Bend Stream of Kogun*, dated 1682, an album of 10 leaves, ink and light color on silk, 16 ¾ × 25 ¼ in. (42.5 × 64 cm). The National Museum of Korea, Seoul

of poetry and painting on the theme of the Nine-Bend Stream of Mount Wuyi. An example of the reverence for Zhu Xi is Yi Sŏng-gil's (b. 1562) long handscroll with this title, dated 1592 (fig. 5). Since the painting bears a great deal of affinity to the actual topography of Mount Wuyi, Korean painters may have actually seen Chinese representations of the subject.[28] Yi I, however, thought it more fitting for Korean scholars to build their own hermitages (Kr. *chŏngsa*; Ch. *jingshe*) in natural settings recalling that of the Chinese model. The first of these was the hermitage complex known as Sŏktam Chŏngsa, built by Yi I in 1578 along a nine-bend stream in Sŏktam, in the Kosan district of Hwanghae Province. In 1576 Yi I composed a poem in Korean entitled "Song of the Nine-Bend [Stream] of Kosan," extolling the natural beauty of each of the nine scenes.

Significantly, Yi I's choice of a Korean location for his hermitage and his use of the Korean language for his poem are consonant with the new direction of Neo-Confucian philosophy that he was advocating. For the Chinese philosopher Zhu Xi and his followers, principle (Kr. *i*; Ch. *li*) and matter-energy (Kr. *ki*; Ch. *qi*) were two distinct entities. Yi I's phrase, "subtlety of *li* and *qi*" (*igi chi myo*), suggests that they were not two distinct entities, but two entities in one inseparable state.[29] This growing independence from the Chinese scholarly and intellectual tradition beginning in the late sixteenth century is evidence that Koreans were also becoming more aware of all things Korean. This awareness encompassed the areas of language, literature, history, geography, and art, most of which were critical to the development of true-view landscape painting in the seventeenth and the eighteenth centuries.

Although scenes from around Yi I's Sŏktam hermitage in Kosan were painted by many artists from the nineteenth century onward, there seems to be no evidence that any were painted during Yi I's lifetime.[30] In the seventeenth century, however, Korean Neo-Confucian scholars who followed the scholarly lineage of Yi I had the scenery surrounding their own retreats painted by famous court painters. One such example is the *Nine-Bend Stream of Kogun*, painted in 1682 by the well-known court painter Cho Se-gŏl (1636–1705).[31] This album of paintings marks a milestone in the development of true-view landscape painting in that it depicts an actual Korean site. The subject of the painting is the

**Figure 7.** Blue Jade Valley, Kogun,
Kang'wŏn Province. Photograph by
Yun Chin-yŏng, 1997.

mountain hermitage of the scholar-official Kim Su-jŭng (1624–1701), in the Hwach'ŏn district of Kang'wŏn Province. After an illustrious official career, Kim retired to Kogun where he built a retreat in the scenic valley along a nine-bend stream. There, he was joined by his friend Song Si-yŏl (1607–1689), who is considered the legitimate heir to the scholarship of Yi I. The second leaf of the album depicts "Blue Jade Valley" (fig. 6), at the second bend of the stream. The mountain in the center and the valley on either side closely resemble a recent photograph of the site (fig. 7). Other leaves also display a striking resemblance to the actual sites they record.

### THE INTELLECTUAL FOUNDATIONS
### OF TRUE-VIEW LANDSCAPE PAINTING

The overthrow in China of the Ming dynasty by the Manchus in 1644 and the subsequent establishment of the Qing dynasty had an important effect on Korea's cultural awareness. While on the surface the Chosŏn court maintained a cordial diplomatic relationship with the Manchus, the majority of high-ranking Chosŏn scholar-officials, including the court, were at heart loyal to the fallen Ming dynasty.[32] Culturally, Koreans felt far superior to the Manchus. Although they had been disgraced militarily in the Manchu invasion in 1636, Koreans looked down on the Manchu "barbarians" (Kr. *horo*; Ch. *hulu*), who were regarded as lacking in culture and scholarship. Furthermore, in the absence of an heir to the Han Chinese tradition in China, Koreans came to consider themselves the legitimate heirs to that grand cultural tradition, an attitude mainly promoted by such Neo-Confucian scholars as Song Si-yŏl and his followers, and by a group of scholars known as the Old Doctrine (*noron*) faction.[33]

Korean regard for Han Chinese culture crystallized in the term "minor China" (*so-chunghwa*),[34] which Korea used to refer to itself as heir to that tradition. The term suggests that it was Korea's role faithfully to follow and perpetuate China's cultural and intellectual traditions, but Korean scholar-officials increasingly began to feel new confidence and self-respect concerning their own culture. Regardless of the extent to which the "minor China" concept may have contributed to the development of true-view landscape painting in the late seventeenth and early eighteenth centuries,[35] it certainly provided the

Chosŏn intellectual class with an incentive to examine their own history. At this time, for instance, the Chosŏn court refurbished the tombs of the Korean kings going back to the legendary founder, King Tan'gun, and the Silla kings.[36]

Perhaps a more important and certainly more formidable intellectual force, from the late seventeenth century, was the School of Practical Learning (Kr. *sirhak*; Ch. *shixue*). The sirhak scholars, who advocated political, economic, social, and educational reforms, took practical affairs as their point of departure, emphasizing not only the traditional humanistic disciplines derived from China, but also social science, natural science, and technology. Their interest in promoting a new understanding of the country's history and culture led to a surge of publications on various aspects of Korean history, literature, language, and geography.

The beginning of the sirhak movement can be traced to the early seventeenth century and Yi Su-gwang's (Chibong; 1563–1628) important treatise *Chibong yusŏl* (Topical Discourses of Chibong), published in 1614, which dealt with a variety of subjects, including astronomy, geography, botany, and Confucianism as well as the society and government of early Korea.[37] Yi Su-gwang, who visited Peking in 1590, 1597, and 1611 as an emissary to the Ming court, was strongly influenced by the philosophy of the eminent thinker Wang Yangming (1472–1529), the leader of the School of the Mind, who developed the theory that knowledge and action are one.[38] Yi Su-gwang's work was followed in 1670 by Yu Hyŏng-wŏn's (Pan'gye; 1622–1673) *Pan'gye surok* (Treatise by Pan'gye), an assessment and a critique of the institutions of the Chosŏn dynasty, including the land system, education, government structure, and military service system.[39] He also wrote extensively on history, geography, linguistics, and literature.[40]

An important scholar in the dissemination of sirhak thought was Yi Ik (Sŏngho; 1681–1763), who published a modestly titled but truly encyclopedic work in thirty volumes, *Sŏngho sasŏl* (Insignificant Explanation by Sŏngho).[41] This work is organized under five broad headings (Heaven and Earth; Myriad Things; Human Affairs; Classics and History; Belles Lettres) and encompasses a wide range of topics in each section. Yi Ik came from an illustrious family of scholars.[42] His grandfather, Sang-ŭi (1560–1624), traveled to Peking with Yi Su-gwang in 1611. Yi Ik's father, Ha-jin (1628–1682), was a high-ranking official who went to China in 1678 and brought back with him many books of Western learning that had been translated into Chinese. Yi Ik and his brothers Cham (1660–1706) and Sŏ (1662–1723) benefited from this vast collection of volumes, among which were maps of the world and works on astronomy, Catholicism, and Western painting, science, and technology. Yi Ik seems to have been especially impressed by a map of the world that showed China to be but one of five continents, with Korea occupying a portion of northeast Asia. The sirhak scholars' comprehension of China's and Korea's geographical position in relation to the rest of the world undoubtedly became one of the main reasons for their rejection of the "minor China" concept as they came to realize that the civilization of China was not the only one deserving of their attention.

The importance of Yi Ik in relation to the development of true-view landscape painting has been pointed out by several scholars.[43] His notations on Western painting reveal a familiarity with paintings brought back from the Qing court by Chosŏn emissaries who had come into contact with the Western learning transmitted to China by the Jesuits as early as the sixteenth century:

> Recently, most emissaries to Yanjing [the Manchu capital, now Beijing] have brought back Western paintings and hung them in the center halls of their homes. When looking at these paintings, one should close one eye and, with the other eye, stare at them for a long time so that the buildings and the walls reveal their true shapes [chinhyŏng]. Those who study these paintings in silence say, "This is due to the wonderful techniques of the painter. Because the distance between objects is clearly delineated, one should look at the painting with only one eye." Even in China, this kind of painting has never existed before. These days, I am reading Euclid's *Geometry*, translated into Chinese by Ri Madu [Matteo Ricci]. There it says: "The method of painting lies in seeing things with one's eyes…. One should be precise about measurements of distances and things in order to represent their degrees and true shapes…. Also, when depicting an image, its convexity and concavity have to be rendered, and when depicting a house, there must be light spots and dark spots."[44]

Yi Ik's view that a painting should reflect reality and be a true view of a scene is expressed in his recorded colophon to a painting titled *Nine-Bend [Stream] of Mount Wuyi*, a work that he clearly believed to be a misrepresentation of the actual landscape:

> When I look at landscape paintings of the past and the present, I am stunned by their strangeness and falsehood. I am sure that there is no such scenery on earth. They were painted only to please the viewers. Even if ghosts and demons were to roam the entire universe, where in the world would they find such scenery [chin'gyŏng]?[45] These strange paintings can be compared to those who tell lies and embellish words to cheat others. What can one take from them?[46]

Apparently, Yi Ik himself had never visited China and had never seen the unusual features of such sites as Mount Wuyi, the landscape of which is indeed strange and scarcely to be believed. His advocacy of landscape painting that resembles the scenery it depicts was without doubt influenced by the Western paintings that looked "real" to him. Since Yi Ik was not himself a painter, his interest in Western realism remained restricted to criticism and theory, though this general view of the Western approach to painting, or at least the emphasis on actual observation, seems to have been shared by many sirhak scholars. A self-portrait by the well-known painter Yun Tu-sŏ (1668–1715), one of the members of Yi Ik's circle of scholars, is further evidence of the growing interest in painting based on actual observation.[47]

This period is also marked by the flourishing of works of historical geography, which can be more directly associated with the development of true-view landscape painting. Among them are Han Paek-kyŏm's (1552–1615) *Tongguk chiri-ji* (Treatise on Korean Geography); Yi Chung-hwan's (b. 1690) *T'aengni-ji* (Ecological Guide to Korea), which can be characterized as cultural geography, as it includes local customs and community values; Sin Kyŏng-jun's (1712–1781) *Toro-go* (Routes and Roads) and *Sansu-go* (Mountains and Rivers); and the map of Korea, *Tongguk chido*, produced by Chŏng Sang-gi (1678–1752) at the command of King Yŏngjo. The last, in nine sheets (one sheet showing the entire peninsula, and eight showing different provinces), which could be folded into an album, was a pioneer work in that it precisely marked the distance between one place and another. When the eight sheets were spread out and put together, they also formed a large map of the peninsula.[48]

This interest in history and geography in the second half of the Chosŏn dynasty can also be directly associated with the widespread interest in travel to scenic spots, not only to the Diamond Mountain region but also to other parts of Korea. Scholars tended to travel widely, sometimes accompanied by their favorite court painters, and most of them left voluminous travel diaries describing what they saw.[49] Much can be learned from comparing their descriptions with true-view landscape paintings of the same areas.

Whether from the conservative noron faction — those scholar-officials who considered Korea a "minor China" — or from the more progressive sirhak camp, the intellectual spirit of the age began to converge on an intense study of Korean history, geography, culture, and natural environment. This common effort in defining Korea's historical and cultural identity led in turn to a renewed interest in depicting the topography of Korea, and to the rise of true-view landscape painting.

### THE ERA OF CHŎNG SŎN

The artist traditionally acknowledged as the leading exponent of the new trend in landscape painting in the early eighteenth century is Chŏng Sŏn (1676–1759), who signed his paintings most often with his studio name Kyŏmjae, or Studio of Modesty. Chŏng, from an impoverished family of the *yangban* ruling class, was recommended by Kim Ch'ang-hŭp (1653–1722) for a position in the royal bureau of painting in Seoul.[50] Despite the fact that he is considered one of the most important painters of the entire Chosŏn period, few facts about his life have been documented.[51] Throughout his long career, he served mostly in the capital except for several local government posts he held from time to time.[52] Late in life, he was honored by King Yŏngjo, who bestowed on him the official title of the fourth rank in 1754 and the second rank in 1756, despite stiff opposition from scholar-officials at court who felt that his lowly status as a painter made him ineligible for the latter position.[53]

The coterie of scholar-officials instrumental in forming Chŏng Sŏn's art and thought, especially the development of true-view landscape painting, included three of six brothers

of the powerful Kim family of Andong, in North Kyŏngsang Province—Ch'ang-jip (1648–1722), Ch'ang-hyŏp (1651–1708), and the above-mentioned Ch'ang-hŭp, who recommended Chŏng to the royal painting bureau. Others were Yi Pyŏng-yŏn (1671–1751), one of the most accomplished poets of the time; Yi Ha-gon (Tut'a; 1677–1724), a scholar-painter who recorded his views on painting in *Tut'a-ch'o* (Draft Writing of Tut'a); and Cho Yŏng-sŏk (1686–1761), a well-known scholar-painter who left an interesting album of genre paintings and who was Chŏng Sŏn's close friend and neighbor. Cho's admiration for Chŏng is evident in his colophon to Chŏng's painting *Three-Dragon Waterfall at Mount Naeyŏn* (pl. 96), in which he remarks that only after seeing the painting was he able to appreciate the natural beauty of the site. Since many of these scholar-officials lived in the shadow of Mount Paegak, in the northern part of Seoul, and composed poetry as well, this group has been referred to by one scholar as the Poetry Society of Paegak (Paegak sadan),[54] although it never existed formally as such.

As has been pointed out by other scholars, the basic elements of Chŏng Sŏn's chin'-gyŏng style, which began to develop in the 1730s, were derived from Chinese Southern School painting.[55] This school took root in Korea as early as the second half of the seventeenth century,[56] when painting manuals such as the *Jiezi yuan huazhuan* (Mustard Seed Garden Manual of Painting) came to Korea soon after their publication in China.[57] There were also a fair number of Chinese paintings in Korea, brought back by Chosŏn emissaries to the Qing court.[58]

In the true-view landscapes of Chŏng Sŏn and his contemporaries, the most visible stylistic elements of Southern School painting are the hemp-fiber texture strokes (long, nearly parallel, somewhat wavy brushstrokes used to describe the texture of earth); Mi ink-dots (soft dots of ink of varying size and degrees of tonality applied horizontally to the surface of mountains to represent vegetation), named after the eleventh-century Chinese painter Mi Fu (1052–1107); and folded-ribbon strokes (dry, light strokes created by dragging the brush sideways and turning it at a ninety-degree angle from horizontal to vertical, to depict rocky surfaces). Of these, Mi ink-dots feature most prominently in Chŏng Sŏn's works throughout his career.

The majority of true-view landscapes of the late Chosŏn period represent aspects of Mount Kŭmgang, a mountain range replete with symbolism and having various appellations. Located in the northern part of Kang'wŏn Province along the coast of the East Sea, Mount Kŭmgang covers a large area, its peaks said to number as many as "twelve thousand." The area is customarily divided into three main parts: Outer Kŭmgang (Oegŭmgang); Inner Kŭmgang (Naegŭmgang); and Coastal Kŭmgang (Hae-gŭmgang). The dividing line between Outer and Inner Kŭmgang is Piro Peak. Sometimes the whole area is simply referred to as Sea and Mountains (*Haeak* or *Haesan*), and painting albums containing a series of views of Mount Kŭmgang are most frequently called Albums of Sea and Mountains (*Haesan-ch'ŏp*). Since the area is to the east of the Chosŏn capital, Hanyang (Seoul), such albums are also called Albums of Travel to the East (*Tong'yu-ch'ŏp*). In win-

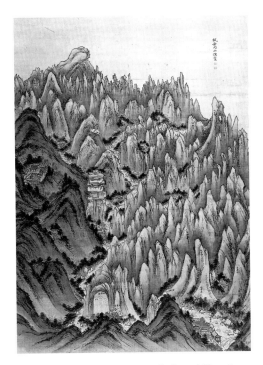

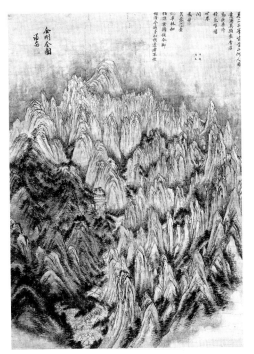

**Figure 8.** Chŏng Sŏn (1676–1759), *General View of Inner Mount Kŭmgang*. Hanging scroll, ink and color on silk, 39 ⅝ × 29 in. (100.5 × 73.6 cm). Kansong Art Museum, Seoul

**Figure 9.** Chŏng Sŏn (1676–1759), *Complete View of Mount Kŭmgang*, dated 1734. Hanging scroll, ink and light color on paper, 51 ½ × 37 in. (130.7 × 94.1 cm). Ho-Am Art Museum, Yongin. National Treasure no. 217

ter, when the rocky peaks are exposed, the mountain is called All Bone Mountain (Kaegol-san), while in the fall, when colorful leaves cover the mountainsides, it is called Autumn Foliage Mountain (P'ung'ak-san).[59]

Although Chŏng Sŏn lived to the age of eighty-three and left behind an enormous body of work, his dated paintings, which fall between the years 1711 to 1751, are relatively few. The earlier date apparently marks Chŏng Sŏn's first visit to Mount Kŭmgang, when he painted the so-called *Album of Paintings of the P'ung'ak Mountain of the Sinmyŏ Year* [1711]. This album contains thirteen leaves of painting, to which is attached a colophon written in 1867 by a descendant of a certain Paeksŏk, whom one scholar has identified as Pak T'ae-yu (1648–1746), a high-ranking official during the reigns of Kings Sukchong (r. 1674–1720) and Yŏngjo. According to the colophon, Pak was accompanied on his second trip to Mount Kŭmgang by Chŏng Sŏn, who produced a series of paintings of the mountain for which Pak's friends later wrote poetry.[60] Although the reliability of this late colophon can be questioned, the paintings in the album all show Chŏng Sŏn's early style, one that is still lacking complete confidence or an individual manner.

Chŏng Sŏn's second trip to Mount Kŭmgang the following year is better documented. During this trip, he painted another album of thirty leaves, entitled *Album of Realistic Representations of Sea and Mountains*, which, although no longer extant, is recorded, along with poems by four of Chŏng Sŏn's contemporaries describing the scenes depicted, in the collected works of various scholar-officials.[61] Chŏng's third documented trip to the area took place in 1747, when he produced yet another album with the same

title. Yi Pyŏng-yŏn's colophons to these paintings confirm the dates of Chŏng's travel. Though records of any other trips to the area between 1712 and 1747 are not known, a recent study shows that Chŏng painted many images of Mount Kŭmgang that were most likely based on early sketches.[62]

Chŏng's favorite composition seems to have been what is known as the Complete View of Mount Kŭmgang (*Kŭmgang chŏndo*), which he painted many times after 1711. Two versions — *General View of Inner Mount Kŭmgang* (fig. 8), an undated work, and *Complete View of Mount Kŭmgang* (fig. 9), dated 1734 — display his painting style at two different periods. The basic composition of each work is evident in the different ways in which the structure and surface of the mountain are rendered, rocky or earthen. The low, densely vegetated earthen peaks in the foreground and along the left edge of the paintings serve to emphasize the imposing presence of the steep, barren rocky peaks they frame. Even for someone seeing these paintings for the first time, it is possible to recognize the concepts of yin and yang revealed in them; and Chŏng Sŏn was known to have studied the *Yijing* (Book of Changes) and applied its principles in his paintings.[63] A recent article has gone so far as to interpret everything in the 1734 painting in terms of yin and yang and the eight trigrams of the *Yijing*. Two of the most obvious features that might lend support to this interpretation are the arched bridge, in the lower left, opposed to the prominent Piro-bong Peak in the far distance. In addition, Chŏng's inscription curiously is written to form a semi-circle, in the center of which are four characters reading "written in winter of the year *kapsin* [1734]."[64]

It is more instructive to read the artist's poetic inscription:

*Twelve thousand peaks of All Bone Mountain,*
*Who would even try to portray their true images?*
*Their layers of fragrance[65] float beyond the* pusang *tree;[66]*
*Their accumulated* qi *swells expansively throughout the world.*
*Rocky peaks, like lotus flowers, emit whiteness;*
*Pine and juniper forests obscure the entrance to the profound.*
*This careful sojourn, on foot through Mount Kŭmgang,*
*How can it be compared with the view from one's pillow?[67]*

The poem at once describes the scene painted and alludes to the profundity associated with Mount Kŭmgang. The last line is a reference to a famous remark by the fourth-century Chinese painter-theorist Zong Bing (375–443): when he grew old and was no longer able to climb mountains, he planned to cover the walls of his room with images of mountains and, lying on his bed, roam around them with his eyes.[68]

Although the painting and similar works by Chŏng Sŏn's followers are supposedly true-view landscapes, *Complete View of Mount Kŭmgang* is instead a conceptualized view of the entire mountain in the tradition of the Nine-Bend Stream of Mount Wuyi, which was painted both as one complete view and as nine separate compositions. In this work, Chŏng

combined the age-old tradition of the complete view (*chŏndo*) with his own visual en-
counter with the peaks of Mount Kŭmgang, creating a memorable image to which he
added the poem that expressed his thoughts and feelings about the mountain.

Even though *Complete View of Mount Kŭmgang* is traditional and conceptual, a com-
parison of this painting with a contemporaneous travel description reveals Chŏng Sŏn's
power of realism. The following is a passage from a travelogue by the literatus Yi Man-bu
(1664–1732):

> Before me rise twelve thousand peaks winding sinuously into the distance. Looking at
> these jagged, craggy peaks soaring into the sky, I am seized with such awe and exhil-
> aration that I feel as if I am immersed in fresh water.[69]

The needlelike peaks were depicted with the distinctive downward brushstrokes (called
*Kyŏmjae sujik chun*, or Kyŏmjae vertical strokes) that Chŏng developed during the course
of painting Mount Kŭmgang many times.

Chŏng Sŏn's *General View of Inner Mount Kŭmgang* shows much crisper brush lines
and stronger contrasts of light and dark. It also uses fewer of the Kyŏmjae vertical strokes
to render the sharp, rocky peaks. Instead, they are outlined with lines of even thickness
and painted with opaque white pigment. These features point to the artist's earlier style,
less confident and less individual, mentioned above in connection with the Mount Kŭm-
gang album of 1711. As if intending to use it for later reference, Chŏng Sŏn inscribed on
the painting, in small neat characters, the names of most of the peaks and temples. This
practice can of course be understood as an extension of topographic landscape rendering
or map-making, in which Chŏng Sŏn himself participated as a court painter.

Besides these "complete views," Chŏng Sŏn painted individual scenes of particular ar-
eas of Mount Kŭmgang as components of albums or screens. The number of scenes vary —
sometimes eight, in other cases thirty or more.[70] He also painted small-scale works depict-
ing one peak or one temple from the *Complete View*. Two undated paintings, *Chŏng'yang-sa
Temple* (pl. 93) and "Hyŏlmang-bong Peak" (fig. 10), show, respectively, the temple com-
plex that is barely visible in the upper left portion and the prominent peak in the upper
right portion of the *Complete View*. Appended to the latter is a poetic inscription by an
unidentified writer, whose sobriquet is Old Man of the Snowy Mountain (Sŏlguk Noin):

> A huge mountain suddenly appears with peaks of exceptional beauty. I built a
> thatched hut on a small, flat spot among them. Because of the passing clouds, it is
> almost impossible to see sunlight, even during the day. Earlier I composed a poem:
>
> *Leisurely clouds, unaware of the four seasons,*
> *Cover this valley year round.*
> *By chance, if the pouring rain stops,*
> *Nothing else will intrude on my delightful seclusion.*[71]

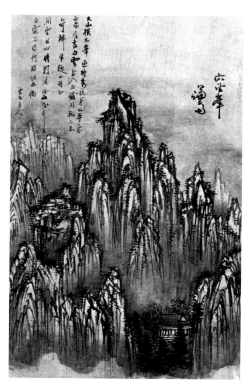

**Figure 10.** (above) Chŏng Sŏn (1676–1759), "Hyŏlmang-bong Peak." Album leaf, ink and light color on silk, 13 ⅛ × 8 ⅝ in. (33.2 × 22 cm). Seoul National University Museum

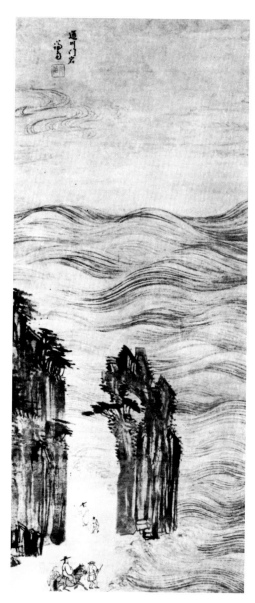

**Figure 11.** (right) Chŏng Sŏn (1676–1759), *Gate Rocks at T'ongch'ŏn.* Hanging scroll, ink on silk, 51 ¾ × 21 in. (131.6 × 53.4 cm). Kansong Art Museum, Seoul

The mountain peaks appear to be floating above clouds, and the light blue wash on the lower part of the peaks gives the appearance of rain mentioned in the poem. The blue tint also softens the hard, solid image of the rocky peaks rendered in Chŏng Sŏn's typical vertical strokes. Although undated, this painting may be considered a late work on stylistic grounds.

Chŏng Sŏn's trips to the mountain must have included a visit to the area of Mount Kŭmgang along the eastern coast, site of a very unusual formation: two enormous rock monoliths that appear to form a massive gate. Chŏng painted the scene in several versions, in both small and large formats, the most impressive of which is a large hanging scroll, *Gate Rocks at T'ongch'ŏn* (fig. 11). In this monochrome work, Chŏng focused on the severity of the scene, which he conveyed through contrasts of horizontal and vertical brushstrokes as well as light and dark ink. He modeled the faces of the columnar rocks in his distinctive vertical strokes of dark ink. Perhaps even more striking than the depiction of the rocks is the linear rendering of the billowing waves, which seem high enough to

**Figure 12.** Chŏng Sŏn (1676–1759), "Apku-jŏng Pavilion," ca. 1740–41. Album leaf, ink and color on silk, 7 ⅞ × 12 ⅜ in. (20.1 × 31.3 cm). Kansong Art Museum, Seoul

engulf the mountain. A man carrying a staff and dressed in a typical Korean costume with a broad-brimmed horse-hair hat, followed by a young servant, passes through the gate, looking backward as if fearful he will be overtaken by the surging tide. In the foreground another group of figures, a man on horseback accompanied by two servants, seems unafraid to confront the waves. The unusual treatment of the waves makes this work one of the most arresting depictions of the sea in East Asian painting.

Chŏng Sŏn's true-view landscapes also cover a wide range of scenes in and around Seoul, where he spent much of his life. In one album, painted between 1740 and 1741, he depicted a series of sights along the Han River.[72] In these he returns to a more traditional composition and to the use of blue and green colors, which he had employed in earlier works. A painting from this album, entitled "Apku-jŏng Pavilion" (fig. 12),[73] depicts the famous pavilion built for Han Myŏng-hoe (1415–1487), a court official of considerable power and wealth who served Kings Sejo (r. 1455–68), Yejong (r. 1468–69), and Sŏngjong (r. 1469–94). The pavilion, the name of which means "intimate with the gulls,"[74] has been conspicuously positioned high on a cliff overlooking the river, its banks dotted with houses of other well-to-do officials. Across the river from the pavilion is Tumo-p'o Ford, where Toksŏ-dang Hall was once located. The tall mountain to the far right, topped with a barely distinguishable stand of pine trees, can be identified as Mount Namsan, the central mountain of Seoul. Other mountains, rendered in light silhouettes, can also be identified by their characteristic contours. In this painting Chŏng portrays a peaceful suburban scene of the mid-eighteenth-century Chosŏn capital.[75] The artist's pride in and attachment to this album are amply expressed in the square seal of four characters placed at the upper right, which reads "not to be exchanged even for a thousand cash."

*Clearing after Rain on Mount Inwang* (fig. 1), painted in 1751, is the last dated work by Chŏng Sŏn. In this he emerges as the most daring and original painter of true-view landscapes. An unusually large horizontal hanging scroll, *Clearing after Rain* shows a well-structured composition of mountain peaks and forests separated by large areas of mist. Mount Inwang rises above the thick clouds after a rain, exposing its brilliant rocky peaks against the sky. Chŏng Sŏn has used rapidly executed bold brushstrokes of saturated ink to define the rounded peaks of the mountain and the enormous boulders of yellowish-

white granite that cover it. A dotted line along the far ridge of the mountain represents the northwestern portion of the fortress encircling the capital, which lies to the east of Mount Inwang. Much of this fortress is still standing today.

In the middle distance, just below the central peak, smaller rocky peaks alternate with soft, white earthen peaks, which have been covered with rows of pine trees described as simple vertical trunks with a few short horizontal branches, a stylized rendering that became one of the hallmarks of Chŏng's late landscapes. In order to enliven the earthen peaks, Chŏng applied Mi ink-dots to indicate clusters of vegetation. The range of tones, from the saturated dark ink to the white color of the paper, and the range of brushstrokes, encompassing traditional Mi ink-dots as well as original sweeping strokes, enrich the visual effect of the painting, leaving the viewer with an unforgettable impression of the mountain.

Chŏng's bold use of contrasting tones of ink and the description of rocks in broad, expansive strokes of dark ink can also be seen in his *Pure Breeze Valley* (pl. 95), which depicts an area in the northwestern section of Seoul. Chŏng apparently painted several versions of this particular scene. One of them, in the Kansong Art Museum, has a date corresponding to the year 1739, but the undated painting exhibited here is closer in style to his later work, as exemplified by the 1751 painting of Mount Inwang.

All artists of the eighteenth century painted some form of true-view landscape, and younger contemporaries of Chŏng Sŏn who painted such landscapes inevitably fell under his influence. His long and prolific career, centered in the capital, and his association with the most learned, sophisticated, and powerful figures of the time naturally attracted many younger artists to him. Modern scholars speak of "followers of Kyŏmjae" (*Kyŏmjae ilp'a*)[76] or School of Chŏng Sŏn (*Chŏng Sŏn p'a*), although these designations were not current in the eighteenth century. The artist's followers can be divided into two groups, distinguished primarily by age. The first group includes those born before the 1740s: Kang Hŭi-ŏn (1710–1764); Kim Yun-gyŏm (1711–1775); Ch'oe Puk (1712–ca. 1786); and Chŏng Sŏn's grandson, Chŏng Hwang (b. 1735). Most of these painters were Chŏng Sŏn's pupils. The second group is composed of artists born after the 1740s and thus active during the late eighteenth century and early nineteenth century: Kim Ŭng-hwan (1742–1789); the brothers Kim Tŭk-sin (1754–1822) and Kim Sŏk-sin (b. 1758), among others.[77] The earlier group happens to have belonged to the upper class, while painters in the second group, who because of their age presumably had no direct contact with Chŏng, were members of the royal bureau of painting and thus belonged to the *chung'in* (literally "middle people") class.

As a concept, School of Chŏng Sŏn is not particularly meaningful when we consider that the adoption or emulation of Chŏng's style was not confined by generation or social class. However, it has by now become firmly established as a term in Korean art history to refer to a wide range of artists whose paintings show traces of direct or indirect influence of Chŏng Sŏn's art.[78]

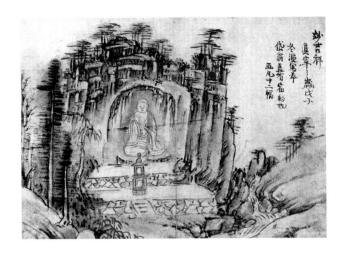

**Figure 13.** Kim Yun-gyŏm
(1711–1775), "Myogilsang," dated
1768. One leaf from an album of 9
leaves, ink and light color on paper,
10 ⅞ × 15 ¼ in. (27.7 × 38.8 cm).
The National Museum of Korea, Seoul

The legacy of Chŏng Sŏn is readily seen in Kang Hŭi-ŏn's "Mount Inwang Seen from Tohwa-dong"(fig. 2), in which the artist depicts Mount Inwang as seen from the opposite side of that shown in Chŏng's paintings of the subject. The sweeping strokes of dark ink, resembling traditional axe-cut strokes but applied more densely, the lavish use of Mi ink-dots, and the simplified rendering of the pine trees are all evidence of Chŏng's influence. As Kang Se-hwang pointed out in his inscription to this painting quoted earlier, Kang Hŭi-ŏn's indebtedness to Chŏng Sŏn also comes from "not sacrificing the [old] masters' methods." In my view, however, what is novel in this painting is Kang's use of light blue to define the empty space in the upper part of the painting as sky. Chŏng Sŏn's *Complete View of Mount Kŭmgang* (fig. 9) does show some blue color in the outlining of the rocky peaks, but Chŏng did not treat the empty space above the mountain peaks as true sky. The modulated blue in Kang Hŭi-ŏn's painting makes this work perhaps the most natural depiction of sky in eighteenth-century Korean painting. (The title, in the upper right, and the artist's inscription, in the upper left, indeed seem to be suspended in the sky.) Kang's treatment of the sky suggests that he might have seen Western paintings brought back to Korea from China by officials of the Chosŏn court.

A second follower, Kim Yun-gyŏm, was an illegitimate son of Kim Ch'ang-ŏp, one of the Kim brothers who were patrons of Chŏng Sŏn. Thus, Kim might have had the opportunity to learn painting directly from Chŏng.[79] He left many true-view landscape paintings of the Mount Kŭmgang area as well as of famous sites of the southern part of the peninsula. "Myogilsang" (fig. 13), a leaf from an album of paintings of Mount Kŭmgang, was painted in 1768, according to the artist's inscription: "Playfully done in winter of the year *muja* [1768] to fulfill a long overdue promise to the Venerable Tae [Taeong]. Twelve leaves in all."[80] Myogilsang, another name for Manjushri, the bodhisattva of wisdom, refers in this painting to the temple site of Myogilsang-am which was laid waste in the late Chosŏn period, leaving only the rock-cut image of the Buddha.[81] In this painting, Kim employed soft, wet brushwork and light colors to create an overall effect of tranquility, which contrasts strongly with the awe-inspiring images of jagged cliffs and rocky peaks in Chŏng Sŏn's paintings. Other depictions of this site, with the figure of the Bud-

**Figure 14.** Kim Yun-gyŏm (1711–1775), "Vanishing Cloud Terrace." One leaf from *Album of Scenic Spots of the Yŏngnam Area*, an album of 14 leaves, ink and light color on paper, 11 ¼ × 14 ⅝ in. (28.6 × 37.1 cm). Dong'a University Museum, Pusan

**Figure 15.** Ch'oe Puk (1712–ca. 1786), P'yohun-sa Temple." Album leaf, ink and color on paper, 15 ⅛ × 22 ½ in. (38.5 × 57.3 cm). Private collection

**Figure 16.** Kim Ŭng-hwan (1742–1789), "Complete View of Mount Kŭmgang," dated 1772. Album leaf, ink and light color on paper, 8 ¾ × 13 ⅞ in. (22.3 × 35.2 cm). Pak Chu-hwan Collection, Seoul

dha in the center, by Kim Hong-do (1745–1806) and Ŏm Ch'i-uk (act. 19th century), testify to the ways in which the painters of true-view landscapes infused their own personality into their paintings.[82]

Kim Yun-gyŏm's appreciation for Western painting is amply evident in a work entitled "Vanishing Cloud Terrace" (fig. 14), a leaf from an album of scenic spots of the Yŏngnam area of Kyŏngsang Province, in the southeastern part of the peninsula. The site portrayed in this leaf is near the present-day port city of Pusan, overlooking the South Sea dotted with small islands. Chŏng Sŏn's influence can easily be seen in the pine groves on the terrace jutting out into the sea, but the viewer is mostly struck by the vast

space and distance created by the varying tonality of the transparent pale blue color and by the diminishing scale of the islands as they recede into the distance. Such realism is rarely found in Korean painting from earlier periods.

Ch'oe Puk was a professional painter from the chung'in class, whose exceptional talent in poetry, painting, and calligraphy brought him into close contact with contemporary literati.[83] He executed a number of paintings that have caused him to be numbered among the members of the School of Chŏng Sŏn. One of these is the well-known "P'yohun-sa Temple" (fig. 15), a leaf from an album depicting Mount Kŭmgang. Together with Chŏng'yang-sa and Chang'an-sa, P'yohun-sa Temple is one of the most frequently painted sites of Mount Kŭmgang. The temple, partly obscured by pine trees, can be spotted in the center of Chŏng Sŏn's *Complete View of Mount Kŭmgang* (fig. 9), just below the tall column of boulders called Kŭmgang-dae, or Diamond Terrace. In his composition, Ch'oe Puk has placed the temple compound on the far left so that it stands just beyond the earthen peaks, while in the center he has reserved a space for a stone bridge and a stream, behind which rises a screen of rocky peaks. The needlelike peaks in the far distance, the identifying feature of Mount Kŭmgang, add to the sense of distance and space. No one can doubt that this painting falls within the large sphere of influence exerted by Chŏng Sŏn, but, at the same time, the more relaxed brushwork and the composition are indicative of Ch'oe Puk's distinctive style.

In the second group of Chŏng's followers, Kim Ŭng-hwan can be singled out as the most devoted painter of true-view landscape painting, though his works, unlike those of others we have discussed, reveal few personal stylistic characteristics. He was a painter in the royal bureau of painting at the same time as Kim Hong-do, the leading court painter during the reign of Kings Yŏngjo and Chŏngjo, and, after Chŏng Sŏn, the principal exponent of true-view landscape painting. Among Kim Ŭng-hwan's Mount Kŭmgang paintings, the one displaying most affinity with Chŏng Sŏn's style is perhaps his own "Complete View of Mount Kŭmgang," painted in 1772 for Kim Hong-do (fig. 16).[84] The artist's inscription in the upper right corner reads: "In the year *imjin* [1772], Tamjol dang [Kim Ŭng-hwan] painted this for Sŏho [Kim Hong-do] in imitation of *Complete View of Mount Kŭmgang*." Although the inscription does not specify whose painting is being imitated, there are obvious similarities with Chŏng Sŏn's work: the painting depicts both rocky and earthen peaks; the earthen peaks appear in the left corner of the composition, alongside the three famous temples, Chang'an-sa, P'yohun-sa, and Chŏng'yang-sa (from bottom to top); and Mi ink-dots combined with light blue washes cover the earthen peaks, while the rocky ones are depicted in black outlines and blue washes.[85] These similarities are very superficial, however, for the landscape conveys nothing of the majestic effect evoked by Chŏng Sŏn's paintings. Instead, there is a great deal of mannerism and stylization, suggesting that Kim Ŭng-hwan in fact painted this scene "in imitation," not from life. This imitative quality is particularly evident in the rhythmic repetition of the V-shaped valleys. At the same time, the painting serves as an important precedent, namely, a Korean court

painter producing a painting in imitation of another Korean painter, rather than a Chinese model.[86]

The title of this section might appear somewhat unorthodox to those knowledgeable about true-view landscape painting of the late Chosŏn period, as it combines the name of a scholar-painter, by definition an amateur, with that of a professional painter. In earlier scholarly writings, it has been customary to treat separately the true-view landscapes of literati artists and professional painters. However, there are good reasons for breaking with this practice. First of all, Kang Se-hwang, besides being the leading scholar-painter and art critic of the eighteenth century, was one of the greatest influences on the development of Kim Hong-do's art.[87] Second, while both men worked in diverse subject areas,[88] they reached new heights in the field of true-view landscape painting in the post-Chŏng Sŏn era. Third, and not least important, the eighteenth-century art milieu was so fluid that it becomes artificial to draw a distinction between "amateurs," or the literati, and professionals, especially when it comes to true-view landscape.

Being a scholar-painter and a promoter of the Chinese Southern School of painting in Korea, Kang Se-hwang was inclined, even when painting true-view landscapes, to adhere to traditional methods of painting, as expressed in his inscription on Kang Hŭi-ŏn's painting of Mount Inwang. He seems, however, to have been equally interested in the depiction of scenery as the eye viewed it. Like many contemporary painters, he took a trip to Mount Kŭmgang, in 1788, which he recorded in a travel diary and an album of paintings.[89] During this trip he by chance met Kim Hong-do and Kim Ŭng-hwan, who were sketching the scenery of Mount Kŭmgang at the order of King Chŏngjo. In a preface he wrote bidding farewell to Kim Hong-do and Kim Ŭng-hwan, he praised the two artists for their skillful and beautiful rendering of Mount Kŭmgang:

> Some say that if mountains and water had spirits, they would abhor being portrayed in such minute detail. But I do not think so. When people want to have their portraits painted, they invite the best painter and treat him with propriety. They will finally be satisfied only if their portraits resemble them closely without missing a hair. Therefore, I think the mountain spirits would not abhor this utmost likeness of their images.[90]

Since Kang was himself a portrait painter, his analogy between portraits and true-view landscapes is natural and understandable. On one occasion, comparing the paintings of Mount Kŭmgang by Chŏng Sŏn and Sim Sa-jŏng (1707–1769), who is often considered Chŏng's disciple, he complained that Chŏng's paintings did not achieve the true likeness of the mountain because he painted them in a disorderly manner using hemp-fiber strokes.[91]

**Figure 17.** Kang Se-hwang (1713–1791), "Approach to Yŏngt'ong-dong." One leaf from *Album of a Journey to Songdo*, ca. 1757, an album of 16 leaves, ink and light color on paper, 12 ⅞ × 21 ¼ in. (32.8 × 54 cm). The National Museum of Korea, Seoul

**Figure 18.** Kang Se-hwang (1713–1791), "View of Kaesŏng." One leaf from *Album of a Journey to Songdo*, ca. 1757, an album of 16 leaves, ink and light color on paper, 12 ⅞ × 21 ¼ in. (32.8 × 54 cm). The National Museum of Korea, Seoul

Kang's twofold interest in realistic depiction of landscape and adherence to traditional painting methods can best be seen in his *Album of a Journey to Songdo*.[92] Although the album itself does not bear a date, there is convincing evidence that the paintings were done in 1757, when he was forty-five, at the time of his trip to Songdo (present-day Kaesŏng).[93] The album is a truly novel work in that the artist expressed his firsthand impression of the unusual scenery with such fresh feeling. The seventh leaf, "Approach to Yŏngt'ong-dong" (fig. 17), perhaps epitomizes the spirit of this album. Kang's own inscription aptly describes the wondrous scenery depicted:

> The stones at the approach to Yŏngt'ong-dong are as big as houses. They are even more surprising because they are covered with green moss. It is said that a dragon rose out of the pool here, but that is rather incredible. Nonetheless, this is a rare sight to behold.

Enormous boulders occupy most of the foreground, their imposing size punctuated by the tiny figure of a traveler astride a donkey who is followed by the even smaller figure of a servant as the pair heads toward the narrow gorge to the right. The rocks are outlined with sharp ink lines and colored in light blue mixed with ink and earthen colors, fresh and transparent, very similar to a Western watercolor. Beyond these rocks and to the right of the gorge, earthen peaks seem softly to rise, the effect of Kang's use of Mi ink-dots, which give the impression of shading. The rocks diminish in size as they become more distant, and the gorge narrows as it winds back into the mountains, giving the viewer an unambiguous sense of depth and distance.

In the first leaf, "View of Kaesŏng" (fig. 18), the wide avenue leading away from the city gate narrows as it recedes into the distance, and the houses on either side gradually diminish in size accordingly. Spatial recession is also achieved by the use of lighter tones to depict the mountains in the background. Many other leaves in the album reveal Kang Se-hwang's interest in rendering the actual appearance of topography. Following the traditional convention of landscape painting, Kang left the sky unpainted, but there is no doubt that without the influence of Western painting, in particular the dramatic spatial recession and the relative scale of compositional elements, the Songdo album would not have been possible.[94]

Kang Se-hwang, who was thirty-two years his senior, knew Kim Hong-do from the time he was a young boy. Kang later reminisced about this lifelong acquaintanceship:

> At first when Sanŭng [Kim Hong-do] was young, I used to praise his talent and taught him the secrets of painting. Later, we served in the same office, seeing each other morning and evening. In the end, seeking distraction in the world of the arts together, I felt as if we were friends.[95]

Kim Hong-do entered the royal bureau of painting sometime before 1765, judging from his activity as a court painter recorded in that year, and his career has been well documented in various sources.[96]

According to Kang Se-hwang, Kim made more than one hundred sketches of various aspects of Mount Kŭmgang during a trip there in 1788. Some scholars have linked this trip with a set of five albums of twelve leaves each entitled *Complete View of Mount Kŭmgang*.[97] Each of the sixty leaves in this set bears Kim's seals. It is generally agreed that the two square intaglio seals reading "Tanwŏn" (the artist's sobriquet) and "Hong-do" on the upper part of each leaf as well as the title of each leaf are spurious. Despite all the excitement at the time the albums were first exhibited in 1995, there are some, including this writer, who have reservations about their authenticity.[98] This issue is discussed below.

The best examples of Kim Hong-do's true-view landscape painting are the album leaves depicting the Tanyang area in North Ch'ungch'ŏng Province, from the *Album of the Pyŏngjin Year* [1796], painted when he was fifty-one. "Oksun-bong Peaks" (fig. 19), which bears the cyclical date as well as the artist's signature and seals,[99] features a group of rocky columns rising vertically above an earthen mound. The angular facets of the rocks are modeled with a variety of lotus-vein texture strokes, and the choppy straight lines have been applied with ease of brush movement. The tallest peak, on the right, has the darkest brush lines, which emphasize its apex. The gradually receding shoreline of the river and the mountain peaks in the far distance create a hazy, but comfortable sense of space. A small boat, at the lower right, accentuates the imposing scale of the natural landscape.

An undated set of eight hanging scrolls of scenes of Mount Kŭmgang provides further evidence of Kim's adherence to tradition as well as close observation of nature. In the second scroll of the set, *Flying Phoenix Waterfall* (fig. 20), Kim used lotus-vein and horse-

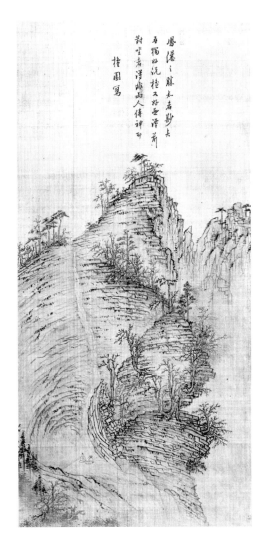

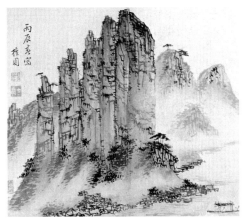

**Figure 19.** (above) Kim Hong-do (1745–1806), "Oksun-bong Peaks." One leaf from *Album of the Pyŏngjin Year* [1796], an album of 20 leaves, ink and light color on paper, 10 ½ × 12 ⅜ in. (26.7 × 31.6 cm). Ho-Am Art Museum, Yongin

**Figure 20.** (left) Kim Hong-do (1745–1806), *Flying Phoenix Waterfall.* Hanging scroll, ink and light color on silk, 36 × 16 ⅛ in. (91.4 × 41 cm). Kansong Art Museum, Seoul

tooth texture strokes to describe the unusual surface of a cliff more than one hundred meters high. Painted on silk, this work shows more careful, less relaxed brushwork than the 1796 album, pointing to an earlier date.

Kim Hong-do also executed a number of documentary paintings that depict actual scenic settings. One of these, a large hanging scroll entitled *Tanwŏn-do*, dated 1785, portrays a gathering at his home in Seoul with several friends, among them the painter Kang Hŭi-ŏn and the poet Chŏng Nan. The subject is a variation on the traditional Chinese theme of the Elegant Gathering in the Western Garden.[100] Another documentary painting, *Evening Banquet of the Songsŏg-wŏn Poetry Society*, painted in about 1791, depicts a gathering of the chung'in "men of culture"[101] in the Songsŏg-wŏn (Garden of Pine and Rocks) of the poet Ch'ŏn Su-gyŏng (d. 1818) in Seoul. Two additional hanging scrolls, from an eight-fold screen, show the autumn scenery at the Hwasŏng Fortress.[102] Finally, *Gathering of the Elders at Manwŏl-tae Terrace*, painted in about 1804, describes a gathering that took place at the site of a Koryŏ palace in Songdo.[103] These paintings of figures in landscape settings recall the earlier sixteenth-century practice of documentary paintings. It is not surprising that we see this combination of true-view landscape and documentation of

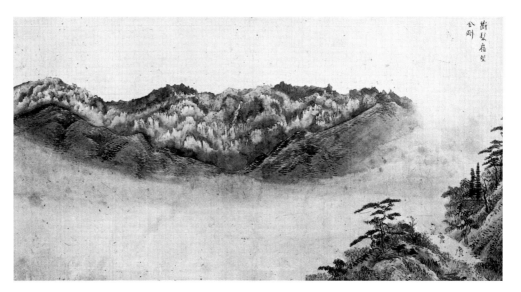

**Figure 21.** Yi In-Mun (1745–1821), "Mount Kŭmgang Viewed from Tanbal-lyŏng Ridge." Album leaf, ink and light color on paper, 9 × 17 ¾ in. (23 × 45 cm). Private collection

contemporary life occurring in the works of Kim Hong-do, the foremost genre painter of the Chosŏn period (see pl. 98).

Two of Kim Hong-do's contemporaries, Yi In-mun (1745–1821), who served with Kim as a court painter, and Chŏng Su-yŏng (1743–1831), deserve mention for their contribution to the later phase of true-view landscape painting. In his "Mount Kŭmgang Viewed from Tanbal-lyŏng Ridge" (fig. 21), Yi In-mun gives us a dramatic view of the mountain emerging in the distance from a dense fog. Yi Man-bu's travel diary (*Chihaeng-nok*) has a description of this setting:

> After following the trail for thirty *ri*, I reached the summit of a hill called Tanbal-lyŏng, a ridge of [Mount] Ch'ŏnma-san … [Mount] Kŭmgang-san rose to the east. Everywhere I looked, its peaks soared, looking like jewels, silver, snowflakes, and ice, stacked one atop another, until they reached heaven and there was no more sky to behold to the east or beyond…. Priest Hyemil said: "People who come here to view Kŭmgang-san regret the dense clouds that always obscure the mountaintop, but today the sky is absolutely clear, allowing a clear view of the summit. How lucky you are to have such a rare opportunity."[104]

Yi In-mun's paintings show a remarkable range of styles in which he demonstrated his knowledge of various schools of Chinese painting. However, in this painting, the scenery is depicted in his unique personal style, characterized by a composition consisting of discrete yet interrelated landscape elements and a heavy reliance on inkwash to impart volume and rhythm to the iciclelike distant peaks. The painting is completely comprehensible without reference to either Chŏng Sŏn or Kim Hong-do.

The literati painter Chŏng Su-yŏng (whose great-grandfather was Chŏng Sang-gi, the maker of the map of the Korean peninsula mentioned earlier) traveled widely through-

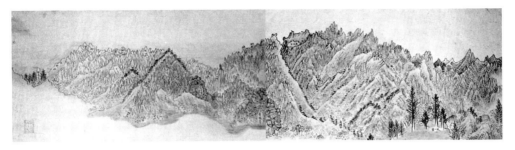

**Figure 22.** Chŏng Su-yŏng (1743–1831), "Mount Kŭmgang Viewed from Ch'ŏnil-dae Terrace." Four leaves from *Album of Sea and Mountains*, dated 1799, ink and light color on paper, 13 ¼ × 24 ¼ in. (33.8 × 61.6 cm). The National Museum of Korea, Seoul

out the country.[105] Several of his paintings and travel diaries recording his trip to the Mount Kŭmgang area survive. *Album of Sea and Mountains* (*Haesan-ch'ŏp*), painted in 1799, two years after his trip, displays his unique painting style (pl. 97). The first three leaves together form an image of a vast expanse of landscape entitled "Mount Kŭmgang Viewed from Ch'ŏnil-dae Terrace" (fig. 22). Many of the major topographical features of the landscape are identified with their names. The sense of space is enhanced by the pronounced recession of the mountains in the left half of the painting. Chŏng Su-Yŏng's characteristic brushwork, hesitant and blunt, reveals his cautious, almost scientific, approach in trying to depict the peaks as they actually appear in nature. At the same time, his use of blue and red seems amateurish, a trait of authentic scholar painting. His paintings are unique in that they do not reveal any contemporary or historical influence.

TRUE-VIEW LANDSCAPE PAINTING IN THE NINETEENTH CENTURY
True-view landscape as a genre of painting seems to have been well established by the end of the eighteenth century. With the groundwork having been laid by Chŏng Sŏn, Kang Se-hwang, and Kim Hong-do, other artists, either by following the stylistic lead of the originators of the genre or by working independently, contributed to the development of this uniquely Korean expression in visual art. After a century and a half of singular creative endeavor, the genre was ready for a more diverse treatment of subjects as well as open to the mass production of certain themes, particularly Mount Kŭmgang, based on "model compositions." It is in this context that the set of five albums of scenes from Mount Kŭmgang attributed to Kim Hong-do have to be examined, since many nineteenth-century true-view paintings seem to derive from them.

Several documents have served as the basis for relating the composition of these albums to Kim's 1788 trip to Mount Kŭmgang.[106] To summarize the story they tell: King Chŏngjo commissioned Kim Hong-do to paint the Sea and Mountains scenery, whereupon the painter produced seventy leaves, which were mounted in five albums. These albums were kept in the palace collection until 1809, when King Sunjo (r. 1800–34), the son of King Chŏngjo, gave them to Hong Hyŏn-ju (1793–1865), the son-in-law of King Chŏngjo. It was at this point, at the request of Hong Hyŏn-ju, that the preface, poems, and

**Figure 23.** (above) Attributed to Kim Hong-do (1745–1806), "Chinju-dam Pond." One leaf from *Complete View of Mount Kŭmgang*, a set of five albums of 60 leaves, ink and light color on silk, 12 × 17 ¼ in. (30.4 × 43.7 cm). Private collection

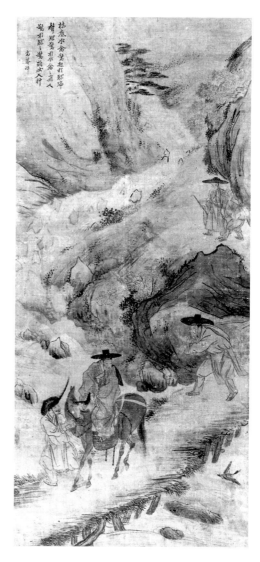

**Figure 24.** (right) Kim Hong-do (1745–1806), *Startled by a Flying Bird.* One of eight paintings now mounted as a screen, dated 1778, ink and light color on silk, 35 ¾ × 16 ⅝ in. (90.9 × 42.1 cm). The National Museum of Korea, Seoul

colophons were created to be incorporated into the albums.[107] The five albums as they exist today, however, contain not seventy but sixty leaves. The title they bear is *Complete View of Mount Kŭmgang* (*Kŭmgang chŏndo*), not *Album of Sea and Mountains* (*Haesan-ch'ŏp*). Finally, the preface, poems, and colophons are not mounted together with the paintings. The albums as now constituted lack any evidence for dating, and there is no direct proof of their relationship to Kim Hong-do's 1788 trip.[108]

Technically, the paintings in the so-called 1788 *Complete View* albums are characterized by crisp brushwork, well-defined forms, and the use of cool, light colors. Above all, the sense of immense space, the sharp definition of the rocks, and the distinctness of forms result in a certain surreal quality. In leaf 43, "Chinju-dam Pond" (fig. 23), for example, the rock formations are broken into numerous facets, all minutely and sharply defined even to the faraway peaks. One expects of early landscapes by Kim Hong-do that there will be a careful rendering of forms, but the paintings in these albums nonetheless do not fall comfortably within what we know of Kim's well-known styles. A set of eight genre paintings (now mounted as a screen) showing various experiences of a traveler, executed by the artist in 1778, contains enough landscape elements to use as a basis for judging

**Figure 25.** Attributed to Kim Hong-do (1745–1806), "Ch'ongsŏk-chŏng Pavilion." One leaf from *Complete View of Mount Kŭmgang*, a set of five albums of 60 leaves, ink and light color on silk, 12 × 17 ¼ in. (30.4 × 43.7 cm). Private collection

**Figure 26.** Kim Hong-do (1745–1806), "Ch'ongsŏk-chŏng Pavilion." One leaf from *Album of the Ŭlmyo Year* [1795], ink and color on paper, 9 ⅛ × 10 ⅞ in. (23.2 × 27.7 cm). Private collection

Kim Hong-do's early landscape style.[109] The first painting bears a dated inscription: "In early summer of the year *musul* [1778], Sanŭng [Kim Hong-do] painted this in the Tamjol-hŏn studio [Kim Ŭng-hwan's studio]." The fourth painting, *Startled by a Flying Bird* (fig. 24), has the most landscape elements. It shows a traveler, astride a donkey, crossing a bridge over a stream that winds its way down from the top of the composition to the foreground, creating a fair sense of space. The banks on either side of the stream are rendered with a variety of brushstrokes, such as hemp-fiber texture strokes with pepper-dots in the upper part, while the large rock in the center is depicted with stronger outline and darker washes. The choppy brushstrokes that characterize Kim's late style are not present here, but the painting conveys a general softness and, above all, a sense of spontaneity that are completely lacking in the 1788 albums.

The unusual sense of vast space in so many of the leaves of the five-album set seems out of place in late-eighteenth-century Korean painting.[110] The influence of Western painting in the late Chosŏn period has been mentioned, yet the sense of space in these albums is not the result of careful observation that marks the paintings of Kang Se-hwang, Kim Yun-kyŏm, and others but appears almost surrealistically artificial. Two paintings depicting the same scene of Ch'ongsŏk-chŏng Pavilion (one from the *Complete View* albums attributed to Kim Hong-do (fig. 25), the other from a dated album by him, *Album of the Ŭlmyo Year* [1795] (fig. 26) — are vastly different in both the use of the brush and the handling of space. While allowing for the possibility of two different styles for one artist during the same period, the tense delineation of rocks and pavilion in the former painting as well as the artificial horizon line seem diametrically opposed to the treatment of the subject in the latter painting, with its confident, casual brush lines that define the rocky columns and pavilion, and the gradually fading distant waves of the sea. Many more such comparisons could be made.

Three other albums should be mentioned in conjunction with the set of *Complete View* albums. An album of forty leaves, called *Album of Sea and Mountains*, has been attributed

to Kim Hong-do.[111] In their compositions and modeling techniques, the paintings are almost identical with those in the *Complete View* albums, though they contain stronger contrasts of light and dark and are extremely mannered. A second album of thirty leaves, entitled *Four Districts of Mount Kŭmgang*, has also been attributed to Kim.[112] While this album includes some scenes that are not in the *Complete View* set and, in its motifs and compositions, displays some similarities with the artist's known works, the style of painting lacks all the subtle qualities of Kim Hongdo's landscapes.

The third album, *Album of Travels to the East*, contains, besides twenty-eight leaves of painting by an unidentified artist, a travel diary and poems by the scholar-official Yi P'ung-ik (1804–1887),[113] who took a month's trip in 1825 to all the scenic places of the inner, outer, and coastal regions of Mount Kŭmgang. There are two prefaces to the album, one by Pak Chong-hun (1773–1841), dated 1838, the other by Pak Hoe-su (1786–1861), dated 1844. It has been correctly pointed out that the paintings in the album do not seem to be works by Yi P'ung-ik himself.[114] Pak Hoe-su indicates that they had been completed before he wrote the preface. It seems likely, therefore, that the album was put together shortly before 1844. The paintings were probably executed by a court painter of considerable skill.[115] The *Album of Travels to the East* has twenty-two compositions in common with the *Complete View* set attributed to Kim Hong-do. A comparison of the painting of "Chinju-dam Pond" in this album (fig. 27) with the one from the *Complete View* (fig. 23) reveals both similarities and differences.

That these various albums contain identical compositions indicates the existence of manuals of "model compositions" of the scenery of Mount Kŭmgang by the end of the nineteenth century. In this connection, we should recall Kang Se-hwang's remark that Kim Hong-do and Kim Ŭng-hwan had made one hundred sketches of Mount Kŭmgang during their trip there at the order of King Chŏngjo.[116] The most prominent court painters of their time, the two could have used their sketches to assemble a kind of "Mount Kŭmgang composition bank," on which not only they but also other court painters could draw for producing sets of albums of the scenery of that region.

Although none are known to survive, it is reasonable to suggest that some sets of model compositions from the royal bureau of painting were produced as woodblock prints for circulation. A widespread practice during the late Ming and early Qing periods was the production of sets of woodblock prints of well-known sites in China — such as Mounts Huang, Lu, and Wuyi, the West Lake in Hangzhou, and the Yuanming Garden — which were either included in local gazetteers and encyclopedic compilations or published independently.[117] Some of these prints and painting manuals were known in Korea, as evidenced by Chŏng Sŏn's painting of Mount Lu,[118] presumably done after the illustration had been published in China in 1726.[119]

Illuminating in this connection is an album of eight woodblock prints entitled *Mount Kŭmgang and Its Old Temples*, now in a Japanese collection.[120] Many of the leaves of this undated album have both Korean and Chinese inscriptions identifying the scenery.

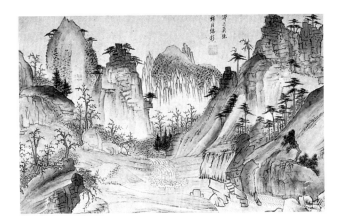

**Figure 27.** Unidentified artist (early 19th century), "Chinju-dam Pond." One leaf from *Album of Travels to the East*, an album of 28 leaves, ink and light color on paper, 10 ½ × 7 ¾ in. (26.7 × 19.8 cm). Sŏnggyun'gwan University Museum, Seoul

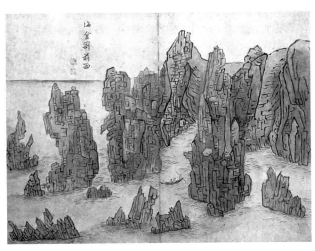

**Figure 28.** Yi Ŭi-song (1775–1833), "Front View of Haegŭmgang." One leaf from *Album of Sea and Mountains*, an album of 60 leaves, ink and light color on paper, 12 ⅝ × 18 ⅞ in. (32 × 48 cm). Private collection

Although not easy to read from the reproductions, some of the legible inscriptions indicate Chinese mountains, such as Mount Lu and Mount Heng. At the same time, the album title suggests the possible existence of woodblock printed sets of the scenery of Mount Kŭmgang. Certainly, the early-nineteenth-century depictions of Mount Kŭmgang by the literati painter Yi Ŭi-sŏng (1775–1833) strongly suggest that prints served as the model for the paintings. A good example is an album leaf titled "Front View of Haegŭmgang" (fig. 28). The brushstrokes that delineate the rock formations are all of uniform thickness, with only a slight variation of ink tone, and there is a complete absence of any further rendering of the texture of the rocks. The sea waves are also described in short lines of even thickness, very different from the billowing sea waves executed with the swift motions seen in Chŏng Sŏn's *Gate Rocks at T'ongch'ŏn* (fig. 11).

Perhaps the most noteworthy painter of true-view landscape painting in the nineteenth century is Kim Ha-jong (1793–after 1875), who was the third son of the court painter Kim Tŭk-sin and the grand-nephew of Kim Ŭng-hwan, and whose activity as a court painter has been well documented.[121] Two sets of paintings of Mount Kŭmgang credited to him are important in understanding nineteenth-century true-view landscape painting. The first is an *Album of Sea and Mountains*, dated 1815.[122] The compositions of some of its twenty-five leaves, such as those of "Myŏnggyŏng-dae Terrace" (fig. 29) and "Kuryong-yŏn Waterfall," show some similarities with those of the *Complete View* albums

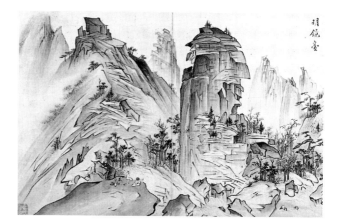

**Figure 29.** Kim Ha-jong (1793–after 1875), "Myŏnggyŏng-dae Terrace." One leaf from *Album of Sea and Mountains*, dated 1815, an album of 25 leaves, ink and light color on silk, 11 ¾ × 17 in. (29.7 × 43.3 cm). The National Museum of Korea, Seoul

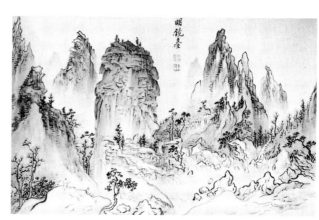

**Figure 30.** Kim Ha-jong (1793–after 1875), "Myŏnggyŏng-dae Terrace." One leaf from *Paintings of Autumn Foliage Mountain*, dated 1865, a set of four albums of 58 leaves, ink and light color on paper, 19 ⅜ × 24 ¼ in. (49.3 × 61.6 cm). Private collection

**Figure 31.** Cho Chŏng-gyu (b. 1791), *Manp'ok-tong Gorge.* Album leaf, ink on paper, 10 ⅝ × 13 ¼ in. (27 × 33.6 cm). The National Museum of Korea, Seoul

attributed to Kim Hong-do but are certainly not identical to them. Moreover, Kim Ha-jong's brushstrokes are broader and bolder, with less frequent use of texture strokes.

The second set, *Paintings of Autumn Foliage Mountain*, dated 1865, contains fifty-eight leaves mounted in four albums.[123] Though the compositions show some affinity to those in the albums attributed to Kim Hong-do, the viewpoint of each scene is somewhat different. "Myŏnggyŏng-dae Terrace" (fig. 30), for instance, compared with the same scene in the artist's earlier album of 1815, reveals Kim Ha-jong's growing mastery of the brush. The painting in general displays the Southern School style, one of softer, more

relaxed brushstrokes. Indeed, in his preface to the album, the scholar-official Yi Yu-wŏn (1814–1888) comments that Kim Ha-jong's style is a combination of that of two Chinese painters of the Southern School, Ni Zan (1301–1374) and Shen Zhou (1427–1509).[124] However, Korean painting of the mid-nineteenth century is characterized by diverse stylistic trends, and Kim Ha-jong's paintings display such eclecticism at its best. With a rich source of stylistic options — such as paintings in the tradition of the Southern School and the works of Chŏng Sŏn and Kim Hong-do — a competent court painter like Kim Ha-jong could handle any subject in any style.

Other professional painters of this period include Cho Chŏng-gyu (b. 1791), whose paintings of Mount Kŭmgang are characterized by personal touches of bold brushstrokes and abbreviated forms, although Kim Hong-do's influence can be seen at times. *Manp'ok-tong Gorge* (fig. 31) is a representative example of his work. Yu Suk (1827–1873) tended to follow Chŏng Sŏn's landscape style, especially in the abbreviated rendering of pine groves, as seen in his *Segŏm-jong Pavilion*, a depiction of a scenic spot in the northern section of Seoul.[125]

If the above sets of paintings of Mount Kŭmgang represent true-view landscapes by professional painters, a leading exponent of the genre by a literatus in the late nineteenth century is Hŏ Ryŏn (1809–1892). A native of Haenam, in the southwestern corner of the peninsula, he painted many scenes of the area, including the environs of his own home and the place of exile of the famous scholar Chŏng Yag-yong (1762–1836). As might be expected in the work of a disciple of Kim Chŏng-hŭi (1786–1856), many of these paintings are heavily influenced by the Southern School style. Some, however, concentrate on evoking the unique features of the scenery. His *Rocks of Five Hundred Generals*, depicting numerous rock formations on either side of a stream coursing down from a steep gorge, is a good example of the way in which Hŏ Ryŏn deviated from his usual Southern School manner and sought to portray the peculiar characteristics of a specific place.[126]

Amid the dominance of Southern School literati painting, the tradition of true-view landscape painting, while continuing in the late nineteenth century, was not pursued with the same degree of zeal and creativity as in the eighteenth century. Among those who worked in the tradition in the late nineteenth century, which in turn became the basis of early-twentieth-century true-view landscapes, might be mentioned An Chung-sik (1861–1919), among the last generation of court painters, who left an impressive ten-fold screen painting entitled *Ch'ehwa-jŏng Pavilion*.[127] Dated 1915, it depicts a village at Yŏnggwang, in South Chŏlla Province. Without this turn-of-the-century production of true-view landscape, the activities of modern painters such as Pyŏn Kwan-sik (1899–1976) and Yi Sang-bŏm (1897–1972) might not have been possible.[128] Both traveled widely and painted a large number of true-view landscape paintings. Even in contemporary Korea, many artists continue to paint scenery of exceptional beauty or uncommon character, and the practice of traveling in order to sketch Korean sites continues to be a living tradition amid the influx of such phenomena as postmodernism and video art. ❧

Kim Hongnam

An Kyŏn and the Eight Views Tradition:
An Assessment of Two Landscapes in The Metropolitan Museum of Art

All evidence, including reliably dated paintings, suggests that the fifteenth century in Korea was charged with the energy of the newly founded Chosŏn dynasty (1392–1910), sophisticated in its cultural pursuits and producing important art patrons at the court as well as talented calligraphers, painters, poets, and eminent Neo-Confucian scholars. Unfortunately, during the wars with Japan at the end of the sixteenth century, the country was devastated, and few art works of consequence were left behind. Therefore, the story of early Chosŏn painting remains sadly unsubstantiated and fragmentary. Vanished are nearly all visual records of the works of the preeminent painter An Kyŏn (act. ca. 1440–70) and his contemporaries, which were celebrated in their time.[1] Considering the rarity of authentic works of fifteenth-century Chosŏn painters, the preservation of such a superb work as *Dream Journey to the Peach Blossom Land* (fig. 2), painted by An Kyŏn in 1447, makes us only more poignantly aware of what has been lost. Since An Kyŏn was the foremost court painter of the early Chosŏn period, serving more than four kings in a career of about thirty years, he was extremely influential, and many important court and professional painters of the day emulated his art. A number of the early Chosŏn landscape paintings that have recently come to light in Japan — the indisputable treasure house of Korean art — are attributed to An Kyŏn, but probably encompass the works of his followers, imitators, and even outright forgers.

**Figure 1B.**
Unidentified artist (15th century), *Evening Bell from Mist-shrouded Temple*. One of a pair of hanging scrolls, ink on silk, 34 ¾ × 17 ¾ in. (88.3 × 45.1 cm). The Metropolitan Museum of Art, Purchase, Joseph Pulitzer Bequest, and Mr. and Mrs. Frederick P. Rose and John B. Elliott Gifts, 1987. 1987.278a,b

A pair of landscapes in The Metropolitan Museum of Art (figs. 1A, B; pl. 84), as I shall demonstrate in this essay, can be confidently ascribed to the early Chosŏn period.[2] I further argue for a fifteenth-century date on the basis of a stylistic comparison with works of the period that have been reliably dated, notably An Kyŏn's *Dream Journey*. That the Metropolitan pair conforms to the general composition, typology, and mood associated with the many well-known sets of paintings on the theme Eight Views of the Xiao and Xiang Rivers, and that the two hanging scrolls were designed to be displayed together, strongly suggest that the paintings originally belonged to a complete set of Eight Views. These were sometimes mounted as an eight-fold screen, a format particularly popular in Korea

**Figure 1A.**
Unidentified artist (15th
century), *Autumn Moon over Lake
Dongting*. One of a pair
of hanging scrolls, ink on silk,
34 ¾ × 17 ¾ in. (88.3 × 45.1 cm).
The Metropolitan Museum of
Art, Purchase, Joseph Pulitzer
Bequest, and Mr. and Mrs.
Frederick P. Rose and John B.
Elliott Gifts, 1987. 1987.278a,b

during the Chosŏn period for depiction of the theme. Moreover, in their composition, brushwork, and painting style, the landscape paintings in the Metropolitan's collection are, in my opinion, more comparable to An Kyŏn's *Dream Journey* than any works heretofore known to us, so much so that a close comparison leads me to ascribe the Metropolitan pair to An Kyŏn himself. It is essential to sort out early Chosŏn paintings and to establish their correct provenance in order to illuminate this period of Korean art. The discovery of works that can be persuasively attributed to An Kyŏn, such as the Metropolitan pair, is therefore of tantamount importance.

## THE METROPOLITAN LANDSCAPES AND THE
### EIGHT VIEWS OF THE XIAO AND XIANG RIVERS

The Metropolitan paintings can be identified as two specific scenes from the repertory of the Eight Views of the Xiao and Xiang Rivers: the one illustrated here on the right (fig. 1A) portrays *Autumn Moon over Lake Dongting*, while the one on the left (fig. 1B) depicts *Evening Bell from Mist-shrouded Temple*.[3] The scrolls were at one point remounted for conservation and repairs, during which process they were washed, with a resulting loss of depth, nuance, and shading in the ink. There is also evidence of repair to the silk and re-touching along a horizontal crack in the upper part of the scroll shown on the right. The paintings contain no information regarding previous ownership; one seal placed in the lower left corner of the scroll on the right is now effaced. In both paintings, the silk has darkened with age, but its original physical condition would not have been much different than the present one, since darkness and a prevailing melancholy mood were originally intended in these scenes of evening and night.

The Eight Views of the Xiao and Xiang Rivers was a celebrated theme of painting and poetry during the Song dynasty (960–1279). The two rivers flow through the modern province of Hunan and feed into Lake Dongting. In poems and paintings the Eight Views theme encompasses the entire landscape of mountains, rivers, and marshes in the Lake Dongting region in admiration of its luxuriant beauty and its romantic aura as a place of retreat and reclusion. These connotations are largely the result of the legend of Qu Yuan (343–278 B C E), a statesman of ancient Chu and the author of the *Chu ci* (Songs of Chu), who was banished to the south because of false accusations against him, and fi-nally, in despair over his fate, drowned himself there. Literary evidence suggests that the

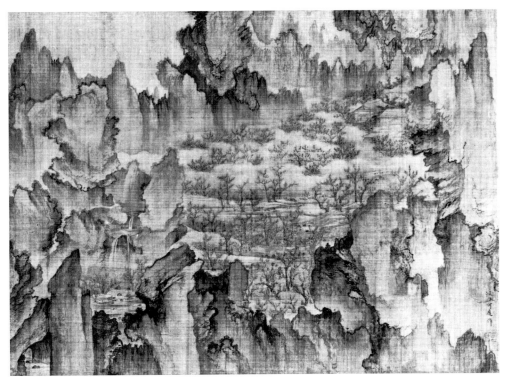

**Figure 2.** An Kyŏn (act. ca. 1440–70), *Dream Journey to the Peach Blossom Land*, dated 1447. Detail of handscroll, ink and light color on silk, 15 ¼ × 41 ¾ in. (38.6 × 106.2 cm). Tenri Central Library, Tenri University, Nara. Important Cultural Property of Japan

Chinese poetic and painting tradition of the Eight Views had been transmitted to Korea by the twelfth century and became very popular there by the fifteenth century.

From the lower right of *Autumn Moon over Lake Dongting* emerges a shore with a path leading to a small hill with a thatch-roofed kiosk on its flat top, indicating a town nearby. Barely visible in the kiosk are two seated figures (fig. 3). Behind the hill at some distance is a valley where a monastic complex is nestled, seemingly separated from the lake by the dramatic overhanging rock formation and protected by the mountains rising vertically beyond the valley. Dimly visible yet prominently placed in the center of the picture, below the overhang, is a tile-roofed, double-storied pavilion standing out from a cluster of houses below. In the foreground is moored an unoccupied boat with one oar. These barely visible elements and the overall darkness of the picture identify it as a nocturnal scene.

Of these details, the double-storied pavilion overlooking the lake is a standard attribute of the scene "Autumn Moon over Lake Dongting." The pavilion has been identified as the Yueyang Lou (South of Mountain Peak Pavilion) in the Eight Views poems as well as in poetic inscriptions attached to early Chinese paintings of this scene, including one by the Southern Song (1127–1279) monk-painter Yujian (act. ca. mid-13th century). Yujian also mentions the name of the pavilion in a poem that he inscribed on his own painting of this scene.[4] The Yueyang Lou, at the West Gate of the city wall of Yueyang, in Hunan Province, was indeed constructed in the style of a double-storied pavilion, offering the best view of Lake Dongting and the surrounding mountains. An important theme in Tang poetry, the Yueyang Lou was the subject of a poem by the celebrated poet Du Fu

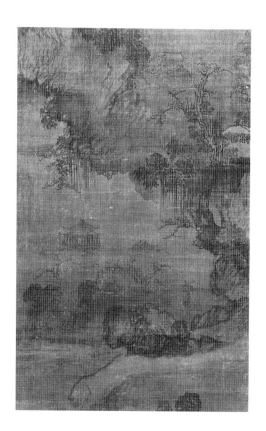

**Figure 3.** Detail of *Autumn Moon over Lake Dongting* (figure 1A)

(711–770), and thereafter became an indispensable subject of Eight Views poems and paintings.[5]

The moon is not visible in the Metropolitan's scroll, but its omission is not unusual. It appears neither in the earliest recorded paintings of the Eight Views by Song Di (ca. 1015–ca. 1080), who is credited with the creation of the pictorial theme, nor is there a moon in the earliest extant set of paintings of the subject by the little-known Southern Song painter Wang Hong (act. ca. 1131–61).[6] The two conversing figures seated in the small kiosk are part of the traditional iconography of *Autumn Moon*. Except for these tiny figures, however, the painting is devoid of any other human presence or narrative details. There are no fishermen or travelers and no fishing boats, all of which can be found in other paintings of the Eight Views theme.

The second scroll, identifiable as *Evening Bell from Mist-shrouded Temple*, is less dark than *Autumn Moon*, with more sharply rendered contrasts of light and dark. The scenery is at first glance rather unspectacular, yet this calls more attention to the misty, somewhat melancholy atmosphere. The painting opens in the foreground with two spits of land that jut into a shallow stream. In the mountain valley beyond emerges a mist-shrouded village, lying low horizontally across the middle ground of the picture plane (fig. 4). Tiled roof-tops visible through the mist suggest the presence of a large monastic complex. A broad band of mist behind this complex obscures the foothills of an imposingly tall mountain range that rises in the distance. As in *Autumn Moon*, the artist has not supplied any of the standard details of human interest — figures, boats, a rustic bridge, a bustling mountain market, or even a well-trodden path — that are commonly found in Eight Views paintings.

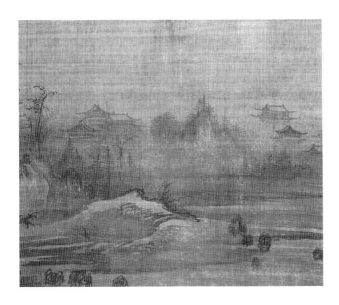

**Figure 4.** Detail of *Evening Bell from Mist-shrouded Temple* (figure 1B).

Seemingly uninhabited and veiled in a misty atmosphere, the landscape is still and silent, in anticipation of that moment when the sound of the evening bell will be carried, pure and resonant, across the valley. The remoteness, serenity, and contemplative mood the composition evokes are qualities that exclude from consideration any identification besides *Evening Bell from Mist-shrouded Temple*. The omission in both Metropolitan landscapes of such routine attributes as a Buddhist monk or a traveler crossing a rustic bridge or a temple pagoda in the high distance is in keeping with the artist's apparent disinterest in narrative details, and his concern with capturing the mood of the landscape and a moment in time.

By the late twelfth century, poetry and painting celebrating the Eight Views theme were already known in Korea. It is recorded that in about 1185 Yi Kwang-p'il (act. late 12th century), a son of the famous painter Yi Nyŏng (act. ca. 1122–46), who worked for a short time in the Imperial Painting Academy of the Northern Song emperor Huizong (r. 1101–25), was ordered by King Myŏngjong (r. 1170–97) to execute a set of paintings to accompany poems on the Eight Views composed by a contemporary scholar-poet Mun Sun-dal (act. late 12th century).[7] Quite a number of Koryŏ (918–1392) and early Chosŏn scholar-poets left poems on the theme. Among the Koryŏ scholar-poets whose poems on the Eight Views have been recorded are Chin Hwa (act. ca. 1200) and Yi In-no (1152–1220), both of whom composed poems entitled "Song Di's *Eight Views*,"[8] a reference to the Northern Song painter who, as mentioned earlier, is credited with the earliest recorded set of paintings identified as the *Eight Views of the Xiao and Xiang*. The title of the poems may indicate that Chin and Yi had seen Song Di's work (either the original or a copy), or simply that their poems were composed in rhyme with Song's own verses.

Another eminent figure in the Korean poetic tradition of the Eight Views is the Koryŏ scholar-official and amateur painter Yi Che-hyŏn (1287–1367), who spent several years in China where he befriended the Yuan scholar-official and artist Zhao Mengfu (1254–1322), Zhao's follower Zhu Derun (1294–1365), and many other leading cultural figures and

painters. Yi Che-hyŏn is thus regarded as having played an important role in the transmission of Yuan painting and calligraphy to Korea, particularly those paintings that followed the Northern Song landscape idiom of Li Cheng (919–967) and Guo Xi (ca. 1000–ca. 1090) and the calligraphy of Zhao Mengfu. Yi's poems on the Eight Views theme inspired those of a later scholar-official and poet of the early Chosŏn period, Yi Sung-so (1422–1484), who composed his own poems on the subject in rhyme with Yi Che-hyŏn's.[9]

Although no existing Eight Views paintings of an unquestionable Koryŏ date are known, two works in Japanese collections have been discussed by some scholars in the context of the Koryŏ period and the Eight Views: a handscroll with an inscription by the eminent Zen monk and literary figure Zekkai Chūshin (1336–1406), in the Shōkoku-ji Temple, Kyoto, and a hanging scroll entitled *Wild Geese Descending to Sandbar* with a seal reading Shikan (Sa-gam) and an inscription by the Chinese monk Yishan Yining (1247–1317), in the Satomi Collection.[10] These two works will be discussed below in relation to the Metropolitan landscapes.

The Eight Views tradition seems to have been revitalized in the early Chosŏn period, as evidenced by extant paintings and written records. Among the figures who were instrumental in this process were Prince Anpy'ŏng (1418–1453), the third son of King Sejong (r. 1418–50) and an eminent collector of Chinese paintings, and members of the prince's artistic circle.[11] In about 1442, Prince Anpy'ŏng saw a set of poems on the Eight Views by the Southern Song emperor Ningzong (r. 1195–1224). He had the poems copied and the eight scenes painted in handscroll format with the title *Poems of Eight Views.* He then had added to the scroll copies of the poems on this theme by the two previously mentioned Koryŏ scholar-poets Chin Hwa and Yi In-no and asked contemporary men of letters who excelled in poetry, including the monk Manu (Ch'ŏn-bong, 1357–ca. 1447), Pak P'aeng-nyŏn (1417–1456), Kim Chong-sŏ (1390–1453), Chung In-ji (1396–1478), and Sin Suk-chu (1417–1475), to contribute verses.[12] That all of these poets also contributed colophons to An Kyŏn's painting *Dream Journey* suggests that the painter of this particular commission may have been An Kyŏn himself.[13] In support of this suggestion it should also be noted that according to Sin Suk-chu's catalogue of the prince's collection, compiled in 1445, the only Korean paintings the prince owned were by An Kyŏn, among which was a set of Eight Views.[14] The prince's interest in the subject is revealed by other entries in the catalogue, namely two Eight Views scenes among the seventeen paintings listed under Guo Xi's name and a full set of Eight Views paintings under the name of a Yuan artist, Li Pi. This aspect of the collection is discussed in more detail below.

Another interesting set of poems from the Chosŏn period, this one bearing the title "Paintings of the Eight Views of the Xiao and Xiang, With the Imperial Signature of the Song Emperor Ningzong," was written by Kang Sŏk-tŏk (1395–1459). Kang, who also contributed a colophon to An Kyŏn's *Dream Journey*, was the father of two famous scholar-painters of An Kyŏn's time, Kang Hŭi-an (1419–1464) and Kang Hŭi-maeng (1424–1483).[15] If the paintings referred to in the title of Kang Sŏk-tŏk's poems

in fact had any link to Emperor Ningzong or his time, the poems would be one of the earliest pieces of literary evidence of such paintings in either China or Korea, together with the set of paintings executed by Yi Kwang-p'il in 1185 at the behest of King Myŏngjong.

There are, of course, a number of fifteenth- and sixteenth-century paintings on the theme attributed to An Kyŏn or thought to be products of the An Kyŏn school. Among other Chosŏn artists known for paintings on this theme are Yang P'aeng-son (1488–1545) and the mysterious early-fifteenth-century painter Bunsei (Munch'ŏng) whose works are extant in both Japan and Korea. A total of fifteen recognized early Chosŏn paintings on the Eight Views theme exist in complete or partial sets in Korea, Japan, and the United States,[16] including a hanging scroll identified as *Wild Geese Descending to Sandbar* that was acquired by the Metropolitan Museum in 1992.[17] All of these works date to the period between An Kyŏn and Yang Paeng-son, that is, from the mid-fifteenth to the mid-sixteenth century. Thus An Kyŏn is the earliest Chosŏn artist who is recorded as having produced Eight Views paintings.

### DATING THE METROPOLITAN PAINTINGS

Eclectic in style, the Metropolitan landscapes reflect the rich and diverse painting traditions, particularly those of China, on which a fifteenth-century Korean artist could draw. These include, most obviously, the Northern Song monumental landscape tradition, embodied in the Li Cheng-Guo Xi idiom (known as the Li-Guo style), and the ink painting of the Southern Song Chan (Kr. Sŏn; Jp. Zen) school led by Liang Kai (act. first half of the 13th century). The very combination of these two stylistic influences in the pair of scrolls strongly suggests the fifteenth century as the date of production, for this blending of styles does not occur in China before the late Yuan and early Ming periods in the fourteenth and fifteenth centuries, and in Korea in the fifteenth century.

Li Cheng and Guo Xi are two of the most important figures in the development of realistic, monumental, and rational landscape painting during the Northern Song. Li Cheng was especially famous for his representations of gnarled, twisted trees and of distant vistas of the barren landscape of north China. Li Cheng's legacy was carried on by his pupil, Guo Xi, who was acclaimed as the greatest artist of his day, even rivaling his master. In *Early Spring* (fig. 5), the most important work known to have been painted by the artist, Guo Xi borrows freely elements of Li Cheng's style but imbues his work with a distinctive rhythmical quality, complexity, and atmosphere. Although no original works of Li are known to exist, his achievements are traceable through his attributed works as well as through Guo Xi's paintings, thus justifying the term Li-Guo style. After the fall of the Northern Song capital, Kaifeng, in 1127 to the Jurchen founders of the Jin dynasty (1115–1234), the Chinese court fled south and made Hangzhou the new capital of the Southern Song dynasty. Landscape art in the Li-Guo style continued to flourish in the north under the Jin, as exemplified by the works of Li Shan (act. early 13th century).

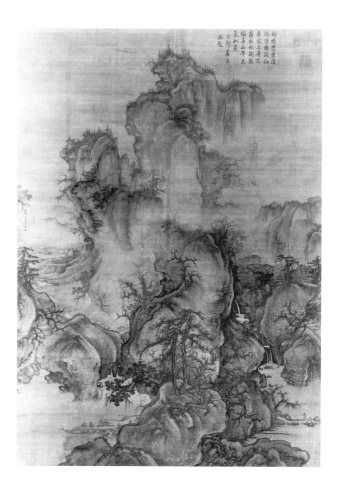

**Figure 5.** Guo Xi (ca. 1000–ca. 1090), *Early Spring*, dated 1072. Hanging scroll, ink and color on silk, 62 ¼ × 42 ⅜ in. (158.3 × 108.1 cm). National Palace Museum, Taipei

In the south the Southern Song Painting Academy and Chan Buddhist painting both played important roles in the creation of new modes of landscape. Gradual resolution of pictorial forms, fragmented and suggestive compositions, expansive use of ink washes and techniques of gradation, and creation of misty atmospheres are common Southern Song stylistic features. There are, however, broad distinctions to be drawn within the Southern Song tradition. The so-called Academy style—represented by Xia Gui (act. ca. 1125–1230) and Ma Yuan (act. ca. 1190–1225)—is typically characterized as "lyrical," with asymmetrical compositions, evocative rather than descriptive modes, and the use of axe-cut texture strokes. The Chan painting style—represented by Liang Kai and Muqi (act. 13th century)—is described as "intuitive and spontaneous," with an emphasis on rapid, calligraphic brushwork. Moreover, Chan Buddhist painters, in addition to depicting landscapes, also drew upon Chan Buddhist allegories for subject matter.

During the succeeding Yuan dynasty (1272–1368), as Richard Barnhart has demonstrated,[18] the classical style of Li Cheng and Guo Xi was continued by such professional artists as Luo Zhichuan (act. ca. 1300–30), Sheng Mou (ca. 1300–ca. 1360), and Tang Di (1287–1355), and there was also a revival of the Northern Song landscape style among literati artists, led by Zhao Mengfu. From this it is clear that Chinese landscape painting evolved along multiple lines, involving both professional and literati artists. The attempt to combine elements of the Southern Song style, such as the use of ink wash, asymmetrical composition, and the construction of the pictorial space, with certain elements of

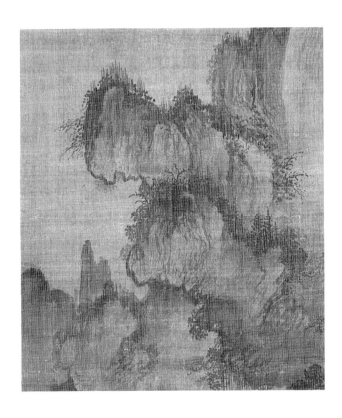

**Figure 6.** Detail of *Autumn Moon over Lake Dongting* (figure 1A)

Northern Song landscape art, such as large-scale, vertical mountain forms and rock masses, had already begun during the Yuan period, as exemplified by the paintings of Sun Junze (act. early 14th century), and continued into the early Ming dynasty (1368–1644) with the works of Dai Jin (1388–1462) and other painters of the so-called Zhe school.[19]

The most important stylistic referent for the Metropolitan pair of landscapes is undoubtedly that of Guo Xi. In their reduced scale, relatively dispersed composition, and placement of the landscape elements further back in the pictorial space, the paintings appear to compromise the monumentality that is the hallmark of the Northern Song style. Yet the interrelation of the landscape elements and the long winding movements of their compositional forces, though considerably weaker in comparison with Guo Xi's *Early Spring*, are nonetheless discernible in the mountain formations of both Metropolitan paintings. Another Northern Song feature retained by the pair is a gradual spatial recession along a level plane, with a low viewpoint. While the principal mountain mass is located near the center, the overall composition of both Metropolitan paintings departs from the Northern Song organization of compositional elements along the vertical axis. At the same time, however, the placement of the mountains does not embody the asymmetrical principles of either the Southern Song Painting Academy or the Zhe school of the Ming dynasty.

In *Autumn Moon over Lake Dongting*, the foreground is dark and spare. It takes some time to adjust one's eyes to the darkness of the scene and to locate the empty boat moored at the shore and the path that leads to the hillock on the right. From the Guo Xi repertory come the foreground hillock with its simple kiosk, the small gnarled trees with "crab-claw" endings to their branches, and the low-lying leafy trees and twigs. Absent in the

foreground are the large gnarled and deciduous trees that are important elements of the Li-Guo style and its followers in the Jin, Yuan, and Ming periods. More fundamental to the Guo Xi legacy, and present in the Metropolitan paintings, are the contorted geological forms of the towering mountain. Indeed, the viewer's attention is immediately attracted to the curiously shaped overhanging rock mass (fig. 6) that projects diagonally from the main peak of the mountain, a rock formation similar to the cloudlike rocks in Guo Xi's *Early Spring*. Executed in the soft, rapid, and fluent brush manner characteristic of Guo Xi, the gently undulating forms of rocks and mountains are built up by means of oblique or vertical ink-wash strokes; in certain areas, unusual wavy textural strokes are employed, probably intended to produce the appearance of rougher surface. Following the Northern Song idiom, mist is used as a device to relate foreground, middle ground, and far distance. For instance, the area between the overhanging rock and the mountains behind is covered in mist, disguising the ambiguity of the spatial relationship of these two landscape elements.

In the painting *Evening Bell from Mist-shrouded Temple*, the artist has skillfully interwoven other artistic conventions with characteristic motifs and traits of the Li-Guo style. This painting displays more control and simplicity in composition. The foreground, for instance, is clearly marked by the two sloping banks that jut into the shallow stream at the right. The composition likewise seems rationally constructed, with a flat recession from foreground to middle ground and with the horizon placed at approximately the same level as in the corresponding *Autumn Moon* scroll. Also, as in *Autumn Moon*, the ground plane is not tilted and therefore is easily readable as a horizontal plane. Although the brushwork and ink-wash method in both paintings follow the Guo Xi idiom, the result in *Evening Bell* is more atmospheric.

The distinctive atmospheric style, although somewhat abbreviated, and the mist-enshrouded distant village prominent in *Evening Bell* point to the possibility of direct contact with Southern Song painting or with Yuan followers of the Li-Guo tradition who incorporated the Southern Song atmospheric style into their interpretation of Northern Song landscape conventions. Moreover, both scrolls express some of the qualities that we associate with Chan Buddhism, notably, the combination of evocative ink wash, simple, brusque brush mode, and the verticality of composition as a remnant of the Northern Song monumental landscape tradition. In this regard, the Metropolitan pair seems to represent a fusion of the earlier Northern Song monumental tradition with the Chan Buddhist style of painting that developed at the end of the Southern Song period in the monasteries of southern China.

These subtle but demonstrable differences between Chinese works and the Metropolitan landscapes are significant in identifying the pair as Korean paintings of the early Chosŏn period. In brief, while the Metropolitan scrolls draw on the Northern Song Li-Guo tradition for some of their vertical mountain forms and level-distance effects, they also recall Chan paintings of the late Southern Song in the abbreviated and wet rendering

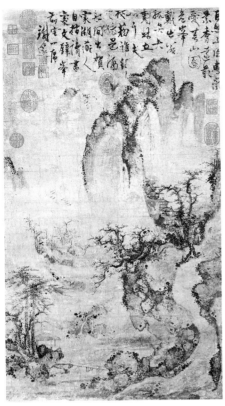

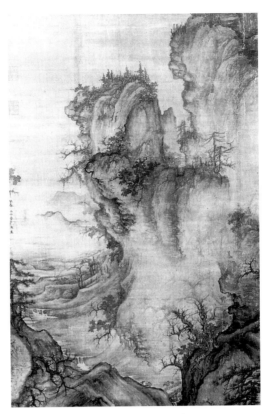

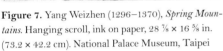

**Figure 7.** Yang Weizhen (1296–1370), *Spring Mountains*. Hanging scroll, ink on paper, 28 ⅞ × 16 ⅝ in. (73.2 × 42.2 cm). National Palace Museum, Taipei

**Figure 8.** Detail of *Early Spring* (figure 5)

of some passages, which display few traces of the Southern Song Academy style. These stylistic traits and their technical manifestations, which are further illuminated below through comparisons with Chinese paintings of the Yuan period, are also unmistakably present in An Kyŏn's *Dream Journey to the Peach Blossom Land*.

In China, the transmission of the Li-Guo tradition during the Yuan period entailed a fragmentation of Northern Song monumental forms. Painters were unable or unwilling to treat the large landscape components as organic wholes, as Guo Xi had done and as the artist of the Metropolitan landscapes has successfully achieved. This is most clearly illustrated by a comparison of *Autumn Moon* with the hanging scroll *Spring Mountains* by the literati artist Yang Weizhen (1296–1370), in the National Palace Museum, Taipei (fig. 7). Yang's painting, as pointed out by Fu Shen, itself looks almost like a fragment from Guo Xi's *Early Spring* (fig. 8).[20]

Indeed, a comparison of the two later works with a detail from *Early Spring* reveals not only an indebtedness to the Guo Xi style but significant differences in the transformation of that style. Both *Autumn Moon* and *Spring Mountains* are strikingly similar in the placement and shape of the rocky hill in the right foreground and in the ambiguous spatial relationship between the vertical mountain group and the cluster of tile-roofed buildings. The relatively small space occupied by the foreground stream and the placement of the distant mountains at the horizon line stifles any sense of a vast, expansive vista. Both scrolls also avoid the Southern Song diagonal compositional scheme, with its emphasis on

empty space, as well as the Yuan river-landscape formula and the archaizing compositions favored by Zhao Mengfu and other late Yuan literati painters. Also similar is the spit of land jutting into the shallow water from the lower right corner and the broad, flat path that slopes upward to the top of the hill. Near the top of the hill, Yang has placed a bifurcated tree where the kiosk is situated in *Autumn Moon*, and behind this a cluster of buildings similarly nestled against the mountain massif.

Alongside these similarities are noticeable differences in the compositional scheme used by Yang Weizhen and by the painter of the Metropolitan landscapes. The minimal treatment of the foreground in *Autumn Moon* creates a comparatively greater distance between the viewer and the scene, focusing attention on the centerpiece: the overhanging rock and the mountain massif, conceived according to the relatively simple Northern Song principle of dominance and subordination. Yang Weizhen, in contrast, introduces foreground details that draw the viewer closer to the scene: a thatched-roof kiosk sheltered by three tall trees sits on a spit of land at the river's edge, and a rustic bridge connects the two opposite banks. As a result of these details, everything appears much nearer in Yang's painting, with the line of the background central mountain pulled down, placing it closer to the foreground. The viewer is both physically and psychologically more engaged with this landscape than that of the Metropolitan paintings, in which the entire scene is more remote.

Yang's painting is also more textured and more unified in its surface pattern, yet less realistic than a Northern Song work, which typically emphasizes the logical separation of parts that nevertheless cohere in a rational order. Yang seems to assert his own interpretation of the Guo Xi style in his deliberate choice of dry, linear brushwork and amateurish dotting, a more self-conscious brushwork than that of Guo Xi or the artist of the Metropolitan pair. In this regard Yang can be paired with Zhu Derun, another late Yuan literati painter who worked in the manner of Guo Xi. The outlines and dots Yang has relied on throughout the picture result in sudden abbreviations and scarcely any sense of gradation, thus diminishing the visual coherence of the entire presentation. *Autumn Moon*, on the other hand, is more faithful to the broad, wet exercise of the Northern Song master's brushwork, with no reference to the Yuan literati preoccupation with calligraphic texture strokes and dotting techniques. Such aspects not only enhance the monumentality of the principal mountains and the effects of atmospheric distance, but also make problems of scale relationships easier to control, imparting the compositional cohesiveness and coherency of spatial recession inherent in a relatively fixed, stable viewpoint. Thus, despite its many similarities with Yang Weizhen's *Spring Mountains*, the Metropolitan's *Autumn Moon* turns out compositionally to be more fundamentally akin to a classical Northern Song landscape style than to the later Yuan interpretation of that style.

Another transformation of the Northern Song style occurred among Yuan professional and court painters, for instance, Tang Di, Luo Zhichuan (fig. 9), and Sheng Mou, who represent the continuation of the classical art of Li Cheng and Guo Xi, from the end

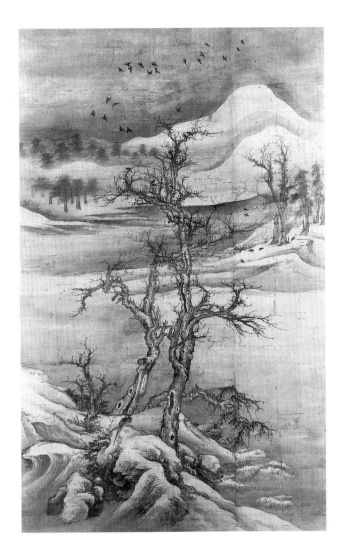

**Figure 9.** Luo Zhichuan (act. ca. 1300–1330), *Crows in Wintry Trees.* Hanging scroll, ink and color on silk, 51 ¾ × 31 ½ in. (131.5 × 80 cm). The Metropolitan Museum of Art, Purchase, Gift of J. Pierpont Morgan, by exchange, 1973. 1973.121.6

of the Song dynasty up to the beginning of the Ming period. Their works carry on the Guo Xi brush manner in the familiar Yuan compositional style of tilted ground planes and high horizon, but in a more self-conscious idiom and with an emphasis on the moralistic overtones of the wintry-tree motif. [21]

The Metropolitan pair is also far from the monumentalized, dramatic Southern Song Academy style practiced by the Yuan professional painter Sun Junze (act. early 14th century) (fig. 10) and continued by Dai Jin and other early-fifteenth-century masters who are grouped together as the Zhe school. As seen in Dai Jin's *In the Shade of Summer Trees* (fig. 11), the Zhe school produced romantic and idealized landscape images with prominent foreground elements, such as magnificent lakeside villas, dramatic trees, and figures at leisure. Though Dai Jin worked in the Guo Xi manner, his brushwork has a nervous energy and a jagged rhythm that are his own, resulting in the undeniable romanticism of his paintings. The Metropolitan pair proceeds very differently, departing from both the predominantly diagonal, open composition of Southern Song models and the more intimate and approachable quality of Zhe school compositions.

The Metropolitan landscapes also stand somewhat apart from nearly contemporary Chinese paintings in the treatment of trees. The artist does not open the compositions

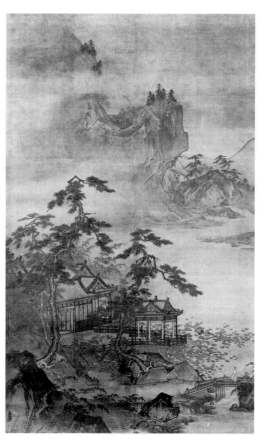

**Figure 10.** Sun Junze (act. early 14th century), *Villas by a Lake*. Hanging scroll, ink and light color on silk, 73 ¼ × 44 ½ in. (185.5 × 113 cm). University Art Museum, University of California at Berkeley, on extended loan from the Ching Yuan Chai Collection

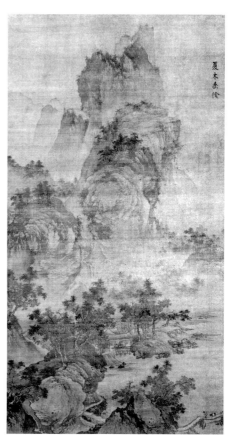

**Figure 11.** Dai Jin (1388–1462), *In the Shade of Summer Trees*. Hanging scroll, ink and light color on silk, 78 × 42 in. (173.3 × 107 cm). University Art Museum, University of California at Berkeley, on extended loan from the Ching Yuan Chai Collection

with foreground tree groups placed either at the right or at the left, a convention widely practiced from the Southern Song period onward; nor does he adopt the Yuan convention of concentrating attention on trees arranged in groups of two or three (abbreviating or eliminating the middle or far distance). Neither does the artist employ typical Zhe school compositions, in which foreground trees, human activities, and dwellings are prominent, nor does he compensate for the conspicuous absence of trees by including figures, bridges, or buildings. The Metropolitan pair does share a few significant traits with Yuan works in the interpretation of Northern Song style, notably the tendency to block off the horizon with distant mountains and to emphasize the tension between centrality and asymmetry in composition, between solid and void in forms, and between linearity and textured surface. Nonetheless, such comparisons with Dai Jin and other early-fifteenth-century Chinese landscapists are more illuminating for the disparities they reveal than for the similarities. These disparities cast light on the different path taken by the painter of the Metropolitan scrolls and on his position within the far-flung evolution of the Northern Song landscape tradition.

Turning to early Ming artists, Li Zai (act. early 15th century), one of the leading landscape masters at the court, worked most faithfully in the Guo Xi manner and left a

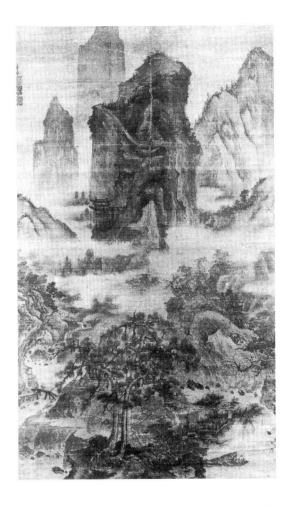

**Figure 12.** Li Zai (act. early 15th century), *Landscape in the Manner of Guo Xi.* Hanging scroll, ink and light color on silk, 32 ¾ × 15 ⅜ in. (83.3 × 39 cm). Tokyo National Museum

number of works that were indeed once attributed to the master himself. A serious comparison with Li Zai's paintings in the Guo Xi manner (fig. 12), however, reveals that the Metropolitan pair does not derive directly from such debased early Ming descendants of Guo Xi's masterworks, unlike the case of the Japanese ink master Sesshū (1420–1506), who directly imitated Li Zai for his monumental landscapes. Li Zai's manner is detailed and realistic, with dramatic genre elements of description and narrative as well as highly superfluous contrasts of light and dark. The mountains, trees, figures, and architecture are constructed firmly and strongly, with the crisp brushwork and detailed attention of a craftsman. Because the foreground, middle ground, and background appear to be on one plane, everything seems nearer. The artist is incapable of or has little interest in creating an illusion of spatial recession and depth.

Probably the most noteworthy feature of the Metropolitan landscapes is their vertical format. It is unknown what format was used by Song Di, but all Southern Song painters who produced paintings of the Eight Views, including Wang Hong, whose painting is the earliest known extant work on the subject,[22] Mu Qi, and Yujian, employed the horizontal format. In Korea, in contrast, the vertical format traditionally has been preferred for this theme. Indeed, all Korean paintings of the Eight Views that I have seen are in this format (in the case of a complete set of eight paintings, the individual hanging scrolls are sometimes mounted as a folding screen). The vertical format is, of course, particularly appro-

priate for representing the mountainous terrain of the Korean peninsula and has been favored throughout the history of Korean landscape painting. The vertical format also links these scrolls to Northern Song monumental landscape paintings.

In this connection, virtually all the fourteenth- and fifteenth-century Eight Views paintings in Japan that are thought to reflect Korean influence are in the vertical format. They include the aforementioned works: the pair of hanging scrolls from a set of Eight Views paintings by Bunsei (figs. 13A, B); the handscroll with an inscription by Zekkai Chūshin, in the Shōkoku-ji Temple (fig. 14); and *Wild Geese Descending to Sandbar* (fig. 15) attributed to Shikan, in the Satomi Collection. In the case of Bunsei, it has been suggested that he studied landscape painting in Korea, as his Eight Views scrolls not only closely resemble the work of An Kyŏn's student Sŏk Kyŏng, but predate his other extant works (the earliest datable work being 1452).[23] John Rosenfield also identifies the Korean style in Bunsei's works and looks at them in the Chan context.[24] Although the Shōkoku-ji handscroll bears a traditional attribution to an otherwise unknown late Yuan painter named Zhang Yuan (act. 13th century), most Japanese and Korean scholars have accepted it as a Koryŏ work.[25] Regarding the Satomi scroll, Yoshiaki Shimizu has written:

> Before 1317, a painter named Shikan — perhaps an amateur painter, a monk in one of Kamakura's Zen monasteries — painted a very different landscape in pure ink, very likely from a sequence of eight hanging scrolls. Shikan's subject had nothing to do with Japan: each scroll celebrated the beauty of one of the Eight Views of Hsiao and Hsiang, a pair of rivers in far-off China. The misty spires of distant mountains in Shikan's scroll find no parallel on the Japanese islands. Shikan himself had probably never seen such peaks, but learned of them through painted landscapes brought to Japan from Korea.[26]

These four works in Japanese collections not only draw on classical Northern Song elements, such as vertical mountain forms and level-distance effects, but also recall Chan Buddhist paintings of the late Southern Song in their abbreviated and wet rendering of some passages, a stylistic feature that has been identified as typically Korean. The fact that all known Korean Eight Views paintings of the fifteenth and sixteenth centuries, including the Metropolitan pair, are in vertical formats strengthens the argument for a Korean origin of the Satomi painting and the pair of paintings by Bunsei.

To anyone accustomed to the well-established stylistic lineages defined by the critical tradition of Chinese painting, the combination of elements of the Guo Xi style with characteristic features of Southern Song and Yuan painting in the Metropolitan landscapes creates an oddly conservative, ancient look. In these essentially conservative scrolls, all borrowings from older styles have been skillfully integrated by the artist, with the result that they do not stand out as archaistic allusions or as outright imitations. Nor is the viewer conscious of any experimental manipulations of form or, for that matter, of anything else very striking or daring. The artist seems less concerned about the revival of

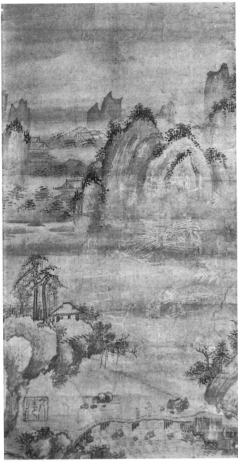

**Figures 13A** (right), **13B** (left). Bunsei (act. early 15th century), *Autumn Moon over Lake Dongting* (right) and *Evening Bell from Mist-shrouded Temple* (left). Pair of hanging scrolls, ink on paper, 43 ⅛ × 13 ¼ in. (109.7 × 33.6 cm). Takano Collection, Aichi Prefecture

specific earlier styles than the representation of an extension of the Northern Song monumental landscape tradition, which in the course of its development had been combined with other stylistic elements. Indeed, the paintings look as if they had been painted that way for ages as a part of a continuing tradition of exceptionally skilled professional artists.

In sum, the Metropolitan pair remains unusually faithful to the Northern Song tradition long after that tradition had been transformed in China, specifically in the post-Yuan period. It is difficult, therefore, to evaluate the works in the context of Chinese painting alone, which prompts us to look at Korean painting and its embrace of the Northern Song tradition, especially the landscape art of Guo Xi. What we find is that the early fifteenth century produced in Korea a pivotal figure, An Kyŏn, who excelled in the Guo Xi manner and left an unforgettable masterpiece, *Dream Journey to the Peach Blossom Land* .

### THE ATTRIBUTION OF THE METROPOLITAN LANDSCAPES TO AN KYŎN

In terms of composition, brushwork, formation of the rocks, and other salient features, such as stylistic sources, the closest parallels to the Metropolitan pair of landscapes can be found in An Kyŏn's *Dream Journey to the Peach Blossom Land* (fig. 2) and in the other works

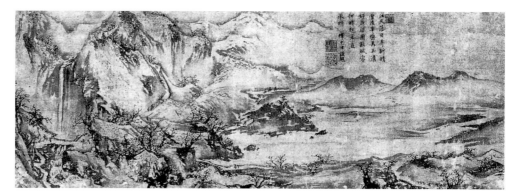

**Figure 14.** Attributed to Zhang Yuan (act. 13th century), *Landscape.* Handscroll, ink on paper, 14 × 37 ⅜ in. (35.5 × 94.9 cm). Shōkoku-ji Temple, Kyoto

attributed to him, all of which have been characterized as "in the style of Guo Xi." However, a comparison between the Metropolitan landscapes and *Dream Journey* must be undertaken with caution. With *Dream Journey* as the artist's only extant authenticated work and with so little other evidence for tracing his artistic development, it is difficult to deduce the complete art-historical position of An Kyŏn or to place his recognized masterwork within a course of stylistic progression. We also need to take into account the fact that *Dream Journey* is an extraordinary landscape painting with a well-defined purpose, namely, to create a mysterious and fantastic dream world.

In *Dream Journey,* An Kyŏn attempts to present a dream within a dream — that is, a land of immortals as imagined by the revered Chinese poet Tao Qian (365–427), which the Korean Prince Anp'yŏng visited a millennium later in his own dream. An Kyŏn, a court painter, was given the task of visualizing the prince's dream in a painting, and undoubtedly chose to limit his borrowings from earlier stylistic traditions to those that best served his purposes. Next to the fantastic scenery of *Dream Journey,* the Metropolitan landscapes, portraying views of the Xiao and Xiang Rivers as adopted from a popular Chinese painting genre, may at first glance appear rather pedestrian and totally unrelated. Nonetheless, efforts to find similarities bear fruit when we penetrate into the fundamental stylistic traits of the two works.

As in the Metropolitan paintings, the style of *Dream Journey* does not reflect any revival of truly archaic styles, nor is it a firsthand imitation of ancient originals. It clearly comes out of a long tradition of Northern Song monumental landscape art, yet this tradition has been manipulated by the painter to create a distinct style that seems too fresh and original to be considered eclectic. Immediately noticeable, for example, is the total absence of narrative details, a feature that separates An Kyŏn's *Dream Journey* from all known Chinese depictions of the Peach Blossom Land and that is also an important characteristic of the Metropolitan landscapes, whose paucity of narrative elements is remarkable within the Eight Views tradition. An Kyŏn's originality is also brilliantly displayed in his dramatic use of the upper and lower borders of the pictorial surface to fragment the scene — one of diverse terrain forms presented with a profusion of turbulent movement and staccato rhythm and with ink washes of varied tonality producing exquisite contrasts

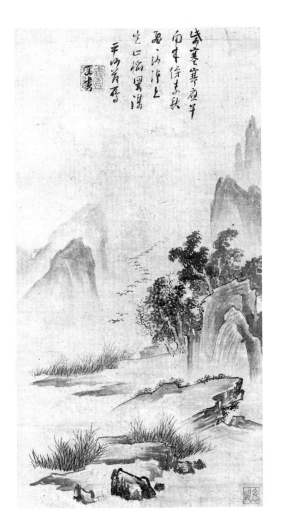

**Figure 15**. Attributed to Shikan, *Wild Geese Descending to Sandbar*, before 1317. Hanging scroll, ink on paper, 22 ⅝ × 11 ⅞ in. (57.6 × 30.3 cm). Satomi Collection, Kyoto

of light and dark. These compelling techniques are further enhanced by the heavy, dark, and seemingly improvisatory accents in the outlines of the rocks and mountains.

Like the Metropolitan paintings, An Kyŏn's *Dream Journey* is similar to an enlarged fragment of a typical Northern Song monumental landscape, but translated into hand-scroll format. With the elimination of the tranquil, open river views that typically form the beginning and ending of such handscrolls, the viewer is pulled immediately into a deep mountain valley in the foreground to the right, then to the middle ground, and finally to the foreground at the far left corner, all presented in a sharply leftward diagonal recession. In other words, the concept of this composition is more akin to that found on hanging scrolls. It also moves away from the typical Northern Song representation of the overall scene as a single coherent unit of continuous movement seen from afar. In this regard, even though its individual parts are disposed in an additive manner, *Dream Journey* is much closer to the Guo Xi tradition as it evolved in the Jin and Yuan periods, which is exemplified, for example, by the works of Li Shan and Li Sheng (act. mid-14th century), especially the latter's *Buddha's Conversion of the Five Bhikshu* (fig. 16).[27] Yet An Kyŏn avoids the Song and Yuan formulaic device in which the composition opens with tall trees, beyond which is a long, level-distance vista. Aside from necessary adjustments for the horizontal format (for instance, the expansion of the foreground, a feature seen also in Li

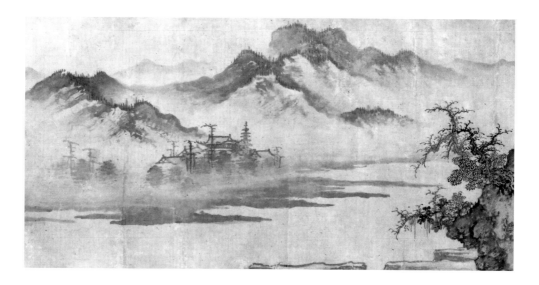

Sheng's works), he seems to have favored a unified scene that makes sense when seen all at once, thus transferring the principles of vertical composition to a horizontal format.[28]

We have already noticed in the Metropolitan pair a seeming disinterest in narrative detail, with the omission of such conventional motifs as foreground trees and bridges, fishermen and travelers. Other than the two barely distinguishable figures in the kiosk in *Autumn Moon over Lake Dongting*, there are no figures to be seen in the Metropolitan pair. This unusual absence is also characteristic of *Dream Journey*, which is totally devoid of figures. Absent is the fisherman who discovered the land of peach blossoms and the boat he left behind, the residents of this imaginary place and their barking dogs—all described by Tao Qian in his poetic essay and portrayed faithfully in innumerable later Chinese versions of the theme. This omission becomes even more significant when we realize that An Kyŏn chose not to portray in his painting Prince Anp'yŏng, who had dreamed of roaming with his friends in the land of peach blossoms. Such disregard for the narrative details related to this particular incident, as well as those traditionally found in paintings on the themes of the Peach Blossom Land and the Eight Views, may be an indicator of a highly confident artist, who eschews such devices in his art. It thus becomes especially significant to discover a detail common to the *Dream Journey* and *Autumn Moon*, a small unoccupied boat with a single oar, moored alongside an earthen bank, which the prince, in his colophon describing the dream, identifies as the boat of a resident of the Peach Blossom Land.

The naturalistic application of the level-distance and the low horizon, both prominent features of the Metropolitan landscapes, are particularly noticeable in the last section of *Dream Journey* (fig. 17). The foreground of this section is likewise distant from the viewer. The shorelines merge convincingly in the distance, following a continuously receding ground plane. As in *Evening Bell*, broad patches of dark ink on the earthen banks in the foreground suggest deep pitting, a realistic description of water erosion. Closely comparable to the Metropolitan's paintings are the shapes of the earthen bank and the rocks in the foreground and the brushwork employed for them.

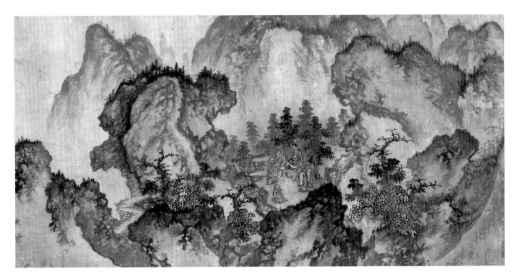

**Figure 16.** Li Sheng (act. mid-14th century), *Buddha's Conversion of the Five Bhikshu.* Handscroll, ink on paper, 11 ⅓ × 43 ½ in. (29.2 × 110.5 cm). The Cleveland Museum of Art

The minimal treatment of the foreground in this final section of An Kyŏn's painting—the fissured earthen banks, the low-lying hills dotted with a few peach trees, and the rocks in the shallow water—is sufficient to inform the viewer that the scene is near the source of a stream. From this remote place at the water's edge, the viewer is then led in silence to the middle ground, where a towering rocky mass begins its upward movement. The horizon, established in the middle ground with unusual clarity, is low (in the lower quarter of the picture) and is consistent throughout the painting, though obscured here and there by rocky masses. These features, including the similarly positioned horizon, have already been noted in the Metropolitan pair.

In this section of *Dream Journey* and in the Metropolitan paintings, the towering quality of the distant mountains is emphasized by the horizontal order of the composition. For instance, the water recedes into the distance more frontally than diagonally, and the foot of the mountain is veiled by a thin mist, which divides all that is above from all that is below. The distant mountains block the horizon, thus taking away the vista. All three paintings are inclined to reduce the expansive potential of the composition by including a massive peak—somewhat top-heavy in appearance and placed nearly in the center—reminiscent of the Northern Song style. They also show a logical recession of space and gradation of ink tonality, thus retaining the unity and even quality of Northern Song landscapes that are absent in Yuan and Ming pastiches.

In *Dream Journey*, An Kyŏn exaggerates to an unusual degree the rough, craggy forms of the rocks and mountains to create an imposing imaginary world. In his arbitrary arrangement of large, contorted rock masses in separate thrusts, he incisively captures an impression of mystery and fantasy. This is a radical but creative departure from the Guo Xi manner, in which the interrelation of the landscape elements and the rendering of compositional forces in long winding movements are prominent. In brush manner, however, An Kyŏn's painting does not differ significantly from the Northern Song tradition of

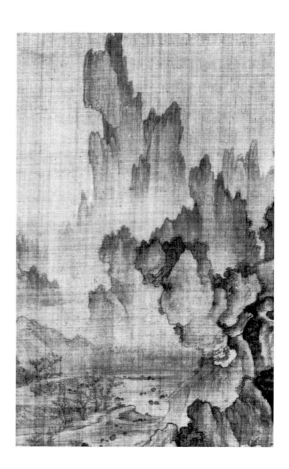

**Figure 17.** Detail of *Dream Journey to the Peach Blossom Land* (figure 2)

Guo Xi. The drawing of rocks and mountains is descriptive, solid, and structural. Here, the fantastic image of rough, craggy rocks has been rendered with carefully modulated but irregular contour lines that are both smoothly flowing and nervously jagged. These contour strokes are coordinated with a variety of meticulously applied inner texture strokes and layers of contrasting light and dark ink wash to suggest volume and surface tension. A noteworthy detail common to An Kyŏn's *Dream Journey*, Guo Xi's *Early Spring*, and the Metropolitan's *Evening Bell* is the use of expressive double, or repeated, brush-strokes to describe the outlines of rocks, mountains, and earthen banks, a technique recommended by Guo Xi in his treatise on landscape painting. In neither *Dream Journey* nor the Metropolitan landscapes does the artist resort to the linear texture strokes and dotting technique developed by Yuan literati painters or the "axe-cut" texture strokes of the Ma-Xia manner.

It is recorded that *Dream Journey* was executed in only three days. Such mastery of execution can only be the outcome of devotion to the development of a wholly individual technique. The maturity of the artist appears in the shapes of the mountains, in his rapid, yet exact brushwork, and, especially, in his virtuoso handling of ink washes. An Kyŏn sketches banks and trees with seemingly casual, dashing speed and directness. Nevertheless, each stroke is drawn and modulated with such knowing intuition that it never fails to respond to the demands of representation.

The brush manner and the mood change in the left section of the painting, which depicts the far distance. The scene becomes an evocative landscape, depicted with an inde-

pendent play of soft ink washes. In comparison with the distant scene of *Evening Bell*, which appears to be more fluently painted, executed with broad, quick strokes and dark, wet ink washes, *Dream Journey* employs a meticulous yet sparing application of soft, dry, and thin brushwork to depict groups of water ripples in fine hair-thin horizontal lines that suggest the gradual recession of water. This difference in brush manner is probably attributable to the subject matter of evening and night scenes, in which objects do not appear as clearly as in daylight, as well as to the fact that the Metropolitan pair represents a more conventional theme, and is a permissible variation within one artist's stylistic range. An Kyŏn indeed has succeeded in turning various artistic legacies to his own use in the creation of this imposing and fantastic landscape.

It is evident from the above comparison that the Metropolitan landscapes and *Dream Journey* have common points of contact in the Northern Song monumental tradition, the continuity of which is traceable in Korean art and of which An Kyŏn was an authentic heir. The fundamental stylistic elements of the Metropolitan paintings are sufficiently consistent with those of *Dream Journey* to be considered to fall in the range of An Kyŏn's landscape style. While the pair of scrolls lacks signature or seals, of all the existing paintings attributed to An Kyŏn, his immediate associates, or his followers, none are as closely comparable in style and quality with *Dream Journey* as the Metropolitan landscapes.

An Kyŏn was extremely influential in the early Chosŏn period, and many of the most important court and professional painters of the time emulated his art. Of the large number of works attributed to him, some appear to be of sixteenth-century date, thus representing the continuing influence of his painting style. The identities of those who painted these later works have been lost, and their works gradually merged with that of An Kyŏn. The affinities become even more significant when the comparison is extended to the album *Eight Views of the Four Seasons* (figs. 18 A, B), in the National Museum of Korea. Despite certain stylistic differences, the album is regarded as the most plausible authentic work by the artist among all An Kyŏn attributions.

This set of paintings, if indeed executed by An Kyŏn, should certainly be dated later than *Dream Journey* and the Metropolitan pair. Although it adheres to the brush idiom of Guo Xi in depicting the riverbanks, mountains, distant trees, and foliage, the brush is applied in a bold, direct, and almost contemptuous manner, with a near absence of subtlety or nuance. The work is more textured and schematized, more unified in surface pattern, and less naturalistic than both *Dream Journey* and the Metropolitan paintings. It is in fact full of mannerisms, such as the arbitrary pairing of darker and lighter shapes and the schematic separation in depth at various points in the composition. The painter of this album seems unable to demarcate clearly land and water or to keep the ground and water planes flat. Distinct horizontal shorelines seem to be avoided, inducing swelling and undulating motions that make both ground and water seem to rock and slip sideward. The recession into the distance is systematic, with trees diminishing gradually in size and detail and successive rises of ground carrying the eye back to the furthest mountains.

Another prominent feature of the album is the abrupt transition between solid and void, which contrasts sharply with the effective rendering of gradual spatial recession seen in *Evening Bell* and in the far left section of *Dream Journey*. At the same time, the painter of the album never loses control of rhythm in brushwork. One cannot help noting the tremendous skill of the hand that created these landscapes. Without resorting to the Yuan literati use of linear texture strokes and dots, *Eight Views of the Four Seasons* seems to represent the highly conventionalized forms of a professional artist's Northern Song style within the academy tradition. Such stylistic traits can point to the end of An Kyŏn's endeavor in the Guo Xi tradition.

A fifteenth-century date for the Metropolitan paintings, as well as an An Kyŏn attribution, become more obvious when the paintings of the An Kyŏn school and its followers in the sixteenth century, such as Yang P'aeng-son (Ahn, fig. 20), are brought forward for comparison. These sixteenth-century paintings all tend to resort to clichés of empty space. The moderated, off-centered verticality of mountains in smaller, fragmented forms in a laterally expansive space is characteristic of sixteenth-century works. This feature is also prominent in two paintings separated from a set of *Eight Views* dating from this period, *Wild Geese Descending to Sandbar*, in the Metropolitan Museum (pl. 85), and *Mountain Market, Clear with Rising Mist*, in the Ho-Am Art Museum (Pak, fig. 29). These works owe more to late derivatives of the Li-Guo style than to early Chinese originals or to works by An Kyŏn, as is apparent when they are compared with paintings by Zhu Derun and Tang Di. The furrowed mountains, built up by the overlapping of similarly shaped units, with little attempt to establish transitions between them in depth, belong to that late stage of the Li-Guo style and have no actual counterparts in Guo Xi or other Northern Song painting. These works are supplied with standard human-interest details — figures boating on the river, or travelers crossing a bridge — but they do not convince us that the place is congenial to human habitation. They have lost the Northern Song sense of monumentality and unity still retained in the Metropolitan pair and in *Dream Journey*, paintings that are, in contrast, serene and contemplative, even while devoid of figures.

## THE METROPOLITAN PAINTINGS AND PRINCE ANP'YŎNG'S COLLECTION

The Metropolitan landscapes and An Kyŏn's *Dream Journey*, as demonstrated above, provide evidence of the continuation and revitalization of the Northern Song painting tradition in Korea. The collection of Chinese paintings assembled by Prince Anp'yŏng, the foremost collector of his time and the patron of An Kyŏn, was the artistic repository of Northern Song ideals and thus had a direct bearing on this phenomenon.

Prince Anp'yŏng amassed his important collection of Chinese paintings during a period of some twenty years, from about 1435 until his death in 1453 at the age of thirty-five. *Hwagi* (Commentaries on Painting), a catalogue of the prince's collection compiled in 1445 at the request of the prince by Sin Suk-chu, a scholar-official and member of the

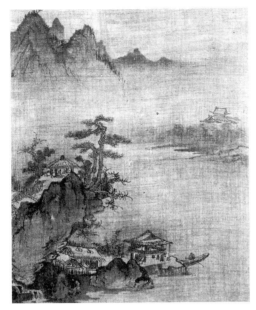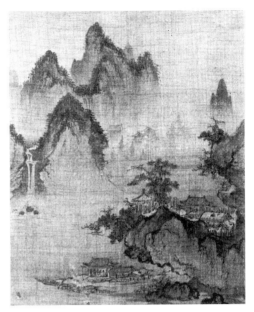

**Figures 18A** (right), **18B** (left). Attributed to An Kyŏn (act. ca. 1440–70), "Late Spring" (right) and "Early Summer" (left), from *Eight Views of the Four Seasons*. Two leaves from an album of 8 leaves, ink and light color on silk, 13 ⅞ × 11 ¼ in. (35.2 × 28.5 cm). The National Museum of Korea, Seoul

prince's inner circle, lists a total of two hundred and twenty-two works and thirty-five artists, ranging from the fourth-century master Gu Kaizhi (ca. 345–406) to Wang Mian (1287–1359).[29] Except for the Korean painter An Kyŏn and the Japanese monk-painter Tekkan, who was active in Yuan China, all the artists listed in the catalogue are Chinese. Sin Suk-chu's commentary, despite its brevity, provides insights into the aesthetic preferences of the patron-collector Prince Anp'yŏng. An Kyŏn occupied a special place as the prince's painter of choice among all Korean artists of the time. Not only was he honored as the only Korean painter whose works were represented in the prince's collection, but he was also given full access to the collection, a privilege that none of his contemporaries seems to have enjoyed. Talented and favored as he was, An Kyŏn naturally was the style-setter of the day in painting. Indeed, we can argue that both he and Prince Anp'yŏng played active and direct roles in creating and shaping Korean artistic tastes and painting styles of the fifteenth century and beyond.

Significant for our study of the Metropolitan pair of landscapes are the following features of the prince's collection:

- Five artists and twenty-nine paintings are classified as Northern Song. Guo Xi, who heads the list with seventeen paintings, is the only landscape painter among all the Northern Song painters recorded in the collection, the others being Guo Zhongshu (act. mid-10th century), Li Gonglin (ca. 1041–1106), Su Shi (1037–1101), and Wen Tong (1018–1079). The titles of the paintings attributed to Guo Xi include two of the Eight Views — *Wild Geese Descending to Sandbar* and *River and Sky in Evening Snow* — that were probably originally part of a complete set.[30]

- Absent from the catalogue are Southern Song painters, except for Ma Yuan, who is nevertheless erroneously placed among the Yuan artists.[31]

- No Jin-dynasty painters are represented.

- Of the twenty Yuan artists represented in the collection, those known for landscape painting, Li Kan (1245–1320), Tang Di, and Luo Zhichuan, were followers of the Li-Guo style.[32] Absent are landscape paintings by such Yuan literati painters as Chen Xuan (1235–1300), Ni Zan (1301–1374), Huang Gongwang (1269–1354), Wu Zhen (1280–1354), and Wang Meng (1308–1385). Zhao Mengfu is listed, not for his achievements in landscape or figure and animal painting, but as a calligrapher and ink bamboo painter. Although Zhao had revitalized the Li-Guo tradition in his time and influenced artists like Tang Di, he experimented in the literati transformation of the Li-Guo manner, while the other Yuan painters named in the catalogue produced works in a more conservative Li-Guo idiom.

- The Ming dynasty is not represented in the catalogue. The only painter who lived into the Ming period is Wang Mian, the famous painter of plum blossoms, who is generally identified with the Yuan period. It is significant that no early Ming Imperial Academy painters are included.[33]

- Two Buddhist monk-painters, most likely of the Chan sect, are listed: the aforementioned Japanese monk Tekkan is credited with two landscape paintings and two paintings of old trees, and a Chinese monk named Zhihuan, with two scrolls of ink bamboo painting.

- A number of Eight Views paintings are catalogued as part of the collection. In addition to the two views attributed to Guo Xi, one full set is listed under An Kyŏn and another credited to the Yuan artist Li Pi. A number of ink paintings bear titles that are reminiscent of the Eight Views theme, including, for example, *Rainy Landscape* and *Summer Scenery, Clear with Rising Mist.*

- An Kyŏn, the only Korean painter included in the catalogue, has a total of thirty paintings under his name, among them a complete set of the *Eight Views*.

The catalogue of Prince Anp'yŏng's collection indicates that the Guo Xi tradition entered Korea through at least two channels, either as paintings that bore Guo Xi's name or as works by Yuan followers of the Northern Song master. The Northern Song landscape idiom, including that of Guo Xi, was most likely introduced to Korea in the Koryŏ period. The Koryŏ court had regular contacts with the Northern Song court and its painting academy starting from 1070, about the time Guo Xi produced his masterpiece *Early Spring*.[34] The Guo Xi style therefore could have been transmitted to Korea as early as the late eleventh century and could have thrived throughout the Koryŏ dynasty. In this regard, we may think of the Northern Song-type landscape background in some Koryŏ Buddhist paintings as well as in two landscapes (figs. 19A, B) traditionally attributed to the fourteenth-century painter Gao Ranhui (Ko Yŏn-hŭi), which some scholars have identified as Koryŏ paintings in the tradition of the Northern Song scholar-artist Mi Fu (1052–1107) and his son Mi Youren (1074–1151), filtered through the interpretation of the Yuan painter Gao Kegong (1248–1310), who followed the Mi-family style.[35] Interestingly, these two scrolls also seem to fuse certain aspects that we associate with Chan

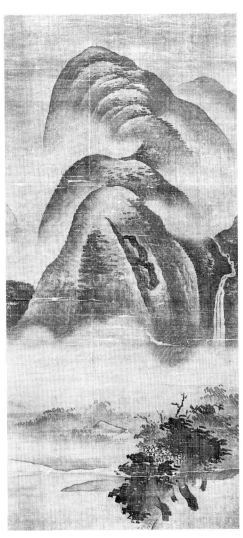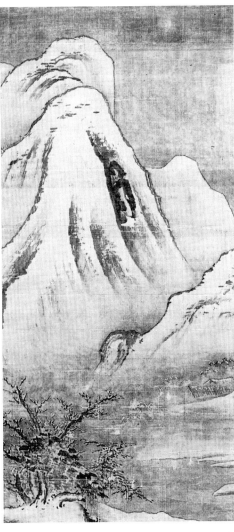

**Figures 19A** (right), **19B** (left). Attributed to Ko Yŏn-hŭi (Gao Ranhui, 14th century), *Summer Landscape* (right) and *Winter Landscape* (left). Pair of hanging scrolls, ink on silk, 48 ⅞ × 22 ¾ in. (124 × 57.9 cm). Konchi-in Temple, Kyoto

Buddhist landscape paintings, particularly those of the Liang Kai school, which will be discussed below.

With the fall of the Northern Song dynasty to the Jurchen Jin dynasty in 1127, the Koryŏ court was forced to establish diplomatic relations with the Jin court and thereby prevented from maintaining official contact with the Southern Song court in Hangzhou. The Northern Song landscape tradition was maintained throughout the Jin period in northern China. These circumstances may explain why, despite the absence of Jin painters in the catalogue of the prince's collection or in other Korean literary records of the period, certain stylistic features common in Jin landscapes in the Guo Xi manner — namely, the breaking up of large units into aggregates of smaller units and the somewhat exaggerated shading — appear in An Kyŏn's *Dream Journey*. In this regard, a handscroll attributed to Guo Xi (fig. 20), which might be a work from the Jin period and is relevant to *Dream Journey* in style, may serve as a missing link.

The fact that Prince Anp'yŏng focused on Guo Xi among the Northern Song landscape masters and had amassed as many as seventeen of his works by 1445 suggests that

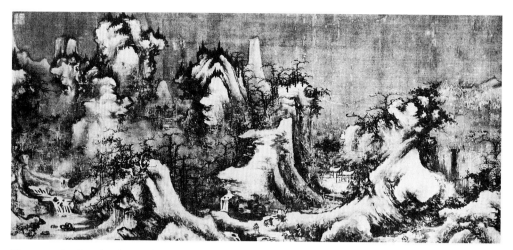

**Figure 20.** Attributed to Guo Xi (ca. 1000–ca. 1090), *Winter Landscape*. Handscroll, ink and light color on silk, 21 ¾ × 189 ¼ in. (55.1 × 480.7 cm). The Toledo Museum of Art

the artist's works must have been collected earlier by the Koryŏ court and other connoisseurs and that this fashion survived the dynastic change to enter the Chosŏn prince's collection. We know that genuine paintings by the artist were difficult to obtain even in China after Guo Xi's death, and whether the seventeen works collected by the prince were originals is, of course, an entirely separate issue. However, we can only assume from the high quality and authenticity of the pictorial references to Guo Xi in An Kyŏn's *Dream Journey* and in the Metropolitan paintings that the works known to An Kyŏn and his circle were not merely debased or spurious imitations.

### THE METROPOLITAN LANDSCAPES: MUROMACHI JAPANESE INK PAINTING AND CHAN BUDDHIST ELEMENTS

The existence of the Metropolitan paintings also supports an argument for Korean influence on one aspect of Japanese landscape painting in the Muromachi period (1392–1573), namely, the school of Shūbun, the Chan Buddhist monk-painter who founded the *suibokuga* (ink painting) tradition, insofar as its Northern Song element is concerned. And, in turn, Japanese paintings that have been singled out for their Korean connection further strengthen the early Chosŏn dating of and an An Kyŏn link to the Metropolitan pair of landscapes. Three seemingly incongruous, but significant, aspects of fifteenth-century Korean and Japanese painting will be discussed here in relation to the study of the Metropolitan paintings: the difference in the aesthetic preferences expressed in the collecting of Chinese painting in Korea and Japan; the effect of different topographies on the landscape art of each country; and the similarity in the retention of Chan Buddhist elements.

The difference in the type and style of Chinese painting collected by Koreans and Japanese gives us some indication of the stylistic lineage and identity of the Metropolitan paintings and the Japanese ink paintings of the Shūbun school. The Japanese Shogunal collection, formed from the fourteenth century onward, reflected the preferences of its owners for works by Southern Song Academy painters as well as by Chan Buddhist paint-

ers of the Southern Song and their followers in the Yuan dynasty, most of whom were not well known or appreciated in China.[36] It appears that the Shogunal collection in the Muromachi period included neither Northern Song paintings nor paintings in the Northern Song style from later periods. Indeed, the Southern Song Academy style was so popular in Japan that it gave rise to many Japanese copies and even forgeries, and profoundly affected Japanese aesthetics and landscape painting style. In striking contrast, there is little indication that the Southern Song style was as widely appreciated in the early Chosŏn period in Korea. The catalogue of Prince Anp'yŏng's collection, a good counterpart to the Shogunal collection from the Korean royal court, shows that the prince had a definitive preference for the works of Northern Song masters and their Yuan followers.

The dissimilarity in collecting patterns, besides being indicative of a fundamental difference in taste and aesthetics, also reflects the different natural environments of the two countries and the circumstances of their cultural contacts with China. Korean landscape painting overall expresses a Korean predilection related to a native mountain tradition, even when it is demonstrably based on Chinese prototypes. Such elements as the vast expanse of rocky mountain peaks depicted by angular motifs with parallel folds are Korean features that can be seen as far back as the Three Kingdoms period, as in the early-seventh-century earthenware tiles of the Paekche kingdom (pls. 7, 8), as well as in a Koryŏ painting by Noyŏng (act. early 14th century), dated 1307 (Ahn, fig. 14) and Chŏng Sŏn's (1676–1759) paintings of Mount Kŭmgang (fig. 21). In this context of the Mount Kŭmgang tradition in Korean painting is an anonymous fan painting in the Liaoning Provincial Museum entitled *Bridge Over a Stream Among Steep Mountains* (fig. 22), which may be a pre-Chosŏn Korean painting depicting Mount Kŭmgang.

The mountains in these works appear to be reminiscent of mountains in Korea, particularly Kŭmgang, famous for its "twelve-thousand" diamondlike rocky peaks, which is located in what is now North Korea. Seventy percent of the Korean peninsula is mountainous, and mountain worship was practiced in Korea through the ages. The historical record abounds in accounts of activities centering around Mount Kŭmgang and of paintings of the mountain executed under royal order. Whatever aesthetic aspect may inhere in the indigenous worshipful attitude toward mountains and in the Mount Kŭmgang cult, soaring rocky cliffs and peaks, with their angular and jagged forms, are hallmarks of the famous mountains of which Koreans are so appreciative and proud. Though the whole concept of and approach to nature in Korea and Japan are different, the Northern Song monumental landscape formula was crucial for Korean painters. In transforming their sources, they accordingly developed a landscape style suitable for the depiction of Korea's mountainous topography and their own aesthetics of mountains. Japanese landscape painting, however, reflects the lyricism and sentiment characteristic of the Japanese approach to nature. The Korean penchant for piled-up angular rocky mountains dotted with a few barren trees and some foliage contrasts with the Yamato-e tradition of Japan, characterized by softly rounded hills fringed with leafy trees and by an intimate, sentimental

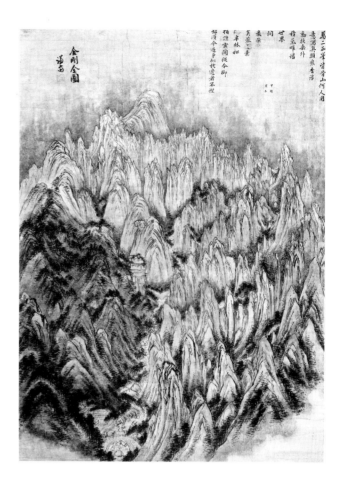

**Figure 21.** Chŏng Sŏn (1676–1759), *Complete View of Mount Kŭmgang*, dated 1734. Hanging scroll, ink and light color on paper, 51 ½ × 37 in. (130.7 × 94.1 cm). Ho-Am Art Museum, Yongin. National Treasure no. 217

beauty. Aesthetically, then, the Southern Song Ma-Xia mode appears as if made for the Japanese taste.

Historically, Japanese and Korean art and culture evolved with Chinese influences — direct or indirect, strong or mild, depending in large part on the character of diplomatic relations with China. Korea had close ties to China during the Northern Song and Yuan periods, when the Northern Song style of landscape flourished. As mentioned earlier, with the fall of the Northern Song dynasty in the north to the Jurchen Jin in 1127, the Koryŏ court was forced into diplomatic relations with the Jurchen court and prevented from having official contact with the Southern Song court in Hangzhou, a situation that bears some relevance to the near absence of Southern Song works in Prince Anp'yŏng's collection. In other words, Korean artists had a far greater opportunity to see paintings that reflected current Chinese taste at the northern court.

Another significant aspect of early Chosŏn painting and the Metropolitan landscapes is the presence of Chan Buddhist elements. There runs in both early Chosŏn and Muromachi paintings a Chan streak.[37] Unlike the Japanese Shogunal collection, Southern Song Academy painters and their Ming followers are not represented in Prince Anp'yŏng's collection, though two monk-painters most likely of Chan denomination are included. Such painting titles recorded in the catalogue as *Eight Views of the Xiao and Xiang* and *Green Mountain and White Clouds* are linked to Chan Buddhist thought and aesthetics. Another work of a Chan subject matter that is recorded outside of this catalogue as part of

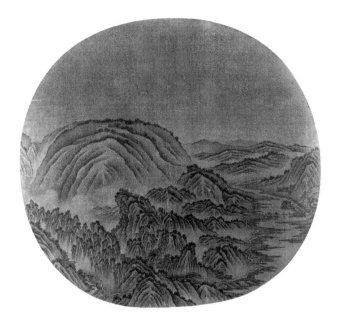

**Figure 22.** Unidentified artist (early 13th century), *Bridge Over a Stream Among Steep Mountains*. Fan, ink and light color on silk, 9 ⅞ × 10 ⅝ in. (25.0 × 27.0 cm). Liaoning Provincial Museum

the prince's collection is Li Gonglin's *Three Laughers*.[38] We also have other concrete evidence that Chan literature and painting flourished in the Koryŏ and early Chosŏn periods, including the existence of a body of Chan painting and poem titles (such as "Three Laughers," "Green Mountains and White Clouds," and "White-robed Guanyin") and the frequent contacts of Koryŏ Chan monks with Chinese Chan monasteries.[39] At Jingcisi Temple, for instance, Koryŏ monks studied under the abbot Pingshan Chulin (1281–1361), who inscribed *Wintry Forest and Returning Woodsman*, a fourteenth-century painting now in the Kyoto National Museum.[40]

The difference in collecting patterns had a significant influence on the development of landscape painting in Korea and Japan. The absence of any record of Northern Song works in major Japanese collections is intriguing considering the Northern Song stylistic influence in Japanese ink painting of the Muromachi period, and supports the theory of Korean influence with respect to this Northern Song aspect, which was particularly prominent in the Shūbun school. Mountains that block the horizon and obliterate the vista are a hallmark of both the An Kyŏn and the Shūbun school.

Korean influence on Muromachi ink painting was most likely prompted by the close relationships between Japanese and Korean Chan establishments until the anti-Buddhist policies of the Chosŏn dynasty took effect. The Chan school developed at the end of the Song dynasty in the monasteries of south China. Shūbun, for example, is recorded as having gone to Korea in 1423 in search of printed Buddhist texts.[41] The Chan monk-painter Bunsei, of Shūbun's period, is another good example of Chan activities in the field of painting in Korea. John Rosenfield has written: "There is a mysterious element in the Bunsei material. A small landscape in the National Museum in Seoul bears a Munch'ŏng, or Bunsei, seal, and closely resembles two landscapes in the Takano Collection; they too have Bunsei seals and are done in the Korean style. Whether these three works may be attributed to the same artist who painted the six listed above is still an issue."[42]

It is in such a Chan context that an evocative and poetic landscape painting, now in the Metropolitan Museum, probably emerged. Currently titled *Rainy Landscape with Travelers* (fig. 23), this hanging scroll can be identified in style and motifs as one of the Eight Views, *Evening Bell from Mist-shrouded Temple*. It follows the common formula of this particular theme by portraying a monk crossing a bridge in a mist-shrouded mountain valley on the way to his temple (not visible in the painting, which is not uncommon) whence comes the sound of the evening bell.[43] "A temple in a misty village in the remotest possible place," a line from the Chan monk Huihong's poem composed for this view, is a fitting description of this picture as well. In fact, Chan monk-painters often painted the Eight Views and otherwise resorted to the general compositional formula of the theme, while Chan monk-poets like Huihong composed poems on the Eight Views. This Chan connection may also have a certain bearing on the great popularity of Eight Views paintings in Korea.

Due to the devastating anti-Buddhist policies of the Neo-Confucian Chosŏn dynasty, many historical documents concerning Koryŏ Buddhism and the activities of monks have been lost, making it difficult to reconstruct the history of Chan art and literature, both of which thrived in the late Koryŏ period. The situation in Muromachi Japan was markedly different from that of early Chosŏn Korea. Japanese ink painting nearly exclusively developed in the cultural milieu of the Zen monasteries.[44]

It is known that Prince Anp'yŏng befriended Chan monks and had the ninety-year-old monk Manu write colophons for An Kyŏn's *Dream Journey* and for a scroll of poems on the Eight Views.[45] Such contact and the survival of Chan tradition in art in general may explain the fusion of Chan elements of the Liang Kai school into the predominantly Northern Song character of the Metropolitan pair of landscapes and *Dream Journey*: the combination of rough, brusque brushwork with the generous use of ink washes, the placement of a massive peak, somewhat top-heavy in appearance nearly in the center, and the use of a more frontal level-distance and short recession with a very low viewpoint. This modification of the Northern Song monumental style is an important aspect of early Chosŏn landscape art and is reflected in the Metropolitan paintings.

The early fifteenth century saw the development of a type of landscape painting in Korea that, although clearly indebted to the styles and techniques of Chinese landscapists of the Song and Yuan periods, resulted in the creation of an original and enduring landscape art expressive of Korean ideals and taste. An Kyŏn was regarded as the most original and influential of the professional and court painters in that era. As the foremost landscape painter of the time, his work was intertwined with the classic art of Song China in such a way as to make it part of a continuation of that lineage in the history of Korean painting. With the passage of time and because of An Kyŏn's preeminence, many Li-Guo-style Korean paintings of the late fifteenth and sixteenth centuries lost their identities and were made to assume the guise of works by the great master. Consequently, the history of early Chosŏn painting has been misdirected into a web of obscurity and insubstantiality.

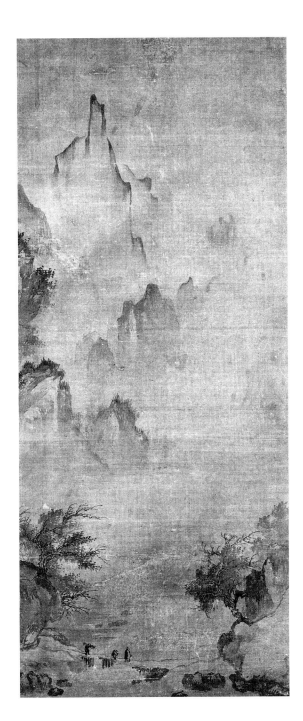

**Figure 23.** Unidentified artist, *Rainy Landscape with Travelers.* Hanging scroll, ink and light color on silk, 29 ½ × 12 ⅜ in. (74.9 × 31.4 cm). The Metropolitan Museum of Art. Rogers Fund, 1918. 18.124.3

Conversely, there exists a body of early Chosŏn paintings whose authorship cannot be determined, and for which no clear attribution can be made. This problem needs to be dealt with through a serious reexamination of the dating and attribution of all early Chosŏn paintings, using the resources, tools, and knowledge that are now available to us. Until his works have been clearly identified and distinguished from those of other masters, neither An Kyŏn nor any of these other artists can be properly evaluated or understood. Putting together works of similar or identical styles and matching themes and compositions are important first steps in such a long and continuing study. In this connection, the Metropolitan paintings are important examples of works very close in style to *Dream Journey*, and an attribution to An Kyŏn needs to be considered seriously. ✿

Pak Youngsook

The Korean Art Collection in The Metropolitan Museum of Art

The Korean collection of The Metropolitan Museum of Art reflects characteristics of the Korean art tradition as a whole, as well as of its reception and appreciation in the West. The rarity of outstanding objects, a consequence of historical vicissitudes, has resulted in Western scholarship's relative lack of emphasis on, and therefore knowledge of, Korean art in comparison to other East Asian art traditions. Nevertheless, the Metropolitan Museum has over time assembled a collection of Korean works of art that spans 1500 years and includes all major media — painting, ceramics, sculpture, metalwork, and lacquerware. Though certain of these areas are better represented than others, the strength of the holdings lies in the high quality of the objects, a vital criterion if Korea's cultural and artistic legacy is to be truly assessed. Some pieces are rare, especially those of the courtly tradition of the Koryŏ dynasty (918–1392). Some can be considered masterpieces, including the impressive Koryŏ celadons, which were among the first Korean objects to be widely admired outside the peninsula, both in East Asia at the time they were produced and, more recently, in Europe and America.

Less well understood or appreciated is Korea's significant role in East Asia's Buddhist artistic tradition. Not only did Korea act as a conduit of Buddhist teachings and art from the continental mainland of China to the Japanese archipelago, but the Korean Buddhist establishment had a profound impact upon the spread of the religion and the development of the art associated with it. The Metropolitan's holdings of Korean

Buddhist art, in particular its paintings from the Koryŏ and Chosŏn (1392–1910) periods, cast light on an area that has yet to be thoroughly studied by Western scholars.

Another strength of the Metropolitan's collection is its selection of landscape paintings from the early Chosŏn dynasty. Although landscape images are known in Korea from the Three Kingdoms period (57 BCE–668 CE) onward, the earliest extant paintings date from the fifteenth century. The group of early Chosŏn landscapes in the Metropolitan contributes significantly to our understanding of an important phase in the tradition of Korean painting from which few examples survive.

Despite such gaps, in the collection and in the historical record, these objects are a window on their time and respective artistic traditions. The different achievements of succeeding historical periods — from the exquisitely crafted gold jewelry of the Silla aristocracy of the fifth and sixth centuries to the refined inlaid lacquer and celadon wares of the twelfth century or the underglaze copper-red decorated porcelains of the eighteenth century — allow us to begin to form a picture of the continuity of Korea's artistic tradition as well as the uses to which the objects were put. Focusing on selected works in the Metropolitan's collection, this essay attempts to provide a chronological and historical overview of the development of the visual arts in Korea. In some cases, particularly in the section on the art of the Koryŏ period, which was profoundly influenced by Buddhism, it seeks to sketch a portrait of the larger historical, religious, and artistic context for the works.

### THREE KINGDOMS PERIOD: ART FOR THE DEPARTED

The southeastern corner of the Korean peninsula, present day North and South Kyŏngsang provinces, was in ancient times the territory of the kingdom of Silla (57 BCE–668 CE) and the Kaya Federation (42–562 CE). Huge tumuli served as the eternal resting places of royalty and the aristocracy. Tombs in Kyŏngju, the capital of Silla, have yielded large quantities of pottery vessels[1] as well as jewelry and other objects for personal use, spectacular ceremonial regalia, horse trappings, and weapons, all made of precious materials. These articles remained intact as a result of the tomb structure: Silla mortuary chambers of the fourth to the sixth century were constructed of wood, sealed with layers of clay to keep out water, and covered with mounds of stones and earth, making them relatively impenetrable.

### Stoneware

A hard, high-fired (around 1000° c) gray stoneware (*kyŏngjil t'ogi*) made of *chŏngnyangt'o*, a fine clay formed of decomposed granite,[2] began to appear in Silla around the third century, replacing the soft, low-fired earthenware (*wajil t'ogi*) that had prevailed until then. Vessels also began to be thrown on a potter's wheel. An improved, climbing-kiln technology imported from China certainly played an important role in the transformation of pottery vessels by making possible the higher temperatures needed to produce the new

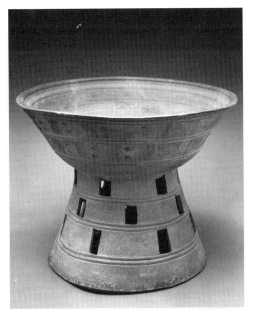

**Figure 1.** Stand, Three Kingdoms period, Silla kingdom (57 B C E–668 C E), 5th–6th century. Stoneware with traces of ash glaze, h. 12 ⅝ in. (32.1 cm). The Metropolitan Museum of Art, Purchase, Lila Acheson Wallace Gift, 1997. 1997.34.21

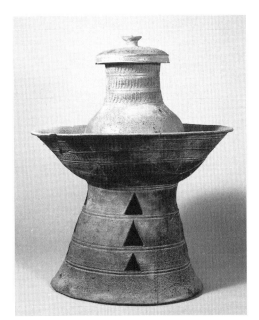

**Figure 2.** Stand and covered jar, Three Kingdoms period, Kaya Federation (42–562), excavated from Tomb no. 44, Chisan-dong, North Kyŏngsang Province. Stoneware with traces of ash glaze, h. 20 ⅛ in. (51.0 cm). Taegu National Museum

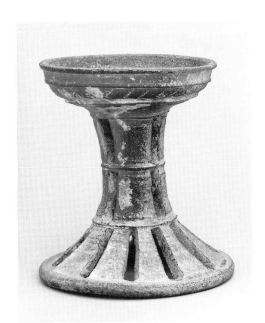

**Figure 3.** Stand, Three Kingdoms period, Kaya Federation (42–562). Stoneware, h. 4 ⅞ in. (12.4 cm). The Metropolitan Museum of Art, Purchase, Lila Acheson Wallace Gift, 1997. 1997.34.19

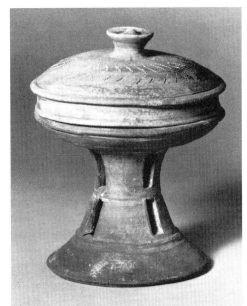

**Figure 4.** Pedestal dish with cover, Three Kingdoms period, Kaya Federation (42–562), excavated from Tomb no. 35, Chisan-dong, North Kyŏngsang Province. Stoneware, h. 6 ⅝ in. (16.7 cm). Kyemyŏng University Museum, Taegu

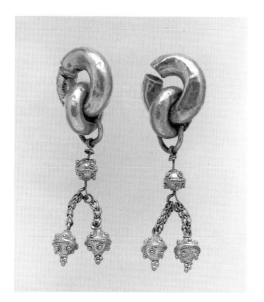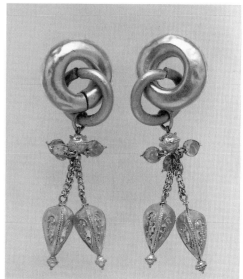

wares.[3] By the fifth century, Silla pottery (from east of the Naktong River) and Kaya pottery (from west of the river) display subtle regional differences in shape and ornamentation. Decoration, for instance, ranges from simple incised geometric lines or dots to perforations and applied-relief figures. Some vessels have been the beneficiary of an accidental ash glaze.[4]

An example of early Silla craftsmanship is a large stoneware stand (fig. 1). A support for a covered storage jar with a round base (fig. 2), it combines an architectonic structure with a spreading foot. On the lower portion, rectangular perforations are arranged in alternating positions in horizontally divided zones, while the deep bowl is incised with combed vertical lines between which are impressed circles and dots. Inside the bowl and around the foot rim are the remains of an accidental ash glaze. The arrangement of the geometric and openwork decoration appears to have been clearly thought out before the object was decorated, for the combination of vertical incised lines with circles and alternating perforations has been found on similar pieces of Silla pottery from the sixth century.[5]

A beautifully proportioned stand (fig. 3) with a wide spreading foot has narrow, rectangular perforations arranged in parallel vertical rows around the central portion. This type of small stoneware vessel with spreading foot appears to be versatile. It can be either a pedestal dish with a cover (fig. 4), in which case the lid of the Metropolitan piece has been lost,[6] or a stand for a small cup with handle. In this example, the upper part of the stand is decorated with a narrow band in which an arrowhead motif has been executed with tiny dotted lines. The use of dots to create a simple linear design on an elegantly shaped small stand or footed dish is characteristic of Kaya pottery. The dating of such Kaya ceramic forms varies. One stand with a similar design of dots and rectangular perforations, found in Ch'angnyŏng, has been dated to the late fifth to the early sixth century, while a stand from Kimhae, whose shape and decoration of elongated rectangular perforations and dotted lines are remarkably similar to the Metropolitan piece, has been dated to the fourth century.[7]

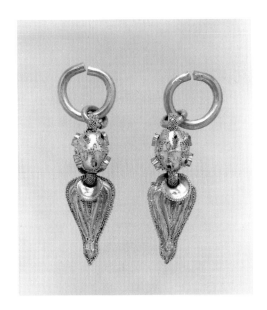

Figures 5, 6, 7. (left to right) Pairs of earrings, Three Kingdoms period, Silla kingdom (57 B C E–668 C E), 5th–6th century. Gold. Figure 5, l. 3 ½ in. (8.9 cm). Figure 6, l. 2 ½ in. (6.4 cm). Figure 7, l. 3 ⅛ in. (7.9 cm). The Metropolitan Museum of Art, Harris Brisbane Dick Fund, 1943. 43.49.9,10, 43.49.11,12, and 43.49.3,4

Great quantities of the Silla and especially the Kaya types of pottery dating from the fifth and sixth centuries have been found in Japan in tombs of the Kofun period, so named for the culture characterized by tumuli (Jp. *kofun*), similar to the Korean tomb mounds, erected over wide areas. Gray pottery and precious metal articles (personal ornaments and horse fittings) from the archaeological excavations of the sixth-century Fujinoki and Niizawa Senzuka tumuli display such close similarities to early Korean material culture that there is little doubt that immigrants from the Korean peninsula settled in early Japan.[8]

## Personal Ornaments

The most sumptuous of the objects found in Silla and Kaya royal tombs are personal ornaments. Deceased Silla nobles, both male and female, were richly adorned with jade and gold. The supernatural qualities attributed by the Chinese to gold and jade were believed to prevent the dead from decaying, thereby ensuring immortality.[9] Silla rulers clearly shared this view of the magical properties of these materials, as evidenced by the vast quantity of gold and curved jade ornaments (*kogok*) unearthed from their tombs. If the tomb occupant were of royal lineage, there would be a pure gold crown[10] along with dozens of earrings, bangles, and rings. The monumental royal tombs in Kyŏngju revealed such an enormous quantity of gold objects that it is not surprising that Silla was known to medieval Islamic merchants as the "kingdom of gold."[11]

Pure gold earrings, of which the Metropolitan possesses a number of representative examples, are mostly found in pairs. They display a variety of designs and accomplished goldsmith techniques, from simple cut gold sheet to complicated filigree and granulation. Analysis of these gold earrings has assisted scholars in determining the dates of tombs.[12] In the earliest type among the Metropolitan earrings (late fourth to early fifth century) the top section is formed by a hollow fat ring and an interlocking thinner ring from which is suspended, attached to a relatively small linking piece, a leaf-shaped pendant cut from plain gold sheet (pls. 44B, 44D). Attached to either side of the pendant is an additional

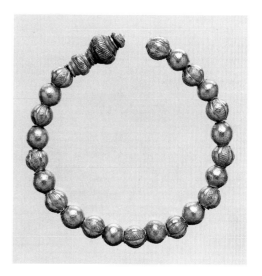

**Figure 8.** Necklace, Greek, Cypriot, ca. 450–400 B C E.
Gold with seedlike pendants, l. 21 in. (53.3 cm). The
Metropolitan Museum of Art, The Cesnola Collection,
Purchase by subscription, 1874–76. 74.51.3397a

small disc. The middle section of one of these two pairs of earrings (pl. 44B) is of a short
cylindrical shape with an openwork design of rings, while the middle section of the other
pair (pl. 44D) consists of two flattened beads between which there might once have
been a section with openwork decoration. Such dainty earrings were discovered in several
Silla tombs in Kyŏngju: Sŏbong-ch'ong Tomb of the Lucky Phoenix, in Nosŏ-dong; and
Ch'ŏnmach'ong Tomb of the Heavenly Horse and the north mound of Hwangnam Great
Tomb, both in Tumuli Park. Similar types were also discovered in a Kaya tomb in
Hyŏpch'ŏn.[13]

In another early example (pl. 44A) among the Metropolitan earrings, the existing top
section consists of a small ring and the middle section of a globular bead and three tiny
pointed leaves. From this hangs a chain to which is attached the bottom section, a small
and a large leaf-shaped pendant with three tiny beads at the tip of the large pendant. The
double band of notched decoration around the bead in the middle section and the single
row of notched decoration around the edges of all the leaves resemble granulation. A sim-
ilar piece, lacking the bunch of leaves attached to the globular bead, was excavated from a
fifth-century tomb, Chisan-dong Tomb no. 44, in Koryŏng, in former Kaya territory.[14]
Judging from other excavated examples, this Metropolitan pair and that of plate 44D have
lost one or more of their upper, interlocking rings (cf. pls. 44B, 44C).

In the sixth century more elaborate earrings (pl. 44C) developed from the simple and
elegant Kaya type (pl. 44A). The middle section contains a globular bead and three small
leaves, similar to the earlier Kaya styles. The bottom section, attached to the middle sec-
tion by two short chains, has twin pendants of a triangular seed shape, resembling beech-
masts (*Fagus cernata*), a variety of which is known in Korea.[15] The top section, which is
complete, shows the fat hollow ring and interlocking middle ring. Granulation is now
applied confidently to create patterns. Very similar types of earrings have been found in
various tombs datable to the sixth century: Kŭmnyŏng-ch'ong Gold Bell Tomb (Silla), in
Kyŏngju, Kyo-dong (Kaya), in Ch'angnyŏng, and Chung'ang-dong (Kaya), in Chinju,
South Kyŏngsang Province; Pongsŏ-ri (Paekche), in Changsu, North Chŏlla Province;

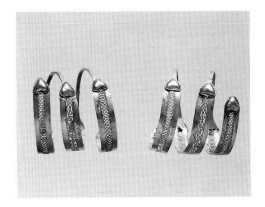

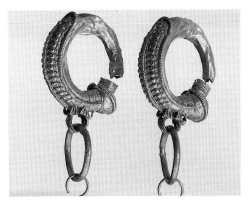

**Figure 9.** Pair of earrings, Etruscan, 7th century B C E. Gold with filigree, 1. 1 ⅜ in. (3.5 cm). The Metropolitan Museum of Art, Purchase, Anne Murray Gift, in memory of Rita C. Murray, 1994. 1994.446a,b

**Figure 10.** Pair of trumpet-shaped earrings, Etruscan, 5th–6th century B C E. Hollow gold, diam. of each 2 ⁷⁄₁₆ in. (6.2 cm). The Metropolitan Museum of Art, Purchase by subscription, 1895. 95.15.174,175

and in Japan, Kamoinariyama in Shiga and Fukuoka (both Kofun period).[16] The close similarities of earrings found in Japan with those from Kaya and Silla tombs suggest that such articles were imported from Korean kingdoms in the south.

Designs for personal ornaments could obviously travel easily from one place to another. Two other Metropolitan earrings (figs. 5, 6) with chains and ball pendants hanging from large interlocking rings share the same basic forms as those mentioned from Silla and Kaya. The ball pendants of the famous "gold bell" earrings from the Silla Gold Bell Tomb are divided into lozenge-shaped compartments by gold granules; in the center of each compartment is a blue glass bead. Although the pendants are not suspended from chains, the beads are set in the same way as those of the Metropolitan earrings (figs. 5, 6). An even more similar example to the Metropolitan earrings, with the ball pendant attached to a chain, has been found in a Kaya tomb.[17]

A pair of ornate earrings (fig. 7) fully demonstrates the mastery of granulation technique. The globular middle section has protruding frames of sheet gold intended for inlaid pieces of glass, now lost. Silla tombs in Kyŏngju dated to the late fifth to the sixth century contain similar earrings, with inlaid middle sections of oval shape, to which are directly attached small leaves and pointed leaf-shaped pendants with granulated ridges. This particular design appears to be unique to Silla.[18]

All the gold jewelry from Korean tombs displays exquisite design and superior technique. To obtain the pointed leaf shape, the gold was first hammered into a flat sheet, then further worked with chasing or repoussé. The various pieces were then soldered. Granulation was applied on the concave surface or along the edges of the earring, or fine gold wire filigree was placed between sections of the earring. Occasionally, colored glass inlays were applied to enhance and enrich decoration. The connecting chains were produced with gold wire, using the double loop-in-loop method.[19] The ultimate source of such elaborate techniques is likely the accomplished Greek and Etruscan goldsmiths of ancient Western Asia and southern Europe. The Metropolitan Museum possesses outstanding examples of such gold jewelry (figs. 8–10). The master craftsmen who served

the Scythian royalty were emigré Greeks whose art and skills were transmitted to countries reaching as far as northern China during the first millennium BCE and, later, the Korean peninsula.[20]

## UNIFIED SILLA: BUDDHIST SCULPTURE

Buddhism, which was introduced into the Korean peninsula from China in the fourth century, flourished as the dominant system of thought in the Unified Silla period (668–935). By the late seventh century, Korea was a major Buddhist country in East Asia, engaged in large-scale building of monasteries and pagodas and in creating numerous Buddhist images in stone, wood, and metal to be enshrined in those structures. Korean craftsmen's mastery of metalwork and goldsmithing, already attested to in the sumptuous regalia and variety of gold jewelry from the preceding Three Kingdoms period, extended also to the casting of gilt-bronze Buddhist images and reliquaries. Numerous small gilt-bronze images, found in former temple sites and in stone pagodas, provide evidence of private worship by monks in monasteries and by individual members of the aristocracy. Buddhist figurines recovered from stone pagodas are votive images, which were enshrined along with relics during consecration ceremonies for the monument.[21]

The Metropolitan's image of a standing Buddha (pl. 68)[22] is in the style prevailing in Korea in the eighth and ninth centuries. The monastic garb, worn draped over both shoulders, displays distinctive regular, narrow folds, with a stylized pattern of oval folds over the thighs. The image was clearly meant to be seen only from the front since the back of both the head and the body is hollowed out, a feature often found in small gilt-bronze images of the late Unified Silla period. The raised right hand and the bestowing gesture of the lowered left hand indicate that this Buddha is most likely Amitabha, who gained great popularity during Unified Silla with the rise of the practice of Pure Land Buddhism. The relatively large face shows Koreanized features in the wide cheekbones and high arched eyebrows. The cranial protuberance (*ushnisha*), one of the thirty-two defining physical characteristics of the Buddha, is unusually wide and squat. This image is very close to a ninth-century Buddha from Ŭmji-ri, Kŭmsan, North Ch'ungch'ong Province (fig. 11). The three-tiered octagonal lotus pedestal on which the Ŭmji-ri Buddha stands provides us with an idea of how the now lost support of the Metropolitan Buddha might have looked. The aureole that would have originally adorned the Buddha is more difficult to reconstruct. Made of fine openwork design, these aureoles easily deteriorated or were lost, and are thus missing from most small gilt-bronze images such as this one.

## ART OF THE KORYŎ DYNASTY

From its beginning, the Koryŏ dynasty embraced Buddhism. The founder of the dynasty, Wang Kŏn, known by his posthumous title of T'aejo, or Grand Founder (r. 918–43), declared Buddhism the state religion, and set forth its importance to the well-being of the state in his Ten Injunctions (Sip hunyo), which he formulated at the end of his life as a

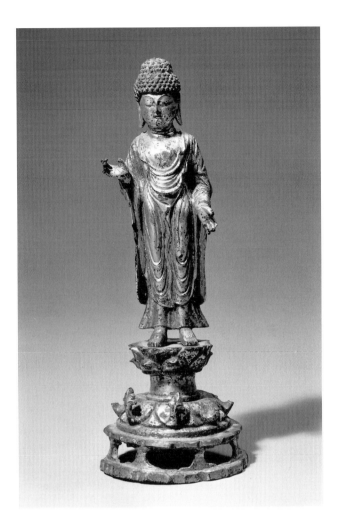

Figure 11. Standing Buddha, Unified Silla period (668–935), 9th century, excavated from Ŭmji-ri, Kŭmsan. Gilt bronze, h. 9 ¾ in. (24.8 cm). Puyŏ National Museum

guide to his successors in ruling the country. Accordingly, the influence of Buddhism extended into all realms of artistic activity in the Koryŏ period, but it can be best appreciated in the many objects and paintings created for use in the Buddhist ceremonies regularly held in temples and in palaces.

## Lacquer

Lacquer objects, which incorporate a labor-intensive yet surprisingly adaptable and flexible method of decoration, were among the most prized articles in ancient East Asia. Because of their fragility, however, very few lacquer objects from before the Chosŏn period have survived in Korea. The earliest extant lacquer objects come from a Bronze Age burial site at Taho-ri, Ŭich'ang County, in South Kyŏngsang Province, dated to the first century BCE, at which a holder for a writing brush and undecorated black lacquer vessels were unearthed. Also uncovered at this site were rectangular and round black lacquer dishes on a high stand with spreading foot, prototypes of the gray stoneware forms of the later Silla period and a type of object unlike contemporaneous lacquerware from China.[23] The use of black lacquer seems to have been widespread in the southern part of Korea. A recent excavation in Kwangju, in South Chŏlla Province, has unearthed a deposit of black lacquer stored in a clay bowl, apparently for later use.[24]

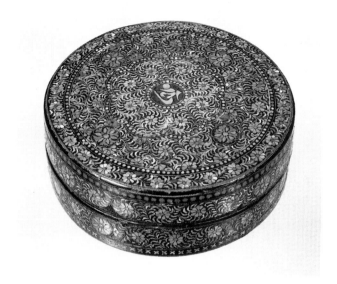

**Figure 12.** Round box, Koryŏ dynasty (918–1392), 13th century. Lacquer inlaid with mother-of-pearl, brass wire, and painted tortoiseshell, diam. 4 ⅞ in. (12.4 cm). Taima-dera, Nara. Important Cultural Property of Japan

**Figure 13.** (facing page) Set of five boxes, Koryŏ dynasty (918–1392), 13th century. Lacquer, diam. of center box 3 ⅞ in. (9.9 cm). Tokyo National Museum

Fragments of lacquer vessels from fifth-century Silla have been discovered at the south mound of Hwangnam Great Tomb, in Kyŏngju. These fragments have decorations of mountains and animal motifs painted in red on a black lacquer ground. As the Han Chinese dominated the territory of the Korean peninsula north of the Han River until the early fourth century, it is not surprising to find that the shapes of Han lacquer objects, as well as the use of black and red for the background and painted decoration, influenced the style of Silla lacquerware produced for court use. As with other organic materials excavated from Korean tombs, these objects have suffered the effects of an acidic soil, leaving only a few fragments.

The few remaining lacquer pieces from the Unified Silla period include a piece of monochrome black lacquer in the shape of a lotus flower. Excavated from Anap-chi (Pond of Wild Geese and Ducks) in the royal palace complex, which was consecrated in 674, its exact use is not known.[25]

During the Koryŏ period, lacquer with mother-of-pearl inlay (*najŏn ch'ilgi*) reached a high point of technical and aesthetic achievement. In the eleventh century, even royal carriages were sumptuously embellished with such decoration.[26] In an account of his travels, *Xuanhe fengshi Gaoli tujing* (Illustrated Record of the Chinese Embassy to the Koryŏ Court During the Xuanhe Era), Xu Jing (1091–1153), who visited the Koryŏ capital, Songdo (modern Kaesŏng), in 1123 as a member of an official mission from the Northern Song emperor Huizong's (r. 1101–25) court, commented on contemporary fashions in horse equipment: "Saddles of the cavalry are exquisite. They are decorated with mother-of-pearl inlay, while the bridle and reins are made of cedar wood and agate."[27] In another passage he commented on this distinctive decorative technique: "The country is scarce in gold and silver wares, but abundant in bronze vessels. As for [plain] lacquer, the work is not very skillful, but those inlaid with mother-of-pearl are very fine and to be treasured."[28] Objects related to the practice of Buddhism, particularly incense containers and sutra boxes, testify to the high level of Koryŏ workmanship in the decoration of lacquer.

Indeed mother-of-pearl inlay was the principal and the most accomplished technique for such pieces.[29]

In the Metropolitan collection is an exquisite, jewel-like three-lobed box decorated with mother-of-pearl and tortoiseshell inlay on a black lacquer ground (pl. 55). The interior of the box is plain black. The translucent tortoiseshell is further embellished in red and yellow, employing a method called "concealed coloring," or reverse painting (*pokch'ae*), in which the pigments are applied directly to the reverse side of the tortoiseshell, creating a luminous effect. This decorative technique of reverse-painted horn was already known in the eighth century in East Asia.[30] The edges of the Metropolitan box are reinforced with twisted brass (*paektong*) wire. On the lid are three blossoms of Chinese pinks made of transparent tortoiseshell, which are painted on the reverse with alternating yellow and red pigments. The spaces in between the pinks are filled with mother-of-pearl inlaid chrysanthemum flowers and small curvy leaves, with the entire design framed by a border of beads. The careful arrangement of the decorative motifs is most apparent on the lid, where half-florets appear along the edges. The round centers of the tightly packed chrysanthemum florets are of tortoiseshell painted on the reverse with yellow pigment, and the beveled edge of the lid is decorated with tiny yellow florets between which are arranged three-petaled leaves in mother-of-pearl. The sides of the box feature two rows of chrysanthemum florets, shining like tiny gems against the black background.

The imaginative combination of inlaid mother-of-pearl and other colored materials and the meticulous execution of the design make this an outstanding object. Pieces stylistically and technically similar to the Metropolitan box are in various collections: the round box at Taima-dera, in Nara (fig. 12), is one of the closest examples. Two other lacquer pieces that appear to have been made in the same workshop as the Taima-dera and Metropolitan boxes are a small jar and what appears to be the handle of a priest's fly-whisk, both of which are in the National Museum of Korea.[31] These four pieces, all in-

METROPOLITAN COLLECTION

413

tended for monastic use, share the same decorative motifs, namely, two different types of flowers and the use of yellow and red reverse-painted tortoiseshell.

The decoration of the Metropolitan's three-lobed box is almost identical to that of a round six-lobed box in the Museum of Fine Arts, Boston, and two three-lobed boxes, one in Keishu-in, Kyoto, the other in the National Museum of Korea.[32] The tightly coiled scrolling leaves on the cover of these boxes are densely packed around a chrysanthemum, the single floral motif. This design also appears on Koryŏ mother-of-pearl and brass-wire inlaid sutra boxes, examples of which are in the British Museum and the Rijksmuseum, Amsterdam.[33] In their decoration, the sutra boxes differ from the boxes discussed here only in the fine incising of the chrysanthemum petals and the absence of yellow and red colored tortoiseshell. One scholar has suggested that the incised chrysanthemum petals indicate a Yuan Chinese, rather than a Koryŏ, derivation for the sutra boxes.[34] However, close inspection reveals that the shapes of both the florets and the leaves on the Metropolitan box are almost identical to those of the sutra box in the British Museum. Moreover, the omission of colored tortoiseshell on the sutra boxes is understandable in view of the high cost of tortoiseshell and the large number of such objects produced for court use. Such precious materials were certainly reserved for gemlike objects like the Metropolitan box.

Extant contemporaneous objects in both celadon and lacquer (fig. 13) suggest that the Metropolitan box was one of four that fit around a central round box. These boxes have traditionally been identified as "cosmetic boxes,"[35] though it is unlikely that all of them were used for this purpose. The round Taima-dera box, which has also been identified as a cosmetic box,[36] has in the center, enclosed within a pearl roundel, the Sanskrit syllable *om* inlaid in mother-of-pearl, which suggests that this superbly crafted object was made for the personal use of an aristocrat, perhaps a high-ranking Buddhist monk. I propose that boxes such as the Metropolitan one were part of a set of incense containers that encircled a centerpiece, like the Taima-dera box, in which a Buddhist rosary was possibly kept. Most of the numerous existing inlaid celadon boxes also were probably used as incense containers, rather than as cosmetic boxes as hitherto interpreted. A round inlaid celadon box was excavated from the Songnim-sa Pagoda, clearly suggesting that the object served as a container for incense.[37]

Incense was an integral part of Buddhist ceremonies and daily monastic life. Buddhist scriptures expound on the merit of offering incense, together with flowers and food, to Buddhist images and places of worship. Sutras enumerate all imaginable types of incense, such as incense for spreading (unguent) or burning, powdered incense, tree incense, and flower incense, just to name a few basic types among the hundreds of different kinds of incense.[38] Frankincense (*yuhyang*), fragrant wood (*hyangmu*), powdered incense (*punhyang*), and fragrant powdered incense (*pangbunhyang*) have all been found to serve as consecration items in Korean pagodas.[39]

Over one hundred kinds of incense from Song China were compiled by the famous Ming bibliophile Mao Jin (1599–1659), in a work entitled *Xiang guo* (The Land of In-

**Figure 14.** Two pairs of buttons, Koryŏ dynasty (918–1392). Gold, diam. of each ¹³⁄₁₆ in. (1.9 cm). The Metropolitan Museum of Art. Rogers Fund, 1921. 21.117.4,5 and 6,7

cense).⁴⁰ In Japan, too, during the Late Heian (951–1185) and Kamakura (1185–1333) periods, many types of incense were produced and used in daily life.⁴¹ Considering such circumstances, it is inconceivable that in Koryŏ Buddhist society various kinds of incense were not produced in order to fill the great demand from Buddhist monasteries as well as from the royal court and aristocracy. Special containers like the Metropolitan lacquer box were made to store the incense. Such a fine piece was most likely the product of the Chungsang-so (Office of Artifacts), an official workshop established during the reign of King Mokchong (r. 997–1009) to supply the royal court with precious lacquerware and other luxurious objects.

The inlay technique, in keeping with the refined court taste, was not limited to the decoration of lacquer during the Koryŏ period, but was widely applied to other media. Bronze vessels for Buddhist ceremonies—incense burners (pl. 53), flower vases, and *kundika* water bottles (pl. 52)—were inlaid in silver, occasionally in gold or brass. Inlaid celadon, called *sanggam ch'ŏngja*, was the natural evolution of this artistic refinement.

## Celadon

By the early twelfth century Koryŏ potters had attained a remarkable level of accomplishment in the production of celadon, not only in the soft luster of the celadon glaze, reflecting their skill in controlling kiln temperatures, but also in form and decoration. The

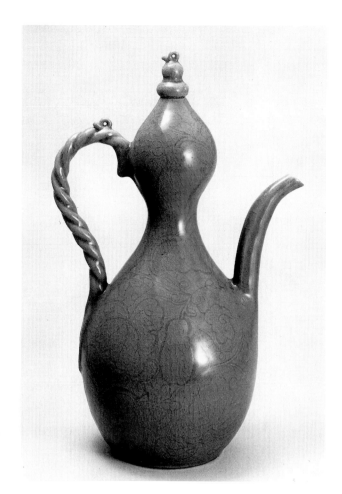

**Figure 15.** Wine ewer, Koryŏ dynasty (918–1392), 12th century. Celadon with carved and incised decoration of gourd plant, h. 12 in. (30.6 cm). Ho-Am Art Museum, Yongin

twelfth-century Chinese envoy Xu Jing was so impressed by the smooth glaze and lovely green tone of "jade-colored celadon" ( *pisaek ch'ŏngja*) that he even compared Koryŏ pieces with the famous Ru ware of the Northern Song (960–1127), rarest of all the ceramics made exclusively for the Chinese court.[42]

The Metropolitan gourd-shaped ewer (pl. 11) is an example of the refined and accomplished Koryŏ celadon of the first half of the twelfth century, as described by Xu Jing. The pictorial decoration, finely carved in light relief, consists of a pair of water birds on a sandbank flanked by a polygonum-like water plant and a pair of geese taking flight. This theme of water plants and water fowl, a familiar one in Song ceramics and flower-and-bird painting, has a long history in China, going back to the Eastern Jin dynasty (317–420),[43] and Koryŏ artisans took full advantage of this popular motif. In Koryŏ metalwork design — on a silver inlaid bronze censer[44] or even on gold buttons (fig. 14) — playful swimming ducks among reeds, lotus, or willow trees became a prominent decorative theme.

The masterfully carved and incised decoration relates the Metropolitan ewer to several of the best known Koryŏ celadons, among them a wine ewer of gourd shape, decorated with a gourd plant and scrolling tendrils (fig. 15), and a *maebyŏng* (Ch. *meiping*, literally "prunus vase") with lotus design, both in the Ho-Am Art Museum; a ewer with a peony design, in the Idemitsu Museum of Art; and fragments of celadon roof tiles with a

scrolling floral pattern known as *posang tangch'o*. These pieces share an effortless elegance in their execution of design, indicating that they likely are products of the royal kiln in Sadang-ni, Kangjin County, South Chŏlla Province, which reached the zenith of celadon production in the first half of the twelfth century.[45] While all of these celadon wares are characterized by an overall design, the Metropolitan ewer stands somewhat apart in the purely painterly quality of its design.

Such virtuosity in carved and incised decoration can be observed in celadon wares from China, especially in Yaozhou ware from Shaanxi Province, which reached its peak of production during the Northern Song period, in the eleventh to the twelfth century. A number of similarities exist between Yaozhou ware and Koryŏ celadons both in the manner of carving and in the organization of the design.[46] It is quite possible that Koryŏ potters saw the fine specimens of Yaozhou ware and used them to advantage for their own decoration.

The Koryŏ court maintained close cultural and diplomatic relations with Song China, whose civilization it greatly admired, while struggling to preserve peaceful relations with the non-Chinese Liao (916–1125) and Jin (1115–1234) dynasties pressing at its northern border. It frequently exchanged diplomatic envoys with these courts in the eleventh and twelfth centuries. Such a high level of diplomatic activity provided the specimens from which Koryŏ artisans took their inspiration.

## Sanggam Inlay

The absence of any remarks by Xu Jing on his visit to the Koryŏ court in 1123 about sanggam inlay, arguably Korea's most extraordinary innovation in ceramic decoration, has led scholars to place the beginnings of this technique in the middle of the twelfth century. Another piece of evidence in support of this date is the absence of inlaid celadon wares in the tomb of King Injong (r. 1122–46), who was the reigning monarch at the time of Xu Jing's visit.

In the sanggam technique, designs are carved into the clay body and the resulting grooves filled in with a white or black paste before the vessel is glazed. This uniquely Korean innovation derives from similar techniques applied in the inlaying of lacquers and metalwork. A brilliant example of the designs achieved by sanggam inlay is the Metropolitan's maebyŏng, or prunus vase (pl. 18). The shape of the Koryŏ maebyŏng derives from Song meiping. But whereas Song examples generally show a single smooth curve of the vessel from shoulder to base, with the sides becoming straight toward the bottom, Koryŏ maebyŏng are broader at the shoulder and have an S-shaped profile, resulting in a slightly spreading base.

In the Metropolitan maebyŏng, the inlaid clouds and cranes, symbols of longevity, stand out sharply. This effect is enhanced by the black outline of the funguslike heads and long trail of the white clouds. Another striking feature of the design are the long, black curved strokes that define the plumage of the birds. This particular method of drawing

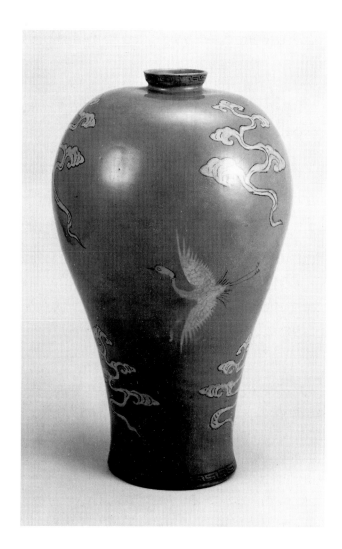

**Figure 16.** Maebyŏng (prunus vase), Koryŏ dynasty (918–1392), 12th century. Celadon with inlaid design of cranes and clouds, h. in. (40.1 cm). Ewha Womans University Museum, Seoul

the cranes and the five-headed clouds in black contour lines is found on a maebyŏng that has been restored from shards excavated from the royal kiln site in Yuch'ŏn-ni, Puan County, North Chŏlla Province (fig. 16). The similarity between the designs is so striking that there is little doubt that the Metropolitan vase was made at the Yuch'ŏn-ni kiln.[47]

The Metropolitan maebyŏng belongs to the early period of sanggam production, that is, the second half of the twelfth century, when the motifs, arranged in the spacious fashion we see here, stand out in splendid isolation. By the thirteenth century, design motifs are often elaborate and densely arranged, such as on the well-known crane maebyŏng in the Kansong Art Museum (Chung, fig. 17). The shape of the Metropolitan maebyŏng also suggests an early date: the proportions of both the shoulder and the lower portion of the vessel are more balanced and altogether less extreme than the thirteenth-century maebyŏng with its pronounced wide shoulder and sudden narrowing of the lower body toward the flared flat base.

Besides the artistic innovation of this decorative technique, recent chemical analysis of the shards of Koryŏ inlaid celadons has underscored the technical contribution of sanggam inlay to ceramic production. Formerly it was thought that the substance of white and black inlay was slip, a mixture of clay and water. Pamela Vandiver's analysis of Korean

inlaid celadons has shown, however, that the white inlays consist mainly of crushed quartz. The black inlays derive their color chiefly from magnetite particles. These inlays, denser than the white inlays, were heated and ground before being applied to the vessels.[48]

A few maebyŏng have retained cup-shaped covers over their small mouths.[49] Such complete Koryŏ examples suggest that this type of vessel was used for storing wine, as was the case in China until the Yuan dynasty.[50] Xu Jing, who has provided so many descriptions of Korean practice in his account of his travels, noted in the section on ceramic vessels:

> In Koryŏ there is no glutinous rice. They make wine of ordinary rice with leaven [barm]. Its color is dark and the taste heavy. One gets easily drunk but recovers quickly. The king's drink is called *yang'on*, a clear wine from the Left Storage.[51] There are two other types of wine as well. The wine is stored in ceramic bottles, and [the mouth] is tightly covered by [a piece of] yellow silk. The Koryŏ people like to drink, but it is difficult to obtain good wine.[52]

Though the popular sanggam motif of clouds and cranes did not originate with Koryŏ potters — a similarly arranged motif was recently discovered in the wall paintings of a Five Dynasties (907–960) tomb in Hebei Province in China[53] — the decorative method of white and black inlay on celadon was decidedly a Koryŏ innovation. That vessels bearing this decorative technique were highly esteemed is demonstrated through a discovery in 1993 by Chinese archaeologists from the Institute of Archaeology in Hebei. Among the items unearthed in a tomb that included the funerary gifts of Shi Tianze, a Yuan-dynasty prime minister buried in 1316, was a mint-condition Koryŏ inlaid maebyŏng with flower medallions and cloud motifs. This discovery attests to the appreciation by the Chinese court of the rarity and excellence of Koryŏ sanggam celadon.[54]

## Bronze Mirrors

Koryŏ bronze mirrors are found in tombs together with other funerary gifts presented to the deceased. Mirrors have of course been found in ancient tombs of all cultures, representing not only items of practical use, but also important ceremonial objects. For example, Manchurian shamans believed mirrors to reflect the soul or spirit of the departed.[55]

Mirrors found in pagodas at temple sites in Korea were used in connection with a ceremony known as *chijin* (suppressing earth spirits), which was held before a pagoda was consecrated.[56] In principle, bronze mirrors placed inside a pagoda as votive items serve the same function as a mirror placed in a tomb (often above the head of the deceased) to ward off evil spirits, as is the case in the north mound of the Hwangnam Great Tomb of the Silla period and in the tomb of the Paekche king Munyŏng (r. 501–23), in Kongju, South Ch'ungch'ong Province.

The dating of Koryŏ mirrors is hampered by lack of provenance. During the long span of the Koryŏ period, Song, Liao, and Jin mirrors were imported and often copied, as

were Japanese mirrors.[57] In such cases a scientific analysis of the metal alloy content (copper, tin, or lead) of the mirrors could enable one to determine the country of origin. Lacking such verification, I shall instead discuss several mirrors that, based on motifs of the period, appear to be most obviously Korean in origin.

In addition to their symbolic use in Buddhism and their magical function in shamanism, mirrors increasingly became an item of daily use among the wealthy and were often given as wedding presents. A sumptuously cast gilt-bronze mirror stand from the Koryŏ period testifies to the heights of luxury that such items attained.[58] Obviously, the shape and design reflected the circumstances and the needs of the user. In this context the most common shapes of mirrors, circular or lobed in imitation of floral forms, had intrinsic connotations of perfection and harmony (round) or auspiciousness and prosperity (floral). In the Koryŏ period, the geometric designs commonly used to decorate the backs of ancient mirrors were abandoned in preference for the elegance of floral and plant scroll designs, dragon motifs, and narrative themes.

One Metropolitan mirror (fig. 17) is decorated with figures in a landscape setting, a narrative subject. The mirror has a scalloped edge with pointed lobes, while stylized clouds fit within the lobes. The back of the mirror has become a picture, with the elegant curvilinear rim serving as the frame. The illustration shows a figure, identified by his hat as a government official, crossing a bridge. A monk (to judge by his apparently shaven head and the staff he carries) indicates the way with a hand gesture. In the background beyond the bridge is a tree, probably a cypress, bearing distinctive clumps of leaves. On the right is a palace gate, in front of which is a seated figure flanked by two attendants. From the half-opened gate emerges another figure. This tantalizing portrayal of a figure standing at a half-opened palace gate was a popular pictorial theme in China, an example of which is found in a mid-twelfth-century Jin-dynasty tomb painting in Fenyang, Shanxi Province.[59]

Several mirrors with similar treatments of this narrative have been found in both Korea and China. An identical mirror, said to have been excavated near Kaesŏng, the Koryŏ capital, is now in the National Museum of Korea.[60] Another example with very similar iconography, also found in Kaesŏng, bears a four-character inscription in seal script reading "*pok nok su ch'ang*" (happiness, official remuneration, longevity, and prosperity) and next to it the characters *Che Son* (Emperor Sun). A mirror with a slightly different arrangement of the same pictorial elements was also unearthed in Imch'ŏn-ni, Paeyang County, Kang'wŏn Province.[61]

In China a mirror similar to the Metropolitan one, with some minor differences in the pictorial decoration, has recently been recovered from a Song-dynasty tomb in Guilin, Guangxi Province.[62] In contrast to its dominant position in the Metropolitan mirror, the palace gate in this mirror is smaller. The decorative clouds embellishing the lobed petals are also absent. The leafy tree, centrally positioned, is probably a cassia. If so, the story depicted is most likely that of the visit by the Tang emperor Ming Huang to the moon,

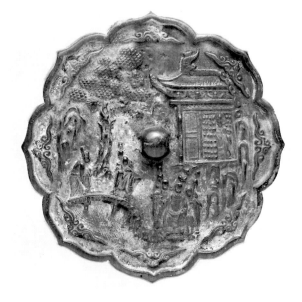

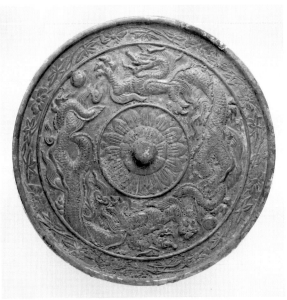

and the gate represents that of the moon palace. A variation on this theme is found in a round mirror of the Koryŏ period, now in the British Museum.[63] The Metropolitan mirror appears to be a good example of a Koryŏ variation on a Chinese theme.

An imposing royal decorative theme — two sinuous, fat dragons chasing pearls — appears on a second Metropolitan mirror (fig. 18). Contrasting the dramatic movement of the dragons in the middle register are floral scrolls filling the outer band.[64] The central knob is in the form of a large lotus flower. One of the earliest examples of a mirror with this archetypical Chinese dragon-pearl motif dates from the late Tang, in the ninth century.[65] Twin dragons appear to have flourished as a design on mirrors during the Liao and Song periods.[66] The twisted body and tail are apparently characteristic features of this auspicious beast, as exemplified in tenth-century Yue bowls, on eleventh- and twelfth-century textiles from Central Asia, and on Chinese textiles from the Northern Song period.[67]

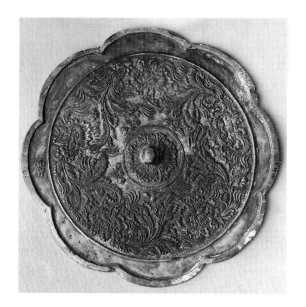

**Figure 19.** Mirror with floral decoration, Koryŏ dynasty (918–1392), first half of the 12th century. Bronze and silver, diam. 8 ½ in. (21.6 cm). The Metropolitan Museum of Art, Rogers Fund, 1911. 11.48.3

A dragon mirror found in the Liao tomb of Yelü Yuzhi, a high-ranking statesman who died in 941, features a single dragon chasing a pearl that also functions as the knob of the circular mirror.[68] The representation of the fat dragon with characteristically twisted body is very close to that on the Metropolitan mirror. From 1018, when its armies defeated the invading Khitans in a decisive battle, the Koryŏ court had maintained political and cultural relations with the Liao. A Koryŏ celadon vessel found in the tomb of the Liao emperor Shenzong (r. 982–1031) in Qingling and finds at other Liao sites testify to cultural exchanges between the two courts.[69] Considering these circumstances, we can tentatively date the Metropolitan's dragon mirror to the eleventh or the twelfth century.

Another mirror in the Metropolitan collection (fig. 19) has a curvilinear eight-lobed rim and is decorated with gracefully rendered feathery foliage and flowers, probably the imaginary *posang* flower (Ch. *baoxiang*), surrounding a large floral knob. Between the flowers are discreetly arranged tufts of grass. Over time, the mirror has acquired a distinctive pale grayish-white patina.

In the unadorned outer band, two small characters reading "Sŏgyŏng" (Western Capital, a reference to present-day P'yŏng'yang)[70] are cast in relief similar to the principal decoration. From the beginning of the Koryŏ dynasty, Sŏgyŏng enjoyed high status due to its geomantically auspicious location. Its administrative position allowed the city's inhabitants to enjoy many privileges and support the production of luxurious and refined articles like the Metropolitan mirror.[71] Sŏgyŏng flourished especially during the reigns of the monarchs Munjong (r. 1046–83) and Sukchong (r. 1095–1105), when it attained status almost equal to the main capital at Songdo. Although it eventually lost its prestigious position, especially after the revolt of Myoch'ŏng, in 1135, who attempted unsuccessfully to persuade King Injong (r. 1122–46) to relocate the main Koryŏ capital there, Sŏgyŏng seems to have remained an important center until the early twelfth century.

For the possible dating of this mirror, we need to consider the historical importance of Sŏgyŏng, as well as similar decorative designs on other types of Koryŏ art. For the lat-

ter, Koryŏ celadon ware provides the best supporting evidence, both in the abundance of design motifs it offers and in the fairly secure dates of objects produced throughout the period. Koryŏ celadon also reached its zenith in the first half of the twelfth century, particularly during Injong's reign. A bowl in the Museum of Oriental Ceramics, Osaka, dated to the first half of the twelfth century, shows a central floret of many petals, surrounded by a peony scroll, a design not unlike that on the Metropolitan mirror.[72] The decorative technique of covering the entire surface of an object with an elegantly executed floral motif is a distinctive feature of Korean celadon design during this period. Though carved or incised floral and plant scrolls, inspired by Northern Song porcelain, were consummately reproduced on Koryŏ celadon bowls and ewers,[73] the feathery foliage and delicate tips might have been innovations of Koryŏ artisans. These two considerations — the historical importance of Sŏgyŏng and the similar floral designs on Koryŏ celadon wares — suggest a date for this mirror not later than the first half of the twelfth century.

## Buddhist Painting

Buddhist painting, known in Korea as *t'aenghwa* (literally "hanging painting"), achieved an extraordinary artistic and religious dimension during the Koryŏ period. It embodied the same aristocratic tastes and refinement that made Koryŏ celadons sought after by a wide public. In addition, Koryŏ Buddhist paintings enable us to gain a glimpse into the nature of Korean society, particularly the combination of religious yearnings and artistic refinement that characterized this most aristocratic of royal dynasties.

As mentioned earlier, the founder of the Koryŏ dynasty, Wang Kŏn, promoted Buddhism as the religion of the state, and the aristocracy followed suit. Thus throughout the Koryŏ period Buddhism was linked with political power and private wealth. Buddhist temples, both public and private, increased in number, their construction motivated in part by the belief that the peace and prosperity of the nation were due to the protection of Buddhism. Documentary sources of the period record the lavish ceremonies that were held regularly in temples and monasteries for the state at public expense and for private wealthy devotees to mark a variety of occasions. In addition to the numerous references to court-sponsored assemblies (*pŏphoe* or *toryang*), a particularly striking feature of Koryŏ Buddhist practice can be seen in the mention of private temples (*wŏndang*, literally "hall of vows") built by Koryŏ monarchs and aristocrats. From the twelfth century onward an increasing number of these temples were consecrated by powerful officials,[74] at which they conducted ceremonies to celebrate their birthdays, to wish for the well-being of their families, or to offer funerary rites and memorial services for deceased family members.[75] For example, Yi Cha-gyŏm (d. 1126) and Kim Pu-sik (1075–1151), among the most powerful statesmen of their time, maintained lavish private temples.[76] All of these state and private religious activities ensured a constant demand for images to serve as objects of worship. Buddhist paintings were commissioned both by members of the royal family and by aristocrats, and doubtless no cost was spared to produce the best work possible.

Generally speaking, Buddhist scriptures encouraged devotees to build monasteries and to donate images in order to obtain religious merit. Such activities were interpreted as a way of guaranteeing a better rebirth, the continuous enjoyment of present prosperity, and, of course, longevity. Ceremonies were held to placate the spirits of enemies and to protect against their vengeance. In the Koryŏ political climate, characterized by frequent foreign invasions by Khitans, Jurchen, and Mongols as well as internal political power struggles, Buddhism offered consolation and comfort. Thus did Buddhist practice in the thirteenth and fourteenth centuries come increasingly to focus on personal salvation and release from the dire circumstances of the present.

In particular, Pure Land Buddhism flourished in the Koryŏ period from the first half of the thirteenth century, especially during the long and devastating period of the Mongol invasions between 1231 and 1257. This devotional sect, centering on the worship of the Amitabha Buddha (Kr. Amit'a; Ch. Amituo; Jp. Amida), the Buddha of Infinite Light, assures personal salvation and rebirth in Amitabha's realm, the Western Paradise, by means of invoking the name of Amitabha with absolute faith. This simple practice, and especially its promise to the faithful of rebirth in Amitabha's paradise, appealed to all classes of Koryŏ society when stricken with misery and extreme hardship.[77] Of the over one hundred surviving Koryŏ Buddhist paintings (of which fewer than a dozen are in Western museums, among them several fine paintings in the Metropolitan's collection), most contain images of the Buddha Amitabha and the bodhisattvas Kshitigarbha (Kr. Chijang; Ch. Dizang; Jp. Jizō), who intervenes on behalf of those suffering in hell, and Avalokiteshvara (Kr. Kwanŭm; Ch. Guanyin; Jp. Kannon), who symbolizes compassion. These paintings provide forthright evidence for the religious pieties of this most fervent and devout Buddhist period in Korean history.

Except in very few cases, Koryŏ Buddhist paintings do not bear inscriptions. It is therefore difficult to date them or to ascertain the workshops in which they were produced. However, it is unlikely, as Korean and Japanese scholars have generally held, that almost all the surviving paintings are from the fourteenth century, whatever significant stylistic discrepancies they may display. In my discussion of individual paintings I shall attempt to date them based on comparative and historical material.

## Korean Buddhist Doctrine

The development of Buddhist doctrine in Korea took a path that distinguished it from Chinese and Japanese Buddhist cultures and that in turn influenced the visual treatment of Buddhist subjects. To understand this development it is necessary to give a short summary of the doctrinal foundations of Buddhism in relation to the practice of the religion in Korea. The form of Buddhism transmitted to Korea from China in the fourth century was Mahayana Buddhism. The various Buddhist sects that gained a following during the Koryŏ dynasty are traditionally divided into two groups: the textual sect (Kyo), which stressed mastery of the scriptures, and the contemplative sect (Kr. Sŏn; Ch. Chan; Jp. Zen),

which emphasized meditation. During both the Unified Silla and the Koryŏ periods, the principal philosophical school of Mahayana Buddhism was the Avatamsaka school (Kr. Hwaŏm; Ch. Huayan; Jp. Kegon), which along with Pure Land Buddhism fell within the Kyo tradition. The adherents of this powerful doctrine stressed the sameness of things, the presence of absolute reality in them, and the identity of facts and ultimate principles. The founder of the school in Korea was the eminent Silla monk Ŭisang (625–701).[78] During the Koryŏ period this school was brought to its acme of spiritual significance under the direction of the monks Kyunyŏ (923–973) and Ŭich'ŏn (1055–1101), the latter the fourth son of King Munjong.[79] The flourishing of the Avatamsaka school in Korea produced not only a rich body of intellectual and theological exegeses, but also explication of doctrine by means of visual representation. Of the illustrated sutras that have survived, the largest number are texts from the *Avatamsaka Sutra* (pl. 79) and the *Lotus Sutra* (pl. 78), which was more frequently copied than any of the three cardinal sutras of Amitabha Pure Land (Sk. Sukhavati) Buddhism.

Though Pure Land Buddhism was already being propagated in Korea by the seventh century, a recent study argues convincingly that the underlying text and religious thought of Koryŏ Amitabha paintings do not stem from the canonical scriptures of Pure Land Buddhism, the *Sukhavati-vyuha* and *Amitayurdhyana* sutras.[80] Instead, painters turned to the last chapter of the forty-volume version of the *Avatamsaka Sutra* (Kr. *Hwaŏm-gyŏng*; Ch. *Huayan jing*) translated by Prajna into Chinese between 796 and 798.[81] The central theme of this complex sutra is the meaning of true enlightenment. The final chapter, entitled "Entering the Unimaginable Enlightened Realm of the Bodhisattva Samantabhadra and His Conduct and Vows," contains sixty-two verses in which the devotee piously vows to follow the exemplary conduct of the bodhisattva Samantabhadra in order to gain merit and escape all evil destinies. Commonly known as *Pohyŏn haeng'wŏn-p'um* in Korean, this chapter was popular in all East Asian countries. By observing the admonitions concerning conduct and vows and by reciting and writing this text, one would be reborn in paradise and encounter Amitabha Buddha.

That Amitabha and his Western Paradise should appear in this version of the *Avatamsaka Sutra*, the most metaphysical compendium among all Buddhist scriptures, requires some explanation. This has been supplied in a commentary on the sutra by the Tang scholar-monk Jing Guan (738–839): since ordinary devotees would find incomprehensible the vast metaphysical world preached by Vairochana, who is regarded in Mahayana Buddhism as the Supreme Buddha, Amitabha Buddha and his paradise have been introduced in this sutra as the "means" (Kr. *pangp'yŏn*; Sk. *upaya*) to effect the salvation of suffering humans, who are the object of Amitabha's compassion. Amitabha's Pure Land thus is one of the innumerable Lotus Repository Worlds elucidated in the *Avatamsaka Sutra*,[82] through which the ordinary devotee comes to an understanding of the world of Avatamsaka. Along similar lines should be mentioned the religious milieu in which Prajna translated the *Avatamsaka Sutra*. In China, the eighth century was the high point of the Ami-

tabha Pure Land cult, as can be seen, for instance, in the mural paintings at Dunhuang, the great Buddhist cave-temple site located along the Silk Road in present-day Gansu Province. In order to promulgate the complex Avatamsaka doctrine, Prajna also incorporated in his translation elements of the more widely popular and readily understood Pure Land doctrine. Despite this seeming simplification of profound religious concepts, we should not underestimate the significance of Amitabha Pure Land Buddhism, which was incorporated during the Koryŏ period at every level of the religious system, whether in the textual Hwaŏm school or, later, in the Sŏn or Meditation school. Pure Land belief was also powerful enough to result in some of the most magnificent Koryŏ paintings: the well-known paintings of the visions of paradise, in Saifuku-ji and Chion-in,[83] and the popular image of Kshitigarbha with the Ten Kings of Hell (see pl. 74), themes that could only be associated with Pure Land Buddhism.

## Production of Koryŏ Buddhist Paintings

Before proceeding to a discussion of the individual Buddhist paintings in the Metropolitan's collection, a few words are in order on the materials of the works. Buddhist painting on silk in the Koryŏ period followed traditional methods already well established in East Asia. The silk used, "picture silk" (*hwagyŏn*), was specially woven, with the warp and weft well spaced so that the resulting weave was more transparent than ordinary silk cloth, and allowed the pigments to permeate evenly throughout. Koryŏ silk is believed to have been dyed a pale tea color, obtained by mixing yellow and a small amount of purple.[84] (The combination of these pigments, rather than the effects of aging or centuries of accumulating dust and dirt, may contribute to the dark background of many Koryŏ paintings.) The prepared picture silk was then stretched flat and sized with a solution of alum and animal glue.[85] From a full-scale cartoon (*ch'obon*), or drawing, visible through the silk cloth from behind, the outlines were drawn on the picture surface, in black ink or red cinnabar, after which colors were applied. Chemical analysis has shown that the principal pigments used in a fourteenth-century Koryŏ Buddhist painting were cinnabar red, malachite green, and lead white.[86] There is nothing to suggest that the pigments employed in the previous century were different.

Color was first applied to the back of the silk — cinnabar red and malachite green on the garment areas, lead white and ochre on the flesh and other remaining areas — and subsequently to the picture surface. The application of pigments on the back of the silk served to fix the pigments on the front and thereby enhanced the intensity and volume of the colors. In addition, the alkalinity of the ochre aided in conservation.[87] This technique of applying color to both sides of the picture surface was invented in China, and both Korean and Japanese painters adopted it for religious paintings that demanded opaque and intense mineral colors.[88] Finally, when all other colors had been applied and contour and drapery lines completed, gold was applied. When a painting was finished, an "eye-dotting ceremony" (*chŏmansik*) was held to give life to the images.

### Amitabha Triad

The *dharmachakra* mudra, or wheel-turning hand gesture, of the Buddha and the presence of the bodhisattvas Avalokiteshvara and Mahasthamaprapta (Kr. Tae Seji; Ch. Da Shizhi; Jp. Dai Seishi) indicate that the central figure of a Buddhist painting in the Metropolitan's collection (pl. 73) is Amitabha, the Buddha of the Western Paradise. Encircled by a large aureole and with a golden nimbus surrounding his head, Amitabha is shown seated on an elaborate lotus throne. He is dressed in a red monastic robe embellished with patterns painted in gold (see detail, fig. 20). On his chest is a *shrivatsa*, an auspicious symbol from ancient India associated with a pre-Buddhist Vishnu cult; on his palms and the sole of his one visible foot are *chakra* (wheel) motifs, symbolizing the ever-turning *dharma* (law), painted in gold. The disc-shaped protuberance in the center of his head, which one scholar has called "the disc of the sun,"[89] first appears in Chinese Buddhist paintings in the tenth century.

The throne consists of three tiers: the lotus-flower seat and a middle and lower section, of which only the front panels are visible (see detail, fig. 21). A swag of textile across the front of the middle section hangs from jeweled loops at the corners. Also at the corners are ornamental legs, of cabriole form, resting on the wider lower tier. Between the legs and just beneath the textile swag is a white lotus flower. The whole construction of the throne is elaborate and fanciful, not easily rendered as a concrete object. This type of throne is often depicted in Koryŏ Buddhist paintings, but no others have legs in the middle section. A square lotus throne supported by cabriole-form legs is found in an early-thirteenth-century painting from the Tangut kingdom of Xixia (1038–1227) in northwest China.[90] Although this may seem a long way from Koryŏ, in the historical context such a similarity is not surprising. The Xixia, Liao, and Jin peoples all had a complex political and cultural relationship with Song China, while Koryŏ too maintained intricate relations with these northern empires.

The slender, tapered figures of the two attendant bodhisattvas, shown standing on lotus-flower pedestals to either side of the throne, are in marked contrast to the powerful presence of Amitabha. On the Buddha's left is Avalokiteshvara, the bodhisattva of infinite compassion and wisdom. He holds with graceful gestures a bottle of pure water in his left hand and a willow branch, painted in gold, in his right hand. In the center of his crown is a *hwabul*, a tiny image of the incarnated Amitabha, his spiritual master (see detail, fig. 21). Opposite Avalokiteshvara is his counterpart, Mahasthamaprapta, who holds in his right hand a rectangular object with a red ribbon. The tiny "precious bottle" in his crown is mentioned in the *Kwan Muryangsu-gyŏng* (Sutra on the Visualization of the Buddha Amitayus). Koryŏ painters excelled in depicting the texture of the delicate traceries of transparent garments, and created some of the most exquisite Buddhist paintings in East Asia, which were later much sought after in Yuan China. The elegant pose and the lovely transparent white robes of the two figures in the Metropolitan painting place them among the most beautiful Koryŏ bodhisattvas.

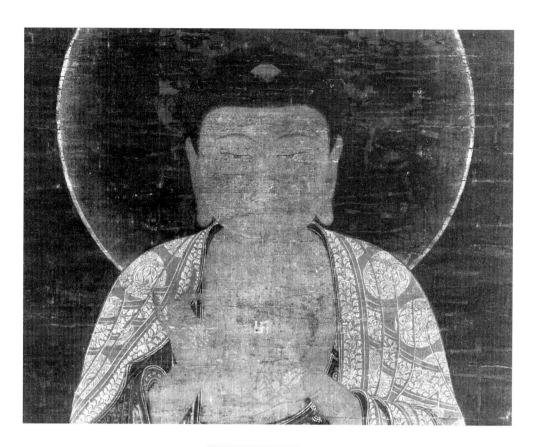

Figures 20 and 21. Details of
*Amitabha Triad* (plate 73)

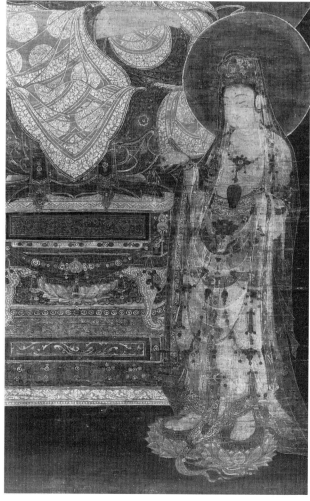

The Metropolitan triad represents one of the two most frequently encountered forms of Amitabha iconography of the Koryŏ period. While such a frontal image is clearly meant to serve as a focus of prayer and meditation, the other form, known as "descending Amitabha" (*naeyŏngdo*), had a more specific function. Hung before the deathbed, it was a reminder of the hope of devotees that they would be taken to the Western Paradise.[91]

The figures of the Metropolitan triad are fluently drawn in cinnabar red. The facial features of the three figures are differentiated: the face of the Buddha is broad while the youthful faces of the bodhisattvas are elongated. The long, narrow eyes of the Buddha contrast with the almond-shaped eyes of his attendants. On all three figures, the eyebrows, executed meticulously with fine individual brush strokes, reveal the hand of a master painter. The sumptuous garments worn by the figures are embellished in gold with motifs of cranes among clouds (on Amitabha's inner garment, visible on the right sleeve), lotus medallions (on his outer robe, covering his shoulders and draped across his left arm), composite chrysanthemum or floral roundels (on the bodhisattvas' translucent robes), and various types of plant scrolls on the borders of the garments of all three figures. These motifs are all familiar from Koryŏ celadons of the twelfth and thirteenth centuries.

A detail that appears to have been carried out by an assistant copyist is the awkward disposition of Mahasthamaprapta's right foot, which appears to be a copy of Avalokiteshvara's left foot. Exactly the same detail appears in another Koryŏ painting, a standing Amitabha Buddha in Tōkai-an, Kyoto,[92] which indicates these paintings may be products of the same workshop. The Tōkai-an Amitabha also shares remarkable stylistic similarities with that of the Metropolitan triad: the same facial features, almost identical decorative patterns on the monastic robes, and the firm, yet eloquent, drapery lines.

The contrast in size between the central and subordinate figures and the relatively small faces and slender figures of the bodhisattvas are analogous to the *Descending Amitabha Triad* in the Tokyo National Museum, which I believe was produced at a slightly later time in a similar style.[93] In the Tokyo triad the medallions on the Buddha's red robe consist of a spiral motif often found in fourteenth-century paintings, such as the well-documented *Amitabha*, dated 1306, in the Nezu Museum, Tokyo.[94]

In the Metropolitan painting, light seems to emanate from the three divine figures, a glowing effect produced by a broad band of blue, now quite faded and barely visible, painted along the inner edge of the golden circle of each nimbus. This distinctive style of nimbus is rarely found in dated fourteenth-century Koryŏ paintings, but it does occur in Southern Song (1127–1279) Buddhist paintings, notably the lohan figure now in the Museum of Fine Arts, Boston, ascribed to the Ningbo painter Zhao Qiong (act. 13th century); the Vairochana Buddha triad in Kenchō-ji, Kita Kamakura; and the Amitabha triad by the Southern Song painter Puyue, in three separate hanging scrolls, in Shōjoke-in, Kyoto.[95] The Shōjoke-in scrolls display other elements of Southern Song Buddhist paintings that have been subtly adapted in the Metropolitan's Koryŏ painting: the plump face and small mouth of the Buddha, the contrapposto pose of the bodhisattvas, the careful differen-

tiation between the two bodhisattvas in the arrangement of the hair on the shoulders, the deep azurite blue (also known as Buddha blue)[96] of the Buddha's head, and the impression of gentleness conveyed by all three figures. The splendid visual rhetoric that is the hallmark of Koryŏ Buddhist painting is confidently manifested here in the ephemeral appearance of the bodhisattvas' garments and in the quiet grandeur and dignity of the Buddha. These visual qualities and the elements derived from Southern Song painting place the approximate date of the Metropolitan triad not later than the thirteenth century, a time when Koryŏ had close cultural contacts with China.

### Kshitigarbha

As Pure Land Buddhism gained adherents in all levels of Koryŏ society, the concept of hell developed logically as a counterpart to its promise of paradise. Because of the Buddhist doctrine of rebirth, this hell was represented as a kind of purgatory, to which sentient beings might be destined as a consequence of conduct during their life. In such distressing circumstances the bodhisattva Kshitigarbha, full of compassion and prepared to rescue ill-fated sentient beings who had wandered onto the three evil paths (those of hungry ghosts, asuras or fighting spirits, and hell), was bound to be popular.[97] Kshitigarbha, known in Korea as Chijang, became an important deity in the Buddhist pantheon with the flourishing of Amitabha Pure Land Buddhism in Central Asia and China toward the end of Tang dynasty, in the tenth century.[98] The iconography of Koryŏ paintings of Kshitigarbha derives mainly from the Five Dynasties and Northern Song representations of the bodhisattva at Dunhuang. He represents the cardinal principle guiding bodhisattvas in Mahayana Buddhism: "Above, seeking enlightenment, below, rescuing all sentient beings." During the Koryŏ dynasty, especially in the thirteenth and fourteenth centuries, Chijang was, together with Avalokiteshvara, the most frequently painted Buddhist image. Whether represented singly or with a retinue of disciples, or presiding over the Ten Kings of Hell, he became a pivotal deity to be worshiped. Most commonly represented as a monk with a shaven head, his attributes are a mendicant's staff and a cintamani, a wish-fulfilling jewel that illuminates even the darkest corners of hell.[99]

In a society like Korea, in which the Confucian tradition of filial piety was deemed one of the cardinal virtues, the fate of deceased relatives was an important concern for living family members.[100] The image of Chijang standing on lotus-flower pedestals and holding his staff and cintamani represented to devotees his power over hell, from which he could deliver unfortunate beings and lead them to paradise.

A Metropolitan painting (pl. 77) is just such a representation. While the iconography closely resembles that in a painting in the Nezu Institute of Fine Arts (fig. 22), the stance of the Metropolitan Chijang seems to mirror that of the Nezu figure, who wears a monk's scarf on his shaven head. The monk's staff is held straight in the Metropolitan painting, obliquely by the Nezu figure, and as a result the Metropolitan image appears more static. The Metropolitan Chijang holds his attributes in exactly the same way as the bodhisattva

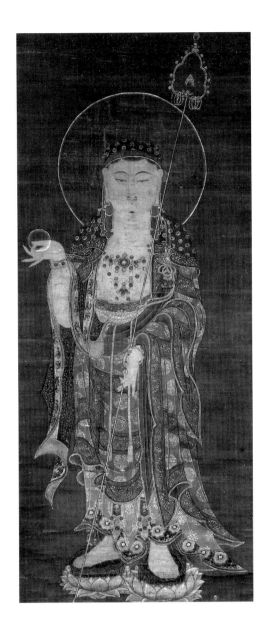

**Figure 22.** Unidentified artist (14th century), *Kshitigarbha* (*Chijang*). Hanging scroll, ink and mineral pigments on silk, 43 ¾ × 17 ⅛ in. (111 × 43.5 cm). Nezu Institute of Fine Arts, Tokyo

in tenth-century Dunhuang paintings in the Musée Guimet and the British Museum, namely, with the cintamani in his left hand and the staff in his right.

The wave pattern on the monk's outer robe in the Metropolitan painting is highly stylized compared to that in the Nezu Chijang. This motif is not usually found on monastic robes in Koryŏ Buddhist paintings. However, it can be seen in Chinese Cizhou wares produced in the Yuan dynasty in the fourteenth century, and it is not difficult to imagine that Koryŏ Buddhist painters experimented with new designs taken from contemporary Yuan paintings and ceramics. The principal jewel of the necklace of the Metropolitan Chijang is inscribed with the Sanskrit syllable *om*. In Korea, such seed syllables, abstract representations of images of Buddhas or formulaic recitations (*mantra*), are found inlaid in silver on bronze censers from the late fourteenth century onward.[101]

A variety of colors—from the malachite green of the gold-edged nimbus and the bright cinnabar red of the underskirt to the bluish-gray monk's robe and the dazzling gold of the textile patterns—provides striking and scintillating contrasts. The rich orna-

mentation of the decorative motifs on the garment is executed with virtuosity. Despite such technical brilliance, however, the bodhisattva's face is somewhat precious, with narrowly set eyes and very small nose and lips, and the drapery is stiff and flat, with little suggestion of volume. The schematic curves of the garment and the pointed corners of the hemlines are details that first appear in fourteenth-century Koryŏ Buddhist paintings. The differences between the Metropolitan's Amitabha triad and this painting of Chijang in the facial features, the rendering of the garments, and the colors are striking. All of these aspects suggest that the Chijang painting was produced no earlier than the late fourteenth century.

### Amitabha and Kshitigarbha

The Metropolitan's representation of a Buddha and a single bodhisattva together in a hanging scroll (pl. 76) is the only known surviving example of such an image in Koryŏ Pure Land Buddhist iconography. Amitabha is shown in frontal view, his hands in the preaching gesture, while the bodhisattva Chijang, to his right, holds a long staff. The latter's right foot is placed slightly behind the left, as if he were about to step back; movement is further suggested by the obliquely swaying necklace. This posture suggests his readiness to lead deceased souls to the Western Paradise. The Buddha's frontal position and downcast eyes likewise suggest his welcome of the newly arrived devotee in his paradise. The task of guiding the deceased devotee to the Western Paradise was undertaken in tenth-century Chinese Dunhuang paintings by Avalokiteshvara, but in Koryŏ Pure Land iconography Chijang became increasingly prominent, assuming the task formerly undertaken by Avalokiteshvara.

During the course of conservation and remounting, it was confirmed that the two figures are on separate pieces of silk. It is possible that the two pieces were originally part of a set of three hanging scrolls, along with a now lost representation of Avalokiteshvara flanking Amitabha on the other side. There is also the possibility that the present condition of the scroll represents its original format, for which there is a precedent in Chinese Buddhist art. An analogous representation of Amitabha and Kshitigarbha in a single painting is found in a Dunhuang image that is dated to the tenth century.[102] In this painting Amitabha's Western Paradise is also depicted. The Buddha and a number of his retinue occupy the upper section of the painting, while in the lower section Kshitigarbha presides with his retinue and the Ten Kings of Hell, all of whom will judge the deceased according to their merits. Though the Metropolitan painting reduces this iconography to its prime constituents, the two deities alone, Buddhist devotees of the Koryŏ period would have understood instantly the intrinsic iconological significance of the painting. Even if the two figures were not originally depicted together, their later pairing in one scroll demonstrates the viability of this iconographic connection to the Dunhuang mural. The schematic facial features and drapery, the golden-colored body, and the subdued tone of the colors suggest that the painting may date from the first half of the fourteenth century.

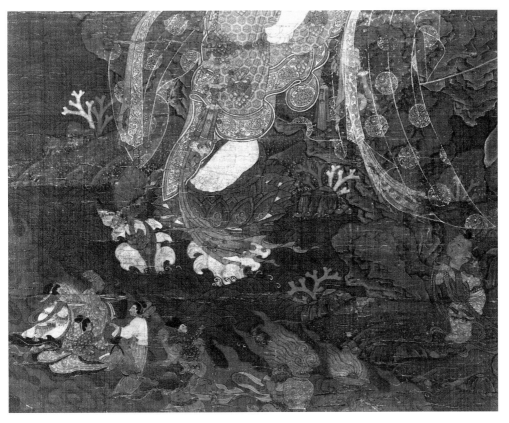

**Figure 23.** Detail of *Water-Moon Avalokiteshvara* (plate 75)

### *Water-Moon Avalokiteshvara*

The Water-Moon Avalokiteshvara (Kr. Suwŏl Kwanŭm; Ch. Shuiyue Guanyin; Jp. Sui-getsu Kannon) was one of the most frequently depicted Buddhist deities during the Koryŏ period. The water and moon reference in connection with the bodhisattva appears to have been established during the Tang dynasty, in the eighth century. Chinese records mention a painting of the Water-Moon Avalokiteshvara by the famous Tang painter Zhou Fang (act. ca. 780–ca. 810) and a poem by Bai Juyi (772–846) in which the image of the bodhisattva appears as a reflection in a moonlit pond.[103]

In the Metropolitan's painting of the bodhisattva (pl. 75), the Water-Moon Avalokiteshvara is shown in three-quarter view seated on a rocky outcrop looking down on a group of figures dressed in court attire and led by the dragon king. They are followed by sea monsters, one of which carries a banner and the others offerings of precious coral and pearls. In the lower right corner a small boy with his hands clasped in the reverence (*anjali*) mudra looks up toward the bodhisattva (see detail, fig. 23). The latter is adorned with jewelry and dressed in a thin transparent white robe decorated with gold spiral medallions and a red skirt bearing honeycomb and lotus patterns. Avalokiteshvara's usual attributes, which are also seen in the *Amitabha Triad* (pl. 73), are all present here: the image of the incarnated Amitabha in his crown and the healing willow branch, which is placed in a *kundika* bottle set in a clear glass bowl on the rocky platform to his right. As in all other Koryŏ images of Water-Moon Avalokiteshvara, the bodhisattva gracefully holds

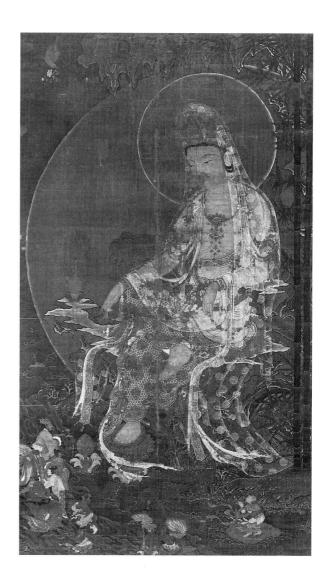

**Figure 24.** Unidentified artist (13th century), *Water-Moon Avalokiteshvara.* Hanging scroll, ink and mineral pigments on silk, 89 ¾ × 49 ⅛ in. (227.9 × 125.8 cm). Daitoku-ji, Kyoto

in one hand a crystal rosary strung on a red silk cord. A large aureole encircles almost the entire figure and a nimbus the head of the saint. Above the bodhisattva is a moon disc in which is depicted a hare pounding an elixir under a cassia tree, a well-known Chinese image associated with immortality.[104] On the right edge of the painting, two stout bamboos, now barely visible, stretch upward. Close inspection reveals the distinct delineation of their large green leaves and the individual segments of the stalks. The bodhisattva's golden body shines amid a subtle coloring of red, white, green, and a tinge of blue.

Two other paintings on this subject have stylistic similarities with the Metropolitan Water-Moon Avalokiteshvara. A painting by Sŏ Ku-bang, dated 1323, is so close that one can be almost certain that the painter of the Metropolitan scroll used the same cartoon (Best, fig. 4). However, the group of figures at the lower left in the Metropolitan painting also closely resembles that in a painting of the Water-Moon Avalokiteshvara in the Daitoku-ji, Kyoto (fig. 24), which can be dated to the thirteenth century.

The textual source of the iconography in Koryŏ paintings of the Water-Moon Avalokiteshvara is a chapter from the widely studied and recited *Avatamsaka Sutra* entitled "Entering the Dharma Realm" (*Gandhavyuha*). The boy Sudhana (Sŏnjae Tongja), on

a journey in search of the ultimate truth, visits fifty-three saints, of whom the twenty-eighth is Avalokiteshvara. When he reaches the island abode of Avalokiteshvara, Mount Potalaka (Kr. Naksan; Ch. Putuo), Sudhana discovers the bodhisattva seated on a "Diamond Seat," amid "fragrant grass" growing in the midst of a pool densely filled with vegetation.[105] The Koryŏ painters described the rocky outcrop on which the bodhisattva sits in shimmering gold and the cushion as soft green grass, both direct visual references to the text.

Scholars have already drawn attention to the close relationship between the Daitoku-ji painting of Water-Moon Avalokiteshvara and elements of the legend of "Avalokiteshvara at Naksan Temple," by the monk Iryŏn (1206–1289), from *Samguk yusa* (Memorabilia of the Three Kingdoms).[106] According to this story, the famous Silla monk Ŭisang, the founder of the Korean Hwaŏm school, had a spiritual encounter with the bodhisattva at Naksan (Potalaka) on the east coast. After seven days of observances, he received a crystal rosary from heaven and after further observances a cintamani from the dragon king of the Eastern Sea. He was told by the bodhisattva to build a temple on the mountain at a spot where a pair of bamboos grew. Ŭisang followed Avalokiteshvara's instructions and enshrined in the temple a carved image of the bodhisattva, together with the cintamani and the rosary.[107] Such stories of miraculous spiritual experience (*yŏnghŏmjŏn*) in connection with the image or holy abode of a deity form a well-known category of Buddhist literature in East Asia.

These textual details are illustrated with some slight variations in the Metropolitan and Daitoku-ji works. In both paintings, the bamboo plants mentioned in the story appear behind the bodhisattva at the far right. The bodhisattva likewise holds a rosary, while the boy on the back of the sea creature carries a cintamani. However, the dragon king in the Daitoku-ji painting is depicted with two white horns protruding from his crown, which are absent in the Metropolitan version. He holds a censer of a type similar to the lotus-shaped bronze incense burner dated 1077 (pl. 51), while the dragon king in the Metropolitan painting carries an oblong golden tray on which a bowl-shaped censer is placed.

Various textual and pictorial sources, primarily Chinese, serve as prototypes for the iconography in the Metropolitan painting.[108] Avalokiteshvara's chief attributes in the Metropolitan painting, the willow branch and the moon, are both agents of healing and cooling. They are described in an esoteric text of the *Thousand-armed Thousand-eyed Avalokiteshvara Dharani* translated by the great tantric master Amoghavajra (705–774)[109] and are represented in a Dunhuang painting, now in the Museé Guimet, in which the Thousand-armed Thousand-eyed Avalokiteshvara appears as the main image and the Water-Moon Avalokiteshvara as the subordinate image.[110] Dated 943, this painting provides pictorial evidence of the religious phenomenon centered on the pervasive and popular Avalokiteshvara cult in China in the tenth century.

A further iconographic element to be elucidated is the group of nobles in elegant court dress and elaborate hairdos in the Metropolitan painting (see detail, fig. 23). They

appear more likely to be donors than members of the retinue of the supernatural dragon king of the Eastern Sea. And indeed a Water-Moon Avalokiteshvara painting from the twelfth century, unearthed in the ancient town of Khara Khoto (modern Heicheng), in the territory of the Xixia kingdom, depicts such a donor figure.[111] In that work, we see an elderly man wearing court dress and an official's hat, possibly a deceased devotee. Borne by a cloud and accompanied by a boy servant, he offers homage to the bodhisattva. He holds a lotus-stem censer in a pose very close to that of the Metropolitan and Daitoku-ji figures. Just below him, to his right, a group of musicians and a dancer gather on the shore, as if rejoicing at his departure from this world for paradise. In the Xixia painting, the youth Sudhana, shown in the upper right corner, descends on a cloud toward the bodhisattva.

A Southern Song painting of the first half of the twelfth century, *Daoist Deity of Water*, in the Museum of Fine Arts, Boston,[112] suggests another visual reference for the figure group in the Metropolitan and Daitoku-ji scrolls. As in the Boston painting, the figures in the two Koryŏ paintings are riding on clouds above waves. The lively sea creatures and the sea monster carrying a banner under his arm are so similar to those in the Boston painting as to suggest borrowing by the Koryŏ Buddhist painter of such pictorial elements from Daoist iconography.

To sum up, the iconography of Koryŏ paintings of the Water-Moon Avalokiteshvara is a complex and skillful composite derived from Buddhist scriptures, local legend, and Chinese and Central Asian pictorial references. One iconographic element that is Korean in origin, namely the crystal rosary that Avalokiteshvara always holds in Koryŏ paintings, appears to reflect the Naksan, or Mount Potalaka, legend. The sacred nature and the efficaciousness of the Naksan Kwanŭm is well documented in Koryŏ historical and literary sources.[113]

The Daitoku-ji painting, on which the Metropolitan Avalokiteshvara appears most directly based, was most likely produced in the thirteenth century.[114] One piece of evidence supporting this date is the vessel carried by one of the sea monsters, a sanggam ceramic jar with an ogival panel on its flattened side. Jars of this type are dated to the thirteenth century.[115] However, both the stylistic similarity of the Metropolitan painting to the earlier-mentioned work of 1323 by Sŏ Ku-bang and the golden body of the bodhisattva (a characteristic feature of paintings of this period, as noted above in the discussion of *Amitabha and Kshitigarbha*) suggest instead that the Metropolitan's *Water-Moon Avalokiteshvara* may date to the beginning of the fourteenth century.

### Illuminated Manuscript of the Lotus Sutra

The copying of Buddhist sutras, the written texts that transmit the teachings of the Buddha, is regarded as one of the most meritorious acts a devotee can perform, and such devotional activity is encouraged in every sutra. Both the production of a sutra and the dedication ceremony for the finished work are clearly spelled out in the colophons (*parwŏnmun*) at the end of an *Avatamsaka Sutra* from Unified Silla, dated 754–55.[116] The

**Figure 25.** Wang Yi, *Frontispiece to the Lotus Sutra*, Song dynasty (960–1279). Woodblock print. National Palace Museum, Taipei

utmost care was to be taken in the production of the materials used for the sutra, such as preparation and dyeing of the paper and the manufacture of ink, pigments, and mounting materials. Ritual purity was demanded of the sutra writer and of his surroundings, and the names of calligraphers, craftsmen, and monks who were involved in the dedication ceremony were precisely recorded. The paramount importance of sutra copying and the costly production of sutras led Koryŏ monarchs to establish the Royal Scriptorium, or Sagyŏng'wŏn. The *Koryŏ-sa*, the official history of Koryŏ, records that King Myŏngjong (r. 1170–97), who was a devout Buddhist, commissioned in 1181 a Tripitaka (Buddhist canon) written in silver on indigo blue paper. During King Ch'ungnyŏl's reign (r. 1274–1308) the Ŭnjawŏn (Scriptorium of Silver Letters) and the Kŭmjawŏn (Scriptorium of Gold Letters) were established. Here, costly gold and silver powders were mixed with animal glue for writing texts and executing frontispieces and illustrations of scenes from the scripture on mulberry paper dyed indigo blue.

Most Koryŏ illuminated manuscripts were produced in a rectangular, accordion format that facilitated reading, unlike handscrolls, which need to be unrolled. The Metropolitan possesses the second volume of the *Sutra of the Lotus Blossom of True Doctrine* (*Saddharmapundarikasutra*), better known as the *Lotus Sutra*, originally translated into Chinese by the Buddhist monk Kumarajiva (344–413).[117] The *Lotus Sutra* is one of the most important Buddhist scriptures and, together with the *Avatamsaka Sutra*, was the sutra most frequently copied during the Koryŏ period. It preaches the essence of Mahayana Buddhism, or the Great Vehicle — namely, the doctrine of universal salvation of all living beings and the attainment of Buddhahood, the ultimate aim of existence.

The frontispiece to the Metropolitan manuscript (pl. 78), a visionary representation of the text that follows, is executed in minute detail and lavishly embellished in gold with great virtuosity and to dazzling effect. It displays the fine art of illumination in the purest

**Figure 26.** Unidentified artist (14th century), *Illustrated Manuscript of the Lotus Sutra*, dated 1340. Folding book, gold on indigo-dyed paper, 12 ½ × 4 ¼ in. (31.8 × 10.8 cm). Nabeshima Foundation, Saga

sense.[118] The silver characters are written in a majestic regular script (Kr. *haesŏ*; Ch. *kaishu*). This frontispiece (*pyŏnsang*, or "transformed image") is spread over four leaves. In the section furthest to the right, the historical Buddha Shakyamuni is depicted preaching to his disciple Shariputra. To the left are narrative scenes illustrating two of the most famous parables from the second chapter of the *Lotus Sutra*—those of the burning house and the prodigal son. Each of these parables illustrates the "expedient methods" that the Buddha employs to save suffering beings.[119]

The prototype of the Metropolitan frontispiece can be traced back to a Song-dynasty woodblock version carved by Wang Yi (fig. 25). The arrangement of the narrative scenes of the Metropolitan's sutra are directly borrowed from the Song illustration. Even the border that frames the illustration employs the same thunderbolt (*vajra*) motifs, which symbolize indestructibility. The direct influence of Song iconography on Koryŏ Buddhist art is not surprising. The vast collection of Buddhist works amassed by the monk Ŭich'ŏn, the national preceptor, during his trip to China in 1085–86 was published as a supplement to the first woodblock edition of the Koryŏ Tripitaka, the complete compendium of Buddhist scriptures completed about 1087.[120] These materials served as a repository from which Buddhist monk-painters could draw. Here, the painter transformed his Song prototype into a characteristic Koryŏ manuscript by changing the architectural forms, trees, and figures, and by decorating every single inch of space with densely packed and dazzling ornament. The border framing the pictorial portions also has an additional chakra motif, symbolizing Buddha's teaching, instead of the usual Song floral pattern between the thunderbolt motifs.

Among existing Koryŏ illuminated manuscripts the Metropolitan's is very close to a *Lotus Sutra*, dated 1340, in the Nabeshima Foundation, Saga Prefecture (fig. 26), and to the *Amitabha Sutra*, dated 1341, in the British Museum.[121] Interestingly, these two manuscripts were transcribed by the same monk, a certain Ch'onggo. Besides serving as scribe for both sutras, he also commissioned the British Museum's *Amitabha Sutra* for his de-

ceased mother. The oval faces of the figures, the dense ornamentation of the pictorial ground, and the abstract spiral design of the garments are similar in all three frontispieces. The painting and calligraphic style of the three illuminated manuscripts are so similar that I believe the Metropolitan's *Lotus Sutra* was also produced in the workshop in which Ch'onggo worked, in about the year 1340.

As mentioned earlier, the *Avatamsaka Sutra* was, along with the *Lotus Sutra*, the most frequently copied Buddhist scripture during the Koryŏ period. The present exhibition includes a superb illuminated manuscript of volume 31 of this sutra, produced in the year 1337, now in the collection of the Ho-Am Art Museum (pl. 79). It is based on the forty-volume version of the sutra translated by the monk Prajna in the late eighth century.

The frontispiece, painted in gold on indigo blue paper, portrays the boy Sudhana on his journey in search of truth. The three figures approached by the young pilgrim are identified in the rectangular cartouches in the top half of the painting (reading from right to left): the Maiden of Heavenly Radiance, the Youth of Universal Friendship, and the Youth of Skilled Knowledge. The architectural features of the heavenly palace and the sumptuous interior settings, including the silk curtains and a folding screen with a landscape scene, are rendered in meticulous detail.

At the end of the handscroll is a dedicatory inscription written in silver and enclosed in a gold cartouche:

> Bestowed by Taebu Sogam, Tongji Miljiksa-sa Ch'oe An-do and [his] wife Madame Ku of Nŭngsŏng District. We dedicate this Hwaŏm-gyŏng written in silver script to the Emperor [Yuan emperor Ningzong, r. 1333–68] with sincere wishes for his longevity, to the sentient beings in the three evil paths, and to [our] deceased parents so that they may be released from suffering and gain happiness. We also wish that we may enjoy a long and happy life free of misfortune, and in the future be reborn in the Lotus Paradise so that we may see the Buddha, listen to his teaching, realize [the state of] nothingness, and cultivate endurance. Like Buddha, we hope to be delivered from the four modes of birth[122] and testify to enlightenment.
>
> <div align="right">Zhiyuan, third year [1337], fourth month,<br>Hwaju [treasurer of the monastery] Kyoyŏn.</div>

The inscription reveals that the manuscript was commissioned by Ch'oe An-do (1294–1340), a high-ranking and powerful official during the reign of King Ch'ungsuk (r. 1313–30 and 1332–39). He assisted the king during his obligatory residence in the Yuan capital, from 1321 to 1325,[123] and for his services earned a privileged position at court as an official in the Office of Ministers-Without-Portfolio (Miljiksa-sa), which oversaw the security of the imperial palace and the country's military affairs. His notorious misuse of power to advance his political status and enhance his personal wealth is recorded in the fifteenth-century *Koryŏ-sa chŏryo* (Essentials of Koryŏ History).[124]

The second half of the fourteenth century was a critical period in Korean history. The country, which during the preceding Koryŏ period had suffered almost a century of Mongol domination, was again beset by invasions of renegade forces from China, while the southern coast of the peninsula was plagued by Japanese pirates. In addition, the accumulated wealth and power of the Buddhist monasteries had led to widespread corruption, a factor that contributed to the downfall of Koryŏ. The new rulers of the Chosŏn dynasty denounced the luxury of the Koryŏ court and initiated a policy of austerity, through which they hoped to rejuvenate the country. To do this, they embraced the philosophical doctrine known as Neo-Confucianism. This ideology had a profound impact on Korean culture. At the same time, the thousand-year-old tradition of official support of Buddhism was at a stroke abolished. With the reorganization of monasteries and the decline in status of monks, Buddhism lost its institutional power base.

## Buddhist Painting

Though it was the source of much artistic activity and creativity during the preceding Koryŏ period, Buddhism suffered an increasing loss of royal and aristocratic patronage during the Chosŏn dynasty, even though several monarchs remained devout Buddhists, for instance, Kings Sejong (r. 1418–50) and Sejo (r. 1455–68). In particular, many female members of the royal family, most notably the Queen Dowager Munjŏng (1501–1565), were ardent Buddhists and continued to foster Buddhist culture. Due to these changed conditions, Buddhist paintings of the fifteenth and sixteenth centuries naturally underwent significant changes in format, materials, and painting style.[125]

### Brahma

The Metropolitan's painting of Brahma (Pŏmch'ŏn) surrounded by attendants and musicians (pl. 81) is a type of painting commonly known as *sinjung t'aenghwa*, or "hanging paintings of devas." Devas are minor deities in the Buddhist pantheon whose function is to defend Buddhist teachings. Historical records and other documents reveal that *sinjung toryang*, ceremonies in which *sinjung* (literally "host of spirits") were the central images, were frequently held during the Koryŏ period to protect the country, especially when it was under attack. Judging from the numerous *sinjung* paintings that date from the eighteenth century onward, these deities had become an important and integral part of the Korean Buddhist pantheon.

The monumental size of the present work — five panels (each fourteen to fifteen inches in width, as woven on the loom, and an additional panel half this width along each margin) sewn together — indicates that the painting was hung in the main hall of a monastery. The dominant central image can be identified as Brahma, King of the Brahma Heaven, by the Sanskrit syllable *om* displayed in a circle above his belly and by his towering height (in the sutras he is said to stand one and a half *yojana*, approximately fifteen

miles, tall). In Hindu mythology Brahma is one of the three supreme gods, along with Vishnu and Shiva, and he is known as "savior of the world."[126] His function of "comforting men and gods in time of trouble" was incorporated into Buddhism, in which, together with Indra, a warlike Hindu god, he became the protector of Buddhist teachings and all Buddhist nations. In various Mahayana Buddhist scriptures he is mentioned as being present at all the assemblies of the Buddha in order to listen to the Buddha's preaching. According to other scriptures, he uses his power to suppress all evil spirits and to come to the aid of unfortunate beings.[127]

In this painting he is surrounded by an entourage of attendants, banner holders, and musicians. The immediately flanking figures are deities of the Sun and Moon, in the top row, with their emblems in their headdress (they are the only distinctively male figures in this painting); two attendant bodhisattvas, in the middle row; and two small assistants on whose shoulders rest the huge hands of Brahma. Most of these attendants are depicted in three-quarter view, facing toward the left, which suggests that the Metropolitan painting was originally the left member of a set of three paintings. The central painting would have depicted the assembly of a preaching Buddha. To the right there might have been a similar painting of Indra with his own entourage. In order to accommodate such a large number of figures, the format of the Metropolitan painting is square as opposed to the more conventional vertical rectangular shape.

Indian mythology describes Brahma's abode, Brahmaloka, as itself "no place for meditation," but a place of pleasure where "saints and heroes and singers and dancers, one of whom is Brahma's own daughter, enliven Brahma's home."[128] The Metropolitan's painting, which shows Brahma accompanied by musicians and a dancer (in the middle row, far right), is a remarkable reminiscence of this ancient Indian myth. Music is an important part of Korean Buddhist ritual. In this painting we find, in the middle row from left to right, figures holding a short vertical flute (*p'iri*), a gong (*ching*), the handle of which is visible, and a hand drum (*sogo*). In the bottom row are depicted musicians playing a mouth organ (*saeng*), a long transverse flute (*taegŭm*), a two-stringed violin (*haegŭm*), a four-stringed lute (*pip'a*) with crooked neck, wooden clappers (*pakchongdu*), and a triangular clay wind instrument (*hun*).[129] To complete this festive ritual, ceremonial fans, insignia, and bejeweled canopies are depicted above the assemblage, held by the assistants in the top row. Most of the instruments shown here are discussed in *Akhak kwebŏm* (Rules of Music), compiled in 1493 by Sŏng Hyŏn (1439–1504), Minister of the Board of Rites. It describes precisely how dance and music are to be performed during court festivities and Confucian ceremonies.[130] The iconography of the Brahma painting thus blends Confucian and Buddhist rituals and offers as well intriguing hints concerning Brahma worship in the pre-Buddhist period in ancient India.

The manneristic figure style, eccentric at its best, is a marked departure from the Koryŏ paintings discussed above. The vertical lines of the voluminous sleeves of the outer robes, which form lotus-petal shapes, contrast with the curvy horizontal hemlines. The

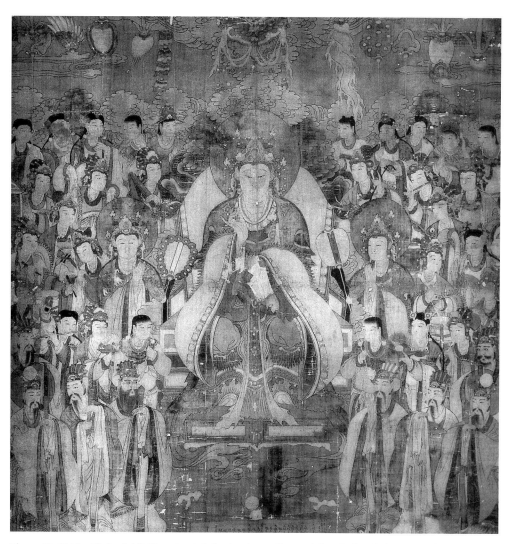

**Figure 27.** Unidentified artist (16th century), *Indra*, dated 1583. Banner, ink and mineral pigments on hemp, 75 ⅞ × 73 ⅛ in. (192.8 × 185.8 cm). Zengaku-ji, Tokushima Prefecture

deep double-looped collars of the white undergarments are an exaggeratedly ornamental transformation of Chinese Ming-style bodhisattva garments, as seen, for instance, in mid-fifteenth-century wall paintings from Fahaisi, near Beijing.[131] The hair of the central figure of Brahma and the two attendant bodhisattvas is arranged in small black roundels, while that of the assistants who hold ceremonial fans and of the musicians is arranged in an open twin-loop style secured with pins. Both hairstyles are derived from tenth-century Chinese Buddhist painting, examples of which can be seen at Dunhuang.[132] The arrangement of half-roundels on the forehead of the Dunhuang bodhisattvas was transformed in the Chosŏn painting into individual stylized roundels. Likewise, the tenth-century hairstyle of Chinese court ladies among the donor figures in Dunhuang was retained in this painting but now serves more as a frame for the face. The artist's attention to detail is seen in the rendering of a small section of the hair loops of two figures holding insignia, who otherwise remain completely hidden behind the large halo of the central figure.

Some well-documented Chosŏn Buddhist paintings of the late sixteenth century provide clues as to the date of the Metropolitan painting. They include *Kshitigarbha and*

*the Ten Kings of Hell*, dated 1568, at Zendō-ji, Fukuoka,[133] and the image of Indra, dated 1583, in Zengaku-ji, Tokushima Prefecture (fig. 27). All of these paintings are characterized by an elongated, manneristic figure style, a stylized abstraction of the garments, and a composition that fills almost the entire pictorial space. When compared with Koryŏ paintings, this work displays a greater concern with the linear quality of the garments than their textures and patterns. (The red and green colors have faded with time, so that the precisely drawn black ink lines now stand out quite starkly.)

The fabric on which this work is painted also marks a significant departure from that used in Koryŏ paintings. The exclusive use of hemp in sixteenth- and seventeenth-century monumental Buddhist paintings (some of which, like Tibetan thankas used in outdoor ceremonies, can be over thirty feet in height) is undoubtedly due to economic circumstances: silk and gold had certainly become too expensive to use for Buddhist images, especially under the conditions of austerity that the early Chosŏn rulers sought to foster. The significant change in patronage, from the royal court to wealthy provincial donors and local monasteries, also played a role. Finally, hemp did not require demanding craftsmanship. As was pointed out above in connection with Koryŏ paintings on silk, the luminosity and durability of the painted images required specialists who could apply the colors to both the back and the front of the painting surface, and for this they needed to have a thorough knowledge of the behavior of mineral pigments. On hemp, which is a thicker fabric and lacks the transparency of silk, the painter merely drew the outlines and applied colors to the front of the painting surface. These differences contribute to the highly stylized and abstract style of sixteenth-century Chosŏn Buddhist paintings.

### Portrait of Sŏsan Taesa

The portrait of the eminent Chosŏn monk Ch'ŏnghŏdang (1520–1604) in the Metropolitan's collection (fig. 28) is a rare early example of a portrait of a Korean monk and an important historical and religious document. The monk, who holds a fly whisk in his right hand, is portrayed in three-quarter view seated on a wooden chair, his shoes neatly arranged below him on a footstool. The painted image is framed by a narrow black border. The careful delineation of the monk's full face, in particular the elongated eyebrows, the broad mustache, and the closely cropped beard, was intended to give a realistic appearance to the sitter. Seen against the natural color of the unpainted hemp cloth, his monastic robe of red with green stripes contrasts harmoniously with the dark green color of the cloth cover, decorated with a cloud motif defined in red, that is draped across the chairback. The same green color is typically employed for the haloes of deities in Chosŏn Buddhist paintings. The lead white pigment used for the face has oxidized, turning a grayish color, while the pigment, probably shell white, used for the collar and sleeves of the undergarment and the hairs of the fly whisk has not changed color.

The painting bears two inscriptions. The one in the upper left corner, originally written in silver but now tarnished, identifies the subject of the portrait as Pujongsu

Ch'ŏnghŏdang Taesa. Pujongsu, a shortened form of Pujongsugyo (Supporting Schools and Establishing Teaching), was the title conferred on Ch'ŏnghŏdang Taesa, or Great Master of the Hall of Clear Emptiness, who was also known by his sobriquet Hyujŏng (Resting Calmness) and posthumously as Sŏsan Taesa (Great Master of the Western Mountain).[134] At a time when Buddhism was severely repressed by the Chosŏn government, he restored order to the community of monks and wrote the basic text for Korean monks, *Sŏn'ga kugam* (Mirror for Sŏn Students), which is still followed today by members of the Sŏn order. In this text and in his teachings, he attempted to synthesize the doctrines of Buddhism, Daoism, and Confucianism. In 1593, when he was seventy-three years old, Sŏsan Taesa, serving the government as Commander of the Eight Provinces and the Sixteen Buddhist Schools, led an army of Buddhist monks against the Japanese invasion forces of Toyotomi Hideyoshi (1536–1598) and helped to recover the Chosŏn capital, Hanyang (modern Seoul). In recognition of his achievement, he was honored upon his retirement in the following year with the highest title that could be bestowed on a Buddhist monk, Kugildo Taesŏnsa Sŏn Kyo Toch'ongsŏp Pujongsugyo Poje Tŭnggye Chonja (Venerable Poje, Upholder of the Tradition, National Preceptor of the Teachings, and Supreme Master of Meditation). The struggle against the Japanese invaders was continued by his disciple Samyŏng Taesa Yujong.[135] Sŏsan Taesa chose as his place of retirement Mount Myohyang, in P'yong'an Province, where he lived from 1594 to his death in 1604. After his death, stelae and halls of reverence were erected throughout the country to commemorate this eminent spiritual leader of the Chosŏn dynasty.

The second inscription, written in black ink and centered below the portrait, records the names of the donors for the painting and the monks who were responsible for the ceremony held to celebrate its completion:

> Yŏngch'ŏn-sa Temple at Mount Pisŭl[136]
>
> Pat'ang siju [main donor]: T'ongjŏng taebu [title of an official of
>    the upper third rank], Sumin poch'e.[137]
>
> P'o siju [donor of hemp cloth]: T'ongjŏng taebu, Chŏngjae poch'e.
>
> Hubae siju [donor of mounting]: Ch'wihaeng poch'e.
>
> Nae Chijŏn[138] [keeper of temple interior]: Sŭng'ŏm poch'e.
>
> Woe Chijŏn [keeper of temple exterior]: Chong'an poch'e.
>
> Ch'ae siju [donors of pigments]: those born in the years of
>    *kapsin, ŭlsa, pyŏng'o, chŏngmi* poch'e.[139]
>
> Paekpan siju [donor of alum]: Pŏmhyŏn poch'e.
>
> Chipsa [administrators of monastery]: Ch'wibaek, Inkŭn, Sŭng'ŏm (?) poch'e.

Such inscriptions are often found on Chosŏn Buddhist paintings.[140] In this instance, the inscription is illuminating for the information it provides about the organization of the monastery and the acquisition of materials for the portrait through the contributions of various donors.

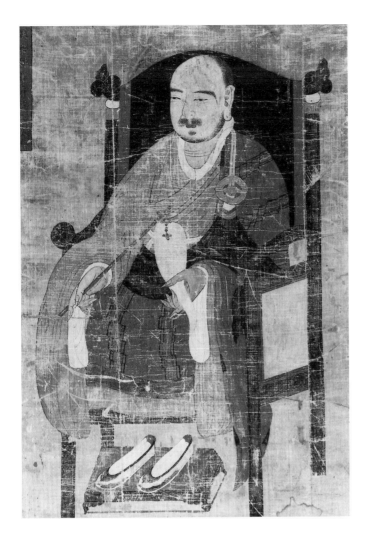

**Figure 28.** Unidentified artist (17th century), *Portrait of Sŏsan Taesa* (Ch'ŏnghŏdang, 1520–1604). Hanging scroll, ink and color on silk, 58 ⅞ × 30 ⅝ in. (149.5 × 77.8 cm). The Metropolitan Museum of Art, Seymour Fund, 1959. 59.19

The birth dates of the donors of the pigments given in the inscription provide an important clue in dating the portrait. The four cyclical dates may be read, at the earliest, as 1604, 1605, 1606, and 1607, respectively.[141] A number of the painting's features strongly support a seventeenth-century date: the subtle tone of the colors and the careful attention to detail, such as the outline of the cloud pattern on the chairback cover, the finely drawn scrolls on the gold fastening pin of the monk's robe, the decoration of the red lacquer handle of the fly whisk, the beautifully worked leather shoes, and, in particular, the red contour lines of the face and hands, which are commonly found in Koryŏ Buddhist paintings. All of these features clearly distinguish the painting from existing Korean Buddhist portraits dated to the eighteenth century.[142]

Portrait paintings of eminent monks, particularly those of patriarchs or founders of schools, were enshrined in Buddhist temples to be revered by disciples. Such portraits, whether executed during the subject's lifetime or after his death, were often an idealized image rather than a commemoration of actual physical appearance.[143] The Metropolitan's painting is one of several surviving copies of a now lost portrait of Sŏsan Taesa executed during the monk's lifetime.[144]

Monochrome landscape painting was favored by both literati and professional court painters in Korea in the fifteenth and sixteenth centuries. A fifteenth-century painting in the collection of the Metropolitan Museum (pl. 85), among the few early Korean landscapes known, is an example of that culture's interpretation of the landscape painting idiom of China's Northern Song dynasty.[145]

The painting's title, *Wild Geese Descending to Sandbar*, identifies the work as one of the Eight Views of the Xiao and Xiang Rivers, a poetic theme traditionally associated with the Northern Song painter Song Di (ca. 1015–ca. 1080) that became a favorite subject for painters not only in Song China but, from the twelfth century onward, in Korea as well.[146]

The distant mountains, the flat riverbanks, and the low hills accented by trees — landscape elements that the artist has carefully organized into distinct ground planes —create a peaceful and expansive vista. The geese descending to a broad sandbank at the foot of the mountains in the distance and the returning fishing boat, seen through a misty haze, suggest an evening scene. Each of these elements is sensitively rendered in differentiated tones of ink and pale ink washes.

Inscribed at the upper right of the painting is the title, followed by a poem that reads:

*On the frozen frontier is a hail of arrows,*
*Along the Golden River [Jinhe]*[147] *there are no rice fields.*
*Brothers one and all, flying down in skeins,*
*After ten thousand li, they arrive at Xiao and Xiang.*
*The distant waters shine like reels of silk,*
*The level sands are white as glinting frost.*
*At the ferry quay, no one is about,*
*Close to the setting sun, the geese descend ever more gracefully.*[148]

The poem is written in irregular verse (Ch. *ci*), a form that was popular during the Song period. The first two lines refer to a hunt in the cold, bleak steppe along China's northern frontier from which the wild geese migrate south, a reference to the conquest of the Song by the Mongols and their subsequent rule of China under the Yuan dynasty.

Wai-kam Ho has pointed out that the open space represented by the "level-distance landscape" is imbued with the "Confucian aesthetic ideal of equilibrium-harmony" and that the visual image of wild geese in flight at sunset suggests the dichotomy of space and time, a concept expressed in Chinese poetry and painting since the third century.[149] The image of descending geese in the distant mountain valley is found in landscape painting as early as the Tang dynasty, in the eighth century, as evidenced in the decoration on the plectrum guard of a *biwa* (*pip'a*; four-stringed lute), now in the Shōsō-in, Nara.[150]

A comparison of the Metropolitan landscape with the hanging scroll *Mountain Market, Clear With Rising Mist* (fig. 29), now in the Ho-Am Art Museum, shows that the two works belong to the same set of Eight Views, painted by an unidentified artist.[151] Not

**Figure 29.** Unidentified artist (late 15th–16th century), *Mountain Market, Clear With Rising Mist.* Hanging scroll, ink on silk, 37 ¾ × 16 ½ in. (96 × 42 cm). Ho-Am Art Museum, Yongin

only are there close similarities in composition, brushwork, and the subtle tones of ink, but the execution of the pine trees in the foreground, the rendering of the buildings, and the modeling of the rocks and mountains with repeated diagonal or vertical strokes and areas of light ink wash reveal the hand of one artist. The relative shortness of the Ho-Am painting suggests that the poem that must have originally been inscribed in the upper left corner was at some point cut off.

Two complete sets of Eight Views paintings in hanging scroll format by Korean artists have survived, one in the collection of Kim Ryong-Doo and the other in Daigan-ji, Hiroshima.[152] Both sets, neither of which bear poems, may be dated to the first half of the sixteenth century. The landscape elements are more formalized, and the contrast between light and dark ink is more stark. In comparison with these paintings, the Metropolitan

and the Ho-Am landscapes retain many of the characteristic features of the painting style associated with the fifteenth-century master An Kyŏn, notably the confidently drawn and firmly rooted pine trees with "crab-claw" branches and the well-controlled thick and thin contour lines of the mountain peaks. These elements, along with the careful attention to pictorial details and the soft, enveloping evening mist, strongly suggest that the Metropolitan painting dates to the late fifteenth century.[153]

### The Influence of *Yangban* Taste on Chosŏn Ceramics

The preeminent social class of the Chosŏn dynasty was the *yangban*, the members of the "two orders" of civil and military officials. Civil officials dominated the political, economic, and cultural life of the period. The yangban, who held the highest positions in government and vigilantly guarded their special privileges, devoted themselves to study and self-cultivation in the Neo-Confucian tradition. They saw as their main role the fashioning of a political and social system based on Confucian ideals, principles, and practices.[154] Of paramount importance in the yangban society were the austere rules governing the ceremonies of ancestral worship and mourning rites.[155]

White porcelain (*paekcha*), which constitutes one of the two main categories of Chosŏn ceramic production (the other being *punch'ŏng* stoneware), was considered an appropriate expression of yangban taste. Associated with purity, the color of the porcelain was especially suitable for objects used by the Confucian-oriented court and yangban households, in particular ritual vessels. During the early Chosŏn period, in the fifteenth century, the official kilns concentrated on the production of pure white undecorated porcelain wares. The restrained beauty of these wares, which were often monumental in size and architectonic in form, testifies to the aesthetic preferences of the aristocracy (see pl. 29).

A small white porcelain wine cup with two handles (pl. 28) in the Metropolitan was used for offering wine on special occasions, such as a memorial ceremony performed at an ancestral altar. The cup would have been held with both hands, as is the custom in East Asian ritual and formal settings. The shape and size of the Metropolitan wine cup are very similar to those of a cup with underglaze cobalt-blue decoration, dated to the fifteenth century, in the Ho-Am Art Museum (pl. 30). Small double-handled wine cups appear to have been produced exclusively for the court and elite yangban households for use in funeral and ancestral rituals. One of the most famous examples is an elegant white porcelain cup with a bluish glaze and two star-shaped handles (fig. 30), excavated from the tomb of Lady Chong (d. 1466), wife of the chief magistrate, Kim Hyo-ro, of Tansŏng, South Kyŏngsang Province.[156]

The white porcelain jar with an underglaze copper-red design of grapevines (pl. 37) represents a type of vessel that was produced during the eighteenth century, probably at a private provincial kiln.[157] Of globular shape, it has a double row of raised lines at the shoulder and an everted rim to which a cloth cover could be secured with string. Such a jar is known as *t'ojuhang* (literally "earth-red" jar) and, according to one scholar, was used

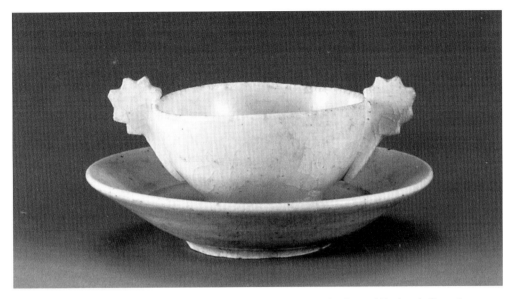

**Figure 30.** Wine cup, Chosŏn dynasty (1392–1910), dated 1466. Porcelain, h. of cup 1 ⅝ in. (4 cm), diam. of saucer at base 1 ¾ in. (4.6 cm). Ho-Am Art Museum, Yongin. National Treasure no. 172

exclusively in ancestral offerings as a container for the finest quality grain.[158] Both the color red and the decoration of vine scrolls symbolize preservation and continuity. The technique of painting in underglaze copper red had been used successfully in Korea since the twelfth century when it was first employed by Koryŏ potters in the decoration of celadon wares.

The limited palette of early Chosŏn ceramics owes much to the dominant Confucian ideology of the time, which favored the modest and restrained qualities of pure white porcelains. Although underglaze blue-and-white decorated wares were produced during this period, their numbers were limited, in part due to the high cost of importing the cobalt blue used in the decoration of these objects, and consequently their use was restricted to the court and yangban households. In the eighteenth century, during the reigns of kings Yŏngjo (r. 1724–76) and Chŏngjo (r. 1776–1800), economic advancements throughout the country led to increased prosperity and a growing demand for blue-and-white porcelains. Indeed, public demand was apparently so great that a court official, in entries to the *Sŭngjŏng-wŏn ilgi* (Diary of the Royal Secretariat) in 1701 and 1702, noted with disapproval that Koreans of the upper and lower classes alike were wasting their money purchasing blue-and-white porcelains of inferior quality imported from China, probably a reference in this instance to the products of local kilns in Zhejiang and Fujian provinces.[159] In response to this expanded market, Korean production of blue-and-white porcelains, using a domestically produced and less expensive cobalt blue, rose sharply along with the production of underglaze iron-brown and copper-red decorated wares. ࣾ

# Endnotes

*"The Art of the Korean Potter: From the Neolithic Period to the Chosŏn Dynasty," by Chung Yang-mo, pp. 220–49*

1. This is confirmed by the excavations at Sang'wŏn-gun, South P'yŏng'an Province. For a discussion of the Paleolithic culture of the Pleistocene period on the Korean peninsula and a general introduction to early Korean culture, see Kim Jeong-hak, *The Prehistory of Korea*, trans. Richard J. Pearson and Kazue Pearson (Honolulu: The University Press of Hawaii, 1978); and Sarah M. Nelson, *The Archaeology of Korea* (Cambridge: Cambridge University Press, 1993).

2. For a detailed discussion and illustrations of early pottery, see Kim Jeong-hak, *The Prehistory of Korea*.

3. The differences in vessel forms gradually diminish, and by the Bronze Age (ca. 10th–ca. 3rd century BCE), flat-bottomed wares are common throughout the Korean peninsula.

4. For the distribution of comb-pattern vessels in Korea, see Kim Jeong-hak, *The Prehistory of Korea*, p. 14, fig. 5.

5. Sarah M. Nelson, *Han River Chulmuntogi* [comb-pattern earthenware], Program in East Asian Studies, Occasional Paper no. 9 (Western Washington State College, 1975).

6. The diverse forms of vessels and decorative techniques that appear at this time include the so-called Misong-ni and Songgung-ni styles; perforated decoration; applied-relief designs; and *p'aeng'i-hyŏng* wares, or vessels in the shape of Korean tops. Red wares, black wares, and painted wares also date from this time.

7. For examples of undecorated (*mumun*) wares of the Bronze Age, see *The National Museum of Korea* (Seoul: The National Museum of Korea, 1991), p. 21.

8. This method of production has been confirmed by the clumps of black lead excavated from the residential site in Poryŏng, Kyosŏng-ni.

9. These sources include *Shanhaijing* (Classic of Mountains and Seas); *Zhanguo ce* (Chronicles of the Warring States); *Wei ji* (Records of the Wei Dynasty); and *Hou Han shu* (History of the Later Han Dynasty). See Sarah M. Nelson, *The Archaeology of Korea*, pp. 165–68.

10. For a historical overview of the Three Kingdoms period, see Lee Ki-baik, *A New History of Korea*, trans. E.W. Wagner and E.J. Shultz (Seoul: Ilchogak; Cambridge: Harvard University Press, 1984), pp. 36–65.

11. See *Kwangju Hwadong kobun* (Ancient Tombs of Hwadong, Kwangju) (Kwangju: Kwangju National Museum, 1996).

12. Roderick Whitfield, ed., *Treasures from Korea: Art Through 5000 Years* (exh. cat., London: British Museum Publications, 1984), p. 54.

13. See Hong Yun-gi, *Han'guk in i mandŭn Ilbon kukpo* (Japanese Treasures Made by Koreans) (Seoul: Munhwa segye-sa, 1995).

14. For a historical overview of the Unified Silla period, see Lee Ki-baik, *A New History of Korea*, pp. 66–91.

15. Xu Jing, *Xuanhe fengshi Gaoli tujing* (Illustrated Record of the Chinese Embassy to the Koryŏ Court During the Xuanhe Era), ch. 32, "Dishes and Tableware" (Seoul: Asia munhwasa, 1972).

16. Taiping Laoren, "Xiuzhongjin," in ed. Cao Rong (1613–1685), *Xuehai leibian*.

17. For a discussion of Southern Song painting and the role of nature and naturalism, see James Cahill, "The Imperial Painting Academy," in eds. Wen C. Fong and James C.Y. Watt, *Possessing the Past: Treasures from the National Palace Museum, Taipei* (New York: The Metropolitan Museum of Art, and the National Palace Museum, Taipei, 1996), pp. 159–99, especially pp. 160–73.

18. For a detailed treatment of developments in various areas of Korean art during this period, see Kim Hongnam, ed., *Korean Arts of the Eighteenth Century: Splendor and Simplicity* (New York: The Asia Society, 1993).

19. See in this volume Yi Song-mi's discussion of the origin and development of true-view landscape painting in Korea.

20. For a discussion of Confucian rites of the time, see Kang Woo-bang, "Ritual and Art During the Eigh-

teenth Century," in ed. Kim Hongnam, *Korean Arts of the Eighteenth Century*, pp. 79–98.

21. In the fifteenth and sixteenth centuries, dishes made specifically for ancestor rites were used only by the royalty or in the national Confucian shrines. In other cases, such rituals were performed using regular dishes that were embellished with the character *che* or had slightly higher bases.

22. The lotus-petal borders at the neck and bottom of this jar are quite similar to those found on blue-and-white and red-and-white Chinese porcelains of the fourteenth and fifteenth centuries. These Chinese-style borders gradually decline in importance in Korean ceramic design, until they disappear altogether.

*"Tradition and Transformation in Korean Buddhist Sculpture," by Kim Lena, pp. 250–93.*

1. In the original form of this mudra, the hands are held with the palms up. See Kim Wŏn-yong, "An Early Chinese Gilt-bronze Seated Buddha from Seoul," *Artibus Asiae*, vol. 23, no. 2 (1960), pp. 67–71.

2. For the Tokyo piece, see Matsubara Saburō, *Zōtei Chūgoku bukkyō chōkokushi kenkyū* (Chinese Buddhist Sculpture) (hereafter cited as Matsubara, *Zōtei Chūgoku*) (Tokyo: Yoshikawa Kobunkan, 1966), pl. 7(b). Another very similar piece was excavated near Shijiazhuang, Hebei Province, and is illustrated in Akiyama Terukazu and Matsubara Saburō, *Arts of China: Buddhist Cave Temples*, trans. Alexander C. Soper (Tokyo: Kodansha, 1969), pl. 188.

3. This tomb painting and its Buddha image were first published in Chinese, "Ji'an Changchuan yihao bihuamu" (Wall Paintings of Changch'ŏn Tomb No. 1 at Chiban), *Dongfang kaogu yu lishi*, vol. 1 (1982), pp. 154–73. Since then several major exhibitions on Koguryŏ wall paintings, including a reconstruction of the Changch'ŏn Tomb no. 1 murals, have been held in Korea. See *Chiban Koguryŏ kobun pyŏkhwa* (The Wall Paintings of Koyuryŏ Tombs at Chiban) (Seoul: Chosŏn ilbo-sa, 1993), pls. 49–71.

4. The National Museum of Korea, *Samguk sidae pulgyo chogak* (Buddhist Sculpture of the Three Kingdoms Period), hereafter cited as National Museum, *Samguk* (exh. cat., Seoul: The National Museum of Korea, 1990), pl. 4.

5. Su Bai, "Nanchao kanxiang yiji chutan" (A Preliminary Study of Buddhist Niches: Images of the Southern Dynasties), *Kaogu xuebao*, no. 95 (April 1989), pp. 389–414. This article is reprinted in Su Bai, *Zhongguo shikusi yanjiu* (Studies of Chinese Cave Temples) (Beijing: Cultural Relics Publishing House, 1996), pp. 176–99. See also Kim Lena,

"Paekche ch'ogi pulgyo yangsik ŭi sŏngnip kwa Chungguk pulsang" (The Establishment of Buddhist Sculptural Style in Early Paekche and Its Relationship with Chinese Buddhist Sculptures), in *Paekchesa ŭi pigyo yŏn'gu* (Comparative Studies of Paekche History) (Taejŏn: Institute of Paekche Studies, Ch'ungnam University, 1993), pp. 23–171.

6. Akiyama and Matsubara, *Arts of China: Buddhist Cave Temples*, pl. 157.

7. Alexander Soper, "South Chinese Influence on the Buddhist Art of the Six Dynasties Period," *Bulletin of the Museum of Far Eastern Antiquities*, 32 (1960), pp. 47–140. See also Yoshimura Rei, "Nambokuchō bukkyō yōshiki shiron" (A Historical Study of the Style of Buddhist Figures in the Northern and Southern Dynasties), *Kokka*, vol. 1066 (Aug. 1983), pp. 1–10. The same article also appeared in Yoshimura Rei, *Chūgoku bukkyō zuzō no kenkyū* (A Study of the Iconography of Buddhist Art in China) (Tokyo: Toho Shoten, 1983), pp. 177–97. See also Yang Hong, "Shilun Nanbei Chao qianqi foxiang fushi de zhuyao bianhua" (A Study of the Major Changes in the Garments of Early Buddhist Sculptures of the Northern and Southern Dynasties), *Kaogu*, no. 189 (June 1983), pp. 330–37.

8. Mizuno Keisaburō et al., *Hōryū-ji: Kondō Shakasanzon* (The Shakyamuni Triad in the Golden Hall, Hōryū-ji Temple) (Tokyo: Iwanami Shoten, 1974), pls. 2–5, 18–21.

9. This sculpture is in the Puyŏ National Museum. See National Museum, *Samguk*, pl. 17.

10. The Buddha illustrated in pl. 61 can also be compared with a similar bronze piece that was discovered at the temple site of Hwangnyong-sa, Kyŏngju, and that is probably the earliest extant example of the type discovered in Silla territory (National Museum, *Samguk*, pl. 55). Comparisons can also be made with Chinese counterparts of these statues from the Eastern Wei period, in the second quarter of the sixth century.

11. National Museum, *Samguk*, pl 4. See also Kim Chewon and Lena Kim Lee [Kim Lena], *Arts of Korea* (Tokyo: Kodansha, 1974), pl. 3.

12. National Museum, *Samguk*, pl. 20; Kim and Lee, *Arts of Korea*, pl. 2.

13. *5000 Years of Korean Art* (San Francisco: Asian Art Museum of San Francisco, 1979), pl. 70; Kim Wŏn-yong et al., *Korean Art Treasures* (Seoul: Yekyong Publications Co., 1986), pl. 60; National Museum, *Samguk*, pl. 6.

14. Matsubara Saburō, "Santōsho shutsudo no butsuzō" (Buddhist Images in Shandong Province), *Kobijutsu*, 99 (July 1991), pp. 72–77; Matsubara Saburō, "Shojoha sekizōko—Nanboku yōshikizō no ichi ni tsuite" (A Study of the Stone Images

from Zhucheng and the Statue Styles of the Northern and Southern Dynasties), *Kobijutsu*, 103 (Aug. 1992), pp. 69–76.

15. Jonathan W. Best, "Diplomatic and Cultural Contacts between Paekche and China," *Harvard Journal of Asiatic Studies*, vol. 42, no. 2 (1982), pp. 443–501; Okada Ken, "Bukkyō chōkoku ni okeru Chōsenhantō to Chūgoku Shantōbantō no kankei" (The Relationship between the Korean Peninsula and the Chinese Shandong Peninsula in Connection with Buddhist Sculptures), in Nara National Museum, *A Report of Joint Research on Korean Buddhist Arts in Japanese and Korean Areas* (1990–93), pp. 11–18.

16. Tokyo National Museum, *Kondōbutsu* (Gilt-bronze Buddhist Statues: China, Korea, Japan) (exh. cat. Tokyo: Tokyo National Museum, 1988), pl. 22; Nara National Museum, *Bosatsu* (Bodhisattvas) (exh. cat., Nara: Nara National Museum, 1987), pl. 55. See also Kim Lena, "Samguk sidac ŭi pongji-bojuhyŏng posal ipsang yŏn'gu" (A Study of Three Kingdoms Bodhisattva Images Holding a Jewel with Both Hands), *Misul charyo*, no. 37 (Dec. 1985), pp. 1–41; Kim Lena, "Hoshu hoji bosatsu no keifu" (On the Lineage of Bodhisattva Images Holding a Jewel), in *Nihon bijutsu zenshū: Hōryū-ji kara Yakushi-ji* (Complete Collection of Japanese Art: From Hōryū-ji to Yakushi-ji) (Tokyo: Kodansha, 1990), pp. 195–200.

17. The first publication of the Chengdu Wanfosi images was by Liu Jiyuan and Liu Jingbi, eds., *Chengdu Wanfosi shige yishu* (Stone Buddhist Sculptures from Wanfosi, Chengdu) (Beijing: Cultural Relics Publishing House, 1958). See also Matsubara Saburō, "Chūgoku Nanchō chōzō shiryō kō" (A Study of Chinese Images from South China), *Bukkyō geijutsu*, no. 130 (May 1980), pp. 66–76; and Yoshimura Rei, "Nihon sōki bukkyō ni okeru Ryō Kudara yōshikino eikyō" (Chinese Liang and Korean Paekche Influences on Early Japanese Buddhist Sculptures), *Bukkyō geijutsu*, no. 201 (April 1992), pp. 29–50.

18. This figure is one of the forty-eight gilt-bronze statues of the Hōryū-ji Temple in the Tokyo National Museum (see Tokyo National Museum, *Kondōbutsu*, pl. 59). See also Tokyo National Museum, *Hōryū-ji gennō hōmotsu* (Special Exhibition of Treasures from the Hōryū-ji Temple) (exh. cat., Tokyo: Tokyo National Museum, 1996), pl. 139.

19. The undergarment, known as *pyŏnsam*, has figured as a subject of debate in discussions of early Chinese, Korean, and Japanese images. See Ōnishi Shuya, "Kudarabutsu saikō — shin hakken no kudara sekibutsu to hensan o chakuyōshita fukusei o megutte" (Reconsideration of Paekche Buddhist Images: On the *Pyŏnsam* of Paekche Stone Buddhist Images), *Bukkyō geijutsu*, no. 149 (Aug. 1983), pp. 11–27; Kim Ch'un-sil, "Samguk sidae simuoe yŏwŏn-in yŏrae chwasang ko" (Seated Buddha Images with Abhaya and Varada Mudras in the Three Kingdoms Period), *Misulsa yŏn'gu*, no. 4 (1990), 1–39.

20. Jonathan Best, "The Sŏsan Triad," *Archives of Asian Art*, vol. 33 (1980), pp. 89–108.

21. See Tokyo National Museum, *Kondōbutsu*, pl. 59; and Kang Woo-bang, "Kŭmdong Irwŏl-sik samsan'gwan sayusang-go" (Gilt-bronze Pensive Images with Crown Combined with Sun and Moon), *Misul charyo*, no. 30 (June 1982), pp. 1–32; no. 36 (Dec. 1982), pp. 1–21.

22. Iryŏn, "Hwangnyong-sa changnyuk-jonsang" (The Hwangnyong-sa Sixteen-foot Buddha), in *Samguk yusa* (Memorabilia of the Three Kingdoms), book 3, chapter 4, "T'apsang" (Pagodas and Buddhist Images). The *Samguk yusa*, one of the earliest surviving histories, by the Korean monk Iryŏn, has been translated by Ha Tae-hŭng and Grafton K. Mintz as *Samguk Yusa: Legend and History of the Three Kingdoms of Ancient Korea* (Seoul: Yŏnsei University Press, 1972). See entry 70, pp. 205–207, for the Hwangnyong-sa image. See also Kim Lena, "Hwangnyong-sa ŭi changnyuk-jonsang kwa Silla ŭi Ayugwang-sang kye pulsang" (The Sixteen-foot Buddha of Hwangnyong-sa and Silla Images Following the King Ashoka-type Buddha), *Chindan hakpo*, nos. 46–47 (June 1979), pp. 195–215. This article is reprinted in Kim Lena, *Han'guk kodae pulgyo chogaksa yŏn'gu* (A Study of Buddhist Sculptures of Ancient Korea) (Seoul: Ilchogak, 1989), pp. 61–84.

23. Earlier, this date was given as 577. See *Chinese Art in the Royal Ontario Museum*, (Toronto: Royal Ontario Museum, 1972), pl. 105. A gilt-bronze Buddha triad from the Sui dynasty, bearing the date 597, now in The Freer Gallery of Art, Washington, D.C., may offer a better comparison; see *The Freer Gallery of Art: I China* (Tokyo: Kodansha, 1972), pl. 118.

24. Several Three Kingdoms gilt-bronze images of this Yangp'yŏng type, with minor variations in the treatment of the garment, are known. See Kim Ch'un-sil, "Samguk sidae yŏrae ipsang yangsik ŭi chŏn'gae: yuksegi-mal ch'ilsegi-ch'o rŭl chungsimŭro" (A Study of the Style of Standing Buddha Images of the Three Kingdoms Period: Late Sixth to Early Seventh Century), *Misul charyo*, vol. 55 (June 1995), pp. 10–41.

25. Kim Ch'un-sil, "Samguk sidae ŭi kŭmdong Yaksa-yŏrae ipsang yŏn'gu" (A Study of the Standing Gilt-bronze Bhaishajyaguru Buddha Statues of the

Three Kingdoms Period), *Misul charyo*, no. 36 (June 1985), pp. 1–24.

26. For the Hwangnyong-sa image, see National Museum, *Samguk*, pl. 57. For Suksu-sa, see Kim Chewon, "Shukusui-ji shutsudo no butsuzō ni tsuite" (On Buddhist Images Discovered at the Temple Site of Suksu-sa), *Bijutsu kenkyū*, no. 200 (1958), pp. 104–21, pl. 3.

27. *Haedong kosŭng-chŏn* (Lives of Eminent Korean Monks), Yut'ong section, "Anham" entry, written in 1215 by Kakhun. See Peter H. Lee, trans., *Lives of Eminent Korean Monks: The Haedong kosŭng chŏn* (Cambridge: Harvard University Press, 1969), pp. 83–88. The names of three monks are mentioned in this entry: Pimozhendi, from Khotan (or Udyana in northern India); Nongjiatuo, from an unidentified place; and Fotuosengjia, from Mathura, India.

28. For example, an impressively large rock-cut relief at Pukchi-ri, Ponghwa, in North Kyŏngsang Province, much of the surface modeling of which has been destroyed. See Hwang Su-young, ed., *Kukpo 2: Kŭmdongbul, maaebul* (The National Treasures of Korea, 2: Gilt-bronze Buddhas and Rock-Carved Buddhas) (hereafter cited as *Kukpo 2: Kŭmdongbul, maaebul*) (Seoul: Yekyong Publications Co., 1984), pl. 130. From Chung'wŏn in North Ch'ungch'ŏng Province come two rock-surface reliefs at Ponghwang-ni and one free-standing Buddha triad in stone at Pijung-ni. See Kim Ch'un-sil, note 25.

29. This statue is now in the Anko-in Temple, Nara.

30. A gilt-bronze bodhisattva statue reminiscent in type and style of the Kyuam-ni bodhisattva from Paekche, especially in the elongated body and the X-crossing of the jewel ornamentation, comes from Sŏnsan, North Kyŏngsang Province. The craftsmanship of the Sŏnsan piece is finer, however, and the face and body are more fully modeled. The Sŏnsan figure is considered to be a Silla piece, which suggests the similarity of the iconography between Silla and Paekche in the late phase of the Three Kingdoms period or, what also may have been the case, the close connections between the two Buddhist communities. Kim Wŏn-yong et al., *Korean Art Treasures*, pls. 71, 72; *Kukpo 2: Kŭmdongbul, maaebul*, pl. 37–38.

31. Jan Fontein and Tung Wu, *Unearthing China's Past* (Boston: Boston Museum of Fine Arts, 1973), entry no. 73, pp. 152–54.

32. Now in the Ho-Am Art Museum. See Kim and Lee, *Arts of Korea*, pl. 38; *Kukpo 2: Kŭmdongbul, maaebul*, pl. 2; National Museum, *Samguk*, pl. 12.

33. Kim and Lee, *Arts of Korea*, pl. 39; National Museum, *Samguk*, pl. 37. The piece is also often compared with Japanese pensive bodhisattva statues that are presumably of Paekche origin. One is in

the temple of Jōrin-ji, Tsushima, which, like the Mount Puso piece, is broken off at the waist but clearly shows a similar drapery pattern. See Ōnishi Shūya, "Tsushima Jōrin-ji no tozo hankazō ni tsuite" (On the Bronze Pensive Bodhisattva of Jōrin-ji Temple, Tsushima), in Tamura Encho and Hwang Su-young, ed., *Hankashiyuzō no kenkyū* (A Study of Pensive Bodhisattva Images) (Tokyo: Yoshikawa Kobunkan, 1985), pp. 307–26; Ōnishi Shuya, "Kudara hankazō no keifu ni tsuite" (On the Lineage of Paekche Pensive Bodhisattva Images), *Bukkyō geijutsu*, no. 157 (Jan. 1985), 53–79. Another gilt-bronze statue, in the collection of the Kanso-in, Nagano Prefecture, is also considered to be of Paekche origin on the basis of drapery pattern and facial expression. See Nara National Museum, *Bosatsu*, pl. 40.

34. Kim and Lee, *Arts of Korea*, pl. 44; *Kukpo 2: Kŭmdongbul, maaebul*, pls. 30–32.

35. An almost identical pensive bodhisattva as National Treasure no. 83, but in granite, was found in Ponghwa, North Kyŏngsang Province. The statue is carved in the round, but all that remains is the lower half, which measures 150 centimeters, indicating that it was once a part of a large statue almost 3 meters high. A statue of this size must have held special importance for the Buddhist community of the time, and its resemblance to National Treasure no. 83 indicates that the latter might also have been made in the Silla kingdom. See Kim and Lee, *Arts of Korea*, pl. 45; Hwang Su-young, ed., *Kukpo 4: Sŏkpul* (The National Treasures of Korea, 4: Stone Buddhas) (hereafter cited as *Kukpo 4: Sŏkpul*) (Seoul: Yekyong Publications Co., 1984), pl. 16.

36. Iwazaki Kazuko, "Kōryū-ji hokan miroku ni kansuru ni, san no kōsatsu" (Problems Concerning the Crowned Bodhisattva of Kōryū-ji Temple), in Tamura and Hwang, *Hankashiizō no kenkyū*, pp. 199–227; Iwazaki Kazuko, "Kankoku Kokuritsu Chūō Hakubutsukan (Sōtokufu Hakubutsukan) zō kondō hankashiizō ni tsuite" (On the Pensive Bodhisattva Images in the Collection of The National Museum of Korea [formerly the Museum of the Government General]), in *Ronsō bukkyō bijutsushi* (Articles on the History of Buddhist Art in Commemoration of the Seventieth Birthday of Machida Kōichi) (Tokyo: Yoshikawa kobunkan, 1986), pp. 251–73. Tamura Enchō, "Hankashiizō no shō mondai" (Problems of Pensive Bodhisattva Images), in Tamura and Hwang, *Hankashiizō no kenkyū*, pp. 3–44.

In Silla, during the late sixth and early seventh century, the government organized a group of young men of the aristocracy, known as the

*hwarang* (flower youth), as part of the military. As future leaders who would one day defend the nation against foreign invaders, the members of this group schooled themselves in political ethics and martial arts. Records reveal that the leader of the hwarang was regarded as an incarnation of Maitreya. Because of this, it has been suggested that large-size statues of this pensive bodhisattva were enshrined as major images of worship in Silla temples. The presence of large images, such as the Ponghwa statue mentioned in note 35 above or another headless stone statue of a pensive bodhisattva discovered at the foot of Mount Songhwa, Kyŏngju (now in the Kyŏngju National Museum, see *Kukpo 4: Sŏkpul*, pl. 17), tends to support such an assumption. At Mount Tansŏk, near Kyŏngju, which is associated with the famous general and member of the hwarang, Kim Yu-sin, there is a group of rock-cut images that represents Maitreya in the form of both a pensive bodhisattva and a Buddha.

37. See Hwang Su-young, "Silla Namsan Samhwa-ryŏng Mirŭk sejon" (The Maitreya Buddha Triad of Silla from Samhwa-ryŏng, Namsan), in *Kim Chewon paksa hoegap kinyŏm nonch'ong* (Festschrift for the Sixtieth Birthday of Dr. Kim Chewon) (Seoul: Ŭryu munhwasa, 1969); this article is reprinted in Hwang Su-young, *Han'guk ŭi pulsang* (Buddhist Sculptures of Korea) (Seoul: Munye ch'ulp'ansa, 1989), pp. 309–39.

38. Iryŏn, "Saeng'ŭi-sa sŏk mirŭk" (Stone Maitreya at Saeng'ŭi-sa), in *Samguk yusa*, book 3, chapter 4, "T'apsang."

39. Iryŏn, "Kyŏngdŏk-wang, Ch'ungdam-sa, P'yohun-taedŏk" (King Kyŏndŏk, Monk Ch'ungdam, Abbot P'yohun), in *Samguk yusa*, book 2, chapter 2, "*Kii*" (Strange Stories).

40. See Tokyo National Museum, *Tokubetsuten Kudara Kannon* (Special Exhibition of the Paekche Avalokiteshvara Statue from the Hōryū-ji Temple) (Tokyo: Tokyo National Museum, 1988).

41. The *Da Tang jiufa gaosengzhuan* (Records of Prominent Tang Dynasty Monks Who Went on Pilgrimage to Western Regions), a travel account of the Tang pilgrim Yijing, who traveled to India between 671 and 695, mentions several Korean monks, including two Silla monks who died on an island in the South Sea on their way to India. The original text is in the *Daizōkyō* (Buddhist Tripitaka), vol. 51, 1–12 (T. 2066). It has been translated with annotation by Adachi Kiroku into Japanese as *Daitō saiiki guhō kōsōden* (Tokyo: Iwanami Shoten, 1942). Yijing's account was also known to the Koryŏ monk Kakhun, who freely adapted it in his work. See Peter Lee, *Lives of Eminent Korean*

*Monks*, pp. 89–98, and *Samguk yusa*, book 4, chapter 5, "Kwich'uk chesa" (Several Monks Who Returned from India).

The Silla monk Hyech'o traveled to India in the early eighth century and also left a valuable record of his journeys to the Five Indies, entitled *Wang-O-ch'ŏnch'ukkuk chŏn*. Little is otherwise known about these Silla monks except for Hyech'o, who was still active in the Tang capital Chang'an in the 780s. Studies of Hyech'o in Western languages include: W. Fuchs, *Huei-ch'aos Pilgerreise durch Nordwest Indien und Zentral-Asian um 726* (Hyech'o's Pilgrimage through Northwest India and Central Asia in 726) (Berlin, 1926); Jan Yun-hua, "Hui Ch'ao and His Works: A Reassessment," *Indo-Asia Culture* (New Delhi), vol. 12, no. 3 (1963–63), pp. 177–90; Jan Yun-hua, "The Korean Record on Varanasi and Sarnath," *Vishveshvaran and Indological Journal*, vol. 4, pt. 2 (Sept. 1966), pp. 264–72.

42. Examples are several soapstone stelae that were discovered in the Yŏn'gi district in South Ch'ungch'ŏng Province. Inscriptions on these stele, with dates corresponding to 673, 678, and 689, inform us that the images, mostly Amitabha Buddhas, were made for officials of the fallen Paekche kingdom. See Hwang Su-young, "Ch'ungnam Yŏn'gi sŏksang chosa" (Study on the Buddhist Stele from Yŏn'gi South Ch'ungch'ŏng Province), first published in *Yesulwŏn nonmun-jip*, vol. 3 (1964), pp. 67–96, reprinted in Hwang, *Han'guk ŭi pulsang*, pp. 233–272. For illustrations see *Kukpo 4: Sŏkpul*, pls. 20–31.

43. Matsubara Saburō, "Shiragi sekibutsu no keifu — tokuni shin hakken no gun'i, sekibutsu sanzon butsu o chūsin to shite" (Trends in Buddhist Stone Images of Silla with Special Reference to the Triad found at Kunwi), *Bijutsu kenkyū*, no. 250 (Jan. 1967), pp. 173–93.

44. Kang Woo-bang, "Sach'ŏnwangsa-ji ch'ult'o ch'aeyu sach'ŏnwang pujosang ŭi pogwŏnjŏk koch'al" (Restoration of Four Guardians from the Temple Site of Sach'ŏnwang-sa, Kyŏngju), *Misul charyo*, no. 25 (Dec. 1979), pp. 1–46. This article is reprinted in Kang Woo-bang, *Wŏnyung kwa chohwa: Han'guk kodae chogaksa ŭi wŏlli* (Infinite Interpenetration and Harmony: The Principles of Ancient Korean Sculpture) (Seoul: Yŏrhwadang Publishing, 1990), pp. 159–201.

45. *Chūgoku sekkutsu, Ryūmon sekkutsu* (Chinese Cave Temples, Longmen Caves), vol. 2 (Tokyo: Heibonsha, Bunbutsu shuppansha [Wenwu chubanshe], 1988), pls. 111, 118, 119.

46. See Kim Chewon and Yŏng Mu-byŏng, *Kamŭnsa-ji palgul chosa pogosŏ* (Kamŭn-sa, a Temple Site of the Silla Dynasty), Special Report of The National

Museum of Korea, vol. 2, (Seoul: Ŭryu Publishing Co., 1961); and Kim and Lee, *Arts of Korea*, pl. 56–59. Although the findings of the East Pagoda have not yet been officially published, they have been reported by The National Research Institute of Cultural Properties, in *Pojon kwahak yŏn'gu*, no. 18 (1997), pp. 205–15. Kim Tong-hyŏn, director of the Research Institute, has kindly provided me with photographs for use in this essay. For similar figures at Fengxiansi, discussed below, see *Chūgoku sekkutsu, Ryūmon sekkutsu*, pls. 112, 127, 128. For another example of a reliquary, see pl. 46 in this volume.

47. Kang Woo-bang, "Anap-chi ch'ult'o pulsang" (Buddhist Images from the Anap-chi Pond in Kyŏngju), in *Anap-chi pogosŏ* (Excavation Report of the Anap-chi Pond) (Seoul: Office of Cultural Properties, 1978), pp. 259–81. Reprinted in Kang Woo-bang, *Wŏnyung kwa chohwa*, pp. 202–48.

48. The iconography of the preaching Buddha was in vogue in India during the Gupta period (4th–6th century): besides many statues in the Ajanta caves, there is the famous stone image of the Buddha's first sermon in the Sarnath Museum. See Benjamin Rowland, *Art and Architecture of India* (Baltimore: Penguin, 1953), pl. 83. Many painted versions exist in China: in the Dunhuang wall paintings of cave 332, for example, which depict Amitabha Buddha in a scene from the Western Paradise with the same preaching posture.

49. Tokyo National Museum, *Hōryū-ji gennō hōmotsu*, pls. 183–85, 187.

50. This piece and other objects found with it, in August 1995, have not been officially published. Kim Tong-hyŏn, director of The National Research Institute of Cultural Properties, has kindly granted permission to illustrate the mold in this article. For a report on the findings at the site, see *Pojon kwahak yŏn'gu*, no. 18 (1997), pp. 242–48.

51. These statues were a part of an inscribed Buddhist reliquary enshrined inside the pagoda, which was erected in 692 at the wish of King Hyoso (r. 692–702) for his deceased predecessor King Sinmun (r. 681–92). When King Hyoso died, the sharira case with an Amitabha Buddha image and the text of the Buddhist law was reinstalled in 706 by his son King Sŏngdŏg (r. 702–37). See Kim Chewon, "The Stone Pagoda of Kuhwang-ni in South Korea," *Artibus Asiae*, vol. 13, nos. 1/2 (1950), pp. 296–302; Umehara Sueji, "Kankoku Keishu Kōfuku-ji to hakken no shari yōki" (The Sarira Reliquary Discovered at the Pagoda of the Hwangbok-sa Temple, Kyŏngju, Korea), *Bijutsu kenkyū*, no. 156 (1950), 31–47.

52. *Kukpo 2: Kŭmdongbul, maaebul*, pl. 41–43.

53. *Kukpo 4. Sŏkpul*, pl. 38.

54. Kim Lena, "Shiragi Kanzanji nyōrai shiki butsuzō no imon to Nihon butsuzō to no kankei" (Buddha Images of the Kamsan-sa Type: Variations and Relationship with Japanese Examples), *Bukkyō geijutsu*, no. 110 (Dec. 1976), pp. 3–24; a Korean version of this article appears in Kim Lena, *Han'guk kodae pulgyo chogaksa yŏn'gu*, pp. 206–38.

55. Matsubara Saburo, *Zōtei Chūgoku*, pls. 256–59.

56. Akiyama Terukazu and Tsujimoto Yonesaburō, *Hōryū-ji, Tamamushi zushi to Tachibana Fujin zushi* (Hōryū-ji: The Tamamushi Shrine and Tachibana Fujin Shrine) (Tokyo: Iwanami Shoten, 1975), pls. 32–36.

57. *Taizokyo* (The Complete Text of the Buddhist Tripitaka), vol. 51, pp. 915–16. See also Samuel Beal, *Si-yu-ki [Xiyouji] Buddhist Records of the Western World* (repr., Delhi: Molital Banarsidass, 1981), pp. 114–21.

58. When imperial envoy Wang Xuance visited the site for the second time in 660, his third out of four trips to India, he paid special tribute to the image by holding a ceremony and had a professional artist copy the image. See Sylvian Levi, "Les Mission de Wang Hsuen-Ts'e dans l'Inde," *Journal Asiatique*, vol. 15 (Mar.–Apr. 1900), pp. 297–341; vol. 15 (May–June 1900), pp. 401–68. On Wang Xuance, see Feng Chengdiao, "Wang Xuance shi ji" (The Historical Record Concerning Wang Xuance), *Qinghua xuebao*, 8 (1932), pp. 1–90. See also Kim Lena, "Indo pulsang ŭi Chungguk chŏllaego" (On Indian Images Brought to China), in *Han U-gŭn paksa chŏngnyŏn kinyŏm sahak nonch'ong* (Collection of Historical Studies Commemorating the Retirement of Professor Han U-gŭn) (Seoul: Chisik sanŏp-sa, 1981), pp. 731–52. This article also appears in Kim Lena, *Han'guk kodae pulgyo chogaksa yŏn'gu*, pp. 270–90).

59. Articles on this subject include Sugiyama Saburō, "Hokei-ji sekibutsu kenkyū chōsetsu" (Introduction to the Study of the Baojingsi Temple Stone Sculptures), *Tōkyō Kokuritsu Hakubutsukan kiyō*, no. 13 (1978), pp. 241–91, and Kim Lena, "Chungguk ŭi hangmach'okchi-in pulchwasang" (Chinese Seated Buddha Images with Bhumisparsha Mudra), in *Han'guk kodae pulgyo chogaksa yŏn'gu*, pp. 291–336.

60. For the history of this monument, see *Samguk yusa*, book 3, chapter 4, "Sabulsan Kulbulsan Manbulsan," and Kim Lena, "Kyŏngju Kulbulsa-ji ŭi samyŏnsŏkpul e taehayŏ" (On the Four-sided Stone Buddhist Images at the Temple Site of Kulbul-sa, Kyŏngju), *Chindan hakpo*, no. 39 (1975), pp. 43–68. This article also appears in Kim Lena, *Han'guk kodae pulgyo chogaksa yŏn'gu*, pp. 239–68, and in Japanese in *Kobijutsu*, no. 52 (1977), pp.

102–17. For illustrations, see Kim and Lee, *Arts of Korea*, pls. 71–73; *Kukpo 2, Kŭmdongbul, maaebul*, pls. 135–38.

61. Kim and Lee, *Arts of Korea*, pl. 73.

62. *Samguk yusa*, book 5, chapter 9, "Tae-sŏng hyo ise pumo shinmundae" (Tae-sŏng Shows Filial Piety to His Parents of Present and Past Births).

63. For illustrations of the cave and its images, see Hwang Su-young, *Sŏkkuram* (Seoul: Yekyong Publications Co., 1989). See also Kang Woo-bang, "Sŏkkuram e ung'yongdoen 'chohwa ŭi mun'" ("La Porte d'Harmonie" Applied to the Sŏkkuram Monument: Proportion and Pratitya-samutpada), *Misul charyo*, no. 38 (Jan. 1987), pp. 1–28. The same article also appears in Kang Woo-bang, *Wŏnyung kwa chohwa*, pp. 356–81, and a similar version in Japanese as "Tōitsu shiragi no Kengon-kyō bijutsu-Sekkutsuan to kegonkyō hensōzu" (The Arts of the Avatamsaka Teaching in the Unified Silla Period: The Sŏkkuram and Sutra Painting of the Avatamsaka Texts), *Nihon bijutsu zenshū*, vol. 4: *Tōdai-ji to Heijō-kyō* (Tokyo: Kodansha, 1990), pp. 196–201.

64. Although this statue was originally found at Sŏngnam-sa, it is now in Naewŏn-sa Temple, Sanch'ŏng, North Kyŏngsang Province. It was first published by Pak Kyŏng-wŏn, "Yŏngt'ae inyŏn-myŏng sŏkcho Pirosana chwasang" (Stone Seated Buddha Statue of Vairochana from the Second Year of Yŏngt'ae, 776), *Kogo misul*, no. 168 (Dec. 1985), pp. 1–21. See also Kang Woo-bang, "Han'guk Pirosana bulsang ŭi sŏngnip kwa chŏn'gae" (Iconographic and Stylistic Development of Vairochana with the *Bodhyagri* Mudra in Korean Buddhist Sculpture), *Misul charyo*, no. 4a (Dec. 1989), pp. 1–66, reprinted in Kang Woo-bang, *Wŏnyung kwa chohwa*, pp. 282–304. The present writer hesitates to accept Kang's suggestion that the bodhyagri mudra of the Vairochana Buddha originated in Silla since the iconography probably came from Tang China.

65. Two images in the Pulguk-sa Temple, a fine gilt-bronze Vairochana Buddha and an Amitabha Buddha, show similar craftsmanship. The present writer once suggested that the two images were possibly part of a set of five directional Buddhas in the esoteric Buddhist mandala. However, in Unified Silla the concept of the Mahavairochana Buddha with four directional Buddhas seems not to have been developed as it was in the Shingon sect in Japan. Kim and Lee, *Arts of Korea*, p. 77. For illustrations, see *Kukpo 2, Kŭmdongbul, maaebul*, pls. 49–50. These statues and one life-size standing Buddha of Medicine, originally from Paengnyul-sa Temple but now displayed in the Kyŏngju National Museum (*Kukpo 2: Kŭmdongbul, maaebul*, pls. 53–4; Kim and Lee, *Arts of Korea*, pl. 108), are among the last representative large-size images in bronze from the late Unified Silla period, when stone or iron became the more common media for large-size statues.

66. Other iron examples include the early-ninth-century Medicine Buddhas at Silsang-sa Temple, Namwŏn, South Chŏlla Province, and Hanch'ŏn-sa Temple, Yech'ŏn, North Kyŏngsang Province, and the Vairochana Buddha at Porim-sa Temple, Changhŭng, South Chŏlla Province, dated 858. *Kukpo 2, Kŭmdongbul, maaebul*, pls. 68–72.

67. Hwang Su-young. "Silla Minae-daewang sŏkt'apki — Tonghwa-sa Piro-am samch'ŭngsŏkt'ap ŭi chosa" (The Inscription of the Stone Pagoda of the Great King Minae of the Silla Dynasty: An Investigation of the Three-story Stone Pagoda at Piro-am of Tonghwa-sa), *Sahakchi*, no. 3 (July 1969), 53–86.

68. *Kukpo 4, Sŏkpul*, pls. 98–100.

69. This late stylistic phase of Unified Silla Buddhist sculpture is well represented by two iron Buddhas from the temple site of Powŏn-sa. See Kang Woo-bang, "T'ong'il Silla ch'ŏlbul kwa Koryŏ ch'ŏlbul ŭi p'yŏnnyŏn siron" (The Dating of Iron Buddha Images of the Unified Silla Period with Particular Reference to the Seated Iron Buddha Images of Powŏn-sa Temple Site, Unsan-myŏn, Sŏsan-gun, South Ch'ungch'ŏng Province), *Misul charyo*, no. 41 (June 1988), pp. 1–31. This article is reprinted in Kang Woo-bang, *Wŏnyung kwa chohwa: Han'guk kodae chogaksa ŭi wŏlli*, pp. 282–304. For several types of late Unified Silla Buddha images showing the bhumisparsha mudra, see Kim Lena, "T'ong'il Silla ŭi hangmach'okchi-in pulchwasang" (Seated Buddha Images in Bhumisparsha Mudra from the Unified Silla), in *Han'guk kodae pulgyo chogaksa yŏn'gu*, pp. 337–82.

70. *Kukpo 2, Kŭmdongbul, maaebul*, pls. 82, 83. Ch'oe Sŏng-ŭn, "Kwangju ch'ŏlbul chwasang e taehan koch'al" (The Seated Iron Buddha Image of the Late Koryŏ Period from Kwangju), *Pulgyo misul yŏn'gu*, no. 2 (Dec. 1995), pp, 27–45.

71. *Kungnip Chung'ang Pangmulgwan* (Catalogue of The National Museum of Korea) (Seoul: The National Museum of Korea, 1997), p. 237.

72. This image wears a cylindrical crown, on top of which is an octagonal canopy with a design of lotus-flower petals on the underside. *Kukpo 4, Sŏkpul*, pls. 125–27. See also Ch'oe Sŏng-ŭn, "Myŏngju chibang ŭi Koryŏ sŏkcho posalsang-e taehan yŏn'gu" (A Study of the Koryŏ Stone Bodhisattva Images of the Myŏngju Region), *Pulgyo misul*, no. 5 (1980), pp. 56–78.

73. *Kukpo 4, Sŏkpul*, pls. 156–58.

74. *Zhongguo meishu quanji, diaosubian 5: Wudai Song diaosu* (Complete Series of Chinese Art, Buddhist Sculptures 5: Sculptures of Five Dynasties and Song) (Beijing: Renmin meishu chubanshe, 1988), pl. 137.

75. *Kukpo 4, Sŏkpul*, pl. 147–48.

76. Several other large-size images exist in this southwestern part of Korea, including one bodhisattva statue in Taejo-sa Temple, Puyŏ (Ibid., pl. 150), and an enormous Buddha triad at Kaet'ae-sa Temple in Yŏnch'ŏn, which was begun by King T'aejo (r. 918–43) (Ibid., pls. 140–2).

77. Kang In-gu, "Sŏsan Munsu-sa kŭmdong yŏraesang pokchang yumul" (The Document Placed Inside the Seated Buddha in Munsu-sa Temple, Sŏsan), *Misul charyo*, no. 18 (June 1976), pp. 1–18.

78. Several images belonging to the same stylistic group, two in The National Museum of Korea, Seoul and one in the Puyŏ National Museum, are probably from the same workshop active in the area of Ch'ungch'ŏng Province in the fourteenth century. Some of the images are in Kim and Lee, *Arts of Korea*, pl. 119. The date I suggested there should be changed to the fourteenth century. See also *Kungnip Puyŏ Pangmulgwan* (Catalogue of the Puyŏ National Museum, 1993), p. 111; Chong Eun-woo [Ŭn-wu], "Koryŏ hugi ŭi pulgyo chogaksa yŏn'gu" (A Study of Buddhist Statues of the Late Koryŏ Period), *Misul charyo*, no. 33 (Dec. 1983), pp. 33–58.

79. There were fifty-five official exchanges of envoys during the reign of King Munjong (r. 1046–83). Records show that texts of the Buddhist Tripitaka and Lohan painting were included as part of these diplomatic exchanges.

80. Frequent contact with Lamaist priests occurred from the end of the thirteenth to the beginning of the fourteenth century. Historical records mention that nineteen Lamaist Buddhist priests came to Koryŏ in 1298 and that King Ch'ungsŏn (r. 1308–13), his father, and princes were baptised. Yi Yong-bŏm, "Wŏn-dae Lamagyo ŭi Koryŏ chŏllae" (The Introduction of Yuan Lamaist Buddhism to Koryŏ), *Pulgyo hakpo*, 2 (1964), pp. 1–60; Chong Eun-woo [Ŭn-wu], "Koryŏ hugi ŭi pulgyo chogaksa yŏn'gu," pp. 33–58. There was in this same period active production of images in Kaegyŏng, and many images were also produced between 1343 and 1345 at the Chang'an-sa Temple at Mount Kŭmgang that was patronized by a Lady Ki of Koryŏ origin who became the empress of the Yuan emperor Shundi (r. 1333–68). See Yi Kok, "Kŭmgang-san Chang'an-sa chung'hŭng-bi" (Erection of Memorial Stele at Chang'an Temple, Mount Kŭmgang), in comp., Sŏ Ko-jong, *Tongmunsŏn* (Anthology of Korean Literature), vol. 118.

81. Kim and Lee, *Arts of Korea*, color pl. 25, p. 45.

82. The present writer once dated this portable shrine to the eleventh to twelfth century (Kim and Lee, *Arts of Korea*, p. 80, pls. 27, 120–122), but now I would like to date it to the fourteenth century due to the Lamaist elements which began to be felt in Koryŏ art from the end of the thirteenth century. See also Mun Hyŏn-sun, "Koryŏ sidae malgi ŭi kŭmdong pulgam yŏn'gu" (A Study of Gilt-bronze Portable Shrines of the Late Koryŏ Period), *Kogo misul*, 179 (Sept. 1988), pp. 33–72.

83. Although it has long been known by scholars, this shrine was first seen by the public in an exhibition organized by the Chŏnju National Museum in 1996; *T'ŭkpyŏljŏn Koryŏmal Chosŏnch'o ŭi misul* (Special Exhibition of Art from the Late Koryŏ to the Early Chosŏn Dynasty) (exh. cat., Chŏnju: Chŏnju National Museum, 1966), pl. 44.

84. The pagoda, which stood in the Kyŏngbok Palace in Seoul for many years, was dismantled in 1996. Now under restoration, it will be on view at the new National Museum in Yongsan, Seoul.

85. Kim Wŏn-yong et al., *Korean Art Treasures*, pls. 328, 329; Chin Hong-sŏp, ed., *Kukpo 6: T'app'a* (The National Treasures of Korea, 6: Pagodas) (Seoul: Yekyong Publications Co., 1988), pls. 203–206.

86. *Kukpo 6: T'app'a*, pls. 210–14. See also *Wŏn'gaksa-ji sipch'ŭng sŏkt'ap silch'ŭk chosa pogosŏ* (Report on the Measurements of the Ten-Story Pagoda at the Temple Site of Wŏn'gak-sa) (Seoul: Munhwajae kwalliguk, 1993).

87. *Pulsari chang'ŏm* (The Art of Sarira Reliquary) (exh. cat., Seoul: The National Museum of Korea, 1991), no. 65, pp. 96–99; Lyu Ma-ri, "Sujong-sa kŭmdong pulgamhwa ŭi koch'al" (A Study of the Buddhist Painting on the Gilt-bronze Portable Shrine from Sujong-sa), *Misul charyo*, no. 30 (June 1982), 37–55.

88. Zhejiangsheng wenwu kaogu yanjiusuo, ed., *Xihu shiku* (Cave-Temples at West Lake) (Hangzhou: Zhejiang renmin chubanshe, 1986), pl. 32. Paula Swart, "Buddhist Sculptures at Feilai Feng: A Confrontation of Two Traditions," *Orientations*, vol. 18, no. 12 (Dec. 1987), pp. 54–61.

89. Ho-Am Gallery, *Koryŏ, yŏng'wŏnhan mi: Koryŏ purhwa t'ŭkpyŏlchŏn* (Exhibition of Koryo Buddhist Painting) (Seoul: Ho-Am Art Museum, 1993–94), pl. 61. The Sanskrit name of the *Wŏn'gak-kyŏng* Sutra is *Mahavaipulya-purnabuddha-sutra-prasannartha-sutra*.

90. Iwai Tomoji and Fukushima Tsunenori, eds., *Kōrai Richō no bukkyō bijutsu-ten* (Buddhist Art of the Koryŏ and Chosŏn Dynasties) (exh. cat., Yamaguchi: Yamaguchi Prefectural Museum of Art, 1997),

pls. 24–25. See also Takeda Kazuaki, "Hyōgo Jūrin-ji gozonbutsuzonzō zuni tsuite" (On the Iconography of the Five Buddha Painting Preserved at Jūrin-ji Temple in Hyōgo Prefecture), *Mikkyō zuzō*, 7 (1990), pp. 9–22.

91. Kim Lena, "Nyuyok Met'ŭrop'olitan Pangmulgwan ŭi Chosŏn sidae Kasŏpchonja sang" (A Wooden Statue of the Disciple Kashyapa in The Metropolitan Museum of Art, New York), *Misul charyo*, no. 33 (Dec. 1983), pp. 59–66.

92. The *mokkak pult'aeng* in Yongmun-sa Temple dates to 1682, one in Namjang-sa Temple dates to 1694; several others exist, including those in Taesŭng-sa Temple and Kyŏngguk-sa Temple, see *Kukpo 2, Kŭmdongbul, maaebul*, pls. 99–102, figs. 70, 99.

*"The Origin and Development of Landscape Painting in Korea," by Ahn Hwi-joon, pp. 294–329.*

1. For a brief summary of the Chinese theory of nature, see Michael Sullivan, *The Birth of Landscape Painting in China* (Berkeley: University of California Press, 1962), pp. 1–10; and George Rowley, *Principles of Chinese Painting* (Princeton: Princeton University Press, 1974 edition), pp. 20–23.

2. Although an engraved design of an agricultural scene is found on a bronze object dating from as early as the Bronze Age, it does not fall within the definition of painting as a work executed in brush and ink. See Han Pyŏng-sam, "Sŏnsa sidae nonggyŏng-mun ch'ŏngdong-gi e taehayŏ" (A Prehistoric Bronze Object with an Engraved Farming Scene), *Kogo misul*, no. 112 (Dec. 1972), pp. 2–13. For an overview of painting in the Three Kingdoms period, see Yi T'ae-ho, "Han'guk kodae sansuhwa ŭi palsaeng yŏn'gu" (A Study of the Beginning of Traditional Landscape Painting in Korea), *Misul charyo*, no. 38 (Jan. 1987), pp. 29–65.

3. An ancient tomb discovered in South Kyŏngsang Province in 1987 and believed to date to about the first century BCE yielded five brushes along with various lacquer and bronze objects. The discovery of these brushes indicates that writing and painting may already have been introduced as early as this time.

4. For Koguryŏ tomb painting, see Kim Wŏn-yong, *Han'guk pyŏkhwa kobun* (Painted Tombs of Korea), *Han'guk munhwa yesul taegye*, series 1 (Seoul: Ilchisa, 1980), pp. 93–95; *Pyŏkhwa* (Wall Paintings), *Han'guk misul chŏnjip*, series 4 (Tonghwa ch'ulp'an kongsa, 1974), pp. 4–5; *Han'guk misul-sa* (Arts of Korea) (Pŏmmun-sa, 1968), pp. 54–59; and *Han'guk misul-sa yŏn'gu* (Studies on Korean Art History) (Seoul: Ilchi-sa, 1989), pp. 289–414. See also Kim Ki-ung, *Chōsen hantō no hekiga kofun* (Wall Paint-

ings in Tombs of the Korean Peninsula) (Tokyo: Rokko shuppan, 1980).

5. See Uehara Kazu, "Sinhŭng-ni kofun no boshimei to hekiga–Kwanggaet'o jidai no geijutsu" (Wall Paintings and Epitaph of the Sinhŭng-ni tomb Art of the Kwanggaet'o Period), *Geijutsu shincho*, no. 350 (Feb. 1972), pp. 53–55 and pls. on pp. 49–52.

6. See note 4.

7. See, for example, the Han-dynasty bronze tubular brush holder with hunting scene in the collection of the Tokyo Fine Arts University, illustrated in Kim Wŏn-yong, *Han'guk misul-sa* (Seoul: Pŏmmun-sa, 1973), p. 61.

8. See Kim Wŏn-yong, *Han'guk pyŏkhwa kobun*, p. 122.

9. The dating of the Nae-ri tomb to the first half of the seventh century is based on the tomb's single-chamber structure, the murals of the Four Guardians, and other structural and stylistic characteristics. See Kim Wŏn-yong, ibid., p. 131.

10. See Ahn Hwi-joon, "Samguk sidae hochwa ŭi Ilbon chŏnpa" (Transmission of Korean Painting of the Three Kingdoms to Japan), *Kuksa-gwan nonch'ong*, vol. 10 (Dec. 1989), pp. 169–80, 217.

11. See Osvald Sirén, *Chinese Painting: Leading Masters and Principles* (New York: The Ronald Press Company; London: Lund Humphries, 1956), vol. 3, pls. 24–28.

12. See Ahn Hwi-joon, "Kimi nyŏn-myŏng Sunhŭng-ŭp Nae-ri kobun pyŏkhwa ŭi naeyong kwa ŭiŭi" (Content and Significance of the Wall Painting of the Naeri Tomb in Sunhŭng-ŭp with an Inscription of the *kimi* Year), in *Sunhŭng-ŭp Naeri pyŏkhwa kobun* (Seoul: Munhwajae kwalliguk, Munhwajae yŏn'gu-so, 1986), pp. 61–98.

13. *Samguk sagi*, vol. 18, Solgŏ section.

14. See Ahn Hwi-joon, "Koryŏ mit Chosŏn wangjo ch'ogi ŭi taejung hoehwa" (Artistic Exchange with China During Koryŏ and Early Chosŏn), *Asea hakpo*, vol. 13 (Nov. 1979), pp. 141–70; and "Korai oyobi Richō Shokei ni okeru Chūgoku-ga no ryūnyū" (The Influx of Chinese Painting During Koryŏ and Early Chosŏn), *Yamato bunka*, vol. 62 (July 1977), pp. 1–17.

15. The *Ŏje pijangjŏn* was originally compiled at the order of the Northern Song emperor Taizong (r. 976–97). It was printed in Korea during the Koryŏ period, first in 983 and again in 996. The latter edition, originally comprising 30 volumes, survives only in part, in the two institutions noted here. See Yi Sŏng-mi, "Koryŏ ch'ojo taejanggyŏng ŭi Ŏje pijangjŏn p'anhwa" (Research on Landscape Painting of the Early Koryŏ: The Ŏje pijangjŏn), *Kogo misul*, vol. 169–70 (June 1986), pp. 14–70. For the woodblock print in the Nanzen-ji, Kyoto, see Max Loehr, *Chinese Landscape Woodcuts* (Cam-

bridge: The Belknap Press of Harvard University Press, 1968), pp. 18–27. Egami Yasushi and Kobayashi Hiromitsu, *Woodcuts in the Nanzenji Bizangguan* (Tokyo: Yamakawa Publishing Co., 1994).

16. Guo Ruoxu, *Tuhua jianwen zhi*, vol. 6 (Koryŏ painting).

17. See Ahn Hwi-joon, "Koryŏ mit Chosŏn wangjo ch'ogi ŭi taejung hoehwa," p. 148; and "Chosŏn wangjo hugi hoehwa ŭi sin tonghyang" (New Trends in Korean Painting in the Late Chosŏn Period), *Kogo misul*, no. 134 (June 1977), p. 12.

18. Ibid.

19. For a detailed discussion of the development of true-view landscape painting in Korea, see Yi Sŏng-mi's essay in the present volume.

20. See note 16.

21. Su Shi's calligraphy and literary works, as well as his painting theory, were well known and greatly admired in Korea during the Koryŏ period. See Ahn Hwi-joon, "Koryŏ mit Chosŏn wangjo ch'ogi ŭi taejung hoehwa," pp. 145–46; and Kwŏn Tŏk-chu, "So Tong-p'a ŭi hwaron" (The Art Theory of Su Dongpo), *Sungmyŏng Women's University Research Publication*, vol. 15 (Dec. 1975), pp. 9–17. A description of Prince Anp'yŏng's collection is included in Kim Hongnam's essay in the present volume.

22. Suzuki Kei, "Rinsen kochi-shū no gaki to Kaku Ki ni tsuite" (On the Painting Records in *Linquan gaozhiji* and Guo Xi), *Bijutsushi*, vol. 109 (Nov. 1980), p. 2.

23. See Ahn Hwi-joon, "Koryŏ mit Chosŏn wangjo ch'ogi ŭi taejung hoehwa," p. 153.

24. Ahn Hwi-joon, *Han'guk hoehwa-sa* (History of Painting in Korea) (Seoul: Ilchi-sa, 1980), p. 72, pl. 29. For an overview of Koryŏ period paintings of the Five Hundred Lohan, see Lyu Mari, "Koryŏ sidae obaek nahan-do ŭi yŏn'gu" (Research on the Five Hundred Lohan Paintings of Koryŏ), in ed. Hwang Su-young, *Han'guk pulgyo misul-sa ron* (Seoul: Minjok-sa, 1987), pp. 249–86.

25. Mun Myŏng-dae, "Noyŏng p'il Amita kujon-do tuitmyŏn pulhwa ŭi jagŏmt'o" (A Reconsideration of the Buddhist Painting on the Back of the Amitabha Buddha by Noyŏng), *Komunhwa*, vol. 18 (June 1980), pp. 2–12.

26. For Xu Daoning, see Osvald Sirén, *Chinese Painting*, vol. 3, pl. 158.

27. Wakimoto Sokurō, "Kō Nen-ki ni tsuite" (On Gao Ranhui), *Bijutsu kenkyū*, vol. 13 (Jan. 1993), pp. 8–16.

28. See Shimada Shūjirō, "Kōrai no kaiga" (Koryŏ Painting), in *Sekai bijutsu zenshu* series, vol. 14 (Tokyo: Heibonsha, 1967), pp. 64–65.

29. Ahn Hwi-joon, "Koryŏ mit Chosŏn wangjo ch'ogi ŭi taejung hoehwa," pp. 149–51. For a discussion of

the Southern Song Painting Academy and the works of Ma Yuan, Xia Gui, and Ma Lin, see Wen C. Fong, *Beyond Representation: Chinese Painting and Calligraphy, 8th–14th Century* (New York: The Metropolitan Museum of Art, 1992), pp. 264–83, 297–302.

30. Ahn Hwi-joon, "Chosŏn wangjo ch'ogi ŭi hoehwa wa Ilbon Siljŏng sidae ŭi sumuk-hwa" (Early Chosŏn Painting and the Ink Painting of Muromachi Japan), *Han'guk hakpo*, vol. 3 (Summer, 1976), pp. 7–9; and "Korean Influence on Japanese Ink Painting of the Muromachi Period," *Korea Journal*, vol. 39, no. 4 (Winter, 1997), pp. 198–99.

31. For a study of An Kyŏn and his painting style, see Ahn Hwi-joon and Lee Byŏng-han, *An Kyŏn gwa Mong'yu Towŏn-do* (An Kyŏn and the Dream Journey to the Peach Blossom Land) (Seoul: Yekyong Publication Co., 1993); and Ahn Hwi-joon, "An Kyŏn and 'A Dream Visit to the Peach Blossom Land,'" *Oriental Art*, vol. 26, no. 1 (Spring, 1980), pp. 60–71.

32. Ahn Hwi-joon, "Jŏn An Kyŏn p'il Sasi p'algyŏng-do" (Eight Views of the Four Seasons Attributed to An Kyŏn), *Kogo misul*, vol. 136–7 (Mar. 1978), pp. 72–78.

33. Ahn Hwi-joon, "Kungnip Chung'ang Bangmul-gwan sojang Sosang p'algyŏng-do" (Eight Views of the Xiao and Xiang in the Collection of The National Museum of Korea), *Kogo misul*, vol. 138–9 (Sept. 1978), pp. 136–42.

34. See Ahn Hwi-joon, "16-segi Chosŏn wangjo ŭi hoehwa wa tansŏn chŏnjun" (Linear Texture Strokes in Chosŏn Dynasty Paintings of the Sixteenth Century), *Chindan hakpo*, vol. 46–47 (June 1979), pp. 217–39.

35. See Ahn Hwi-joon, "Two Korean Landscape Paintings of the First Half of the Sixteenth Century," *Korea Journal*, vol. 15, no. 2 (Feb. 1975), pp. 36–40.

36. Ahn Hwi-joon, "Korean Influence on Japanese Ink Painting of the Muromachi Period," pp. 195–220.

37. See Ahn Hwi-joon, ed., *Sansuhwa (sang)* (Landscape, Part One), in *Han'guk ŭi mi* series, vol. 11 (Seoul: Chung'ang ilbo, 1980). For a thorough study of the Zhe school and the work of professional painters of the Ming dynasty, see Richard M. Barnhart, *Painters of the Great Ming: The Imperial Court and the Zhe School* (exh. cat., Dallas: Dallas Museum of Art, 1993).

38. This painting is discussed in detail in Hong Sonp'yo, "Injae Kang Hŭi-an ŭi Kosa kwansu-do" (Research on Kang Hŭi-an's Lofty Scholar Viewing the Water), *Chŏngsin munhwa yŏn'gu*, vol. 27 (Winter, 1985), pp. 93–106.

39. For example, see *Scholar Seated Under a Tree*, illustrated in Barnhart, *Painters of the Great Ming*, cat.

no. 69, p. 238. While Kang Hǔi-an may not have actually seen paintings by the artist, Wu Wei, whose work almost singlehandedly revived figure painting in the Ming Zhe school, exerted a powerful influence on Korean art.

40. See Ahn Hwi-joon, "Han'guk Chŏlp'a hwap'ung ǔi yŏn'gu" (Research on Zhe School Style Korean Painting), *Misul charyo*, vol. 20 (June 1977), pp. 36–47.

41. See Ahn Hwi-joon, ed., *Sansuhwa (sang)*, pls. 23–25.

42. A painting attributed to the artist is illustrated in James Cahill, *Chinese Painting* (Geneva: Editions d'Art Albert Skira, 1960), p. 104.

43. See Ahn Hwi-joon, "Chosŏn wangjo ch'ogi ǔi hoehwa wa Ilbon Siljŏng sidae ǔi sumuk-hwa," pp. 9–21; and *Sansuhwa (sang)*, pl. 21 and reference pls. 7–11.

44. See Ahn Hwi-joon, ed., *Sansuhwa (sang)*, p. 165.

45. See Ahn Hwi-joon, "Chosŏn wangjo hugi hoehwa ǔi sin tonghyang," pp. 10–11.

46. See Ahn Hwi-joon, "Southern School Landscape Painting in Korea," pp. 16–20.

47. See Yi Tong-ju, "Kyŏmjae Ilp'a ǔi chin'gyŏng sansu" (True-View Landscape Painting of the Chŏng Sŏn School), *Wŏlgan asea*, (April 1969), pp. 160–86; and *Uri nara ǔi yet kǔrim* (Traditional Paintings of Korea) (Seoul: Pakyŏng-sa, 1975), pp. 151–92. See also Ch'oe Sun-u "Kyŏmjae Chŏng Sŏn," in *Kansong munhwa*, vol. 1 (Oct. 1971), pp. 23–27; and *Kyŏmjae Chŏng Sŏn* (Seoul: Chung'ang ilbo, 1977). According to Kim Wŏn-yong, Chŏng Sŏn began to produce true-view landscapes when he was about thirty years old. See Kim Wŏn-yong, "Chŏng Sŏn sansu hwap'ung ǔi chinsu" (Chŏng Sŏn: The Essence of Landscape Painting), in *Han'guk ǔi in'gansang*, vol. 1 (Seoul: Sin'gu munhwa-sa, 1965), p. 307. See also Lena Kim Lee, "Chŏng Sŏn: A Korean Landscape Painter," *Apollo* (Aug. 1968), pp. 85–93.

48. Park Eun-soon, *Kǔmgang san-do yŏn'gu* (A Study of Paintings of the Diamond Mountain) (Seoul: Ilchi-sa, 1996); and Ch'oe Wan-su, *Kyŏmjae Chŏng Sŏn chin'gyŏng sansuhwa* (Chŏng Sŏn's True-View Landscape Painting) (Seoul: Pŏmmun-sa, 1993).

49. See Yi T'ae-ho, "Chin'gyŏng sansuhwa ǔi chŏn'gae kwajŏng" (The Development of True-View Landscape), in Ahn Hwi-joon, *Sansuhwa (ha)* (Landscape, Part Two), *Han'guk ǔi mi* series, vol. 12 (Seoul: Chung'ang ilbo and Kyegan misul, 1982), pp. 212–20; and "Chosŏn hugi munin hwagadǔl ǔi chin'gyŏng sansuhwa" (True-View Landscape Painting of Late Chosŏn Scholar-Artists), in *Hoehwa* (Painting), *Kukpo*, series 10 (Seoul: Yegyŏng Publication Co., 1984), pp. 223–30.

50. Chŏng Sŏn's closest friend, the contemporary scholar-artist Cho Yong-sŏk, wrote that Chŏng studied the works of major artists of the Ming

Southern School. See Ahn Hwi-joon, "Kwanajaego ǔi hoehwasa-jŏk ǔiǔi" (The Significance of Kwanajego), in *Kwanajego* (Seoul: Han'guk chŏngsin munhwa yŏn'guwŏn, 1984), pp. 14–15.

51. For a comprehensive overview of Kang Se-hwang's painting, see Pyŏng Yong-sŏp, *P'yoam Kang Se-hwang ǔi hoehwa yŏn'gu* (Research on the Works of Kang Se-hwang) (Seoul: Ilchi-sa, 1988).

52. The most comprehensive treatment of Kim Hong-do and his work is *Tanwŏn Kim Hong-do*, vols. 1–3 (exh. cat., Seoul: Samsung Foundation of Culture, 1995), which was published on the occasion of a special exhibition on the artist held at The National Museum of Korea, Seoul.

53. Ahn Hwi-joon, *Han'guk hoehwasa* (The History of Korean Landscape Painting) (Seoul: Ilchi-sa, 1980), pp. 278–79.

54. See Ahn Hwi-joon, "Chosŏn wangjo malgi ǔi hoehwa" (Painting at the End of the Chosŏn Dynasty, ca. 1850–1910), in *Han'guk kǔndae hoehwa paengnyŏn, 1850–1950* (One Hundred Years of Modern Korean Painting, 1850–1950) (Seoul: Samhwa sŏjŏk chusikhoe-sa, 1987), pp. 191–209.

*"Artistic Tradition and the Depiction of Reality: True-View Landscape Painting of the Chosŏn Dynasty," by Yi Sŏng-mi, pp. 330–65.*

1. Ahn Hwi-joon, *Han'guk hoehwa-sa* (History of Korean Painting) (Seoul: Ilchi-sa, 1980), p. 256.

2. O Se-ch'ang, *Kǔnyŏk sŏhwa-jing* (Biographical Dictionary of Korean Calligraphers and Painters) (Seoul: Pomun sŏjŏm, 1975 reprint), entry on Chŏng Sŏn, p. 166.

3. For the most comprehensive annotated English translation of Jing Hao's *Bifa ji*, see Kiyohiko Munakata, *Ching Hao's Pi-fa chi: A Note on the Art of the Brush* (Ascona: Artibus Asiae, 1974).

4. For translations of the key parts of the *Linchuan gao zhi*, see Susan Bush and Hsio-yeh Shih, *Early Chinese Texts on Painting* (Cambridge: Harvard University Press, 1985), pp. 150–54.

5. See Yi T'ae-ho, "Chosŏn hugi chin'gyŏng sansu ǔi paltalgwa t'oejo" (The Development and Decline of True-View Landscape Painting of the Late Chosŏn Period), in *Chin'gyŏng sansu-hwa* (True-View Landscape Painting) (exh. cat., Kwangju: Kwangju National Museum, 1987).

6. Pak Ǔn-Sun, *Kǔmgangsan-do yŏn'gu* (A Study of the Paintings of Diamond Mountain) (Seoul: Ilchi-sa, 1997), p. 83. For the definition of the Chinese term *tianji*, see Susan Bush, *The Chinese Literati on Painting: Su Shih (1037–1101) to Tung Ch'i-ch'ang (1555–1636)* (Cambridge: Harvard University Press, 1971), pp. 57–58.

7. These terms are found in several official records from 1688 to 1902. See Yi Sŏng-mi, Yu Song-Ok, and Kang Sin-hang, *Chosŏn sidae Ŏjin Kwan'gye Togam Uigwe yŏn'gu* (A Study of the Records of the Superintendency for the Painting or Copying of Royal Portraits of the Chosŏn Dynasty) (Sŏngnam: The Academy of Korean Studies, 1997), pp. 25–26, 64.

8. *Han'guk hanjaŏ sajŏn* (Dictionary of Korean Terms Written in Chinese Characters) (Seoul: Center for Oriental Studies, Tan'guk University, 1995), vol. 3, p. 555.

9. For the transcription of the inscription and an interpretation of the term *chin'gyŏng* as simply "real scenery," see Pyŏn Yŏng-sŏp, *P'yoam Kang Se-hwang hoehwa yŏn'gu* (A Study of the Painting of Kang Se-hwang) (Seoul: Ilchi-sa, 1988), p. 190, n. 75, 76.

10. The earliest recorded map of the Korean peninsula is *P'alto chi'do* (Map of the Eight Provinces), made by Yi Hoe in 1402. Although the original version is no longer extant, the map is incorporated in a mid-fifteenth-century map of the world produced by Yi Hoe and other scholars drawing on material from Chinese sources. For an illustration of this later map, see *Chosŏn chŏn'gi kukpo chŏn* (Treasures of the Early Chosŏn Dynasty) (Seoul: Ho-Am Art Museum, 1997), pp. 102–103, pl. 65.

11. For the sources of these recorded works, see Ahn Hwi-joon, "Chosŏn wangjo hugi hoehwaŭi sin tonghyang" (New Trends in Late-Chosŏn-Period Painting), *Kogo misul*, no. 134 (June 1977), p. 19, no. 19.

12. Mun Myŏng-dae has identified the subject of this small lacquer screen as a scene of King T'aejo praying on Mount Kŭmgang. See Mun, "Noyŏng ŭi Amita Chijang Posal e taehan koch'al" (On Noyŏng's Amitabha and the Bodhisattva Kshitigarbha), *Misul charyo*, 25 (Dec. 1979), p. 47–57.

13. *Veritable Records of King T'aejo*, vol. 13, 1398, April, *imin* day. It is recorded that the king assigned to the painters Cho Chun and Kim Sa-hyŏng one scene each from the eight scenes, whereupon Chŏng To-jŏn (1337–1398) composed a poem for all eight scenes. See Ahn Hwi-joon, ed., *Chosŏn wangjo sillok ŭi sŏhwa saryo* (Articles on Painting and Calligraphy in the Veritable Records of the Chosŏn Dynasty) (Sŏngnam: The Academy of Korean Studies, 1983), pp. 16–17.

14. Kijŏn refers to the area within a radius of 500 *ri* (about 200 kilometers) from the capital.

15. *Veritable Records of King Sejong*, vol. 53, 1431, August, *muo* day. See also *Veritable Records of King Tanjong*, vol. 14, 1455, intercalary June, *chŏngmi* day. Besides these entries, many more recorded instances of requests by Chinese emissaries for paintings of Mount Kŭmgang can be found throughout the Chosŏn period.

16. *Veritable Records of King Munjong*, vol. 3, 1450, August, *kyŏngja* day.

17. *Veritable Records of King Myŏngjong*, vol. 26, 1560, June, *chŏngyu* day.

18. This screen, entitled *General View of P'yŏng'yang*, is attributed to Yi Ching (b. 1581).

19. See *Veritable Records of King Myŏngjong*, vol. 30, 1564, June, *sinsa* day, for a list of twenty-three documentary paintings, some of which definitely would have contained views of actual scenery of the site at which the examinations were given.

20. For a detailed study of this painting, see Yi T'ae-ho, "Han Si-gak ŭi Puksae Sŏnun-do wa Pukkwan Silgyŏng-do" (Han Si-gak's *Puksae Sŏnun-do* and *Pukkwan Silgyŏng-do*), *Chŏngsin munhwa yŏn'gu*, no. 34 (1988), pp. 207–35.

21. For a comprehensive account of the origins and development of *kyehoe-do* in the Chosŏn period, see Ahn Hwi-joon, "Literary Gatherings and Their Paintings in Korea," *Seoul Journal of Korean Studies*, 8 (1995), pp. 85–106.

22. The Tumo-p'o Ford area is now called Oksu-dong; a massive high-rise apartment complex stands on the site of the former Toksŏ-dang Hall.

23. Beginning with the reign of King Sejong (r. 1418–50), the court granted a recess period to younger scholar-officials so that they could devote time to study for self-improvement. The Toksŏ-dang Hall, built in 1517, was used for this purpose until its destruction during the Japanese invasion of Korea at the end of the sixteenth century.

24. There is another version of the *Toksŏ-dang kyehoe-do*, dated to about 1531, in a private collection in Japan. See Ahn, "Literary Gatherings and Their Paintings in Korea," fig. 1.

25. *Veritable Records of King Chungjong*, vol. 84, 1537, March, *pyŏngsin* day.

26. Yu Chun-yŏng, "Kugok-to ŭi palsaeng-gwa kinŭng e taehayŏ" (On the Origin and Function of Paintings of the Nine-Bend Stream), *Kogo misul*, no. 151 (1981), pp. 1–20.

27. See Yun Chin-yŏng, "*Chosŏn sidae Kugok-do yŏn'gu*" (A Study of Paintings of the Nine-Bend Stream of the Chosŏn period), M.A. thesis (Academy of Korean Studies, 1997), p. 10, for a list of Chinese paintings on the theme retrieved from John C. Ferguson, *Lidai zhulu huamu* (Taipei: Chunghua shu-chu, 1968).

28. For the possible route of transmission of a Chinese painting of Mount Wuyi to Korea, see Yu Chun-yŏng, "Kugok-to ŭi palsaeng-gwa kinŭng e taehayŏ," pp. 4–7.

29. For a discussion of Yi I's theories, see Ch'oe Yŏng-

sŏng, *Han'guk Yuhak sasang-sa* (History of Korean Neo-Confucian Thought) (Seoul: Asea munhwa-sa, 1995), vol. 2. For Zhu Xi's teachings, see Zhu Xi, *Reflections on Things at Hand: The Neo-Confucian Anthology*, trans. Wing-tsit Chan (New York: Columbia University Press, 1967).

30. In the nineteenth century, scenes of the nine-bend stream at Kosan were painted with Yi I's poetry inscribed at the top of each scene. Perhaps the most well-known painting of the subject is a joint work by ten painters, including Kim Hong-do, now in a private collection.

31. See Yu Chun-yŏng, "Kogun Kugok-to rŭl chung-sim ŭro pon sipch'il segi silgyŏng sansu ŭi ilye" (One Seventeenth-Century Example of Real-Scenery Painting: *Kogun Kugok-do*), *Chŏngsin munhwa*, vol. 8 (1982), pp. 38–46.

32. The following publications were consulted for the intellectual background of the seventeenth and eighteenth centuries: Ch'oe Yŏng-sŏng, *Han'guk Yuhak sasang-sa*, vols. 2–4; Lee Ki-baik, *A New History of Korea*, trans. Edward W. Wagner and Edward Shultz (Seoul: Ilchogak, 1984); Ch'oe Wan-su, "Kyŏmjae Chŏng Sŏn chin'gyŏng sansuhwa-go" (A Study of the True-View Landscape Paintings of Chŏng Sŏn), *Kansong munhwa*, 21 (1981), pp. 39–60; Kang Kwan-sik, "Chosŏn hugi misul ŭi sasangjŏk kiban" (The Intellectual Foundations of the Arts of the Late Chosŏn Period), in *Han'guk sasangsa taegye* (An Outline of History of Korean Thought) (Sŏngnam: Academy of Korean Studies, 1992), pp. 535–92.

33. The split of scholars into various factions during the late Chosŏn dynasty is too complex a subject to introduce here. Suffice it to say that the various factions, which were engaged in power struggles, played important roles, both positive and negative, in the political and cultural spheres of late Chosŏn society. For a discussion of these factions, see Lee Ki-baik, *A New History of Korea*, pp. 208ff.

Among Korean scholars, loyalty to the former Ming dynasty was expressed in a number of ways. For example, in 1703 Kwŏn Sang-ha (1641–1721), the principal follower of Song Si-yŏl, built the Mandong-myo Shrine in Song's native village of Hwayang, in Koesan district, North Ch'ungch'ŏng Province, for the purpose of performing memorial services to the Ming emperors Shenzong (r. 1573–1620) and Sizong (r. 1628–44). Emperor Shenzong was remembered fondly by Koreans because of his military aid to Korea during the Japanese invasion of 1592. The shrine remained in existence until the 1940s; only the stele and stone terraces remain today. In 1704, on the occasion of the sixtieth anniversary of the fall of the Ming, court

officials persuaded King Sukchong to have the Taebo-dan Platform erected in the rear garden (now known as the Secret Garden) of the Ch'angdŏk-kung Palace, in Seoul, as the setting for memorial rites for Emperor Taizu (1368–98), the founder of the Ming, and Emperor Sizong. The scholars in the Young Doctrine (*soron*) faction disapproved of these memorial services as an inappropriate act by the Chosŏn court. Another expression of loyalty to the Ming was the continued use of the dynasty's last reign date (*Chongzheng*) in most documents aside from official court documents, which had to be dated in accordance with reign dates of the new Qing dynasty. Chosŏn Neo-Confucian scholar-officials continued using the Ming reign date for more than one hundred years after the fall of the dynasty.

34. The term "*so-chunghwa*" can be found in Cho Ku-myŏng's (1693–1737) "Kwanwŏl-ch'ŏp sŏ" (Preface to the Kwanwŏl-ch'ŏp Album), dated 1720, in which he writes: "It has been a long time since our Eastern Country called itself *so-chunghwa*." See Ch'oe Wan-su, "Kyŏmjae Chŏng Sŏn chin'gyŏng sansuhwa-go," p. 46. In his essay, however, Ch'oe Wan-su uses the term "*Chosŏn chunghwa*" instead of "*so-chunghwa*."

35. For example, Ch'oe Wan-su considers the "minor China" concept to be the major intellectual force behind the development of Chŏng Sŏn's true-view landscape painting. Ibid., pp. 46–47.

36. Ibid., p. 47.

37. For more information on Yi Su-gwang's *Chibong yusŏl*, see Ch'oe Yŏng-sŏng, *Han'guk Yuhak sasang-sa*, vol. 3, pp. 370–79. Also see Lee Ki-baik, *A New History of Korea*, p. 236.

38. For Wang Yangming's philosophy and its development in Korea, see Ch'oe Yŏng-sŏng, *Han'guk Yuhak sasang-sa*, vol. 3, pp. 283–388. See also Wang Yangming, *Instructions for Practical Living and Other Neo-Confucian Writings*, trans. Wing-tsit Chan (New York: Columbia University Press, 1963).

39. Ibid., pp. 388–401. See also Lee Ki-baik, *A New History of Korea*, pp. 233–34.

40. The works on Korean history and culture, literature, and geography discussed above were followed in the eighteenth century by other such studies, among them *Tongguk munhŏn pigo* (Reference Compilation of Documents on Korea), a chronological overview of the country's geography, government, economy, and culture, commissioned by King Yŏngjo (r. 1724–76) and published in 1770, and *Tongsa kangmok* (Annotated Account of Korean History), an equally important historical survey, from the legendary founding of the country by King Tan'gun to the end of the Koryŏ

period, published in 1778 by Yi Ik's chief disciple, An Chŏng-bok (1712–1791). During the reign of King Chŏngjo (r. 1776–1800), other significant works were produced, including *Haedong yŏksa* (History of Korea) by Han Ch'i-yun (1765–1814) and *Yŏllyŏsil kisul* (Narratives of Yŏllyŏsil [Yi Kŭng-ik]) by Yi Kŭng-ik (1736–1806).

41. For a discussion of the content of the book and a biography of Yi Ik, see Han U-gŭn, "Introduction," in *Kugyŏk Sŏngho Sasŏl* (*Sŏngho Sasŏl* Translated into Korean), vol. 1 (Seoul: Minjok munhwa ch'ujinhoe, 1977/1982), pp. 1–41.

42. Yi Ik was related through marriage to Yu Hyŏng-wŏn, whom he looked upon as his mentor. (The eldest daughter of Yi Ik's great-uncle, Chi-wan [1575–1617], was married to Yu Hyŏng-wŏn's father, Yu Hŭm.) Many of the scholars of the late Chosŏn dynasty were related to one another by marriage. See the forthcoming paper "Sŏngho Yi Ik (1681–1763) ŭi saeng'ae wa sasang" (Sŏngho Yi Ik's Life and Thought) by Professor Yi Sŏng-mu, of the Academy of Korean Studies, for the complicated marriage relationships of several generations of Yi Ik's family members.

43. Of these, I am especially indebted to Professor Yi Sŏng-mu for his view of Yi Ik's role in late-Chosŏn-period scholarship. His forthcoming paper (see n. 42 above) provides a solid background for understanding Yi Ik's position within his scholarly milieu.

44. See "Hwasang yodol" (Convexity and Concavity of Painted Images), in *Kugyŏk Sŏngho Sasŏl*, vol. 2, pp. 64–65.

45. Here, the character for *gyŏng* in *chin'gyŏng* is that meaning "boundary" or "realm."

46. The colophon appears in Yi Ik, *Sŏngho sŏnsaeng chŏnjip* (Complete Works of Sŏngho), vol. 2 (Seoul: Kyŏng'in munhwa-sa, 1974), p. 401. My English translation is based on the Korean translation of the colophon in Pak Ŭn-sun, *Kŭmgangsan-do*, pp. 94–95.

47. See Ahn Hwi-joon, *Han'guk hoehwa-sa*, pl. 88. The portrait is in the collection of Yun Hyung-sik, Haenam.

48. The map was made to a scale of 1:420,000. See the entry on "*Tongguk chido*" in *Han'guk minjok munhwa tae paekkwa sajŏn* (Encyclopedia of Korean Culture), vol. 7, pp. 179–80.

49. See Ch'oe Kang-hyŏn, *Han'guk kihaeng munhak yŏn'gu* (A Study of Korean Travelogues) (Seoul: Ilchi-sa, 1982).

50. It was not uncommon for a person of *yangban* origin to become a member of the royal bureau of painting, a job traditionally held by the *chung'in* class. The chung'in class stands between the yang-ban class and the *sangmin* (commoner) class. Technical officials and local government clerks came from this class. The date Chŏng Sŏn joined the painting bureau is not known.

51. The most comprehensive research on Chŏng Sŏn's life appears in Ch'oe Wan-su, *Kyŏmjae Chŏng Sŏn chin'gyŏng sansuhwa* (The True-View Landscape Paintings of Kyŏmjae Chŏng Sŏn) (Seoul: Pŏmu-sa, 1993), pp. 266–75, cited hereafter as *Kyŏmjae Chŏng Sŏn*.

52. Chŏng served as district magistrate of Hayang (1721–26), of Ch'ŏngha (about 1733), and of Yang-ch'ŏn (1740–45).

53. According to the National Code (*Kyŏngguk taejŏn*) compiled in 1485, a painter of the royal painting bureau could not be promoted beyond the sixth rank in the nine-rank system of the bureaucracy. Although there were some exceptions, this rule was generally adhered to. For the case of Chŏng Sŏn, see *Veritable Records of King Yŏngjo*, vol. 81, 1754, March, *kapsin* day.

54. Ch'oe Wan-su, "Kyŏmjae Chŏng Sŏn yŏn'gu," in *Kyŏmjae Chŏng Sŏn*, pp. 266–337. Ch'oe's description of the *Paegak sadan* as an advocate of the so-chunghwa ("minor China") concept is misleading in light of the fact that Kim Ch'ang-ŏp (1658–1721), another of the Kim brothers and a member of the group, was favorably impressed by the new Qing dynasty during his visit to Peking. Kim describes his encounter with Chinese books and paintings in his travelogue, *Kajae Yŏnhaeng-gi*.

55. Ahn Hwi-joon, "Chosŏn hugi mit malgi ŭi san-suhwa" (Landscape Painting at the End of the Chosŏn Period), in *Sansuhwa* (Landscape Painting), vol. 12, *Han'guk ŭi mi* (Beauty of Korea) (Seoul: Chung'ang ilbo, 1982), p. 206; and Ch'oe Wan-su, *Kyŏmjae Chŏng Sŏn*, pp. 275ff.

56. For the pioneering study of Southern School painting of the Chosŏn dynasty, see Ahn Hwi-joon, "Han'guk namjonghwa ŭi pyŏnch'ŏn" (Vicissitudes of Korean Southern School Painting), in *Han'guk hoehwa ŭi chŏn'tong* (Traditions of Korean Painting) (Seoul: Munye ch'ulp'an-sa, 1988), pp. 250–309. For a more recent study, see Yi Sŏng-mi, "Southern School Literati Painting of the Late Chosŏn Period," in *The Fragrance of Ink: Korean Literati Paintings of the Chosŏn Dynasty (1392–1910) from Korea University Museum*, ed. Kwon Young-pil (exh. cat., Seoul: Korean Studies Institute, Korea University, 1996), pp. 164–91 (in Korean and English).

57. Other Chinese painting manuals that found their way to Korea were *Gushi lidai mingren huapu* (Painting Manual of Master Gu) and *Tangshi huapu* (Illustrated Manual of Tang Poetry).

58. Although most Chinese paintings now remaining in Korea in several public and private collections date from the late Qing period, we know from travel diaries and other collected writings that Chinese paintings of the Ming period and earlier were seen by seventeenth- and eighteenth-century Korean scholar-painters. See Yi Sŏng-mi, "Southern School Literati Painting of the Late Chosŏn Period," pp. 183–84.

59. For a detailed discussion of the history of the different names of Mount Kŭmgang and their meanings and symbolism, see Pak Ŭn-sun, *Kŭmgangsan-do*, pp. 14–34.

60. See Yi T'ae-ho, "Chosŏn hugi chin'gyŏng sansu ŭi paltalgwa t'wejo." Unfortunately, the poetry section has been separated from the painting. Ch'oe Wan-su, on the other hand, has identified a poem by Yi Pyŏng-yŏn as having been written for Chŏng Sŏn's painting. This assumes that Chŏng Sŏn was traveling to the area at the invitation of Yi, who was then serving as magistrate of the Kŭmhwa district, the entrance to the vast Diamond Mountain area. See *Kyŏmjae Chŏng Sŏn*, p. 16.

61. For example, in ch. 2 of *Sunam-jip*, the writings of Yi Pyŏng-sŏng (1675–1735). Yi was the younger brother of Yi Pyŏng-yŏn. See Ch'oe Wan-su, *Kyŏmjae Chŏng Sŏn*, p. 20.

62. Pak Ŭn-sun points out that Chŏng's several paintings depicting the Chang'an-sa Temple at different dates all show the arched bridge, Pihong-gyo, very prominently. As documented by several scholar-officials who traveled in the area, however, this bridge was destroyed by flood in about 1723. Pak Ŭn-sun, *Kŭmgangsan-do*, pp. 136–38.

63. See Pak Chun-wŏn's *Kŭmsŏk-chip* (Collection of Epigraphy), quoted in O Se-ch'ang, *Kŭnyŏk Sŏhwa-jing*, pp. 162–63.

64. O Chu-sŏk, "Yet kŭrim iyagi" (Story of Old Paintings), *Pangmulgwan sinmun* (Monthly News of The National Museum of Korea), no. 306 (Feb. 1, 1997), p. 3.

65. "Layers of fragrance" is a translation of *chunghyang*, another name for Mount Kŭmgang.

66. In Chinese myth, *pusang* (Ch. *fusang*) is an imaginary tree in the Eastern Sea whence the sun rises.

67. My English translation is based on the modern Korean translation in O Chu-sŏk, "Yet kŭrim iyagi."

68. This story is recounted in the biography of Zong Bing in Shen Yue (441–513), comp., *Song shi*, ch. 53, Liezhuan.

69. Yi Man-bu, *Chihaeng-nok* (Records of Traveling the Land), Korean trans. by Yi Ch'ang-sŏp (Seoul: Mongnam munhwa-sa, 1990), p. 259. The English translation is taken from Yi Sŏng-mi, "Koreans and Their Mountain Paintings," *Koreana*, vol. 8, no. 4 (Winter, 1994), p. 23.

70. See Pak Ŭn-sun, *Kŭmgangsan-do*, pp. 131–35, for a list of Chŏng Sŏn's paintings of Mount Kŭmgang in album or screen format.

71. My English translation of the inscription is a slightly modified version of a Korean translation by Ch'oe Wan-su in *Kyŏmjae Chŏng Sŏn*, p. 42.

72. This album, in the Kansong Art Museum, contains at least thirteen leaves. See Ch'oe Wan-su, *Kyŏmjae Chŏng Sŏn*, pls. 32–44.

73. The size of the leaves in the album varies slightly.

74. The name suggests that in his retirement Han Myŏng-hoe spent time at leisure here observing the waterfowl on the river.

75. Today this area, still called Apku-jŏng-dong, is densely packed with high-rise apartment buildings, the unmistakable sign of Korea's modernization.

76. The term "*Kyŏmjae ilp'a*" was introduced by Yi Tong-ju in his "Kyŏmjae ilp'a ŭi chin'gyŏng sansu" (True-View Landscape Paintings by a Group of Followers of Kyŏmjae), in *Urinara ŭi yet kŭrim* (Old Paintings of Our Country) (Seoul: Pagyŏng-sa, 1975), pp. 151–92. This article was originally published in *Asea*, no. 4 (1967).

77. Yi T'ae-ho, "Chosŏn hugi chin'gyŏng sansu ŭi paltalgwa t'oejo," pp. 16–17. Since Yi T'ae-ho's work was published, more information on Ch'oe Puk, including his dates, has been discovered. Yi included Ch'oe Puk in the second group because at that time his dates were given simply as "eighteenth century." See Yu Hong-jun, "Hosaenggwan Ch'oe Puk," *Yŏksa pip'yŏng*, no. 14 (Fall, 1991), pp. 386–94.

One artist who is not usually included in this group is Sim Sa-jŏng (1707–1769). He was a member of the yangban class but was not permitted to hold office because his grandfather had participated in the attempted coup against the crown prince, the future King Yŏngjo. Although Sim Sa-jŏng is often referred to as Chŏng Sŏn's disciple, there is little evidence to support this identification. While he produced some true-view landscapes, his works generally reflect a strong influence of Chinese painting manuals.

78. Although one of the artists traditionally numbered among this group, Ch'oe Puk might not be pleased to be included. Ch'oe was an exceptionally free and eccentric spirit, and his paintings display strong personal characteristics that outweigh any specific affinity with Chŏng Sŏn's style.

79. On Kim Yun-gyŏm's work, see Yi T'ae-ho, "Chinjae Kim Yun-gyŏm ŭi chin'gyŏng sansu" (True-View Landscapes of Kim Yun-gyŏm), *Kogo misul*, no. 52 (Dec. 1981), pp. 1–23.

80. Only eight of the twelve leaves mentioned in the inscription survive. They are now in the National Museum of Korea.

81. For a brief history of the Myogilsang-am Temple, see *Han'guk minjok munhwa tae paekkwa sajŏn*, vol. 8, p. 109.

82. The Kim Hong-do painting is reproduced in *Tanwŏn Kim Hong-do* (The Art of Kim Hong-do) (exh. cat., Seoul: Samsung Foundation of Culture, 1995), pl. 63, and the Om Ch'i-uk painting in *Chin'gyŏng sansu-hwa* (Kwangju: Kwangju National Museum, n.d.), pl. 132. Both works are in the National Museum of Korea.

83. A special issue on Ch'oe Puk, with contributions by Yi Chu-sŏng (on documentary sources), Hong Sŏn-p'yo (on Ch'oe's life and art), Pak Ŭn-sun (on his landscape painting), and Song T'ae-wŏn (on his figure painting), was published in *Misulsa yŏn'gu*, no. 5 (1991).

84. This painting is now mounted in an album of paintings by Kim Ŭng-hwan and poems by Hong Chin-yu (b. 1722). The album is in the Pak Chu-hwan Collection, Seoul.

85. See catalogue entry no. 60 by Yi T'ae-ho in *Sansuhwa* (Landscape Painting), vol.12 of *Han'guk ŭi mi*, pp. 238–39.

86. The practice of emulating a Korean master occurred much later, in the nineteenth century, among painters who were adherents of the Southern School literati painting of the Chosŏn period. See Yi Sŏng-mi, "Southern School Literati Painting of the Late Chosŏn Period," pp. 186–87.

87. The most comprehensive study of Kang Se-hwang is by Pyŏn Yŏng-sŏp, *P'yoam Kang Se-hwang hoehwa yŏn'gu* (A Study of P'yoam Kang Se-hwang's Paintings) (Seoul: Ilchi-sa, 1988). Hereafter cited as *P'yoam Kang Se-hwang*.

88. Kang Se-hwang was one of the few scholar-painters who painted figures, including self-portraits. In the history of Korean painting, Kim Hong-do's genre painting is considered his foremost achievement (see pl. 98).

89. Kang Se-hwang's travel record is preserved in *P'yoam yugo* (Collected Writings of P'yoam) (Sŏng-nam: The Academy of Korean Studies, 1979), pp. 254–62.

90. My English translation is based on the Korean translation by Pyŏn Yŏng-sŏp, *P'yoam Kang Se-hwang*, p. 117.

91. *P'yoam yugo*, pp. 261–62.

92. This album consists of sixteen leaves: two leaves of calligraphy—one inscription by Kang Se-hwang and another by a certain Susa—twelve leaves of painting depicting scenic spots in and around Songdo (present-day Kaesŏng), and two leaves with colophons by a certain Namch'onin. The title of the album is given as *P'yoam sŏnsaeng yujŏk* (Master P'yoam's Remaining Paintings).

93. See Pyŏn Yŏng-sŏp, *P'yoam Kang Se-hwang*, pp. 102–105, for evidence that the album was painted in 1757. The confirmation of this date comes from Hŏ P'il's colophon to *Myogil-sang do*, in which Kang's trip to Songdo is mentioned.

94. Pak Ŭn-sun considers the album to be a work executed by Kang after his trip to Yanjing (Peking), when he was "in his old age" (1784), in that the paintings reflect the influence of Western painting; see Pak, *Kŭmgangsan-do*, p. 256. However, as we have seen, other mid-eighteenth-century paintings by Korean artists display just as much influence of Western painting.

95. "Tanwŏn-gi" (Records of Kim Hong-do), in *P'yoam yugo*, p. 251. Judging from his comments, Kang's relationship with Kim Hong-do does not seem to have been that of master and pupil.

96. See O Chu-sŏk, "Hwasŏn Kim Hong-do, kŭ in'gan gwa yesul" (The Immortal Painter Kim Hong-do: His Life and Art), in *Tanwŏn Kim Hong-do*, vol. 2, pp. 44–104, for extensive documentation on Kim Hong-do's life and time.

97. Also known as *Kŭmgang sagun-ch'ŏp*, or the album of paintings of the four districts of Mount Kŭmgang.

98. The albums, now in a private collection in Seoul, were publicly seen for the first time in 1995 at an exhibition organized by the National Museum of Korea, the Ho-Am Art Museum, and the Kansong Museum of Art. The albums were published in their entirety in the exhibition catalogue, *Tanwŏn Kim Hong-do*, pls. 1–60.

99. Signature: Tanwŏn. Seals: (1) square relief: Hong do; (2) square intaglio: Sanŭng.

100. For a discussion of this theme, see Ellen Laing, "Real or Ideal: The Problem of the Elegant Gathering in the Western Garden in Chinese Historical and Art Historical Records," *Journal of the American Oriental Society*, 88, no. 3 (July-Sept. 1968), pp. 419–35.

101. During the late eighteenth century, many members of the well-educated chung'in class became actively engaged in such activities as poetry, calligraphy, music, and painting, pursuing the cultural traditions of the literati.

102. The paintings are now in the collection of Seoul National University Museum. One shows a hunting scene at Hwasŏng Fortress, and the other a scene of chrysanthemum-viewing at the Hanjŏng Pavilion. The entire process of constructing the Hwasŏng Fortress was recorded in *Hwasŏng sŏng'yŏk ŭigwe* (Record of the Construction of the Hwasŏng Fortress) in which the two screens were also recorded. For King Chŏngjo and the Hwasŏng Fortress, see Hongnam Kim, "Tragedy and Art at

the Eighteenth Century Chosŏn Court," *Orienta-tions*, vol. 25, no. 4 (Feb. 1994), pp. 28–37.

**103.** *Tanwŏn Kim Hong-do*, pls. 146–47.

**104.** Translation quoted in Yi Sŏng-mi, "Koreans and Their Mountain Paintings," p. 24.

**105.** On Chŏng Su-yŏng's life and art, see Yi T'ae-ho, "Chinjae Chŏng Su-yŏng ŭi hoehwa" (Chinjae Chŏng Su-yŏng's Painting), *Misul charyo*, no. 34 (June 1984), pp. 27–44.

**106.** These documents are: (1) Hong Sŏk-chu's (1774–1842) preface, dated 1812, to the painting *Sea and Mountains* (*Haesan kwŏn*) owned by Hong Hyŏn-ju (1793–1865); (2) Hong Sŏk-chu's "Selection of Twenty-Three Poems out of Seventy Written for Tanwŏn's Album of Sea and Mountains" (*Haesan ch'ŏp*), dated 1821; and (3) Hong Kil-chu's (1766–1841) colophon to the Album of Sea and Mountains, dated 1829. The first two are found in Hong Sŏk-chu's collected writings, *Yŏnch'ŏn-jip*, chs. 20 and 4, respectively; the third is in Hong Kil-chu's collected poems and writings, *P'yorong ŭlch'am*, ch. 5.

**107.** The preface, poems, and colophon referred to here are those listed in n. 106 above. See catalogue entry by Ch'oe Wan-su, in *Tanwŏn Kim Hong-do*, p. 242.

**108.** Ch'oe Wan-su, while admitting some of the difficulties in reconciling the discrepancies between the existing albums and the documentation, concludes, on the basis of the "characteristic traits of Kim Hong-do's style," that the five-album set is the original form of the *Haesan-ch'ŏp*. Based on this "possibility," he proceeds to identify these paintings with the more than 100 sketches that Kang Se-hwang recorded as having been done by Kim Hong-do during Kang's trip to Mount Kŭmgang. See *Tanwŏn Kim Hong-do*, p. 242, and catalogue entries 1–60 by Ch'oe Wan-su.

**109.** The paintings are reproduced in *Tanwŏn Kim Hong-do*, pls. 96–104.

**110.** See *Tanwŏn Kim Hong-do*, pls. 11, 27, 28, 30, 31, 59, 60.

**111.** The album is reproduced in Pak Ŭn-sun, *Kŭmgangsan-do*, pls. 99-1 to 99-10, and in reference pls. 40-1 to 40-6.

**112.** The album is in the Pak Chu-hwan Collection, Seoul.

**113.** The paintings, diaries, and poems, mounted in ten albums, are in the collection of the Sŏnggyun'gwan University Museum, Seoul. The albums have been published in a monograph, *Tong'yu-ch'ŏp* (Album of Travel to the East) (Seoul: Sŏnggyun'gwan University Press, 1994). The monograph contains an essay by Cho Sŏn-mi, "A Study on the Tong'yu-ch'ŏp," as well as transcriptions and translations of all the diaries and poems into modern Korean.

**114.** See Cho Sŏn-mi, *Tong'yu-ch'ŏp*, pp. 280–81. Her

reasons for not accepting Yi P'ung-ik as the painter of the album are as follows: (1) The preface by Pak Hoe-su, in which he praises Yi for not overlooking the smallest detail in the scenery, should be understood as a comment on Yi's taste and his ability to bring together a travel diary, poetry, and painting; (2) As a high official and a talented literatus, Yi was often praised in contemporary writings, though no mention of his painting talent can be found; (3) No passage in the travel diary indicates that Yi actually painted any scenery, while there are references to his composing poetry; (4) The paintings themselves disclose that they were done by a skillful professional painter who had access to "model sketches" of Mount Kŭmgang that undoubtedly existed in court circles.

**115.** Pak Ŭn-sun's attempt to attribute the *Tong'yu-ch'ŏp* paintings to Yi P'ung-ik is not convincing. See Pak, *Kŭmgangsan-do*, pp. 344–45.

**116.** "Song Kim Ch'albang Hong-do Kim Ch'albang Ŭng-hwan sŏ" (Preface to Sending Off Kim Hong-do and Kim Ŭng-hwan), in *P'yoam yugo*, pp. 237–38.

**117.** See *Zhongguo banhuashi tulu* (Illustrated Catalogue of the History of Chinese Woodblock Prints) (Shanghai: Renmin meishu chubanshe, 1983), vol. 1, pls. 162–96. Under the category of "topography" are listed various woodblock-printed landscapes published during the late Ming and early Qing periods.

**118.** *Chŏng Sŏn, Han'guk ŭi mi*, no. 1 (Seoul: Chung'ang ilbo, 1977), p. 79.

**119.** The possibility that Koreans had access to Chinese painting manuals and other printed books with woodblock illustrations during the late Chosŏn period is discussed in Yi Sŏng-mi, "Imwŏn Kyŏngjeji e nat'anan Sŏ Yu-gu ŭi Chungguk hoehwa mit hwaron e taehan kwansim" (Sŏ Yu-gu's Interest in Chinese Paintings and Painting Theory as Expressed in the *Imwŏn kyŏngjeji* [Treatise on Rural Economy]), *Misul sahak yŏn'gu*, no. 193 (Mar. 1992), pp. 33–62.

**120.** Published in *Richō no kaiga* (Paintings of the Chosŏn Dynasty) (exh. cat., Tokyo: Fuji Art Museum, 1985) cat. no. 50.

**121.** See Yi Sŏng-mi et al., *Changsŏgak sojang karye togam ŭigwe* (An Analysis of the Records of the Superintendency for Royal Weddings of the Chosŏn Dynasty Preserved in the Changsŏgak Library) (Sŏngnam: Academy of Korean Studies, 1994), charts no. 3 (p. 83) and 5 (p. 93). Kim Ha-jong participated in the event marking the 1851 wedding of King Ch'ŏlchong (r. 1849–63). See also Yi Sŏng-mi et al., *Chosŏn sidae Ŏjin Kwan'gye togam Uigwe yŏn'gu*, pp. 43 and 88. Kim participated in

making the copy of King Taejo's portrait in 1837. See also Pak Ŭn-sun, *Kŭmgangsan-do*, pp. 331–32.

122. The album formerly was dated to 1875, but the date has been revised to 1815 (the same cyclical year, *ŭlhae*, sixty years earlier) in accordance with the dates of one of the colophon writers, the official Yi Kwang-mun (1778–1838). See Pak Ŭn-sun, *Kŭmgangsan-do*, p. 333.

123. The albums, now in a private collection, first came to be known at a Sotheby's auction in 1991. Three leaves of painting are reproduced in *Korean Works of Art* (New York: Sotheby's, October 22, 1991), no. 38. Also see Pak Ŭn-sun, *Kŭmgangsan-do*, pp. 355–59, for the contents of the entire album. A fifth album contains writings on Mount Kŭmgang by the well-known scholar-official Yi Yu-wŏn (1814–1888), who traveled to the area and asked Kim Ha-jong, then eighty years old, to paint the scenery.

124. Pak Ŭn-sun, *Kŭmgangsan-do*, p. 357.

125. Yu Suk's painting is illustrated in *Sansuhwa*, vol. 12 of *Han'guk ŭi mi*, pl. 182.

126. Hŏ Ryŏn's painting is illustrated in *Sansuhwa*, vol. 12 of *Han'guk ŭi mi*, fig. 13.

127. Reproduced in *Chin'gyŏng sansu-hwa*, pl. 148.

128. For Yi Sang-bŏm, see Yi Sŏng-mi, "Ch'ŏngjŏn Yi Sang-bŏm ŭi hoehwa" (Ch'ŏngjŏn Yi Sang-bŏm's Paintings), in *Ch'ŏngjŏn Yi Sang-bŏm* (exh. cat., Seoul: Ho-am Art Museum, 1997), pp. 16–25, English summary, pp. 26–29.

*"An Kyŏn and the Eight Views Tradition: An Assessment of Two Landscapes in The Metropolitan Museum of Art," by Kim Hongnam, pp. 366–401.*

1. For a selected list of major studies of early Chosŏn landscape painting and An Kyŏn, see Ahn Hwi-joon, "Korean Landscape Painting in the Early Yi Period: The Kuo Hsi Tradition" (Ph.D. diss., Harvard University, 1974); "Two Korean Landscape Paintings of the First Half of the Sixteenth Century," *Korea Journal* (Feb. 1975), pp. 31–41; "An Kyŏn and 'A Dream Visit to the Peach Blossom Land,'" *Oriental Art*, vol. 26, no. 1 (Spring, 1980), pp. 60–71; *An Kyŏn kwa Mong'yu Towŏn-do* (An Kyŏn and The Dream Journey to the Peach Blossom Land) (Seoul: Yekyong Publishing Co., 1991). See also Yi Tong-ju, *Uri yet kŭrim ŭi arŭmdaum* (The Beauty of Our Old Paintings) (Seoul: Sigongsa, 1996); Matsushita Taka'aki and Ch'oe Sun-u, *Richō no suibokuga* (Yi Dynasty Ink Painting) (Tokyo: Kodansha, 1977); Kumja Paik Kim, "Two Stylistic Trends in Mid-Fifteenth Century Korean Painting," *Oriental Art*, vol. 29, no. 4 (Winter,

1983/84), pp. 368–76; *Chosŏn chŏn'gi kukpojŏn* (Treasures of the Early Chosŏn Dynasty, 1392–1592) (exh. cat., Seoul: Ho-Am Art Museum, 1996); Itakura Shōtetsu, "Shō-Shō Hakkeizu ni miru Chōsen to Chūgoku" (Korea and China Through the Paintings of Eight Views of the Xiao and Xiang Rivers), in *Richō no kaiga* (Yi Dynasty Painting) (exh. cat., Nara: Museum Yamato Bunkakan, 1996).

2. Although they had been considered by some Japanese connoisseurs and scholars as Korean paintings of the Chosŏn period, the pair of landscapes became known outside Japan only after they were published by Suzuki Kei, as Korean paintings of the Yi (Chosŏn) dynasty in the Chinese painting collection of Yabumoto Sōgoro; see *Chūgoku kaiga sōgō zuroku* (Comprehensive Illustrated Catalogue of Chinese Paintings), 5 vols (Tokyo: University of Tokyo Press, 1982–83), vol. 4: Japanese Collections: Temples and Individuals, pl. JP 12-084-1,2, p. 238. The provenance of the paintings prior to the time they were acquired by Yabumoto, who had them for some twenty years, can be traced to Murayama Ryūhei, the founder of *Asahi Shinbun* and an eminent collector and founder of the Kōsetsu Museum in Kobe, Hyōgo Prefecture. Apparently, the Murayama collection once possessed a number of paintings of Korean attribution and connection, most of which were deaccessioned after his death. In addition to this pair, for example, the collection included a landscape hanging scroll, with an attribution to Shōkei of the Muromachi period (1392–1573), very similar to Yang P'aeng-son's (1488–1545) famous work now in The National Museum of Korea and a folding screen of *Eight Views* attributed to Shūbun (now reattributed to the Muromachi painter Kaō). I am indebted for much of this historical information, as well as for invaluable help with my research in Japan, to Yoshida Hiroshi, a leading authority and connoisseur in Korean art.

3. For studies of the Eight Views, see Shimada Shūjirō, "Sō Teki to Shōshō Hakkei" (Song Di and the Eight Views of the Xiao and Xiang), hereafter cited as Shimada Shūjirō, "Song Di," *Nanga kanshō*, 10 (1941), pp. 6–13; Ahn Hwi-joon, "Kungnip Chung'ang Pangmulgwan sojang So-Sang P'al-gyŏngdo" (The Eight Views of the Xiao and Xiang in the Collection of The National Museum of Korea), *Kogo misul*, no. 138 (1978); Richard Stanley-Baker, "Mid-Muromachi Paintings of the Eight Views of Hsiao and Hsiang" (Ph.D. diss., Princeton University, 1979); Alfreda Murck, "Eight Views of the Hsiao and Hisang Rivers by Wang Hung," in Wen C. Fong et al., *Images of the Mind*, hereafter cited as Alfreda Murck, "Eight Views" (Princeton:

The Art Museum, Princeton University, 1984), pp. 214–35; and "The Eight Views of Xiao-Xiang and the Northern Song Culture of Exile," *Journal of Sung-Yuan Studies* 26 (1996); Richard M. Barnhart "Shining Rivers — 'Eight Views of the Hsiao and Hsiang Rivers' in Sung Painting," in *Proceedings of the International Colloquium on Chinese Art History: Painting and Calligraphy* (Taipei: National Palace Museum, Taipei, 1991).

4. Toda Teisuke, ed., "Mokkei, Gyokukan" (Muqi, Yu-jian), *Suiboku bijutsu taikei* (Complete Collection of Japanese and Chinese Ink Paintings Through the Centuries), hereafter cited as *Suiboku taikei* (Tokyo: Kodansha, 1973), vol. 3, pl. 99, pp. 138–39.

5. Morohashi Tetsuji, comp., *Dai kanwa jiten* (Chinese-Japanese Dictionary) (Tokyo: Taishūkan shoten, 1974), vol. 4, p. 240.

6. Wang Hong's two handscrolls, painted in about 1150, are in the collection of The Art Museum, Princeton University; see Alfreda Murck, "Eight Views," pp. 222–23. According to Zeng Maixing (act. 11th century), who saw the paintings, Song Di's *Eight Views* did not show the moon; see Shimada Shūjirō, "Song Di."

7. Kim Chong-sŏ et al., comp., *Koryŏ-sa chŏryo* (Essentials of Koryŏ History) (pub. 1452; repr. Seoul: Minjok munhwa, chujin wiwŏnhoe, 1968), vol. 2, p. 240.

8. The poems by Chin Hwa and Yi In-no are found in Sŏ Kŏ-jŏng (1420–1488), comp., *Tongmunsŏn* (Anthology of Korean Literature), vol. 6, pp. 214–16 and vol. 20, pp. 397–99. Chin Hwa's poems are also included in his literary collection, *Maeho sŏnsaeng yugo* (Writings of Master Maeho), ch. 1, pp. 21a–21b.

9. Yi Che-hyŏn's poems are included in his literary collection, *Ikchae nango* (Random Notes of Ikche), ch. 3, pp. 8–9. Yi Sung-so's are recorded in Sin Yong-gae (1463–1519) et al., comp., *Sok Tongmunsŏn* (Anthology of Korean Literature) (second series, pub. 1517), ch. 10, pp. 722–23.

10. The Shōkoku-ji handscroll is published in *Sansui: The Ideas and the Art of Landscape* (exh. cat., Kyoto: Kyoto National Museum, 1983), pl. 96; Yoshida Hiroshi, catalogue entry in Matsushita and Ch'oe, *Richō no suibokuga*, pl. 2, p. 133; James Cahill, *Hills Beyond a River: Chinese Painting of the Yuan Dynasty, 1279–1368* (Tokyo: Weatherhill, 1976), pl. 29 (detail). The Kyoto National Museum catalogue dates it to the Koryŏ period, while Yoshida Hiroshi of the Yamato Bunkakan ascribes it to the very beginning of the Chosŏn dynasty. Cahill, however, takes seriously a traditional attribution to the Yuan painter Zhang Yuan; see James Cahill, *Hills Beyond a River*, pp. 75–76.

For the Shikan scroll, see *Nihon no suibokuga* (Japanese Ink Painting) (exh. cat., Tokyo: Tokyo National Museum, 1987), pl. 1; Yoshiaki Shimizu and Carolyn Wheelwright, eds., *Japanese Ink Paintings from American Collections: The Muromachi Period, An Exhibition in Honor of Shūjirō Shimada* (exh. cat., Princeton: The Art Museum, Princeton University, 1976), fig. 2; Matsushita Taka'aki and Tamamura Takeni, "Josetsu, Shūbun, San-Ami," *Suiboku taikei*, vol. 6, p. 45. Both the Princeton and the Tokyo National Museum catalogues date the hanging scroll to the fourteenth century, during the Kamakura period. The latter regards it as an amateur work and relates the scroll to another painting of *Autumn Moon* bearing Shikan's seal and found among Kanō Tanyū's reduced copies of old paintings as coming from one complete set of the Eight Views. Matsushita does not exclude the possibility of a late Koryŏ or early Chosŏn date for the two works; see *Suiboku taikei*, vol. 6, pp. 42–45.

11. For much of what we know of the prince, we are indebted to Professor Ahn Hwi-joon's extensive studies on An Kyŏn and his time. See note 1 above.

12. See *Chosŏn chŏn'gi kukpojŏn*, pls. 67/1–6. The handscroll, now re-mounted as an album, is owned by Mr. Im Ch'ang-sun, an eminent scholar in Chinese studies and Korean calligraphy. See also Ahn Hwi-joon, *An Kyŏn kwa Mong'yu Towŏndo*, p. 42.

13. In Ahn Hwi-joon's list of An Kyŏn's recorded paintings with known dates, one set from the year 1442 is referred to as "authorship unproven." This date coincides with the prince's commission of Eight Views poems and paintings mentioned above, leading us to infer that they are probably the same paintings.

14. For a study of the contents of the prince's collection, see Ahn Hwi-joon, "Kōrai oyobi Richō shoki ni okeru Chūgokuga no ryūnyū" (Importation of Chinese Painting into Korea during the Koryŏ and the Early Yi Dynasties), *Yamato bunka*, no. 62 (July 1977).

15. Kang Sŏk-tŏk's Eight Views poems are recorded in Sŏ Kŏ-jŏng, *Tongmunsŏn*, ch. 22, pp. 532–34. However, the name of the Song emperor, Chenzong, given in this reference is a misprint of Ningzong, as evidenced by the original set of Kang's poems surviving in the collection of Yim Ch'angsun, an eminent scholar of calligraphy. Kang Hūi-maeng also left a set of Eight Views poems titled simply "So-Sang p'algyŏng," recorded in Sŏ Kŏ-jŏng, *Tongmunsŏn*, ch. 10, pp. 725–28.

16. Itakura Shōtetsu, "Shō-Shō Hakkeizu," pp. 13–14. Of the many later Eight Views paintings produced in Korea, one of the most noteworthy is an anonymous set of paintings mounted as a screen, which recently came to light in Japan. Formerly in the

Mori collection, now in the collection of the Japanese Ministry of Culture, the paintings have been ascribed to the late fifteenth century and are mounted together with a 1584 transcription of Chin Hwa's eight poems by the Chosŏn scholar-official Kim Hyŏn-sŏng (1542–1621); published in *Richō no kaiga*, cover illustration and pl. 1, cat. entry p. 82. For more information on this screen, see Toda Teisuke, "Shō-Shō Hakkeizu oecho byōbu," *Kokka*, no. 124 (1996).

17. Published in *Sansui: The Ideas and the Art of Landscape*, pl. 98, as a Korean painting from the first half of the sixteenth century in the tradition of An Kyŏn's Guo Xi-style landscapes; *Richō no kaiga*, fig. 6, p. 14; Toyama Museum of Fine Art, *Korean Paintings of the Yi Dynasty from the Kongetsuken Collection* (in Japanese) (Toyama: Toyama Museum of Fine Art, 1985), fig. 7, p. 85.

18. Richard M. Barnhart, "A Lost Horizon: Painting in Hangzhou After the Fall of the Song," in Richard M. Barnhart et al., *Painters of the Great Ming: The Imperial Court and the Zhe School* (Dallas: Dallas Museum of Art, 1993), pp. 21–51.

19. For studies of Dai Jin and the Zhe school, see Mary Ann Rogers, "Visions of Grandeur: The Life and Art of Dai Jin," in Richard Barnhart et al., *Painters of the Great Ming*, pp. 127–94.

20. Shen C.Y. Fu, "A Landscape Painting by Yang Weizhen," in *National Palace Museum Bulletin, Taipei*, vol. 8, no. 4 (1973).

21. Richard M. Barnhart, *Wintry Forest, Old Trees: Some Landscape Themes in Chinese Painting* (exh. cat., New York: China Institute in America, 1972).

22. See Alfreda Murck, "Eight Views."

23. *Suiboku taikei*, vol. 6, pls. 94–96, p. 158.

24. John Rosenfield, catalogue entry in Yoshiaki Shimizu and Carolyn Wheelwright, *Japanese Ink Paintings*, p. 78.

25. James Cahill, *Hills Beyond a River*, p. 75.

26. Yoshiaki Shimizu and Carolyn Wheelwright, *Japanese Ink Paintings*, p. 17.

27. For more information, see Sherman E. Lee and Wai-kam Ho, *Chinese Art Under the Mongols: The Yuan Dynasty (1279–1368)* (Cleveland: The Cleveland Museum of Art, 1968), cat. entry 222. For a comparison, see Li Shan's *Wind and Snow in the Fir-Pines* in The Freer Gallery of Art, published in *The Freer Gallery of Art* (Tokyo: Kodansha, 1972), pl. 44.

28. Ahn Hwi-joon, *An Kyŏn kwa Mong'yu Towŏndo*, p. 64.

29. Sin Suk-chu, "Hwagi," in Sin Suk-chu, *Pohanjae jip* (Collected Writings of Pohanjae), vol. 14.

30. Other paintings listed include: *Landscapes* (two scrolls depicting spring and autumn scenes); *Cold Wind and Flying Snow*; *Cool Breeze in Summer Scenery*; *Old Tree in Level-Distance Landscape*; *River and Sky in Evening Snow*; *Pavilion in a Grove of Trees* (in fan format); *Rain Storm* (in fan format); and *Bull-Fighting* (pair of scrolls).

31. We cannot rule out the possibility, however slight, that this is a miswritten entry referring to the Yuan painter Ma Wan (act. 1325–65). Evidence exists, however, of the importation of works ascribed to Ma Yuan and Liu Songnian (act. ca. 1175–after 1195), another Southern Song court artist. See Ahn Hwi-joon, "Koryŏ mit Chosŏn wangjo ch'ogi ŭi Taejung hoehwa kyosŭp" (Artistic Exchange with China During the Koryŏ and Early Chosŏn), *Asea hakpo*, vol. 13 (Nov. 1979), pp. 141–70, esp. pp. 149–51. See also Ahn Hwi-joon, *Han'guk hoehwa ŭi chŏnt'ong* (The Tradition of Korean Painting) (Seoul: Munye ch'ulp'an-sa, 1988), p. 122.

32. For Tang Di, see Chen Gaohua, *Yuandai huajia shiliao* (Source Materials on Yuan Dynasty Painters) (Shanghai: Renmin meishu chubanshe, 1980), pp. 214–36. For Luo Zhichuan, see Shimada Shūjirō, "Ra Chisen Sekkōhozu ni tsuite" (Concerning Luo Zhichuan's *Snowy Riverbank*), *Hōun* 22 (1938), pp. 41–52. See also Richard Barnhart, *Painters of the Great Ming*, pp. 23–25, 42–44. Luo Zhichuan had been nearly forgotten in Chinese art history until he was recently rediscovered by scholars.

33. This may be attributed to two principal reasons: the newly founded Ming royal house had yet firmly to establish the Imperial Academy; and Ming-Chosŏn relations did not extend to cultural diplomacy. For a discussion of the Ming Imperial Academy, see Richard M. Barnhart, "The Return of the Academy," in Wen C. Fong, James C.Y. Watt et al., *Possessing the Past: Treasures from the National Palace Museum, Taipei* (exh. cat., New York: The Metropolitan Museum of Art and National Palace Museum, Taipei, 1996), pp. 335–67.

34. Kim Chong-sŏ et al., comp., *Koryŏ-sa*, vol. 122, Biography vol. 35, Arts and Crafts section, Biography of Yi Nyŏng.

35. The two paintings ascribed to Gao Ranhui are discussed in *Suiboku taikei*, vol. 3, pls. 110–111, and cat. entry, p. 177. See also *Tae Koryŏ kukpo-jŏn*, pls. 54–55, pp. 292–3; Shimao Arata, "Suibokuga: Nōami kara Kanōha e" (Ink Painting: From Nōami to the Kanō School) in *Nihon no bijutsu*, vol. 7 (1994), pl. 74, p. 53. Studies of these scrolls by Korean and Japanese scholars, including Ebine Toshirō, Yoshida Hiroshi, Shimao Arata, and Ahn Hwi-joon, refer to them as Koryŏ paintings in the landscape tradition of Mi Fu and his son, Mi Youren. Shimao further identifies the pair as fourteenth-

century Koryŏ paintings and finds a stylistic affinity in the monumental tradition of Northern Song landscape. A representative example of Gao Kegong's work is *Clouds Encircling Luxuriant Peaks*, in the National Palace Museum, Taipei.

36. Tani Shin'ichi, "Gyomotsu on'e mokuroku" (The Catalogue of the Shogunal Collection), in *Bijutsu kenkyū* 58 (1936), pp. 439–47; Richard Stanley-Baker, "The Ashikaga Shogunal Collection and Its Setting: A Matrix for Fifteenth Century Landscape Painting," in *Influence in Oriental Art: International Symposium on Art Historical Studies*, no. 7 (Osaka: The Society for International Exchange of Art Historical Studies, 1990), pp. 87–98.

37. For an in-depth study of Chan Buddhist art and its subject matter, see Jan Fontein and Money L. Hickman, *Zen Painting and Calligraphy: An Exhibition of Works of Art Lent by Temples, Private Collectors, and Public and Private Museums in Japan* (exh. cat., Boston: Museum of Fine Arts, 1973).

38. Prince Anp'yŏng asked Ch'oe Kyŏng, a court painter, to copy *The Three Laughers*, a painting which was in Zhao Mengfu's collection. There is a painting of a White-Robed Avalokiteshvara with Ch'oe's signature in Japan. See Ahn Hwi-joon, *An Kyŏn kwa Mong'yu Towŏn-do*, p. 64, note 66.

39. In addition to Ch'oe Kyŏng's paintings on Chan subjects, mentioned in the preceding note, a painting titled *Green Mountains and White Clouds* treats another Chan subject that appears to have been very popular at the time of An Kyŏn, who executed at least one painting on this topic for the prince, according to Sin Suk-chu's catalogue. For the existence of a body of Chan poems and the frequency of contacts between Koryŏ and Chinese Chan monks and monasteries, see Yin Kwŏn-hwan, *Koryŏ sidae pulgyo si ŭi yŏn'gu* (Research on Koryŏ Period Buddhism) (Seoul: Korea University, 1989), pp. 23–25.

40. Jan Fontein and Money Hickman, *Zen Painting and Calligraphy*, entry 18.

41. Yoshiaki Shimizu and Carolyn Wheelwright, *Japanese Ink Paintings*, p. 78.

42. Ibid., p. 78.

43. See Shōkei's *Evening Bell from Mist-shrouded Temple*, ca. 1506. Published in *Suiboku taikei*, vol. 6, pl. 141.

44. Yoshiaki Shimizu and Carolyn Wheelwright, *Japanese Ink Paintings*, p. 20.

45. This is indicative of the continuation of Chan Buddhist involvement in art and literature during the early Chosŏn dynasty. For a further discussion of the authors of the colophons to *Dream Journey*, see Ahn Hwi-joon, *An Kyŏn kwa Mong'yu Towŏn-do*, pp. 109–11.

*"The Korean Art Collection in The Metropolitan Museum of Art," by Pak Youngsook, pp. 402–49.*

1. Food remains in the pottery vessels from excavated tombs are evidence that food was offered at funerary ceremonies. The densely packed pottery vessels show that enough provision was made for the use of the deceased in the next world. For information on Kaya tombs, see *Sinbi ŭi kodae wangguk Kaya tŭkpyŏljŏn* (Kaya: The Mysterious Ancient Kingdom) (exh. cat., Seoul: The National Museum of Korea, 1991), pl. 141; *Kodai bijutsu* (Ancient Art), vol. 1 of *Kankoku bijutsu* (The Art of Korea) (Tokyo: Kodansha, 1987), pl. 262.

2. See Kim Wŏn-yong and Ahn Hwi-joon, *Sinp'an Han'guk misulsa* (The History of Korean Art) (Seoul: Sŏul Taehakkyo, 1993), p. 130; p. 147 n. 30.

3. A first-century Han Chinese bronze mirror decorated with four guardian animals and a geometric pattern resembling the letters TLV that was found during recent excavations at a fourth-century Kaya tomb, in Taesŏng-dong, Kimhae, South Kyŏngsang Province, is evidence of early trade relations between the ancient Korean kingdoms and China. See *Sinbi ŭi kodae wangguk Kaya tŭkpyŏljŏn*, pl. 61.

4. See Kim Wŏn-yong and Ahn Hwi-joon, *Sinp'an Han'guk misulsa*, p. 131.

5. For a similar piece, see *T'ogi* (Earthenware), vol. 5 of *Han'guk ŭi mi* (Beauty of Korean Art) (Seoul: Chung'ang ilbosa, 1981), pl. 54.

6. For a small cup with handle on a stand, see *Kodai bijutsu*, vol. 1 of *Kankoku bijutsu*, pl. 262.

7. For the Ch'angnyŏng stand, see *Kungnip Chinju Pangmulgwan* (Catalogue of the Chinju National Museum) (Seoul, 1984), pl. 124; for the Kimhae stand, see *Sinbi ŭi kodae wangguk Kaya tŭkpyŏljŏn*, pl. 255.

8. For examples of pottery objects, see *Niizawa Senzuka no iho to sono genryu-tokubetsuden: 1500-nen mae no Shiruku Rōdo* (Art from the Silk Road: Archaeological Treasures from the Niizawa-Senzuka Burial Mounds) (Nara: Kenritsu Kashiwara Kokōgaku Kenkyūjo, 1992), pp. 24, 27, 32, 58; *Nikkan kōryū bunkaten* (Exhibition on Cultural Exchanges between Japan and Korea) (Osaka: Shiritsu hakubutsukan, 1980), pls. 206–10; *Hankyū Fujinoki kofun kaibō* (Introduction to the Fujinoki Tomb in Hankyu) (Tokyo: Yoshikawa kobunkan, 1989), pls. 6, 8, 17, 31, 63.

9. The association of gold and jade with immortality was expanded upon by one of the pioneers in alchemy in China, Ge Hong (283–343). See Helmut Brinker and Francois Louis, "Gold und Silber im alten China" (Gold and Silver in Ancient China), in *Chinesisches Gold und Silber: Die Samm-*

*lung Pierre Uldry* (Chinese Gold and Silver in the Pierre Uldry Collection) (Zurich, 1994), p. 16ff. For a discussion of the association of jade with Daoism in ancient China, see James C.Y. Watt, "Jade," in Wen C. Fong and James C.Y. Watt, *Possessing the Past: Treasures from the National Palace Museum, Taipei* (New York: The Metropolitan Museum of Art, 1996), p. 54.

10. See plate 45 in this volume for an example of a gilt-bronze crown of the Silla period.

11. Lee Hee-soo, "Early Korean-Arabic Maritime Relations Based on Muslim Sources," *Korea Journal* (Summer 1991), pp. 21–32.

12. Choe Pyong-hŏn has proposed a categorization of Silla earrings; see *Silla kobun yŏn'gu* (Study of Silla Tombs) (Seoul: Ilchi-sa, 1992). Choe's system has been profitably used by Joo Kyeong-mi for the dating of earrings; see "A Study of Ear Ornaments in the Three Kingdoms Period of Korea," *Misulsahak yŏn'gu*, no. 211 (Sept. 1996), pp. 5–28.

13. For earrings from Silla tombs, see *Kungnip Kyŏngju Pangmulgwan* (Catalogue of the Kyŏngju National Museum) (Seoul: T'ongch'ŏn munhwasa, 1995), pls. 235, 236. For Kaya examples, see *Kaya bunkaten* (The Ancient Kingdom of Kaya) (exh. cat., Tokyo: Tokyo National Museum, 1992), pl. 106.

14. *Kaya bunkaten*, pl. 131.

15. See Kim Tae-wook, *Wonsaek togam Han'guk ŭi sumok* (The Woody Plants of Korea) (Seoul: Kyohaksa, 1994), p. 68.

16. For illustrations, see *Kobun kŭmsok* (Ancient Metalwork), vol. 1 of *Kukpo* (National Treasures) (Seoul: Yekyong ch'ulp'ansa, 1983), pl. 74; *Kungnip Chinju Pangmulgwan*, pls. 20, 92, 140; *Kungnip Chŏnju Pangmulgwan* (Catalogue of the Chŏnju National Museum) (Seoul: Samhwa ch'ulp'ansa, 1990), p. 49, pl. 41; *Miryoku no Nihonkai bunka* (Attractions of Japanese Coastal Culture) (Ishigawa: Ishigawa Kenritsu Rekishi Hakubutsukan, 1990), pl. 203; *Kaya bunkaten*, pls. 135–37. A pair of earrings with one pendant rather than two is also in the collection of the Ho-Am Art Museum; see *Masterpieces of the Ho-Am Art Museum*, vol. 2 (Seoul: Samsung Foundation of Culture, 1997), pl. 140.

17. For the "gold bell" earrings, see *Kobun kŭmsok*, vol. 1 of *Kukpo*, pl. 74. For the ball pendant earrings, see *Kungnip Chinju Pangmulgwan*, pl. 140.

18. *Kobun kŭmsok*, vol. 1 of *Kukpo*, pl. 33 (Hwangnam Great Tomb no. 14); pl. 74 (Gold Bell Tomb); pl. 79 (Tomb no. 1 in the area of King Mich'u's Tomb); pl. 99 (Houch'ong and Pomun-dong tombs), all in Kyŏngju.

19. A recent study on Chinese gold has shown that the gold wire was not drawn but was produced by the "strip-twisted" method, which gave the appearance of drawn wire. See Emma C. Bunker (with technical advice from Richard Kimball and Julie Segraves), "Gold Wire in Ancient China," *Orientations* (Mar. 1997), pp. 94–95.

20. The following are among the many books that have been published on this subject: *Greek Gold: Jewellery of the Classical World* (London: British Museum, 1994); Victor Sarianidi, *Bactrian Gold* (Leningrad: Aurora Art Publishers, 1985); *L'or des Scythes: Tresors de l'Ermitage, Leningrad* (Brussels: Museés Royaux d'Art et d'Histoire, 1991). See also Pak Youngsook, "The Origins of Silla Metalwork," *Orientations* (Sept. 1988), pp. 44–53.

21. Among the best-known examples are two exquisite gilt-bronze Buddha images from the three-story pagoda (consecrated in 706) at the Hwangbok-sa Temple site, in Kyŏngju. See *Pulsari chang'ŏm* (The Art of the Sarira Reliquary) (exh. cat., Seoul: The National Museum of Korea, 1991), p. 25, and throughout the catalogue. In the same volume, see Kang Woo-bang, "Pul'sari chang'ŏm non: Pulgyŏng Pult'ap, pulsang ŭi sanggwan kwan'gye," on the relationship between the Buddhist scriptures, pagodas, and images.

22. For a more detailed discussion of this sculpture, see Kim Lena's essay on Korean Buddhist sculpture in this volume.

23. Yi Kun Moo et al., "Ŭich'ang Taho-ri yujŏk palgul chinjŏn pogo" (Research Report of the Excavation of the Proto-Three-Kingdoms Burial Site at Taho-ri, Ŭich'ang County), *Kogohakchi*, no. 1 (July 1989), pp. 23–26, 83–84.

24. *Pangmulgwan sinmun* (Newspaper of The National Museum of Korea), no. 311 (July 1997), p. 1.

25. *Kungnip Kyŏngju Pangmulgwan*, pl. 324.

26. *Koryŏ-sa* (History of the Koryŏ Dynasty), Sega, book 9, 34th year (1080), seventh month of the reign of King Munjong. See Chin Hong-sop, ed., *Samguk sidae-Koryŏ sidae* (Three Kingdoms to Koryŏ Periods), vol. 1 of *Han'guk misulsa charyo chipsŏng* (Compilation of Materials on Korean Art History) (Seoul: Iljisa, 1987), p. 614.

27. Xu Jing, *Xuanhe fengshi Gaoli tujing* (Illustrated Record of the Chinese Embassy to the Koryŏ Court During the Xuanhe Era) (Seoul: Asia munhwasa, 1972), ch. 15, Cavalry; pp. 75, 121.

28. Ibid., ch. 23, Native Products; p. 121.

29. A number of significant studies have been undertaken on Korean lacquer, especially that of the Koryŏ period. Among these are G. St. G.M. Gompertz, "Korean Inlaid Lacquer of the Koryo Period," *Transactions of the Oriental Ceramic Society*, vol. 43 (1978–79), pp. 1–31; *Han'guk ch'ilgi ich'ŏn-nyŏn* (2000 Years of Korean Lacquerware) (exh. cat., Seoul: National Folklore Museum, 1989);

James C.Y. Watt and Barbara Brennan Ford, *East Asian Lacquer: The Florence and Herbert Irving Collection* (exh. cat., New York: The Metropolitan Museum of Art, 1991), pp. 303–25. For Japanese studies on Korean lacquer, see Watt and Ford, *East Asian Lacquer*, p. 311.

30. The technique of inlaying mother-of-pearl, amber, tortoiseshell, or semiprecious stones on a lacquer background was used during Unified Silla in the decoration of the backs of mirrors. See *Han'guk ch'ilgi ich'ŏnnyŏn*, pl. 36. For a brief introduction to lacquerware and references to lacquer objects, see Pak Youngsook, *Koreanische Tage: Korean Art, 5th–20th Century* (Ingelheim am Rhein, 1984), pp. 54–55. A good example of the use of *pokch'ae* in Unified Silla can be seen on a bronze mirror in the Ho-Am Art Museum, in which inlaid white mother-of-pearl is used in combination with colorful red amber for the petals of a large *posang* flower. The background of the overall decoration is embedded with tiny pieces of turquoise. In this mirror the painterly quality is achieved by finely incised lines for the foliage and the animals inlaid in mother-of-pearl. See *Masterpieces of the Ho-Am Art Museum*, vol. 2, pl. 150.

31. The handle is illustrated in *Han'guk ch'ilgi ich'ŏnnyŏn*, pl. 42. The jar is reproduced in Gompertz, "Korean Inlaid Lacquer of the Koryo Period," pl. 3c.

32. For illustrations of the three boxes, see ibid., pl. 3; and Nishioka Yasuhiro, "Concerning the So-Called Koryŏ Dynasty Mother-of-Pearl Inlaid Sutra Boxes: A Re-examination of Manufacturing Sites and Period Dating," in *International Colloquium on Chinese Art History*, vol. 2 (Taipei, 1991), pls. 3–5.

33. For other examples in Japanese collections, see *Tae Koryŏ kukpochŏn* (The Great Koryŏ Exhibition) (Seoul: Ho-Am Art Museum, 1995), pls. 80, 83.

34. Nishioka Yasuhiro, "Concerning the So-Called Koryŏ Dynasty Mother-of-Pearl Inlaid Sutra Boxes," pp. 625–27.

35. For instance, Ikutaro Itoh and Yutaka Mino, *The Radiance of Jade and the Clarity of Water: Korean Ceramics from the Ataka Collection* (exh. cat., Chicago: The Art Institute of Chicago, 1991), p. 32, fig. 9, identifies a set of inlaid celadon boxes as a "toilet box."

36. Nishioka Yasuhiro, "Concerning the So-Called Koryŏ Dynasty Mother-of-Pearl Inlaid Sutra Boxes," p. 623.

37. See *Pulsari chang'ŏm*, p. 29.

38. Ariga Yuso, *Kō to Bukkyō* (Incense and Buddhism) (Tokyo: Kokusho kankokai, 1990), pp. 10–17, 28–65.

39. *Pulsari chang'ŏm*, pp. 169, 172.

40. *Meishu congshu* 20 (Shanghai, 1935), pp. 295–327.

I am grateful to Roderick Whitfield for bringing this reference to my attention.

41. See the list of incense names in Ariga Yuso, *Kō to Bukkyō*, pp. 223–34.

42. Xu Jing, *Gaoli tujing*, ch. 32, pp. 172–73. Most Western-language publications have followed Gompertz in translating the term *pisaek* as "kingfisher color"; see Gompertz, "Hsü Ching's Visit to Korea in 1123," *Transactions of the Oriental Ceramic Society*, vol. 33 (1960–63); and *Korean Celadon* (London: Faber and Faber, 1963), p. 41. However, I translate the term as "jade color."

43. *Chūgoku no kachōga to Nihon: kachōga no sekai* (Chinese Flower and Bird Painting and Japan: The World of Flower and Bird Painting), vol. 10 (Tokyo: Gakken, 1983), pls. 33–34; Yonezawa Yoshio, "Roganzu ni tsuite" (Concerning Images of Geese and Reeds), *Kokka*, no. 929 (1970), p. 31f; and Jan Wirgin, "Sung Ceramic Designs," *Museum of Far Eastern Antiquities Bulletin*, no. 42 (1970), p. 166ff.

44. See *Masterpieces of the Ho-Am Art Museum*, vol. 2, pl. 108.

45. *Masterpieces of Korean Ceramics from the Koryŏ to the Chosun [sic] Periods from the Collection of the Ho-Am Art Museum in Korea* (Tokyo: Fuji Art Museum, 1992), pls. 6, 17, 18, 26. See also the publication of celadons of superior quality assembled in *Kōrai seiji e no izanai* (An Introduction to Koryŏ Celadon), sec. 2 (Osaka: Museum of Oriental Ceramics, Osaka, 1992), pls. 14, 16–26; the Idemitsu ewer is illustrated in pl. 26. For roof tiles, see *Koryŏ toja myŏngmun* (Inscriptions on Koryŏ Celadons) (Seoul: The National Museum of Korea, 1992), pl. 2.

46. *Shaanxi Tongchuan Yaozhou yao* (Excavations of Yaozhou Kiln Sites at Tongchuan, Shaanxi Province) (Beijing: Science Press, 1965), figs. 25, 28; pl. 14; also see the chart of plant and bird motifs employed in Yaozhou wares, p. 60.

47. In addition to this maebyŏng, another discovery from this kiln is a broken lid from a maebyŏng decorated with a very similar crane with a long black line for the plumage. See *Puan Yuch'ŏn-ni yo Koryŏ toja* (The Kilns of Puan Yuch'ŏn-ri: Koryŏ Ceramic Wares) (Seoul: Ewha Womans University Museum, 1983), pl. 52 (lid) and pl. 280 (restored maebyŏng).

48. Pamela B. Vandiver, "The Technology of Korean Celadons," in Ikutaro Itoh and Yutaka Mino, *The Radiance of Jade and the Clarity of Water*, pp. 152–53.

49. See the inlaid maebyŏng (Treasure no. 342) in The National Museum of Korea, illustrated in *Ch'ŏngja t'ogi* (Celadon Ware), vol. 3 of *Kukpo*, pl. 44; for other examples of covered maebyŏng, see

the objects in the Yi Hon Collection, *Koryŏ ch'ŏngja myŏngp'um* (Koryŏ Celadon Masterpieces) (Seoul: The National Museum of Korea, 1989), pl. 96, and in the Museum of Oriental Ceramics, Osaka, *Kōrai meipin-ten* (Exhibition of Meiping Vases of the Koryŏ Dynasty) (Osaka: Museum of Oriental Ceramics, Osaka, 1985), pl. 18.

50. From the Ming dynasty onward, the meiping was mainly used as a flower vase. See Liao Baoxiu, "Meiping lueshi" (A Short History of Meiping), *Gugong wenwu yuekan*, no. 122 (1993), p. 53.

51. The Chwago, or Left Storage, belonged to the Yang'onsŏ, the royal office in charge of producing the wine for the royal household. Hence the wine was called *yang'on*.

52. Xu Jing, *Gaoli tujing*, ch. 32, Vessels; p. 172, Pottery Bottles. The description "covered by [a piece of] yellow silk" led Koezuka Ryozo to conclude that the decorations on the shoulders of some sanggam maebyŏngs were imitations of fabric designs. *Kōrai meipin-ten*, p. 3.

53. "Hebei Quyang Wudai pihuamu fajue jianbao" (Excavation of a Five Dynasties Tomb with Mural Paintings at Quyang, Hebei Province), *Wenwu* 9 (1996), pp. 8–9.

54. "Shijiazhuang shi Houtaibao Yuandai Shishi mugun fajue jianbao" (Excavation of the Shi Family Cemetery of the Yuan Dynasty at Houtaibao, Shijiazhuang), *Wenwu* 9 (1996), p. 52 and fig. 17.

55. Mircea Eliade, *Shamanism: Archaic Techniques of Ecstasy*, Bollingen Series 76 (Princeton: Princeton University Press, 1974), pp. 153ff.

56. Kang Woo-bang, "Pul'sari chang'ŏm non: Pulgyŏng Pult'ap, pulsang ŭi sanggwan kwan'gye," p. 151ff. Pagodas that contain mirrors included in this catalogue are Hwangnyong-sa (645), p. 14; Punhwang-sa, Pulguksa Sŏkkat'ap (ca. 751), p. 32; Sudŏk-sa, p. 95; and Wŏljŏng-sa, p. 124.

57. See Lee Nan-yong, *Han'guk ŭi tonggyŏng* (Korean Bronze Mirrors) (Seoul: The Academy of Korean Studies, 1983), pp. 14–17.

58. In the collection of The National Museum of Korea; see *Tae Koryŏ kukpochŏn*, pl. 219.

59. The possible date of this tomb is 1156. See "Shanxi Fenyang Jin mu fajue jianbao" (Excavation of the Jin Dynasty Tombs in Fenyang, Shanxi Province), *Wenwu* 12 (1991), p. 24 and pl. 7.

60. *Han'guk ŭi tonggyŏng* (Special Exhibition of Korean Bronze Mirrors in the Collection of National Museums of Korea) (exh. cat., Ch'ŏngju National Museum, 1992), pls. 101, 102.

61. See *Chung'yo palgyŏn maejang munhwajae torok* (Catalogue of Important Excavated Cultural Objects), vol. 1 (Seoul: Office of Cultural Properties, 1989), pl. 51.

62. Yu Fengshi, "Guangxi chutu gudai tongjing xuanjie" (A Brief Introduction to the Ancient Bronze Mirrors Excavated in Guangxi Province), *Wenwu* 5 (1997), p. 82, fig. 7; p. 83.

63. For a short discussion of the story depicted on the British Museum mirror, see Pak Youngsook, *Koreanische Tage*, cat. no. 75. The story of Ming Huang is discussed in E.H. Schafer, "A Trip to the Moon," *Journal of the American Oriental Society*, vol. 96, no. 1 (1976), pp. 27–37.

64. See *Kungnip Kwangju Pangmulgwan* (Catalogue of the Kwangju National Museum) (Seoul, 1990), pl. 107; and Pak Youngsook, *Koreanische Tage*, cat. no. 74. In some cases the floral design on the narrow outer band is replaced with clouds.

65. See the entry by James C.Y. Watt in *A Decade of Collecting: Friends of Asian Art 1984–1993* (New York: The Metropolitan Museum of Art), p. 10. See also Helmut Nickel, "The Dragon and the Pearl," *The Metropolitan Museum of Art Journal*, 26 (1991), pp. 139–46. In his article Nickel makes a cross-cultural comparison between the Late Roman, Central Asian, and Chinese depiction of this motif. I am indebted to James Watt for bringing this interesting article to my attention.

66. Sun Xiangxing and Liu Yiwan, *Zhongguo dongjing dujian* (Illustrated Dictionary of Chinese Bronze Mirrors) (Beijing: Wenwu chubanshe, 1992), pls. 692, 693.

67. James Watt kindly pointed out these objects to me in our discussions during my study trip to the Metropolitan Museum in April 1997.

68. "Liao Yelü Yuzhi mu fajue jianbao" (Excavation of Yelü Yuzhi's Tomb of the Liao Dynasty), *Wenwu* 1 (1996), p. 16, fig. 31.

69. See Lee Ki-baik, *A New History of Korea*, trans. Edward W. Wagner and E.J. Shultz (Seoul: Iljogak; Cambridge: Harvard University Press, 1984), p. 126; and Chung Yang-mo, "Koryŏ ch'ŏngja" (Koryŏ Celadons), in *Koryŏ ch'ŏngja myŏngp'um* (Famous Pieces of Koryŏ Celadon) (exh. cat., Seoul: The National Museum of Korea, 1989), p. 272.

70. During the Koryŏ period, aside from the main capital at Songdo (present-day Kaesŏng), Sŏgyŏng served as one of the three other subsidiary capitals together with Tonggyŏng (Eastern Capital, present-day Kyŏngju), and the centrally located Namgyŏng (Southern Capital, present-day Seoul).

71. An uninscribed but otherwise identical mirror is in the collection of the Ch'ŏngju National Museum. See *Han'guk ŭi tonggyŏng*, pl. 69.

72. *Kōrai hishoku seiji* (Jade-Colored Celadon from the First Half of the Twelfth Century, Koryŏ Dynasty) (Osaka: Museum of Oriental Ceramics, Osaka, 1987), pl. 36.

73. See, for example, *Koryŏ ch'ŏngja myŏngp'um*, pls. 21, 108, 109, 140; and *Kōrai seiji e no izanai*, pls. 18, 19, 22, 23, 26.

74. Hŏ Hŭng-shik, *Koryŏ Pulgyo-sa yŏn'gu* (Study of Koryŏ Buddhism) (Seoul: Ilchogak, 1986), pp. 334, 535ff.

75. A full discussion of this aspect of Koryŏ Buddhism in relation to Buddhist paintings appears in Pak Youngsook, *Korean Buddhist Paintings: Kshitigarbha Bodhisattva of the Koryŏ and Early Chosŏn Periods* (Seoul: Yekyong Publications Co., forthcoming 1999).

76. Lee Ki-baik and Min Hyŏn-gu, *Saryoro bon Han'guk munhwasa: Koryŏ-p'yŏn* (Cultural History of Korea through Literary Texts: Koryŏ Dynasty) (Seoul: Iljisa, 1986), pp. 35f, 101, 284.

77. Hŏ Hŭng-shik, *Koryŏ Pulgyo-sa yŏn'gu*, pp. 816, 866.

78. Ch'oe Byŏng-hon, "*Samguk yusa e nat'anan Han'guk kodae Pulgyo-sa insik*" (Consensus of Ancient Korean Buddhism from the Account in the *Samguk yusa*), in *Samguk yusa ŭi chonghaphchŏk kŏmt'o* (Inquiries into the *Samguk yusa*) (Seoul: The Academy of Korean Studies, 1987), pp. 185–204. The *Kegon Engi* of the Kamakura period, a famous handscroll illustrating the origins of the Avatamsaka School, provides an illustrated biography of Ŭisang.

79. A. Buzo and T. Prince, trans., *Kyunyŏ-jŏn: The Life, Times and Songs of a Tenth Century Korean Monk*, University of Sydney East Asian Series, no. 6 (1993). For information on Ŭich'ŏn, see Ch'oe Byŏng-hon, "Haejae" (Commentary), in *Taegak Kuksa munjip* (Collected Writings of the Taegak National Preceptor), vol. 89-1, *Kugyŏk ch'ongsŏ* (Compendium of Korean Translations of Korean Classics) (Seoul: The Academy of Korean Studies, 1989), pp. 19–35.

80. Ide Teinosuke, "Kōrai no Amida gazō to Fugen Gyōgen-bon" (A Koryŏ Painting of Amida and the Fugen Gyogen-bon), *Bijutsu kenkyū*, no. 362 (1995), pp. 8ff.

81. *Taishō*, vol. 10, no. 293, pp. 846c, 848a. There are two previous translations of the *Avatamsaka Sutra*: a 60-volume version by Buddhabhadra, dated 420 (*Taishō*, vol. 10, no. 278) and an 80-volume version by Siksananda, dated 699 (*Taishō*, vol. 10, no. 279). The third version, in 40 volumes, is by Prajna, who is identified in the title of the sutra as a monk from a place known in Korean as Kyebin'guk (present-day Kashmir).

82. Ide Teinosuke, "Kōrai no Amida gazō to Fugen Gyogen-bon," p. 10.

83. See Kikutake Jun'ichi and Yoshida Hiroshi, eds., *Kōrai butsuga* (Koryŏ Buddhist Painting) (Tokyo: Asahi shinbunsha, 1981), pls. 1, 2.

84. Yi T'ae-ho, "Koryŏ Pulhwa ŭi chejak kipŏb e taehan koch'al-yŏmsaek kwa paech'aepŏb ŭl chung-simŭro" (A Study of Koryŏ Buddhist Paintings with Emphasis on Dyeing and Coloring on the Reverse Side), *Misul charyo*, no. 53 (June 1994), pp. 141–43.

85. Alum is an important medium of fixing pigments. See, Yu Feian, *Chinese Painting Colors: Studies of Their Preparation and Application in Traditional and Modern Times*, trans. Jerome Silbergeld and Amy McNair (Hong Kong: Hong Kong University Press; Seattle: University of Washington Press, 1988), p. 18.

86. The pigment analysis was carried out by Messrs. Koezuka and Takayasu at the Nara Bunkazai Kenkyūjo. See Park Chi-Sun, "Yi Hak sojang Koryŏ pulhwa Suwŏl Kwanŭm-do ŭi pojon subok e kwanhayŏ" (Restoration of the Koryŏ Buddhist Painting, *Water-Moon Avalokiteshvara*, in the Yi Hak Collection), *Tanho munhwa yŏn'gu*, no. 1 (Dec. 1996), pp. 62, 73–75.

87. This aspect of conservation is discussed by Park Chi-sun, the conservator of paintings at The National Museum of Korea, in "Kyŏnbon hoehwa pojon suri e issŏsŏŭi munjechŏm" (The Problem of the Conservation of Paintings on Silk-Lining paper), *Pojon kwahak hoeji*, vol. 5, no. 2 (Dec. 1996), pp. 58, 61.

88. The technique of applying pigments on the back and front of painting silk was revealed during the course of the Tokyo National Museum's restoration of *Shakyamuni Descending from His Mountain Retreat*, by the Southern Song painter Liang Kai; see *Conservation*, no. 3 (1996), pp. 28–29.

89. Mikhail Piotrovsky, ed., *The Lost Empire of the Silk Road: Buddhist Art from Khara Khoto (X–XIIIth Century)* (exh. cat., Lugano: Thyssen-Bornemisza Foundation, 1993), cat. no. 38; p. 180.

90. Ibid., cat. no. 52; p. 215.

91. See Chung Woo-thak, *Kōrai Amida gazō no kenkyū* (Study of Koryŏ Amitabha Paintings) (Kyoto, 1990); and Pak Youngsook, "Amitabha Triad: A Koryŏ Painting in the Brooklyn Museum," in *Sambul Kim Wŏn-yong kyosu chŏngnyŏn t'oeim kinyŏm nonch'ong II* (Festschrift for Professor Kim Wŏn-yong on His Retirement), vol. 2 (Seoul: Iljisa, 1987), pp. 513–36.

92. Kikutake Jun'ichi and Yoshida Hiroshi, *Kōrai Butsuga*, pl. 7.

93. Ibid., pl. 17.

94. Ibid., pl. 10.

95. The lohan painting is published in Wu Tung, *Tales from the Land of Dragons: 1,000 Years of Chinese Painting* (Boston: Museum of Fine Arts, Boston, 1997), pl. 96, p. 89. For the Kenchō-ji triad, see *Kamakura Kokuhōkan annai* (Short Introduction to National Treasures Hall, Kamakura) (Kita Ka-

makura, 1978), p. 13. For the Amitabha triad, see *Kaiga 2* (Painting), in vol. 8 of *Jūyō bunkazai* (Tokyo: Mainichi shinbunsha, 1973), pls. 10, 279.

96. Yu Feian, *Chinese Painting Colors*, p. 8.

97. See Whalen Lai, "The Chan-ch'a ching: Religion and Magic in Medieval China" in ed. Robert E. Buswell, *Chinese Buddhist Apocrypha* (Honolulu: University of Hawaii Press, 1990), pp. 175ff; Lothar Lederrose, "A King of Hell," in *Chūgoku kaigashi ronshū Suzuki Kei sensei kanreki-kinen* (Articles on Chinese Painting in Celebration of the Sixtieth Birthday of Professor Suzuki Kei) (Tokyo: Yoshikawa kobunkan, 1981), pp. 33–42; Stephen F. Teiser, *The Scripture of the Ten Kings and the Making of Purgatory in Medieval Chinese Buddhism* (Honolulu: University of Hawaii Press, 1994); Pak Youngsook, "The Role of Legend in Koryŏ Iconography (I): The Kshitigarbha Triad in Engakuji," in eds. K.R. van Kooij and H. van der Veere, *Function and Meaning in Buddhist Art* (Groningen: Egbert Forsten, 1995), pp. 157–65.

98. See Roderick Whitfield, *The Art of Central Asia: The Stein Collection in the British Museum* (Tokyo: Kodansha, 1981), vol. 1, pls. 10, 15, 19; vol. 2, pls. 8, 22–24; and Jacques Giès, *Les arts de l'Asie centrale: La collection Paul Pelliot du Musée National des Arts Asiatiques-Guimet* (Tokyo, Kodansha, 1994), vol. 2, pls. 51–65.

99. On Koryŏ Kshitigarbha iconography, see Pak Youngsook, "The Role of Legend in Koryŏ Iconography (I): The Kshitigarbha Triad in Engaku-ji," pp. 157–66. Chee-yun Kwon, a Ph.D. candidate at Princeton University, is preparing a dissertation on the subject of Korean depictions of the Ten Kings of Hell.

100. We find such concern expressed in inscriptions on a painting of Kshitigarbha that was produced for an anniversary ceremony in honor of a Uighur princess. The inscription at the top reads "Reverence to the bodhisattva Kshitigarbha," and at the bottom, in small script, "painting dedicated for the anniversary of death." See Jao Tsung-i, *Hua ning Guohuashi lunji* (Essays on Chinese Painting) (Taipei, 1993), p. 154.

101. For examples of these incense burners, see *Chosŏn chŏn'gi kukpojŏn* (Treasures of the Early Chosŏn Dynasty, 1392–1592) (exh. cat., Seoul: Ho-Am Art Museum, 1996), pl. 175 (dated 1397); pl. 176 (dated 1584); and pl. 177 (15th century). An earlier and stylistically distinct censer, dated 1218, is illustrated in *Masterpieces of the Ho-Am Art Museum*, vol. 2, pl. 111.

102. Jacques Giès, *Les arts de l'Asie centrale*, vol. 2, pl. 66-1.

103. Matsumoto Eiichi, *Tonkōga no kenkyū* (Study of Dunhuang Paintings) (Tokyo: Tōhō bunka gakuin Tokyo kenkyū, 1937), p. 344.

104. For a discussion of this image and its appearance in the pictorial decor of early Chinese tombs, see Audrey Spiro, *Contemplating the Ancients: Aesthetic and Social Issues in Early Chinese Portraiture* (Berkeley: University of California Press, 1990), pp. 138, 141.

105. In the 60-volume version of the *Avatamsaka Sutra* translated by Buddhabhadra, dated 420, the bodhisattva's abode is referred to by the Chinese name Guangmingshan, or Radiant Mountain; in the 80-volume version by Sikshananda, dated 699, it is called Mount Potalaka.

106. Hayashi Susumu, "Kōrai jidai no Suigetsu Kannonzu ni tsuite" (Concerning the Water-Moon Avalokiteshvara in the Koryŏ Period), *Bijutsushi* 102 (1977), p. 124.

107. For this story, see "Naksan idaesŏng" (Two Great Saints at Naksan), in *Samguk yusa*, book 3, ch. 4.

108. Recent studies on the origin of the Water-Moon Avalokiteshvara have improved our understanding of this bodhisattva. Wang Huimin discovered among the Dunhuang Buddhist manuscripts kept in the Tianjin Museum a sutra of Water-Moon Avalokiteshvara, *Shuiyue Guanyinjing*, dated 958. This short apocryphal text is taken almost verbatim from a Tang-dynasty version of the Dharani text of the Thousand-armed Thousand-eyed Avalokiteshvara, translated by Bhagavatdharma. See Wang Huimin, "Dunhuang xieben 'Shuiyue Guanyinjing yanjiu'" (Study of the Forged Dunhuang "Sutra of the Water-Moon Guanyin"), *Dunhuang yanjiu*, no. 3 (1992), pp. 93–98. Cf. *Taishō* vol. 20, no. 1060, pp. 106–107.

Devotees are urged to recite the sutra of the Water-Moon Avalokiteshvara in order to obtain the Buddha's wisdom, to leave this suffering world as soon as possible, and to escape from hell. Furthermore, the sutra was to be hand copied by a member of the family on the fourteenth day after the death of the deceased, and thus was closely connected with memorial services. Tan Zhanxue, "Sanjiao yonghe de Dunhuang sangsu" (Funeral Customs Combining Confucian, Buddhist, and Daoist Rituals), *Dunhuang yanjiu*, no. 3 (1991), p. 78. For an article based on Wang Huimin's and Tan Zhanxue's studies, including an investigation of pictorial materials, see Pan Liangwen, "Suigetsu Kannonzu ni tsuite no ichi-kōsatsu" (Concerning the Water-Moon Avalokiteshvara: An Investigation), *Bukkyō geijutsu*, no. 224 (Jan. 1996), pp. 106–16; no. 225 (Mar. 1996), pp. 15–39.

109. *Taishō* 20, no. 1064, p. 117.

110. Jacques Giès, *Les arts de l'Asie centrale*, vol. 1, pls. 83, 96, 96-5 (detail). The bodhisattva's pose and at-

tributes (the willow branch and the moon) as well as the bamboos also appear in all paintings of the Water-Moon Avalokiteshvara from Dunhuang (10th century) and Xixia (12th century). See Roderick Whitfield, *The Art of Central Asia*, pl. 52; Mikhail Piotrovsky, *Lost Empire of the Silk Road*, p. 199; and Yamamoto Yoko, "Suigetsu Kannonzu no seiritsu ni kansuru ichi-kōsatsu" (Enquiry into the Establishment of the Water-Moon Avalokiteshvara), *Bijutsushi* 125 (1989), vol. 38, no. 1, pp. 30–32.

111. Mikhail Piotrovsky, *Lost Empire of the Silk Road*, pp. 198–200. Also see an essay on this painting by Kira Fyodorovna Samosyuck, "The Guanyin Icon from Khara Khoto," *Manuscripta Orientalia*, vol. 3, no. 1 (Mar. 1997), pp. 53–61.

112. Wu Tung, *Tales from the Land of Dragons*, pl. 23.

113. For example, see *Koryŏ-sa*, Sega, book 27, 3rd year (1262) of the reign of King Wŏnjong; and the writings of Yi Kyu-bo (1168–1241), in *Han'guk munjip ch'onggan* (Compilation of Korean Literary Writings), vol. 1 (facsimile reprint, Seoul: Minjok munhwa ch'ujinhoe, 1993), p. 554a.

114. I have presented two papers on this painting, one in 1994 at the Ho-Am Art Museum, Seoul, and the second in 1995 at the Association of Asian Studies Congress, Washington, D.C. The latter paper is being prepared for publication.

115. For examples of these jars, see plate 17 in this volume, and Roderick Whitfield, ed., *Treasures from Korea: Art Through 5000 Years* (London, British Museum Publications, 1984), pls. 171, 172.

116. *Masterpieces of the Ho-Am Art Museum*, vol. 2, pl. 1–4; p. 209.

117. *Taishō*, vol. 9, no. 262.

118. Hence I refer to the Koryŏ manuscripts as "illuminated manuscripts." See Pak Youngsook, "Illuminated Buddhist Manuscripts in Korea," *Oriental Art*, vol. 33, no. 4 (Winter 1987–88), pp. 357–74. Also see Hayashi Susumu, "Kōrai jidai no sōshokugyō" (Decorated Sutras of the Koryŏ Dynasty), in Kikutake Jun'ichi and Yoshida Hiroshi, *Kōrai butsuga*, pp. 31–38.

119. The scene of the burning house, at the upper left, depicts the story of a wealthy man and his children. The children are playing in their house, unaware that it is plagued by demons, poisonous insects, and snakes and that it is also on fire. Their father, in order to entice his children away from the danger, offers them three carts, drawn by an ox, a deer, or a goat according to the children's respective preferences and interests. When the children exit the burning house, however, they each receive a resplendent cart even more magnificent than they expected. This parable illustrates how "expedient methods" (the more modest carts) can lead sentient beings (the children) from the fleeting and perilous world of sensual perception (the house) to a greater goal, the one vehicle of Mahayana Buddhism (the resplendent carts).

The second parable, depicted at the lower left, concerns an old man and his son, who in his youth had abandoned his father and lived for many years in another land. As he grew older, he became increasingly poor and sought employment in prosperous households. After wandering from place to place, he stumbled upon the new residence of his now wealthy and successful father. Not recognizing his father, the son fled in fear that he would be enslaved. His father, realizing that his son was incapable of living as the sole heir to such a prominent man, disguised himself as a moderately wealthy man and hired his son as a laborer, to clear away excrement. He gradually entrusted his son with greater responsibilities, so that the young man grew accustomed to administering his master's affairs and slowly developed self-assurance and generosity. At that time, his father revealed his true identity and bestowed upon his son his entire fortune. In this parable the father represents the Buddha, and the son symbolizes the ignorant sentient beings. Their master, recognizing that they are unprepared to accept this greater glory, waits until they are accustomed to their more modest roles before bestowing upon them the promise of ultimate enlightenment. At the end of the sutra, devotees are warned that those who disregard the *Lotus Sutra* will be reborn as deformed beings, as reviled as the wild dog being chased by the children in the lower left corner.

For an English translation of the two parables, see Leon Hurvitz, *Scripture of the Lotus Blossom of the Fine Dharma* (New York: Columbia University Press, 1976), pp. 58–64, 78, 85–88.

120. The woodblocks were destroyed in the thirteenth century during the Mongol invasions. A new edition, completed in 1251, is kept today at Haein-sa Temple, South Kyŏngsang Province.

121. For the British Museum manuscript, see Pak Youngsook, "Illuminated Manuscript of the Amitabha Sutra," *Orientations* (Dec. 1982), pp. 46–48. This manuscript was formerly in the Victoria and Albert Museum, London. For the Nabeshima *Lotus Sutra*, see *Tō Ajia no Butsudachi* (Buddhist Images of East Asia) (exh. cat., Nara: Nara National Museum, 1996), p. 285.

122. For a description of the "four modes of birth," see Isao Inagaki, *A Dictionary of Japanese Buddhist Terms* (Kyoto, 1984), p. 306; Mochizuki Shinko, *Bukkyō daijiten* (The Great Dictionary of Bud-

dhism), vol. 2 (reprint, Taipei: The Horizon Publishing Co., 1979), p. 1842b.

123. A brief discussion of Koryŏ relations with Yuan China is found in Lee Ki-baik, *A New History of Korea*, trans. E.W. Wagner and E.J. Shultz (Seoul: Ilchogak; Cambridge: Harvard University Press, 1984), pp. 155–58.

124. *Kugyŏk Koryŏ-sa chŏryo* (Essentials of Koryŏ History), vol. 3 of *Kojŏn kugyŏk ch'ongsŏ* (Compendium of Korean Classics and Histories) (Seoul: Minjok munhwa kanhaenghoe, 1985), pp. 326, 328, 338, 354; Chinese text, pp. 594, 599, 606.

125. For a discussion of Chosŏn Buddhist paintings, see Kim Hongnam, *The Story of a Painting: A Korean Buddhist Treasure from The Mary and Jackson Burke Foundation* (New York: The Asia Society, 1991); and Hendrik Sorensen, *The Iconography of Korean Buddhist Painting* (Leiden: E.J. Brill, 1989).

126. E. Washburn Hopkins, *Epic Mythology* (reprint, Delhi: Motilal Banarsidass, 1974), pp. 189, 191.

127. Mochizuki Shinko, *Bukkyō daijiten*, vol. 4, pp. 3428b, 3427b, 3428a.

128. E. Washburn Hopkins, *Epic Mythology*, p. 193.

129. I am grateful to Kenneth Moore, of the Department of Musical Instruments at The Metropolitan Museum of Art, for his assistance in identifying these instruments.

130. *Akhak kwebŏm* (Rules of Music), in vol. 2 of *Kojŏn kugyŏk ch'ongsŏ* (Compendium of Korean Classics) (Seoul: Minjok munhwa ch'ujinhoe, 1980). For the original Chinese text and illustrations, see chs. 6–8, pp. 32f, 48f, 55f, 79–80. For a discussion of the role of music in Buddhist ceremonies, see "Pulgyo ŭisike issŏsŏ ŭmak ŭi wich'i: Puljŏn e nat'anan Pulgyo ŭmak ŭi sŏsŏljŏk yŏn'gu" (The Role of Music in Buddhist Ceremonies: A Preliminary Study of Music in Buddhist Scriptures), in Munhwajae yŏn'guso, Yenŭng minsok yŏn'gusil (Institute of Cultural Heritage, Folk Art Section), *Pulgyo ŭisik* (Buddhist Ceremonies) (Seoul: Kyemunsa, 1989), pp. 130–44.

131. The paintings are dated by inscription to 1443. See Wei Shuzhou, ed., *Fahaisi bihua* (Wall Paintings in Fahaisi Temple) (Beijing: China Travel and Tourism Press, 1993), pls. 61, 69, 73.

132. See Roderick Whitfield, *The Art of Central Asia*, vol. 2, pl. 68; and Jacques Giès, *Les arts de l'Asie centrale*, pls. 91, 98.

133. *Bukkyō geijutsu*, no. 97 (1974), p. 127, fig. 1.

134. Sŏsan Taesa's biography is recorded in a stele dated 1630. See *Chŭngbo kyojŏng Chosŏn sach'al saryo* (Compilation of Historical Documents of Monasteries in Korea), vol. 1 (Seoul: Koryŏ sŏrim, 1986), pp. 322–27. For an excellent study of Sŏsan Taesa's life and thought, see Hee-Sung Keel, "Words and Wordlessness: Hyujŏng's Approach

to Buddhism," *Korean Culture*, vol. 9, no. 3 (Fall 1988), pp. 25–37.

135. A portrait of Samyŏng Taesa Yujong is in the collection of the Museum of Fine Arts, Boston.

136. Mount Pisŭl is located between Talsŏng and Ch'ŏngdo districts in North Kyŏngsang Province. Yŏngch'ŏn-sa Temple was founded in 670; it was restored twice, in 1261 and 1631.

137. The Buddhist term *poch'e* (literally "protected body"), which appears in this inscription after each personal name, is used only for living persons.

138. The term "Chijŏn" refers to those monks who were responsible for maintaining the temple and preparing incense.

139. The donors of the pigments are identified here only by the cyclical dates of their birth rather than their surnames.

140. For an analysis and interpretation of the inscriptions on Chosŏn Buddhist paintings, see Pak Youngsook, *Korean Buddhist Painting: Kshitigarbha Images* (Seoul: Yekyong Publications Co., forthcoming).

141. This method of dating employs a set of terms to denote each lunar year that repeats every sixty years. Therefore, in the case of this inscription the dates could refer to later occurrences of the cyclical terms, ranging, for example, from 1664 to 1667.

142. See, for example, Mun Myŏng-dae, comp., *Chosŏn pulhwa* (Chosŏn Buddhist Paintings), vol. 16 of *Han'guk ŭi mi* (Beauty of Korean Art) (Seoul: Chung'ang ilbosa, 1984), pl. 3, *Buddha Assembly*, dated 1653; pls. 160–67, *Sixteen Lohans*, dated 1725.

143. For a pioneer work on Buddhist portraiture, see Helmut Brinker, *Die Zen-Buddhistische Bildnismalerei in China und Japan* (Zen Buddhist Portrait Painting in China and Japan), *Ostasiatische Studien, Band 10* (Wiesbaden: Franz Steiner Verlag, 1973). Also see Helmut Brinker, "Body, Relic and Image in Zen Buddhist Portraiture," in *Portraiture* (symposium papers) (Kyoto: The Taniguchi Foundation, 1987), pp. 46–61. Dietrich Seckel's comprehensive study of East Asian portraiture provides a definition of "ideal" and "real" portraits; see *Das Porträt in Ostasien, Band 1, Einführung und Teil I: Porträt-Typen* (Heidelberg: Universitätsverlag, 1997), pp. 271–84.

144. Another copy of the portrait is in the Asian Art Museum of San Francisco.

145. See Barbara Ford's description of the painting in *The Metropolitan Museum of Art Bulletin, Recent Acquisitions: A Selection* 1992–1993, vol. 41, no. 2 (Fall 1993), p. 90.

146. For a thorough discussion of the theme and its origins, see Alfreda Murck, "Eight Views of the

Hsiao and Hsiang Rivers," in Wen C. Fong et al., *Images of the Mind: Selections from the Edward L. Elliott Family and John B. Elliott Collections of Chinese Calligraphy and Painting at The Art Museum, Princeton University* (Princeton: The Art Museum, Princeton University and Princeton University Press, 1984), pp. 214–35.

**147.** The river, also known as the Heihe (Black River), is located in present-day Mongolia.

**148.** Translation by Roderick Whitfield.

**149.** Wai-kam Ho, "The Literary Concepts of 'Picture-like' (*Ju-hua*) and 'Picture-Idea' (*Hua-i*) in the Relationship between Poetry and Painting," in eds. Alfreda Murck and Wen C. Fong, *Words and Images: Chinese Poetry, Calligraphy, and Painting* (New York: The Metropolitan Museum of Art and Princeton University Press, 1991), pp. 394–95.

**150.** See *Shōsō-in no kaiga* (Paintings in the Shōsō-in) (Tokyo: Benrido, 1968), pls. 33, 34.

**151.** The latter painting is published with the English title *Cold Breeze in a Mountain Town* in *Masterpieces of the Ho-Am Art Museum*, vol. 2, pl. 19.

**152.** For illustrations of both sets, see *Chosŏn chŏn'gi kukpojŏn*, pls. 16, 17.

**153.** The brushwork in paintings of the An Kyŏn School is derived from that of the Northern Song masters Guo Xi and Li Cheng, but the composition and use of ink represents a Korean landscape painting style. See Ahn Hwi-joon and Yi Pyŏng-han, *An Kyŏn kwa Mongyu Towŏn-do* (An Kyŏn and the Dream Journey to the Peach Blossom Spring) (Seoul: Tosŏ ch'ulp'an-sa, 1980); and Burglind Jungmann, *Die koreanische Landschaftsmalerei und die chinesische Che-Schule. Vom späten 15. bis zum frühen 17. Jahrhundert* (Stuttgart: Franz Steiner Verlag, 1992), pp. 50ff.

In her essay in this volume, Kim Hongnam dates the Metropolitan and Ho-Am landscapes discussed here to the sixteenth century.

**154.** Unlike their Chinese counterparts, the Chosŏn literati did not pursue painting as the favored private pastime, but were more interested in philosophical debates, literature, poetry, and travel to local scenic spots. This is supported by the research findings of Rose Lee, a Ph.D. candidate at the School of Oriental and African Studies, University of London, in her investigation of travel documents, diaries, poetry, and paintings on the subject of Mount Kŭmgang in Korea.

**155.** See Martina Deuchler, *The Confucian Transformation of Korea* (Cambridge: Harvard University Press, 1993), pp. 129ff, 179ff.

**156.** The cup and stand were found along with a white porcelain epitaph, which gives the date of Lady Chong's death. See *Masterpieces of the Ho-Am Art Museum*, vol. 1, pls. 107, 108; and Ch'oe Sunu, "Chinyanggun yŏng'in Chŏng ssi myo ch'ult'o ŭi paekcha sanggam" (Inlaid White Porcelains from the Tomb of Lady Chong of Chinyang), *Misul charyo*, no. 8 (Dec. 1963), pp. 23–26.

**157.** See Chung Yang-mo's essay in this volume.

**158.** This was pointed out to me by Yun Yong-i. An almost identical jar is in The National Museum of Korea; see Roderick Whitfield, *Treasures from Korea*, pl. 210. For other similar pieces, see *Richō shinshū-ten* (Exhibition of White Porcelain with Underglaze Copper Red of the Chosŏn Dynasty) (exh. cat., Osaka: Museum of Oriental Ceramics, Osaka, 1985), pls. 7–15; and Ikutaro Itoh and Yutaka Mino, *The Radiance of Jade and the Clarity of Water: Korean Ceramics from the Ataka Collection* (exh. cat., Chicago: The Art Institute of Chicago, 1991), pl. 99.

**159.** See Chung Yang-mo, "Sipp'al segi ŭi ch'ŏnghwa paekcha e taehayŏ" (Blue-and-White Porcelain of the Eighteenth Century), in *Chosŏn paekcha-jŏn* (Exhibition of Chosŏn White Porcelain) (exh. cat., Seoul: Samsung Foundation of Culture, 1987), p. 65.

# Bibliography

*Selected list of publications in the English and Korean languages*

ENGLISH:

*The Arts of Korea.* 6 vols. Seoul: Dong Hwa Publishing Co., 1979.

Deuchler, Martina. *The Confucian Transformation of Korea.* Cambridge and London: Harvard University Press, 1992.

Eckhardt, P. Andreas. *A History of Korean Art.* Translated by J.M. Kindersley. London and Leipzig: E. Goldston, 1929.

*5,000 Years of Korean Art.* Seoul: National Museum of Korea, 1979.

Griffing, Robert. *The Art of the Korean Potter, Silla, Koryŏ, Yi.* New York: The Asia Society, 1968.

Han Woo-keun. *The History of Korea.* Seoul: The Eul-yoo Publishing Co., 1970.

Itoh Ikutarō and Mino Yutako et al. *The Radiance of Jade and the Clarity of Water: Korean Ceramics from the Ataka Collection.* Chicago: The Art Institute of Chicago, 1994.

Kim Chewon and Lena Kim Lee, eds. *Arts of Korea.* New York and Tokyo: Kodansha, 1974.

Kim Chewon and Wŏn-yong Kim. *Treasures of Korean Art: 2000 Years of Ceramics, Sculpture and Jeweled Arts.* New York: Abrams, 1966.

Kim Han-gyo, ed. *Studies on Korea, A Scholar's Guide.* Honolulu: University Press of Hawaii, 1980.

Kim Hongnam, ed. *Korean Arts of the Eighteenth Century: Splendor and Simplicity.* New York: The Asia Society Galleries, 1993.

Kim Hongnam. *The Story of a Painting: A Korean Buddhist Treasure from The Mary and Jackson Burke Foundation.* New York: The Asia Society Galleries, 1991.

Kim Kumja Paik, ed. *Hopes and Aspirations: Decorative Painting of Korea.* San Francisco: Asian Art Museum of San Francisco, 1998.

Kim Wŏn-yong. *Art and Archaeology of Ancient Korea.* Seoul: The Taekwang Publishing Co., 1986.

————. *Recent Archaeological Discoveries in the Republic of Korea.* The Center of East Asian Cultural Studies, UNESCO. Tokyo: Hinode Printing Co., 1983.

Kim Wŏn-yong et al. *Korean Art Treasures.* Edited by Roderick Whitfield and Youngsook Pak. Seoul: Yekyong Publications Co., Ltd., 1986.

*Korean Art: 100 Masterpieces.* Seoul: Editions API, 1995.

Korean Buddhist Research Institute, ed. *The History and Culture of Buddhism in Korea.* Seoul: Dongguk University Press, 1993.

Kwon Young-pil, ed. *Fragrance of Ink: Korean Literati Paintings of the Chosŏn Dynasty (1392–1910) from Korea University Museum.* Seoul: Korean Studies Institute, Korea University, 1997.

Lee Ki-baik. *A New History of Korea.* Translated by Edward W. Wagner with Edward Shultz. Cambridge and London: Harvard University Press, 1984.

Lee, Peter H., ed. *Sourcebook of Korean Civilization, Volume One: From Early Times to the Sixteenth Century.* New York: Columbia University Press, 1993.

————. *Sourcebook of Korean Civilization, Volume Two: From the Seventeenth Century to the Modern Period.* New York: Columbia University Press, 1996.

*Masterpieces of the Ho-Am Art Museum.* 2 vols. Seoul: Samsung Foundation of Culture, 1996.

McCune, Evelyn. *The Arts of Korea: An Illustrated History.* Rutland: Tuttle, 1962.

Medley, Margaret. *Korean and Chinese Ceramics from the 10th to the 14th Century.* Cambridge: Fitzwilliam Museum, 1976.

Moes, Robert J. *Auspicious Spirits.* International Exhibition Foundation, 1983.

————. *Korean Art from the Brooklyn Museum Collection.* New York: Universe Books, 1987.

Nelson, Sarah M. *The Archaeology of Korea.* Cambridge: Cambridge University Press, 1993.

Pak Youngsook. *Koreanische Tage: Korean Art, 5th to 19th Century, from European Museums and Collections.* Ingelheim am Rhein: Internationale Tage, 1984.

Swann, Peter. *Art in China, Korea, and Japan.* Third edition. New York: Praeger, 1965.

Whitfield, Roderick, and Roger Goepper, eds. *Treasures from Korea: Art Through 5000 Years.* London: The British Museum, 1984.

KOREAN:

Ahn Hwi-joon. *Han'guk hoehwa-sa* (History of Korean Painting). Seoul: Ilchi-sa, 1980.

————. *Han'guk hoehwa ŭi chŏnt'ong* (Traditions of Korean Painting). Seoul: Munye ch'ulp'an-sa, 1988.

Ahn Hwi-joon and Pyŏng-han Yi. *An Kyŏn kwa Mong'yu Towŏn-do* (An Kyŏn and Dream Journey to the Peach Blossom Land). Seoul: Yekyong Publications Co., Ltd., 1993.

Chin Hong-sŏp. *Han'guk ŭi pulsang* (Buddhist Sculpture of Korea). Seoul: Ilchi-sa, 1976.

Cho Sŏn-mi. *Han'guk ŭi ch'osang-hwa* (Portraiture of Korea). Seoul: Yŏrhwadang, 1983.

Chung Yang-mo. *Han'guk ŭi tojagi* (Ceramics of Korea). Seoul: Munye ch'ulp'an-sa, 1991.

Hwang Su-yŏng. *Han'guk ŭi pulsang* (Buddhist Sculpture of Korea). Seoul: Munye ch'ulp'an-sa, 1991.

Kang Kyŏng-suk. *Han'guk toja-sa* (History of Korean Ceramics). Seoul: Ilchi-sa, 1989.

Kang Woo-bang. *Wŏnyung kwa chohwa: Han'guk kodae chogak-sa ŭi wŏlli* (Infinite Interpenetration and Harmony: The Principles of Ancient Korean Sculpture). Seoul: Yŏrhwadang, 1990.

Kim Lena. *Han'guk kodae pulgyo chogak-sa yŏn'gu* (Research on the History of Ancient Korean Buddhist Sculpture). Seoul: Ilcho-gak, 1989.

Kim Wŏn-yong and Ahn Hwi-joon. *Sinp'an Han'guk misul-sa* (Revised History of Korean Art). Seoul: Seoul University Press, 1993.

Mun Myŏng-dae. *Han'guk chogak-sa* (History of Korean Sculpture). Seoul: Yŏrhwadang, 1984.

Yi T'ae-ho. *Chosŏn hugi hoehwa-sa ŭi sasil chŏngsin* (Realistic Spirit of Korean Painting in the Late Chosŏn Period). Seoul: Hakkojae, 1996.

Yi Tong-ju. *Uri nara ŭi yet kŭrim* (Ancient Painting of Korea). Seoul: Hakkojae, 1995.

Yun Yong-i. *Han'guk toja-sa yŏn'gu* (Studies on the History of Korean Ceramics). Seoul: Munye ch'ulp'an-sa, 1993.

# Index

*Compiled by Robert J. Palmer*

Alphabetization of this index is word by word with hyphens counting as blank spaces. Artists are paired with works according to knowledge or attribution. Page references to illustrations are in *italics*.

Muqi (act. 13th century), 376, 383

Muromachi period (1392–1573), 312, 315
  ink painting and Chan Buddhism in, 396–401

Muryangsu-bul, 259

music, Buddhist, 441

Muyong-ch'ong (Tomb of the Dancers), 296, 297, 297

Myoch'ŏng (act. 1135), 422

"Myogilsang" (Kim Yun-gyŏm), 351, 352

Myogilsang-am Temple, 351–52, 351

"Myŏnggyŏng-dae Terrace" (Kim Ha-jong, 1815), 363–64, 364

"Myŏnggyŏng-dae Terrace" (Kim Ha-jong, 1865), 364, 364

Myŏngjong, King (r. 1170–97), 373, 437

Myŏngjong, King (r. 1545–67), 176, 289, 336

Nae-ri tomb no. 1, 299–300, 299

naeyŏngdo (descending Amitabha), 429

nahan (arhats), 279

najŏn ch'ilgi. See lacquer — with mother-of-pearl inlay

Naksan Temple, 435, 436

Naktong River, 15

Namsan (South Mountain), 263

Nanjing (China), Buddha image in (5th century), 255

Nara (Japan)
  Hōryū-ji Temple, 256, 261, 264–65, 270, 274, 276, 300
  Taima-dera, 412, 413, 414

Tōdai-ji Temple, 278

nature
  East Asian perception of, 295
  sense of order in, 236

necklace, Greek Cypriot, 408

Neo-Confucianism, 32–33, 35–36, 134, 242, 289–90, 338, 440
  Chosŏn porcelain and, 84, 246–47, 248–49, 448, 449
  continued allegiance to Ming by, 340
  of Yi I, 339

Neolithic period, ceramics in, 44, 45, 221–231–23, 223

Ni Zan (1301–1374), 322, 327, 365, 394

nimbus, 429

Nine-Bend Stream (Kr. Kugok-kye; Ch. Jiuqu qiu), 338–39

Nine-Bend [Stream] at Mount Wuyi, 338–39, 342, 346

Nine-Bend Stream of Kogun (Cho Se-gŏl), 339–40, 339, 340

Nine-Dragon Waterfall, 206

Ningzong, Emperor (r. 1195–1224), 374

Nonsan, 286

noron (Old Doctrine), 340, 343

Northern Wei dynasty (386–534), Buddhism in, 141, 251, 253, 254, 256–58

Northern Qi dynasty (550–77), 146, 260–63, 268

Northern School of painting, 320–21

Northern Song dynasty (China; 960–1127), 233, 395, 412, 416, 417
  painting in, 303–5, 307, 310, 332–33, 373–75, 378, 380, 384–85, 392, 430
    importance for Korean painters, 397
    Japan and, 399 porcelain in, 423
    in Prince Anp'yŏng's collection, 393, 397

Northern Zhou dynasty (557–81), 266

Nosŏ-dong (Kyŏngju), 408

Note on the Art of the Brush, A (Jing Hao), 332

Noyŏng (act. early 14th century)
  Kshitigarbha and Attendants, 305, 307
  lacquer screens by, 305, 307, 336, 397

Ŏ Mong-nyong (b. 1566), Plum (pl. 89), 192, 194

"Ode to the Red Cliff" (Su Shi), 331

Ŏje pijangjŏn (woodblock-printed book), 303–4, 304

"Oksun-bong Peaks" (Kim Hong-do), 356, 357

Old Doctrine (noron), 340, 343

om, 431, 440

Ŏm Ch'i-uk (act. 19th century), 352

"one-corner" composition, 311

ox-horn inlay, Box (pl. 57), 132, 133

Pae-dong mountain sanctuary, 263, 265

paekcha ware. See porcelain — white

Paekche kingdom (18 BCE–660 CE)
  art of, 229. See also tiles — Paekche
  Buddha images in, 254–55, 255, 257–58, 257, 260–63, 260, 262
    influence on Japanese art, 264–65, 270
    "Paekche smile," 262, 262
    Seated Maitreya (pl. 63), 144, 145, 267
    standing Buddha of Medicine, 260, 260, 261
  Buddhism in, 21–23, 252
    Standing Avalokiteshvara (pl. 64), 144, 145, 265–66
  ceramics of, 52, 53, 228, 229
  Confucianism in, 21
  conquest of, 26, 229, 230, 272
  diplomatic missions to China from, 20–21
  fighting between Silla and, 25, 229
  rise of, 18, 226
  tombs of, 229, 408, 419

Paeksŏk (Pak T'ae-yu), 345

"Paeksŏk-tam Pond" (Kang Se-hwang), 323, 324

# Photograph Credits

*Photographs are reproduced courtesy of the individuals, institutions, and sources cited below.*

All the color photographs of the paintings and objects in this book, except for those specifically noted below, were made in Korea by

Han Seok-Hong, Han's Photo Studio, Seoul

Paul Lachenauer, The Photograph Studio, The Metropolitan Museum of Art.
    Plates 55; 56; 57

Patricia Mazza, The Photograph Studio, The Metropolitan Museum of Art.
    Plate 44

Museum of Oriental Ceramics, Osaka.
    Plate 16

Bruce J. Schwarz, The Photograph Studio, The Metropolitan Museum of Art.
    Plates 3; 6; 10; 11; 18; 28; 37; 68; 73; 75; 76; 77; 78; 80; 81; 84; 85; 88

Yi Tong-ju, ed. *Kankoku bijutsu* (Korean Art), vol. 3. Tokyo: Kodansha, 1986.
    Plate 100: pl. 86

Black-and-white figures are identified by the initials of the authors in whose essays they appear, followed by the figure number.

AH    Ahn Hwi-joon
CY    Chung Yang-mo
JB    Jonathan W. Best
KH    Kim Hongnam
KL    Kim Lena
PY    Pak Youngsook
YS    Yi Sŏng-mi

Ahn Hwi-joon.
    AH 3; 4; 5; 6; 8; 9; 10; 11; 40

Ahn Hwi-joon, *Han'guk hoehwa-sa* (The History of Korean Painting). Seoul: Ilchi-sa, 1996.
    AH 16: pl. 21

Barnhart, Richard, ed. *Painters of the Great Ming: The Imperial Court and the Zhe School.* Dallas: Dallas Museum of Art, 1993.
    KH 10: cat. no. 2, p. 27; KH 11: cat. no. 43, p.135; KH 12: fig. 38, p. 82

*Bunjinga suihen* (Selected Masterpieces of Literati Painting). Tokyo: Chūō kōronsha, 1974–79.
    KH 20: vol. 2, pl. 34

*Chosŏn chŏn'gi kukpo chŏn* (Treasures of the Early Chosŏn Dynasty. 1392–1592). Yongin: Ho-Am Art Museum, 1996.
    CY 26: pl. 133, p. 183; AH 30: pl. 40, p. 70; KH 18A: pl. 10-6, p. 33 top; KH 18B: pl. 10-3, p. 32 top; PY 29: pl. 115, p. 164

The Cleveland Museum of Art.
    AH 25; KH 16

Cox, Susan. "An Unusual Album by a Korean Painter Kang Se-hwang," *Oriental Art* n.s. vol. 19, no. 2 (Summer 1973), pp. 157–68.
    JB 5: pl. 12

Han Seok-Hong. Han's Photo Studio, Seoul.
 CY 3; CY 5; CY 6; CY 7; CY 9;CY 10; CY 17;
 KL 1; KL 4; KL 6; KL 13; KL 14; KL 15; KL 16;
 KL 21; KL 30; KL 32; AH 12; YS 17; PY 11; PY 16

*Han'guk ui mi* (The Beauty of Korea). Seoul:
Chung'ang ilbo, 1980.
 AH 33: vol. 1, pl. 5; YS 10: vol. 1, pl. 22;
 YS 13: vol. 12, pl. 19; YS 14: vol. 12, pl. 22;
 YS 15: vol. 12, pl. 52; YS 16: vol. 12, pl. 60;
 YS 20: vol. 21, pl. 58

Ho-Am Art Museum, Yongin.
 CY 13; CY 24; KL 7; KL 8; YS 1; YS 9; YS 19;
 KH 21

Hwang Su-young and Ahn Jang-heon. *Sŏkkuram.*
Seoul: Yekyong Publications Co., Ltd., 1980.
 JB 3: pl. 12, p. 57

Kang Woo-bang, *Han'guk pulgyo chogak ŭi hŭrŭm*
(The Development of Korean Buddhist Sculpture).
Seoul: Taewŏn-sa, 1995.
 KL 2: p. 105; KL 9: p. 181; KL 25: p. 319

*Kansong munhwa,* no. 45 (1993).
 YS 8: col. pl., p. 3; YS 12: fig. 24, p. 26

*Kankoku bijutsu* (Korean Art). Tokyo: Kodansha, 1986.
 CY 1: vol. 1, pl. 6, p. 13; CY 2: vol. 1, pl. 3, p. 12;
 YS 21: vol. 3, pl. 82, p. 67; PY 2: vol. 1, pl. 144, p.
 65; PY 4: vol. 1, pl. 262, p. 112; PY 12: vol. 2, pl.
 305, p. 177

Kim Chewon and Lena Kim Lee. *Arts of Korea.*
Tokyo: Kodansha, 1974.
 KL 18: pl. 55; AH 14: pl. 217

Kim Lena.
 KL 17; 31

Kim Wŏn-yong, et al. *The Arts of Korea.* Seoul:
Dong Hwa Publishing Co., 1979.
 AH 7: vol. 2, pl. 31; AH 23: vol. 2, pl. 48;
 YS 11: vol. 2, pl. 65

Kim Wŏn-yong, et al. *Korean Art Treasures.* Seoul:
Yekyong Publications Co., Ltd., 1986.
 JB 4: pl. 10, p. 49; CY 4: pl. 161, p. 199;
 KL 26: pl. 95, p. 130

*Koguryŏ kobun pyŏkhwa* (Murals of Koguryo
Tumulus). Tokyo: Korean Pictorial Co., Ltd., 1985.
 JB 2: pl. 56

*Kōrai Richō no bukkyō bijutsuten* (Buddhist Art of
Koryo and Chosŏn Dynasties, Korea). Yamaguchi:
Yamaguchi Prefectural Museum, 1997.
 KL 33: cat. 24, det. p. 39

*Korean Art: 100 Masterpieces.* Editions API, 1995.
 CY 8: p. 80

*Kukpo* (National Treasures of Korea). Seoul:
Yekyong Publications Co., Ltd., 1984.
 KL 10: vol. 2, pl. 113; KL 11: vol. 2, pl. 109;
 KL 12: vol. 4, pl. 9; KL 22: vol. 4, pl. 39;
 KL 23: vol. 2, pl. 144; KL 24: vol. 4, pl. 45;
 KL 28: vol. 4, pl. 122; KL 29: vol. 2, pl. 62;
 KL 34: vol. 2, pl. 96; AH 1: vol. 10, pl. 3;
 AH 2: vol. 10, pl. 5; AH 20: vol. 10, pl. 44;
 AH 22: vol. 10, pl. 49; AH 28: vol. 10, pl. 70;
 AH 31: vol. 10, pl. 75; AH 32: vol. 10, pl. 64;
 AH 34: vol. 10, pl. 108; AH 36: vol. 10, pl. 111/1-4;
 AH 37: vol. 10, pl. 126; AH 38: vol. 10, pl. 130;
 AH 39: vol. 10, pl. 133; YS 2: vol. 10, pl. 100

*Kungnip Chung'ang Pangmulgwan Han'guk sŏhwa
yumul torok* (Korean Paintings and Calligraphy of
The National Museum of Korea). Seoul: The
National Museum of Korea, 1993.
 YS 5: vol. 3 b/w pl. 1/2–4

Kwak Che-u, Tokyo.
 KH 13A, 13B

Kyoto National Museum.
 PY 24

*Liaoning sheng bowuguan cang huaji* (Collection of
Paintings in the Liaoning Provincial Museum).
Beijing: Wenwu chubanshe 1962.
 KH 22: vol. 1, pl. 80

*Masterpieces of the Ho-Am Art Museum.* Seoul:
Samsung Foundation of Culture, 1996.
 AH 29: vol. 2, pl. 18-2; PY 15: vol. 1, pl. 10;
 PY 29: vol. 2, pl. 19

The Metropolitan Museum of Art, The Photograph
Studio.
 CY 20; KL 35; KH 1; KH 3; KH 6; KH 9; KH 23;
 PY 8; PY 9; PY 10

The National Museum of Korea, Seoul.
 KL 27

National Palace Museum, Taipei.
 KH 7; PY 25

The National Research Institute of Cultural
Properties, Seoul.
    KL 19; KL 20

Nezu Institute of Fine Arts.
    PY 22

*Nun kurim yukpaengnyŏn: kkum kwa kidarim ŭi yŏbaek*
(600 Years' Emotions on Korean Images of Snow).
Chŏnju: Chŏnju National Museum, 1997.
    AH 26: pl. 3, p. 8; AH 27: pl. 4, p. 9

Osaka City Museum.
    AH 15; KH 19

Pak Eun-soon, *Kŭmgangsan-do yŏn'gu* (Studies of the
Paintings of Mount Kŭmgang). Seoul: Ilchi-sa,
1997.
    YS 18: pl. 85-1, p. 241; YS 22: pl. 86-4, p. 244;
    YS 27: pl. 107-5, p. 328; YS 28: pl. 106-7, p. 325;
    YS 29: pl. 104-1, p. 313; YS 30: pl. 108-5, p. 369;
    YS 31: pl. 114, p. 382

*Samguk sidae pulgyo chogak* (Buddhist Sculpture of
Three Kingdoms Period). Seoul: The National
Museum of Korea, 1990.
    KL 3: pl. 52; KL 5: pl. 22, p. 41

Schwarz, Bruce J. The Photograph Studio, The
Metropolitan Museum of Art.
    CY 11; CY 12; CY 14; CY 16; CY 18; CY 19;
    CY 21; CY 22; KH 1a; KH 1b; KH 2; KH 3;
    KH 7; PY 1; PY 3; PY 5; PY 6; PY 7; PY 14;
    PY 17; PY 18; PY 19; PY 20; PY 21; PY 23; PY 28

Seiji Shirono.
    CY 15; AH 24

*Sekai tōji zenshū* (Ceramic Art of the World). Tokyo:
Shogakukan, 1980. vol. 19.
    CY 25: pl. 126, p. 150; CY 27: pl. 186, p. 188;
    CY 28: pl. 60, p. 85

Shimada Shūjirō and Yoshitaka Iriya, eds. *Zenrin
gasan.* Tokyo: Mainichi shinbun, 1987.
    KH 14: no. 89 p. 281

*Sŏul Taehakkyo Pangmulgwan sojang Han'guk
chŏnt'ong hoehwa* (Korean Traditional Paintings in
Seoul National University Museum). Seoul: Seoul
National University Museum, 1993.
    YS 4: pl. 1, p. 18

*Tae Koryŏ kukpojŏn* (The Great Koryŏ Exhibition).
Seoul: Ho-Am Art Museum, 1995.
    AH 18: pl. 53, p. 57

Takeda Kazuaki.
    PY 27

*Tanwŏn Kim Hong-do.* Seoul: Samsung Foundation
of Culture, 1995.
    AH 35: pl. 168, p. 136; YS 23: pl. 43, p. 35; YS 24:
    pl. 99, p. 81; YS 25: pl. 4, p. 14; YS 26: pl. 72, p. 55

Tenri Central Library, Tenri University, Nara.
    AH 19; KH 4; KH 17

*Tō Ajiya no hotoketachi* (Buddhist Images of East
Asia). Nara: Nara National Museum, 1996.
    AH 13: pl. 194, p. 199; PY 26 : pl. 213, p. 214

Tokyo National Museum.
    AH 17; AH 21; CY 23; KH 15; PY 13

The University Prints. Winchester, Massachusetts.
    JB 1

White, Bruce. Montclair, New Jersey.
    KH 5; KH 8

Yi Sŏng-mi.
    YS 3; YS 6; YS 7